CLARENDON STUDIES IN THE HISTORY OF ART

General Editor: Dennis Farr

ALESSANDRO VITTORIA AND THE PORTRAIT BUST IN RENAISSANCE VENICE

Remodelling Antiquity

THOMAS MARTIN

CLARENDON PRESS · OXFORD

1998

Oxford University Press, Great Clarendon Street, Oxford OX2 6DP

Oxford New York

Athens Auckland Bangkok Bogotá Buenos Aires Calcutta
Cape Town Chennai Dar es Salaam Delhi Florence Hong Kong Istanbul
Karachi Kuala Lumpur Madrid Melbourne Mexico City Mumbai
Nairobi Paris São Paolo Singapore Taipei Tokyo Toronto Warsaw

and associated companies in
Berlin Ibadan

Oxford is a registered trade mark of Oxford University Press

Published in the United States
by Oxford University Press Inc., New York

British Library Cataloguing in Publication Data
Data available

Library of Congress Cataloging in Publication Data
Martin, Thomas.
Alessandro Vittoria and the portrait bust in Renaissance Venice:
remodelling antiquity / Thomas Martin.
(Clarendon studies in the history of art)
Includes bibliographical references and index.
1. Vittoria, Alessandro, 1524–1608—Criticism and interpretation.
2. Busts, Renaissance—Italy—Venice. 3. Classicism in art—Italy-Venice.
I. Title. II. Series.
NB623.V6M37 1998 730'.92—dc21 97-43407
ISBN 0-19-817417-9

1 3 5 7 9 10 8 6 4 2

Typeset by Best-set Typesetter Ltd., Hong Kong
Printed in Great Britain
on acid-free paper by
Butler & Tanner Ltd, Frome and London

To Gretchen

PREFACE

John Pope-Hennessy rightly described Alessandro Vittoria as a 'great, but difficult' artist; this has resulted in relatively little scholarly attention having been devoted to him. In many ways, the earliest account of Vittoria's career remains the best: the biography by Tommaso Temanza in his *Vite dei più celebri architetti e scultori veneziani*, published in Venice in 1778. The most thorough single work on the artist is the edition of Temanza published in 1827 by Gianantonio Moschini. Because Moschini had access to Vittoria's account book, which he discovered in the archives of S. Zaccaria, he was able to add much documentary detail to Temanza's biographical outline.[1] Moschini's edition of Temanza provides a good, solid appreciation of the artist's career and art.

In the early nineteenth century, Count Benedetto Giovanelli wrote a life of Vittoria that is primarily an example of Trentine *campanilismo* and little else.[2] The accurate information in it derives from either Temanza or Moschini; the parts provided by Giovanelli are often pure fancy.

In 1908 Riccardo Predelli published the vast amount of documentation in the Venetian archives that derives from Vittoria's personal papers, including the artist's account book.[3] Beyond a few minor errors, Predelli's transcriptions are impressively faithful. Even so, these documents have yet to be utilized to their full extent to shed light on Vittoria's career.

In 1923, Luigi Serra's monograph on Vittoria appeared and it remains the only full monograph.[4] The book is by now seriously out of date, and is marred by Serra's lack of sympathy for the artist's monumental works. Although the author considers the portrait busts to be Vittoria's greatest achievement, he provides little more than a list of them, arranged in questionable chronological order in his narrative. He makes no attempt to set them in an historical or cultural context, nor do his analyses of the objects themselves amount to more than generalized praise for their 'lifelikeness'.

Leo Planiscig's chapter on Vittoria in *Venezianische Bildhauer der Renaissance* (of 1921) and Adolfo Venturi's chapter in *Storia dell'arte italiana* (of 1937) provide good surveys but are necessarily brief and summary.[5] Francesco Cessi's five booklets on the artist—the most recent published study of Vittoria—are full of mistakes, misrepresentations, and misattributions.[6] Finally, Manfred Leithe-Jasper's unpublished dissertation dating from 1963 is a serious and detailed examination of Vittoria's monumental sculpture.[7] The portrait busts—which, ever since Vasari, have been considered the glories of Vittoria's career—have never been studied in and for themselves.

This book attempts to inaugurate serious study of the busts. Basic information on them is often lacking, and, more importantly, visual knowledge of them is misleading. If one wants

[1] See Martin (1988), p. 5, n. 12.

[2] Giovanelli was a Trentine antiquarian who lived from 1776 to 1846; see Ambrosi (1894), pp. 221–3. He finished his manuscript in 1830, and it was published posthumously by Tommaso Gar in 1858; see Giovanelli (1858), p. ii.

[3] Predelli (1908), pp. 1–265.

[4] Serra (1923).

[5] Planiscig (1921), pp. 435–524; Venturi (1937), pp. 65–179.

[6] The busts are discussed in Cessi (1961*b*) and Cessi (1962).

[7] Leithe-Jasper (1963).

to acquaint oneself with the portraits, the best photographic sources available remain the publications by Planiscig, Venturi, and Cessi. To my eyes, of the twenty-three busts illustrated by Planiscig, only ten are actually by Vittoria; of the twenty-four illustrated by Venturi, only sixteen are autograph, and of the forty-three in Cessi, only twenty-five can be described as being from the master's hand. This is why my book includes not only a contextual examination of the phenomenon of the sixteenth-century Venetian portrait bust as popularized by Vittoria, but a detailed catalogue of the works as well.

Vittoria is a challenging artist because he worked in various media and genres. Neither he, nor late sixteenth-century Venetian art as a whole, can be appreciated until all aspects of his *œuvre* have been studied. I hope that my work advances knowledge of Venetian Renaissance art.

The first version of this work appeared as a dissertation at Columbia University, where my principal adviser was David Rosand. He aided me in countless ways and it gives me great pleasure to acknowledge here his help and his friendship. The Gladys Krieble Delmas Foundation have helped me on two separate occasions, first in 1984–5 when I was awarded a grant that allowed me to live in Venice during that year; the primary research on which the catalogue is based could never have been done without that extended residence *nelle lagune*. The Delmas Foundation assisted me yet again in the summer of 1994 so that I could travel to Venice to gather together various loose ends for this book. Most of the additional research and writing that transformed (I hope) a dissertation into a book was carried out at the Metropolitan Museum, which awarded me a J. Clawson Mills Senior Fellowship in 1991–2, and I especially thank my hosts at the museum, the Department of European Sculpture and Decorative Arts, whose chair is Dr Olga Raggio. My friends in ESDA have been tremendously supportive over the years, and the department remains a home for me in many deeply felt ways. I also owe great gratitude to the staff of the Watson Library at the Metropolitan Museum, especially to the late Patrick Coman. I am likewise indebted to the staffs of the Biblioteca del Museo Civico Correr, the Biblioteca Nazionale Marciana, and the Archivio di Stato, all in Venice. The University of Tulsa has aided the completion of this book by various small grants.

The debts one acquires in a project such as this are in many ways pleasures. I would like particularly to mention Anne Ashby (my editor), Andrea Bayer, Bruce Boucher, James David Draper, Peta Evelyn, George Knox, Michael Knuth, Manfred Leithe-Jasper, Susan Rainey, Sally Spector, Gianfranco Toso, and Tinina and Maurizio Vogliazzo. When I began my dissertation, my other supervisor was Howard Hibbard. I would surely have profited greatly from his advice, as also from that of another very missed adviser, Milton Lewine. My interest in Vittoria was kindled by work on Bernini. I was extremely fortunate to have worked on Bernini with Margot Wittkower, whom I would like to remember here. I would also like to remember my mother, Catherine Martin, who died in May 1994 and who thus did not see the completion of this project. Since 1992, my life has been happier than I ever thought possible, and thus my greatest thanks go to my wife, Gretchen Porter Wold, for all of her support, and for her proofreading. The writing of the book was in essence completed by the autumn of 1994.

March 1996 T. M.

CONTENTS

PART I. THE SIXTEENTH-CENTURY VENETIAN PORTRAIT BUST AND VITTORIA

PART II. CATALOGUE

LIST OF PLATES

1. Giulio del Moro, busts of Doges Ziani and Memmo, façade of S. Giorgio Maggiore, Venice (Böhm 3580)

2. Follower of Palladio (?), monument of Doge Leonardo Donà (d. 1612), S. Giorgio Maggiore, Venice (Böhm 3671, dtl.)

3. Alessandro Vittoria, monument of Vincenzo Morosini (busts of sons are later additions), S. Giorgio Maggiore, Venice (Fondazione Giorgio Cini, Istituto di storia dell'arte, 24598)

4. Monument of Doge Domenico Michiel, tomb by B. Longhena (c.1640), bust by G. B. Paliari, in passageway to right of tribune, S. Giorgio Maggiore, Venice (Böhm 4606)

5. G. Gnoccola, bust of Doge Carlo Contarini (d. 1656), over portal of S. Vidal, Venice (Böhm 4918)

6. Tomb of Benedetto Brugnolo (d. 1505), S. Maria Gloriosa dei Frari, Venice (The Conway Library, Courtauld Institute of Art, B72/1930)

7. Bartolomeo Bergamasco, bust of Matteo de' Eletti, Cà d'Oro, Venice (orig. S. Geminiano, Venice) (Alinari/Art Resource)

8. Bust of Agnesina Badoer Giustinian, Widener Collection, © Board of Trustees, National Gallery of Art, Washington, DC (Museum photo)

9. Mino da Fiesole, bust of Piero de' Medici, Museo Nazionale del Bargello, Florence (Alinari/Art Resource 2738)

10. Michelangelo, bust of Brutus, Museo Nazionale del Bargello, Florence (Alinari 2718)

11. Baccio Bandinelli, bust of Duke Cosimo I, Museo Nazionale del Bargello, Florence (Alinari 4770)

12. Benvenuto Cellini, bust of Duke Cosimo I, Museo Nazionale del Bargello, Florence (Alinari 2662)

13. Bust of Emperor Caracalla, Museo Archeologico Nazionale, Naples (Alinari/Art Resource, AN 23058)

14. Leone and Pompeo Leoni, bust of Emperor Charles V, Museo del Prado, Madrid (Museum photo)

15. Bust of Hercules, Emperor Commodus as model, Musei Capitolini, Rome (Alinari/Art Resource AL1549)

16. G. M. Cavalli (?) or Andrea Mantegna (?), portrait of Andrea Mantegna, S. Andrea, Mantua (Alinari/Art Resource AL18657)

17. Antico (Pier Jacopo Alari-Bonacolsi), 'Youth', Liechtenstein Collection, Vaduz (by gracious permission of His Serene Highness, the Prince of Liechtenstein)

18. Antico (Pier Jacopo Alari-Bonacolsi), 'Young Marcus Aurelius', Collection of the J. Paul Getty Museum, Los Angeles, California (Museum photo)

19. Ludovico Lombardo, bust of an ancient Roman, Liechtenstein Collection, Vaduz (by gracious permission of His Serene Highness, the Prince of Liechtenstein)

20. Simone Bianco, bust of an ancient Roman, Musée du Louvre, Paris (© Réunion des musées nationaux)

LIST OF ABBREVIATIONS

ASV	Venice, Archivio di Stato
b.	busta
c.	carta
fasc.	fasicle
fo., fos.	folio, folios
m.v.	*more veneto*
proc.	protocol

PART I

THE SIXTEENTH-CENTURY VENETIAN PORTRAIT BUST AND VITTORIA

1

PROBLEMS OF THE ORIGIN OF THE VENETIAN PORTRAIT BUST

IT often seems, when visiting Venice today, that there is scarcely a church in the city lacking some kind of memorial featuring a portrait bust. Standing in the Piazzetta, for instance, between the Ducal Palace and the Libreria, and looking across the Bacino at Palladio's church of S. Giorgio Maggiore, one sees two monuments on its façade, each of which bears a bust (Pl. 1). In S. Giorgio itself, one finds tombs on the inside façade (Pl. 2), at the foot of the left-hand aisle, over the door leading to the campanile (Pl. 3), and in the passageway leading to the sacristy (Pl. 4), each of which again displays a portrait bust as its crowning feature. The same situation obtains in other parts of the city. The route from the Piazza S. Marco to the Accademia leads past the church of S. Vidal, where a bust perches directly over the entrance portal (Pl. 5). Another bust similarly set over the entrance appears on the façade of S. Salvatore, near the Rialto Bridge.

It comes, then, as something of a surprise to learn that, in marked contrast to Florence and Rome, the sculptured portrait bust almost did not exist in Venice prior to the 1550s. Indeed, almost all of the above-mentioned items date from the seventeenth or eighteenth century. The pattern for the Venetian genre of a monument whose main feature is a portrait bust was set by the tomb of Giovanni Battista Ferretti, in S. Stefano (Pl. 48), where the original bust was made by Alessandro Vittoria in 1556–7.[1]

Vittoria (1524/5–1608) was, together with his contemporary Giambologna, the foremost sculptor of the late sixteenth century in Italy. While he worked in many media and genres, his portraits have enjoyed particular critical acclaim since Vasari first praised them. Vittoria popularized the genre of the portrait bust in Venice during the second half of the sixteenth century, transforming it into the dominant mode of sculptured portraiture, and exerted a near monopoly on its production. These busts have been justly termed one of the greatest contributions Venice made to the history of sculpture.[2] In terms of the extent and breadth of his portraiture, the only other Italian sculptor to produce a comparable œuvre was Bernini in the next century. While Bernini's work has long been recognized and acclaimed for the vivacity and mobility he imparted to his sitters, his immediate forerunner was Vittoria. Although Bernini apparently never encountered Vittoria's work, he counts none the less as the only true continuer of the latter's achievement as a portraitist, since Vittoria's immediate followers and the members of his school were uninspired imitators rather than innovators.[3]

[1] A copy was put in place in the 18th cent.; see Ch. 4 below, and cat. no. 6.

[2] Pope-Hennessy (1980), p. 331.

[3] Lavin (1968), p. 239 and n. 107, posits that there was influence on Bernini from Vittoria, although conceding that 'comparisons with Vittoria's portraits are never very precise; the relationship was one of spirit rather than detail'. Since Bernini never visited Venice, it is hard to see how, as Lavin would have it, the bust of

Prior to Vittoria's appearance on the scene, the portrait bust was not an established art form in Venice, and the way in which the status and popularity of the genre changed has until now received little attention. A recent survey of Venetian Renaissance art rightly notes the 'low esteem' in which most patrons regarded portrait busts and observes that this situation changed only in the latter part of the sixteenth century; the author notes, however, that the reasons for this reversal remain 'obscure'.[4] If, however, both the immediate local background to this event, as well as the larger artistic and social context in which it occurred, are examined, it is possible to begin to understand the phenomenon of the Venetian portrait bust in the Renaissance.

Vittoria's innovation at the Ferretti monument brought about a marked change in the appearance of Venetian tombs, the preferred formats for which in the fifteenth and sixteenth centuries consisted of either a plain sarcophagus or a sarcophagus mounted by a gisant figure. Only two portrait busts survive that were on public display in the city prior to Vittoria's bust of Ferretti: that of Benedetto Brugnolo, still *in situ* on his tomb in the Frari (Pl. 6), and that of Matteo de' Eletti (Pl. 7), originally in S. Geminiano and now in the Cà d'Oro. Brugnolo was a humanist from Verona who taught for forty years at the School of S. Marco. After he died on 7 July 1502, his monument was set up by Giovanni Querini in 1505, as attested by the tomb's inscription.[5] Brugnolo's marble bust, which consists of a head and a very small torso, forms but one visual element of the tomb's many-tiered architecture. The under-life-size bust, which rests on a base above the trapezoid-shaped inscription, lies on the central axis of the monument, surrounded by a circular frame set in a long, rectangular panel. Above this panel, a plain frieze supports the base for Brugnolo's box-like sarcophagus, on top and to either side of which lie small piles of fictive books. The sarcophagus is in turn set in an architectural frame that culminates in a rounded pediment with rosettes on its intrados. The tomb's resemblance to that of Giovanni Battista Bonzio (executed 1525–6) in SS Giovanni e Paolo—in its silhouette, the shape of the inscription at the bottom, and the use of roundels in *antico rosso*—has often been remarked and, because the Bonzio tomb has been attributed to Giovanni Maria Mosca, the Brugnolo tomb has also been ascribed to him; 1505, however, is much too early for Mosca to have been doing anything, and the Brugnolo tomb is best characterized as being from the school of Pietro Lombardo.[6]

The bust of Eletti, sculpted by Bartolomeo di Francesco Bergamasco, was made some time before 17 June 1525, when it is recorded as being in place in S. Geminiano.[7] Eletti was the parish priest of that church, one of the oldest in Venice which, before its destruction in the nineteenth century, stood directly opposite St Mark's. Starting in 1505, Eletti saw to the reconstruction of the church by Cristoforo da Legname. Bartolomeo Bergamasco was a sculptor of some distinc-

Cardinal Gasparo Contarini (which is not, in any case, by Vittoria; see cat. no. 69) could have influenced Bernini. Bernini's busts of Venetian subjects—Cardinal Giovanni Dolfin and Cardinals Agostino and Pietro Valier—were all made in Rome and sent to Venice; see Wittkower (1981), no. 16, p. 182, and no. 25, pp. 194–5. Martinelli (1956), p. 31, unconvincingly argued that Bernini was familiar with busts by Vittoria via Camillo Mariani, a view rightly doubted by Wittkower (1981), no. 24*b*, p. 192.

[4] Wolters and Huse (1990), p. 159.
[5] For the inscription, see Chavasse (1988), p. 456.

[6] Mosca was apprenticed to the Paduan Giovanni Minello in 1507 and his first documented work comes from 1516. He was born around 1495 in Padua and thus was not working on the Brugnolo tomb in 1505; for Mosca's dates, see Rigoni, 'Notizie riguardanti Bartolomeo Bellano e altri scultori padovani', in Rigoni (1970), pp. 127–8 and 138–9. Schulz (1985), pp. 75–110, has attributed the Bonzio tomb to Paolo Stella.
[7] Schulz (1984), pp. 257–74, provides an in-depth discussion of what is known about Bartolomeo and his work. On p. 257, she transcribes the letter that documents Eletti's bust as being already in S. Geminiano. Eletti's name is sometimes given as 'Matteo dai Letti'.

tion in Venice during the 1520s who died between September 1527 and December 1528; he supplied all three statues for the high altar of S. Geminiano and two statues on the high altar of S. Rocco. Although the commissioning of Eletti's bust is not documented, it was most probably made after the sitter's death on 14 September 1523. The portrait was located between two columns, just to the left of the high altar. Whether this marked a memorial to Eletti or his actual tomb is not known.

In comparing these two portraits with each other, a difference in quality is quickly discernible. The bust of Benedetto Brugnolo reads as little more than a worked-up death-mask, and while that of Eletti may also derive from a death-mask, its larger scale and more thought-out composition, enlivened by the turn of the sitter's head and the stole draped over his shoulders, make it easily the more impressive work.

It is hard, none the less, to see either the *Brugnolo* or the *Eletti* as precursors to Vittoria's production. The Brugnolo tomb especially, where the physically small portrait is set near the bottom of the whole ensemble, follows an entirely different approach from the Ferretti monument, in which the portrait bust dominates the composition. Indeed, while Brugnolo's tomb takes its place in a long series of Venetian wall tombs featuring a sarcophagus as their principal element, its particular use of a portrait head remains unique in Venetian art, with no reflections in any later tombs. In contrast, the original location of Eletti's bust between two columns in S. Geminiano suggests that it was the dominant element of the original design, since the space would have been far too narrow for any elaborate architectural framework. None the less, the *Eletti* too seems to have had no influence on later monuments, for no other Venetian tomb or memorial features a portrait bust until the *Ferretti*.

Is the evidence, however, incomplete because many objects like the Brugnolo and Eletti busts have been lost? Francesco Sansovino's great guidebook of 1581, *Venetia, città nobilissima et singolare*, plus its later editions and successor guidebooks, offers quite a full inventory of memorials in Venetian churches. An examination of these sources shows not that numerous portrait busts from Venetian churches have been lost, but that almost none existed prior to the Ferretti monument.[8] Although Sansovino makes no reference to Brugnolo's tomb, he specifically mentions Eletti's bust as being in the presbytery of S. Geminiano; it is due to him that the bust's original location is known. Sansovino devotes particular attention to tombs and other memorials, and if there had been busts like that of Eletti in other churches, he would say so. Thus the best available evidence indicates that the images of Brugnolo and Eletti were the only public portrait busts in Venice prior to 1557.[9]

Portrait busts commissioned for private display seem to have been more common. On 15 March 1526, the Marquis of Mantua (Federico Gonzaga, the son of Isabella d'Este, who in 1530 became the first Duke of Mantua) asked his agent in Venice to commission bronze 'heads'

[8] Some lost sculptures have been mistakenly called busts in the secondary literature. An example would be the tomb of Doge Pietro Lando in S. Antonio di Castello, destroyed with the church in the early 19th cent. Planiscig (1935*b*), p. 353, states that Pietro da Salò carved a bust of the Doge for this tomb. But both Vasari and Sansovino clearly state that Salò's image of the Doge was a standing full-length figure; see, respectively, Vasari (1878–85), vii, p.

517, and Sansovino (1664), p. 32. It is known from Sansovino, that there were many standing tomb figures that now are lost or destroyed. If there had been many busts, it is to be expected that they would be known about as well.

[9] I thus disagree with Wolters's suggestion that memorials featuring busts came into fashion in Venice during the 1520s; see Wolters and Huse (1990), p. 169.

of six famous military leaders.[10] Gonzaga was the captain-general of the Venetian armies, and this must be why he ordered bronzes of the men listed in his letter: Gattamelata, the Count of Carmagnola, Bartolomeo Colleoni, Bartolomeo d'Alviano, Niccolo Piccinino, and Roberto Sanseverino, all of whom, with one exception, were his fifteenth-century predecessors as captains-general of the Venetian armies.[11] When Gonzaga's agent in Venice replied to him on 22 March 1526, he stated that he had spoken to 'the most excellent masters' in Venice about making bronze heads and that they all quoted a similar price. He added that there was one particularly good master (whom he did not name) who had shown him heads of Doge Grimani and Cardinal Grimani 'which were made recently and could not be more beautiful'.[12]

Just the preceding month, Marino Sanudo had mentioned these same Grimani busts. On the evening of 1 February 1526 Sanudo had gone with Doge Andrea Gritti and many other members of the Signoria to S. Maria Formosa for vespers. (The Doge always went to S. Maria Formosa on the eve of the Purification of the Virgin, 2 February; this was one of the regular ducal processions (*andate*) made to various Venetian churches.[13]) He writes that the new pastor there had fitted up the church for this ceremony with items apparently either borrowed from the nearby palazzo Grimani or left to the church by Cardinal Domenico Grimani. Besides several pieces of gold cloth, and some pictures said to have been made in Rome by Michelangelo, Sanudo saw 'two bronze portraits, life size from the bust up, of the Doge Antonio Grimani and of his son Cardinal Grimani'.[14] These images, since Gonzaga's agent says they were recently made, must have been posthumous, Doge Antonio Grimani having died on 7 May 1523, and his son Cardinal Domenico having died in Rome on 27 August 1523. Cicogna saw a bronze bust of the Doge, still in the Grimani palace in the early nineteenth century, that was said to be the one mentioned by Sanudo.[15]

These items have not been traced. Two identifiable portrait busts of Venetian patricians from the 1540s do, however, still survive: the terracottas of Girolamo Giustinian and his wife Agnesina Badoer still in the chapel of the family villa in Roncade, outside Treviso. It has been convincingly argued that these works were commissioned by the couple's son, Marc'Antonio Giustinian, after the death of his mother Agnesina in late 1542.[16] Later bronze versions of the *Girolamo* exist in the Louvre and in the Hermitage; bronze versions of the *Agnesina* are found also in the

[10] The letter is printed in Bertolotti (1890), p. 55.

[11] The only false note here is Niccolo Piccinino (given as 'Nicolò Picenino'), a condottiere in the employ of Milan who was the great foe of the Venetians in the second quarter of the 15th cent. He certainly does not fit in with the other names on the list. The Marquis would seem to have made a mistake here, especially since he says he wants heads of the illustrious captains 'who served Venice (quali hanno servito alla Ill[ustrissi]ma S[igno]ria)'. Perhaps he meant to say Jacopo Picinino, who became governor-general of the Venetian army in 1453? Or perhaps he meant to say Niccolò Pittigliano, another great condottiere for Venice who, like all the others named (and like Gonzaga himself) was a non-Venetian. In ch. 12 of *The Prince*, Machiavelli, in talking about Venetian condottieri, mentions Gattamelata, Carmagnola, Sanseverino, and the 'count of Pitigliano'.

[12] Wolters in Wolters and Huse (1990), p. 159, suggests that Gonzaga's letter provides evidence of the high opinion in which Venetian portraitists were held, but I do not think the letter can be used this way. Gonzaga is writing to Venice for portraits of men who (like himself) had all commanded the Venetian army. If he had wanted portraits of Florentine military men, surely he would have made enquiries in Florence. The letter as it stands tells no more about Venetian bronze portraiture in the 1520s than that it existed.

[13] See Sansovino (1664), p. 493.

[14] Sanudo (1879–1903), xl, cols. 758–9: 'e vidi do retrati come el vivo dal busto in su di bronzo, vedelicet il serenissimo missier Antonio Grimani e suo fiol cardinal Grimani.'

[15] Cicogna (1824–53), i, p. 171. Perry (1981), pp. 218–20, describes the building campaign carried out at the palace by Patriarch Giovanni Grimani in 1567–9. On the south-east corner of the piano nobile was a room honouring Doge Antonio, which featured a marble bust of him over the fireplace. Hence, there were many images of the Doge in the palace.

[16] Lewis (1983), pp. 307–52.

Hermitage and the National Gallery, Washington (Pl. 8), while the Musée Jacquemart-André in Paris owns nineteenth-century bronze versions of both busts.[17]

This is not a tremendous number of objects, confirming how rare the portrait bust was in Venice during the first half of the sixteenth century. How this compares with bust production in the second half of the 1500s is easily seen by a list of tombs with busts that follow the *Ferretti* in 1557: Benedetto Manzini in S. Geminiano (1561; by Vittoria), Marc'Antonio Grimani in S. Sebastiano (1561; by Vittoria), Giovanni Badoer in S. Giovanni Evangelista (1560s; by Danese Cattaneo); Niccolo Massa in S. Domenico di Castello (*c.*1570; by Vittoria); Giulio Contarini in S. Maria del Giglio (*c.*1571; by Vittoria); and so on. This sudden popularity of the portrait bust marks a definite trend that stands in clear contrast to what preceded it.

The contrast operates on a formal level as well. The fifteenth-century florescence of the portrait bust originated in Florence, and the formal type employed there, what is often termed the reliquary bust, had already been codified by 1453, from which year comes the earliest such dated piece, Mino da Fiesole's *Piero de' Medici* (Pl. 9).[18] Seemingly modelled on saints' reliquaries, it is a solid, self-supporting object, finished all around, and features a straight baseline and termination that cut directly through the body, just below the shoulders (in other examples the termination varies from just below the sternum to about the level of the elbows). Mino worked in Naples and Rome as well as in Florence, and the type became widely employed. Laurana's busts for the Neapolitan court, for instance, follow this format.

The reliquary bust-type remained the dominant form in Italian (and European) sculpture well into the next century; the busts of Brugnolo and Eletti belong to this type.[19] In the sixteenth century, however, a new typology starts to appear, what is usually called the classicizing or *all'antica* bust. Its formal characteristics derive from ancient Roman busts, not from medieval reliquaries, and hence, in contrast to its quattrocento forebears, the *all'antica* bust is mounted on a socle, has a rounded termination, and is hollowed out in the back.[20] Vittoria's production, such as the *Ferretti*, participates in the sixteenth-century revival of this ancient type, which became the norm in Italian sculptured portraiture after 1550.

Michelangelo's *Brutus* (Pl. 10) has often been put forward as the catalyst for the revival of the *all'antica* bust. With its traditional date of 1539–40, it precedes by just a few years what is usually assumed to be the first cinquecento bust of a contemporary person in the *all'antica* format, Bandinelli's bust of Cosimo I (Pl. 11), which was soon followed by Cellini's bust of Cosimo dating from 1546–7 (Pl. 12).[21] I have demonstrated elsewhere that the accepted date of the *Brutus* has no basis in fact and relies on very questionable assumptions; it could easily date from a whole

[17] Boucher (1991), ii, cat. nos. 114–15, pp. 370–1, rightly rejects Lewis's attribution of the bronzes to Sansovino, agreeing with Bode's old suggestion that the works are best described as by a Venetian artist from the first half of the 1500s.

[18] Piero's bust bears an inscription that gives his age as 37, thus giving 1453 or 1454 as the date of the bust; see Zuraw (1993), pp. 317–39, esp. p. 317.

[19] The type was brought to the court of the English Henry VII, for instance, by the Florentine Torrigiani (best known as the man who broke Michelangelo's nose) who specialized in portraiture and worked in Florence, Rome, the Netherlands, and Spain as well as England. For Torrigiani see Pope-Hennessy (1971*a*), pp. 304–5 and, more recently, Galvin and Lindley (1988), pp. 892–902. The classicizing socle now on the *Eletti* is a later addition;

see Schulz (1984), p. 273, n. 54 on how the sculpture has been reworked.

[20] For these typologies, see Keutner (1969), pp. 27–8, and Lavin (1975), p. 357. While Zuraw (1993) makes a good case for interpreting Mino's bust of Piero de' Medici as an evocation of antique busts, she scants (p. 322 and n. 41) the marked morphological differences between it and the 16th-cent. *all'antica* bust.

[21] Both Keutner (1969) and Lavin (1975) accept the priority of the *Brutus* as the first classicizing bust of the Renaissance. For *c.*1544 as the date of Bandinelli's marble bust of Cosimo, see Pope-Hennessy (1970), p. 366. Cellini received a payment of 300 gold scudi for gilding his bronze bust of Cosimo in Feb. 1547; see Pope-Hennessy (1985), p. 216.

decade later. A close examination of its only source, Vasari's 'Life of Michelangelo' in the 1568 edition of the *Lives*, shows that the work was given to Tiberio Calcagni, who finished the torso and the base, only in the mid-1550s. It is furthermore highly doubtful that the *Brutus*, traditionally regarded as an anti-Medicean image, should have served as the impetus to Bandinelli's and Cellini's propagandistic busts that explicitly liken Cosimo to a Roman emperor.[22]

That the *all'antica* bust should have derived from a single source—one which, whenever it was started, remained unfinished in Michelangelo's studio in Rome until he gave it to Calcagni in the mid-1550s, and then remained in Calcagni's studio until he died in 1565—becomes even more questionable when one notices how many artists, in various places, were employing the *all'antica* mode for a variety of sitters: the already mentioned busts of Cosimo by Cellini and Bandinelli; Guglielmo della Porta's massive bust of Pope Paul III dating from 1546–7; the bust of the poet Sannazaro on his tomb in Naples dating from the late 1530s or early 1540s; Leone Leoni's bust of Charles V dating from 1553–5, made in Milan then sent to Brussels and then to Spain; Danese Cattaneo's bust of Pietro Bembo in Padua dating from 1548. It seems unlikely that all of these busts descend in a linear manner from the *Brutus*. The Metropolitan Museum, for instance, recently acquired an *all'antica* marble bust of Cosimo by Bandinelli that the museum dates to 1539–40, the exact years to which the *Brutus* is usually assigned.[23]

It is hardly surprising that Michelangelo should have employed an ancient format to depict an ancient Roman. Already in the early 1500s, the Roman tomb of the sculptor Andrea Bregno as well as that of the Bonsi brothers had appropriated the ancient sepulchral type of the *imago clipeata*, and the monument to the Satri family in S. Omobono is a copy of an ancient Roman sepulchral slab.[24] Roman types had been appropriated for a long time and the *Brutus* is not needed as a precedent for Bandinelli's or Cellini's bust of Cosimo. Ancient imperial portraits were widely available as models for Renaissance portrayals of rulers, and it has been suggested that both the *Brutus* and Cellini's *Cosimo* took their inspiration from the Farnese *Caracalla*, one of the most copied of all ancient busts (Pl. 13).[25] Bandinelli's bust of Cosimo in the Metropolitan Museum seems likewise influenced by the power and forcefulness of the *Caracalla*; this famous ancient model could easily have struck and influenced all three artists independently. Likewise, the bronze bust of Charles V by Leone and Pompeo Leoni (Pl. 14), with its socle supported by kneeling caryatids, clearly derives from a prototype such as the *Commodus as Hercules* (Pl. 15).[26] The popularity of an *all'antica* format springs from more complex reasons than the slavish imitation of Michelangelo, and any single explanation for the adoption of the Renaissance *all'antica* bust should be treated with caution. In seeking the origins of the classicizing bust in Venice, for example, the most determining factor seems to be the particular fervour manifested in Northern Italy towards the cult of the antique, which led to the production of all kinds of pseudo-antique objects.

[22] See Martin (1993*b*), pp. 67–83.

[23] See Raggio (1988), p. 26.

[24] For the Bonsi tomb, see Grisebach (1936), p. 9 and cat. no. 1. For the Satri tomb, see Panofsky (1964), pp. 69–70. For Bregno's tomb, see Schütz-Rautenberg (1978), pp. 64–8.

[25] See Fittschen (1985), pp. 410–11.

[26] The use of such a model provides in this case an ideological message by depicting the current Holy Roman Emperor as the direct descendant of the ancient Roman emperors. For Leone's bust of Charles V, which was finished by Dec. 1553, see *Leoni* (1994), no. 3, pp. 112–14. The bust of Commodus was not discovered until 1874; see Jones (1926), p. 142.

Ever since Vasari, it has been frequently stated that Venetian artists were interested in colour (*colorito*), not in drawing (*disegno*); nevertheless, the earliest collections of drawings assembled by non-artists were formed in the Veneto.[27] Similarly, it has often been argued that the Venetians did not study or understand the works of antiquity. In fact, the two issues are often made to depend on each other. The *locus classicus* (or at least *florentinus*) for such sentiments comes at the begining of Vasari's 'Life of Titian' where the author criticizes the practice begun by Giorgione of working without preliminary drawings. The artist who draws, says Vasari, 'need not conceal under the charm of his colouring his lack of knowledge of how to draw, as for many years (having never seen Rome or any completely perfect works of art) did the Venetian painters, Giorgione, Palma, Pordenone, and the rest'.[28] In the opening pages of his life of Alessandro Vittoria, Tommaso Temanza addresses precisely this issue. They are greatly mistaken, he writes (in evident response to Vasari), who claim that Venetian artists of the sixteenth century had little skill in *disegno* because they never saw antique statues. As proof of his assertion, Temanza advances Vittoria, who became one of the greatest sculptors of his age although he not only never went to Rome, but never even travelled outside Venetian territory.[29]

Temanza does not argue that Vittoria had no need to study the antique, but rather that he had ample resources for doing so in Venice itself:

The Venetians, who were so zealous in conquering territories in the east to increase their commerce, were not so naïve, as some people claim, to neglect to transport into this metropolis the most precious remains of antiquity, among which one can count a goodly number of statues, bas-reliefs, and medals, which, dispersed among the houses of the nobles, in churches, and in other public places, were repeatedly copied by artists.[30]

Just as the first collections of drawings were formed in the Veneto, so was one of the first public museums of ancient sculpture instituted in Venice: the Statuario Pubblico, donated to the Republic by Patriarch Giovanni Grimani.[31]

The Grimani donation, which still forms the nucleus of the present-day Museo Archeologico in Venice, was made in two parts. Following the death of Cardinal Domenico Grimani in Rome in 1523 (the same man whose bronze bust was displayed in S. Maria Formosa in 1526), sixteen pieces of sculpture from his collection were given to the Serenissima; eleven of these objects were portrait busts. They were placed in a room on the second floor of the Ducal Palace which was known, because of the preponderance of the busts, as the Sala delle Teste.[32] Of the eleven busts, two are now recognized as sixteenth-century copies or imitations.[33] The second part of the donation came in 1587 when Domenico's nephew, Giovanni Grimani, the Patriarch of Aquileia, gave his entire collection of antiquities to the city of Venice.[34] Out of the sixty-three busts given by the Patriarch Giovanni, eleven are now designated as works of the Renaissance.[35]

[27] For a discussion of the *disegno-colorito* controversy, see Rosand (1982), pp. 15–26. For the collections of drawings in the Veneto, see Held (1963), p. 78.

[28] Vasari (1878–85), vii, pp. 427–8.

[29] Temanza (1778), p. 477. Vittoria did, however, visit Ferrara at least once; see Ch. 3, below.

[30] Ibid., p. 476.

[31] See Perry (1972), pp. 75–150.

[32] See Perry (1978), pp. 215–44.

[33] Traversari (1968), p. 102, no. 85, and p. 108, no. 98.

[34] See Perry (1972), pp. 78–82.

[35] See Traversari (1968), p. 101, no. 83; p. 102, no. 84; p. 104, no. 87; p. 106, nos. 92 and 93; p. 107, nos. 94 and 95; p. 108, no. 97; p. 109, nos. 99, 100, and 101.

Two additional portrait busts that entered the Statuario Pubblico in the latter part of the sixteenth century are also now catalogued as copies or fakes.[36]

The Grimani collections demonstrate how prevalent the practice was in the Veneto of making pseudo-antique busts. Moreover, the presence of such objects in the donation of Cardinal Domenico in 1523 shows that such activity was already going on in the first quarter of the century. It should be noted that this was not due to a lack of perspicuity on the part of Renaissance collectors: many of these objects were not identified for what they really are until the nineteenth or twentieth century.[37]

Antiquities were sought after and collected in the Veneto with a special keenness. As Roberto Weiss has pointed out, Venice was in the forefront among Italian cities in the collecting of antiquities in the fifteenth century; several collections had already been formed there by the first half of the quattrocento.[38] It was only with the Venetian Pietro Barbo—first as a cardinal and later as Pope Paul II—that large-scale collecting of antiquities began in Rome.[39]

A nexus clearly exists between the collecting of antiquities and the making of portrait busts (and other objects) *all'antica*. This connection forcefully appears at the court of Isabella d'Este in Mantua where antique and modern art were displayed side by side as equals, providing a fertile and receptive environment for classical revivals.[40] It was there, in the relief of Mantegna on his tomb, that the earliest *all'antica* portrait of a contemporary, historical person can be seen (Pl. 16).[41] It is there as well that a fellow court artist of Mantegna, Antico, fashioned a revival of the classical sculptured portrait.

Six *all'antica* busts, all in bronze, are generally ascribed to Antico's hand: *Antoninus Pius* (Metropolitan Museum), *Bacchus* and *Ariadne* (Kunsthistorisches Museum), '*Cleopatra*' (Museum of Fine Arts, Boston), a '*Youth*' (Pl. 17; Liechtenstein Collection, Vaduz), and '*Young Marcus Aurelius*' (Pl. 18; Getty Museum.).[42] What are sometimes termed Antico's copies and restorations of ancient Roman busts have been cited as antecedents for the *Brutus*.[43] But while Antico did restore and copy antique sculptures, such verbs hardly describe the status or nature of the above objects: these 'copies' of ancient art are highly expensive and luxurious pieces made on commission. Moreover, of the six busts listed above, only the '*Young Marcus Aurelius*' has a specific, identifiable antique model.[44] Although no individual source has been identified for the bust of *Antoninus Pius* in New York, it is closely based on antique prototypes, in conformance with the widespread interest during the Renaissance in the iconography of the first twelve Caesars.[45] Intriguing antique parallels have been found for the '*Cleopatra*' and the *Ariadne*, while none have yet been

[36] See Traversari (1968), p. 104, no. 88, and p. 105, no. 90.

[37] Kurz (1982), p. 182, reminds the reader that Renaissance *all'antica* objects prove that Max Friedländer's dictum about the life of a forgery being roughly 30 years, is not always so.

[38] Weiss (1969), p. 200; these collections have now been discussed in Zorzi (1988), pp. 15–24, and by Favaretto (1990), ch. 3.

[39] Weiss (1969), p. 186.

[40] For the antiquarian climate at Isabella's court, see Fletcher (1981), pp. 51–63, with earlier bibliography.

[41] For the portrait of Mantegna, see the entry by Anthony Radcliffe in *Mantegna* (1992), no. 1, p. 90, with earlier bibliography. Fictive depictions of Roman sculptured portraits abound in Mantegna's paintings, such as the busts of the Caesars on the

ceiling of the Camera Picta; for the latter, see Lightbown (1986), cat. no. 20, pp. 415–19. Mantegna's father-in-law, Jacopo Bellini, made one drawing of Roman sepulchral *clipeatae* reliefs in his famous notebooks; see Eisler (1989), pl. 84 and pp. 206–11.

[42] For a chronology and discussion of the busts by Antico, see Draper (1985), pp. 209–12, no. 133, and id. (1987), pp. 257–60. See now also Allison (1993–4), pp. 35–310, esp. pp. 54–6 and cat. nos. 30–42.

[43] Keutner (1969), p. 28, and Lavin (1975), pp. 357–8, n. 7.

[44] Fittschen (1990), pp. 113–26.

[45] For the *Antoninus Pius*, see Draper (1985), p. 211, and Allison (1993–4), pp. 251–4. On the interest in the twelve Caesars, see Middeldorf (1979), p. 297, and Ladendorf (1958), pp. 35 and 98.

suggested for the *Bacchus* and the '*Youth*'.[46] The latter are Antico's creations, works of art that derive from antiquity but have no specific model or prototype.[47] They are poetic inventions, and, in their imaginative use of antiquity, their closest comparisons lie in the ancient world depicted in Mantegna's paintings.

In terms of their historical significance, none the less, these busts are just as original and innovative as the *Brutus*, a sculpture likewise derived from, but not copied after, an antique prototype.[48] Probably the private, poetic, gem-like character of these bronzes by Antico has placed them in the shadow of Michelangelo's rough, heroic *Brutus*. Yet they precede the *Brutus* by a good thirty to forty years and, in their subtlety of modelling and pose, they present a psychological sophistication and physical presence all their own. Finally, although the busts by Antico are not over-life-size, as is the *Brutus*, they are life-size and thus different in type from contemporary miniature heads of classical inspiration.[49]

Antico's bronzes demonstrate the demand for, and appreciation of, pseudo-antique portraits.[50] The cult of the antique was also strong in Venice, and *all'antica* busts enjoyed quite a vogue there as well as in Mantua.[51] Although it seems surprising that Tullio Lombardo, who made *all'antica* relief portraits, never fashioned a bust in that style, his nephew Ludovico (1507/8–75) produced at least one very impressive example (Pl. 19).[52] An older contemporary of Ludovico who specialized in pseudo-classical sculptures and by whom a number of works survive is Simone Bianco (*c.*1490–1555), a Tuscan by birth who conducted his career in Venice. Six works by Simone—all signed in Greek—survive; significantly, they all are *all'antica* portrait busts.[53]

When Simone began his production of busts is not known, but they must have been an established part of his repertory by the time the first reference to them appears in a letter dated 25 June 1538 to Simone from Aretino. Aretino closes this letter by wishing Simone good health, as he works on a marble, 'transforming it into heads similar to those . . . sent to the king of France'.[54]

[46] Fittschen (1990), pp. 120–3.

[47] Fittschen, ibid., has rightly criticized the methodology often used to determine the extent to which a Renaissance work depends on its presumed antique model. His discovery of what does appear to be the exact model for the Getty bust makes him suspicious of the generally held view that Antico exercised considerable freedom in his versions of classical models. While his statement that 'the inability to name models [for Antico's busts] does not mean they never existed', is quite true, it is equally true that the identification of the Getty bust as an exact copy does not mean that *all* of Antico's busts must also be exact copies. A good comparison can be drawn from Antico's bronze statuettes. The model for the *Apollo* (Venice, Cà d'Oro) is the *Apollo* Belvedere; yet Antico's statuette is hardly an exact reduction of it. So here is an example where, like the Getty bust, we know the exact classical model, but, unlike the Getty bust, it is a version, not a copy. For the *Apollo*, see Legner (1967), pp. 102–18.

[48] Vasari states that it was modelled on a head of Brutus on an ancient gem belonging to Giuliano Ceserino in Rome; see Vasari (1878–85), vii, p. 262.

[49] These small-scale heads of classical inspiration form an important subgroup within the genre of the classicizing portrait bust; they also are frequently from Northern Italy. For illustrations of such objects, see Bode (1980), pls. 76, 107, 108, 244, and 253.

[50] For other Mantuan pseudo-antique busts, both in bronze and marble, that derive from Antico, see Levi (1932), pp. 276–91, and Allison (1976), pp. 213–24. Cristoforo Romano's semi-classicizing terracotta bust of Francesco Gonzaga (Mus. del Pal. Ducale, Mantua) is yet another example from this milieu; for this bust, see the entry by A. Radcliffe in *Gonzaga* (1981), pp. 140–1, no. 62. See now also Radcliffe's discussion of Gian Cristoforo Romano's career as a portraitist in Radcliffe (1992), no. 5, pp. 72–3.

[51] Ferretti (1981), esp. pp. 120–2, gives several famous and characteristic examples of the Venetian cult of the antique. On the purposeful fragmentation of statuettes to make them appear like ancient pieces, see Planiscig (1921), pp. 335–6, and Leithe-Jasper (1986), p. 146, no. 33.

[52] For Tullio's reliefs, see Luchs (1989), pp. 230–6, with earlier bibliography. For the bronze bust by Ludovico Lombardo, see Draper (1985), pp. 212–13, no. 134 and Fittschen (1985), p. 399. There are versions of Ludovico's bust in the Louvre and in Vaduz; a third version, formerly in the Pourtalès collection, is currently at Wildenstein's in New York.

[53] For an overview of Simone Bianco's life and work, see Meller (1977), pp. 199–209, and also Favaretto (1985), pp. 405–21.

[54] Aretino (1957–9), i, p. 120, letter 76.

Since the three surviving busts in France—two in the Louvre (one of Julius Caesar and the other of an anonymous Roman (Pl. 20)) and one in Compiègne—are known to have been in the royal collection, they must be the very ones referred to by Aretino.[55] By at least 1538, therefore, Simone's reputation for making *all'antica* busts was already such as to attract French royal patronage.[56]

If only a few of the many attributions to Simone are correct, his *œuvre* distinguished itself for its variety of medium and scale.[57] The signed busts—those already mentioned in France plus those in Copenhagen, Vienna, and Stockholm—demonstrate that Simone had adopted a standard style by the 1530s and probably even earlier: rounded at the bottom, hollowed-out at the back, and raised above a socle.[58] Before the traditional date of Michelangelo's *Brutus*, Simone was making *all'antica* busts that, fully signed with his own name (and hence not intended as fakes), were in demand as pseudo-antique objects, as imitations or re-creations of antiquity. For the most part these busts depict people with generically Roman-looking features and thus, like the *Brutus* and Antico's busts, do not qualify as 'true' portraits, i.e. the rendering of contemporary, historical personages.[59]

He did, none the less, make at least one portrait, unfortunately lost, of a Venetian noble-woman; the source is once again Aretino who, in a letter to Simone from May 1548, sings the praises of a bust the latter has recently made of the wife of Niccolo Molin.[60] Given that all of the surviving busts by Simone belong to the classicizing type, it would seem highly unlikely that the bust of Signora Molin was not also of this type. If this was indeed so, then, four years after Bandinelli made his classicizing bust of Cosimo, and only one or two years after Cellini made his—works that Simone could not have known—the *all'antica* bust was being employed in Venice within the circle of artists there who specialized in imitating classical art. Furthermore, it was being employed to depict not a sovereign ruler, mythological character, or ancient Roman personage, but a contemporary member of the Venetian patriciate.[61]

Although only nine years separate the bust of Molin from Vittoria's portrait of Ferretti, the work of artists who made pseudo-antique objects provides but one aspect of the complex classicizing culture of Venice in the years around 1550. While Venice had long been a site of intense interest in the antique, as attested by artists such as Simone Bianco and collectors such as Cardinal Domenico Grimani, the classicizing phenomenon shifted into a higher gear and assumed a programmatic character when, following the Sack of Rome in 1527, an attempt was made to appropriate the legacy and aura of Imperial Rome to Venice. By the 1530s, this pro-gramme had achieved official recognition and support with the architectural work of Sansovino

[55] On the royal provenance of the three busts in France, see Courajod (1884), p. 221. This sale by Simone to the King of France seems to have been well known: Vasari also mentions it in 1550; see Vasari (1878–85), iii, p. 651. To the best of my knowl-edge, no one has ever linked these three busts in France to the sale in 1538.

[56] Around this time Francis I began collecting copies and casts of antique sculpture; see Haskell and Penny (1981), pp. 1–15. For an illustration of the bust in Compiègne, see Meller (1977), Pl. 6.

[57] For other attributions (many of which are doubtful) to Simone, see Meller (1977), pp. 204–9, and also Favaretto (1985).

[58] For illustrations, see Meller (1977), Pls. 5, 7, and 11.

[59] The bust in Stockholm, however, possesses a particularity of physiognomy that suggests it depicts an actual sitter.

[60] Aretino (1957–9), ii, pp. 244–5, letter 654.

[61] Schlegel (1990), pp. 148–52, has identified a bust in a private collection as being the lost portrait of Molin. While her attribu-tion to Simone Bianco is very convincing, the features of the sitter are so generically described that it is difficult to accept the bust as the portrait of an actual person, let alone of a specific, identifiable person. It should be noted, however, that this piece is in the *all'antica* format.

in Piazza S. Marco under Doge Gritti. When, as Tafuri has written, Venice began to recover from the disasters of the War of the League of Cambrai, '*Auctoritas* was expressed through an architecture *all'antica* that was called upon to speak of political stability and a new aristocratic pride'.[62] This phase in the emulation of the antique would eventually find its purest and most renowned exponent in Palladio.

It is no accident that the demand for portrait busts coincides with the introduction of the classicizing bust in Venice. A portrait *all'antica* not only showed a devotion to the classical past, ever a status symbol among the Renaissance élite, it also marked another stage in Venice's quest during the sixteenth century to invest itself with antique *auctoritas*. The Venetian portrait bust in the Renaissance is best seen as a cultural phenomenon, and it was this culture, promulgated by an avant-garde of artists, patrons, and intellectuals, that allowed Vittoria's gifts as a portraitist to flourish. From the time he arrived in Venice from his native Trent in 1543, Vittoria formed part of this avant-garde, as did his earliest patrons who in several cases also patronized Sansovino and Palladio. While the tensions between this group and more conservative factions limited the number of commissions Palladio received in Venice, the classicizing portrait bust as expounded by Vittoria enjoyed widespread popularity and became one of the most visible elements by which Venetians could clothe themselves with the aura and trappings of the ancient world.

Another vital element in the origin of the Venetian portrait bust came not from artists such as Simone Bianco but from a group of humanists and antiquarians in Padua. It was due to their interests and efforts that, during the ten years preceding the appearance of Vittoria's bust of Ferretti on his monument (Pl. 48), the classicizing bust was revived in Padua to honour famous contemporary men. These humanists provided the precedent that was then employed by the group of Venetian patricians who commissioned classicizing portrait busts from Vittoria.

[62] Tafuri (1989), pp. 111–12.

THE REVIVAL OF THE CLASSICIZING PORTRAIT BUST IN PADUA

THE immediate preface to the florescence of the *all'antica* portrait bust lies in Padua during the years 1520 to 1550, for it was there, out of an ambitious and sophisticated antiquarian culture, that the classicizing portrait bust first appeared in the Veneto. A formative influence on the character of Paduan antiquarianism was exerted by Alvise Cornaro (*c.* 1484–1566), who, in partnership with Giovanmaria Falconetto (1468–1535) of Verona, created a piece of *Romanitas* behind Cornaro's palazzo in Padua.[1] All standard histories of Renaissance architecture cite the Loggia built there by Falconetto in 1524 as the first building in the Veneto to observe correct Roman style (Pl. 21). It was recognized as such in its own time as well, for Vasari writes that Falconetto 'was the first . . . to bring the true manner of building and the "buona architettura" [i.e. the classical style] to Verona, Venice [and other parts of the Veneto]'.[2] Significantly, Vasari also reports that Cornaro and Falconetto knew each other through Pietro Bembo, a humanist famed throughout Italy and a member of both the Venetian and Paduan cultural élites, who will appear many times in this story.[3] Due to the efforts of Cornaro and Falconetto, archaeologically accurate Roman architecture already existed in Padua before its principal promulgators in the Veneto appeared on the scene: prior to Michele Sanmicheli's return to Verona in 1526, after a long period in Rome, and before Jacopo Sansovino arrived in Venice after the Sack of Rome in 1527. Vasari astutely notes the historical connection between these three men, recognizing that Falconetto's work was furthered and deepened in turn by Sanmicheli and Sansovino.[4]

A new stage in Cornaro's emulation of antiquity was reached in the 1530s when his courtyard was enclosed by the building he called the Odeon (Pl. 22), where Cornaro himself was responsible for the architecture and the decoration.[5] Like the Loggia, the Odeon faithfully follows the canons of Vitruvius. The further step taken here is that the spatial layout of the Odeon re-creates a specific building from Roman antiquity that was assumed to be the country villa of Marcus Terrence Varro.[6] Varro was a late Republican polymath whose writings include a history of the Latin language and a book on antiquities; he was also interested in agriculture, as was Cornaro, who, in his own writings, repeatedly cites Varro's *De Re Rustica*.[7] Cicero describes Varro's country

[1] The primary work on Falconetto and his relations with Cornaro remains Schweikhart (1968), pp. 17–67.

[2] Vasari (1878–85), v, p. 324 (this occurs in the Life of Falconetto appended to the Life of Fra Giocondo).

[3] Ibid., pp. 321–2.

[4] Ibid., p. 324. Vasari also points out how this was due to the 'ruin' of Rome, meaning the diaspora of artists caused by the Sack.

[5] Wolters (1980), p. 72. Carpeggiani (1977) p. 94, suggests a collaboration between Cornaro and Falconetto on the Odeon. The building was constructed by Andrea della Valle, Falconetto's successor.

[6] Keller (1971), no. 14, pp. 29–53. As Keller notes, the building identified as Varro's house was actually part of a bath complex.

[7] Ibid., pp. 36–40.

villa as having been used for meditation, writing, and literary studies.[8] Cornaro wished his house to be, like Varro's, a retreat or home of the Muses, which explains his choice of model.

The ground-plan of what was thought to be Varro's villa was well known in the fifteenth and sixteenth centuries, and the Odeon reproduces its principal feature, a central, octagonal room bordered by four semicircular niches (Pl. 23). Not only the ground-plan, however, but also the decoration of the Odeon derived from antiquity. According to drawings of 'Varro's' villa, such as those by Giuliano da Sangallo, it was richly stuccoed, and Cornaro followed suit.[9] The stuccoes in the Odeon, by Tiziano Minio, mark the first time the Roman style of stucco was used in the Veneto. The Odeon also displays one of the earliest (if not the first) instances of *all'antica* grotesque ornament in the Veneto.[10] The great exponent of this kind of decoration was Giovanni da Udine who had revived it in Rome, in emulation of Nero's Golden House, in projects with Raphael such as the palazzo Madama, and who was to bring it to Venice at the Grimani palace near S. Maria Formosa at the end of the 1530s.[11]

Although modest in scale, Cornaro's Odeon marks the first time, in Venetian territory, that antiquity is followed in spatial layout, as well as in both the programme and medium of the decoration, while the magnificence of the stuccoes emulates both antique and modern Roman grandeur. As Gunther Schweikhart has written: 'The determination with which Cornaro adopted a new architecture and a new type of decoration derived from Roman antiquity was highly influential in the Veneto.'[12]

Cornaro provided an example for similar efforts, both private and public, that extolled antiquity in a Paduan context. Not long after the Odeon was built, one such public *all'antica* project was undertaken by the Venetian patrician Girolamo Corner (1485–1551; a third cousin of Alvise), the military governor (*Capitano*) of Padua from 1539 to 1540. Corner was an active patron, employing Sanmicheli, for instance, in work on part of the city fortifications known as the 'Bastion Cornaro'. His most significant action, however, came in 1540 when he commissioned the restoration and redecoration of the Sala dei Giganti in the grounds of the University.[13]

In the late fourteenth century, Guariento and Altichiero had headed a team of painters who used Petrarch's *De viris illustribus* as the basis for a programme of frescoes featuring thirty-six 'famous men', practically all of whom, except for figures such as Petrarch himself, were drawn from Roman antiquity.[14] By the sixteenth century, only the portrait of Petrarch was still legible, and Corner hired a new team of painters—composed of Domenico Campagnola, Gualtieri dall'Arzere (also known as Padovano; he had frescoed the octagonal room of the Odeon Cornaro), and Stefano dall'Arzere—to fresco forty-four large-scale figures, now shown

[8] See Cicero (1926), p. 169. Varro himself mentions his villa in the 3rd book of *De Re Rustica*; he gives a long description of his aviary and also mentions that there was a 'museum' on the grounds; see Varro (1934), p. 453.

[9] For these (and other) drawings, see Keller (1971), *passim.*

[10] Wolters (1980), p. 73.

[11] On Giovanni da Udine, see Dacos and Furlan (1987); pp. 165–73 discuss the pal. Grimani. Wolters (1968b), p. 271, has noted that a ceiling in the Odeon copies the layout of the antique ceiling in the Villa Adriana at Tivoli, and that, in 1539, Giovanni da Udine reused this same scheme in the Sala di Diana at the pal. Grimani.

[12] Schweikhart (1980), p. 68. See also Olivato (1980), pp. 106–10.

[13] Puppi (1977), p. 116, suggests that Sanmicheli worked in the Sala dei Giganti as well. In Puppi (1986), p. 98, it is proposed that the architect designed and built the *trifora* of the Sala in 1535–6.

[14] For an overview of this theme, see Donato (1985), pp. 97–152.

in more archaeologically correct costume and attitudes (Pl. 24).[15] Below each figure is a smaller chiaroscuro scene from that man's life and a painted inscription. Corner asked the local antiquarian Alessandro Bassano ('il Giovane') to advise the project because of the latter's vast knowledge of ancient epigraphy and numismatics; Bassano selected the subjects of the frescoes and their iconography. Significantly, almost all of the characters portrayed appear in works by the Roman historian Livy, who had been born in Padua, thereby giving the ensemble a local resonance that reinforced the city's links to its classical past, to what was called its 'patavinitas'.[16]

One of the most distinguished teachers at the University at this time was Marco Mantova Benavides (1489–1582). Having received his doctorate from Padua in 1511, Benavides was elected to the chair of law in 1515, which he occupied for almost seventy years. A figure of European reputation, he was knighted by Charles V in 1545 and served as the Paduan ambassador to Venice in 1545–6. His stature in the Paduan cultural scene derived not only from his academic and humanistic pursuits, but from his activities as a collector and patron of art as well. He was a friend of Paolo Giovio, whose collection in Como of portraits of famous men and women inspired similar collections by the Medici and Habsburgs.[17] Portraits of *uomini famosi* figured prominently in Benavides's collection as well and, doubtless inspired by Giovio's efforts to publish illustrated volumes of his portrait collection, Benavides authored a book that featured woodcuts of famous lawyers.[18] The theme of the Sala dei Giganti was hence of great personal importance to him.

As the Sala dei Giganti was undergoing its campaign Benavides built himself a new house in Via Porciglia, near both the church of the Eremitani and Pietro Bembo's house. When it came time to decorate this palazzo, around 1541, Benavides called upon the same team that had worked in the Sala dei Giganti: Domenico Campagnola, Gualtieri dall'Arzere, Stefano dall'Arzere, and Lambert Sustris as well.[19] Although nothing survives of their frescoes, eighteenth-century sources record that the entrance was painted with 'hieroglyphs', i.e. grotesques, by Stefano dall'Arzere while Campagnola painted another room with a 'Triumph of Caesar'.[20] Not surprisingly, the decoration was redolent of antiquity, as at Cornaro's Loggia and Odeon. The main body of the house was given over to Benavides's museum, which included many antique pieces.[21]

Nor was the interior of his house Benavides's only concern; like Cornaro, he too created a setting imbued with *Romanitas* in his courtyard. By 1544, the colossal *Hercules* he had commissioned from Bartolommeo Ammannati, which was far larger than any previous Renaissance

[15] See Mommsen (1952), p. 105, for the view that the work of the 16th cent. was that of complete refinishing rather than of restoration. Cf. Lorenzoni (1977), p. 41. Rossetti (1765), pp. 291–2, attributes most of the figures to Campagnola, and the others to Stefano and Gualtieri dall'Arzere. Stefano and Gualtieri were related; the latter was the brother-in-law of Tiziano Minio; see Rigoni (1970), p. 204. On Domenico Campagnola (†1569), see Puppi (1974), pp. 312–17; Puppi (1976), pp. 69–72; and Saccomani (1985), pp. 241–52.

[16] Zorzi (1962a), pp. 76–8, has traced the Livian derivation of most of the figures, observing that much of the symbolism used derives from sources Bassano knew from his numismatic studies.

[17] For bibliography on Giovio and Benavides, see Favaretto

(1990), pp. 108–15. On Giovio, see Zimmerman (1976), pp. 406–24, and de Vecchi (1977), pp. 87–93.

[18] Benavides (1566); there were Venetian editions in 1567 and 1570. On this book, see Dwyer (1990), pp. 59–70. For a survey of the broader phenomenon of biographies printed with portraits of the subjects, see Rave (1959), pp. 119–54. It was Giovio who inspired Vasari to write his *Lives* of the artists. See also Klinger (1985), p. 181.

[19] For the dating, see Puppi (1977), p. 126, and id. (1978), p. 314.

[20] Rossetti (1765), describes these projects on pp. 333–4, adding that they are 'il tutto di gusto antico'.

[21] For the inventory of Benavides's collection, see Favaretto (1972), pp. 35–164, and also Favaretto (1990), pp. 110–13, for a description of the layout of the collection.

statue, was set up (Pl. 26). Benavides was to boast many times, in both Latin and Italian, that Ammannati was 'the first since antiquity who had dared to carve a colossus'. The use of the verb 'to dare' clarifies the differing approaches of Benavides and Cornaro: while at the Odeon the past had been copied, in the courtyard of the Benavides palace it was challenged and equalled. The *Hercules* naturally not only demonstrated how great an artist was Ammannati, but how splendid his patron was as well. Benavides's role as Maecenas was proudly proclaimed by the inscription on the statue's pedestal, and he also had a number of medals bearing his own portrait placed within the base of the statue so as to link his fame with that of the colossus.[22]

The *Hercules* was but one part of a larger self-glorifying programme. Benavides also commissioned from Ammannati, probably the following year, 1545, a triumphal arch ('come que' di Roma' wrote the patron) set up on an axis to the *Hercules* (Pl. 26). In niches to either side of the arch stand statues of Jupiter and Apollo; Victories fly in the spandrels; the attic contains two reliefs, whose subject-matter remains uncertain but which probably refer to events in the patron's life from 1545.[23]

As a shrine to antiquity, the courtyard behind Benavides's palace was surely meant to eclipse and outshine that behind Cornaro's house. The courtyard has been characterized as designed to be both 'out-of-time and out-of-place': an escape back into the glorious world of the ancients. The most explicit articulation of this message occurs over the portals of the long entrance-way to the courtyard, where an inscription taken from Virgil's First Eclogue proclaims: 'Deus nobis haec otia fecit (a god has made this peace for us)'. As all good classicists would know, the god spoken of here by the shepherd Tityrus is 'Urbem quam dicunt Romam': the city they call Rome. As Davis has written, the courtyard of the Benavides palazzo 'was an antiquarian fantasy symptomatic of the romanticism that ran through Paduan antiquarianism of the 1500s'.[24]

Benavides wished to evoke antiquity not only in his earthly residence but in his final resting place as well. Immediately after the work on the courtyard was completed, he commissioned his tomb—once again from Ammannati—in the nearby church of the Eremitani (Pl. 27). It was already in place by 1546.[25] A large mural monument closely modelled on Michelangelo's Medici tombs, Benavides's sepulchre shows not one Christian image among its seven statues. At its very centre, directly below a figure of Immortality, sits a full-length stucco statue of Benavides himself.[26] The tomb is the most transparent example of how Benavides used contemporary art inspired by antiquity to redound to his own glory as a *uomo famoso*.

In 1546–7, further homage to antiquity occurred in Padua when a memorial to its most famous local son of classical times, the historian Livy, was set up in the Salone, the great room on the piano nobile of the Palazzo della Ragione in the heart of the city: Livy's memorial occupies the place of honour in the centre of the west wall. The origins of this memorial reach back to

[22] See the discussion in Davis (1976a), pp. 37–41, to which my account is deeply indebted. Portenari (1623), p. 458, states specifically that the medals bore Benavides's image. A vase of oil was also placed in the base of the statue, so that in 100 years it would become balsam, which was thought to preserve intact any substance.

[23] For information on the triumphal arch, see Kinney (1976), p. 150.

[24] Davis (1976a), p. 41.

[25] Kinney (1976), p. 134.

[26] Davis (1976a), p. 38, considers the figure of Benavides as an autograph work, in contrast to earlier scholars who have stated that the figure was fashioned after Benavides's death by someone other than Ammannati. If Davis is correct, then the seated figure of Benavides could have acted as a precedent for the seated bronze statue of Tommaso Rangone over the portal of S. Giuliano in Venice (see below, Ch. 4). Weddigen (1974), p. 51, states that Benavides and Rangone knew each other.

the first half of the fourteenth century, when a Roman grave inscription to a 'Titus Livius Halys' was discovered in the cloister of S. Giustina and accepted, erroneously, as Livy's gravestone. In 1413, a skeleton found at the same site was proclaimed, likewise erroneously, as the earthly remains of the historian himself. After having been enshrined at various sites, the inscription and bones were, by the first half of the sixteenth century, set above the external balcony of the Palazzo della Ragione, overlooking the main square of the city.[27]

They were moved from there to the Salone at the instigation of Alessandro Bassano, who has already appeared as the adviser to the project at the Sala dei Giganti, and Lazzaro Bonamico, who held the chair of Greek and Latin at the University (and hence was a colleague of Benavides).[28] Bassano was the principal driving force, however, for on 31 May 1546, the City Council assigned to him the task of seeing to the adornment of Livy's epitaph that was 'to be set up in the Palace [the Palazzo della Ragione]'.[29] It seems that at this time the architectural component was erected, containing the supposed bones of Livy and his supposed grave inscription. Further monies were given to Bassano the next year, on 30 August 1547, and the work was apparently finished by 22 September 1547, when the artist Agostino Zoppo was paid the balance for his work (Pl. 28).[30] Bassano donated the bust of Livy set at the top of the memorial: it is a copy by Zoppo of a head of Livy owned by Bassano. The small bronze figures of Minerva and Eternity, the relief of the Capitoline Wolf suckling Romulus and Remus, the reliefs of the Tiber and the Brenta as reclining river gods, and the cartouche containing an inscription composed by Bonamico, were all cast by Zoppo as well. In 1552, the decoration of the monument was completed when Domenico Campagnola painted the chiaroscuro medallions of Augustus and Tiberius (under whose reigns Livy lived) on either side of the monument.

Bassano and Bonamico were members of the same cultural élite that included Alvise Cornaro and Benavides. Alessandro Bassano il Giovane (1508–87) owned a renowned collection of inscriptions (seventy in number, now in the Museo Civico).[31] His greatest passion, however, was numismatics and, at the instigation of Pietro Bembo, he wrote a detailed study of the coins of the first twelve Caesars (never published). Like Benavides, he was a patron of Domenico Campagnola who, besides working on the Livy memorial, painted a fresco of Livy in Bassano's house, which was known as the Casa di Tito Livio because it was thought to have been Livy's home.[32] This house, which contained Bassano's epigraphical collection and whose façade and courtyard were decorated with inscriptions, was, like the residences of both Cornaro and Benavides, a shrine to antiquity. After his work on the Livy monument and on the Sala dei Giganti, Bassano acted for the third time as a civic antiquarian in 1556 when he assisted the architect Sanmicheli on a temporary arch erected in honour of Bona Sforza's entry into Padua: Bassano wrote the Latin inscriptions and chose the symbolic figures.[33]

[27] On the cult of Livy in Padua, see Ullman (1955), pp. 55–79, and Anti (1942). On the vicissitudes of 'Livy's' remains, see Anti (1942), pp. 10–15, and Frey (1955), pp. 132–5.

[28] Scardeone (1560), p. 250, attests to Bassano's and Bonamico's sponsorship of the monument. According to Anti (1942), p. 24, Bonamico also aided Bassano in choosing the subjects for the Sala dei Giganti, but I have found no documentary support for this.

[29] Published by Bresciani Alvarez (1980), p. 282, who gives the reference as Archivio di Stato di Padova, Cassa della Città, b. 193.

[30] Ibid., p. 282.

[31] For Bassano's birth date, see Bodon (1988), pp. 85–6. Franzoni (1981), p. 228, n. 144, states that Bassano's collection was 'undoubtedly' the most important private collection of Latin epigraphs in the Veneto.

[32] See Joost-Gaugier (1983), pp. 113–24.

[33] See Zorzi (1962a), pp. 74–91; her article remains the standard work on Bassano. See now also Bodon (1991).

Bassano employed the sculptor Agostino Zoppo on many occasions. A native Paduan, Zoppo was born about 1520, had already become a master in 1539, and died on 3 March 1572.[34] He was a student of Guido Lizzaro, who was the father of Tiziano Minio, the stuccoist of the Odeon Cornaro. Indeed, it has been suggested that Zoppo worked with Minio on the external decoration of the Odeon and at the Loggia.[35] Zoppo was highly thought of as a founder, and from 1553 to 1563 he helped to cast Sansovino's bronze sacristy door for S. Marco. One of his specialities was portrait busts: as early as 1545, he was making marble and bronze *all'antica* heads for Bassano. At his death, he was owed by Bassano for a bronze head of Julius Caesar; he was owed as well for busts of four prominent Paduans. Zoppo's activities in the pseudo-antique trade were well known. During the 1560s, the Augsburg financier J. J. Fugger hired agents to buy antiquities for him in Italy. On 12 October 1567, one of these agents, Niccolo Stoppio, wrote to Fugger that another agent, Jacopo Strada, had recently bought nine heads of Roman personages, all of which he (Stoppio) believed were of recent, not ancient, production. One of the heads, claims Stoppio, was made by 'augustin Zotto in padua'.[36]

The Livy monument thus assumes fundamental importance in the task of tracing the origins of the revival of the *all'antica* bust. A group of humanists, charged with setting up a public monument in the ancient manner to a 'great man', used a pseudo-antique bust by a contemporary artist as the monument's visual climax. Considering the patrons involved and the man they were honouring, anything other than a classicizing style for the monument would have been inconceivable. They were erecting something to their hero, to the person who, along with Antenor (the Trojan who supposedly founded Padua), personified *patavinitas*: Padua's strong and uninterrupted links with the ancient world.[37]

Earlier in the same year as the Livy monument was set up, Pietro Bembo (born in 1470) died in Rome on 18 January 1547. Before being made a cardinal at the end of 1538, he had lived continuously in Padua from 1522, where his friends were Bassano, Bonamico, Benavides, and other personages already encountered (as noted, he had introduced Falconetto to Alvise Cornaro). When he left for Rome in October 1539, his collection of antiquities (sometimes called the best private collection in Italy) remained in Padua, where it continued to draw visitors.[38] And it was in Padua that a memorial was set up to him in the nave of the Santo.[39] The bust of Bembo in the monument, by Danese Cattaneo, may well be the first public *all'antica* bust in Italy (Pl. 29). Finished in 1548, it was set up between 1549 and 1553.

In early 1534 Bembo had asked that he be allowed, during his lifetime, to erect a sepulchral tablet of bronze on the middle column of the Santo, and permission was granted on 9 February 1534.[40] Bembo never acted on it, however, and was buried in Rome in the choir of S. Maria sopra Minerva, between the tombs of Leo X and Clement VII. The concession for the Santo

[34] The two fundamental studies of Zoppo are Rigoni (1970), pp. 301–10, and Leithe-Jasper (1975), pp. 109–38. In the latter, Leithe-Jasper attributes two bronze busts to Zoppo; for these busts, see cat. no. 80, below.

[35] Bresciani Alvarez (1980), pp. 282–3, n. 27.

[36] See Weski and Frosien-Leinz (1987), p. 462, Quellenhang no. 86.

[37] The meaning of this term has been discussed by Muraro (1968), pp. 387–97, and Gorini (1973), p. 112.

[38] Weiss (1969), p. 200, called it the best private collection in Italy. For the history of Bembo's collection, see Favaretto (1990), pp. 103–7.

[39] Although the architecture of Bembo's tomb is usually ascribed to Sanmicheli (see Puppi (1986), p. 128), Burns (1979), pp. 19–20, attributes it to Palladio. It seems to me much more likely, as suggested by Rossetti (1765), p. 75, that Cattaneo designed the architecture.

[40] See Sartori (1983), i, p. 667, nn. 21–2, and p. 679, n. 95.

remained none the less in effect, and Girolamo Querini, named by Bembo as one of his two executors, sponsored the monument in Padua, which was erected, as requested in 1534, on the central pier of the right side of the nave.[41]

Fortunately, Aretino's correspondence provides much valuable information about the bust of Bembo.[42] In a letter to Cattaneo of April 1548 Aretino asks when he can view the bust; it must have been finished by then, since Aretino complains that Titian and Sansovino have already been to see it (while he has not).[43] The bust was still in Venice more than eight months later for, in a letter of January 1549 to Monsignor Benedetto dei Martini, Aretino writes of having gone to Cattaneo's studio the previous day to admire it again in the company of Martini, Sansovino, the painter Lorenzo Lotto, and Girolamo Querini.[44] It was still there because, as stated in a letter to Querini that same month, the bust was then meant to be set up in S. Salvatore in Venice, where Bembo's parents were buried.[45] So the bust was not sent to Padua until some time after January 1549. In his letter to Querini, Aretino remarks how appropriate it is that Bembo's bust should go to S. Salvatore, and that it would be sufficient to send the terracotta model of it to Padua.[46] Hence, the monument in Padua was definitely planned by then and probably under way. All that is known for certain, however, is that it was in place by 1553 because, in the concession granted by the Santo to the Contarini family to build Alessandro Contarini's tomb, the Bembo monument is specifically mentioned (see below, Chapter 4, n. 42). Most likely, it was in place by 1549 or 1550.

The bust of Bembo in the Santo marks a strong break with precedent. Like Zoppo's bust of Livy, Cattaneo's bust of Bembo follows the format of ancient Roman portraits: the back is hollowed out, the baseline is rounded, and the whole is set on a socle. It thus differs distinctly from the traditional form of a bust in the reliquary format, where the bust is finished all around and the whole is self-supporting without a base. How different in form (and spirit) this *all'antica* monument was from its predecessors can be gauged if it is compared with the contemporary Paduan tomb of Giovanni Antonio de' Rossi by Vincenzo and Giovanni Girolamo Grandi (Pl. 30). De' Rossi was a law professor at the University of Padua and his tomb was commissioned on 23 April

[41] Scardeone (1560), p. 396, gives a full account: 'Hieronymum Quirinum Ismerii filium patr. Venetum, Petrus Bembus Card. ita dilexit, ut eum moriens & in secundis haeredibus scripserit, & testamenti sui executorem esse voluerit. QUIRINUS ergo ut viventibus suam in Bembu[m] vita functum, singularem pietatem ostenderet, ipsius Card., imaginem marmoream Danesii Catanei Carrariensis eximii nostrae aetatis statuarii manu factam, posteritati dicavit. Impetrato prius a Republica Patavian loco, qui iam viventi Bembo ad tumulum Maurocenae, & Lucilii illius filii publice decreto decurionum datus fuerat.' The inscription on the monument reads: 'PETRI BEMBI CARD. IMAGINEM | HIERONYMUS QUIRINUS ISMERII F. | IN PUBLICO PONENDAM CVRAVIT | VT CVIVS INGENII | MONUMENTA AETERNA SINT | EIVS CORPORIS QVOQ. MEMORIA | NE A POSTERITATE DESVDERETVR. | VIX. ANN. LXXVII. D. XXXIX. | OBIIT XV. CAL. FEBR. M. D. XLVII'. The Girolamo Querini who commissioned the bust was the son of Smerio, and should not be confused with Girolamo Querini di Francesco di Marco of S. Canciano, brother of Isabella Querini Massolo, friend of Bembo and Aretino, and patron of Titian. Nor is either to be confused with

Girolamo Querini di Francesco di Gerolamo who lived at S. M. del Giglio in Venice and maintained a house in the Vico Ognissanti in Padua where he and his son Francesco built up a distinguished epigraphical collection; see Mancini (1995), esp. pp. 13–17.

[42] The only accurate account of this monument is supplied by Burns (1979), pp. 19–20. The memorial is often wrongly referred to as Bembo's tomb, and wrongly dated to 1547, the year of Bembo's death.

[43] Aretino (1957–9), ii, pp. 213–14, letter 413.

[44] Ibid., ii, p. 274, letter 495. This Monsignor dei Martini owned an important collection of antiquities in Venice, including the famous bronze *Adorante* now in Berlin; see Franzoni (1981), pp. 220–1.

[45] Aretino (1957–9), ii, pp. 273–4, letter 494.

[46] Ibid.: 'perché a Padova basta il modello di getto crudo o di terra cotta.' Puppi (1986), p. 128, citing this letter (which he misdates to Apr. 1548; he also confuses S. Salvatore with S. Sebastiano), writes that it demonstrates that the monument in Padua must have already been in progress.

1545, after his death.[47] Following a format that goes back to Riccio's Trombetta monument in the Santo, de' Rossi is shown as if *in cathedra*. The bottom slab of the monument serves as a fictive lectern, on which two closed and one open book are propped. De' Rossi appears above the lectern, shown half-length and complete with his arms, peering down at the open book before him, as if about to lecture. Being aligned with the bottom shelf, the baseline of the bust is completely flat. In terms of its format, the portrait of de' Rossi is identical to that of Verrocchio's *Bust of a Lady* in Florence. Although the fluted and swagged consoles surrounding de' Rossi and the sarcophagus above him derive from an antique decorative vocabulary, nothing about his portrait does.

The *Bembo* thus participates in the vogue at this time for *all'antica* heads and busts. As has been seen, Zoppo was already making them in Padua during the 1540s, and the sculptor Simone Bianco in Venice seems to have made a specialty of such items, which he was producing by at least the 1530s.[48] None of Zoppo's portraits, however, was ever set up in public. Bianco's busts were likewise private images and, with only one known exception, either depicted actual Roman personages, such as Cicero and Caesar, or were ideal heads of Roman-looking types.[49] Bembo's bust may be the first time that a contemporary person, shown in contemporary dress, was honoured with a public bust in the *all'antica* format.[50]

This was possible because of the special circumstances of its commissioning in terms of patron, sitter, and context. In a city where Cornaro had erected a replica of Varro's villa, and where Benavides had revived the ancient colossal statue, it would hardly be out of place to revive the *all'antica* portrait. The antiquarians Bassano and Bonamico had raised a memorial to Livy with an *all'antica* bust only shortly before Girolamo Querini was to set up Bembo's memorial. By about 1550, then, two classicizing busts were on public view in Padua: that of Livy in the Palazzo della Ragione, and that of Bembo in the Santo. Although not born in Padua, Bembo was considered as much a local son as Livy, and I would suggest that the design of Bembo's monument was intended to evoke connections between the two men. An *alla romana* bust of Bembo in Padua casts him as the modern successor to Livy as an historian and as a model of Latin prose style. Bembo, as already mentioned, was a devoted collector of ancient art and, as one of Pope Leo X's secretaries, propounded a Latin style that relied on a strict Ciceronianism. The format of the bust, however, must also refer to Bembo's fame as a modern classic: he not only upheld the dignity of Tuscan as a legitimate literary language in both his poetical and prose works, but he also edited the Aldine editions of Petrarch and Dante, editions that accorded these writers the status of classics by being printed in the same format and in the same series as the Aldine editions of Greek and Latin authors.[51]

[47] For this monument, see Rigoni (1970), p. 228. The tomb was originally in S. Giovanni di Verdara, and was moved in the 19th cent. to the novitiates' cloister of the Santo, where it remains today.

[48] See Ch. 1, above.

[49] See Ch. 1, n. 61, above, for the exception.

[50] Designating anything as a 'first' is always problematic because of lost works and unsure chronologies. None the less, Cellini's and Bandinelli's busts of Duke Cosimo I seem not to have been dis-

played publicly in the Medici palace; see Martin (1993b), nn. 36 and 64.

[51] A telling example of Bembo's status can be seen in Bronzino's portrait of Ugo Martelli where, on the table to Martelli's side, lie books by Virgil, Homer, and Bembo; on the *Martelli*, see Cropper (1985), pp. 149–60. A good account of Bembo's career and on his role in the 'problema delle lingue' can be found in Mazzacurati (1980), pp. 1–59.

It would seem no coincidence that the second classicizing sepulchral bust set up in Padua should be that of Lazzaro Bonamico, the professor of Greek and Latin who composed the inscription for the Livy memorial. Bonamico, who was born in 1477/8, died on 10 February 1552, and Scardeone writes that although he was first buried provisionally in the Santo, his remains were later transferred to S. Giovanni di Verdara after his tomb had been constructed there.[52] The tomb thus definitely post-dates Bonamico's death and it is very likely that the bust does as well; I date it to 1552–3. Cattaneo made Bonamico's bronze bust (Pl. 31); hence, the same artist was employed both for him and for Bembo, two stars of the Paduan antiquarian world. Indeed, although Bonamico and Bembo were buried in different churches, Bonamico's tomb is a copy of Bembo's, further underlining the connection between them.[53]

In 1551–2, yet another *all'antica* commemoration appeared in Padua, this time under the auspices of Giovanni Battista Ramusio (1485–1557).[54] He was a member of the citizen class in Venice, not a patrician, who served the Senate and eventually became Secretary of the Council of Ten. Renowned as a linguist and historian of the new age of exploration, he too, like Bassano, owned an epigraphical collection. He was a close friend of Bembo, and had aided him extensively while Bembo was librarian of the Marciana. Ramusio's two greatest friends, however, were the famous physician Girolamo Fracastoro (1478–1553) and the diplomat and poet Andrea Navagero (1483–1529). Navagero, like Ramusio and Bembo, was a collaborator of the great printer of classical texts, Aldus Manutius, and was Bembo's predecessor both as librarian of the Marciana and as official historian of the Venetian Republic. Fracastoro, best known now for having coined the term syphilis, was a major figure in Paduan (and Italian) intellectual life on account of his medical as well as his philosophical studies.[55]

After having retired to Padua, Ramusio set up a public monument that evoked Rome and honoured these two 'famous men'. In 1551, he received permission from the Venetian government to open up the wall near the bridge of S. Benedetto and to place on either side of the arch two large bronze medallions of Fracastoro and Navagero that he had commissioned from Giovanni da Cavino.[56] They must have originally appeared like the roundels in the spandrels of Roman triumphal arches. To these *all'antica* images he added an actual piece of antiquity, a Roman inscription from an altar in Spalato in Dalmatia; all was in place by 1552 (i.e. prior to Fracastoro's death the following year).[57] In the life of Fracastoro published in 1555 and probably penned by Ramusio himself, it is stated that Ramusio did all this 'for the benefit of future scholars, and so that the images of these two most learned men, who had lived in the closest intimacy, could be admired in the same place, in the most illustrious Academy in the

[52] Scardeone (1560), p. 247. For a biography of Bonamico, see Avesani (1969), pp. 533–40; see now also Piovan (1988). Zorzi (1962a), p. 62, says that Bonamico was Alessandro Bassano's closest friend.

[53] For the dependence of Bonamico's tomb on Bembo's, see Boucher in *Genius* (1983), pp. 361–2, no. S5. S. Giovanni di Verdara was suppressed (not, as sometimes stated, demolished) in 1818. Bonamico's bust was acquired then by the Roberti family, and was subsequently given by Giambattista Roberti in 1841 to the museum in Bassano, where it remains today. In 1871, Bonamico's tomb was moved from S. Giovanni to the novitiates'

cloister in the Santo, where a stone copy of the bust was placed in the niche of the tomb.

[54] On Ramusio, see the account and bibliography in Zorzi (1988), pp. 48–9. The fullest biography of Ramusio remains del Piero (1902), pp. 5–112.

[55] On Fracastoro, see Ongaro (1981), pp. 112–18. Fracastoro dedicated his dialogue on syphilis to Bembo.

[56] See Cicogna (1824–53), ii, p. 320.

[57] Although some sources give 1551 as the date of the monument, Salomonio (1701), p. 549, states that after the epigram were the words 'Anno Incarnat. Verbi MCLII.' The medallions, which

world'.[58] Ramusio's gesture in itself could be called a homage to antiquity: Franzoni has cited Cicero's *De Amicitia* as an inspiration to Ramusio's act (and also noted that Fracastoro likewise celebrated this triple friendship towards the end of his life when he wrote the dialogue *Naugerius sive de poetica* and dedicated it to Ramusio).[59]

The artist of the medallions of Navagero and Fracastoro, Giovanni da Cavino (1500–70), was yet another prominent character on the Paduan antiquarian scene. As Hill has written, Cavino was the 'most famous of all imitators of ancient Roman coins' on account of whom 'the name "Paduans" came to be applied to most sixteenth-century imitations of Roman sesterti and medallions'.[60] Enea Vico first recorded him as an imitator of ancient coins.[61] He was apparently a student of Riccio, for in addition to making the now-lost portrait medallion on Riccio's tomb, he was named in 1532, along with Alessandro Bassano, as an executor of Riccio's will.[62] Cavino was a close friend of Bassano (near whom he lived) from young manhood; like his friend, he too was a collector, and on one occasion gave an ancient altar to Bassano. Not surprisingly, he was also a friend of Benavides, and it was he who coined the commemorative medals Benavides placed in the base of Ammannati's *Hercules*.[63]

Although active as a goldsmith, he specialized in portrait medals in the latter part of his career. Two of his medals depict himself with Bassano on the obverse; one of these depicts Benavides on the reverse as well. He also made medals of Girolamo Corner, the patron of the Sala dei Giganti.[64] On these medals, the sitters are frequently draped in an *all'antica* manner.

The 1540s and 1550s were a busy time for *Romanitas* in Padua.[65] In conjunction with the cult of antiquity in Padua, the honouring of famous men in *all'antica* visual formats had taken strong hold there by the early 1550s. Pope-Hennessy has suggested that the Florentine fifteenth-century bust owed its birth to an interrelated group of humanists; I believe that, as this survey has demonstrated, a similar situation obtains among an interrelated group of Paduan humanists in relation to the revival of the *all'antica* bust.[66]

measure 48 cm. in diameter, were removed from the gate in 1808 and are now in the Museo Bottacin in Padua.

[58] Pellegrini (1952) p. 20.

[59] Franzoni (1981), pp. 244–5.

[60] Hill (1967), p. 73.

[61] Vico (1558), p. 16.

[62] Cavino's lost portrait medallion of Riccio, himself an important contributor to the revival of classical style and subject-matter in Padua, naturally predates those of Fracastoro and Nav-

agero and may well have served as a model for them. A recent study of Riccio's milieu is Krahn (1988).

[63] The most recent studies of Cavino are Norris (1979), pp. 109–12; Gorini (1973), pp. 110–20; and id. (1987), pp. 45–54.

[64] See Hill (1967), p. 74, no. 396.

[65] For a related overview of the Paduan cultural scene at this time, see Azzi Visentini (1984), esp. pp. 149–215.

[66] Pope-Hennessy (1966), pp. 75f. A different interpretation is found in Zuraw (1993).

3

VITTORIA'S EARLY CAREER

As recounted in the preceding chapter, the revival of antique forms—even of whole complexes *alla romana*—was seriously and extensively pursued in Padua around the middle of the sixteenth century. By 1552–3, the medallions of Navagero and Fracastoro were flanking the gate of S. Benedetto like tondi in a Roman triumphal arch, and the *all'antica* busts of both Cardinal Bembo and of Lazzaro Bonamico were in place on their tombs. By this time Alessandro Vittoria, whose work was to popularize the classicizing bust in Venice, had started his independent career and was engaged in similar activities. From late 1551 to early 1553 he used Vicenza as his base, where, in partnership with Palladio at the palazzo Thiene, he directly contributed to the culture of Romanist revivalism.

Vittoria was born in Trent, outside the Venetian republic, in either 1524 or 1525, the son of Vigilio, a tailor.[1] Tradition has it that he received his earliest training under Antonio Medalia (who until 1538 was the architect of Cardinal Cristoforo Madruzzo, the ruler of Trent) and then served an apprenticeship to Vincenzo and Gian Gerolamo de' Grandi of Padua, who designed and carved the cantoria of S. Maria Maggiore in Trent between 1534 and 1542. Still according to local tradition, it was Cardinal Madruzzo, who had studied under Marco Mantova Benavides in Padua and who was to patronize Palladio in the early 1550s, that sent the 18-year-old Alessandro to Venice in 1543 to work under Jacopo Sansovino.[2]

Whatever the validity of these traditions, and they may very well be accurate, Vittoria himself documents that he first came to Venice on 25 July 1543: 'Ricordo io Alessandro Vit[t]oria chome gionsi in Venetia la mia prima volta il giorno di Santo Iachomo di luio de. 1543.' This notice survives from an account book of sixty-eight pages in Vittoria's hand now preserved in the State Archives in Venice.[3] He is first documented as being in Sansovino's workshop a year later on 15 July 1544, when he and another assistant were paid 40 ducats for polishing the bronze reliefs of the second, i.e. the left-hand, cantoria in S. Marco.[4] In May 1546 Vittoria and a certain 'Antonio' received 20 ducats for work on the wax models for Sansovino's great bronze sacristy door of S. Marco.[5]

Nothing more is heard of him for four years, until 29 March 1550, when he records in the first entry of his account book a payment from the Procurator Vettor Grimani for having carved four

[1] For details on Vittoria's birth date see Martin (1988), pp. 1–4.

[2] Giovanelli (1858), p. 3, first records these traditions. It should be noted that Giovanelli is very unreliable.

[3] For the history of this account book, and other surviving documents by Vittoria in the Venetian archives, see Martin (1988), pp. 5–7. These materials were published by Predelli (1908), pp. 1–265. Although one often gets the impression that the entry

referring to 1543 was written in that year and is the first item in Vittoria's account book, it in fact appears on the *last* page of the account book and was probably written down in 1562.

[4] Ongania (1881–93), xiv, p. 43, doc. 223. See also Boucher (1991), i, p. 194, doc. 90 (where the amount is incorrectly given as 90 ducats).

[5] Ongania (1881–93), xiv, pp. 43–4, doc. 224. See also Boucher (1991), i, p. 201, doc. 112.

River Gods in the spandrels of the arcade of Sansovino's Libreria in the Piazza S. Marco.[6] Although still at work on projects headed by Sansovino, Vittoria was probably working here as a *lavorante*, a master in the guild who subcontracted work from other artists.[7] The second entry in the account book, from 26 April, records a payment for a commission Vittoria had received from the monks of S. Geremia to carve a small, marble St John the Baptist (Pl. 32), which confirms that by 1550, if not earlier, Vittoria had set up on his own as an independent master.[8]

The next notice of the artist, from April 1551, places him in his home town, to which he had most likely returned in the hope of receiving work in connection with the Council of Trent, whose second session was to open on 1 May.[9] It is not known when he came to Trent but he definitely remained there until some time after 21 September.[10] If Vittoria did return to Venice in the autumn of 1551, he did not stay there long, for he was in Vicenza by December.

The source for this information is a letter from Aretino to Vittoria, which also supplies the earliest indication of the famous *dissidio* or quarrel between Vittoria and Sansovino. The letter, which is dated only 'December 1551', thanks Vittoria for a gift of pears sent from Vicenza, and states that the writer offered them to Titian and Sansovino at dinner. Aretino recounts that when he told Sansovino that the pears came from Vittoria, he found that, to his surprise, the mention of the latter's name upset the older sculptor. Sansovino explained that he was very angry with Vittoria because of a 'disrespectful' letter received from the latter, which he promised to show to Aretino. Aretino concludes by saying that he has not seen the letter, is upset that there should be any bad feelings between men whom he describes as being 'like father and son', and offers his services in patching things up.[11]

Aretino's words and tone demonstrate that he was quite taken aback by Sansovino's response. This is a clear indication that the ill feelings between Sansovino and Vittoria, however long in the making, had only lately broken out, and that the letter that so upset Sansovino must

[6] Predelli (1908), p. 176 (he mistranscribes the entry of '20' ducats as '50'). Ivanoff (1961a), pp. 242–50, identifies these river gods as the figures over, and on the intrados of, the third arch of the Library from the Campanile; he also attributes to Vittoria the head of Saturn on the keystone of the second arch and a relief of the Fall of the Giants on the intrados of the fourth arch. In Ivanoff (1968), pp. 50f, he repeats his earlier attributions, but now suggests that the four river gods are those over the second arch as well as the third. To my eye, his attributions, while perhaps correct, are not compelling. All of these sculptures are very indebted to Sansovino, and I see no sure signs of an individual hand.

[7] Because Vittoria states in the account book that he became a *patrone* in the guild on 25 July 1557 (Predelli (1908), p. 219), it is often assumed that Vittoria was not a master until this date. There were, however, two grades of master mason in the Venetian stonecutter's guild: *padroni di corte* and *lavoranti*. The main difference between the two was one of capital: a *padrone* owned or rented premises and ran his own business, while a *lavorante* worked for a *padrone* or was paid by the day on a building site. See Connell (1988), p. 54. The entry from 1557 in Vittoria's accounts records when he became a *padrone*; he had been a *lavorante*—a master—since at least 1550, when he was paid for his work at the Libreria (see above) and for the marble *Baptist* (see below).

[8] The work in question here is the *St John* now on the right-hand holy-water fount in S. Zaccaria. The monks at S. Geremia owned it until 1565, when Vittoria bought it back (explained and documented by Predelli (1908), p. 132). From then until his death, the statue remained in the artist's house, and in his last two wills he left it to the convent of S. Zaccaria, where he is buried and whose abbess he made the executor of his will. Both Cessi (1961b), p. 15, and Venturi (1937), p. 82, date the *St John* to the early 1540s, but as Leithe-Jasper (1963), p. 11, points out, the entry in Vittoria's account book clearly records a first instalment. There are no grounds for ascribing the statue to any other date than 1550.

[9] The only record of this work, which refers to decorations Vittoria made in preparation for the visits to Trent of the future Philip II of Spain and the future Emperor Maximilian, is given by Predelli (1908), p. 14.

[10] Oberziner (1911), pp. 65–71, published a letter from that date of Teodoro Busio, a local noble, in which Busio asks his sister to engage as a companion the sister of 'messer Alessandro scultor già fiola di Messer Villio sartor'. Busio asks this because Vittoria, whom he calls his very good friend, wants to leave Trent to return to Venice and does not want his sister to remain in Trent 'because of all the foreigners who are here'.

[11] Aretino (1957–9), ii, p. 389, letter 612. The situation is very reminiscent of when Sansovino sent an angry letter to Michelangelo in June 1517; see Boucher (1991), i, p. 24.

have been of recent origin. The quarrel must have occurred in 1551, not earlier as is often maintained.[12]

From late 1551 until the spring of 1553, Vittoria both lived and worked at the palazzo Thiene. It is not known how he became involved in this project, which marks his earliest documented contact with Palladio. It was an appropriate partnership, both men being highly involved with the revival of antique forms. Their professional contact was to continue at the Villa Pisani in Montagnana, and at S. Giorgio Maggiore. Personal ties also connected the two men: Palladio's son Marc'Antonio worked as a *lavorante* for Vittoria for over twenty years, and Palladio himself was the agent through whom Vittoria bought Parmigianino's *Self-Portrait in a Convex Mirror*.[13] Although it is fitting that the two should have found each other early in Vittoria's career, how they came to work together in Vicenza is a matter of speculation. If it is true that the teenage Vittoria worked with the Grandi in Trent, then this would provide a link between him and Palladio, for Vincenzo de' Grandi was Palladio's godfather.[14]

The project on which Vittoria and Palladio were engaged was one of the most significant then under way in Italy, for the palazzo Thiene is an extraordinary building (Pl. 33). As Howard Burns has written: 'The scale and magnificence of the project is unique among Palladio's palace designs, and it was only paralleled by contemporary buildings in Rome: the Cancelleria, Bramante's Tribunali, the palazzo Farnese.'[15] Indeed, the original project, which may be Palladio's modification of a design by Giulio Romano, was for a building specifically in the style of a Roman palace: a massive structure occupying a whole block—an insula—with a large interior courtyard. Never had so Roman a project been formulated on this scale in the Veneto, far outdoing the efforts of Cornaro and Benavides in Padua.[16]

The desire for grandeur and pomp inherent in the project came from its patron, Count Marc'Antonio Thiene. The Thiene were one of the richest of the noble families of Vicenza; in the census of 1563, Marc'Antonio's son, Ottavio, is designated the wealthiest man in the city.[17] In the *Quattro Libri*, Palladio numbered Thiene—together with his brother Adriano, G. G. Trissino, and Antenore Pagallo—as one of those 'who, having died, have left as eternal memorials to themselves their beautiful and ornate houses'.[18] Palladio describes Marc'Antonio as a great lover of architecture, and he was one of the architect's principal supporters in obtaining for him the commission for the Basilica in Vicenza, which was to be the breakthrough of his career. Thiene was knighted by Charles V in 1523, and the knighthood was reconfirmed in 1546. Puppi has suggested that this latter chivalric honour may have been the spur to the enlargement and redesign of the house the family already owned on the site.[19]

Marc'Antonio Thiene would certainly have valued his knighthood for, like most Vicentine aristocrats, his family were extremely proud of their nobility and fostered links with other noble

[12] Among those who date the quarrel to some time prior to 1551 are: Temanza (1778), p. 480; Cessi (1960b), pp. 25–33; Pope-Hennessy (1970a), p. 415; and Wolters in Wolters and Huse (1990), p. 168. For an extended discussion of this issue, see Martin (1988), p. 15. Leithe-Jasper (1963), p. 18, first noted that the quarrel must have occurred in 1551.

[13] On Marc'Antonio Palladio, see Zorzi (1965a), pp. 304–5. For Vittoria's purchase of Parmigianino's self-portrait on 14 Jan. 1560 (m.v.?), see Predelli (1908), p. 130. *M.v.* is the abbreviation for *more veneto*, the Venetian practice of dating the year from 1 Mar. not 1 Jan.

[14] Rigoni (1970), pp. 319–24.

[15] Howard Burns in *Palladio* (1975), p. 36, #47.

[16] Forsmann (1973), p. 43, writes of the pal. Thiene that 'if the palace had been finished it would be the only manifestation of a truly Roman architecture outside of Rome'.

[17] See Battilotti (1980), p. 27.

[18] Palladio (1570), p. 5. [19] Puppi (1973), ii, p. 254.

and royal families.[20] Marc'Antonio's father, Gian Galeazzo, spent time in exile in Mantua during the War of the League of Cambrai because of his imperialist loyalties to the Holy Roman Emperor.[21] His brother Adriano, with whom he commissioned the palace from Palladio, entered the service of the French King Henry II in the 1540s, dying in France in 1550.[22] Ottavio, Marc'Antonio's son, followed his uncle's example and also served Henry II. In 1554 he married Laura Boiardo, the scion of an Emilian noble family. When Laura's uncle, Ippolito, died in 1560 the Boiardo family became extinct; their fiefdom of Scandiano, however, was awarded to Ottavio in 1565 by Duke Alfonso II d'Este of Ferrara.[23] Ottavio lived primarily at Scandiano, as a feudal lord, from then until his death in 1574.

So, although subjects of the Venetian Republic, the Thiene cultivated ties with individual princes. In contrast to Padua, in Vicenza aristocrats, rather than humanist professors, sponsored the revival of antique forms. Marc'Antonio and Adriano Thiene clearly desired a seigneurial, quasi-princely, residence, and while the design for a full insula was never built, the Thiene palace was far grander than any of its predecessors in Vicenza, and it set the style and tone for its successors, such as the palazzo Chiericati. Contemporaries were impressed not only by the scale of the house, but also by the magnificence of its interiors. The *Estimo* of Vicenza dating from 1563–4 itself makes this point by describing the Thiene palace as 'built in a stupendous, superb and honourable manner and designed with great mastery and diligence . . . with a grand courtyard . . . and with many varied rooms and fireplaces . . . all with arched ceilings, and with most beautiful halls and corridors', praise that no other palace in Vicenza received.[24]

The building deserved such praise because the Thiene and Palladio, like Cornaro, Falconetto, and Benavides in Padua, made sure that the interior of the structure was as Romanizing as the exterior. At the palazzo Thiene, Vittoria—and following him Bartolomeo Ridolfi—fashioned the most extensive programme to date of *all'antica* stuccoes in the Veneto, well outdoing those in the Odeon Cornaro as well as the two small rooms decorated by Giovanni da Udine in 1539 for the palazzo Grimani in Venice.[25] The stuccoes are not only more extensive but also much richer in style than any worked previously because they are the first examples in Italy of the highly sculptural type of stucco called strapwork because it imitates leatherwork.[26]

Vittoria worked on the ground floor of the building in the four rooms known as the Sala degli Dei, the Sala di Proserpina, the Sala di Psiche, and the Sala dei Principi.[27] Executed in 1552, they all employ single motifs and compositional arrangements borrowed from antiquity. The most striking room, however, is the Sala dei Principi (Pl. 34), which is an octagonal, vaulted space with four half-niches. At the base of each of the eight sections of the vault is an *all'antica* bust in stucco by Vittoria; seven depict men from Roman antiquity: Julius Caesar, Augustus, Mark Anthony,

[20] On the *carattere aristocratico* of the Vicentine élite, see Ventura (1964), pp. 118–25.

[21] Puppi (1973), ii, p. 251, gives citations to Sanudo for the records of Giangaleazzo's pardon for 'ribelion' on 28 July 1513.

[22] See Zorzi (1969), p. 109. Adriano may have gone to France in order to escape suspicions of heresy; see Stella (1967), p. 56.

[23] See Litta (1819–1902), ii, 'Boiardo of Reggio', unpaginated.

[24] Battilotti (1980), p. 49. Barbieri (1987), p. 68, has pointed out how little such pomp corresponded to the houses of the typical Venetian patrician (the significant exception to this is the Grimani

of S. Maria Formosa, to which branch both the Procurator Vettor Grimani and his brother, the Patriarch Giovanni Grimani, belonged; see Ch. 4, below).

[25] None the less, all the individual rooms stuccoed by Vittoria and Ridolfi in the pal. Thiene are relatively small in scale; they always look much larger in photographs than they actually are.

[26] A study devoted to the appearance of strapwork in Italy is greatly needed.

[27] For a chronology and division of hands between Vittoria and Ridolfi, see Conforti Calcagni (1980), pp. 177–8.

Antoninus Pius, Vespasian, Brutus, Pompey, plus one contemporary figure, King Henry II of France (who is there due to the family's connections with the French court). In light of the similarities in both ground-plan and decoration between this room and the main room of the Odeon Cornaro, it is hard not to see the Sala dei Principi as yet another re-creation or evocation of Varro's villa. Palladio surely knew the Odeon—he probably witnessed it going up when he was a young man in Padua.[28] It has been pointed out that the Odeon provided the immediate precedent for the palazzo Thiene in terms of its architecture as well as its decoration.[29] An exemplar of Paduan antiquarianism, it was now inspiring progeny in Vicenza.[30] Wolters has similarly noted that Vittoria surely knew the Odeon because he relied upon it when designing the stuccoes for the Sala dei Principi.[31] A modification in Vittoria's work, however, is that he peopled the space with actual ancient personages.

The eight busts in the palazzo Thiene share identical formats: each consists of a very small torso set on a flat, slab-like pedestal, with both head and torso backed by a scallop-shell frame. As such, they bear a striking resemblance to the bust that appears in a tomb design made by Falconetto (Pl. 35).[32] Whether Vittoria knew this drawing is impossible to say. A definite link to Padua, however, presents itself in the gesso models Vittoria used for the busts in the Sala dei Principi for, by great good luck, some of these models have survived. Now in the Museo Liviano in Padua, they arrived there from the collection of Marco Mantova Benavides.[33] The connection between the heads in Padua and those in the Sala dei Principi was established by Irene Favaretto, who noticed that five of the gessoes correspond to Vittoria's busts of Mark Anthony, Pompey, Julius Caesar, Brutus, and Augustus.[34] Because the correspondences are so exact and because, as Favaretto avers, it is hard to imagine Vittoria copying models not his own without modifying them in the least, she concludes that the gessoes in Padua must be the artist's own models for the heads in the Sala dei Principi.[35]

But this seems not to be the case. Heike Frosien-Leinz, in her work on the collection of antiquities in the Residenz in Munich, has discussed a variant in that collection of the Benavides gesso called the 'Milicho' (Pl. 25). This is the head Vittoria used for his bust of Brutus in the palazzo Thiene. Frosien-Leinz observed that the Benavides model must already have been known (and presumably was already in the Benavides collection) in 1540, when it served as the model for the figure of Brutus (Pl. 24) in the Sala dei Giganti.[36]

[28] As suggested by Puppi (1973), i, p. 8 (who also notes, ii, p. 253, at the pal. Thiene '. . . le vitruviane, ancora "stanze ottangule" agli spigoli dell'edificio, già sperimentate però da Falconetto nell'Odeo Cornaro . . .').

[29] Magagnato (1968), p. 174.

[30] A very direct link is supplied by a member of Palladio's équipe, the stuccoist Bartolomeo Ridolfi. Ridolfi, who provided the stucco work at Palladio's pal. Porto-Festa in 1551–2, and who was to stucco the 2nd-storey rooms in the pal. Thiene, was Falconetto's son-in-law; see Conforti Calcagni (1980), p. 172.

[31] Wolters (1968b), p. 273.

[32] For this drawing, which is RF 1075 in the Louvre, see the entry by G. Schweikhart in Marini (1980), no. 4.4, pp. 90–1.

[33] The gessoes are listed in the inventory of Benavides's collection drawn up by his great-nephew in 1695; see Favaretto (1972), nos. 353, 355, 363, 370, and 374. The gessoes are identified neither by the name of their maker nor by the name of the person whom they represent, being listed under the heading 'Diverse Teste di Gesso e terra cotta'.

[34] Favaretto (1976–7), pp. 401–11.

[35] Ibid., p. 408 and n. 26. She gives the same argument in Favaretto (1980), p. 134, and I accepted this in my dissertation. Fittschen (1985), p. 402, calls the Benavides gessoes the only such casts from the 16th cent. thus far known.

[36] See Weski and Frosien-Leinz (1987), i, cat. 274, p. 392. The figure of Brutus is generally held to be by, or at least designed by, Domenico Campagnola; see Grossato (1966), p. 179.

Her identification, which I find totally convincing, means that the gessoes are not by Vittoria; rather, he must have borrowed them from Benavides to use at the palazzo Thiene. Hence Vittoria was closely involved with one of the foremost patrons and cultivators of antiquity in Padua, as described in Chapter 2. This in turn suggests that Vittoria and Benavides already knew each other when the artist started work at the palazzo Thiene, which is not at all improbable. Although the earliest evidence of contact between the two men comes from December 1552, Benavides could have known Vittoria as early as 1545–6, when he was the Paduan ambassador to Venice, and it should be noted that he liked to patronize young artists, especially sculptors.[37] It should also be remembered that nothing is known of Vittoria's whereabouts and doings from May 1546 to March 1550 and for a good deal of 1550–1. Vittoria could easily have spent part of that time in Padua.[38]

The matter of the gessoes aside, Vittoria appears as a portraitist for the first time in the palazzo Thiene. Significantly, he was here profiting from his contacts with Paduan antiquarian circles and making pseudo-antique busts: the very activity pursued by Agostino Zoppo, and in which Simone Bianco had been engaged for some time in Venice.[39]

The bust of Mark Anthony (Pl. 36) is perhaps the best of the eight busts and can thereby serve as a stylistic guide or measure for the whole ensemble. In it, many features of Vittoria's mature portrait style are already present. The composition has three components: the base, the shell frame, and the bust itself. The strongest characteristic of the statue is the movement the artist has imparted to it, which allows the bust to overcome its architectural setting near the top of the room. Unlike the planar compositions of Simone Bianco or Cattaneo, Mark Anthony's head leans forward to break the frontal plane established by the base while his body assumes a *contrapposto* pose: his head not only bends forward but also turns to the left while it tilts to the right. The axis of head and torso lies clearly to the right of the central axis, yet his glance is directed to the left. An active opposition is thereby set up between the direction in which the sitter moves and the direction towards which he draws his attention and mental powers.

This opposition or divergence of focal points is carefully worked out and varied by Vittoria throughout the bust so that the character of the subject is depicted as mobile, active, and alive. The scallop-shell frame, for instance, could have been seen as a confining or constricting

[37] For Benavides's patronage of the young Ammannati, see Davis (1976b), pp. 472–84; for his relations with the young Girolamo Campagna, see Boucher (1980), pp. 159–64. For the 1552 contact between Vittoria and Benavides see the discussion of Andrea Loredan in Ch. 5, below.

[38] The 1695 inventory of Benavides's collection documents that he owned several works by Vittoria: no. 341, a stucco model for one of the caryatids now on Vittoria's tomb in S. Zaccaria (it survives; Pl. 116); also nos. 252–3, two small stuccoes of Old Men (these do not survive). Benavides also owned a painted portrait of Vittoria (Favaretto (1972), p. 123). A letter of 7 Jan. 1553 from Vittoria testifies that he sent two medals to Benavides—they have not been identified. In the 18th cent. Temanza (1778), pp. 477–8, posited a Vicentine period for Vittoria from 1547 to roughly 1550. While Temanza's account is suspect, and his attribution to Vittoria of the stuccoes in the pal. Arnaldi in Vicenza is contested, a period of Vicentine activity cannot be ruled out; see Martin (1988), pp. 25–33.

[39] The only hard evidence that Vittoria did make pseudo-antique pieces comes from Girolamo Gualdo the Younger (1599–1656) who stated that he owned by Vittoria a *St Sebastian*, a *Madonna and Child with St John*, and 'una testa di Ercole, la quale cossi l'hebbi in dono dal praeclarissimo & virtuosissimo signor Bernardo Moresini che del Vittoria tiene scolpito il nome e l'affetto nel cuore'; see Gualdo (1972), p. 65. (Both Gualdo's uncle and great-uncle were portrayed by Vittoria; see cat. nos. 14 and 38.) Perhaps the head of Hercules was related to the incident from 1552 when Vittoria tried to take away from Sansovino a commission for a statute of Hercules; see above. Pizzo (1989), pp. 103–16, has made some hopeful attributions to Vittoria of pseudo-antique pieces.

boundary or, if it had been larger, as a surround that diminishes the force of the object it contains. But because Vittoria has Mark Anthony's head come up to the very top of the frame, and because the flutes of the shell seem to extend the lines of his shoulders out to the very edge, the feeling communicated is less of energy contained than of energy about to burst out. (About nine years later, in the bust of another Mark Anthony, the *Marc'Antonio Grimani*, the head will actually break the border of the frame (Pl. 55).)

That the head tilts to the right of the axis, while the body seems to move in the same direction, weights the composition towards the right; nevertheless, the strong vertical of the flap of Mark Anthony's cloak over his left shoulder—which runs from the shoulder clasp down to the pedestal and joins up there to the right tip of the base—provides a firm stop to the rightward movement. Furthermore, this is all balanced on the left by Mark Anthony's leftward glance along with the turn of his head and the strong projection of his right shoulder.

Both the cloak-flap on the right and the central fold of Mark Anthony's garment overlap the base of the bust and thereby endow the statue with greater three-dimensionality. Finally, the base of the bust plays a part by its asymmetricality, being much higher on the left than on the right; Vittoria was to use this type of 'crushed' or 'squashed' base throughout his career. The quality emphasized by the irregularity of the base is again that of movement.

The contacts the Thiene family maintained with various noble courts have already been mentioned, and Vittoria tried to profit from them. In the spring of 1552, the artist was presented to Duke Ercole d'Este by Lodovico Thiene, as documented by a letter Vittoria penned to the Duke on 16 April 1552. Vittoria recounts that, after Count Lodovico showed the Duke a medal Vittoria had made of the 'Prince of Spain', the future Emperor Maximilian, the Count then presented the artist himself to the Duke. Ercole asked if Vittoria could make a portrait of him, but the latter had to reply that he could not then take on such a task because of other commitments. Now, however, he reports that he has completed 'alcune mie opere' (the Thiene stuccoes?) and is at the Duke's disposal.[40] A mere five days later, in fact on 21 April, he was in Venice with the Ferrarese ambassador, intent on stealing from Sansovino a commission the latter had from Duke Ercole to make a colossal statue of Hercules.[41] On 30 May, Vittoria writes again to the Duke to tell him he has finished a model of Hercules, and instructs the Duke to send any letters to his current residence, the palace of Count Marc'Antonio Thiene.[42]

This is all that is known of the *Hercules*, which Vittoria did not succeed in taking away from Sansovino. In January 1553 he is still in Vicenza, from where he wrote a letter to Marco Mantova Benavides.[43] In that same month, Aretino corresponded once again with Vittoria. After expressing thanks for the gift of another basket of pears and for two portrait medals, Aretino concludes by saying that 'if I have ever taken the famous master Jacopo Sansovino for a Christian and a good

[40] This letter, in the Archivio di Stato, Modena, was most recently published by Boucher (1991), i, doc. 218, p. 223. The medal shown to the Duke seems not to have survived, but Aretino, in Nov. 1552, mentions a medal Vittoria has made of 'Massimiano, il principe di Piemonte e di Spagna'; see Aretino (1957–9), ii, pp. 412–13, letter 638.

[41] Ambassador Ferruffini's letter reporting on his and Vittoria's trip to Sansovino's workshop was most recently published by

Boucher (1991), i, doc. 217, pp. 222–3.

[42] Published ibid., doc. 219, p. 223.

[43] This letter, dated 7 Jan. 1553, survives in an 18th-cent. copy by Giuseppe Gennari conserved at the Biblioteca del Seminario di Padova, MS 619, vi, no. 129. First published by Temanza (1778), p. 479, it has been frequently reprinted, most recently by Cessi (1960b), p. 95, who incorrectly gives its date as 2 Jan.

person, the proof is that I have experienced his benevolence'.[44] A reconciliation, apparently orchestrated by Aretino, has been brought about.

Vittoria is documented as back in Venice from a letter penned by the sculptor to Benavides dated 10 May 1553, in which he tells the jurist that he has accepted a commission for two large statues, the caryatids known as the *Feminone* at the entrance to Sansovino's Libreria (Pl. 38), and that he plans to remain in Venice 'for the time being'.[45] He ended up staying there for the rest of his life. On 3 June he records payments in his account book for work on the *Feminone* carried out by assistants, and on 26 July he rents a house in the calle della Pietà.[46] In the meantime, Sansovino had finished his *Hercules* in June 1553 and sent the statue off to Modena that August.

The *Feminone*, although not Vittoria's most distinguished work, was a plum commission on the most prestigious contemporary building in Venice. It places Vittoria at the very heart of the classicizing movement in Venice, and moves my focus to the cult of antiquity in the Serenissima itself.

[44] Aretino (1957–9), ii, pp. 427–8, letter 653: 'se il famoso Sansovino messer Jacopo mai l'ebbi per cristiano e per buono, l'avvervi raccolto la sua benevolenza il conferma.'

[45] This letter does not survive, only a synopsis of it made by Gennari (as in n. 43), p. 36, no. 130, which reads: 'Da Venezia alli X. maggio 1553. Scrive [Vittoria] al Mantova d'essere in Venezia, impiegato in fare due statue grandi che vanno alla porta della libreria di piazza. E s'egli raccomanda per le cose di S. Giustina.' Among Cicogna's unpublished notes for a biography of Vittoria, which are found under 'V' in *Famiglie Venete e Forestiere*, Bibl. Civ. Correr,

Cod. Cicogna 3430, I found a direct quotation from this letter. Cicogna writes that in a letter from Vittoria to Benavides of 10 May 1553, the sculptor says: 'credo fermarmi qui per ora, avendo tolte sopra di me due figure grandi che vanno alla porta della Libraria di piazza, imprese non men onorevole che utile.' Giovanelli (1858), p. 119, also reports this information.

[46] For the payments on the *Feminone*, see Predelli (1908), p. 176. For the renting of the house in the calle della Pietà, see ibid., p. 41, which, in the first line, reads '1583, Luglio 26' for '1553, Luglio 26'.

4

THE CLASSICIZING BUST AND THE CULT OF
THE ANTIQUE IN VENICE

THE building for which Vittoria was to carve the *Feminone*, Sansovino's Libreria (Pl. 37), can
serve as a paradigm for the ambitions and efforts of the supporters of classicizing art in mid-
cinquecento Venice. Over the last twenty-five years, the interpretation and understanding of the
cultural contexts and political meanings of the Libreria, particularly as to how it formed part of
a broad ideological campaign launched by Andrea Gritti, have been greatly enriched by the work
of Tafuri, Howard, and Hirthe.[1] During the reign of Doge Gritti (1523–38), as Venice recovered
from its near extinction during the War of the League of Cambrai, an ambitious series of
reforms was launched by the Doge and his allies with the intent of restoring Venice to its former
glory. Improvements were made in the territorial defences of the city, and a reform of the legal
system was also attempted, although the latter came to nought.[2]

Gritti was an enthusiastic patron of the arts, and cultural reforms played a central role in his
programme of renewal for Venice. It was Gritti who persuaded the Procurators of St Mark's to
employ the great Flemish composer Adrian Willaert as the organist of S. Marco. It was he who
welcomed refugees from the Sack of Rome such as Pietro Aretino to the lagoon city. And it
was Gritti who welcomed yet another such refugee, Jacopo Sansovino, commissioning him to
restore the domes of S. Marco, and thus launching the architect on his Venetian career, which
would last until his death in 1570.

Gritti had a profound interest in architecture, testified to by Sebastiano Serlio in the introduc-
tion to the first volume of his architectural treatise published in 1537.[3] Around 1530, Gritti and
the Procurators began a period of building activity, the heart of which was Sansovino's transfor-
mation of the Piazza San Marco. Following the Sack of Rome in 1527, Venice was eager to
establish itself as the 'New Rome', and the Piazza was where this ambition was most grandly
visualized through the use of classicizing architecture.[4] Sansovino's original plan, approved by
Gritti and his supporters among the Procurators, in particular Vettor Grimani, called for erecting
a unified design on all three sides of the Piazza, likening it to an ancient forum.[5]

Although this ambitious project was never fully carried out, its earliest and key element, the
Libreria, was. In an oft-cited passage in the *Quattro Libri*, Palladio called the Library the richest

[1] Tafuri (1969); Tafuri (1984); Howard (1975); Hirthe (1986),
pp. 131–76. See also the synopsis by Zorzi (1987), pp. 121–71.
[2] On the attempted legal reforms, see Cozzi (1980), pp. 122–52,
and Cozzi (1982), pp. 293–318.
[3] Serlio (1537). Serlio states that Gritti vastly influenced the
revival of Venetian architecture that had taken place in the previ-
ous 10 years.

[4] For the topos of Venice/Rome, see Marx (1980), pp. 325–73,
Tafuri (1984), and Hirthe (1986). Cf., however, Wolters (1987),
pp. 256–9.
[5] Serious study of the Piazza was begun by Lotz (1966), pp.
114–22, and continued by Tafuri (1969), Howard (1975), and
Hirthe (1986). See also the discussion by Wolters in Wolters and
Huse (1990), pp. 42–6.

and most ornate building constructed since classical times, and, along with the Loggetta built by Sansovino at the base of the Campanile in the Piazza, it remains the most ostentatiously *all'antica* structure in Venice.[6] Ever since 1468, when Cardinal Bessarion left to the Republic his collection of 500 Greek manuscripts, the government had intended to build a library to house the collection. Nothing happened, however, until 4 April 1532, when Vettor Grimani urged his fellow Procurators to make the construction of the Library their top priority. On 22 April, at the instigation of Pietro Bembo (who had been appointed librarian in 1530), Doge Gritti called the Procurators together to discuss the matter, and it was decided to erect the Library on its present site, opposite the Ducal Palace. Actual construction began in 1537, the year before Gritti's death.

It was a great victory for Romanists such as Doge Gritti, Vettor Grimani, and Bembo to succeed in sponsoring such an unabashedly classicizing project at the political and religious centre of the city, directly across from the medieval Ducal Palace.[7] As Howard has pointed out, the many striking resemblances between the Library and ancient descriptions of classical libraries can hardly have been accidental.[8] Sansovino even used the building's classical inspiration as the basis for a publicity stunt in 1539, when he proposed an open competition for architects to submit solutions for the corner of the building that would comply with Vitruvius's recommendation that half a metope should fall at the end of a Doric frieze (the contest was rigged for Sansovino had already come up with his own solution to the problem). As Howard has summed up the situation: the Library's *all'antica* character 'not only reflects the contents of Bessarion's bequest, but also expresses the grandeur of the city's political centre as a whole, the classical reminiscences gratifying the yearning of the Serenissima to emulate ancient civilisations'.[9]

Vittoria had already carved four river gods on the Libreria prior to his sojourns in Trent and Vicenza in the early 1550s (see above, Chapter 3). His return to Venice in 1553 to carve the *Feminone* (Pl. 38) at the entrance to the Library put him at the very node of the classicizing avantgarde in Venice. It also marks the beginning for him of half a century of patronage by the Procurators, for whom he would continue to work, both as a corporate body and on behalf of individual Procurators, for the rest of his career.

The Procurators of St Mark's held special élite posts in the Republic of Venice: a procuratorship, after the dogeship, was the most prestigious office in the *cursus honorum* for a patrician.[10] Set up in the Middle Ages—perhaps as early as the ninth century—as the Doge's deputy to care for and oversee the basilica of S. Marco, the office soon assumed further responsibilities, in particular that of financial administrator of the estates and trusts left by testators to S. Marco. By 1319 these administrative duties, and the amounts of money involved, had grown so great that the

[6] For the Loggetta, see Boucher (1991), i, pp. 73–88.

[7] See Tafuri (1989), *passim*, for the conflict between Romanists and traditionalists in 16th-cent. Venice.

[8] Howard (1975), p. 26. Cf., however, Boucher (1991), i, p. 258, n. 5. Hirthe (1986) has rightly emphasized the varied uses of the building and suggested that it is perhaps best termed the 'palazzo dei procuratori'. It is frequently stated, such as by Ivanoff (1968), p. 44, that the building was almost never termed a library until Francesco Sansovino (1581) called it such, and that the structure was usually called simply the 'fabbrica nuova' or the 'fabbrica

incontro 'l palazzo'. While this is substantially true, the 1553 letter from Vittoria to Benavides quoted in n. 45 of Ch. 3 above, in which Vittoria calls the building the 'Libraria di piazza', proves that the building was referred to as a library early on.

[9] Howard (1975), p. 27.

[10] Good general discussions of the Procurators, with bibliography, are available in Howard (1975), pp. 8–9, and Boucher (1991), i, pp. 39–40. Hirthe (1986), especially pp. 133–41, provides a richly detailed discussion of the 'self-image' of the Procurators in the 16th cent.

office was divided into three branches: the Procurators *de Supra*, who were directly in charge of S. Marco and its properties in the Piazza (the reason why the Procurators were the patrons of the Libreria); the Procurators *de Citra*, in charge of properties on the S. Marco side of the Grand Canal; and the Procurators *de Ultra*, who administered properties on the Rialto side of the Grand Canal. By the mid-fifteenth century, there were normally three Procurators in each branch making a total of nine. Although the position brought only a nominal stipend, Procurators were given offices in the Piazza and they exercised considerable influence—and artistic patronage—because of their fiduciary responsibilities. It was the only post, besides the dogeship, to which one was elected for life and the Doge usually came from their ranks. Procurators were also part of the government, for they were *ex officio* members of the Senate, and of the Council of Ten, and thus formed part of the Signoria. They wore special robes and marched almost directly behind the Doge in all processions. The office was universally perceived as being reserved for the best and the brightest. A Procurator was usually of mature, if not advanced, age, quite rich, the veteran of many governmental posts and, in the increasingly oligarchic society of cinquecento Venice, a member of one of the same few dominant families.[11]

Although work had begun on the Libreria in 1537, considerable efforts were made in 1551 to speed up construction. By 1551, after a decade and a half of work, only seven bays had been completed; three years later fourteen bays were up and by 1556 the total stood at sixteen. Not surprisingly, the call to Vittoria to carve the *Feminone* was made during this time span, and he worked on them from 1553 to 1555.[12]

Like most sculptors, Vittoria found it more congenial to work in an under-life-sized rather than an over-life-sized scale. As his very first large-scale work in marble, the *Feminone* were bound to feature awkwardnesses, as indeed they do: 'le due mastodoniche figure' is how one critic has not unjustly described them.[13] Although not of the highest quality, these caryatids were critical for Vittoria's career in a number of ways: their conspicuous place at the entrance to the most prestigious contemporary building in the city proclaimed him as an important sculptor of public works who, on his return to Venice, was to be fully accepted into the ranks of an older generation of masters.

They proclaimed him as such firstly by their size. Although not literally colossal, they participate in the fad for Michelangelesque gigantism that was widespread in cinquecento Italy and that produced Ammannati's and Benavides's genuinely colossal *Hercules* in Padua in the 1540s.[14]

[11] During the 16th cent., especially in the 1520s and 1530s, procuratorships were sold as extraordinary fund-raising efforts. As a result, the number of Procurators grew and certain men attained the office at an unusually young age. Two of these 'procuratori straordinari' were Sansovino's strongest partisans, Vettor Grimani and Antonio Cappello. (Giulio Contarini, a close patron of Vittoria (see Ch. 6, below) was another such young Procurator.) Boucher (1991), i, pp. 39–40, analyses this development, rightly noting that Sansovino's project for the Piazza would probably not have come about unless '[the Procurators'] ranks had . . . been swelled by wealthy and cosmopolitan Procurators who sought to transform the Piazza S. Marco with an appropriately modern architectural style'.

[12] For payments in connection with the *Feminone*, see Predelli

(1908), p. 176. Lorenzetti (1909), pp. 65–8, published a *terminazione* from the Procurators of 11 Aug. 1553, in which they bemoan the scarcity of sculptors in Venice capable of doing the work needed to complete the Libreria. The document specifically mentions the need for someone to execute 'due figure grandi che devono esser poste all'entrar della scala de essa fabricha'. Why they say this two months after Vittoria had started work I do not know.

[13] Ivanoff (1968), p. 54. Vasari and Temanza, however, both praised them as elegant.

[14] This whole phenomenon is fully treated by Bush (1976). A recent overview is supplied by Boucher (1991), i, ch. 9. On the problems inherent in translating a small model into a very large stone or bronze statue, see ibid., especially pp. 129 and 134.

Indeed, it should not be forgotten that when Vittoria was working on the *Feminone*, the most conspicuous large-scale sculpture in Venice was located on the top of the Libreria: Ammannati's *Neptune*, which stood at the corner of the building until it fell and was destroyed in the eighteenth century.[15] In the early 1550s, large-scale sculpture was very much in vogue in Venice. As discussed in Chapter 3, Sansovino had just finished his colossal *Hercules* for the Duke of Ferrara, and in 1554 the statues of Neptune and Mercury, 'i Giganti', for the exterior staircase of the Ducal Palace were commissioned from him (they were not set in place until 1566).[16] Although Vittoria lost to Sansovino in the competition for the *Hercules*, he managed to enter the discourse on large-scale sculpture with the *Feminone*. Purely because of the prestige accounted at this time to such undertakings (a good deal of which was owed to the classical heritage of the genre), the *Feminone* marked Vittoria as the newest contender in the field of Venetian sculpture, the young competitor to Sansovino and Ammannati.[17]

Formally, the *Feminone* have been rightly linked to earlier female figures by Sansovino (perhaps actually carved by Cattaneo) that act visually as architectural supports, particularly those at the villa Garzoni in Pontecasale.[18] Unlike the caryatids at Pontecasale, however, the *Feminone* do not function as near-mirror images, but in a more complex way. While, as Leithe-Jasper has observed, the right figure is aligned in a rather flat, parallel way with its support, the left figure was carved almost diagonally in relation to its support.[19] The latter thereby gains a multiplicity of viewpoints, creating a tension between it and the surface it is set upon. Leithe-Jasper rightly calls this figure Vittoria's first large-scale *figura serpentinata*, and his first truly mannerist sculpture. The *Feminone* are Vittoria's first attempt to compose a dialogue between stone sculpture and its architectural setting, and his first attempt to create a multi-figured *contrapposto*. The contrappostal relationship set up between the two figures by their poses, and the dynamic relationship created between the left figure and the surface of the building reveal the artist's life-long preoccupation with how to exploit asymmetry so as to suggest movement. While I do not fully agree with Leithe-Jasper's definition of mannerist sculpture as statues having multiple viewpoints, the *Feminone* do pointedly adopt up-to-date, complicated, twisting poses that pledge allegiance to prototypes by exponents of the *maniera*, such as Giulio Romano and Parmigianino.

Nor are the *Feminone* the only aspect of Vittoria's activity at the Library that associates him with a group of younger artists who were the vanguard of their time in Venice. By 1555, the Procurators had turned their attention to the decoration of the interior, and contracts for paintings to fill the roundels of the reading room were awarded in 1556. The seven painters chosen for this work—Veronese, Battista Franco, Andrea Schiavone, Giovanni da Mio, Giuseppe Porta ('il Salviati'), Giulio Licinio, and Giambattista Zelotti—were all associated with the new mannerist-influenced art, patronized by patricians such as Vettor Grimani and Daniele Barbaro, that had

[15] The statue of Neptune preceded the *Hercules* in Padua and probably spurred Benavides to commission the latter from Ammannati. Temanza (1778), p. 222, n. *a*, gives an account of the fall of the *Neptune*. Kinney (1976), pp. 85–6, however, thinks that the *Neptune* was life-size.

[16] See Boucher (1991), i, ch. 9.

[17] Vittoria finally trumped his competitors in the 1570s when he made the very large figures of *Justice* and *Venice* over the south and west *finestroni* at the top of the Ducal Pal., which are arguably

the two most conspicuous sculptures in the city. Interestingly, the area around the Piazzetta continued as an arena for gigantism later in the century with the commissioning in the 1590s of the large figures by Campagna and Aspetti for the vestibule of the Mint (now the entrance to the Bibl. Marciana).

[18] Boucher (1991), ii, no. 57, pp. 351–2.

[19] The discussion in Leithe-Jasper (1963), p. 65, is the most detailed analysis of the figures and I am much indebted to it.

started appearing in Venice during the previous decade.[20] Vittoria, whose figural style was greatly influenced by Parmigianino, was a natural member of this group. At the Library, as at the Odeon Cornaro and the palazzo Thiene, *alla romana* stuccoes were ordered and, in that same year of 1556, Vittoria was commissioned to fashion the stuccoes on the ceiling of the great staircase, which led to the reading room of the library, the offices of the Procurators, and the classroom of the school for young aristocrats that had been set up in the building (Pl. 39). It is to this staircase that the portal flanked by the *Feminone* leads.

The date of this project has been subject to some confusion. On 29 February 1560 (1559, *m.v.*), the Procurators drew up a contract with Vittoria to do the stuccoes 'juxta il principio ci mostra per esso messer vittorio sin hora fatto'.[21] Vittoria's account book shows entries for payments to assistants on the project from 16 December 1559 to 6 April 1560.[22] The account book also, however, shows payments for work on the staircase of the Library from April 1556. Howard has suggested that these latter entries must also be from 1560 because they fit into the weekly intervals of the previous payments, and that the date 1556 seems to result from a *lapsus calami*.[23]

An examination of the account book itself, however, does not bear this out. All the entries concerned with the Libreria appear on one page, carta 85*t*. Starting on 16 December 1559, they indeed run at regular weekly intervals from then until 6 April 1560, at which point appear the last three entries on the page, which are dated 13, 20, and 27 April 1556. It would seem very strange that, after having written down a whole string of payments from 1560, Vittoria all of a sudden in the last three entries would mistakenly record the year as 1556. An additional feature of the page proves that this was not a mistake on Vittoria's part, for he drew a line across the page to separate the last three entries from those above them, to show that they are out of sequence. The entries from 1556 must record payments from that year.[24] Wolters's explanation for this state of affairs is very convincing: that Vittoria started on the staircase at the Library in 1556 but was interrupted to take on yet another commission, that of the stuccoes over the Scala d'Oro in the Ducal Palace, returning to finish the staircase at the Library only after the Scala d'Oro was completed.[25]

Sansovino won the competition for this latter project, the Scala d'Oro, in 1556, defeating Palladio, among others. It is the staircase used as the official, ceremonial entrance to the Ducal Palace, and thus functions as one of its most important sites. Vittoria made these stuccoes in 1558–9 (Pl. 40).[26] It is generally agreed that the format of the decoration originated with Sansovino while the individual motifs of the separate compartments were designed by Vittoria.

[20] The rich bibliography on mannerism in Venice starts with Coletti (1941), pp. 109–26. A broad survey of the situation and its protagonists is provided by *Da Tiziano a El Greco* (1981), particularly in R. Pallucchini's introductory essay, pp. 11–68. See also Zorzi (1987), pp. 141–3 and the bibliography cited there. The introduction of mannerist art to Venice is usually considered to start with the visits there by Francesco Salviati and Giovanni da Udine in 1537 and that of Vasari in 1541.

[21] Archivio di Stato di Venezia (hereafter ASV), Procuratia de Supra, b. 68, proc. 151, fasc. 2, *c.*23 (I thank Victoria Avery for the current archival reference for this document).

[22] Predelli (1908), pp. 181–2.

[23] Howard (1975), p. 166, n. 86 (her ref. to Predelli is incorrect).

[24] Predelli (1908), p. 10, long ago accurately noted that Vittoria did not enter records in his account book as they occurred: 'Dalla fisionomia della scrittura e dalla disposizione delle varie annotazioni apparisce che il V. le faceva non contemporaneamente al fatto annotato, ma bensì di tempo in tempo a gruppi, raccogliendole da note staccate: vi si può anche osservare che lasciò passare spazi abbastanza lunghi di tempo senza fare annotazioni.'

[25] Wolters (1968*a*), p. 23, n. 76. The contract of 1560 must therefore be a second contract, presumably drawn up because of the interruption of the project. In Wolters and Huse (1990), p. 44, Wolters convincingly argues that the 'ceremonial' treatment of the staircase at the Library was taken as a challenge by the government, and that this was why the same team was chosen to decorate the Scala d'Oro.

[26] Lorenzi (1868), publishes the documents, pp. 286–8, 297–9, 308–9. Both the gilding and painting of the stuccoes were under way by Nov. 1561, so Vittoria's work must have been over by then.

Perhaps a somewhat more autonomous arrangement held at the Library.[27] At the Scala d'Oro and on the first ramp of the Libreria, Battista Franco painted the frescoes that alternate with Vittoria's figural work in the compartments of the ceilings; on the second ramp of the Library, Battista del Moro did the paintings.

In both the Scala d'Oro at the Ducal Palace and the staircase at the Libreria, Vittoria took his achievements in stucco at the palazzo Thiene in Vicenza to a new and higher level. This is clearly seen just past the entrance to the Libreria, in the dome over the first landing (Pl. 41). Its timid, planar organization, where the ornament is kept absolutely subordinate to the strict (and rather mechanical) geometrical framing of the various fields, shows that Vittoria's thought at this moment had not developed beyond what he did in the Sala del Camino (also known as Proserpina) in Vicenza. Quite a different matter are the domes that abut each other above the second landing (Pl. 42), where the cartouches and their various elements burst out from their architectural setting. Instead of the fussy, repetitive, octagonal compartmentalization of the first dome, the simple quadripartite organization here reads as much more unified, organic, and dynamic, with the scrollwork bending forward only to dart back. The whole field of the dome now dances, as do the putti cavorting at the top of each cartouche. Previously, ornament was something added to a surface; now, ornament sculpts a surface as if it were an exercise in high relief.[28] Such dynamism had never before been seen in the city—with the accents and colour added by the gilding and the frescoes, these stucco ceilings must have seemed a kind of classical, Roman response to the mosaics of an earlier, Byzantine Venice.

It has gone mostly unremarked that the stuccoes by Vittoria in the Palazzo Ducale and Library were in their time the most extensive ever done in Venice and hence comprise one of the most salient *all'antica* efforts in the city.[29] With the completion of the interior decoration of the Libreria a new kind of visual splendour was on display in Venice by about 1560. The richness and ornateness of the building's painted and sculpted decorations were unprecedented, and Hirthe has convincingly interpreted the splendour of the edifice as a proclamation by the Procurators of their authority, wealth, and glory.[30] Their appropriation of classicizing architecture and decoration as a means of self-representation complements, as Hirthe has noted, the comparisons of the procuratorship to the ancient Roman office of *aedile* that occur in sixteenth-century panegyrics.[31] The *alla romana* stuccoes in the Library, as well as those in the Ducal Palace, confirmed Vittoria as a major presence on the Venetian artistic scene. The Libreria, in fact, stands as a powerful manifesto by a group of young artists, inspired by features of Roman and Tuscan mannerism; two of them, Vittoria and Veronese, were to be leaders of the new generation.

In contrast to the *all'antica* campaigns at the Odeon Cornaro in Padua and the palazzo Thiene in Vicenza, the Libreria was a public, not a private, building. A similar tendency, however, on the

[27] See the discussion in Boucher (1991), i, p. 170.

[28] See Wolters (1968a), pp. 47–50. I agree with Wolters that the first dome must be before, and the other two domes must be after, the artist's work on the Scala d'Oro. It was at the latter that he developed the even more strongly sculptural style of stucco present in the second and third domes of the staircase at the Libreria.

[29] Wolters (1987), pp. 29–30, rightly notes that the rich decoration of these two staircases contrasts with those found in private palaces and even in those of the Scuole grandi. He also observes that the one example of a staircase *more romano* in a private palace, that of the Grimani in S. Maria Formosa, copies the Scala d'Oro. It is not surprising that the grandiloquent Grimani of S. Maria Formosa should be the exception.

[30] Hirthe (1986), *passim*.

[31] Ibid., p. 136 and n. 61.

part of private patrons in Venice towards a magnificence expressed in a classical mode can be noted at this time, particularly in two architectural projects. As Tafuri has written, 'only two patrician buildings built in the sixteenth century dared to break the continuity of the Grand Canal with their dimensions and triumphal language'.[32] These are Sansovino's palace for the Corner family, designed and constructed in the 1530s and 1540s, and the palazzo that Michele Sanmicheli began in 1556 for Senator Girolamo Grimani. Significantly, these two projects of classicizing architecture were both for families who patronized central Italian mannerizing artists and the Venetian artists influenced by them. It is a marked feature of mid-sixteenth-century patronage in Venice that a certain group desired to set themselves apart from older patterns of patronage on two different, but often related, fronts: classicism and mannerism.[33]

In 1555, the year before work on the palazzo Grimani began, Sanmicheli was the principal artist involved in another example of private (and procuratorial) magnificence that was under way back in Padua: the tomb of the Procurator Alessandro Contarini (Pl. 43), situated in the nave of the Santo directly facing the monument to Cardinal Bembo. An elaborately complex ensemble, it was by far the most ostentatious tomb in Padua since that of Benavides went up during the preceding decade. The base depicts five ships carved in shallow relief. Above this appears Contarini's large and extensive epitaph, carved on black marble; to either side of the epitaph stand two slaves that act as telamons, with one additional slave on each of the far sides of the monument. The epitaph and telamons support a long slab, the front face of which contains a dense *alla romana* relief of armoured trophies, trumpets, shields, and helmets, all presided over by the victorious lion of St Mark. At the top of the tomb stand statues of Thetis and Abundance, who are supported by bases whose fronts carry reliefs of conch-blowing tritons. Between these statues rises a six-stepped pyramid set on a pedestal that holds a relief of festoon-bearing putti. A bust of Contarini rests within a round niche near the bottom of the pyramid, while at the apex of the pyramid a statue of winged Fame stands on a globe. The monument was first attributed to Sanmicheli by Vasari and is a vastly expanded version of his tomb of Lavinia Thiene in Vicenza dating from 1542.[34]

Born in 1486, Alessandro Contarini came from the S. Sofia branch of a prominent patrician family and led a distinguished naval career. He was elected a Procurator, with the aid of a large grant of money from his family to the government, on 28 June 1538, and in 1540 reached the height of his military career when he was named Captain-General of the Fleet.[35] He has been identified as the Alessandro Contarini mentioned by Enea Vico as a collector of ancient coins and as the man named by Ludovico Dolce in the *Aretino* as one of the Venetian noblemen who were serious amateur draughtsmen.[36]

As Cicogna first suggested, however, the Procurator and the collector/dilettante are two different contemporaries.[37] In 1559, Dolce published a letter to an Alessandro Contarini that Mark

[32] Tafuri (1989), p. 7.

[33] Tafuri, ibid., has given the most recent discussion of these issues, particularly pp. 6–11. Logan (1984), p. 288, in his discussion of 16th-cent. patronage, emphasizes what he calls the 'culto della magnificenza' which, he argues, must be viewed at least in part in connection with the enthusiasm for central Italian artists.

[34] Vasari (1878–85), vi, p. 357. For the Lavinia Thiene monu-

ment, see Puppi (1986), p. 123. A preliminary drawing, unattributed, for the bottom part of the tomb has been published by Schweikhart (1991), pp. 317–19.

[35] For a biography of Contarini, see the entry by Baiocchi (1983), pp. 72–4.

[36] Vico (1558), p. 16, and Dolce (1968), p. 108.

[37] Cicogna (1824–53), iii, pp. 235–6.

Roskill convincingly dates to late 1554 or early 1555.[38] Roskill identifies this man as the Procurator Contarini, but since the latter died in 1553, this cannot be correct.[39] The Alessandro Contarini who collected antique coins, practised drawing, and was the recipient of Dolce's letter, was certainly the man identified as such by Cicogna, who was a well-known humanist, poet, and musician. He would seem to be the same man who, in late 1565, informed Federico Vendramin that the latter's brother, Luca, was selling off medals and drawings from their uncle's great collection (to, among others, the Andrea Loredan who will appear in the next chapter).[40] Here, then, is an Alessandro Contarini documented as involved with the collecting of ancient art and hence almost certainly the same man mentioned by Vico, and definitely not the man portrayed in the Santo.[41]

Contarini died in Padua, where he had lived since 1551, on 16 March 1553, and later that same year the governors of the Santo granted permission to Contarini's brother Pandolfo to build the monument. The summary of Pandolfo's petition included in the concession shows that it was Alessandro himself who wanted to be buried in Padua so as to show how 'dear' the city was to him 'at the end of his life'. He asked his brother to see to it that he be buried in Sant'Antonio, in front of the column opposite the Bembo monument, and that his 'effigy' be made along with an epitaph ('lettere') that spoke of his love for Padua.[42]

Pandolfo Contarini, with his brother Pietro, assembled a distinguished group of artists to work on their brother's tomb. As already stated, Michele Sanmicheli designed it, the architect who, along with Sansovino, codified classical vocabulary and style in the Veneto and who, it should be remembered, raised a triumphal arch in Padua in 1556 with the help of Alessandro Bassano, one of the instigators of the Livy monument. All four of the sculptors involved with the project were members of Sansovino's school: Pietro da Salò did the *Abundance* on the upper right as well as the two telamons on the right while Agostino Zoppo, the artist of the Livy monument encountered in Chapter 2, carved the two lateral slaves on the far sides. Vittoria also worked on this project, receiving payments from 1555 to 1558 for the statues of the two slaves on the left-hand side, as well as for the *Fame* on top and the *Thetis* on the left.[43] Significantly, he here crosses the path of the Paduan portrait bust, for Cattaneo sculpted the likeness of Contarini on the tomb, the third *all'antica* bust he made for a Paduan monument.

[38] The letter was first published in Dolce (1559). Roskill discusses it in Dolce (1968), p. 248.

[39] Roskill in Dolce (1968), p. 248, also names Procurator Alessandro Contarini as a patron of Titian by citing Vasari (1878–85), vii, p. 439. But all Vasari says here is that Titian painted a *Supper at Emmaus* for 'un gentilhuomo da cà Contarini', hardly enough information to identify a specific member of the family. See also S. Marinelli in Marini (1980), p. 195, and n. 22.

[40] See Ravà (1920), p. 155.

[41] Calore (1988), pp. 71–9, bases much of his unconvincing attribution of the Contarini tomb to Vittoria on the assumption that Contarini is the same man mentioned by Dolce.

[42] The concession, dated only 1553, is printed in Sartori (1983), p. 667, no. 24. The Massari granted permission to Pandolfo Contarini to bury his brother in front of the column opposite Bembo's monument and to erect a portrait of him on the condition that it not be attached to the column as was similarly done 'nella figura del predetto reverendissimo Cardinale [i.e. Bembo] per non debil-

itare esso Pilastro'. This notice not only documents when the Contarini project was begun, but also provides a firm *terminus ante quem* for the Bembo monument. Puppi, in Puppi (1971), p. 130 (followed by Leithe-Jasper (1975), p. 113 and n. 13), states that Contarini's tomb was perhaps begun in 1544, taken up again in 1556–7, and finished by 1558, citing Gonzati (1852–4), ii, pp. 184 ff., for the claim that the tomb was begun in 1544. But Gonzati makes no such statement. The only dates he cites concerning the tomb are those of the payments received by Vittoria in 1555–8 (see below). In the 1986 edn., p. 126, Puppi still suggests that the design was formulated in 1544, but gives no grounds for this date. He suggests that the actual construction of the tomb did not begin until after Contarini's death.

[43] In his account book, Vittoria records payments from Piero and Pandolfo Contarini for this project from 12 Oct. 1555 to 22 Dec. 1558, when he received the balance for the 'dua figure tonde e li. 2. schiavi'; see Predelli (1908), pp. 180–4.

The tomb demonstrates tremendous pseudo-Roman triumphalism. With its many-tiered, many-figured composition it bombastically overpowers Bembo's simple and restrained monument across the nave. Indeed, it is twice the size of the latter: Bembo's monument measures 3.4 metres across at the base and 7 metres high, while Contarini's measures 7 metres across and reaches 14 metres in height. The use of large-scale allegorical figures could well have been inspired by the tomb of Benavides; the winged Fame, for instance, rises directly above the bust of Contarini just as the figure of Immortality perches directly above the statue of Benavides on his tomb.

Even Benavides's tomb, however, seems restrained when compared with the lavishness of Contarini's monument, and I would suggest that the latter clearly shows the influence of Sansovino's Libreria. The festoon-bearing putti, for instance, who appear below the pyramid on Contarini's tomb, and who carry a device showing the heads of the Three Ages of Man (the *tricipitium*, a symbol of Prudence), are almost identical to those who run along the frieze of the second storey of the Libreria.[44] As stated above, all four sculptors involved with the Contarini tomb worked for Sansovino and all of them, except Zoppo, carved figures on the Library.[45]

The tomb relies on the same kind of ostentatious display employed at the Libreria as well as at the Corner and Grimani palazzi; Contarini's is one of the most elaborate non-dogal tombs of a Venetian throughout the entire century. In terms of its scale and the thoroughness of its appropriation of antique motifs, it fits quite well into the Paduan atmosphere already encountered through the patronage of Alvise Cornaro and Benavides. And the *all'antica* format of Contarini's bust has its obvious immediate precedents in the busts of Bembo and Bonamico.

But the use of an *all'antica* bust on Contarini's tomb gives it a decidedly different connotation and meaning from its antecedents because it now portrays someone *outside* the scholarly, humanist milieu of Bembo, Bonamico, and Bassano discussed in Chapter 2. Contarini was from the patrician élite (as was Bembo) but he was politically important and powerful (which Bembo was not). At the Contarini tomb, the *all'antica* bust, rather than commemorating someone for whom the cult of antiquity was a central part of his psyche, is instead employed to celebrate someone from the upper echelon of the patrician political and military élite.

The intent here would seem to be not only the evocation of antiquity but the clothing of the sitter in the trappings of imperial power. Unlike Bembo or Bonamico, Contarini is shown, appropriately, in military attire. His cloak—which suggests a toga as well as depicting a knight's cape (and which was to become practically a canonic element of the patrician bust as later popularized by Vittoria)—even increases the *all'antica* feeling of Contarini's bust compared with those of Bembo and Bonamico. Depicted on his tomb above a relief bearing military trophies that is in turn shouldered by chained captives, Contarini is tendentiously compared with a Triumphator: while previously the *alla romana* style had been appropriated in Padua for the *vita contemplativa*, it now honours the *vita activa* as well.

[44] See Foscari (1984), pp. 23–30, for the meaning and importance of this motif in 16th-cent. Venice. On the *tricipitium*, see also Tafuri (1989), pp. 11–13 (who notes that the motif appears on the Odeon Cornaro).

[45] Nor was Sanmicheli opposed to lavishness himself, as his work on the pal. Grimani in Venice was to show, and as the pal. Bevilacqua in Verona had already demonstrated.

Although it is impossible to say how large a role Contarini himself played in the design of the monument, it was he who instructed that his tomb should directly face that of Bembo and that it should include a portrait.[46] Because Contarini had been living in Padua since 1551, he certainly knew the monuments to Bembo and Bonamico and may well have had an *all'antica* memorial in mind. Whether he did or not, the artists his brothers employed ensured that such would be the case, especially in the choice of Cattaneo to carve another classicizing bust directly facing the *Bembo*, the artist's first essay in the genre.

Contarini's tomb not only shows a change in the status of the person honoured by an *all'antica* portrait bust, it also participates in a larger phenomenon in art and patronage, namely, the increasing number of prominent and costly Venetian tombs erected to men of non-dogal rank. While, in the fifteenth century, the grandest tombs were, almost without exception, erected solely for and by Doges, by the middle of the sixteenth century, members of other ranks of Venetian society were constructing sepulchres that vied with those of the Doges in terms of scale and magnificence.[47] Contemporaneous with the construction of the Contarini tomb in Padua, an even more grandiose commemoration of an individual was in progress in Venice itself, at S. Giuliano, where from 1552 to 1559 Tommaso Rangone erected a monument that featured a bronze, seated statue of himself in the lunette above the entrance portal (Pl. 44), a location usually reserved for a statue of a saint.

As a façade monument honouring an individual, Rangone's was not the first of its kind. The earliest Venetian façade to bear a portrait was that of S. Elena, whose lunette shows the great naval commander Vettor Cappello (†1467) kneeling before St Helen (Pl. 45). Variously attributed to Antonio Rizzo and to Antonio Dentone, the Cappello monument on S. Elena was the only memorial of its kind until the middle of the sixteenth century, when a spurt of activity occurred with respect to façade monuments. A project similar to that at S. Elena was carried out by the Grimani family at S. Antonio di Castello (Pl. 46) where a statue of the Procurator Pietro Grimani was set in the lunette of the church, kneeling before the Virgin. Although the project was first broached in Pietro Grimani's will of 1516, the façade lunette was not set in place until *c.*1550, under the patronage of Procurator Vettor Grimani (Pietro's nephew).[48]

Both the Grimani and Cappello monuments are remarkable projects, for they seem to break with the traditional Venetian disapproval of public honorific statues to individuals. As has often been observed, the government notably discouraged the celebration of individual as opposed to collective achievements.[49] The whole Myth of Venice was predicated on the assumption that Venice existed as a commonality, as a harmonious balance of mixed elements governed by wise and virtuous patricians who were more the servants than the masters of the state.[50] The great

[46] The concession for the tomb (see Sartori (1983), p. 667), states that Contarini requested his brother Pandolfo to see to it that 'gli sia fatta la sua effigie'.

[47] This phenomenon has been little noted. See, however, the recent discussion and overview in Simane (1993), pp. 123–39. I thus strongly differ from the thesis advanced in Hiesinger (1976), p. 283, that a general trend can be observed in north Italian tombs demonstrating that the 'vaingloriousness characteristic of Quattrocento monuments was being mitigated by the new spirit of Catholic reform'.

[48] For the Grimani monument at S. Antonio, see Foscari and Tafuri (1982), pp. 100–23, and also Boucher (1991), ii, no. 112, pp. 369–70. Pietro was meant to be accompanied by a statue of his father, Doge Antonio, but this was never carried out.

[49] See, for instance, Chambers (1970), pp. 140–4, Finlay (1980), p. 29 and pp. 34–5, as well as the extensive discussions in Sinding-Larsen (1974) and Wolters (1987).

[50] See the recent discussions of the Myth in Finlay (1980), pp. 14–43, Muir (1981), pp. 13–61, and Queller (1986), pp. 2–28.

sixteenth-century codification of the Myth, Gasparo Contarini's book on the magistracies of Venice, which through its numerous translations became the prime means for the Myth's diffusion throughout Europe, even claims that one of the proofs of the selflessness of the Venetian ruling class is the very absence in the city of monuments to individuals.[51] The ostentatiousness of the Corner and Grimani palazzi occupies, with these façade monuments, a similar adversarial relationship to the communal underpinnings of the Republic; like the earlier fifteenth-century Cà Foscari and palazzo Loredan, they flouted the (mythical) law proposed by Zeno Daulo at the foundation of the original city at Rivoalto: that, in the interests of social harmony, all residences should be equal and alike, both in size as well as in ornamentation.[52]

It must be noted that the façade statues of Cappello and Grimani were constructed not at governmental expense, but by the individual families. Contarini's claim that there were no statues to individuals in Venice is of course not literally true, but even the most salient exception to his statement, Verrocchio's equestrian statue of Bartolommeo Colleoni, shows the effect of the attitude behind his words. Colleoni's statue was paid for with his own funds, which he bequeathed to the government of Venice on the condition that his statue be placed in the Piazza. While the government commissioned the statue, it voided the testator's choice of site, deeming S. Marco, as the centre of the government, inappropriate for a statue of an individual, and placed the statue in the campo by SS Giovanni e Paolo, near the Scuola di S. Marco.[53]

Privately financed honorific statues in public places could be erected, but within limits. Significantly, neither the Cappello nor the Grimani façade is in a prominent location in Venice, since both S. Elena and S. Antonio (which was destroyed in the early nineteenth century) are on the eastern outskirts of the city. Additionally, the portraits in these lunettes occupy clearly subsidiary visual positions in relation to the holy figures to whom they kneel.[54]

Something more like the Rangone monument, however, appeared some time after 1542, when a monument was set up on the façade of S. Maria Formosa to Vincenzo Cappello, who was a famed naval commander like his grandfather Vettor (Pl. 47). The full-length statue of Cappello above the entrance portal is by Domenico da Salò, a follower of Sansovino (and the son of the Pietro da Salò who worked on the Contarini tomb in Padua).[55] This Cappello façade monument differs from the two examples discussed above and resembles the Rangone monument in that the standing Cappello and the seated Rangone are independent statues, unrelated to any other figure. Indeed, they contain no religious imagery at all, in strong contrast to the lunettes at S. Elena and S. Antonio. Furthermore, unlike S. Elena and S. Antonio, both S. Giuliano and S. Maria Formosa are quite near Piazza San Marco.

[51] Contarini (1544), fo. 4rv: '. . . in Venice there are to be found few monuments to our ancestors . . . There are no tombs, no statues, no naval spoils, no enemy flags . . .'

[52] Sansovino (1664), p. 382, gives a 16th-cent. account of these events: 'Si legge che ne primi tempi, volendo i nostri mostrare unione & patria in tutte le cose loro, edificarono in virtù della legge Daula, le case tutte uguali in altezza.' Domenico Morosini in his *De bene instituta Republica* of 1497 demanded uniformity of houses in accordance with the ancient law. See also Tafuri (1989), pp. 1–7.

[53] For the Colleoni monument, see Pope-Hennessy (1971), pp. 298–9.

[54] And thus are like the portrayals of Doge Francesco Foscari and of Doge Andrea Gritti on, respectively, the Porta della Carta and the Piazzetta façade of the Ducal Palace. Each of them kneels humbly in submission before the lion of St Mark.

[55] Because the portal of S. Maria Formosa was under construction in 1542, the statue of Cappello is usually assigned to this date as well. None the less, Domenico da Salò is documented only from the 1550s to the 1570s, and it is quite possible that Cappello's statue dates from the 1550s and thus could be either contemporaneous with or even post-date Rangone's monument at S. Giuliano. On Domenico da Salò, see Planiscig (1935a).

Rangone's monument, however, differs radically from the other examples mentioned here because of the status of the person it represents. The other three façade monuments—those of the Cappello at S. Elena and S. Maria Formosa, and that of the Grimani at S. Antonio—honour deceased members of the highest stratum of Venetian patrician society. Pietro Grimani had been, besides a Procurator, a Capitano dal Mar, as had both Vettor and Vincenzo Cappello. As military leaders, this includes them in a category of men who, starting in the early sixteenth century, were increasingly given prestigious tombs, with portraits, in Venice.[56] Rangone shared none of these characteristics: neither a soldier nor a patrician—not even a Venetian by birth— he was a wealthy physician who did not die until 1577, almost twenty years after his monument at S. Giuliano had been set up.

How Rangone was able to arrange to have a statue of himself—a living, non-patrician, civilian native of Ravenna—depicted on the façade of a church in a city so ostensibly opposed to the aggrandizement of individuals, is still bewildering. But arrange it he did and, most interestingly, Vittoria played a key role in the project. The complicated history of Rangone's monument was laid out by Gallo and has recently been refined by Boucher.[57] The project was first voiced in 1552, when Rangone approached his parish priest, Benedetto Manzini, about financing the façade of S. Geminiano, located at the opposite end of the Piazza from S. Marco, stipulating that it include a statue of himself.[58] When this proposal was turned down by the government—on the grounds that, as in the case of Colleoni's statue, an image of an individual was deemed unsuitable for the religious and governmental centre of the city—Rangone turned his efforts elsewhere and in 1553 the Senate accepted his offer of 1,000 ducats to build a marble façade for S. Giuliano on the condition that a seated or standing bronze statue of himself be placed above the portal. The commission was awarded to Sansovino and work commenced. In November 1555, however, the founder, having bungled the casting, handed back to Rangone Sansovino's 'ruined' wax model for the statue. In March 1556, Rangone entered into an agreement with two new founders, Tommaso delle Sagome and Giacomo di Conti. They promised to cast Rangone's 'image in bronze that is to go above the portal of the façade of S. Giuliano according to the model made by Alessandro of Trent' (i.e. Vittoria). Now it is Vittoria, not Sansovino, who supplies the model. On 1 February 1557, Rangone reported that the statue had been successfully cast, and the façade was completely finished by 1559.

Despite there being no overtly classical precedents for these façade monuments, it is certainly striking that three of them appear in Venice within the same ten-year period that the *all'antica* bust is revived in Padua. Both the façade monument and the classicizing bust form part of the ever-increasing repertoire employed in the cinquecento to commemorate the individual, whether dead or living. Although Vittoria was to become the greatest exponent of the sculptured bust in the sixteenth century, the façade monument to Rangone must have been of signal importance to him on account of its precedent-shattering nature and because of his own

[56] See Puppi (1982), pp. 21–35. The tomb of Benedetto Pesaro in the Frari is an obvious example of this phenomenon; for Pesaro's tomb see Goffen (1986), pp. 62–72, and bibliographical references.

[57] See Gallo (1957), pp. 96–104, and Boucher (1991), i, pp.

113–19, and ii, cat. 31, pp. 338–9, with bibliography and documentary references.

[58] Gallo (1957) gives this information; neither Howard (1975) nor Boucher (1991), however, could locate the documents he cited.

personal involvement with the project. The one memorial by Sansovino that does not rely on a traditional formula, it would have spurred the younger artist to attempt a format unknown in Venice—as he was soon to do at the Ferretti tomb.[59] While nothing in the Rangone monument formed Vittoria stylistically, its impact and presence were fundamental for him and for the development of the Venetian portrait as it would take place through his sculptured busts.[60] This impact is twofold: firstly, as has already been mentioned, a completely new format for commemorating an individual was executed on a large, public, ambitious scale, and secondly, the portrait dominates the monument and indeed the entire setting of the monument. Tommaso Rangone not only provides the focal point for the façade of S. Giuliano, a bare two-to-three minute walk from Piazza San Marco, he and his monument form an everlasting presence in the Campo San Giuliano—by now they have looked over this lively intersection of Venetian street life for almost 450 years. Although Vittoria was never to design a full-length or seated portrait, nor depict a sitter in an interior, as with the *Rangone*, all of his sculpture, in particular the portraits, was to engage in a dialogue not only with its architectural support, but also with its larger spatial environment and surroundings. The confident, not to say egomaniacal, assertiveness of the Rangone monument opened up a new freedom in the treatment of Venetian sculptured portraiture from which Vittoria was to profit for the rest of his career.

As has been seen by now, a significant number of memorials were made around 1550, in both Venice and Padua, that emphasize personal imagery: the façades of the Grimani at S. Antonio, Cappello at S. Maria Formosa, Rangone at S. Giuliano, as well as the *all'antica* busts of Bembo, Bonamico, and Contarini in Padua, and the pseudo-triumphal arch featuring Fracastoro and Navagero in Padua.[61] This was the immediate background to the start of Vittoria's career as a portraitist in Venice. As already noted, the sculptor contributed significantly to the Contarini monument. And only a few months after his model for the *Rangone* had been cast in 1557, his bust of Giovanni Battista Ferretti was set up on the latter's tomb in S. Stefano in Venice (Pl. 48).

The *Ferretti* marks a turning-point both in Vittoria's career and in Venetian art: it is the artist's earliest documented bust, and thus his first known activity in the genre after the palazzo Thiene. More importantly, it is the first *all'antica* portrait bust set up in Venice, and thus marks the transfer of the Paduan sepulchral mode, already used by Cattaneo for Bembo, Bonamico, and Contarini, to the Serenissima. It thereby marks the beginning of a new phase in the adoption of classicizing formats in Venice, a phase in which individuals present themselves in an *all'antica* manner. (As shall be seen, this was a mode particularly attractive to men holding the office of Procurator.)

[59] Pope-Hennessy (1970a), p. 410, rightly calls the Rangone monument '. . . unique in its combination of firmly defined architectural forms . . . and illusionism in the treatment of the interior space . . .'.

[60] While Pope-Hennessy (1970a), p. 98, saw two sharply distinguished hands in the head of Rangone's statue (which he attributed to Sansovino) and the independent bronze bust made later by Vittoria (see Ch. 5, below, and cat. no. 20), Boucher (1991), i, pp. 116–17, and n. 38, sees the statue on S. Giuliano as entirely from Vittoria's hand. What Boucher says, p. 117, about the modelling of Rangone's body is very similar to what I wrote in my dissertation (1988), p. 80 and n. 28, namely, that the drapery patterns on the *Rangone* are quite close to what one sees on other statues by Vitto-

ria. In respect to a collaboration such as the Rangone monument, it seems to me wise not to split attributive hairs too finely. Since Sansovino no longer did any actual sculpturing at this date, the statue itself must be principally the work of Vittoria; this is what Leithe-Jasper (1963), p. 76, has written: that while the overall composition undoubtedly derives from Sansovino, the 'painterly modelling of the surfaces' comes from Vittoria.

[61] Cattaneo's full-length statue of Girolamo Fracastoro in the Piazza dei Signori in Verona should also be noted in this context. Commissioned by the communal council on 21 Nov. 1555, the statue has never been properly researched or investigated; for basic information on Cattaneo, see Campori (1873), p. 62. And see now Rossi (1995).

Despite its seminal significance, however, the *Ferretti* has received scant attention in the literature, largely due to the disappearance of Vittoria's original portrait, which was replaced with a copy in the middle of the eighteenth century. The monument, with the copy of Ferretti's bust still in place today, has only once before been even illustrated.[62] The rich and complex history of Ferretti's tomb and its patronage deserves a full treatment.

Two entries in Vittoria's account book, from 12 and 13 November 1557, document the work. The first entry records a final instalment of 35 scudi, plus a piece of marble, that the artist received from Daniele Barbaro for the bust, while the second records a payment Vittoria made to an assistant for work on the pedestal of the statue.[63] The bust, on its pedestal, appears above a sarcophagus, under which runs the inscription:

IOAN. BAPT. FERRETTO | VICENT. IUR. UTR. DOCT. | PRAESTANTIS ET INTE | GER. VIRO. IULIA UXOR | PIIS. ET SIBI POSUIT.[64]

Vasari mentions the bust in the 1568 edition of the *Lives*, as does Francesco Sansovino in his guidebook to Venice dating from 1581.[65] From then on the tomb is regularly mentioned in the guide literature. Although the tomb has on occasion been ascribed to Michele Sanmicheli, this attribution has not been accepted by modern scholarship.[66]

The monument is not in its original location. When erected in 1557, it was set in the wall of the left aisle between the second and third altars, those, respectively, of the Annunciation and St Nicholas of Tolentino. In 1704 it was moved further up the left aisle to between the fifth altar, that of the Scuola dei Calafati, and the door leading to the cloister. In 1742, the tomb was moved for the second and last time into the left apsidal chapel, which is dedicated to St Thomas Villanova, and placed on the right wall of the chapel (Pl. 49). Thus, the tomb now faces the wall where it was originally placed. In 1742 the Ferretti family obtained Vittoria's original and substituted the copy still in place.[67] The last notice of the original marble occurs in 1856.[68] Only recently has this lost bust been identified at the Louvre (Pl. 50).[69]

Giovanni Battista Ferretti was a lawyer from Vicenza.[70] He is first documented in 1518 when he was appointed to the second chair of canon law at the University of Padua, right after the reopening of the Studio following the War of the League of Cambrai.[71] Ferretti seems to have had a rather stormy relationship with the university, leaving his post before August 1521.[72] He returned to this chair at the end of 1531 only to depart a second time in 1535 because he had not been promoted to the first chair.[73] In 1544, he finally attained the first chair of canon law but

[62] The illustration appeared in Langenskiold (1938), pl. 57*B*.

[63] See Predelli (1908), p. 185.

[64] 'Julia, his most pious wife, set up [this monument] to Giovanni Battista Ferretti, most excellent doctor of both laws and a most virtuous man.'

[65] Sansovino (1581), p. 50. For the reference to Vasari, see the beginning of Ch. 5, below.

[66] For a full account of the bibliography on Sanmicheli in respect to the Ferretti monument, see N. Carboneri's annotated bibliography in *Sanmicheli* (1960), pp. 255–6. The most recent book on the architect—Puppi (1971 and 1986)—does not mention the Ferretti monument.

[67] See cat. no. 6.

[68] Zanotto (1856), p. 184, n. 1, states that the original was in the possession of 'Consiglio' Richetti. Richetti was a prominent art dealer in Venice in the 19th cent.; see the short entry on him in Zorzi (1988), p. 160.

[69] See Martin (1994), pp. 48–54.

[70] The only account of Ferretti's life and career is in Santa Maria (1778), iv, pp. 98–101. Nevertheless, Santa Maria gives a confused and inaccurate account of Ferretti's career at Padua because he often misreports information from his sources. A coherent account of Ferretti's career at Padua can be obtained from Facciolati (1757), *passim*.

[71] Facciolati (1757), ii, p. 96.

[72] Ibid., p. 96. [73] Ibid., pp. 86 and 81.

again left Padua, apparently for the last time, in 1545.[74] Santa Maria states that, according to certain 'Memorie' in his possession, Ferretti was also the 'Avvocato Concistoriale' at Rome and the 'Avvocato Ecclesiastico' in Venice.[75] He died in Venice on 2 April 1556, a year and a half before his tomb was set up.[76] Since the account book shows Vittoria receiving a final instalment in November 1557, the bust is undoubtedly posthumous.

As his earliest documented portrait, the *Ferretti* is a precious incunabulum of Vittoria's career. The original in the Louvre and the eighteenth-century copy still on the Ferretti tomb (Pl. 48) correspond exactly, except that they are reversed. Although curious, this can be explained by the reversal of the tomb itself. As stated above, the monument originally rested on the wall of the left side-aisle of S. Stefano. With the Louvre bust in that location, Ferretti turns to his right, towards the entrance. In 1742 the tomb was moved to the right-hand wall of the apse chapel. Thus, if the original had been exactly reproduced, the copy would still be looking towards its right, but gazing meaninglessly out of the back window of the chapel. Reversing the copy preserved the bust's original orientation of facing towards the entrance.[77]

As already noted, Ferretti's bust occupies an important place not only in Vittoria's *œuvre* but in Venetian art as a whole as the first known use of a classicizing portrait bust in Venice. It also inaugurated a new sepulchral format, for Ferretti's was the very first Venetian tomb featuring a sarcophagus topped by a portrait bust, a format that became increasingly popular as the century advanced. Why was this format adopted for Ferretti in a city where, as was discussed in Chapter I, there was no tradition of tombs with busts? And why does the transfer of the Paduan type of classicizing sepulchral bust occur here?

As has been seen, the classicizing portrait bust had achieved a certain currency in Padua by 1557, and Vittoria had been involved with the most recent tomb featuring one, that of Alessandro Contarini. Ferretti's tomb even bears a general resemblance to Contarini's—in some ways, the former is a miniature version of the latter—where the bust is set above a sarcophagus-like lintel that encloses an inscription. Because Ferretti spent a great deal of his career in Padua, being, like Lazzaro Bonamico, a professor at the university, it would therefore have been appropriate that his tomb in Venice should make reference to a Paduan type.

The identity of the patron of Ferretti's bust, moreover, supplies further Paduan–Venetian connections. Although the sepulchral inscription states that Ferretti's wife Giulia raised the monument, the entry from 12 November 1557 in Vittoria's account book testifies that Daniele Barbaro—patriarch-elect of Aquileia, commentator of Vitruvius, and the great friend and patron of Palladio—paid the artist for the bust. Why he should have done so is unclear. A book entitled *Predica de i sogni* by 'Hypneo da Schio' (Venice, 1542), has often been attributed to Barbaro and, according to a handwritten note in the copy in the Marciana, was dedicated by

[74] Facciolati (1757), p. 81.

[75] Santa Maria (1778), iv, p. 100. These claims are supported by the introduction written by Ferretti's nephew to the collection of Ferretti's legal opinions, Ferretti (1572), where, on p. 2ʳ, it is stated: 'Clarissimi utriusq. iur. doctr. dom. Ioan. Baptistae Ferretti Vicentini, et advocati consistorialis celeberrimi, primum volument Responsorum, & Consiliorum suorum Paduae, dum ibi ius Canonicum publice profiteretur, & Venetiis causa in foro

Canonico patroncinaretur, absolutorum, optimis auspiciis, Incipit.'

[76] See cat. no. 6 for Ferretti's necrology.

[77] The only time the Louvre bust has been published was by Vitry (1933), p. 85: 'Vittoria (Jacopo Alessandro). No. 1886: Buste d'homme. (Marbre). Legs Chauchard, 1910. H. 0,87' [no illustration]. I am most grateful to Prof. William E. Wallace, who drew my attention to the bust in the Louvre.

Barbaro to a 'Giulia Fereti'. Perhaps this is the same person as Ferretti's wife.[78] Whether the poems are by Barbaro or not, other connections existed between him and Ferretti. Barbaro lived in Padua for a ten-year period between 1530 and 1545; Ferretti was teaching there during 1531–5 and 1544–5, so the two men could have known each other at this time or later on in Venice. More importantly, a definite link was forged between the two by the *causa Grimani*, the legal difficulties that arose when Giovanni Grimani named Barbaro as his heir to the patriarchate of Aquileia. As the *avvoccato ecclesiastico* in Venice, Ferretti was consulted by the Council of Ten about the case in 1550.[79] Furthermore, in Ferretti's book of collected legal opinions, four *consilia* deal with the *causa Grimani*, and all of them support Barbaro's claim to be Grimani's rightful successor.[80]

Whatever the exact nature of the relationship between Ferretti and Barbaro, it was Barbaro who paid Vittoria for the *all'antica* bust of Ferretti.[81] I suspect that he turned to Vittoria because of the connection they both had with Palladio. Daniele Barbaro and his brother Marc'Antonio were Palladio's strongest supporters among the Venetian patriciate. It was in the middle of the 1550s, after his failed attempts to win the position of Protomagister (official architect) of the Salt magistracy and to get the commission for the Scala d'Oro that, through the Barbaro, Palladio received his first work in Venice itself: the cloister of the collegiate canons at S. Maria della Carità (now the Accademia) and the design for the façade of the cathedral, S. Pietro di Castello. Palladio and Vittoria had already worked together at the palazzo Thiene in Vicenza, and, by the time of the Ferretti bust, they had also worked at the villa Pisani at Montagnana.[82] Barbaro was a canon of the cathedral in Montagnana and was related to the Pisani family. (I am, however, in agreement with those who do not see Vittoria's presence at Barbaro's villa Maser together with those of Palladio and Veronese.[83]) As will be discussed more fully in the next chapter, during the very year the Ferretti bust was commissioned, Vittoria was making stuccoes in Camillo Trevisan's palazzo on Murano, a building that was probably designed by Daniele Barbaro. Finally, Howard Burns has suggested that the Ferretti tomb was designed by Palladio, which would furnish yet another link between Barbaro and Vittoria.[84]

Even more importantly, Barbaro held a commanding position among the Venetian intellectuals who worshipped all things antique, and this support was cemented by his commentaries on

[78] Laven (1957), p. 68, doubts that the book is in fact by Barbaro. Howard Burns, in a talk at the Annual Meeting of the College Art Association in Boston, 1987, accepted the attribution of the book to Barbaro, identified Giulia as Ferretti's wife, and suggested that Barbaro's continued attachment to Giulia accounted for his patronage of Ferretti's tomb.

[79] Laven, in an appendix to his dissertation, publishes the relevant document (ASV, Consiglio dei Dieci, Secreti, Sesta) dating from 25 Oct. 1550 in which the Council states that 'Havemo fatto fare doi consegli dalli Eccellenti Dottori Giganti et Fereto . . .'. Girolamo Gigante was elected *Consultore della Republica* in Dec. 1541; see Cecchetti (1874), ii, p. 399.

[80] Ferretti (1572), consilia 7, 11, 12, and 13.

[81] Circumstances remain unclear. Did Barbaro only pay for the bust, on behalf of Giulia Ferretti, or did he himself commission it? Did Barbaro also commission the tomb? It is also very curious that, only the year before his activity at the Ferretti tomb, Barbaro published in his commentary on Vitruvius (1556) a

passage highly critical of tombs being placed in churches ('Non è lodevole che i monumenti, o sepolture siano nelle Chiese . . .'), a passage much toned down in the 1584 edition; see Wolters (1987), p. 75.

[82] For the date and patron of the villa Pisani, see Lewis (1984), pp. 227–39.

[83] See the text and bibliographic notes in Battilotti (1985), p. 35, n. 20, and p. 48, n. 103.

[84] Burns, CAA talk (as in n. 78 above). While Barbaro's patronage of Palladio has received extensive coverage, his patronage of Vittoria for the Ferretti bust has received no attention. The family patronage continued in 1582, when Marc'Antonio Barbaro, Daniele's brother, commissioned from Vittoria the terracotta bust of Doge Niccolo da Ponte for the Doge's tomb (see below, Ch. 6, and cat. no. 19). Barbaro was a patron of Battista Franco, who frescoed Vittoria's stuccoes in both the Scala d'Oro and the Libreria. Franco was also, at the very end of his life, to work with Palladio at Villa Malcontenta.

Vitruvius published in 1556. He also enjoyed deep connections with Padua and its antiquarian élite.[85] Barbaro must have been quite familiar with, and interested in, the classicizing busts there of Bembo, Bonamico, and Contarini (he was the successor to Bembo as official historian of the Republic). For all these reasons it seems quite appropriate that Barbaro should be the patron of the Ferretti bust, which introduced the Paduan sepulchral mode to Venice by depicting a law professor in the guise of an ancient Roman.

While the particulars of the Ferretti monument provided the immediate occasion for the introduction of the *all'antica* bust to Venice, the *Ferretti* is no isolated incident. As has been seen, an intense spate of activity in both Padua and Venice had been taking place, in the decade prior to the *Ferretti*, in terms of monuments emphasizing personal imagery. In both the Rangone and Ferretti monuments, a new kind of personal imagery appeared on public display in Venice: an imagery that is highly personalized and very secular.[86] Tellingly, Vittoria was involved with both of them. In fact, during 1556–7, he was working on the figures for the Contarini tomb in Padua, making the model for the figure of Rangone at S. Giuliano, and carving the bust of Ferretti for S. Stefano. Ferretti's tomb followed so closely on the completion of the Rangone monument, with Vittoria the only connection between the two, that he must be seen as a key figure in the development taking place in terms of personal imagery in Venice. With the Ferretti bust, Vittoria entered a new phase of his career as the popularizer of the *all'antica* bust in Venice.[87]

[85] A good discussion is found in Azzi Visentini (1984), ch. 4. She notes on p. 168 that Benavides was a member of the Accademia degli Infiammati, which was founded by Barbaro (and whose symbol was Hercules, the mythological figure favoured by Benavides).

[86] Significantly, one finds no Christian imagery whatsoever on the Bembo, Contarini, Bonamico, Rangone, or Ferretti monu-

ments. This directly contradicts Hiesinger's findings that in later 16th-cent. wall tomb monuments, '[p]ersonalized images . . . of the deceased were severely reduced in scale and/or numbers and often replaced entirely by strictly Christian images'; see Hiesinger (1976), p. 287.

[87] Semenzato (1962) and id. (1967), places proper emphasis on the importance of the cult of antiquity for Vittoria's portraiture.

5

VITTORIA'S EARLY PATRONS AND THEIR PORTRAIT BUSTS

By the mid-1560s, Vittoria had produced a significant body of portraits, as witnessed by Vasari who, in the 1568 edition of the *Lives*, supplies a list of eight busts by the artist. Presumably they all were finished at the time of Vasari's visit to Venice in the summer of 1566, and are thus the artist's earliest efforts in the genre. The passage runs:

Il medesimo Vittoria ha fatto molti retratti di marmo e bellissime teste e somigliano, cioè quella del signor Giovanbatista Feredo, posta nella chiesa di Santo Stefano, quella di Camillo Trevisano orator posta nella chiesa di San Giovanni e Polo, e il clarissimo Marcantonio Grimani, anch'egli posto nella chiesa di San Sebastiano, et in San Gimignano il piovano di detta chiesa [Benedetto Manzini]. Ha parimente ritratto Messer Andrea Loredano, Messer Priamo da Lagie, e dua fratelli da Cà Pellegrini oratori, cioè Messer Vincenzio e Messer Giovanbatista.[1]

It has been seen how Vittoria's earliest documented portrait, that of Giovanni Battista ('Giovan-batista') Ferretti, which heads Vasari's list (as Feredo) and was the first public *all'antica* bust in Venice, introduced the Paduan antiquarian sepulchral mode to the Serenissima. That the subject of the bust was a former professor at Padua, and the patron Daniele Barbaro, clearly establishes ties to Padua and to antiquarian interests.

Similar relationships are evident in the patronage of the other busts by Vittoria mentioned by Vasari, such as the now-lost portrait of Andrea Loredan. Vittoria was in contact with this man by at least 1552, for in a letter of 5 December of that year to Marco Mantova Benavides, Loredan mentions letters from Benavides that had been delivered to him by 'Alessandro Vittoria, scultore ecellentissimo.'[2] He excuses himself for not having replied earlier, writing that Vittoria had promised to return, but has not. The letter proves Vittoria's acquaintance with Loredan and further supports the belief that relations between Vittoria and Benavides were well established by 1552.[3]

[1] Vasari (1878–85), vii, pp. 519–20. It should be noted that Vittoria and Vasari kept in touch after the latter's stay in Venice from roughly 21 to 27 May 1566. Frey and Frey (1923–40), ii, pp. 274, 360, 382, 394, 434, 581, and 684, show that Vittoria sent greetings to Vasari via Cosimo Bartoli in Aug. 1566, Dec. 1567, June 1568, Aug. 1568, June 1569, Apr. 1571, and June 1572 (thus up to the year of Vasari's death). In 1567, Vittoria even sent Vasari a model of a horse. See also *Vasari* (1981), no. 55, pp. 295–6 (by Charles Davis).

[2] This letter has been published only once, by Bottari and Ticozzi (1822–5), viii, no. 157, p. 353, and has been referred to in the secondary literature only by Favaretto (1976–7), p. 410. It survives in an 18th-cent. copy by Giuseppe Gennari conserved in the Biblioteca del Seminario di Padova, MS 619, vi, no. 54.

[3] It also shows how mobile Vittoria was in these years, *pace* the sources that present the artist as being in a kind of 'Vicentine exile' from Venice during 1551–3.

Andrea Loredan (*c.*1490–1569), the son of Bernardin, owned one of the largest collections of ancient art in sixteenth-century Venice.[4] Francesco Sansovino mentions him twice, once among a list of antiquarians ('Sono anco lodati gli studii d'Andrea Loredano raccolto con lunghezza di tempo, & fornito di bellezze esquisite') and once in reference to his house ('A San Pantaleone, i Loredani vi fecero il suo [palazzo], abbellito di molte figure antiche').[5] Enea Vico praises Loredan highly in his book on antique medals, and also provides the information that Loredan retired early from public life (he was once the *podestà* of Brescia) in order to devote himself to collecting.[6]

On 26 June 1553, Loredan again corresponded with Benavides, asking for information about the arrangement of the latter's collection, and he thanked him on 1 July 1553 for having sent 'il modello dello studio'.[7] Presumably, Loredan based the display of his *museo* on that of Benavides. Like many collectors, he was very acquisitive by nature and tried, surreptitiously, to buy items from the famous collection of Gabriel Vendramin.[8] In 1567, however, Loredan sold his collection to Duke Albert V of Bavaria (through the Duke's agent, Jacopo Strada), and it survives today in the Antiquarium of the Residenz in Munich.[9] For 7,000 ducats, the Duke acquired 120 bronzes, 91 marble heads, 43 marble statues and torsos, 33 reliefs, 14 miscellaneous objects, and 2,480 coins and medals.[10]

Loredan thus shared the interests and pursuits noted among the Paduan antiquarians who brought about the revival of the public, classicizing portrait bust. His acquaintance with Vittoria through one of the leaders of this group, Benavides, may have spurred him to commission from the young artist a bust of himself like those of Bembo and Bonamico. The portrait of Loredan was perhaps among the earliest of Vittoria's busts, made not long after his return to Venice from Vicenza in 1553.[11]

Loredan's son, Bernardino (1533–1611), also shared the antiquarian interests of his father and occupied a significant place among the humanist élite in Venice. In acknowledgement of his talents and breadth of culture, he was appointed librarian of the Marciana in September 1558 (and thus was a successor to Bembo). In that year, he published an edition of Cicero's *De Lege Agraria*, which he dedicated to Girolamo Grimani—the builder of the palazzo Grimani at S. Luca, a patron of Veronese, and the subject of a portrait by Vittoria, who will be met again in the next chapter. Bernardino was also an enthusiastic supporter of the Accademia della Fama, sponsoring the academy's successful proposal to meet in the vestibule of the Libreria. He resigned as librarian on 12 May 1575, however, and almost nothing is known of him after that date.[12]

[4] See the entry on Loredan in Zorzi (1988), pp. 63–4, and also the *Genealogia di famiglie patrizie* (Bibl. Civ. Correr, MSS P. D. c. 2803), p. 267.

[5] Sansovino (1664), pp. 372 and 386.

[6] Vico (1558), p. 53. The Andrea Loredan described here has been identified with the Andrea Loredan who, in 1506, nearly outbid Isabella d'Este for a Roman onyx vase (now in the Herzog Anton Ulrich Mus.); see Brown (1969), p. 374. Nevertheless, the Andrea described here was probably too young in 1506 to have been this person.

[7] See Favaretto (1990), p. 113, with archival reference.

[8] See Ravà (1920), pp. 155–81. Vittoria, along with Jacopo Sansovino, Tommaso da Lugano, Tintoretto, and Orazio Vecellio (Titian's son), served as experts in evaluating Vendramin's collection in 1567–9; see Zorzi (1988), p. 49.

[9] See Weski and Frosien-Leinz (1987), i, pp. 37–8.

[10] For these numbers, see Anderson (1979), p. 640. See also Weski and Frosien-Leinz (1987), i, p. 37, and also pp. 454–5, for an inventory of Loredan's collection.

[11] See cat. no. 55.

[12] For information on Bernardino Loredan, see Zorzi (1987), pp. 173–6.

The Accademia della Fama, also known as the Accademia Venetiana, led a complex existence during its short life from its foundation by Federico Badoer in 1557 to its suppression by the state in 1561.[13] In what seems to have been an attempt to set up a kind of state cultural institution, the academy proposed a wildly ambitious series of programmes: they petitioned the Senate in 1558 for permission to collect and reform the Republic's law; in 1560, they offered to reorder and manage the Libreria; they planned the publication of 300 volumes, many of which would have been editions and translations of Greek and Roman works. The academy hoped to encompass an encyclopaedic range of interests: both humanistic and scientific matters were to be addressed, investigated, and debated. Its suppression was ostensibly due to ambiguous financial dealings, mostly on the part of Badoer. The suppression must also have been undertaken, however, because the programme was simply too ambitious and impinged on prerogatives guarded by the state. While there are no concrete connections between the activities of the academy and Vittoria, it is striking that several of his patrons were associated with the organization. It is probably no accident that a group of men interested in a new art form would also be involved with the most radical cultural undertaking of the times.[14]

Connections with the Accademia appear in respect to another now-lost bust recorded by Vasari, that of Camillo Trevisan. Camillo, the son of Bernardo, was born *c.*1515 to a branch of the Trevisan family who were *cittadini originari*, i.e. native-born.[15] He studied law in Padua—certainly under Benavides (and perhaps under Ferretti)—and was highly renowned for his eloquence and for his skills as a lawyer. He must have known Bernardino Loredan, for he taught civil law at the Accademia della Fama. He made his will on 22 October 1564 in his house at S. Maria del Giglio, where he died five days later, and was buried in SS Giovanni e Paolo.[16]

Although not a patrician himself, Camillo Trevisan was a member of the cultivated circles dominated by patricians, and ran a kind of salon in the garden of his palazzo (often called a villa) on Murano, which was much frequented by *bembisti*: Trevisan and his salon are mentioned by Valerio Marcellino in his *Diamerone* (1563) as well as by Gianmaria Verdizotti and Orsato Giustiniani in *De le rime di diversi nobili poeti toscani raccolte da M. Dionigi Atanagi* (1565).[17] Francesco Sansovino dedicated one of his books to Trevisan, and Celio Magno (one of the original members of the Accademia della Fama) wrote two sonnets in his honour.[18] The founder of the Accademia della Fama, Federico Badoer, frequented this salon, as did probably the poet Girolamo Molin, of whom a bust was commissioned from Vittoria around 1570.[19]

The palazzo that housed the salon survives, though now a ruin. It was frescoed by Veronese and stuccoed by Vittoria. In his account book, Vittoria recorded payments for this work between 20 February and 24 September 1557.[20] So it was at the very time that Vittoria was executing the *Ferretti* bust commissioned from him by Daniele Barbaro, that the artist was working at Trevisan's

[13] Tafuri (1989), pp. 114–22, discusses the academy and provides a full bibliography. Among recent works are: Rose (1969), pp. 191–242; Pagan (1973–4), pp. 359–92; Bolzoni (1981), pp. 117–67; and Vasoli (1981), pp. 81–106.

[14] Zorzi (1987), p. 143, calls the academy 'l'evento più importante di quegli anni nel mondo della cultura [veneziana]'. On pp. 143–52, he gives a good overview of the academy and draws parallels beween its programme and that of the painted decorations of the reading room of the Libreria.

[15] See Lane (1973), pp. 151–2, on the various grades of Venetian citizenship.

[16] See Urbani de Gheltof (1890), pp. 13–24.

[17] Giustiniani was to be sculpted by Vittoria in the late 1570s; see Ch. 6 and cat. no. 7.

[18] Messia (1565); Magno's sonnets appear in Magno and Giustiniani (1600), pp. 16 and 163.

[19] For Molin's bust, see Ch. 6, below, and cat. no. 40.

[20] Predelli (1908), pp. 184–5.

villa, which was itself probably designed by Barbaro with the assistance of Palladio.[21] This build-
ing was one of the most accomplished for its time in the new Roman style. Francesco Sansovino,
in the earliest known reference to it, called it 'veramente reale, con un giardino e con una fontana
alla Romana di eccessiva bellezza'.[22]

Trevisan must have commissioned the design for the building after he inherited the land on
Murano from his aunt in 1554, and the building must already have been finished at the time
Vittoria was at work on its decoration.[23] The façade featured frescoes by Prospero Bresciano
that depicted Hercules and Neptune as statues standing in rusticated niches while above them
other scenes showed the Rape of Europa and allegories of the liberal arts.[24] Rusticated pilasters
that support a Doric frieze articulate the atrium, which, in turn, leads to an oval room punctu-
ated with niches (which perhaps originally held statues by Vittoria). The most striking feature of
this centralized room is its vaulted ceiling (Pl. 51) decorated *all'antica* with grotesques set in alter-
nating rectangular, hexagonal, and octagonal frames; it is very similar to a ceiling in the Odeon
Cornaro.[25] Then comes the garden loggia, which still contains three stucco reliefs by Vittoria.
In a room to the right of the loggia are the remains of a fireplace designed by Vittoria, which was
formerly flanked by stucco figures on either side of it (and above which originally rested an
antique Roman portrait bust); this room also contained frescoes by Veronese of mythological and
allegorical subjects.[26] The garden façade of the villa was frescoed by Battista del Moro (Vittoria's
collaborator on the second ramp of the Libreria staircase) and his son Marco. There were further
frescoes by Veronese on the piano nobile, some of which still survive, although in a very damaged
state.[27]

Trevisan's house on Murano shares many features common in Paduan antiquarian circles: it
was a place devoted to the Muses where discussions of poetry and other intellectual matters
could take place in an ambience adorned with both painted and stuccoed work inspired by
antiquity. As at the Odeon Cornaro and the palazzo Thiene, the motif of a centralized room
decorated *all'antica* appears. The two principal artists Trevisan employed, Vittoria and Veronese,
were both rising stars of the new generation of mannerizing artists, both of whom had already
enjoyed the favour of Daniele Barbaro. Considering Trevisan's interests and associates, it is little
wonder that he chose Vittoria to execute the stuccoes on Murano. Nor is it any wonder that such
a patron—or his heirs—selected Vittoria to make an *all'antica* bust of him.[28]

[21] Ridolfi (1914–24), i, pp. 322–3, first named Barbaro as
the architect of the pal. Trevisan. Although attributions to
Sanmicheli were advanced in the 1960s, I agree with the argu-
ments put forward by Bassi (1987), pp. 535 and 538, who notes
how both the brickwork in the atrium of the pal. Trevisan resem-
bles that in the cloister of the church of the Carità by Palladio (also
noted by Urbani di Gheltof (1890)), and that the frieze of bucra-
nia and patens on the loggia facing the garden at Trevisan repeats
almost exactly the frieze at the Carità. She concludes that these
features, as well as the similarities in the ground-plan, point to Pal-
ladio or to someone working with him. Tafuri (1989), p. 122, states
that it was probably Barbaro who directed the work on Murano,
and also notes Trevisan's membership in the Accademia della Fama.
On pp. 119–20, Tafuri draws connections between Barbaro and
the intellectual pursuits of the academy, while noting that no
proof exists that Barbaro officially belonged to it. Azzi Visentini

(1984), pp. 209–12, supports an attribution of the pal. Trevisan to
Barbaro, noting the affinities of the garden and grotto there
(which she describes as being without precedent in Venice) with
those at Maser.

[22] Sansovino (1562), p. 28ᵛ.

[23] See Bassi (1987), p. 528.

[24] Ibid., p. 530.

[25] The resemblance between the two ceilings was noted by
Wolters (1968a), p. 42.

[26] Two fragments of these frescoes are now in the Louvre; see
Caiani (1968), pp. 52–3, and figs. 60–1.

[27] For these frescoes, see ibid. and Pignatti (1976), i, pp. 113–14,
nos. 64–8. For a recent discussion of the pal. Trevisan, see
Romano (1986), pp. 95–101.

[28] See cat. no. 58 for the sparse information known concerning
the bust.

The other two no longer extant busts mentioned by Vasari portrayed people associated with Trevisan. After stating that the artist had depicted Andrea Loredan and Priamo da Lezze, Vasari concludes with the names of 'two orator-brothers of the Pellegrini family, namely, Messer Vincenzio and Messer Giovanbattista'. This is the only contemporary notice of these busts; Giovanelli claims that both brothers died in the same year, either 1567 or 1568.[29]

That this cannot be correct, however, is demonstrated by Vittoria's *Memorie*. On 30 March 1569, the artist records paying 'Vincenzo Pelegrini' 35 lire for defending him 'al Coleio [collegio]' in the property case brought against him by the Memmo family.[30] Vincenzo Pellegrini was thus the artist's lawyer and still alive in 1569. Since Vittoria knew Vincenzo, he presumably knew the brother, Giovanni Battista, as well.

Like Ferretti and Trevisan, Vincenzo Pellegrini was a prominent lawyer.[31] Garzoni lists the 'dottissimo Pellegrino' among the leading advocates of his day and, more importantly, Valerio Marcellino cites Pellegrini as a member of the circle of Camillo Trevisan.[32] So in the case of Pellegrini, Vittoria's patron was yet again someone with whom he was personally acquainted and who belonged to the same social and intellectual circles under discussion.

What little is known about the other patronage bestowed by the Pellegrini suggests why they should have been drawn to Vittoria. On 24 June 1557, Vincenzo Pellegrini was ceded the first altar on the left in S. Sebastiano.[33] He commissioned the altarpiece of this chapel, *Christ and Companions [Pilgrims] on the Way to Emmaus*, still *in situ*, from Andrea Schiavone, who frescoed the ceiling as well (Pl. 52).[34] Like Vittoria, Schiavone was one of the leading mannerist artists in Venice: they both admired and collected the works of Parmigianino. And like both Vittoria and Veronese, Schiavone had worked at the Libreria. Furthermore, Schiavone was a close friend of Vittoria: the sculptor was one of the witnesses for the painter's will of 22 May 1563 (he died on 1 December 1563).[35]

So Pellegrini had personal, professional relations with Vittoria, he was a member of Trevisan's social circle, he employed Vittoria's close friend Schiavone and was thus (like Trevisan) a patron of the new, mannerizing art in Venice. The ceiling of the Pellegrini chapel, which contains the frescoes by Schiavone, is elaborately stuccoed in strapwork (Pl. 52). Considering Vittoria's great expertise in this medium, and considering his close friendship with Schiavone, it seems very probable that the stuccoes are by him.[36]

[29] Giovanelli (1858), p. 39.

[30] Predelli (1908), p. 142: '30. Dito [Marzo] per contadì a M. Vincenzo Pelegrini che parlò in Coleio quando el presentò la suplica scudi cinque val . . . L. 35 s.——.' This comes from c. 62 of the *Memorie*, in a section under the heading '+ Al nome de Dio, adì, 28, febraro, 1568 [*m.v.*], in Venetia'. For the lawsuit with the Memmo, see ibid., pp. 24–5.

[31] Of the eight busts cited by Vasari, three depicted lawyers: Ferretti, Trevisan, and Pellegrini.

[32] See Garzoni (1586), p. 134; other eminent lawyers cited by Garzoni are Camillo Trevisan and Giovanni Battista Ferretti. The 'valorisissimo M. Vicenzo Pellegrini' is mentioned among the salon of the pal. Trevisan in the introduction (unpaginated) to Marcellino (1563). Matteacci (1613) p. 92t, calls Vincenzo an 'orator & giureconsulto famosissimo' and states that his son Pietro was a secretary to the Council of Ten (thus a successor to

Ramusio); see also Cicogna (1824–53), i, p. 262, and cat. nos. 56 and 57, below.

[33] See Cicogna (1824–53), iv, p. 131.

[34] For the altarpiece, see Richardson (1980), cat. no. 243, pp. 151–2 (who suggests a probable date of 1557); for the frescoes, see ibid., cat. nos. 303–5, pp. 180–1. The subject of the painting is, of course, a pun on the patron's name.

[35] See ibid., pp. 11–12. Pellegrini had already employed Schiavone prior to the work at S. Sebastiano. Pellegrini owned a (now destroyed) villa between Chioggia and Monselice that, according to Vasari (1878–85), vii, p. 96, was frescoed by Schiavone, Gualtieri Padovano, and Lambert Sustris. For this project, see Ballarin (1968), p. 116. Ballarin dates the work at Pellegrini's villa to the 1540s. See also now Mancini (1991).

[36] These stuccoes have gone unremarked in the literature.

Schiavone and Vittoria worked together on another project at S. Sebastiano: in the third chapel on the left side of the nave (two down from the Pellegrini chapel), which had been ceded to Marc'Antonio Grimani in 1544.[37] Schiavone painted the grisailles on the vault (Pl. 53) while Vittoria executed three sculptures: the statues of Sts Mark and Anthony Abbot to either side of the altar (Pl. 54) and the monument to the patron, Marc'Antonio Grimani (Pl. 55).[38] The latter is located on the left wall of the chapel and consists of a bust, the pedestal to the bust, and the *targa* (plaque) underneath containing the epitaph.

Happily, Vittoria's sculptures not only survive *in situ* but can also be closely dated, for Grimani mentioned them several times in his will with its two codicils.[39] When the will was written, on 21 September 1558, none of the sculpture had yet been executed. The bust is not mentioned although the epitaph is ordered to be made and Grimani states that he has 'ultimamente' had two niches fashioned inside the chapel, which he orders to be occupied by statues of his patron saints, Mark and Anthony Abbot.[40]

Both the bust and statues are mentioned in the first codicil which was written in sections over a period of five years: from 10 October 1559 to 7 March 1564. The chapel is not referred to in the section from 1559. In the part of the codicil written some time in 1561, Grimani specifies that the monks of S. Sebastiano are to care for the chapel:

. . . lassi ut supra tuti siano et stiano in mano delli sop[ra]ditti fratti over convento continuamente ben governati et custoditi p[er] il sop[ra]dito efeto cercha la cons[er]vation de la antedita capella la qual volgio sia in sua protecion et governo et manenimento con tute sue et mie figure in dita poste con tuti li soi belli et rari adornamenti stando et restando quella a laude del s[ignor] Idio prima et a memoria mia in eternum . . .[41]

The phrase 'tute sue et mie figure' refers to the bust and to the statues of the saints. All three pieces of sculpture in the chapel can thus be dated to 1559–61, at least five years before Grimani died.

With this bust, an early surviving portrait by Vittoria, the artist was moving into a higher echelon of patronage, for the bust of Grimani brought him into procuratorial circles. Marc' Antonio Grimani was the son of Francesco, the son of Piero; his mother was a daughter of

[37] Cicogna (1824–53), iv, p. 156. Although the chapel was ceded to Marc'Antonio in 1542, the official documents certifying this were not drawn up until 1544.

[38] The grisailles are ascribed to Schiavone by Richardson (1980), p. 179. Pignatti (1966), p. 76, unconvincingly attributed them to Veronese and suggested a date of 1555. Puppi (1980), pp. 55–6, agrees with Pignatti as to Veronese's authorship of the frescoes but dates them to 1553 because Cicogna records that the steps of the chapel were laid down then; he also says there are good reasons for dating Veronese's frescoes after those of Schiavone in the 'adjacent' (i.e. Pellegrini) chapel. In Puppi (1988), p. 35, Puppi states that Marc'Antonio Grimani involved Veronese in the decoration of the Grimani chapel in 1553, citing Cicogna as his source. These statements are quite inaccurate. The Pellegrini chapel is not 'adjacent' to the Grimani chapel and Schiavone did not work there until at least 1557 (when the Pellegrini were ceded the chapel). Although elements of the architectural framework of the Grimani chapel were completed as early as 1553, Grimani's will demonstrates that the decoration

did not commence until 1558; see cat. no. 10. That the frescoes in the Grimani chapel are by Veronese is by no means agreed upon (Schiavone is the preferable attribution), and it is certainly in error to state that the frescoes were painted in 1553.

[39] ASV, Notarili e Testamenti, Cesare Zilliol, b. 1262, fasc. 1, fos. 18ʳ–61ʳ (an autograph copy is contained in ASV, C. Zilliol, b. 1260, no. 759). The will and two codicils are long and complicated documents. See discussion in cat. no. 10. Richardson (1980), p. 179, refers to a will by M. A. Grimani from 1555; no such document ever existed. Because of this, Richardson misdates the *terminus ante quem* for Schiavone's frescoes in the chapel.

[40] ASV, C. Zilliol, b. 1262, fasc. 1, fo. 20ʳ; for this passage, see cat. no. 10. Since both the *targa* containing the epitaph of Grimani and the bust are by Vittoria and since Grimani does not mention the bust when he orders the epitaph to be made, its commission could not yet have been given.

[41] ASV, C. Zilliol, b. 1262, fasc. 1, fo. 44ʳ. For the dating of this passage, see cat. no. 10.

Andrea Diedo. Born in 1484, he married Beatrice Tron in 1510. In 1538 he served as a *savio di Terraferma* and was *podestà* of Padua in 1552–3. He was balloted for Doge in 1553. Elected a Procurator *de Ultra* on 1 February 1565, replacing Andrea Cappello, he died on 25 February 1566.[42] Marc'Antonio was the third member of his immediate family to have achieved the rank of Procurator; his brother Vincenzo (†1546) had been elected a Procurator *de Citra* in 1529, while another brother, Pietro (†1553), was elected a Procurator in 1538.[43] From 1538 to 1546, then, two of Marc'Antonio's brothers were Procurators simultaneously. Moreover, Marc'Antonio's son, Ottaviano (who was also to have his bust carved by Vittoria), was elected a Procurator in 1571. Although Grimani commissioned his bust at least four years prior to his election as a Procurator, he clearly came from a very rich, prominent, and powerful family. Like their Grimani cousins at S. Maria Formosa, the branch that included the Procurator Vettor Grimani and his brother the Patriarch Giovanni, they were patricians for whom the Procuratorship was a *de facto* hereditary position.

Marc'Antonio Grimani was thus not only an important new patron for Vittoria, he was also the first patron of the rank of Alessandro Contarini to adopt the Paduan mode of sepulchral portraiture for his tomb in Venice. Andrea Loredan was a patrician but, like the Pellegrini, he commissioned a private portrait; Trevisan, Ferretti, and the Pellegrini were not patricians. Although Grimani is not known to have displayed any evident interests of an antiquarian nature that could have drawn him to Vittoria, he surely would have become familiar with the monuments to Livy, Bembo, and Bonamico while he was the *podestà* of Padua in 1552–3. His own monument suggests that he was advised to employ some of the young men who had just received so much notice at the Libreria. As a result, the Grimani chapel shows a prestigious patrician adopting the *all'antica* mode of self-representation in a church dominated by the new mannerizing art of Schiavone, Vittoria, and Veronese.[44]

Just as Marc'Antonio was decorating his chapel in S. Sebastiano, another Grimani chapel was being worked on at S. Francesco della Vigna by Marc'Antonio's (somewhat distant) relative, Giovanni Grimani, the Patriarch of Aquileia. The Patriarch owned the largest collection of ancient sculpture in Venice and, like so many of Vittoria's patrons, shared a taste for antique art and for modern, mannerist art.[45] He held the patronage of the family chapel, which is the first on the left in S. Francesco, with his brother, the Procurator Vettor who, as mentioned earlier, was the primary proponent of the Libreria (and the patron of the façade monument at S. Antonio di Castello to his and Giovanni's grandfather, Doge Antonio).[46] After Vettor's death in 1558, Giovanni not only sponsored the decoration of the chapel, whose primary element was its

[42] For the above information, see Cicogna (1824–53), iv, pp. 157–8, who gives a simple biography of Grimani. The inscription on Grimani's monument states that he died on 25 Feb. 1565, but this date is in *more veneto* as attested by his necrology. All necrologies are in *more veneto* and Grimani's reads: '25 Feb. 1565: Il cl[arrissi]mo M[esser] Marc ant[oni]o Grimani Procurator, am[malat]o da vechiezza, S. Boldo' (ASV, Provveditori e Sopravedditori alla Sanità, b. 801, unpaginated).

[43] See Cicogna (1824–53), ii, p. 66, and Cicogna (1824–53), vi, p. 603.

[44] There was a portrait of Grimani by Veronese in the Sala del Maggior Consiglio, but it perished in the fire of 1577; see Cicogna (1824–53), iv, p. 158.

[45] See Zorzi (1988), pp. 24–40, on the Grimani in general as collectors of the antique, and pp. 30–1, on Giovanni in particular.

[46] In the fifth chapel on the right in S. Francesco the Barbaro have their funerary chapel, whose altarpiece was commissioned by Daniele Barbaro from Battista Franco *c.*1552, right after his return from the ambassadorship to England; see Foscari and Tafuri (1983), pp. 131–3, and also Rearick (1958–9), pp. 105–38. It should be remembered that Giovanni Grimani selected Barbaro as his heir to the patriarchate of Aquileia.

ceiling frescoes by Battista Franco (Pl. 57), but also commissioned the façade of the church from Palladio. An *alla romana* campaign was being waged both on the exterior and the interior of the church.[47]

These two Grimani chapels in churches at opposite ends of the city present striking parallels. Both Grimani patrons were employing members of the mannerizing avant-garde: Vittoria and Schiavone at S. Sebastiano, Franco at S. Francesco. Physical similarities appear as well. Both chapels have a central altarpiece flanked by scallop-shell niches below stucco festoon panels meant to hold statues (in S. Francesco, the statues—of bronze and by Tiziano Aspetti—were not made until the 1590s), and both feature a frescoed Resurrection directly above the altarpiece.

Their closest similarity lies in the barrel-vaulted, frescoed ceilings where, in each chapel, the paintings are arranged according to the decorative scheme Sansovino had popularized in the portico and the reading room of the Libreria. The rich stuccoed frames for the frescoes in S. Sebastiano are still in place and, for stylistic reasons and on account of his actual presence at the chapel, must be attributed to Vittoria.[48] The fifteen frescoes by Franco on the ceiling of the chapel in S. Francesco were also originally framed by stucco mouldings, as were the three frescoes he painted in the lunette above the altarpiece. Furthermore, the altarpiece, painted by Federico Zuccari in 1564, originally had a stucco frame and was flanked by caryatids of the same material.[49] These stuccoes were all destroyed in 1833.[50]

Considering his stature as a stuccoist, Vittoria is the most likely candidate for this lost work. Indeed, when it is remembered that he and Battista Franco had only just finished their work on the frescoes and stuccoes at the Scala d'Oro and were just beginning their work on the stairway at the Libreria at this precise time, it seems to me that Vittoria is the only candidate for the stuccoes at S. Francesco.[51] If this was indeed so, then the Grimani chapels at S. Sebastiano and at S. Francesco shared an artist as well as their general ambience and *alla romana* stance. While the Grimani chapel in S. Francesco has been called 'the most complete outpost of classical mannerism in Venice', its 'cousin' chapel in S. Sebastiano shared many of its features.[52]

Simultaneously with his work at S. Sebastiano, Vittoria promulgated his new portrait style at S. Geminiano, one of the most venerable churches in Venice and one that, due to its position on the Piazza, was under the jurisdiction of the Procurators. By September 1561, Vittoria's bust of the priest of S. Geminiano, Benedetto Manzini (Pls. 58–9), was in place in the church.[53]

By this date, the long-planned completion of the church's façade had just been carried out by Sansovino. Its simple, serene design was yet another element of the classicizing of the Piazza, along with the Libreria. In 1557 Manzini had persuaded all three procuracies, along with the Senate, to pay for the project, and the two Procurators appointed to supervise the work together

[47] See Foscari and Tafuri (1983), p. 137.

[48] Wolters (1968*a*), p. 33, n. 103, calls an attribution of the Grimani chapel stuccoes to Vittoria 'probable', as does Hubala (1974), p. 341.

[49] Rearick (1958–9), p. 137, n. 124, gives a full description of the chapel.

[50] See ibid. and Paravia (1833), pp. 7–16. These stuccoes have also been noted by Howard (1975) p. 69, who writes that the vault

'must have resembled those designed by Sansovino for the Scala d'Oro . . . and the staircase of the Library'.

[51] Vasari (1878–85), vi, p. 586, names Franco as the designer of the stuccoes, an attribution accepted by Wolters (1968*a*), p. 22. This is the only notice of the artist ever working in the medium of stucco.

[52] Rearick (1958–9), p. 137.

[53] See cat. no. 16 for the dating of Manzini's bust.

with Manzini were Sansovino's closest allies, Vettor Grimani and Antonio Cappello. They selected Sansovino for the project, which apparently was completed quickly.[54]

Manzini (1500–70) was a canon of S. Marco (the canons were appointed by the Procurators) and, from 1545, the *piovano* (parish priest) of S. Geminiano. While the commissioning of the façade from Sansovino was undoubtedly due to Grimani and Cappello, it should be noted that Manzini was Sansovino's parish priest, since the architect lived in the *procuratie vecchie*, next to the Clock Tower. Manzini was also Tommaso Rangone's parish priest since Rangone lived literally next door to the church. Indeed, if it is true that Rangone at first tried to have his monument placed on the façade of S. Geminiano, this must have been done with Manzini's approval and co-operation.

Significantly, Manzini also had close relations with Daniele Barbaro, evidenced by his being the first rector appointed by the Barbaro family to administer the church at their estate at Maser.[55] Manzini was already the rector there by November 1554 but had ceased being so by May 1564. There is no reason to suspect that anyone other than Manzini ordered his bust (a sepulchral inscription for him had already been set up in 1552); perhaps Vittoria was recommended to him by Barbaro or Rangone.[56] Considering, however, the work Vittoria had already been doing for the Procurators both at the Palazzo Ducale and at the Libreria, and considering that Sansovino was the architect in charge at S. Geminiano, it is hard to imagine anyone other than Vittoria getting the commission.[57]

The last bust mentioned by Vasari, that of Priamo da Lezze (Pl. 63), again draws its subject from procuratorial circles, and in particular from Procurators allied with Sansovino. Da Lezze was one of the most distinguished and respected patricians of his time. Born in 1469, he held a series of important offices during his career: *podestà* and *capitano* of Belluno in 1506, he held the same posts in Treviso in 1520 and was named *capitano* of Padua in 1530. In 1554, he was balloted for Doge (just one year after Marc'Antonio Grimani had been so balloted). Elected a Procurator *de Citra* on 6 April 1556, he died on either 7 or 8 September 1557.[58]

Priamo's son, Zuanne (1506–80) must have been the patron of the bust. Named by Vasari as one of Sansovino's strongest supporters, Zuanne became a Procurator *de Supra* (for the price of 14,000 ducats) on 1 July 1537.[59] In 1556–7, then, both Priamo and his son were serving as Procurators. Zuanne was sent as Venetian ambassador to the meeting at Bologna in 1532 between the Emperor Charles V and Pope Clement VII; at that time, Charles knighted him and also made him a Count of the Holy Cross. Hailed in 1546 as a 'grande amatore di architettura', he was one of

[54] Howard (1975), pp. 81–4, gives a clear, succinct account of Sansovino's work at S. Geminiano.

[55] See Bassi (1968), p. 172, no. 5, and p. 173, n. 7.

[56] For the inscription, see cat. no. 16.

[57] Because Cattaneo has never been seriously studied (see now, however, Rossi (1995)), it is difficult to compare his bust production with Vittoria's. Besides the busts of Bembo, Bonamico, and Alessandro Contarini in Padua, Cattaneo did make sepulchral busts in Venice. Sansovino attributes to him the bust of Giovanni Andrea Badoer still *in situ* on Badoer's tomb in S. Giovanni Evangelista (see Sansovino (1664), pp. 194bis–195bis; this work is of poor quality and probably not autograph). Vasari (1878–85), vii, p. 523, assigns to Cattaneo a bust of Giustiniano Giustiniani (in S.

Croce on the Giudecca; lost), and a bust of a Tiepolo (identified as '3-times a general'; also lost). For the bust of Cardinal Gasparo Contarini, sometimes attributed to Cattaneo, see cat. no. 69. Vasari also mentions a bust of Girolamo Gigante; this is probably a mistake on his part for the Bonamico bust. While Cattaneo did remain active, plum commissions like those for the Grimani and Manzini busts would seem to demonstrate that Vittoria quickly superseded his older contemporary in this area.

[58] See G.-A. Cappellari Vivaro, *Il Campidoglio Veneto* (Bibl. Marciana, MS It. cl. VII, 8305), ii, fos. 207ʳ–209ʳ.

[59] Giulio Contarini, whose bust by Vittoria dates from around 1570, became a Procurator *de Ultra* in the same year for the same price; see Ch. 6, below.

the principal promoters of the construction of the Libreria.[60] He held many other offices while serving as a Procurator for forty-three years until his death on 9 March 1580.[61]

As one of the promoters of the Library, da Lezze clearly belongs among those actively promoting the Venetian appropriation of *Romanitas* and hence would naturally have inclined towards ordering an *all'antica* bust of his father. Although Priamo's bust now forms the centrepiece on the da Lezze family tomb that covers the entire inside façade of S. Maria della Assunta (it is one of the few elements from the earlier church of S. Maria dei Crociferi that survived its eighteenth-century remodelling), the bust must have been in the da Lezze palace near S. Marziale when Vasari heard of it, for the tomb was not erected until 1576–80.[62] Indeed, Vasari's list of the busts provides evidence for this, for he grouped them into two units: four (*Ferretti*, *Trevisan*, *Grimani*, and *Manzini*) are identified by their locations in churches, while the remaining four (*Loredan*, *da Lezze*, and both the *Pellegrini*) are given no specified location, presumably because they were not in public places. Since da Lezze's bust is included in the latter group, along with those of Andrea Loredan and the Pellegrini, for which there is no record that they ever were in a public place, it follows that the *da Lezze* was not on public display in 1566. Although the bust could date from anywhere between 1557 and 1566, I would place it *c.*1563–6.[63]

The cast of characters depicted in Vittoria's earliest portraiture reveals a clearly defined group taste for the artist and his classicizing busts. Numerous intersecting interests bind these eight busts and their patrons together: Loredan's activities as a collector of ancient art; Daniele Barbaro's scholarly antiquarian pursuits; Camillo Trevisan's commisioning of a villa *alla romana*; Zuanne da Lezze's support of Sansovino and the Libreria; Manzini's close connections with Barbaro, Sansovino, and Rangone. Vincenzo Pellegrini was a friend of Trevisan, as well as being Vittoria's lawyer and a patron of Schiavone. The busts of both Grimani and da Lezze demonstrate how quickly the new style appealed to certain patrons of high rank.

A portrait, however, is always a dialogue between the portrayed and the portrayer and it remains to examine Vittoria's artistic contribution to this production. Owing to the loss of the *Trevisan*, *Loredan*, and *Pellegrini* busts, it is not possible to know if the *Ferretti* was Vittoria's very first marble portrait (Pl. 50). It must be one of the earliest, however, for it differs from all later surviving busts in both technique and quality. First of all, the overall carving is rather pedestrian and not very fluent.[64] Compared with the busts in the palazzo Thiene, it seems like a step backwards rather than forwards. The *Ferretti* is fairly static and stolid; although the sitter's head turns to the left and his right shoulder rises higher than his left shoulder, the bust is basically symmetrical along a straight central axis. Not surprisingly, it recalls Cattaneo's portraits.[65] The prosaic nature of the bust could be due to the artist's relative inexperience in the genre or perhaps because it was done posthumously. It may, however, have been deliberately restrained in style to soften or play down the monument's radical break with earlier Venetian sepulchral imagery.

[60] The quotation comes from Guazzo (1546), p. 222.

[61] Zorzi (1987), pp. 130, and 454, nn. 63 and 65, provides a good biographical sketch of da Lezze, who was often referred to as 'el Kavalier' to distinguish him from his fellow Procurator, Zuanne da Lezze, the son of Michiel.

[62] See cat. no. 15.

[63] Ibid.

[64] As such, it is similar to other marbles carved by Vittoria at this time, such as the *Slaves* on the Contarini tomb in Padua, and the *Mercury* on the piazzetta side of the Ducal Palace. While Vittoria was a born modeller—as the stuccoes in the pal. Thiene in Vicenza attest—he developed slowly as a carver.

[65] That the beard is attached to the torso is a Cattanesque (and Sansovinesque) motif.

For however conservative its style, the *Ferretti* marks a major transformation in Venetian funerary art in two ways. It introduced the classicizing bust to Venetian art, appropriating an *all'antica* format, codified during the Roman Republic, for a contemporary servant of the Venetian Republic. And, more importantly, it established a new typology for tombs, one that features a bust as its primary visual component.

When one recalls that the most common tomb type in Venice in the fifteenth and sixteenth centuries was a plain sarcophagus or box (*cassa*) without any personal imagery at all, and that the dominant type that did feature an image of the deceased was the recumbent, gisant tomb, the novelty of Ferretti's tomb becomes even more striking. As opposed to earlier recumbent figures that depict the sitter as dead, a bust—like a standing or equestrian figure—portrays the sitter as alive. Indeed, when the *Ferretti* was in its original location, with the sitter depicted as looking towards the entrance of S. Stefano, it was ready to confront, psychologically and dramatically, any visitor entering the church, thereby involving the bust, and its tomb, in a larger spatial environment. To depict the sitter as alive and, even more importantly, to show him in motion, became the expressive aim of Vittoria's portraiture for the rest of his career.

While the antiquarian proclivities of his patrons supplied the occasion for the appearance of this new portrait type in Venetian sepulchral art, it was Vittoria's proclivities as an artist that pushed the form to new heights. Vittoria's career as a sculptor is at heart one long meditation on *contrapposto* and the *figura serpentinata*. Because of his desire to invest his sculptures with movement, he was temperamentally incapable of making a gisant figure: significantly, he never made one—even though they continued to be carved throughout the century—confining himself solely to busts on his sepulchral monuments.[66] After the tentative beginnings of the *Ferretti*, Vittoria began to explore the expressive potentialities of the bust format, and his distinctly personal voice appears in the two portraits he carved in the early 1560s, those of Benedetto Manzini and Marc'Antonio Grimani.

In the *Manzini*, the depiction of the sitter in motion has taken central stage: as opposed to the simple turn of Ferretti's head, Manzini's whole body moves within a rigorously asymmetrical composition (Pls. 58 and 59). Bernini's bust of Antonio Cepparelli (Pl. 60) has been called 'the first time in the history of the sculptured bust [when] the whole body is conceived as if it were in motion'.[67] But what gives the *Cepparelli* this look, primarily the absence of straight axes, is already present in the *Manzini*, which precedes Bernini's bust by sixty years.

The main features of the *Manzini* are placed off axis, unlike the straight axis that bisects the *Ferretti*. Most of his head, and his entire face, are well to the left of the central axis; the gorge of his tunic runs on a diagonal from lower right to upper left; Manzini's left shoulder lies higher and further back than his right; and his truncated right arm must be imagined as coming forward and across his torso, countering the body's thrust to the left. Reinforcing this dynamic *contrapposto* is an asymmetrical socle (the 'squashed' socle seen previously at the palazzo Thiene) that is lower on

[66] He did, on behalf of Sansovino, supervise the contract work on the effigy of Doge Venier on the Venier monument in S. Salvatore in 1558; see Predelli (1908), pp. 187–8. The gisant format remained the preferred model for dogal tombs, such as the Priuli and Cicogna tombs in S. Salvatore and Marino Grimani's tomb in S. Giuseppe. For these and other examples, see Simane (1993),

passim. For the gisant tomb of Bishop Livio Podocataro, built in the 1560s in S. Sebastiano, see below.

[67] Lavin (1968), p. 242. Many of the devices employed to animate the *Manzini* can also be seen in Cellini's bronze bust of Bindo Altoviti in the Isabella Stewart Gardner Museum, Boston. For the bust of Altoviti, see Pope-Hennessy (1985), pp. 218–21.

the left side, as if it were physically giving way under the pressure of Manzini's body. The marked improvement in Vittoria's marble carving technique adds further power to the portrait, particularly in the quality of the textures: hair, flesh, and cloth are carefully differentiated and, to heighten these contrasts, the tunic and skin are more highly polished than Manzini's hair and beard. In the guidebook by Francesco Sansovino from 1561 that first mentions the bust, Vittoria is credited with saying that he had 'never done anything better [than it]'.[68] In comparison to the *Ferretti*, the *Manzini* shows a new aesthetic.

The artist's concern with involving a sculpture with its larger spatial context was also given scope in S. Geminiano. Manzini's strongly dynamic bust was originally placed 'between two columns' to the right of the high altar in the church (Pl. 61), corresponding to the bust of a previous pastor of the church, Matteo de' Eletti (Pl. 7), between the two columns on the left.[69] Manzini's pose, therefore, not only endows the sitter with life and movement, but also activated the whole apse of the church, for he would originally have been turning to look towards the bust of his predecessor, Eletti.[70] By their placement at the entrance to the choir, the two pastors marked the liturgical division of S. Geminiano between the area reserved for the clergy and that for the congregation. More poignantly, Manzini's pose and glance indicated the special historical relationship between the two pastors, for Manzini, who brought the rebuilding of S. Geminiano to a conclusion, looks towards Eletti, who began the rebuilding project.[71]

As noted in Chapter 1, the *Eletti* was one of only two portrait busts on display in Venetian churches prior to Vittoria's activity. The juxtaposition of Eletti's and Manzini's busts not only underlined their special relationship, but also illustrated Vittoria's relationship to his artistic predecessors. It is easy to imagine that this opportunity to display his new style alongside an example of the old portraiture helped to inspire the particularly forceful depiction of Manzini that Vittoria carved. The commission thereby functioned as a manifesto for Vittoria's brand of portraiture.

Yet another element of competition may have underlaid Vittoria's efforts with the bust of Manzini. It has never been noted that the organ shutters painted by Veronese for S. Geminiano include a disguised portrait of Manzini.[72] When closed, the shutters depict a fictive architectural niche in which stand, from left to right, a mitred saint (S. Geminiano), an acolyte who holds up an open book, and another bishop. The latter figure, who is usually identified as S. Severo, bears Manzini's features (Pl. 62). Veronese's shutters seem to date from around 1560, which would make Vittoria's and Veronese's portraits roughly contemporaneous.[73] Veronese probably carried out this tribute because Manzini helped to pay for the organ.[74]

The presence in the church of both a sculpted and a painted portrait of its pastor raises intriguing issues. Comparison between them, whether intended or not, of course operated on one level as a *paragone*: the foremost sculptor and one of the two foremost painters of the younger

[68] Sansovino (1561), p. 22: 'confessa tal hora di non haver a far mai meglio.'
[69] Sansovino (1581), p. 43a, provides these locations.
[70] For the Eletti bust, see Ch. 1, above, and Schulz (1984).
[71] The rebuilding of S. Geminiano began in 1505; see Howard (1975), pp. 81–2.
[72] See Martin (1991a), p. 313.

[73] See Pignatti (1976), i, p. 124, no. 120, and also Rearick (1988), nos. 29–31, pp. 69–71; Rearick dates the picture to 1560.
[74] Gallo (1957), n. 82, cites a document from 29 Oct. 1558 in which Manzini offers 200 ducats for the organ (in an earlier article, Gallo (1939), p. 145, the date of this document is given as 9 Oct.). In his article from 1957, Gallo also quotes from Manzini's will that he paid for the 'novo l'organo doppio cum li soi ornamenti'.

generation were competing openly in the same space. But in a deeper sense, these portraits permeated the whole interior of the church with the presence of its pastor. At the entrance to the choir, his sculpted, three-dimensional portrait showed him depicted as himself, as a living, contemporary individual. On the organ shutters, located above the lateral entrance to the church, his flat, painted portrait showed him as a saint dead for centuries, but still watching over his flock from (literally and figuratively) above. And for the nine years prior to his death in 1570, the real, actual Manzini would also have been a character on this stage, operating between his two images. An almost theoretical examination of the nature of portraiture was taking place.

Although this larger context was lost when Napoleon destroyed S. Geminiano in the early nineteenth century, Vittoria's next portrait, that of Marc'Antonio Grimani (Pl. 55), can still be experienced *in situ* in S. Sebastiano. The artist's only busts signed in Italian, not Latin, the *Marc'Antonio Grimani* and *Manzini* closely resemble each other in pose and attitude, reflecting their proximity in time.[75]

As in the *Manzini*, Grimani's body and head are placed off-axis to conform to the pose, in which both the head and the body turn to the left. Once again, the sitter's left shoulder is significantly higher and further back than his right shoulder, and the right arm must again be imagined as coming forward and across the body. But just as the *Grimani* is physically larger than the *Manzini*, so is its *contrapposto* pose more fully and richly developed.[76] While in the *Manzini* the sitter's movement to the left is countered by his right arm, and all is anchored on the right side by the firmly vertical drapery folds, in the *Grimani* all the draperies respond to the movement of the body, the folds of the cloak swinging down to the lower right where the edge of the cloak overlaps the socle. (On the lower left, the cloak swings so far to the right that it reveals the spine of the bust.) In this way, the counterbalances of the pose are more fully emphasized and worked out. The aggressive turn of Grimani's head, supported by the penetrating stare of his eyes and by his outstretched chin (accentuated by his jutting beard), continues through the thrust of his right shoulder. This visual arrow is then carried down and to the right by the drapery folds to return up to the head through the meander of the fur-edged flap of the cloak over Grimani's left shoulder. Even the socle, with its convex front bulging out over the pedestal, adds to the sculptural volume of the whole.

Vittoria richly exploited the dramatic and emotional potential of such an animated depiction of the sitter. Besides the bust, Vittoria also carved the figures of Sts Mark and Anthony Abbot that flank the altar (Pl. 54). Placed in niches, these statues each look down and turn to their right; their closed poses and attitudes are fully contained within the space of the chapel alone. But Grimani's strong turn to the left not only activates his image, it also makes him function as the visual and kinetic link between two spatial realms. Placed within the chapel on its left-hand wall, but turned towards and looking up the nave, Marc'Antonio acts metaphorically as a hinge between the family chapel and the nave of the church, between the Grimani family and the rest of the congregation. The bust affirms the vitality of the sitter, unlike a dead, gisant figure. And because Marc'Antonio's bust was to continue to move and turn long after his death, his

[75] The *Manzini* is signed: ALESSANDRO VITORIA F; the *Grimani*: ALESSĀDRO VITORIA F. Both are signed on the edge of the sitter's right arm.

[76] The *Grimani* measures 85 cm. high, with its base, and 70 cm. across at its widest point; the *Manzini* is 72 cm. by 54 cm.

simulacrum symbolically links the living and the dead as well. As with the bust of Manzini, Vittoria strove here to connect an object with its larger spatial environment.[77]

Again, as at S. Geminiano, Vittoria's work here stands as a manifesto of the new sepulchral style due to its proximity to Sansovino's tomb to Bishop Podocataro which, located in the right transept of S. Sebastiano, lies almost directly across the nave from the Grimani chapel (Pl. 56). Constructed according to a design by Sansovino between 1558 and 1565, it dates from the same years as the Grimani chapel.[78] Within an aedicule framed by two large Corinthian columns set on high bases and supporting an entablature and triangular pediment, the full-length effigy of Podocataro, dressed in his episcopal robes, lies on a sarcophagus. His eyes are closed, and the rest of his figure, from neck to toes, is muffled in his brocaded cope. Besides his face, only his right hand lies exposed to view. Depicted as a dead body, the image of the deceased is physically and emotionally immobile, contained, on its bier, within its architectural setting. The closed, inert form contrasts completely with Grimani's extroverted turn towards the nave.

In the busts of Benedetto Manzini and Marc'Antonio Grimani, Vittoria found his own idiom for portraiture, an idiom that he was to refine and develop for the rest of his career. In these two busts the artist is confidently in control of an active, engaged mode of portraiture. That no subsequent busts display the almost abrupt quality of pose and movement seen in these two examples bespeaks a deliberate attempt on the artist's part to stake out a personal approach, one that is similar to the contrappostal concerns of his figural sculpture.

Other factors, however, must also have come into play. Both sitters, for instance, were people Vittoria knew and of whom he had first-hand experience: their portraits were 'taken from life', unlike the posthumous *Ferretti*. Manzini did not die until 1570, nine years after his bust had been put in place; Grimani died in 1566, at least five years after his portrait had been set up. These two busts illustrate the ever-fluid dynamic between artist and sitter, for although Vittoria employed artistic devices to characterize these sitters as men of action and resolve, their own personalities must have influenced such a decision, for they were both remarkable men.

Francesco Sansovino's two tributes to Manzini are telling. In *Delle cose notabili che sono in Venetia*, the Venetian narrator who guides the *Forestiero* through the city describes the pastor of S. Geminiano as the church's greatest glory.[79] No other pastor is mentioned in the book, but Manzini is praised for his affable manners, eloquence, and modesty. In the 1583 edition of the *Delle cose*, Sansovino writes: 'l'architetto di esso [S. Geminiano] fu il Sansovino, ma il promotore e finitore di tutta l'opera fu il Manzino.'[80] After Rangone's offer to build a new façade for the church came to nought, Manzini himself convinced the Senate and the Procurators of S. Marco to finance the completion of S. Geminiano.[81] He must have been a man of great determination and persuasive power.

The forcefulness of the portrayal is perhaps best observed by following the turn of Manzini's body and moving to the side of the bust to confront the subject head-on (Pl. 59). In the face,

[77] The *Grimani* is Vittoria's first surviving monument, and an example of what I call the *targa* type: a bust, often set within a shell, above a framed inscription. Others of this type include the tombs of G. B. Peranda, Alvise Tiepolo, and Vincenzo Morosini. To my knowledge, the Grimani monument features the earliest known sculptured 'Sansovino' frame.

[78] For the Podocataro tomb, see Boucher (1991), i, pp. 123–5, and ii, pp. 340–1, no. 33.
[79] Sansovino (1561), p. 22*b*.
[80] Sansovino (1583), p. 60.
[81] See Howard (1975), p. 81.

Vittoria employed a favourite device of his, a sharp differentiation between the frontal and lateral planes of the head. This concentrates the main features of the face—eyes, mouth, eyebrows, forehead—on to the frontal plane, and makes the intense gaze of the sitter even more concentrated: Manzini's eyes flash out from their deep sockets under scowling, heavy eyebrows. His sharp, bony nose leads down to the firm, almost stern mouth while his full, thick beard contrasts with the closely cropped hair on the top of his head. These leonine features, the fierce gaze, clouded forehead, and aggressive mouth, had already by Vittoria's time been codified as belonging to a certain kind of heroic portraiture.[82] It was precisely this heroic character that Venturi caught when he described the 'mandibole possenti, il naso deforme, le sopracciglia tempestose, le grandi labbra che sembran rivelare del sangue moro in questa testa di risoluto condottiero di ciurme, piuttosto che di pastor d'anime'.[83]

As for Marc'Antonio Grimani, the best guide to his character is his will.[84] Its length alone—a closely written eighty-seven pages—reveals a great deal about how Grimani thought of himself and his affairs. Of particular interest are his many comments concerning his chapel, which he describes at length several times, down to the candles and altarcloths.[85] He was especially proud of his bust, specifying that, after his death, a marble copy of it was to be made and placed in the family palace.[86] He calls the statues in the chapel 'per l'arte dela scultura cose veramente rarissime' and instructs his fellow Procurators to care for them.[87] He even goes so far as to say that, should the church suffer any kind of accident, or the monastery of S. Sebastiano fall into 'ruina', the sculptures in the chapel, 'massime la mia statua marmorea', should be removed and placed in his Procurator's office.[88]

The aggressive nature of Vittoria's bust of Grimani depicts him as a man not likely to react to events passively. Heroic features reappear in Grimani's bust, such as the furrowed brow, intense gaze, and firm mouth. The survival of the bust in its original setting, moreover, makes it possible to see how Vittoria experimented with tensions between the bust and its frame to further his characterization. As already noted, the bottom edge of the socle breaks forward beyond the edge of its pedestal. The bust completely fills its frame: Grimani's right shoulder touches the flat rim of the shell while his left shoulder breaks beyond it. And the very tip of Grimani's head rises just above the rim of the shell when viewed from directly in front; when viewed from the side and below—from the main viewpoint (Pl. 55)—his head seems to jut well above the rim of the shell, to break out physically from it.

Vittoria did not, however, make his portraits uniformly extroverted, as seen by the very different sense of personality expressed by the next bust in the series, that of Priamo da Lezze (Pl. 63). Da Lezze's death date of 1557 and the calm, still composition of the bust have generally led to a dating of the late 1550s for his bust, prior to the *Manzini* and *Marc'Antonio Grimani*. But the shape of the torso suggests that it probably dates from a time after these two. With respect to the overall shape of their torsos, the *Ferretti*, *Manzini*, and *Marc'Antonio Grimani* form a coherent

[82] See Meller (1963), pp. 53–69.
[83] Venturi (1937), p. 152.
[84] ASV, Notarili e Testamenti, Cesare Zilliol, b. 1262, fasc. 1, fos. 18ʳ–61ʳ.
[85] Ibid., fos. 19ᵛ, 22ʳ, 58ʳ, 59ʳ, 61ʳ.

[86] Ibid., fo. 50ʳ. This apparently was never carried out. Grimani asks that the copy be made by 'valenti come de M[esser]o alexandro'.
[87] Ibid., fo. 59ʳ. [88] Ibid., fo. 59ᵛ.

group: in each, the lateral profiles curve outwards from the head through the shoulders and then curve inwards to terminate by rounding off above the socle. Although in the *Ferretti* the break between the convex and concave sections of the lateral profiles comes right at the horizontal axis while in the *Grimani* and *Manzini* the break comes below the horizontal axis, the overall silhouette of the three busts remains similar.

But the silhouette of the *da Lezze* differs significantly. The broad shoulders extend quite far out from the head. The transition between shoulder and arm, however, is abrupt; instead of the lateral profiles continuing down the outline of the arms, as in the *Manzini* and *Grimani*, in the *da Lezze* the upper profile of the torso stops just below the shoulder. The lateral profiles then move in towards the socle on diagonals of roughly 45 degrees and then terminate in a broad, shallow curve above the socle.

The effect differs from the busts previously discussed. The horizontal expansion increases because of the increased breadth of the shoulders. Furthermore, breaking the silhouette just below the shoulders allows the tips of the shoulders to be imagined as extending further out into space, easily filling in and activating the empty space created by the sharp inward curve of the lateral profiles. In contrast to the *Manzini* and *Grimani,* which seem to push against, and want to burst out into, the surrounding space, the *da Lezze* flows into its spatial environment.

Accordingly, the presentation of da Lezze's personality contrasts with those of Manzini and Grimani. Instead of the impetuous movement and headstrong, aggressive impulse seen in the latter two, the *da Lezze* radiates calm authority, security, and *gravitas*. In 1561, four years after his death, Priamo da Lezze was still remembered for precisely these qualities as witnessed by Francesco Sansovino's tribute to him:

Fu anco per reverenda auttorità notabile Priamo da lezze che fu Procuratore di S. Marco, percioche havendo nei tempi della sua virilità maneggiato la Repubblica con somma prudenza, & con diverse operationi mostrato a suoi cittadini, qual fosse la sincera bontà dell'animo suo, merito esser fatto Procuratore con grandissimo assenso di tutta la Nobiltà.[89]

No doubt da Lezze's reputation for 'reverenda auttorità' influenced Vittoria's design for the bust which so fitly expresses this exact quality. While the posthumous nature of the *da Lezze* may explain some of its more restrained, static quality in comparison with the *Manzini* and the *Marc'Antonio Grimani*, Vittoria does not fail to activate the portrait: the central pleat of da Lezze's gown lies off-axis, his shoulders are not level, the right edge of his stole is folded back, and the bottom edge of the baseline overlaps the top of the socle.

By the middle of the 1560s, then, a group taste for the *all'antica* portrait bust had clearly emerged in Venice. This group was composed of both powerful patricians and prominent citizens connected by distinct interests: Barbaro, the patron of Ferretti's bust, was one of the leaders as well as the foremost theoretician of the classicizing avant-garde; Camillo Trevisan, the Pellegrini, and Manzini all moved in Barbaro's circle; Andrea Loredan was one of the most important collectors of ancient art in Venice; Zuanne da Lezze, patron of his father Priamo's bust, was one of the principal supporters of the Libreria and of the transformation of the Piazza

[89] Sansovino (1561), p. 74*b*.

S. Marco into the likeness of a Roman forum. These men, along with Marc'Antonio Grimani, patronized the group of younger artists, influenced by central Italian mannerist trends, that was becoming established in Venice. Vittoria, the dominant sculptor among the younger artists, benefited from the demands of this group by producing a series of classicizing portraits and by establishing a new type of sepulchral monument with the *all'antica* bust as its defining characteristic.

THE 1570s AND THE CODIFICATION
OF STYLE

By the end of the 1550s, Vittoria was well known to the Procurators for his work at the Ducal Palace and, especially, for his work at the Libreria; it should be remembered that the staircase at the Library led to the new offices of the Procurators and that the iconography of Vittoria's stuccoes is based on a programme honouring the Procuracies.[1] During the 1560s he continued to receive both public and private commissions from the Procurators; his two major undertakings of the decade, in fact, derive from these sources. On 21 November 1561, the Procurators *de Citra* signed a contract with the artist to make the figures for the altar in the Montefeltro chapel in S. Francesco della Vigna (Pl. 65).[2] This chapel is the second on the left side of the church, directly next to the Grimani chapel, where Vittoria may have fashioned the stuccoes and where his collaborator at the Ducal Palace and the Library, Battista Franco, had frescoed the ceiling.

Niccolo da Montefeltro died in 1397, leaving 2,000 ducats to S. Marco for the endowment of a funeral chapel in the basilica. The Venetian government, however, did not want his tomb there and transferred it (in a move similar to that concerning the Colleoni monument) to S. Francesco della Vigna. After an extremely long delay the chapel, which is dedicated to St Anthony Abbot, was consecrated in 1550.[3]

One of the relatively few sculptured altarpieces of mid-sixteenth-century Venice, the Montefeltro altar features statues of Sts Roch, Sebastian, and Anthony Abbot, and is Vittoria's second altarpiece, his work in the Grimani chapel in S. Sebastiano being completed by this time.[4] Vittoria executed only the statues (which are all of Rovigo stone), although he is usually credited as the designer of the retable as well; the latter, however, was commissioned from Francesco 'Tagliapietra' in 1557.[5] Although Vittoria undertook to finish the work by 1562, the statues were not

[1] See Hirthe (1986), pp. 136–8.

[2] For 150 scudi, Vittoria promised to finish his work by Nov. 1562. Serra (1923), p. 45, gives a summary of the contract, for which he gives an outdated citation; see now ASV, Archivio dei Procuratori di S. Marco Misti, b. 12A, fasc. 1 (I thank Victoria Avery for this reference).

[3] The only accurate discussion of the chapel is in Leithe-Jasper (1963), pp. 112–13. Planiscig (1921), p. 451, dates the sculptures to 1561–3 and states, erroneously, that they were commissioned from Vittoria by Montefeltro. Pope-Hennessy (1970a), p. 417, citing Planiscig, also calls Montefeltro the patron. Strangely, the chapel is not discussed by Foscari and Tafuri (1983). Humfrey (1993), pp. 126 and 274, has rightly noted the procuratorial preference for sculptured altars. This, plus a date of execution long after the death of the testator, are two characteristics the Montefeltro altar shares

with a pair of projects discussed by Humfrey, the Verde della Scala altar in SS Giovanni e Paolo (p. 359, no. 97; work commissioned 1523, death of testator in 1394) and the Emiliani chapel in S. Michele in Isola (p. 360, no. 100; works commissioned in 1527; will of testator from 1427).

[4] A recent overview of the Venetian sculptured altarpiece up to 1530 is supplied by Humfrey (1993), ch. 8, pp. 273–99.

[5] See Leithe-Jasper (1963), p. 112. In the contract of 27 July 1557 with the Procurators *de Citra*, Francesco Tagliapietra da S. Francesco, of the parish of SS Trinità, promises to complete the altar in six months; for the contract (which is signed by Priamo da Lezze), see ASV, Procuratori di San Marco Misti, b. 12, fasc. 1 (I am indebted for this reference to Victoria Avery). Wolters in Wolters and Huse (1990), p. 169, thus offers a mistaken analysis of the retable as Vittoria's earliest effort at an altar.

completed until late 1563 or early 1564, as attested by entries in his account book, where he records buying the stone for the St Sebastian on 24 July 1563, and paying a final instalment for the stone for the other two figures on 3 December 1563.[6]

It must have been around the time that the altar in S. Francesco della Vigna was completed that the artist was commissioned by the Procurator Girolamo Zane to make the most ambitious and large-scale work of his career, the now sadly mutilated Zane altar in the Frari (Pl. 67). The work was definitely already commissioned by 1566 since Vasari gives a fairly detailed description of it, with its many-figured composition and large relief of the Assumption.[7] The statue of St Jerome, which is the major surviving element of the ensemble, and which has generally been dated to 1565, was, in fact, not executed until later. In a letter to Vasari of 23 August 1566 (three months after Vasari's visit to Venice), Cosimo Bartoli writes that he has seen Vittoria that very day, who asked him to his house to see 'some little models . . . for the St Jerome for the Frari'.[8] The statue seems to date from even later than 1570, for, in Zane's will of that year, he speaks of a piece of marble that he wants Vittoria to carve into a St Jerome.[9] This major project must have dominated Vittoria's work at this time, perhaps contributing to the general absence of portrait commissions during the later 1560s.

Sansovino took little interest in either the portrait bust or the sculptured altarpiece, and Vittoria was the most vital and dynamic force in the development of both genres in later sixteenth-century Venice.[10] Unfortunately, not only the Zane altar in the Frari, but also an altar for Bishop Domenico Bollani in Brescia are gone; thus two of the most important works of Vittoria's maturity have been lost.[11] From surviving work it is possible, none the less, to follow the artist's thought concerning the sculptured altar from the 1560s into the 1570s. The Montefeltro altar at S. Francesco della Vigna operates as a compromised effort, since the statues had to conform to an already pre-existing frame. The Grimani chapel in S. Sebastiano, however, reveals the artist's first attempt at an integrated ensemble (Pl. 54). As has been analysed in the previous

[6] See Predelli (1908), p. 131. In the entry from 24 July, Vittoria writes that he has bought the stone 'per fare' the St Sebastian, implying that it had not yet been begun (the purchase was made from the widow of Pietro da Salò). The payment of 3 Dec. is a final installment for the stone used for the Sts Roch and Anthony; Vittoria states that they 'fu posti' in S. Francesco, implying that those two statues were completed by this time. Vittoria received a payment for polishing the figures as late as 10 Oct. 1564 (reference from Victoria Avery).

[7] Vasari (1878–85), vii, p. 519. The altar was dismembered in the 18th cent. by the monks of the Frari; see Temanza (1778), p. 484, quoted in n. 15, below.

[8] Frey and Frey (1923–40), ii, p. 274, no. 545.

[9] Leithe-Jasper (1963), pp. 129–30, established that the *St Jerome* must date from after 1570. The delays were undoubtedly in part due to Zane's personal problems. Appointed Captain-General of the Venetian fleet in early 1570, he then led a completely bungled expedition to Cyprus that destroyed his career. Removed from command at his own request in Dec. 1570, in 1572 he was tried for incompetence by the Council of Ten. He was acquitted only after he had died, in prison, in Sept. 1572; see Norwich (1982), pp. 467–72. There had been problems with the commission, though, even before Zane's political problems began, as can be learned

from Zane's will of 10 Feb. 1569 (*m.v.*, thus 1570) in ASV, Notarili e Testamenti, C. Zilliol, b. 1263, fos. 86ᵛ–88ʳ. On fo. 87ᵛ he writes: 'Messero Alessandro scultor sta ala pietà si trova in le mano una pietra grande di marmoro molto bella che mi costò duc. 44, la qual li diti per far uno S[anto] Ier[onim]o per meter in mezo del nostro altar dove è riservato il loco . . .' Later on the page Zane states that he has not paid Vittoria the agreed-on 100 ducats 'vedendo il poco lavor che lui ha fato, se ben sono anni tre forse 4 che la essa pietra sia in mano et ho pagato la portadura di essa pietra quando usite et si mandò di casa'.

[10] Humfrey (1993), pp. 298–9, rightly observes that the period 1530–70 was much less productive for the sculptured altarpiece in Venice than was the period 1460–1530, and that it was only with Vittoria and Campagna that the Venetian sculptured altarpiece 'recovered the importance that it had achieved during the earlier Renaissance'.

[11] Close studies of these destroyed projects are much to be desired. The damaged statues of *Faith, Charity,* and the *Risen Christ* from the Bollani altar, which was destroyed in 1708 when the campanile of the Duomo Vecchio ('la Rotonda') collapsed, survive in the Museo Civico dell'Età Cristiana in Brescia. The project seems to have been complete by 1579.

chapter, the statues of Sts Mark and Anthony, both directed to the left, lead to the bust of the patron, who swings aggressively to turn towards the nave of the church. The ensemble thereby activates the entire space of the chapel, even reaching outside the chapel itself into the larger environment of the church.

The Zane altar must have taken this attempt at integration even further, and an impression of what the project looked like can be derived from the descriptions left by Vasari and Temanza.[12] The central opening of the altar, which is quite tall, was filled by a stucco relief of the Assumption showing Mary surrounded by angels. Below it stood five figures of saints: Jerome (the patron saint of Girolamo Zane), John the Baptist, Peter, Andrew, and Leonard. St Jerome, the only marble figure, was the sole statue in the round and occupied the centre, as he still does today. He was originally flanked by the saints in stucco, in high relief, now attached to the architectural frame of the altar. To either side of these stood two more saints in stucco, in low relief.

This was a highly ambitious project in all sorts of ways. Its location in the Frari must first of all be kept in mind, for it lies directly opposite the Pesaro altar by Titian (Pl. 66). If one stands in the centre between the Pesaro and Zane altars, Titian's glorious *Assunta* appears directly ahead on the axis between them, framed by the old choir screen (Pl. 68). The Zane altar thereby formed one angle of a triangle whose other two angles end in two of Titian's most important and famous works. Vittoria's altar thus automatically, purely by its location, responds, challenges, and competes with the greatest artist of the Venetian cinquecento.

Was this why the Assumption was chosen as subject-matter, to make a sculptured response to the high altarpiece? Was this why a combination of various forms of sculpture—from sculpture in the round, to high relief, to low relief—was chosen, as a three-dimensional attempt to rival the painterly as well as the sculptural qualities of Titian's brush?[13] Such an attempt to make an altarpiece in so many degrees of relief is unprecedented in Venetian sculpture, and surely one of the main reasons Vittoria and Zane proceeded as they did was in order to foster a dynamism as yet seen only in painted altarpieces.[14]

Some idea of this dynamism can be gained by imagining the surviving stucco figures, apparently St Peter on the left and St Andrew on the right, back in their original positions to either side of St Jerome (Pl. 67). Each of the latter wears long, flowing robes which contrast to Jerome's nudity. Each of their poses responds to that of St Jerome, Andrew's sharp twist to the left directly countering Jerome's sharp turn to the right, while Peter, like Jerome, faces to the right, but, unlike Jerome, leans backwards instead of forwards. The lost figures in low relief must have struck even further contrapuntal notes. Although the S. Giorgio Maggiore altar by Girolamo Campagna (Pl. 69) is perhaps now seen as the apotheosis of the trend to increase the dynamism of the sculptured altar (a commission Campagna won over Vittoria), an important precedent for Campagna must have been the Zane altar. Its wanton destruction by the monks of S. Maria

[12] See n. 7, above, and esp. Leithe-Jasper (1963), pp. 129–37.

[13] The most overt manifestation of Vittoria's homages to, and competitions with, Titian is the Fugger altarpiece (now in the Chicago Art Institute), an almost exact copy of the painter's S. Salvatore *Annunciation*. See also the discussion of the bust of Doge da Ponte and its relationship to Titian's portrait of Andrea Gritti, below.

[14] This is an aspect of Vittoria's vaunted 'painterliness' that has gone unexamined in the literature. In terms of precedents, the Zen altar in S. Marco, though not at all similar in its set-up to the Zane altar, none the less employs a very sophisticated combination of both relief and sculpture in the round. For a highly complex, multi-figured project in SS Giovanni e Paolo modelled after the Zen altar, but which never came off, see Humfrey (1993), p. 290.

Gloriosa dei Frari has severely compromised not only the study of Vittoria, but also any review of Venetian cinquecento sculpture as a whole.[15]

Just as Vittoria's approach to the altarpiece entered a new phase with the Zane altar, so around 1570 the artist embarked on a series of portraits that further expanded his artistic range and secured the dominance of his style in Venice. In this group of work he created and codified his own unique solution to the formal problems of the portrait bust. The series begins with the busts of Giulio Contarini, Girolamo Grimani, and Tommaso Rangone (Pls. 70, 77, 80), all of which date from the first half of the 1570s. These patrons share many of the interests observed in his earlier patrons and, in the cases of Contarini and Girolamo Grimani, show distinguished Procurators adopting the *all'antica* mode of self-depiction.

Giulio Contarini was born about 1500, the son of Giorgio (Zorzi); he married Andrianna Minio in 1524. After having served as a *Camerlengo di Commun*, he was elected a Procurator *de Ultra* on 21 June 1537 for the price of 14,000 ducats. That year was one of two times in the sixteenth century when the rule of nine Procurators was abrogated, and seven nobles were permitted to purchase procuracies as an emergency fund-raising measure in response to the Turkish siege of Corfu.[16] Zuanne da Lezze also purchased his procuracy at this time. Contarini resided in his family's palace near S. Maria del Giglio, where he died on 7 April 1580, having served as a Procurator for almost forty-three years.[17]

Some evidence survives attesting to his activities as an art patron. In 1554, while serving as a *Provveditore sopra le fabriche del Palazzo*, he and Antonio Cappello (one of Sansovino's most loyal allies among the Procurators) signed the contract with Sansovino for the statues of Mars and Neptune to go at the top of the outdoor staircase leading into the Ducal Palace.[18] Contarini's personal patronage seems to have been limited to his parish church of S. Maria del Giglio, which he and his brother Giustiniano restored.[19] The family owned the rights to the high altar chapel, and in 1552 Giulio commissioned from Tintoretto the paintings of the four evangelists that originally decorated the inside panels of the organ, located on the balcony on the back wall of the chancel.[20] A now-lost *Conversion of St Paul* by Tintoretto originally decorated the outside panels of the organ and, as Lorenzetti has suggested, Contarini probably commissioned it as well.[21]

The other work Contarini commissioned for the church involved Vittoria. When his closest friend, the poet Girolamo Molin, died in late 1569, Contarini arranged for the poet's burial in S. Maria del Giglio, commissioned a bust of Molin (Pl. 74) from Vittoria (still *in situ*), composed the epitaph immured above the bust, and arranged for a volume of Molin's poetry to be published.[22]

[15] One can only echo the imprecations of Temanza (1778), pp. 484–5, penned not long after the altar was dismantled: 'Se la nobilissima famiglia Zane, testè spenta, sussistesse ancora, quei malaccorti Padri non avrebbero tolto alle bell'Arti cotanta opera, ne spogliata avrebbe questa Metropoli di così raro ornamento.'

[16] See Grendler (1977), p. 43, n. 48. Not until 1556 did the number of Procurators return to its canonical nine; see Morozzo della Rocca and Tiepolo (1958), p. 229.

[17] See cat. no. 1 for a full discussion of the problem of Contarini's dates of birth and death.

[18] Published in Boucher (1991), i, p. 224, doc. 226.

[19] Sansovino (1581), p. 44*b*.

[20] See Lorenzetti (1938), pp. 129–39; on p. 137, Lorenzetti publishes the contract of 20 Apr. 1552 and also the new contract of 6 Mar. 1557 between Contarini and Tintoretto. The evangelists are now displayed on the back wall of the chancel below the organ.

[21] Ibid., pp. 312–34. The bust of Contarini, with its head turned in the direction of the organ, was perhaps 'looking' at these paintings when they were in their original locations.

[22] For the bust of Molin, and his friendship with Contarini, see cat. no. 40.

The artist and patron evidently developed a special personal relationship. The earliest indication of this is also the most striking: on 28 February 1569, Ottaviano Contarini, Giulio's son, bought for Vittoria at the price of 1,010 ducats the house in the calle della Pietà where the artist lived and had his studio from then until his death.[23] The house still exists and now forms part of the Hotel Bisanzio. Such an act of generosity on Contarini's part bespeaks a friendship of long standing, which may well have started with Vittoria's return to Venice in 1553 when he received the commission for the *Feminone* from the Procurators. A further record of their relationship survives in Vittoria's will of 29 July 1576. At the beginning of this document, the sculptor asks that Cesare Gigiolo and Francesco Sonicha be his executors. He then adds that, should there be any difficulty in this matter, he is sure 'for the infinite courtesies that I have received from the most famous lord and meritorious Procurator Giulio Contarini, that he will not fail to provide the sound counsel that he has always bestowed on his slave [schiavo] Alessandro Vittoria, as is openly known to all the world'.[24] Vittoria apparently considered Contarini his special protector and patron.

Like Giulio Contarini, Girolamo Grimani was a member of the upper echelon of the patrician élite. Born in 1497, Grimani came from the S. Luca branch of the family. A distinguished senator, he was sent by the government four times as orator to honour a newly elected pope: twice in 1555 for the short-lived Marcellus II and for Paul IV, in 1559 for Pius IV (who knighted him), and in 1566 for Pius V. Vasari states that Grimani took Veronese with him to Rome, presumably in either 1559 or 1566, during one of these appointments as orator.[25] In 1559, Grimani was balloted for Doge, emerging as the most serious rival to the eventual victor, Girolamo Priuli. On 15 April 1560 he was elected a Procurator *de Citra* and served as such for ten years until his death in 1570.[26] Grimani thus was one of the commissioners of the Montefeltro altar in S. Francesco della Vigna, and may even have been influential in bestowing the work on Vittoria. He seems to have had antiquarian interests as suggested by the dedication to him in 1558 of an edition of Cicero's *De Lege Agraria* by Bernardino Loredan, librarian of the Marciana and son of Andrea Loredan, another of Vittoria's patrons.[27]

Grimani's major activity as an art patron, however, was his palace on the Grand Canal designed by Sanmicheli. As already noted, the Grimani palace at S. Luca was, along with Sansovino's palazzo Corner, among the first houses in the sixteenth century to break with the traditional Gothic façades along the Grand Canal by employing an *all'antica* vocabulary and scale. Such a project clearly places Girolamo Grimani in the camp of Vettor Grimani (a distant cousin) and Zuanne da Lezze as an aggressive supporter of the new classicism in Venice. The commission was given to Sanmicheli in 1556 (the year after he had designed Alessandro Contarini's monument in Padua). Following the architect's death in 1559, the work was continued by Giangiacomo dei Grigi, although Grimani seems also to have personally directed the operations for a while.[28] On 3 December 1563, Vittoria was paid by dei Grigi for the reliefs of the Victories he carved in

[23] Predelli (1908), pp. 25, 43, 46, and 252–6, publishes all the relevant documents. Vittoria had previously resided in a rented house that was also on the Calle della Pietà; see ibid., pp. 24–5.

[24] ASV, Notarili e Testamenti, V. Maffei, b. 657, no. 13 (first published by Gerola (1924–5)). I have been unable to identify further Gigiolo and Sonicha.

[25] See Pignatti (1976), i, pp. 26 and 29.

[26] See cat. no. 8 for details of Grimani's biography.

[27] See above, Ch. 5.

[28] On the pal. Grimani, see Gallo (1960), pp. 120–5, Puppi (1971), pp. 136–42, and Fontana (1980), pp. 41–53.

the spandrels of the arch of the entrance portal of the palace (still *in situ*). [29] Although this was subcontract work from dei Grigi, it seems likely that Grimani himself played an active role in the commissioning of such a conspicuous feature of his palace.

Grimani was not only an active, major supporter of the new Roman style brought to Venice by Sansovino and Sanmicheli but, as his numerous appointments to the Holy See indicate, he was a *papalista*, i.e. a patrician who advocated positive and conciliatory relations with the papacy. This feature of his career links him to his fellow Procurator, Giulio Contarini. Like the latter, Grimani served several times as one of the *Tre Savi sopra eresia* (the three commissioners of the Inquisition), and both have been characterized as particularly 'devoted to the Holy See'. [30]

It should be remembered that the most traumatic episode in Venetian sixteenth-century history, the War of the League of Cambrai, was spearheaded by Pope Julius II. The war not only brought Venice near the brink of extinction, but, as part of the terms to end the war, Julius exacted humiliating concessions from the Venetian Church that greatly limited its autonomy, particularly in the area of ecclesiastical appointments. [31] Anti-papalism thus ran strong throughout the 1500s, culminating in the episode of the Interdict laid upon Venice by Pope Paul V in the first decade of the seventeenth century, from which Venice emerged victorious. [32]

There was, none the less, a prominent *papalista* group among the patricians. Not surprisingly, the leaders of this group came from the families who held almost a monopoly on the great ecclesiastical benefices conferred by the Holy See: the Grimani, the Pisani, and the Cornaro. In a well-known incident, the papal nuncio to Venice wrote in 1534 that these three families 'want to enclose all the clergy into their domain'. [33]

It has often been noted that these families, and others allied with them by marriage or common interests, were the most prominent patrons of both the classicizing and the mannerizing art that started to appear in Venice during the 1530s and 1540s. Vettor Grimani, for instance, was the brother of a patriarch of Aquileia and the nephew of no fewer than three cardinals. The only contemporary competitor, in terms of the use of Roman triumphal forms, to Girolamo Grimani's palace was the Cà Corner, the palace Sansovino built for Zorzetto Cornaro, who was the nephew and the brother of cardinals. A great many of the country villas modelled on antique forms that Palladio built were commissioned by families—the Foscari, Barbaro, Badoer, Cornaro, Emo, and Pisani—who supported pro-papal policies. [34]

Many of these names appear among those of Vittoria's patrons: Daniele Barbaro, Marc'Antonio Grimani, Girolamo Grimani, Francesco Pisani (for whom Vittoria carved figures of the Seasons in his Palladian villa in Montagnana), and Domenico Bollani. Cozzi has rightly noted the political implications of the 'attraction to Roman culture' on the part of an important section of the patrician class. These implications provide yet another reason why a portrait style modelled on Roman busts would have appealed to these men. Indeed, Tafuri has noted the frequency of *papalista* sentiment on the part of the classicizing élite in Venice. [35]

[29] Predelli (1908), p. 131; this is the same entry in which the artist records having paid the final installment for the stone used for the statues of Sts Roch and Anthony in S. Francesco della Vigna.

[30] Grendler (1979), p. 294.

[31] See Prodi (1973), pp. 409–30, especially pp. 409–12 and 417–18.

[32] See Cozzi (1979).

[33] This comes in a letter by Girolamo Aleandro from 23 Nov. 1534; see Gaeta (1958), i, p. 301.

[34] See Cozzi (1984), pp. 21–42, esp. p. 27.

[35] See Tafuri (1989), pp. 7–10 and particularly pp. 112–14.

The heresy office was one of the most important posts in the government and, as Paul Grendler has demonstrated, it was dominated by an inner élite of very rich, powerful men. Significantly, no fewer than seven patricians whose portraits were carved by Vittoria served in this office: Giulio Contarini, Girolamo Grimani, Tommaso Contarini, Francesco Duodo, Vincenzo Morosini, Niccolo da Ponte, and Giovanni Donà.[36] Equally significant is the fact that, with the exception of Donà, all of these men were also Procurators. Although, as I will discuss later, they do not form a politically homogeneous group—Niccolo da Ponte and Giovanni Donà, for instance, were vigorous opponents of the papacy—they amply document how prestigious Vittoria's sitters were.

Tommaso Rangone's determination to forge a new kind of personal imagery at the church of S. Giuliano was described in Chapter 4. He employed Vittoria on many occasions, and the two men may have known each other in Padua in the early 1550s, even before they worked together at S. Giuliano later in the decade.[37] After work on the façade was completed, Rangone employed the artist as an architect at S. Giuliano.[38] Besides the bronze and terracotta busts Vittoria made of Rangone, he also fashioned portrait medals of the man,[39] and, like Giulio Contarini, Rangone enjoyed a personal friendship with the artist: Rangone witnessed Vittoria's will of 24 October 1566, in which the artist left to Rangone the statue he had commissioned of St Thomas, which is a very idealized portrait of Rangone and originally stood over the portal of the convent of S. Sepolcro.[40] The physician futhermore was Guardian of the Scuola Grande di S. Marco when Vittoria became a member in 1562.[41] Although Rangone was not a patrician, he was knighted by Doge Girolamo Priuli in 1562, and was thus, like Girolamo Grimani and Zuanne da Lezze, a *cavaliere*. Furthermore, he did in a certain sense share their very high rank for, as Gasparo Contarini wrote in his book on Venetian magistracies, a citizen who held an office in one of the Scuole Grandi was considered to occupy a status equivalent to that of a Procurator among the patriciate.[42]

These portraits, then, all depict men prominent in sixteenth-century Venice; their stylistic and chronological place in Vittoria's *œuvre*, however, has never been adequately investigated or explained. The only one of Vittoria's portraits of these three men securely documented is that of Girolamo Grimani (Pl. 77). The bust was made after Grimani's death in 1570, being paid for by his son Marino on 6 August 1573, a full ten years after the *Marc'Antonio Grimani*.[43] Eventually, in the 1580s, it was to be placed in the high altar chapel of S. Giuseppe di Castello, where Grimani lies buried.[44] Although this bust, like Ferretti's, is posthumous, Vittoria significantly did not revert to the static portrayal he used with Ferretti, but again depicted the sitter in action, as he had with the busts of Manzini and Marc'Antonio Grimani. Indeed, by 1573, Vittoria had moved into a

[36] See Grendler (1979), *passim*.

[37] Weddigen (1974), p. 51, suggests this.

[38] For Vittoria's architectural work at S. Giuliano, see Gallo (1957), p. 101, Weddigen (1974), p. 65, and Boucher (1991), i, pp. 115–16. Howard (1975), p. 86, unduly de-emphasizes Vittoria's role in the architecture of the church.

[39] For these medals, see Weddigen (1974), pp. 45–9. See Ch. 7, below, for a discussion of Rangone's terracotta bust.

[40] On the *St Thomas*, see Weddigen (1974), pp. 68–9.

[41] Vittoria recorded this event in his account book on 24 Jan.

1561 (*m.v.*); see Predelli (1908), p. 131.

[42] Contarini (1544), pp. 68 f.

[43] Marino Grimani was to succeed his father as a Procurator and outdo him by becoming Doge—he was also to be the subject of two busts by Vittoria; see cat. nos. 11 and 12.

[44] For the documentation of this project, see Martin (1991*b*), pp. 825–33. Vittoria's receipt to Marino Grimani for 60 ducats for the marble bust of Girolamo is dated 6 Aug. 1573 and is contained in ASV, Archivio Grimani-Barbarigo, b. 29. See also cat. no. 8.

new phase in his attempts to animate and activate a portrait bust: he was now experimenting with the shape and termination of the torso in order to make it—along with the pose—more two-dimensionally substantial and three-dimensionally alive.

The *Girolamo Grimani* manifests new solutions in the way its termination and baseline differ from those of the earlier busts. While the latter all conform to a relatively abstract semicircular shape in which the bottom edge overlaps the top of the socle, the baseline of the *Girolamo Grimani* runs flush directly above the socle. Its left lateral profile resembles that of the *Ferretti*, *Manzini*, and *Marc'Antonio Grimani* busts in that the upper and lower profiles meet in the middle of the torso. The right profile, however, ascends along a slower, more gradual curve to meet the upper profile at a much lower point, creating a marked asymmetry between the two profiles. The baseline is, in addition, canted in respect to the socle (Pl. 75), rendering the twist of Grimani's shoulders more prominent. Because of the extension of the right lateral profile, Grimani's torso is broader and wider, more expansive, than the torsos of the busts from the 1560s.

The *Girolamo Grimani* thus demonstrates a marked change in Vittoria's formal vocabulary, and, significantly, no bust postdating it has a semicircular baseline. The *Grimani* has previously been dated to the 1580s; that it is now documented to 1573 allows for a more precise sense of the development of Vittoria's style in bust portraiture; it helps, for instance, in dating the bust of Priamo da Lezze, who died in 1557 (Pl. 63). Because of the latter's rounded termination and baseline, it connects very strongly with the *Ferretti*, *Marc'Antonio Grimani*, and *Manzini* busts, thus stylistically confirming the pre-1566 date supplied by Vasari. Coincidentally, da Lezze's portrait, like Girolamo Grimani's, predates the monument it is set on, for the da Lezze tomb was not built until after 1576.[45] As the marble bust of Girolamo Grimani was made in the early 1570s but not set up on a monument until the late 1580s, so da Lezze's bust—which I would date to *c.*1564— was not set up in public until the late 1570s. The methodological lesson to be learnt from these examples is that, just as a sitter's death date does not automatically supply the date of a bust's execution, neither does the date of execution necessarily indicate when the bust was set in place.

The *Ferretti*, *Manzini*, *Marc'Antonio Grimani*, and *da Lezze* busts are the only ones with rounded baselines, and they all date from the 1550s and 1560s. During these years, then, Vittoria employed a standard, traditional morphology for his busts: in form—especially in their terminations—they are like the many pseudo-antique busts produced at the time, like Cattaneo's busts in Padua, as well as like Michelangelo's *Brutus* and Della Porta's papal portraits in Rome. But by 1573, as demonstrated by the *Girolamo Grimani*, Vittoria had started making his own modification of the classicizing bust by using an unconventional torso.

When did this start? The torso of Niccolo Massa's bust, originally in S. Domenico di Castello and now in the Ateneo Veneto, does not have a curved termination (Pl. 79): the lateral profiles descend sharply from the shoulders, and the baseline runs straight directly above the top of the socle. The *Massa* was not mentioned by Vasari, but is noted by Sansovino in his *Venetia, città nobilissima et singolare* in 1581, so it must date from between *c.*1566 and 1580. While the shape of its silhouette resembles the *da Lezze*, it lacks the experimental expansiveness of the *Girolamo*

[45] The will of Zuanne da Lezze (Priamo's son), ASV, Notarili e Testamenti, G. Secco, b. 1194, fo. 85ᵛ, written on 26 July 1576, makes it clear that the tomb was not finished by that date (and perhaps not even begun); see Ch. 5, below, and cat. no. 15.

Grimani that dates from 1573, and I would place it in the second half of the 1560s; the traditional date for the bust, i.e. *c*.1569, Massa's death date, may well be correct.[46]

Massa's bust affords a good introduction not only to members of Vittoria's clientele from outside the patriciate, but also to the issue of decorum in Vittoria's portraiture. Niccolo Massa (1489–1569) was one of the most distinguished anatomists of his day; since he was not involved with the revival of antique culture, his patronage shows the appeal of Vittoria to other circles among the Venetian intelligentsia. His bust notably lacks the strong movement found in the portraits of Manzini and Marc'Antonio Grimani. Although it sits slightly to the left of the axis of the socle, Massa's torso is straight and lines up along the central pleat of his robe. While the head turns slightly to the left, it neither bends nor tilts. The shoulders lie level and even. The folds on Massa's garment are shallowly cut and arranged in a fairly symmetrical order with the exception of the folded-back pleat to the right of the central fold (a visual cousin to the folded-back stole of da Lezze's bust).[47]

Moreover, as in the case of the *da Lezze*, the static nature of the *Massa* can be explained in terms of decorum. The physician's calm, focused bearing appropriately corresponds to his status as a famous natural philosopher. Furthermore, Massa went blind during the latter part of his life, and it would surely have been inappropriate to depict an aged blind man in an energetic, *mouvementé* pose. In the case of the *Massa*, Vittoria deliberately toned down and muted his natural tendency to employ strong *contrapposto* poses. The artist did, however, employ his knowledge of antique sculpture to honour his sitter. The modelling of the head is exceptionally fine, and Massa's high, noble brow, deep eye sockets, firm mouth, and flowing beard mark him as an intellectual. Is it just an accident of physiognomy that his bald head, beard, and pug nose lend his features a Socratic cast? I find it hard to think that Vittoria did not deliberately emphasize these aspects of Massa's face so as to liken him to the great, ancient Greek philosopher, thus drawing on antiquity in a somewhat different way from the examples already looked at.

The termination of the bust of Giulio Contarini in S. Maria del Giglio (Pls. 70, 72) also differentiates it from Vittoria's work of the 1550s and early 1560s. It must date from before 1576 because, in his will of that year, Vittoria requested that his own tomb be designed like that of Contarini.[48] The pose is essentially a tamer version of the *Girolamo Grimani*: the baseline runs straight above the socle, then rises up gently to meet the lateral profiles. The *Contarini* tilts upwards on the right side by means of a wooden wedge stuck in the back of the bust between the torso and socle. This rather awkward way of achieving asymmetry is conveyed in the *Girolamo Grimani* through the carving alone, indicating that the *Contarini* dates from before 1573; I date it to about 1571. Circumstantial evidence also argues for a date from the early 1570s. As already noted, Giulio Contarini's son Ottaviano bought a house for Vittoria in 1569. The artist paid tribute to his patron and benefactor by portraying his idealized features in the marble *St Jerome* on the Zane altar in the Frari dating from the early 1570s (Pl. 71).[49] Finally, Contarini's

[46] See Serra (1923), p. 54, and Cessi (1962), p. 36. The baseline of the *Massa* also resembles that of the terracotta of Girolamo Grimani, which probably was modelled before Grimani's death in 1570; see cat. no. 9. The marble bust of Apollonio Massa, Niccolo's nephew, which is also on the ground floor of the Ateneo Veneto, is not by Vittoria, although it has often been attributed to him; see cat. no. 74.

[47] Bernini often employed the device of a folded-back pleat, as in his busts of Monsignor Pedro de Foix Montoya and Francesco Barberini; see Lavin (1968), pp. 240–1.

[48] Gerola (1924–5), p. 350, n. 1.

[49] For the *St Jerome* as an idealized portrait, see Knox and Martin (1987), p. 161.

monument, in which the bust is set below a pediment supported by caryatids, seems to be the first of its type.[50] It closely resembles the *targa* Vittoria made in the Ducal Palace to commemorate the visit of King Henry III of France in 1574 (Pl. 73).[51] That the Contarini bust and monument connect closely with biographical and artistic events in Vittoria's career from the early 1570s supports a dating of the monument to that time.

The high quality of Contarini's bust further attests to the special friendship between the sitter and Vittoria. It is perhaps Contarini's worn face with its sombre, melancholic expression that makes the greatest impression (Pl. 70). As his head turns to the right and bends slightly forward, Contarini peers out from under heavy eyebrows and a furrowed brow. Each irregular wrinkle is lovingly delineated, each pucker of skin is given its own individuality, particularly those at the bridge of the nose. The eye sockets, as is usual with Vittoria's portraits, are quite large and here seem even bigger than normal because of the intensely linear activity surrounding them: the bushiness of the eyebrows, the vertical wrinkles above the nose, the diagonal wrinkles above the eyebrows, and the manifold concentric lines under the eyes. Contarini's eyes remain calm under their heavy lids, unlike the fiery eyes of Manzini or Marc'Antonio Grimani. So too does his overall pose. While Contarini's head tilts slightly to the left and turns to the right, it bends forward to counteract the leftward tilt of the torso. All is kept in bounds. Although not as static as the *da Lezze* or the *Massa*, neither is Contarini's bust as impetuous as those of Manzini and Marc'Antonio Grimani.

Vittoria's bust of Tommaso Rangone (Pl. 80), his sole portrait in bronze, which is now displayed in the Ateneo Veneto, was originally in S. Geminiano, like the *Benedetto Manzini*. It must date from before the summer of 1577 since Rangone mentions it in his will of August of that year. The bust has usually been dated to 1571 because Rangone was granted a concession then to build a sottoportico near the sacristy and to place his bust on it.[52] The project may have been begun that year, but the bust must date from later. In the same way as the portraits of Girolamo Grimani and Priamo da Lezze demonstrate that a bust may be set in place more than ten years after it was carved, so a concession for a project does not automatically supply a date of execution. Rangone's statue on S. Giuliano underlines the pitfalls of using this over-simple methodology: the figure is still often dated to 1552, when the project began, but it is known that the statue was not cast until 1556.[53]

Stylistically, the busts of Giulio Contarini, Girolamo Grimani, and Tommaso Rangone relate closely to each another. In each, the left lateral profile is similarly rounded, the sitter's head turns to the right while bending slightly forward, and his left shoulder extends further out and higher up than his right, creating an asymmetrical relationship between the left and right profiles. This asymmetry grows increasingly more pronounced from the *Contarini* to the *Grimani* to the *Rangone*. Whereas in the *Contarini* the left and right profiles differ only slightly, in the *Grimani* the right profile reaches markedly up and out. In the *Rangone*, the extension of the right side of

[50] Although one cannot say for sure, it is likely that the shell currently framing the bust of Niccolo Massa formed part of his original tomb, which probably resembled Marc'Antonio Grimani's monument: a bust set within a shell above a framed inscription. Other monuments like Contarini's are those of Vittoria himself in S. Zaccaria, of Tommaso Contarini in the Madonna dell'Orto, Jacopo Soranzo in S. Maria degli Angeli on Murano,

and Antonio Montecatino in Ferrara.

[51] Vittoria made a series of payments to Marc'Antonio Palladio, the son of the architect, from July to Aug. 1575 for work on this monument; see Predelli (1908), p. 190. On the *targa*, see Franzoi (1990), p. 175.

[52] Pope-Hennessy (1970a), p. 416, and cat. no. 20.

[53] See above, Ch. 4.

the torso is still further increased because the baseline runs straight out from the socle, thereby creating an even stronger contrast between left and right sides.

The literal result of this process is expansion, imparting an emotional expansiveness to the sitter. If one compares the *Rangone* to the *Niccolo Massa*, the change is immediately striking: the diagonals connecting the baseline to the lateral profiles are still present, but they no longer act as truncating, confining boundaries. Rather, they serve as mere subsidiary passages between the broad shoulders and expansive baseline. Rangone turns to his left, and his right shoulder descends at roughly a 45 degree angle while his upper arm descends at a slightly sharper angle until the lower silhouette returns to join the baseline. His left shoulder descends more slowly— punctuated by the fold in the stole—as the 'fin' of the upper arm recedes from the frontal plane. The extension of the right side is best seen along the baseline, which projects straight out from the socle as opposed to the rising curve of the left profile of the bust. Unlike the *Massa*, *Giulio Contarini*, and *Girolamo Grimani*, where the straight portion of the baseline was confined to the area directly above the socle, the baseline on the right side of the *Rangone* projects straight out from the socle into the surrounding space.[54]

On account of these characteristics, I date the *Rangone* to about 1575, after the *Girolamo Grimani*. By placing the *Giulio Contarini* before the *Girolamo Grimani* and the *Rangone* after it, I am positing that Vittoria's busts from the 1570s exhibit a fairly linear progression in terms of enlarging and expanding the torso.[55] The *Rangone* must post-date the *Girolamo Grimani* because the extension of the right side of the baseline straight out from the socle is a feature absent from all earlier busts. This hypothesis is confirmed by all of the busts that are documented to the 1580s and later, which all exhibit similar straight baselines on both sides of the socle. These busts, such as those of Paolo Costabile and Doge da Ponte (Pls. 88, 90), show the direction Vittoria's work took after the *Rangone*. The shape of the torso has now become standard: the diagonals connecting the shoulders and arms to the baseline are purely secondary and read almost as verticals because the horizontal breadth of the torso has been filled in. The baseline is completely straight and extends well beyond both the left and right edges of the socle: the girth of the baseline defines the breadth of the whole bust.

This development of the baseline is of great interest and meaning, because it breaks away from one of the standard features of a classicizing bust: that it be rounded at the bottom. In adopting a straight, cut-off termination for the torso, the artist in effect returned to the solution employed in the quattrocento reliquary bust where the torso was cut straight through, usually just above the elbows. That Vittoria, whose chief concern throughout his career as a portraitist was the depiction of movement and presence, should use such a device is not surprising, for it counters the abstract, ideal form of the classical bust, a form that inhibits movement and imparts an emotional remoteness. Making the baseline spread out from the socle and project beyond it invites the viewer to imagine the torso as expanding, to picture the whole body despite its truncation in bust form. By the mid-1570s Vittoria had, in effect, combined for his own purposes features from the classicizing portrait bust and the fifteenth-century bust to fashion his own personal solution to

[54] The torso of the terracotta version of the Rangone is, however, quite different from the bronze and more radical; see cat. no. 21.
[55] See Rinehart (1967), p. 443, for the observation that Bernini's busts became bigger as his career advanced.

the truncation and fragmentation of the body inherent in the bust form. While maintaining a hollowed-out back and mounting the whole on a socle, he did away with a rounded termination, substituting in its place an unorthodox, straight termination. Despite his beginnings as a maker of pseudo-antique busts, his solution to the problem of the baseline is decidedly unclassical.

During the late 1560s and the first half of the 1570s, then, Vittoria experimented extensively with the torsos and terminations of his portraits. His final solution is seen in the busts of Ottaviano Grimani, Orsato Giustiniani, Paolo Costabile, Sebastiano Venier, and Doge Niccolo da Ponte (Pls. 82, 87, 88, 89, 90). They must postdate the *Rangone* because their baselines run straight out from the socle on both sides, a clear difference from the artist's earlier production. The busts of Costabile and da Ponte are fortunately documented, the former dated to 1583 and the latter to 1582–4, providing a time-frame for this development and confirming my reading of Vittoria's stylistic development. The shapes of the baselines and torsos of the busts thus provide sound morphological guidelines for charting Vittoria's work: he employed rounded, semicircular baselines during the 1550s and 1560s, developed a transitional format during the late 1560s and early 1570s in which the torso grew increasingly broader and larger while the baseline flattened out, and began to use very broad, massive torsos with completely straight baselines by the late 1570s and early 1580s.

These features furnish stylistic criteria for dating Vittoria's numerous undocumented busts, such as the terracotta in Vienna (Pl. 92), which is his only portrait of a woman.[56] Cessi dates this piece to the 1550s, but its straight baseline demonstrates that it cannot be that early and would have to be at least from the later 1570s or, more probably, from the 1580s.[57] I would suggest a similar dating for the two terracottas in London (Pls. 94, 96).[58]

By the late 1570s and 1580s, then, Vittoria had formulated his unique solution for the termination of a portrait bust. With the advantage of historical hindsight, one can see this solution as the natural outcome of his efforts from the early 1560s to resolve the issue of how to make a bust interact with its surroundings. While in the *Manzini* and *Marc'Antonio Grimani* he relied on activating the pose as much as possible, by the 1570s he had turned to making the bust itself, as an object, reach out into its surroundings. He accomplished this primarily by discarding the spatially confining, semicircular termination of the traditional classicizing bust and replacing it with a torso that penetrates and expands into the space around it.

The portraits of Ottaviano Grimani and Orsato Giustiniani may be the first in which he employed the solution of a completely straight baseline. The former, as previously mentioned, was the son of Marc'Antonio Grimani, Vittoria's first patron from among the procuratorial ranks to commission a portrait. Very little is known about Ottaviano Grimani, who was born in 1516, but, like his father and two of his uncles, he also was elected a Procurator, becoming a Procurator *de Citra* on 17 January 1571. He died in 1576, perhaps a victim of that year's devastating plague. Most likely, he (or his heirs) ordered the bust from Vittoria because the artist had already portrayed his father. Because the baseline is straight, the bust must date from after c.1575; I date it to 1575–80 (Pl. 82).[59]

[56] See cat. no. 27. I do not consider the female terracotta bust in Washington to be by Vittoria; see cat. no. 81.
[57] See Cessi (1961b), p. 34. [58] See cat. nos. 25 and 26. [59] See cat. no. 13.

The bust of Orsato Giustiniani (1538–1603; Pl. 87), which I also date to the late 1570s, portrays once more a patron of high patrician rank with antiquarian interests. After having served in many governmental posts, he dedicated himself to poetry in 1571 as a *bembista*. In his youth, like the poet Girolamo Molin who was the best friend of the Procurator Giulio Contarini, he was a member of the circle of Domenico Venier. In 1600, a selection of his verses entitled the *Rime di Celio Magno et Orsatto Giustiniani* was published in Venice. The most notable instance of his involvement with the classical world is his translation of Sophocles's *Oedipus the Tyrant*, which was the text chosen by the Accademico Olimpico for the première of the Teatro Olimpico in Vicenza in 1585; the translation was published that same year in Venice. This performance of *Oedipus* was probably the most elaborate revival of an ancient Greek drama undertaken in the sixteenth century, complete with costumes, stage set, and musical settings of the choruses by Andrea Gabrieli.[60] Here again Vittoria portrayed someone whose interests and activities were intellectually and emotionally concentrated on the classical past.[61]

If the *Grimani* and *Giustiniani* busts are taken together—they must be quite close in date—certain similarities are quickly evident (Pls. 82, 87). The two men are dressed exactly alike: a thick cloak, pinned by a broach on the sitter's right shoulder, is draped around his shoulders and covers the front plane of the torso; underneath, the sitter wears a high-collared tunic set with small, closely spaced buttons. In each bust, the cloak is similarly arranged: a great swathe of drapery extends from the clasp to encircle the sitter's neck, while other folds swing down from the clasp and to the right (in both the *Grimani* and the *Giustiniani* one fold reaches all the way from the clasp to the bottom right tip of the torso). Both busts feature swags that descend from each shoulder to provide a kind of interior visual framing for the torso. (The bust of Sebastiano Venier (Pl. 89), from the same period, shows this feature even more clearly because the swags extend below the baseline.)

Brinckmann thought that Vittoria's portraits were so monotonous and superficial that they could have been machine-made ('Fabrikware').[62] Although the same basic format was employed in both the *Ottaviano Grimani* and the *Orsato Giustiniani*, the closer one looks, the more one sees the subtleties of touch and pose that differentiate one from the other.

Grimani's body lines up along the central axis of the bust that passes through his turned head just to the left of his right eye. The straight termination of the torso extends beyond the socle to the same length on either side. Grimani's shoulders, however, are not straight: his right shoulder projects significantly in front of his left shoulder. Grimani turns his head forcefully to the right while tilting it slightly in the same direction.

The face is one of Vittoria's most sensitive depictions (Pl. 83). Grimani's eyes, large and wide open (only a sliver of eyelid shows), are set in deep sockets under thick, bushy eyebrows that taper off into the finest of chisel strokes. Above the eyes spreads his furrowed forehead with a mercilessly sensitive rendering of the bumps and knobs on his head and upper brow. Below the eyes hang bags surrounded by crow's-feet that are rendered as minute, careful wrinkles

[60] While the event of the *Oedipus* has received much scholarly attention—see, for instance, Puppi (1987), pp. 189–200, and Beyer (1987)—Giustiniani's role is mostly ignored. See, however, Schrade (1960), esp. pp. 33–63, for information on Giustiniani and, pp. 64–5, a reprint of his introduction to the translation.

[61] See the biography of Giustiniani in cat. no. 7.

[62] Brinckmann (1925), p. 87.

and puffs of skin. The lower edge of the eye sockets, like the upper edge, is far larger than in reality. The cheekbones are pronounced as are the smile lines. The beard, full and volumetric, reveals the shape of the chin as it curls and falls naturally. Perhaps the most striking feature of the face is the intensity of the eyes below their beetling brows. They are not aggressive as in the bust of Ottaviano's father Marc'Antonio Grimani, but gentler, more reserved, more troubled and complex.

Throughout the bust, in both head and torso, the stone is deeply cut to create strong chiaroscuro contrasts. The depth at the area of the buckle or clasp is, for instance, particularly pronounced, causing the buckle to project very strongly which in turn increases the projection of the left shoulder by making it seem to come forward even more. The edges of the drapery are very sharply cut. The drapery swags at either side as well as the central swathe that goes round his neck are thick and massive, thereby increasing the power and scale of the torso.

The play of drapery patterns is organized contrappostally between left and right sides. The basic organizing principle is that the drapery be more agitated and lively on the left side than on the right because Grimani turns his body and head to the right. The more lively drapery patterns on the left thus help balance the composition and keep the left side from becoming dead. This becomes immediately apparent if one looks at the baseline where a flat, planar section occupies the right corner as opposed to the left side where the bottom edge moves in and out with the various pleats and folds of the cloak. Even the terminations of the arms contribute to this contrast since Grimani's right arm is larger than his left and the folds there lead outward while on his left arm they point down. At the point where the flap that continues around the neck turns from inside to outside, the descending diagonal fold points in the opposite direction from Grimani's chin.

By this careful balancing of directional pulls, by the breadth of the torso, and by the depth and vigour of its carving and modelling, the *Ottaviano Grimani* impresses as very forceful, concentrated, strong, compact, and solid. The *Orsato Giustiniani*, on the other hand (Pl. 87), is more elegant and refined, more elongated and complex in its movement. A younger man (and a poet), Giustiniani's hooded glance is cooler than Grimani's, his eyebrows rise slightly to give a questioning cast to his features, his neck bends forward while his head tilts back slightly and to the left. Giustiniani's physiognomy—especially his aquiline nose—is sharper and livelier than Grimani's squarish, ponderous features and this basic physical and psychological contrast informs the differences between the two busts. Whereas Grimani's head, shoulders, and neck all move or jut in the same direction, Giustiniani assumes a more complicated pose: although his head faces to the right, the right shoulder is higher and projects forward of the left shoulder (as in the *Rangone*), providing a lively *contrapposto*.

The portraits of Ottaviano Grimani and Orsato Giustiniani demonstrate where Vittoria was by the end of the 1570s: sure and confident in his idiom, solidifying and refining his achievements from the first half of the decade. The *Sebastiano Venier*, from the late 1570s or early 1580s, exhibits the same solutions (Pl. 89), as do the two busts that can be securely documented to the early 1580s, those of Paolo Costabile and Doge Niccolo da Ponte. [63]

[63] See cat. no. 22 for the bust of Venier.

The *Costabile* was made posthumously after the sitter's sudden, unexpected death in Venice on 17 September 1582 and before Vittoria received a final payment of 56 scudi on 25 May 1583 (Pl. 88).[64] It must date from the first half of 1583. Because Costabile died during a visit he was making to Venice in his role as general of the Dominican order, it is most unlikely that Vittoria could ever have seen, let alone known, the man; the very sunken cheeks and huge eye sockets of the bust probably indicate that the artist based the likeness after a death-mask.

As an example of Vittoria's portraiture, the *Costabile* is of considerable interest as it is the only bust of a cleric in ecclesiastical dress, just as the near-contemporaneous *da Ponte* is the only depiction of a Doge in ducal robes. In response to the need to present Costabile in his Dominican monk's habit, Vittoria made his most geometrically simple and abstract composition, one that serves to underline the deeply introspective mood of the portrait. Despite the fact that Vittoria could not have been acquainted with Costabile, the bust seems very personal.

This feeling may arise precisely because of Costabile's unusual garb. Freed from having to depict yet another Venetian patrician in his standard costume, Vittoria tried for a different effect here. The *Costabile* is the sole portrait in which the sitter looks down, away from the world and into himself. The few, sharply ridged, simple folds of his cowl expand down and out from the ring of his collar. No great contrasts are made or sought to upset the mood of inner contemplation: the whole torso is basically symmetrical with but a gentle tilt of the baseline and a slight displacement of the shoulders to the left in consonance with Costabile's glance.

Psychologically and physically the bust is closed and tightly bounded, in this way a change in direction from the busts of the late 1570s. The simplicity of the drapery here—in contrast to the complicated patterns of the customary patrician's cloak—possesses its own power, and the feeling generated by the torso remains similar to that of the other busts from the 1570s: great physical presence is communicated by the portrait's sheer breadth. Instead of an extroverted expansion into space such as one sees in the *Rangone*, the sense here is of great, heavy emotions held in check. The focus is on concentration, as evidenced by Costabile's gaunt, ascetic face, which is reminiscent of portraits of the aged Michelangelo.

This rendering of powerful bulk reaches its apotheosis in what is probably Vittoria's greatest portrait—a 'masterpiece . . . of an almost unhuman life-likeness', as Planiscig put it—the bust of Doge Niccolo da Ponte from 1582–4 (Pl. 90).[65] A better term than Planiscig's *lebenswahrheit* (life-likeness) might be *Überlebenswahrheit*, since the sheer scale of this statue—one metre in height—sets the tone for the whole work. The artist's largest portrait by far, the *da Ponte* is also his only depiction of a Doge in ducal regalia and his only half-length work.

Many characteristics of Vittoria's earlier busts are here not so much repeated as recapitulated, making the *da Ponte* a summa of Vittoria's portraiture. Above the squashed asymmetrical socle, the straight baseline tilts down to the right, the direction in which the sitter looks. To counter the rightward tilt of the baseline, the shoulders recede in depth to the left. The axis of da Ponte's body, defined by the central join of his undergarment, lies just to the left of the axis of the socle. The baseline extends far out from the socle both laterally and in depth (the apron of the bust is very thick). The richly brocaded robe flares open to impart a further sense of movement. As in

[64] See cat. no. 2. [65] See cat. no. 19.

the *Ottaviano Grimani*, the drapery is arranged contrappostally, being more activated on the left side where the cavernously deep folds spring out into space to contrast with the planar, closed right side.

To me, the bust evokes Titian's equally stupendous portrait of Doge Andrea Gritti, now in the National Gallery of Art, Washington, DC, and usually dated to the 1540s (Pl. 91).[66] Common to both are the forceful turn of the head, the half-length marked by a belt, and the turned-back mantle that reveals a seemingly expanding torso of heroic size and scale. It was Titian who provided the model for the vivacity, the presence, the sheer physicality that Vittoria sought for his own portraiture. Unlike Vittoria's bronze Fugger *Annunciation* (now in the Chicago Art Institute) that more or less copies Titian's *Annunciation* in S. Salvatore, the *da Ponte* seems truly a sculptural reworking, rethinking, not a copy, of the grandiloquence that Titian imparted to his painted portraits. Just as Vittoria vied with the older artist in the Frari by answering the Madonna of the Cà Pesaro with what must have been, at the Zane altar directly opposite it, an unusually 'painterly' sculptured altarpiece, so does the *da Ponte* vie with Titian's revolutions in Venetian portraiture.[67]

As is the case with Titian's *Gritti*, the solution Vittoria found for da Ponte remains quite simple. The tremendous force of the torso is generated by the three waves of drapery on the left and the single fold on the far right edge. No more was needed. The simplicity and immense scale of the statue combine to give it an iconic quality befitting the quasi-sacral office of the Doge. Although da Ponte was over 90 when the bust was made, his gnarled, wrinkled face with its crafty glance and hook nose shows him alert and sentient. His craggy visage reads as wise in experience, not feeble or superannuated. The *da Ponte*, besides being a summary of his mature portrait aesthetic, ranks as Vittoria's greatest achievement in harmonizing veristic physiognomy with propagandistic content.

[66] See the entry by David Alan Brown on this portrait in *Tiziano* (1990), pp. 252–4.

[67] Can it be coincidence that these two responses to Titian (the Fugger *Annunciation* and the *da Ponte*) are in painterly bronze and terracotta, not marble?

VITTORIA AND THE VITTORIESQUE PORTRAIT

THE bust of Doge Niccolo da Ponte not only epitomizes the formal characteristics of Vittoria's mature portrait style, it also demonstrates how remarkably successful the new genre of the portrait bust had become during the course of the artist's career. Coming from the Doge himself, the commission marks the culmination of Vittoria's official patronage, and, most significantly, da Ponte's is the very first dogal tomb ever to feature a bust.[1] Ducal tombs follow the general trend in Venetian sepulchres: when a tomb featured an image of the deceased, and most ducal monuments did, the rule was for a full-length gisant figure; in a very limited number of cases, Doges such as Niccolo Tron employed a standing figure. Seen in context, da Ponte's tomb, which was destroyed in the early nineteenth century when S. Maria della Carità was converted into the Accademia delle Belle Arti, stands out as a fairly radical innovation, and it provided the precedent for all later ducal tombs that feature busts, such as that of Leonardo Donà (Pl. 2) on the interior façade of S. Giorgio Maggiore.[2] A gisant figure could easily have been planned for da Ponte's large and lavish wall monument. That a bust portrait was commissioned instead was due surely not to budgetary restraints on the part of the patron, but because the master of sculpted portraiture in sixteenth-century Venice made only busts.[3]

The *da Ponte* puts Vittoria's achievement in perspective. The genre of the portrait bust, which practically did not exist in Venice prior to 1550, had, by the 1580s, been adopted as the mode of self-depiction by the person at the very head of Venetian society. It has already been shown how quickly Vittoria was patronized by rich and politically powerful men such as Marc'Antonio Grimani, Girolamo Grimani, and Giulio Contarini. With the bust of Doge da Ponte the artist reached the patriciate's highest rung, fashioning a far more prestigious image than any painted portrait could be, since the bust was destined for what was meant to be the Doge's most lasting memorial, his tomb.[4]

[1] The precedent-breaking nature of the da Ponte tomb, noted in Martin (1988), p. 199, has only recently received attention; see Simane (1993), pp. 82–95, especially p. 90. Interestingly, da Ponte's tomb stood directly opposite an equally innovative tomb, that of Marco and Agostino Barbarigo, the only brothers to be successive Doges; for this earlier project, see Schulz (1981), pp. 171–92, and also Roeck (1992), pp. 1–34.

[2] For the dispersal of da Ponte's tomb in the early 19th cent., see cat. no. 19. For the tomb of Doge Donà, see Cooper (1990), p. 140.

[3] Some writers, however, have overly credited the popularity of the portrait bust in Venice, such as Thomson (1993), p. 220, n. 47, who claims that the genre's popularity in Venice is 'attested by the large number of busts commissioned by Procurators of Saint Mark's for personal commemoration in the destroyed church of San Gemignano at the far end of the Piazza San Marco from the basilica, many of which are in the Cà d'Oro'. I know of only three busts that were ever in the church, those of Tommaso Rangone, Benedetto Manzini, and Matteo de' Eletti; none of them was a Procurator and only busts of the latter two are in the Cà d'Oro. S. Geminiano did, however, contain a full-length standing statue of Melchiorre Michiel, a prominent Procurator of the 16th cent.

[4] Two other men portrayed by Vittoria became Doge: Sebastiano Venier (cat. no. 22) and Marino Grimani (cat. no. 11). Both busts were made before the sitter's election and thus do not

The Doge entrusted the commissioning of his tomb to Marc'Antonio Barbaro, Daniele Barbaro's brother, who had become a Procurator in 1572.[5] Barbaro commissioned the monument itself from Vincenzo Scamozzi, the figural sculpture from Girolamo Campagna, and the bust from Vittoria; such a division of labour was not uncommon at the time.[6] Vittoria's share of the project confirms how highly he was recognized as a specialist in portraits.[7] Marc'Antonio Barbaro shared the classicizing tastes of his brother, so it is little wonder that he continued his family's patronage of Vittoria twenty-five years after Daniele Barbaro had commissioned the *Ferretti* from the artist. After Palladio died in 1580, Marc'Antonio took a special interest in the work of Scamozzi, supporting him for a number of projects, successfully in the case of the completion of the Libreria and the Procuratie Nuove, unsuccessfully in the case of the new bridge at Rialto.[8] The commission for da Ponte's tomb must have arisen about the same time as his commission, from Barbaro, to complete the Procuratie Nuove (5 April 1582).[9] Marc'Antonio Barbaro may have continued to patronize Campagna; as Timofiewitsch has noted, Campagna's commissions for the high altars of both of Palladio's Venetian churches—S. Giorgio Maggiore and the Redentore—came only shortly after the commission for the da Ponte tomb.[10]

The *da Ponte* shows how, by the 1580s, a portrait bust by Vittoria appealed to patrons of varied interests, for da Ponte himself seems not to have shared the antiquarian interests so dear to the Barbaro and to so many of Vittoria's patrons.[11] Nor did he share the pro-papal sentiments of patrons such as Girolamo Grimani and Giulio Contarini. On the contrary, da Ponte was one of the papacy's most implacable foes among the Venetian aristocracy.[12] These political factors, however, clearly did not influence the choice of the artistic style of his tomb, demonstrating that by the 1580s a bust by Vittoria appealed to a group defined more by rank and status than by special interests. The Doge was seemingly quite proud of his bust for it is the only feature of the tomb that he refers to in his will.[13]

Da Ponte's patronage shows that, by the 1580s, an *all'antica* portrait bust by Vittoria was desired by many of Venice's most prominent patricians regardless of their politics or cultural concerns. A 'Vittoria' had become a status symbol in and of itself, and as such it found an increasingly receptive market among Venetian aristocrats and other citizens.

This increased demand was met, however, by coming to rely on a formula, and the codification of Vittoria's style that occurs in the 1580s with works such as the *da Ponte*, *Costabile*, and

present him in ducal regalia. Grimani's, since it is in one piece (see cat. no. 4 for this feature), was apparently made with the intention of using it as a private image in the home, not as a public image.

[5] Stringa provides this information; see cat. no. 19.

[6] The tomb of Alessandro Contarini, discussed in Ch. 3, provides a notable precedent for the practice, where the tomb was commissioned from Sanmicheli, the figural sculpture from Vittoria, Pietro da Salò, and Agostino Zoppo, and the portrait bust from Cattaneo. The Dolfin/Pisano monument in S. Salvatore is another example, where both Campagna and Giulio del Moro executed sculptures; see Simane (1993), pp. 137–8.

[7] Simane (1993), p. 83, calls it a 'Prestigefrage' to have commissioned the bust from Vittoria instead of from Campagna; cf. Timofiewitsch (1972), p. 21.

[8] Tafuri (1989), p. 168, writes that 'Scamozzi's erudition and

antiquarian theorization . . . made him . . . a "natural" ally of the scientistic and Romanist patrician culture'. For Barbaro's other activities in the 1580s, see ibid., ch. 7, *passim*.

[9] See Tafuri (1989), p. 167.

[10] Timofiewitsch (1972), p. 21.

[11] The evidence here, however, may be incomplete, for da Ponte did have serious humanist interests and training. In Mar. 1514, he received his doctorate from the Collegio dei Dottori Medici in Venice and from 1521 to 1523 was the public lecturer in philosophy at the School at Rialto. He held a reputation for eloquence and supposedly wrote treatises on geometry. See Nardi (1963), pp. 130–9, and Brown (1974), *passim*.

[12] See Brown (1974), *passim*, particularly ch. 5. The Doge's younger brother Andrea was a heretic, and Pope Pius V went so far as to accuse da Ponte of heresy in 1565.

[13] For the passage from da Ponte's will, see cat. no. 19.

Venier busts hardened into a replication of style. The *Tommaso Contarini* (1580s; Pl. 98), the *Giovanni Battista Peranda* (1586; Pl. 100), and the *Francesco Duodo* (1580s; Pl. 101) are but watered-down versions of the *Sebastiano Venier* (Pl. 89).[14] In time, even a standard torso is produced and is repeated below different portrait heads.[15] This torso appears, for instance, in the *Vincenzo Morosini* (Pl. 103) of 1587–8 in S. Giorgio Maggiore. It is then regurgitated, fold for fold, in the *Antonio Zorzi* (1588; Pl. 104) in S. Stefano, the *Alvise Tiepolo* (1594; Pl. 105) in S. Antonin, the *Domenico Duodo* (1596; Pl. 106) in the Cà d'Oro, and in the *Lorenzo Cappello* (c.1599; Pl. 107) in Trent.[16]

The above nine busts not only show a dry repetitiveness, they demonstrate so little autograph participation on the part of Vittoria that I assign them all to the workshop. Until the mid-1580s, the bust production had been almost entirely autograph, but after about 1585 the role of the workshop increases radically, explaining the need for models, patterns, and formulas.[17] This was the result at least in part of Vittoria's increasing old age and infirmity. He was nearing 60 in 1584, in which year he fell seriously ill.[18] That workshop participation in the busts (and in Vittoria's work as a whole) increases so greatly about this time, indicates that this illness affected the artist's ability or desire to carve. After about 1585, Vittoria seems, with very few exceptions, only to have overseen the execution of his designs, and not to have taken an active role in them.[19] In 1604, he was described as the best sculptor in Venice, but who 'on account of old age and illness no longer works [himself]'.[20] It seems likely that this had been the situation for some time.

That the bust production from the later 1580s and the 1590s belongs primarily to the workshop also receives documentary support, for every payment in Vittoria's account book to an assistant for work on a portrait postdates 1585. It cannot be just coincidence that, from 1550 to 1586, the account book holds no payments to assistants for work on a portrait bust, while from 1586 to 1599 there are four such entries.[21] Increased workshop participation is also clearly evident in Vittoria's figural work from the 1580s, such as the statue of Christ over the portal of the Frari and the sculptures on the façade of the Scuola di San Fantin (now the Ateneo Veneto), participation that is similarly documented by payments to assistants recorded in the account book.[22]

[14] For the busts of Tommaso Contarini, Peranda, and Francesco Duodo see, respectively, cat. nos. 32, 43, and 4.

[15] Baker (1995), esp. pp. 826–7, has convincingly argued that Roubiliac's practice was to cast moulds of his clay models, and then to use those moulds not only for fashioning multiples of a portrait bust, but also in order to re-use a torso for another sitter 'by casting it from the mould and then inserting a freshly modelled head into the new cast . . .'. I suspect that Vittoria followed a similar procedure, casting moulds from a model torso.

[16] For the busts of Morosini, Zorzi, Tiepolo, Duodo, and Cappello see, respectively, cat. nos. 42, 49, 45, 35, and 30.

[17] The only bust from before the 1580s that I attribute to the workshop is that of Girolamo Molin; see cat. no. 40.

[18] In May 1584, Vittoria made a will in which he describes himself as sick and in bed; see Gerola (1924–5), p. 353 (that this was the only time the artist made a will between 1576 and 1595 suggests the gravity of the illness). In a letter to the tax commissioners of Venice, which seems also to date from 1584, Vittoria

states that 15 days previously he had almost died from an illness; see Predelli (1908), pp. 61–3, nos. 27 and 28.

[19] Sansovino as well apparently stopped carving while in his sixties; see Boucher (1991), i, pp. 155–8.

[20] For this quotation, which comes in a letter to Duke Francesco Maria II of Urbino from his ambassador in Venice, see Gronau (1919–32), p. 259.

[21] A payment from 1557 in connection with the *Ferretti* specifies that the assistant's work was confined to the base of the bust; see cat. no. 6. Otherwise, payments were made to assistants for work on the *Vincenzo Morosini* in 1586, *Giovanni Battista Peranda* in 1586–7, *Domenico Duodo* in 1596, and the *Antonio Montecatino* in 1599; see cat. nos. 42, 43, 35, and 41. The payment for the *Morosini* was to Virgilio Rubini; I suspect that it is his hand that can be seen there and in other busts such as the *Tommaso Contarini*.

[22] For these projects at the Frari and the Scuola di San Fantin, see Predelli (1908), pp. 191–3.

Recognition of the role of the workshop during the artist's late career should correct a common criticism of Vittoria. He has often been taken to task for the repetitiveness of his work; as noted in the previous chapter, Brinckmann likened the busts to objects churned out by machine.[23] While this is indeed the case for much of his work from the later 1580s and 1590s, it does not hold for his earlier portraits. Judgement of Vittoria has become distorted because too many workshop pieces are accepted as touchstones of his work.[24]

The differences in quality between master and workshop become readily apparent when one compares an autograph bust from the 1580s, such as the *Pietro Zen*, with a bust from the workshop, such as the *Vincenzo Morosini*. The formal sympathies of the terracotta *Zen* (Pl. 108) relate to the expanding torso of the *da Ponte* (Pl. 90) and the introspection of the *Costabile* (Pl. 88). Like Costabile, Zen is quiet and calm: he turns his head gently to the right while directing his glance slightly down. His expression seems sad, even mournful, his eyebrows gently raised to furrow his brow, his eyes calm and hooded. The full beard falls over the collar of his tunic, linking the head and torso. Gone is the leonine theatricality of the busts of Manzini or Marc'Antonio Grimani. Zen's melancholic attitude, which seems almost tentative or timid, continues the exploration of interiority begun in the bust of Priamo da Lezze (Pl. 63).

The torso of the bust continues the understated tone of the work by furnishing a balance between symmetrical and asymmetrical elements. The gorge of Zen's brocaded senator's robe opens slightly to reveal a groove that marks the exact centre of the torso; this groove anchors the whole piece by lining up with the centre of the socle. The right side of the torso (the side with the stole), however, extends further out from the socle than does the left side. The lapel on the left side is broader than that on the right side, and its steeply diagonal outer edge curls back irregularly. The diagonal line of the lapel is then twice repeated on the left, terminating in the outer edge of Zen's truncated arm. This sequence of folds serves to counter the rightward turn of the head and acts as a balance to the smoother right side and the heavy mass of the stole over Zen's left shoulder. The composition is carefully planned for a restrained variety in depth and pattern; this is doubtless why it provided the model for the torsos on the busts of Antonio Zorzi, Domenico Duodo, Vincenzo Morosini, Alvise Tiepolo, and Lorenzo Cappello.

As in the *Costabile* and *da Ponte*, all is really very simple; the torso in no way detracts from the focus on Zen's tenderly delineated melancholic face. The bust seems to have been meant as a private object and as such remained in the Zen palace until the nineteenth century.[25] That a work so private in tone and feeling could come so close in time to the paradigmatically public presentation of da Ponte shows that, even towards the end of his autograph production, Vittoria's sense of decorum, his *varietà*, and his penetration into the character of his sitters was as sharp and flexible as ever.

The *Morosini* (Pl. 103), from 1588, lacks the qualities exhibited by the *Zen*, *c*.1585. It is only necessary to compare the rote, mechanical repetitions of horizontal lines on Morosini's forehead

[23] Pope-Hennessy (1971), p. 98, has taken a similar view: '. . . the artist of whom [Vittoria] most forcibly reminds us in his portrait sculptures is Tintoretto, not only in the vigour with which the externals of character are rendered, but in his repeated recourse to formulae.'

[24] This is a problem in Venetian sculpture as a whole, as has recently been pointed out by Wolters in Wolters and Huse (1990), p. 133: 'As in the Gothic age mediocrity preponderated— to judge by the surviving works—in the Venetian Renaissance. This makes it all the more important to separate the wheat from the chaff.'

[25] See cat. no. 23.

with Zen's furrowed brow to see the difference in hands. The irregular grooves on Zen's forehead read as creases in skin, not striations in stone. On Zen's face each line has a specific beginning and end, swelling or thinning, according to its own rhythm; the parallel lines on Morosini's forehead, in contrast, demonstrate no such individual character. Similar features appear in the treatment of hair: while Zen's facial hair differs texturally from the hair on top of his head, no such distinction differentiates Morosini's beard from his other hair.

The *Zen* and the *da Ponte* raise numerous issues concerning the meaning and importance of Vittoria's work in terracotta. An important element of the expressiveness displayed by both these busts is their terracotta medium, for Vittoria was ever a more gifted modeller than carver, as demonstrated by the virtuosity of his early stuccoes. Although the autograph busts in marble contain wonderful touches of spontaneity, such features are even more pronounced in the terracottas. I consider thirteen terracotta busts to be autograph: *Francesco Duodo* (Pl. 102, cat. no. 5), *Girolamo Grimani* (Pl. 78, cat. no. 9), *Marino Grimani* (Pl. 110, cat. no. 12), *Giovanni Battista Gualdo* (Pl. 85, cat. no. 14), *Apollonio Massa* (Pl. 109, cat. no. 17), *Niccolo da Ponte* (Pl. 90, cat. no. 19), *Tommaso Rangone* (Pl. 81, cat. no. 21), *Pietro Zen* (Pl. 108, cat. no. 23), the '*Zorzi*' (Pl. 112, cat. no. 24), three unidentified patricians (Pls. 94, 96, and 114, cat. nos. 25, 26, and 28), and one unidentified woman (Pl. 92, cat. no. 27).

Four of these thirteen exist in other media: there are marble versions of the *Girolamo Grimani*, *Marino Grimani*, and *Francesco Duodo*, plus the bronze version of the *Rangone*.[26] Because these four exist in other versions, they, and by implication the terracottas as a whole, are usually termed models.[27]

Like all Renaissance sculptors, Vittoria used three-dimensional sketches and models. When he made his last will in 1608, for instance, he bequeathed to his nephew, Vigilio Rubini, 'tutti gl'instrumenti et tutte cose pertinenti alla scultura, disegni a mano et a stampa, modelli de terra et di cera, e tutti li rilievi de giesso'.[28] During the Renaissance and Baroque periods, a sculptor's models were generally of three sorts: a small sketch in wax or clay that was used to generate the basic design (the *bozzetto*); a somewhat larger, but still small, *modello* in wax or clay that had more detail and could be used as a guide for execution; and a full-scale model of clay, plaster, or stucco that guided execution or was used to judge how the completed statue would look *in situ*.[29]

Vittoria probably used all these types of models. Only one connected with his figural sculpture, however, has survived: a small terracotta for the figure of Architecture on the artist's tomb in S. Zaccaria (Pl. 116).[30] As far as the portrait busts are concerned, the terracottas of Francesco Duodo and of Marino Grimani (Pls. 102 and 110) seem to have functioned as full-scale models.[31] I say this because the only significant difference between them and their marble versions (Pls. 101

[26] There was also a terracotta of the *Tiepolo* but it is lost; see cat. no. 45.

[27] There exists no discussion of the terracotta busts as a discrete part of Vittoria's production; see, however, Martin (1988), ch. 4. The terracotta of Apollonio Massa has often been called a model for a marble bust of Massa that is now in the Ateneo Veneto. This latter bust, however, is not by Vittoria; see cat. nos. 17 and 74.

[28] See Predelli (1908), p. 225.

[29] See Boselli (1978), pp. 113–14. Dent-Weil's chapter, ibid., 'Bozzetto-Modello: Form and Function', pp. 113–34 remains the best treatment of the subject. Montagu (1989), adds much new material but fails to give as clear an overview as Weil.

[30] Originally owned by Marco Mantova Benavides, it is now in the Mus. of Archaeological Science at the University of Padua; see Favaretto (1976–7), pp. 401–3.

[31] Full-scale models seem to have been in use by the middle of the 16th cent; see Boselli (1978), pp. 114–15.

and 111) is a reduction in scale: besides being fresher and more animated, the terracotta is literally larger and more expansive in feeling. The *Marino Grimani* dates from 1591–2, the *Duodo* from the 1580s, and the tight, constricted, mechanical quality of the torsos of the marble versions bespeaks the hand of the workshop. In these two cases it seems that while the master made the terracottas and gave the finishing touches to the faces of the marble versions, the workshop took primary responsibility for executing the marbles after the terracotta models. Since both of these projects date from the latter part of Vittoria's career when the workshop was assuming an ever-increasing role, the terracottas would have been needed to guide the assistants in the execution of the bust, and their existence would thereby relate directly to the workshop practice.

That Marino Grimani paid a lump sum for both his marble and terracotta busts further indicates that the two objects were made in close connection with each other.[32] It was the same with the bust of Alvise Tiepolo in S. Antonin where Vittoria's payment again included both the terracotta and marble bust.[33] That a patron would desire the models for the finished project apparently became quite common in the course of the seventeenth century.[34] Perhaps the patrons paid for these terracottas because they knew that the marbles were not fully autograph?

Such a clear-cut relationship between model and final version is not the case, however, for the terracotta and marble *Girolamo Grimani* or for the terracotta and bronze *Tommaso Rangone*, where each of the two versions displays significant changes in composition. In the marble *Girolamo Grimani*, the way the torso pushes forward from left to right, how it literally projects out from the socle to correspond to the projection of the sitter's left shoulder, is completely absent in the terracotta. There, in contrast, the baseline is straight, parallel to the socle—not ascending to the right as in the marble—and is completely flush with the plane of the socle (Pls. 77 and 78).

Stylistically, the terracotta *Girolamo Grimani* relates strongly to the marble busts of Niccolo Massa and Giulio Contarini and thus would seem to date from about 1570. Perhaps it was made before Grimani died in that year. Documentary evidence confirms that the marble bust of Grimani dates from 1573. Because the pose and expression of the heads are identical, Vittoria certainly drew upon the terracotta to make the marble. But the substantial changes to the torso prove that the conception was transformed between the terracotta and marble versions. It is probably quite telling that the receipt for the marble *Girolamo Grimani* makes no mention of the terracotta.[35] There are similar differences between the terracotta and bronze versions of the *Tommaso Rangone*. Calling these two terracottas simply models for their other versions does not do justice to what is surely a more complicated situation.

It was standard practice at the time to make a terracotta model for a portrait bust. Almost none survives, however, from the sixteenth century and very few survive even from the seventeenth century. While Bernini's usual practice was to make several small terracotta studies for his sculptures, it seems that he would, at least on occasion, follow the general practice of making a large, full-scale model of a portrait that was referred to as a guide for sculpting the marble.[36] The main reason these models do not survive is because they were not valued, despite

[32] See cat. nos. 11 and 12.

[33] See cat. no. 45, n. 2.

[34] See Montagu (1989), p. 36.

[35] See cat. no. 8 for the receipt.

[36] See Boselli (1978), p. 132; cf., however, Wittkower (1951), p. 8. Even if Bernini did regularly make full-scale models for his busts, none survives.

the growing interest in such objects mentioned above. As Rudolf Wittkower has written concerning a terracotta bust by Melchiorre Caffà, 'the seventeenth century hardly rated such models as works of art. They had a clearly defined utilitarian purpose and, when made to serve for casts in metal, were usually destroyed after a mold had been taken from them.'[37] Aretino's correspondence documents, for instance, that there was a terracotta model of Cattaneo's bust of Bembo; it has not survived even though Aretino at one point suggested that it, not the marble version, be displayed on the cardinal's memorial in Padua.[38]

It is anomalous that such a large number of terracottas by Vittoria has survived. Only seven terracotta busts by Algardi, for instance, survive, of which six can be connected with closely corresponding marble or bronze versions.[39] Furthermore, comparison of a terracotta by Algardi, such as the *Cardinal Paolo Emilio Zacchia* (Pl. 117), with Vittoria's terracottas reveals another striking feature. While Algardi's piece looks like a model—it is sketchy in character and roughly worked out—not one terracotta by Vittoria is anything but carefully and highly finished. The large number of surviving terracottas by Vittoria—most of which cannot be connected with a version in another medium—along with their high state of finish suggests that they were not, for the most part, made to serve as models. They were instead independent objects appreciated for their own intrinsic aesthetic value in their own time.

The bust of Doge da Ponte provides official confirmation of this. As already noted, the *da Ponte* breaks sharply with tradition as the first bust portrait ever set on a Doge's tomb; previously, full-length standing or recumbent figures were the norm. It has been suggested that the *da Ponte* is a model for which the bronze version was never cast and certainly the expense of casting so large a statue would have been great.[40] But da Ponte was fabulously rich: his tomb, like his family palace, was tremendously costly—why would the bust be the only element of the tomb left unfinished?[41] Furthermore, if the terracotta had been meant to be cast, why was it placed on da Ponte's tomb even before he died, as his will shows that it was?

Although no further documentary evidence exists as a guide, it seems plausible that, since da Ponte and Marc'Antonio Barbaro felt confident enough to break with tradition by ordering a bust for a dogal tomb, they could well have decided to break with tradition in terms of medium as well. The visual evidence of the portrait shows how deeply Vittoria responded to the commission (Pl. 90). A connoisseur like Barbaro could well have realized, from the sheer magnificence of the object itself, that such an image could not be improved upon and was content with the terracotta. Considering the fragility as well as the lowly status of terracotta in the hierarchy of materials, this was an audacious act.

[37] Wittkower (1959), p. 198.

[38] See Ch. 2, above. Aretino's suggestion to place the terracotta on the memorial in Padua suggests that the model was full-scale.

[39] Montagu (1985) accepts 7 terracottas as being by Algardi: *Lelio Frangipane*, cat. no. 147.B.1, p. 426; *Muzio Frangipane*, cat. no. 148.B.1, p. 426; *Innocent X*, cat. no. 156, p. 431; *Gaspare Mola*, cat. no. 168, p. 439; *Giacinta Conti*, cat. no. 175.B.1, pp. 443–4; a member of the Spinola family, cat. no. 179.B.1, p. 446; and *Cardinal Paolo Emilio Zacchia*, cat. no. 182.B.1, pp. 447–8. Only Mola's bust has no version in another medium. Montagu provides no discussion of these works as a distinct class of objects.

[40] Boucher (1991), ii, p. 327, no. 18, suggests this was the case with Sansovino's *Loggetta Madonna*, which was in effect destroyed when the Campanile collapsed at the beginning of the 20th cent.

[41] Brown (1974), pp. 56–7, describes the palazzo da Ponte built near S. Maurizio (which still survives as 2746 calle del Dose) as 'extravagant', stating that it 'represented an enormous investment in the kind of display for which the sixteenth century appetite was insatiable. It does not conform to da Ponte's general reputation for avarice.'

It was no doubt the vibrance of the terracottas that made them so appreciated. Both in them and in the marble busts, Vittoria's gift for differentiating textures, for bringing out the underlying structure of the skull as well as the volume and mass of the body beneath the sitter's garments, endows the busts with life. One senses in them a vitality; one seems to see the blood flowing through their veins, and feels the spirit behind their piercing eyes.

These qualities distinguish Vittoria's production from that of his contemporaries. When the artist began his independent career in the 1550s, there was no tradition of bust portraiture in Venice. Although Simone Bianco and others had employed the classical bust type for depictions of imaginary people, the praxis of portraying modern, historical persons in a classicizing format had only just begun with Cattaneo's busts in Padua of Bembo, Bonamico, and Alessandro Contarini. Long before his death in 1608, however, Vittoria had determined the form and development of this genre in his city and its domains.

Artists such as Girolamo Campagna emulated Vittoria without achieving the same results. In portraits such as that of Andrea Dolfin (Pl. 118), Campagna drew upon the Vittoriesque schema: a convincing portrayal of the sitter's features, a large torso in which the drapery patterns are simply rendered, even a mostly straight, cut-off termination of the baseline. But Campagna took inspiration from the later busts of Vittoria—when workshop participation and formula had begun to dominate—and, compared to Vittoria's autograph production, Campagna's busts seem tame and colourless, as evidenced by Andrea Dolfin's blank stare, uninflected skin texture, and mechanically drilled beard. As, in Florentine art, Poggini's portraits pale when set beside those of Cellini (Pl. 12), so do Campagna's busts lack the bite and immediacy of Vittoria's images.[42]

Tiziano Aspetti pursued a different path. In his three bronzes of Sebastiano Venier, Antonio Barbarigo, and Marc'Antonio Bragadin in the palazzo Ducale (Pls. 119–121), his approach is not unlike that of Poggini and the Florentine mannerism the latter exemplified: iconic portraiture, in which the sitter seems removed from life and its signs of transience, such as facial wrinkles and bodily movement.

Aspetti's portraits typify Pope-Hennessy's characterization of the High Renaissance sculptured portrait as 'more often than not a public affirmation, the portrayal of an office-holder not as he was but as he wished to be'.[43] Of the twenty-eight busts by Vittoria I consider to be autograph (or substantially so), fourteen are marble, thirteen are terracotta, and one is bronze. Of the fourteen marble busts, twelve were either publicly displayed on a tomb or were probably meant to be so displayed. Even three of the terracottas, whose medium practically demands a private domain, were displayed on tombs (the single bronze bust was also publicly displayed).[44] In Venice, nobles were practically by definition office-holders, and although Vittoria's autograph

[42] With the sole exception of his bust of Zuanne da Lezze on the da Lezze tomb in the Gesuiti, the same applies to Giulio del Moro; see Martin (1993a).

[43] Pope-Hennessy (1971), p. 93.

[44] Marble busts that were publicly displayed are: *Giulio Contarini, Paolo Costabile, Giovanni Donà, Giovanni Battista Ferretti, Girolamo Grimani, Marc'Antonio Grimani, Priamo da Lezze, Benedetto Manzini,* and *Niccolo Massa.* The marbles of Domenico Duodo, Ottaviano Grimani, and Sebastiano Venier seem to have

been intended for public display. Francesco Duodo instructed that his marble be displayed but this was never carried out. The only marbles seemingly never intended for public display are those of Orsato Giustiniani and Marino Grimani. See cat. no. 4 for morphological features that seem to indicate whether a marble was intended for public or private use. The bronze of Rangone was on view in S. Geminiano. The terracottas of Giovanni Battista Gualdo and Niccolo da Ponte were placed on their tombs, while that of Apollonio Massa was on a memorial to him in a church.

production declined steeply during the latter part of his career, the status of his clientele did not. Vincenzo Morosini, Tommaso Contarini, the brothers Francesco and Domenico Duodo, Alvise Tiepolo, Jacopo Soranzo, Lorenzo Cappello, Marino Grimani, Giovanni Donà, and Antonio Zorzi all held important magistracies in the government. It is in the middle of the 1580s, in fact, that the 'official' nature of Vittoria's production increases markedly as the sitters start to be depicted in their robes of state. While neither Giulio Contarini nor Ottaviano Grimani, in their busts from the 1570s, is attired as a Procurator, almost all office-holders portrayed by Vittoria after 1585 are shown in their official robes.[45] It surely was in response to this demand that the model torso was employed.

While Vittoria's portraits of office-holders do not depict them as iconic mannequins of authority, the related issues of politics and social status help to explain the sudden popularity of the classicizing bust in Venice. Social as well as aesthetic issues brought forth these classicizing images of the Venetian nobility.

The fundamental basis of the whole Venetian ideology was the ostensible equality of all male nobles: because each patrician was a voting member of the Great Council (the *maggior consiglio*), was eligible for election to all governmental offices, and had but one vote, they were all absolutely equal in the eyes of the constitution.[46] This principle of aristocratic egalitarianism is likewise apparent in the Daulo law that, supposedly at the very birth of Venice, stipulated that all residences be equal and alike in appearance (see Chapter 4, above). Such concerns also extended to attire, as articulated in a whole series of sumptuary laws, such as one from 1668 that read in part: 'Along with the internal equality that reigns in the hearts of the citizens, it is desired that they be attired similarly as well . . .'[47]

The sixteenth century in Italy (and elsewhere) was, however, a time when society underwent an increasing aristocratization: nobles co-opted more and more privileges and power to themselves at the expense of their social inferiors.[48] Nor did the inferiors demur—whenever possible, they tried to join the ranks of the aristocrats and to ape their manners, a phenomenon memorably described by Braudel as the 'defection' of the bourgeoisie during the cinquecento.[49] While the Venetian aristocracy was a closed caste, unable since the *serrata* of the Great Council in 1297 to be penetrated by any *nouveau riche* baker or tradesman, aspects of this same process of aristocratization can be detected in the Serenissima. As Edward Muir has written, 'there seems to be considerable evidence of a growing divergence between the classes during the sixteenth century as the patricians put greater emphasis on aristocratic privilege at the expense of communality'.[50] While Muir was speaking here of relations between patricians and non-patricians (the *popolani*) in Venice, similar divergences were appearing within the aristocracy itself.

The most telling manifestation of this phenomenon was the acquisition by many patrician families of land (and titles), signalling their switch from the traditional Venetian activity of maritime commerce to the paradigmatic aristocratic occupation of holding feudal territory and

[45] Vincenzo Morosini, Domenico Duodo, Alvise Tiepolo, Lorenzo Cappello, Giovanni Donà, Antonio Zorzi, Marino Grimani, Pietro Zen.

[46] See, for instance, Cozzi (1986), pp. 139–57, especially p. 139: 'Base del sistema aristocratico veneziano era l'uguaglianza di diritti e di doveri tra tutti i patrizi che ne erano membri.'

[47] Quoted ibid., p. 140; see also Bistort (1912), *passim*.

[48] See the fundamental study by Donati (1987), esp. ch. 4.

[49] See Braudel (1973), ii, pp. 725–34.

[50] Muir (1981), p. 42.

exacting one's wealth from it. Such a change seems to be a direct response to the typical disdain directed at the Venetian patrician/merchant conveniently summarized by Machiavelli:

the gentlemen of [Venice] are so more in name than in fact because they do not have large incomes from landed estates, their wealth being founded upon commerce . . . Moreover, none of them have a castle or jurisdiction over subjects. [Among them] the name of 'gentleman' is . . . [not] based on any of the things that confer the title of 'gentleman' in other cities.[51]

Palladio's villas, for instance, owe their existence to this social and economic phenomenon: besides being examples of the *all'antica* style transferred to the Venetian terra firma, they also encapsulate the desire on the part of certain patricians to advertise themselves and their wealth according to the traditional aristocratic trappings of country estates.[52] The choice of an *all'antica* portrait bust to adorn one's tomb or house needs to be considered in relation to this social process. As has already been noted more than once in this work, all sorts of affinities exist between Palladio's and Vittoria's patrons, affinities that were caused by more than a general aesthetic taste for the *all'antica* style. Like the building of a classical villa on terra firma, so the choice of a classicizing portrait bust marked the patron as a member of a particular élite.

The sitters for Vittoria's portraits were indeed members of an élite. Most of them, in the first place, were patricians. Those who were not belonged to other élites: Niccolo and Apollonio Massa and Giovanni Battista Peranda were distinguished physicians (Niccolo had a European reputation as an anatomist); Giovanni Battista Ferretti, Camillo Trevisan, and Vincenzo Pellegrini were well-known, prominent jurists.

In examining his patrician sitters, however, it becomes clear how very élite they were. Three of them—Niccolo da Ponte, Sebastiano Venier, Marino Grimani—became Doge. These three had previously been Procurators; including them, Vittoria or his workshop portrayed fifteen men who were at one time or another Procurators.[53] A truly revealing, almost stunning, statistic is that, of the twenty identifiable patricians portrayed by Vittoria and his workshop, only six—Giovanni Donà, Orsato Giustiniani, Pietro Zen, Girolamo Molin, Andrea Loredan, and Antonio Zorzi— did *not* serve as Procurators! Of these six, three had no political ambitions: Andrea Loredan left a promising career to concentrate on his art collection; Orsato Giustiniani devoted himself to writing; Girolamo Molin was interested only in being a poet. The other three, Giovanni Donà, Pietro Zen, and Antonio Zorzi, led distinguished careers but never attained the highest offices.[54]

The results of this survey are unambiguous: in the pyramidal structure of the Venetian government, Vittoria portrayed those at the very top. His sitters were drawn almost exclusively from members of the 'inner ring' of thirty to forty patricians who controlled and dominated the Venetian government year after year.[55] Because of the pressures of the War of the League of

[51] Machiavelli (1950) book I, ch. 55, p. 257. See Cozzi (1986), pp. 146–7, for an example of actual feudal control exercised by the Vendramin family *outside* Venice in the Friuli.

[52] On the Venetian move towards agriculture, see Beltrami (1955); Braudel (1958); Woolf (1968), pp. 172 ff.; Pullan (1973), pp. 379 ff.; Ventura (1968), pp. 674–722; Tucci (1973), pp. 346–78.

[53] Giulio Contarini, Francesco Duodo, Domenico Duodo, Girolamo Grimani, Marc'Antonio Grimani, Marino Grimani, Ottaviano Grimani, Priamo da Lezze, Niccolo da Ponte, Sebas-tiano Venier, Lorenzo Cappello, Tommaso Contarini, Vincenzo Morosini, Jacopo Soranzo, and Alvise Tiepolo.

[54] See cat. nos. 3, 23, and 49 for biographies of these men.

[55] Both Lowry (1971), pp. 275–310, and Grendler (1979), employ the term 'inner ring', which is often defined as 32 men: the Doge, his 6 councillors, the Council of 10, and the Council's *Zonta* of 15. It should be noted that Procurators could and regularly did hold several of these posts, which are often designated as the 'great offices'.

Cambrai at the beginning of the sixteenth century, the holding of the great offices devolved more and more upon a few wealthy families with the result that oligarchical power was strengthened.[56] A related development was the concentration of power into a very few offices.[57]

These phenomena aroused much hostility from the excluded poorer nobles, which culminated in the famous 'Reform' of 1582, when the *Zonta* of the Council of Ten was abolished by the Great Council. The *Zonta* was an extra-constitutional group of fifteen men who aided and advised the Ten. It was rightly seen as a tool of the oligarchy because of its extra-constitutional status and because its members were nominated by the Ten, albeit subject to the approval of the Great Council. While the abolishment of the *Zonta* has sometimes been called a victory for an anti-oligarchical faction of the patriciate, Lowry has demonstrated how, during and even after the 'Reform', the same men or members of their families remained in control, proving what he has termed 'the full resilience of the oligarchy'.[58]

The *all'antica* portrait bust was adopted by a group of rich, politically powerful men from among this ruling oligarchy. It was Giovanni Donà (Pl. 123, cat. no. 3), tellingly, who made the memorable phrase, 'Summus tot reges—we are so many kings.'[59] While many of Vittoria's patrons shared the humanist interests of the antiquarians and collectors who sponsored the revival of the classicizing bust in Padua, their political prestige gave its form a different meaning. *Romanitas* can communicate many kinds of messages: while *all'antica* forms imply reverence for antiquity, they also, as the Procurators demonstrated at the Libreria, carry with them the aura of imperial power. A sculptured portrait bust, after all, being made of imperishable materials, is meant to be a lasting monument. Would not the use of a 'Roman' format imply that the object is to last as long, and be as powerful, as the Eternal City itself?

The *all'antica* bust in Vittoria's hands became a part of the self-representation of the Venetian patriciate. None the less, because the artist gained a near-monopolistic control over this art form's production, a paradoxical yet very Venetian situation arose. On the one hand, the busts are images of power that depict, furrow by furrow and crow's-foot by crow's-foot, the individual, élite rulers of the city. On the other hand, however, the sitters take on a group identity due to Vittoria's style, to the uniform format of the objects, and, very frequently, to the attire of the sitters. One could easily describe most of Vittoria's sitters as wearing uniforms, which by nature emphasize societal values of concord, harmony, and communality. If the sitters had wanted to be attired differently from their fellows, they surely could have been. But they chose not to, as if automatically observing a sumptuary law. When criticized for its seeming monotony by Brinckmann or Pope-Hennessy, from a connoisseur's point of view, Vittoria's production may well be being faulted for a deliberate, intended effect. Politics and aesthetics collide.

However much the stylistic unity of Vittoria's portraits may seem to acknowledge the Venetian myth of communality, the rise and popularity of the *all'antica* bust forms just one of numerous visual challenges to the Myth of Venice during the cinquecento. Sinding-Larsen referred years ago to what he called the 'emancipation' of Venetian portraiture during the late

[56] See Gilbert (1973), esp. p. 290: '. . . in these critical years [of the war] the final step was made in establishing as rulers of Venice a small, closely united group, which kept in its hands all decisions about the life of the inhabitants and the policy of the republic.' See also Cozzi (1973), esp. pp. 305–9 on the growing power of the Council of 10 during the 1500s, and Muir (1981), pp. 34–44.

[57] Grendler (1979), p. 287.

[58] Lowry (1971), esp. pp. 298–306. [59] See ibid., p. 287.

fifteenth and sixteenth centuries, an emancipation that derived from a weakening 'of the Venetians' traditional censorious attitude towards the glorification of the individual'.[60] Such indeed was the case, and this new, or more forcefully executed, desire for individual glory has already been encountered in the sphere of tomb design, namely, in how, during the 1500s, an increasing number of prominent and costly Venetian tombs were erected to men of non-dogal status.[61]

The portrait busts indeed participate in a larger phenomenon in Venetian cinquecento art that still remains largely unexplored: all sorts of new, related developments in personal imagery were occurring during the middle years of the century. Another such phenomenon was the portrayal of Venetian magistrates alongside Jesus Christ and the Virgin Mary in pictures designated for government offices.[62] Yet another is the florescence of the façade monument beginning around 1550.[63] Among all these events, the revolution in tomb decoration brought about by Vittoria and his school emerges as one of the most radical challenges to the myth of Venetian communality. The new form of the portrait bust literally changed the physical face of Venice: that, by the end of the sixteenth century and by means of the portrait bust, the interiors of Venetian churches were full of vivid images of patricians, often posed as if turning to interact with the spectator, presents a new kind of individualism, even egotism, in Venetian portraiture. This could happen only because these patricians (and others) were presented not as recumbent corpses, but as living, moving, sentient people.[64]

Although the bulk of Vittoria's work accords with the Renaissance conception of the sculptured portrait as something by nature public and official, one group of busts takes a distinctly different tack. I would characterize at least five of the busts as melancholic depictions of their subjects: those of Giulio Contarini, Paolo Costabile, Priamo da Lezze, Pietro Zen, and the anonymous man depicted in the terracotta at the Louvre (Pls. 70, 88, 63, 108, 114). It is quite striking that this group oversteps distinctions of medium (three of the busts are marble while two are terracotta), distinctions of function (three were public pieces and the other two private), distinctions of patronage (Giulio Contarini had close personal relations with the artist while Paolo Costabile had none whatsoever), even chronological distinctions (the *da Lezze* is an early work while the *Zen* is quite late). Among all these distinctions, one feature, not surprisingly, remains constant: all these busts are autograph.

The depiction of sadness or interiority in sculpture has been little studied. The permanent, 'everlasting' aspect of sculpture in general endows sculptured portraiture with a monumental and public nature that is automatically inhospitable to explorations of unguarded, private moments. Such unusual depictions by Vittoria of interior psychological states demonstrate the artist's range and reveal how strongly he had internalized the achievements of Venetian painted portraiture. They seem to me the first sculptures where one sees an approach similar to that pioneered by Giorgione, such as in the *Broccardo* now in Budapest.[65]

[60] Sinding-Larsen (1962), p. 152 and pp. 161–9.

[61] See above, Ch. 4.

[62] Like the classicizing portrait bust, it too comes into its own in the middle of the century; see Kleinschmidt (1977), pp. 104–18, and Wolters (1987), pp. 136–50.

[63] This subject still lacks a thorough investigation; see, however, Frank (1985–6), pp. 109–26, Wolters (1987), pp. 75–6, and Simane (1993), ch. 8, *passim*.

[64] Here again, my findings directly contradict those of Hiesinger (1976).

[65] Alessandro Ballarin has treated Giorgione's portraiture extensively; see most recently Ballarin (1993).

Because Vittoria had a long career and worked in many media and genres, scholarly studies—like this one—have tended to focus on one aspect of his *œuvre* instead of examining it as a whole. I maintain, however, that the history and interpretation of the portrait busts cast light on the artist's entire career.

Indeed, there are those who see no connection between the various aspects of Vittoria's art. One critical stance posits a dichotomy between the busts and the other works: that while Vittoria was a 'mannerist' in his figural sculptures, he was a 'realist' in his portraits. Planiscig is the foremost exponent of this view, writing that '. . . [Vittoria's] terracotta and marble portraits do not conform to the mannerist traits of his figural and decorative work. While an abstract formalism dominates the latter, the portraits overall exhibit an intensely executed naturalism.'[66]

Calling the busts realistic or naturalistic is very problematic, for at least two issues complicate such a stance. By far the majority of Vittoria's sitters were elderly men: many were portrayed aged 70 or over (Doge da Ponte was in his nineties). While these men are all recognizably old and their faces carry in abundance the furrows of time, not one appears feeble or weak. How could they, since most of them were members of the very highest reaches of Venetian society? It must be remembered that, as in veristic Roman portraiture, the frank depiction of scarred old age was quite complimentary in a gerontocracy such as Venice, for it denoted wisdom, experience, and prudence. Although Vittoria, as a portraitist, seems to have delighted in the depiction of wrinkles, furrows, and crow's-feet, such features had, none the less, an honorific meaning in Venetian society.

A similar consideration presents itself in terms of the typology employed by Vittoria. I have drawn much attention to the significance of the baselines of the busts as criteria for establishing their date. Of course, this solution—using a classicizing bust with a straight baseline—creates not only formal but psychological significance as well, for it tendentiously compliments the personality of the sitter by increasing the massiveness of his torso to endow him with a more imposing physical presence.

I would argue that not only is the naturalist/mannerist dichotomy a false one, but that the portraits and Vittoria's other work share deep similarities and affinities in terms of their goals and aims. The suggestion of an imposing, even monumental, scale was one of Vittoria's two main techniques throughout his career for characterizing his sitters. The other was the suggestion of movement. As I have already argued, it was the artist's lifelong obsession with *contrapposto* and the *figura serpentinata* that forms a common link between the portraits and his other sculpture. His foremost goal as a portraitist—to make the sitter a living, moving actor within his spatial setting—parallels his efforts in figural sculpture from the same time, such as in the altar of the Merciai in S. Giuliano (Pl. 122), from the early 1580s.[67] The statues of St Daniel and St Catherine have here been freed from any architectural restraint, with the result that their poses endow them with great spatial and psychological participation in the whole ensemble: they twist inwards and look upwards in harmony with the poses of the apostles in Palma Giovane's altarpiece above them of the *Assumption of the Virgin*. Sculpture and painting form an overall

[66] Planiscig (1921), p. 458; his book is admittedly dated. Leithe-Jasper (1963) also argues for a strong dichotomy in Vittoria's work (see esp. pp. 42–3) as does Cessi (1961b) and (1962), *passim*.

[67] A similar situation obtains at the altar of the Lunganegheri in S. Salvatore.

ensemble, bringing to fulfilment the experiments begun by Vittoria at the Zane altar. Is this not similar to Marc'Antonio Grimani's vigorous turn towards the nave of S. Sebastiano that unites the Grimani chapel with the main space of the church (Pl. 54)? Consideration of Vittoria from this point of view not only shows the bonds or threads between his various work, but also reveals him as perhaps the strongest bridge in Italian sculpture between the Renaissance and baroque periods.

PART II

CATALOGUE

INTRODUCTION

The following catalogue is divided into five sections:

1. Autograph busts (cat. nos. 1–28): works that I accept as being from Vittoria's hand.

2. Workshop (cat. nos. 29–54): busts closely connected with the master, definitely or seemingly made during his lifetime, but not from his own hand. Probably some of these pieces would be better termed 'circle of Vittoria' or 'follower of Vittoria', but present knowledge of the workshop is so sketchy that it would be presumptuous to do so.

3. Lost busts (cat. nos. 55–8).

4. After Vittoria (cat. nos. 59–68): casts or replicas of known works by the master; some of these could well be by the workshop.

5. Not by Vittoria (cat. nos. 69–81): works that have been ascribed to Vittoria, but which cannot be connected with him or his workshop.

Within each section, the works are ordered alphabetically by name of the sitter. 'Left' and 'right' in reference to signatures refer to proper left and proper right. My attributions and datings will doubtless be refined by future research. I hope that this catalogue will make the work of future students easier and more exact.

AUTOGRAPH WORKS

1. GIULIO CONTARINI (Pls. 70, 72)

Marble
Dimensions unknown; over life-size
Unsigned[1]
Bust and socle are separate
Inscribed (on socle): IUL. CONT. DIVI. MR. PROC.
S. Maria del Giglio, Venice, set in a monument on the left wall of the apse

Vittoria's will of 29 July 1576 gives the earliest notice of the monument to Giulio Contarini. After asking that his tomb be placed in S. Giovanni in Bragora the artist states:

E desidero mi sia finita quela sepolturina di quele dua donine che io feci per mio conto, le qual è in casa mia appresso la porta, la sua cima chome quela del clarissimo signor Giulio Contarini, over chome alcuni dissegni che si ritroverà ne la chasselete dil mio scritor. Sotto li piedi di le figure nel fondo si troverà un schizo di pena rotolato insieme l'altro che feci per il Contarini ne le chasselete picole dil scritor.[2]

As Gerola pointed out, these statements supply a *terminus ante quem* of 1576 for the monument.[3]

There is another significant mention of Contarini in the 1576 will. Vittoria requests at the beginning of the document that two men—Cesare Gigiolo and Francesco Sonicha—be his executors. But he then adds that, should there be some difficulty in this matter,

. . . son certissimo per le cortesie infinitissime che io ho ricevuto da l'illustrissimo signor ben Giulio dasseno e Contarini procurator meritamente, che'l non mancherà del bon et ordinario consiglio che sempre gli a dato al suo schiavo Alessandro Vittoria, chome apertamente si sa da tuto il mondo.[4]

However infinite the courtesies the sculptor received from Contarini, only one definite instance is recorded: on 28 February 1569, Ottaviano Contarini—Giulio's son—bought for Vittoria, at the price of 1,010 ducats, the house in the calle della Pietà where Vittoria lived from then until his death.[5] Why the Contarini did this for Vittoria is not known, but such an act must imply a rather long-standing relationship.

In the archives in Venice there survives one will by Contarini from 1575 as well as codicils from 1577, 1578, 1579, and 1580.[6] None of these documents contains a reference to either the bust or the monument (the inscription on the tomb, however, did: see n. 13). Likewise, neither Celio Magno nor G. M. Verdizotti, in their accounts of how Contarini set up in S. Maria del Giglio a monument and bust to his friend Girolamo Molin, mentions a monument or bust to Giulio Contarini in that church.[7]

Thus, on a documentary basis, only Vittoria's will of 29 July 1576 indicates that the monument to Contarini precedes that date. Stylistically, the bust seems to date from c.1570–2, just after the Contarini bought Vittoria's house for him; see the discussion of this issue in Chapter 6. Perhaps the monument was made as a form of thanks or payment on Vittoria's part.[8] In another tribute to his patron and friend, Vittoria modelled the features of his *St Jerome* in the Frari on Contarini (Pl. 71).[9]

Giulio Contarini—the son of Giorgio (Zorzi), knight—was born c.1500.[10] In 1524 he married Andrianna Minio.[11] After having served as a *Camerlengo di Commun*, he was elected a Procurator *de Ultra* on 21 June 1537 for the price of 14,000 ducats.[12] He resided in the Contarini palace near S. Maria del Giglio and died there on 7 April 1580.[13] He was buried in his family vault in the centre of the high altar chapel of S. Maria del Giglio, of which the Contarini held the patronage.[14]

For Contarini's activities as a politician and as an art patron, see Chapter 6. His patronage concentrated on his parish church of S. Maria del Giglio, which, according to Francesco Sansovino, was restored 'first' by his brother Giustiniano and then by him.[15] Giustiniano Contarini died in 1567, so presumably the restoration was continued by Giulio during the late 1560s and into the 1570s. Contarini had his friend, the poet Girolamo Molin, buried in S. Maria del Giglio, commissioned the bust of Molin from Vittoria, composed the epitaph above the bust, and arranged for a volume of Molin's poetry to be published.[16] Towards the end of his life Contarini, like Niccolo Massa (cat. no. 18), went blind.[17]

[1] The only other autograph marble busts that are unsigned are those of Giovanni Battista Ferretti (cat. no. 6) and Priamo da Lezze (cat. no. 15). It should be noted that each of the caryatids that frame Contarini's bust are prominently signed—perhaps this is why the bust was left unsigned.

[2] ASV, Notarili e Testamenti, Vittore Maffei, b. 657, no. 13; this passage was first published by Gerola, see n. 3.

[3] Gerola (1924–5), p. 350, n. 1. A *terminus post quem* cannot be derived from Vittoria's previous will of 7 Nov. 1570 because in that will Vittoria specifies that he wants to be buried in the floor of S. Sepulcro: a mural monument is not in question here.

[4] ASV, Vittore Maffei, b. 657; Gerola (1924–5), pp. 349–50. I do not know who Cesare Gigiolo and Francesco Sonicha were.

[5] Predelli (1908), pp. 25, 43–6, and 252–6, publishes all the relevant documents. See also Predelli's n. 17 on Vittoria and Contarini.

[6] These documents are all found in ASV, Notarili e Testamenti, Cesare Zilliol, b. 1264, fasc. 11; fos. 28ʳ–34ʳ contain the will of 28 Nov. 1575; fo. 34ʳ, the codicil of 3 July 1577; fos. 34ᵛ–35ᵛ, that of 21 Nov. 1578; fo. 35ᵛ, that of 22 Oct. 1579; and fos. 36ʳ–36ᵛ, that of 3 Apr. 1580.

[7] Magno (1573) and Verdizotti (1573); both of these are prefixed to the *Rime di M. Girolamo Molin* (Venice, 1573).

[8] No other sepulchral monument by Vittoria displays the high quality, even in the decorative detail, present in that of Giulio Contarini. Certainly this is a sign of the particular care given by the artist to this work. Cessi (1962), p. 6, is utterly mistaken in seeing the bust and monument as largely the product of Vittoria's workshop.

[9] See Ch. 6, above.

[10] I have found no birth date for Contarini. According to Magno (1573), by 1572 Contarini had been a senator for 46 years, i.e. since 1526. Normally, the youngest age at which one became a Venetian senator was 35, and if Contarini was 35 in 1526, he then was born in 1490 or 1491. But Contarini did become a Procurator at an extraordinarily young age, and probably he achieved senatorial rank while quite young as well.

[11] Marco Barbaro, *Genealogie Venete* (Bibl. Civ. Correr, Cod. Cicogna 2499), ii, fo. 364ᵛ.

[12] Ibid., fo. 364ᵛ; fo. 273ᵛ gives the price as 13,000 ducats.

[13] Contarini's correct death date is given in a note on the first page of his will, fo. 28ʳ: '1580. 7 Aprilis obiit'. All other sources give incorrect dates, ranging from 1575 to 1593. Contarini's tombstone, which no longer survives in S. Maria del Giglio, read: 'D.O.M. | Iulii Contareni | D. Marci proc. | his cineres latent. |

digna vero tanto huius templi | benefactore memoria | maiori in sacello sculpta patet | obiit VII. idus aprilis | anno MDXXC.'This translates as: 'To the best, greatest God; here lie the ashes of Giulio Contarini, Procurator of St Mark's; the worthy record [memorial] to such a true benefactor of this church is clearly visible, being sculpted in the high chapel; he died on the seventh day before the ides [13] of April 1580.' The inscription shows that, although Contarini never mentioned his monument in his will, he did draw attention to it in his epitaph. For the inscription, see E. A. Cicogna, *Inscrizioni nella chiesa di S. Maria del Giglio d.a. S. M. Zobenigo* (Bibl. Civ. Correr, Cod. Cicogna 2012, no. 7), p. 4[v], no. 58.

[14] Cicogna, ibid., says that Contarini's tombstone was 'in mezzo' of the high chapel. Lorenzetti (1938), p. 130, states that the Contarini family had the *ius patronato* of that chapel. In his will, Contarini refers to the chapel as 'nostra'.

[15] Sansovino (1581), p. 44*b*. In the secondary literature, going back at least to Tassini (1887), p. 391, the Contarini have also been given credit for the restoration of S. Maria del Giglio carried out in the late 17th cent. Nevertheless, Martinelli (1705), p. 31, lists the families involved in the 17th-cent. restoration and the Contarini do not appear among them.

[16] The story of Contarini's deeds for his friend is found in Magno (1573) and Verdizotti (1573); see n. 7 above, and also cat. no. 40, on Molin.

[17] Contarini himself supplies this information in the codicil to his will from 21 Nov. 1578: 'Sono alcuni anni che (havendo così parso a Dio per li peccati mei) ho perso in tutto quasi la vista.'

2. PAOLO COSTABILE (Pl. 88)

Marble
Height (without base): 70 cm.; breadth (at shoulders): 63 cm.
Signed (on rim of right shoulder): ALEX. VICTO. F.
Bust and socle are separate
Museo Nazionale del Bargello, Florence
Provenance: S. Domenico di Castello, Venice, until 1807; acquired in 1808 by Count Giovanni Costabili, Ferrara, and in the collection of the Costabili family until 1911; in the Museo Nazionale del Bargello in Florence since 1911[1]

The original location of this bust has been repeatedly misidentified, with Giovanelli, Serra, and Cessi all claiming that it was in S. Sebastiano.[2] Yet Stringa and Martinioni (who both ascribe the bust to Vittoria) as well as Cicogna confirm its original location as the cloister of S. Domenico di Castello.[3] Cicogna provides the additional information that, although the bust and inscription to Costabile were in the cloister, his remains were buried inside the church.[4] The inscription perished when S. Domenico was torn down in 1807.[5]

The bust fortunately is documented. Cicogna records that he saw a receipt from Vittoria in the archives of the church acknowledging a payment of 56 gold scudi for the bust on 25 May 1583.[6]

Paolo Costabile, General of the Dominican Order, arrived in Venice on 3 August 1582 as part of a visit to the Dominican province in the Veneto. He died in the lagoon city, suddenly, on 17 September 1582.[7] The bust must be posthumous and, considering the brevity of Costabile's stay in Venice, it would seem most unlikely that Vittoria ever saw him. The sculptor must therefore have worked from an image of the deceased, probably from a death-mask.

Hence, the Dominican monks of Venice, not Costabile or his family, were the patrons of the portrait. Vittoria's bust of Niccolo Massa was already in the cloister of S. Domenico di Castello when the commission was made for Costabile's portrait.[8] No evidence survives as to what kind of monument the bust was set in originally. In dating from the first half of 1583, the bust of Costabile comes right before that of Doge da Ponte.[9]

Cicogna provides a full life of Costabile.[10] Born in 1520, he joined the Dominican order in 1534. During the reign of Pius V, Costabile became the Inquisitor-General in Ferrara and then in Milan. He was elected General of the Dominican Order in 1580.

[1] For notice of the bust in S. Domenico, see n. 3 below. Cicogna (1824–53), iii, p. 488, provides the information that Count Costabili managed to acquire the bust after S. Domenico was suppressed. In 1911, the Bargello bought the bust from the Costabili family for 9,000 lire; its inventory number is 428 (communication of 26 June 1985 from the Soprintendenza per i beni artistici e storici di Firenze).

[2] Temanza (1778) does not mention this bust. In Temanza (1827), Moschini lists the bust as no. 9 in n. 58 on p. 53; he gives no location. Giovanelli (1858), p. 88, dates the bust to 1583 and says it was in S. Sebastiano. Serra (1923), pp. 54–5, says the bust is probably to be identified with that of Paolo Costabili, 'registrato in S. Sebastiano di Venezia dal Giovanelli' and dates it to pre-1570. Planiscig (1921) does not note the portrait. Venturi (1937), p. 174, calls it a terracotta. Cessi (1962), p. 10, states that Giovanelli dates the bust correctly to 1583, that Serra dates it wrongly to pre-1570, and calls the bust 'già in S. Sebastiano a Venezia'. Zorzi (1972), ii, p. 329, writes that the bust was in the cloister of S. Domenico and gives the information from Cicogna (see n. 1) that it was acquired by the Costabile family in 1808; he does not say that the bust ended

up in the Bargello. The Bargello seems not to know whom the bust represents or its original location. In their communication to me, they identified the bust only as 'un frate della famiglia Costabili'.

[3] Sansovino (1604), p. 114a: 'Vi si giacciono anco quelli [ossa] di Paolo Costabile Ferrarese, Theologo, et Filosofo prestantissimo, sotto la cui statua posta ad alto et scolpita in marmo dal Vittoria'; Sansovino (1664), pp. 27–8: 'Nel Claustro, dove sta sepolto Paulo Costabile Ferrarese, si vede la statua scolpita dal Vittoria'; see also Cicogna (1824–53), i, pp. 121–2.

[4] Ibid., p. 122.

[5] Cicogna, ibid., gives the full inscription: 'PAULO COSTABILI PATRICIO FERRARIENSI PRAED. FAMIL. GENERALI MAGISTRI QUI PHILOSOPH. AC. THEOLOG. INTERP. HAERET. PRAVIT. INQUISIT. SACRI PALATII MAGIST. SUMMIS VIRTUTIBUS AD SUMMAN DIGNITAT. IN SUO ORD. SIBI ADITUM PATEFECIT. UNDE PROVINC. PERLUSTRAN. ET COMMUNI COMMOSO AD QUOD NATUS ERAT OMNI ANIMI AC COR-PORIS CONTENTIONE CONSULEN. ANN. AETA. SUAE LXIII. DECESSIT XV. KAL. OCTOB. MDLXXXII.'

[6] Ibid., p. 122.

[7] Ibid., p. 122.

[8] See cat. no. 18.

[9] See cat. no. 19.

[10] Cicogna (1824–53), i, pp. 122–3. See also now 'Costabili' (1984).

3. GIOVANNI DONÀ (Pl. 123)

Marble

Height (without socle): 78 cm.; breadth (at shoulders): 75 cm.; baseline: 47.5 cm.

Signed (on rim of right arm): < ALEXANDER < VICTO-RIA < F <

Bust and socle are separate

Galleria Giorgio Franchetti alla Cà d'Oro, Venice

Provenance: originally on the south side of SS Giovanni e Paolo over the door leading to the campo; removed from there c.1830 [?] and transferred to the Museo Archeologico; c.1926 transferred to the Cà d'Oro[1]

Condition: the bust is worn and abraded from having been exposed outside. It is now without its socle, which remains over the south door of SS Giovanni e Paolo, surmounted by a nineteenth-century copy of the bust. The socle is inscribed: BERNARDI DONATI FILIUS; the lintel of the door reads: NUNQUAM MIHI SED SEMPER PATRIAE. A large crack runs across Donà's forehead

Nothing is known about the commissioning of this portrait. In the Archivio di Stato in Venice, there survive for Donà a will from February 1585 (*m.v.*) and codicils from 9 February 1587 (*m.v.*) and 17 November 1588.[2] In none of these documents does Donà mention a bust of himself or even state

where he wishes to be buried. Because the statue was made in two pieces, with the socle separate from the bust, the likelihood is strong that it was intended as a public monument, probably for the site it originally occupied over the south entrance to SS Giovanni e Paolo.[3] The memorial probably was either commissioned after the codicil from 1588 was written, or was planned and executed posthumously. Stylistically, a dating from the late 1580s or early 1590s fits since the huge volume of the torso corresponds closely to the busts of Paolo Costabile dating from 1583 and of Doge da Ponte dating from 1584–5.[4]

Although this statue is, to the best of my knowledge, the first time a portrait bust was ever placed on the exterior of a Venetian church, the monument has gone completely unstudied in the literature. Strangely, neither Stringa nor Martinioni notes it. Martinelli in 1704 gives the earliest securely dated notice of it.[5] Grevembroch, however, considered the monument worthy to be illustrated in his compendium published in the mid-eighteenth century (Pl. 124).[6] In Moschini's guide to Venice of 1815, he remarks on the 'bel busto' of Bernardo Donà's son over the side portal of SS Giovanni e Paolo but, like Martinelli and Grevembroch, gives no attribution.[7] Nor does Moschini note the bust in his 1827 edition of Temanza's *Life* of Vittoria. The bust was apparently still *in situ* in 1822 when Soravia mentions it.[8] But at some later date it was taken down, substituted by the copy, and placed in the Museo Archeologico where the sitter's identity was lost. The bust of Donà must be that listed in the 1872 catalogue of the museum as: 'n. 9: Busto di un patrizio veneziano, scolpito da Alessandro Vittoria che v'in-cise il suo nome'.[9] The bust remained unidentified until 1929 when Andrea Moschetti, in his catalogue of the Cà d'Oro, correctly named the sitter as Donà and recorded the bust's original location.[10] Neither Planiscig nor Serra notes this bust.[11] Venturi illustrates the *Donà*, calling it a 'procuratore veneziano' and implies a dating from the 1570s.[12] Cessi repeats the information given by Moschetti (without citing him) and dates the bust to the early

1590s.[13] Although the Touring Club Italiano does not point out the Donà monument in its guide to Venice, Lorenzetti does.[14] Zava Bocazzi, in her monograph on SS Giovanni e Paolo, makes no reference at all to the monument, nor does Zorzi.[15]

As the first portrait bust placed on the exterior of a church, the *Donà* takes its place in a line of commemorative statues of a particularly Venetian genre. Preceded by the standing statue of Vincenzo Cappello on the façade of S. Maria Formosa (Pl. 47) and the seated figure of Tommaso Rangone on the façade of S. Giuliano (Pl. 44), the bust of Donà over the side door of SS Giovanni e Paolo is followed by those of Doges Tribuno Memmo and Sebastiano Ziani on the façade of S. Giorgio Maggiore (Pl. 1) and those of three members of the Cappello family over the campo façade of S. Maria Formosa.[16] The two façades of the latter church were financed by the Cappello family as was that of S. Giuliano by Rangone; Doges Memmo and Ziani figured prominently in the early history of S. Giorgio. Why Donà should have been so singularly honoured at SS Giovanni e Paolo is not known. Indeed, it is not even known where he was buried—the principal family *archa* seems to have been in S. Maria Formosa.[17]

Hence, more questions than answers remain concerning the bust of Giovanni Donà.[18] Why it was set up over the side portal of SS Giovanni e Paolo and who put it there are matters of speculation. Donà had a reputation as a composer of funerary inscriptions; the 'mihi' of his own inscription would imply that he composed it.[19] The worn condition of the bust makes judgements of quality difficult, but the overall quality appears quite high. I would date the bust to the early 1590s, executed after the sitter's death. It is the only bust that depicts the sitter with his mouth open; presumably this refers to Donà's fame as an orator.

Giovanni Donà (Zuanne Donato), son of Bernardo, was born on 23 December 1509 and died on 19 January 1592.[20] Because of his eloquence—and the length of his speeches—he was known as 'delle Renghe'.[21] He was a *Savio del Consiglio* and a member of the Council of Ten, and was once balloted for Doge.[22] Renowned for writing epigrams and inscriptions with 'elegantia et giudittio maraviglioso', he composed the inscription for Vittoria's tomb.[23] In the sculptor's will of 6 May 1584, he asks that his executors bury him in whatever convent-church they deem fit 'in quel modo che io ho preparando, con le figure, et inscrizione che mi devone [*sic*] essere date per il clarissimo mio signor Zuan Donado'.[24] Hence, Vittoria and Donà were seemingly personal friends. Although often called a Procurator, Donà never achieved that office. He is depicted in Tintoretto's *Madonna and Child with Four Senators*, now in the Accademia, dating from 1553.[25]

[1] See text below.

[2] The will and both codicils are in ASV, Notarili e Testamenti, M. A. Cavanis, b. 194, no. 542. The index of wills in the Archive lists the documents from 1585 and 1587 but not the one from 1588. Instead, it lists an item from 11 Dec. 1590. If a further codicil from 1590 does indeed exist, it is not in b. 194, no. 542. I was unable to find a document for Donà from 1590 in Cavanis's notarial papers.

[3] See the discussion concerning busts made in one or two pieces in cat. no. 4, on the marble bust of Francesco Duodo.

[4] See cat. nos. 2 and 19.

[5] Martinelli (1705), pp. 161–2.

[6] Jan Grevembroch, *Monumenta veneta ex antiquis rederibus Templorum, aliarumq. Aedium Vetustate collapsarum. Collecta, Studio, et Cura Petri Gradonici* (Bibl. Civ. Correr, MSS Gradenigo 228, 1754–9), iii, p. 89.

[7] Moschini (1815), i, p. 138.

[8] Soravia (1822), p. 43.

[9] Valentinelli (1872), p. 17; Valentinelli also states that the Accademia made a gesso of the bust in 1850, so it must have been removed from SS Giovanni e Paolo prior to that year.

[10] Moschetti (1929), p. 77; I assume that Moschetti simply noticed that the features on the bust corresponded to those of the copy on SS Giovanni e Paolo.

[11] Serra (1923), p. 93, writing before the opening of the Cà d'Oro, lists only 3 busts by Vittoria in the Museo Archeologico: those of Benedetto Manzini, Marino Grimani, and Alessandro Contarini. This last bust is a misidentification of Girolamo Contarini, still today in the Ducal Palace (see cat. no. 31). The bust of Donà should still have been in the Museo Archeologico at this time (see Lorenzetti in n. 14, below); why Serra did not record 4 busts is puzzling.

[12] Venturi (1937), pp. 158 and 160.

[13] Cessi (1962), p. 20.

[14] Lorenzetti (1963), p. 339: 'nel lunettone [of the side portal of SS Giovanni e Paolo] copia moderna del Ritratto di Giov. Donà . . . il cui originale trovasi a Palazzo Ducale'. One should remember that the original edn. of Lorenzetti dates from 1926, therefore he is noting the location of the *Donà* in the

Archaeological Museum which at that time was still in the Ducal Palace (see above, n. 11).

[15] Zava Bocazzi (1965) and Zorzi (1972).

[16] Concerning the monuments to Vincenzo Cappello and Tommaso Rangone, see Ch. 4, above, and also Wolters (1987), pp. 75–6; for the busts of the other Cappello at S. Maria Formosa, see Timofiewitsch (1972), cat. no. 25, p. 281; concerning the involvement of Doges Memmo and Ziani in the history of S. Giorgio, see Cicogna (1824–53), iv, pp. 402–5 and *passim*.

[17] Lorenzetti (1963), p. 381.

[18] Probably the only source that could provide an answer would be the archives of SS Giovanni e Paolo.

[19] See biography of Donà at the end of this entry below.

[20] See Gullino (1991), pp. 732–3, who gives Donà's death date as 23 Jan. 1593. On the back of Donà's will dating from 10 Feb. 1585 (*m.v.*) is a notarial addition, however, recording that he died on 19 Jan. 1591 (*m.v.*) and that the will and codicils were published the next day. See above, n. 2, for the archival references. See also Grendler (1979), pp. 319–21.

[21] Sansovino (1587a), p. 193.

[22] See Marco Barbaro, *Genealogie Venete* (Bibl. Civ. Correr, Cod. Cicogna 2499), iii, p. 178, no. 5.

[23] Sansovino (1664), p. 614.

[24] This passage is published by Gerola (1924–5), p. 353. Donà's epigraph for Vittoria, however—'Qui vivens vivos duxit a marmore vultus'—is not very original. The same sentiment was used by Agostino Beatiani in reference to Sansovino in a poem written in 1548 in honour of the funeral of Pietro Bembo: 'Sansovine, . . . Qui ducis vivos de marmore vultus'; see Lorenzetti (1927), p. 9.

[25] See Ludwig (1902), p. 45.

4. FRANCESCO DUODO (Pl. 101)

Marble

Height: 84 cm.; breadth: 61 cm.; socle: 10.5 cm.; baseline: 48 cm.

Signed (on rim of right arm reading from top down): F ALEXANDER VICTORIA

Bust and socle are in one piece

Galleria Giorgio Franchetti alla Cà d'Oro, Venice

Provenance: palazzo Duodo in Venice; palazzo Duodo at Monselice from at least *c*.1663 until 1899; Accademia delle Belle Arti, Venice, until 1926; on loan from the Accademia to the Cà d'Oro since 1926[1]

Francesco Duodo, who died on 12 November 1592, mentions this bust in his will:

Item voglio ch'el mio retratto de marmoro che è in casa de mano de ms. Alessandro Vittoria, sculptor optimo, sia posto in chiesa de Maria Zobenigo appresso il mio altar dalla parte verso il rio con quelli adornamenti et epitaffio che parerà alli mei comissarii, et heredi, et questa sia in memoria delle mie fatiche fatte ad honor

della maestà divina, et utile della nostra patria, et che sei delle mie bandiere quadre dorate siano messe in detta chiesa una per volta, et il stendardo quadro sia attacato pendente nel mezo di detta Chiesa . . .[2]

Unfortunately, the will is not dated, but it must have been written after 1587 because Duodo calls himself a Procurator, an office to which he was elected in that year. Hence, all that can be determined on documentary grounds is that the bust predates 1592, was made in the sitter's lifetime, and was commissioned as a private image since it had been kept 'in casa'.

Although Puppi and Olivato state that it is not known whether Francesco's wishes in his will were carried out or not, this is in fact known from information supplied by Stringa. In his additions to Sansovino's account of S. Maria del Giglio, Stringa writes:

Vi pendono da ambe le parti per ogni colonna alquante bandiere di seta cremesina, & un bandierone dal soffitto, che furono di Francesco Duodo Procurat. qual si trovò Capitano delle Galere grosse nel giorno della felicissima Vittoria. Egli giace insieme con un'altro suo fratello, che fu fatto dopo di lui Procurator in un sepolcro vicino al suo Altar di S. Francesco.[3]

Stringa thus records that Duodo's request to have his flags hung up in S. Maria del Giglio was indeed carried out, although his wish to be buried in S. Angelo was not.[4] Significantly, Stringa does not mention a bust of Duodo as being in S. Maria del Giglio. Since in 1604—twelve years after Duodo's death—the flags had been set up but the bust had not, we can conclude that the bust was never placed in the church.[5] When Francesco states in his will that he wants his bust placed 'apresso il mio altar dalla parte verso il rio', he must mean the third altar on the left side of the church, the side toward the Grand Canal. This altar holds an altarpiece by Domenico Tintoretto depicting Christ as Saviour, St Giustina, and St Francis of Paola.[6] The St Francis is a portrait of Francesco Duodo.[7] Stringa says that Francesco was buried 'vicino al suo Altare di S. Francesco'—this must be the altar where Duodo wanted his bust set up.[8]

The bust of Francesco, along with that of Domenico Duodo by Vittoria and a seventeenth-century bust of Pietro Duodo—one of Francesco's sons—was placed in a memorial at the Duodo palace in Monselice. The memorial was erected by Alvise Duodo, Pietro's nephew. This monument, consisting of three niches which hold the busts, still survives but now contains copies of the busts of Francesco and Domenico (Pl. 125). The epigraphs under each niche bear datings of 1658 for Pietro, 1663 for Francesco, and 1670 for Domenico. Hence, Francesco's bust was in Monselice by c.1663; whether it had already been moved there before this date, or was until this time still in Venice, is not known.[9]

The passage in Duodo's will stating that his marble bust was 'in casa' during his lifetime provides the only clue to solving one of the problems concerning the marble busts: why some are in two pieces, with the socle separate from the torso, while others are in one piece like the terracottas. I would suggest that the bust of Duodo indicates that marbles in one piece were intended for private display, while those in two pieces were meant for public display. The bust of Manzini is in two pieces and was meant for his tomb; this is also the case with the marbles of Marc'Antonio Grimani, Giulio Contarini, Girolamo Grimani, Paolo Costabile, Giovanni Donà (which was a public image although not on a tomb), and Vincenzo Morosini.[10] It seems to me that this pattern can hardly be coincidence and that it enables the status of marble busts, for which there is no further information, to be determined. For example, the busts of Ottaviano Grimani and of Domenico Duodo are in two pieces and hence, although never set up in public, must have been commissioned for public display. Likewise, because the marbles of Orsato Giustiniani and Marino Grimani are in one piece, they must have been meant as private images; this would explain why their whereabouts prior to the twentieth century are unknown. Duodo's will demonstrates, however, that a private piece could be converted into a public image—he wanted the bust to be set up on his tomb but his wish was never carried out.

The quality of the *Duodo* is not very high. Despite the high praise given it by Serra and Cessi, Venturi's judgement of its 'inferior' quality is more accurate.[11] The mechanical quality of the beard and drapery suggests workshop participation or assistance in contrast to the autograph freshness of the terracotta (see cat. no. 5). With the knowledge that the bust must predate Duodo's death in 1592, a dating in the latter half of the 1580s seems correct, at the time when more and more of the portraits were worked on by the studio.[12] It follows the canonical solution Vittoria worked out during the 1570s of a straight baseline.

Cicogna provides a life of Duodo.[13] Born on 16 December 1518, he was the son of Pietro, the son of Francesco, and of Pisana Pisani. From 1559 to 1561 he was the *bailo* of Corfu and in 1566 became the *Luogotenente* of Udine. Elected commander of the fleet against the Turks in 1569, he was captain of the middle galleys at the battle of Lepanto, 7 October 1571, under the overall command of Sebastiano Venier; the devastating artillery fire carried out by these galleys played a large role in the Christian victory. On his return to Venice, he continued to receive high offices: ducal counsellor in 1573–4; captain in Padua, 1574–5; *sopravedditore alla Sanità* during the terrible plague of 1577; captain at Brescia in 1588. Despite the protests of the 'giovani' on account of his pro-papal sympathies, Duodo was elected a Procurator *de Ultra* on 28 March 1587, replacing Agostino Barbarigo.[14] He died on 16 November 1592. Sansovino notes that he and his brother Domenico (see cat. no. 35) owned a collection of curiosities and antiquities.[15] Duodo seems to have been principally interested in collecting ancient coins.[16]

[1] For the provenance of the bust, see the text of this entry and also Moschini-Marconi (1962), p. 296, with full bibliography. This bust and that of Domenico Duodo were given to the Accademia in 1896 by the Balbi-Valier family, who were the heirs of the Duodo; although the busts still technically belong to the Accademia, they have been in the Cà d'Oro since it opened in 1926.

² ASV, Notarili e Testamenti, Vincenzo Conti, b. 240, no. 155. The will was discovered and this passage published by Puppi and Olivato (1974), p. 70, n. 31. On the back of the will, it is stated by the notary that Francesco Duodo died on 12 Nov. 1592 and that the will was published on 16 Nov. 1592.

³ Sansovino (1604), p. 89b. The 'Vittoria' referred to is the battle of Lepanto, which took place on 7 Oct. 1571 and in which, as Stringa relates, Duodo commanded the galleys in the centre of the battle array.

⁴ Duodo states in his will: 'El mio corpo voglio sia sepulto nella nostra archa in Giesia de St. Anzolo . . .' This was indeed the church where the Duodo family *archa* was located; see Cicogna (1824–53), iii, p. 177. Domenico Duodo also asked to be buried in S. Angelo; his wishes were also not followed; see cat. no. 35.

⁵ Puppi and Olivato (1974), p. 70, n. 31, hypothesize that the bust was set up in S. Maria del Giglio but removed *c*.1660, when the church underwent extensive restoration and reconstruction, and then moved to Monselice.

⁶ For information on the painting see Palluchini and Rossi (1982), i, p. 254, #A113. The authors cite a record of an apostolic visit to the church on 1 June 1581 in which the altar is referred to as the 'Altare sancta Justina nob. Francisci Duodo', name Duodo as the patron of the picture, and date it to 1581–2.

⁷ See ibid. for the identification of St Francis as a portrait of Francesco Duodo.

⁸ Puppi and Olivato (1974), p. 70, n. 31, identify the altar as the 3rd on the right. This altar also belonged to the Duodo family but is dedicated to the Visitation.

⁹ The inscriptions were first published by Salomonio (1701), but Cicogna (1824–53), iii, p. 177, gives more accurate readings; all of the inscriptions state that Alvise Duodo set up the monument.

¹⁰ An exception to this rule is the bust of Niccolo Massa (see cat. no. 18)—but perhaps, like the *Duodo*, it was made as a private image and only later placed on his tomb.

¹¹ Venturi (1937), p. 176. See Serra (1923), p. 83, and Cessi (1961*b*), p. 34.

¹² Planiscig (1921), p. 519, and Venturi (1937), pp. 176–8, place the bust in the 1590s; Cessi (1961*b*), p. 34, writes that it must have been made soon after the battle of Lepanto (in 1571), which dating is too early.

¹³ Cicogna (1824–53), iii, pp. 177–8. See also now Gullino (1993), pp. 30–3.

¹⁴ See the discussion of *papalista* leanings among many of Vittoria's patrons in Ch. 6, above.

¹⁵ Sansovino (1581), p. 138*a*.

¹⁶ See Gullino (1993), pp. 31–3, and the references cited in his bibliography.

5. FRANCESCO DUODO (Pl. 102)

Terracotta
Height: 84 cm.; breadth: 66 cm.; socle: 12.5 cm.; baseline: 50 cm.
Signed (on rim of left arm): AL.VICT. F.
Bust and socle are in one piece
Museo Civico Correr, Venice
Provenance: in collection of Teodoro Correr in the early nineteenth century, from there passed into the Museo Correr

Condition: overall good condition; the bust is covered with black paint; the left ear is almost completely broken off

This bust entered the literature in 1834 when Cicogna noted it in the collection of Teodoro Correr.¹ It was thought to represent Sebastiano Venier (cat. no. 22), to whom Duodo bears little resemblance. Nevertheless, Giovanelli and Lazari also call it Venier.² Urbani de Gheltof first correctly identified the bust, on the basis of comparing it with the marble in Monselice (cat. no. 4); he also correctly noted that the bust is in fact signed: AL. VICT. F.³ Serra, who dates the marble version to Vittoria's 'maturità avanzata', calls this piece 'forse preparazione all'esemplare all'Accademia [the marble was at that time still in the Accademia, see cat. no. 4]: dignitoso, fiero, sereno, finemente trattato'.⁴ Planiscig seems to place this piece in the 1590s.⁵ Cessi, who dates the marble to shortly after the Battle of Lepanto in 1571, calls the terracotta 'la prima redazione'.⁶

The terracotta is slightly larger and broader than the marble version. More importantly, its facture is fresher, and although the two busts are very similar, the turn of Duodo's head and body seems stronger and more vivid in this piece than in the marble. I see no reason to doubt that this piece is autograph, but can give it no more precise date than the late 1570s or early 1580s: the form of the torso corresponds closely to other busts from these years, such as the *Sebastiano Venier* (cat. no. 22) and the *Orsato Giustiniani* (cat. no. 7). I agree that this piece served as the model for the marble version, which I feel may be attributed in large part to the workshop.

Cantalamessa, in a short article from 1902 about the Correr, noted this bust as being in the collection. Interestingly, he states that he has seen other terracottas of Francesco Duodo, which he says must have been old casts.⁷ This is probably what cat. no. 61 is. This is also how I would explain cat. nos. 59 and 60 of Giulio Contarini, cat. nos. 66 and 67 of Apollonio Massa, and cat. no. 62 of Palma Giovane.

For a biography of Duodo, see cat. no. 4.

[1] Cicogna (1824–53), iv, p. 692: 'No. 7. Busto in terra cotta rappresentante Sebastiano Venier generale d'armata poscia doge, colle sigle di dietro A.V.F. . . . sta nell'atrio del museo Correr sopra piedistallo.'

[2] Lazari (1859), p. 270, no. 1527; Giovanelli (1858), p. 119.

[3] Urbani de Gheltof (1877), pp. 5–7.

[4] Serra (1923), p. 83.

[5] Planiscig (1921), p. 519.

[6] Cessi (1961b), p. 34.

[7] Cantalamessa (1902), pp. 31–3.

6. GIOVANNI BATTISTA FERRETTI
(Pls. 48, 50)

Marble
Height: 87 cm.
Unsigned
Bust and socle are separate
Musée du Louvre, Paris
Provenance: on Ferretti's tomb in S. Stefano, Venice, until 1742, when it was replaced by a stone copy (the copy is still *in situ*[1]); Ferretti family until *c.*1850;[2] in collection of Alfred Chauchard by the late nineteenth century; in the Louvre since 1910[3]

This bust, the earliest documented by the artist, has been untraced since the middle of the nineteenth century and only recently identified.[4] Two entries concerning it appear in Vittoria's account book:

ali. 12. Novembrio 1557
R.vi io Alessandro dal R.mo Monsignor Barbaro per resto e saldo dil retrato di marmo dil Ecell.mo S.or giovanbattista fereto scudi trentacinque computando un pezo di marmo grando piedi. 5. e mezo. Vale in tuto Scudi n.o—35. come apar per un mio ricevere fato a Sua S.[5]

ali. 13. Novembrio 1557
L.3 s.18 A Antonio di m.o Picio per avere lavorato tre giornate sul piedino dil ritrato dil fereto va posto in s.to stefano . . . L.3 s.18.[6]

The bust rested on a pedestal (the 'piedino' mentioned above) over a sarcophagus, under which reads the inscription: IOAN. BAPT. FERRETTO | VICENT. IUR. UTR. DOCT. | PRAESTANTIS ET INTE | GER[IMMO] VIRO. IULIA UXOR | PIIS. ET SIBI POSUIT.[7]

When erected in 1557, the tomb was set in the wall of the left aisle between the second and third altars, those, respectively, of the Annunciation and St Nicholas of Tolentino (Pl. 49).[8] In 1704, it was moved further up the left aisle to between the fifth altar, that of the Scuola dei Calafati, and the door leading to the cloister.[9] In 1742, the tomb was moved for the second and last time into the left apsidal chapel, which is dedicated to St Thomas Villanova, and placed on the right wall of the chapel.[10] The tomb thus faces in the opposite direction from its original orientation: this is doubtless why the copy of the bust on the tomb reverses the pose of the original. It was in 1742 that the Ferretti family obtained the original bust and substituted the copy.

The tomb itself has been attributed to Michele Sanmicheli, but this attribution is not accepted by modern scholarship.[11] It is seemingly the first monument of its kind in Venice: a sarcophagus mounted by a portrait bust.[12]

For a biography of Ferretti, and a discussion of the importance of the design of his tomb, see Chapter 4. Ferretti died in Venice on 2 April 1556, a year and a half before his tomb was completed.[13]

[1] Niero (1978), p. 82, describes the copy as of 'pietra tenera'.

[2] Zanotto (1856), p. 184, states that the original is on the market, giving a *terminus ante quem* of 1856 for when the bust left the Ferretti family collection.

[3] See Vitry (1933), p. 85. On Chauchard and his collection, which he bequeathed to the Louvre in 1906, see *Donateurs* (1989), p. 171.

[4] See Martin (1994), pp. 48–54.

[5] Predelli (1908), p. 185.

[6] Ibid., p. 185. Although these entries appear on the same page of the account book, they are separated by 5 other entries: 4 of these latter concern payments Vittoria received from the Scuola di San Giovanni Evangelista for models of the 5 silver figures he made for them (27 June 1557, 21 Sept. 1557, 17 Oct. 1557, and 31 May 1558), and 1 entry from 30 Oct. 1557 for a payment to the same 'Antonio di m.o Picio' for 5 days work on the *Pietà* of the Venier monument in S. Salvatore.

[7] 'Julia, his most pious wife, set up [this monument] to Giovanni Battista Ferretti, most excellent doctor of both laws and a most virtuous man.'

[8] The correct information as to the varying locations of the Ferretti monument is to be found in Agostino Nicolai, *Memoria manoscritta sopra la chiesa e monastero di Santo Stefano in Venezia* (Bibl. Civ. Correr, Cod. Cicogna 1877), unpaginated, no. 37, under 'Lapidi Sepolchrali che sono nella Chiesa di S. Stefano di Venezia'.

The manuscript was written in the middle of the 18th cent. prior to 1762. For a full *apparatus criticus* on the Ferretti tomb, see Martin (1994).

[9] Nicolai, no. 37. At this original site was set up a now-lost inscription that read: 'MDLVII | Olim servabat Locus iste | Insigne sepulchrum | Ferretti; | Claustri sed modo | Porta tenet' ('1557. This site used to hold the famous tomb of Ferretti; now the door of the cloister will keep it').

[10] Ibid. In 1742, the monks of S. Stefano discovered that the organ, to the left of the high altar, was causing structural damage to the church. They petitioned the Senate for permission to move the organ to over the door in the right aisle that leads to the campo where Longhena's monument to Bartolomeo Alviano was originally located. The monks thus also petitioned the Senate for permission to move Alviano's monument to over the door on the left side of the church leading to the cloister, with the hope of moving the two 'piccioli Depositi di private Persone' set over that door. One of these 'depositi' was the Ferretti monument. On 29 July 1742, the Senate granted these petitions on the condition, 'com'è giusto', that the monks first receive the approval of the families to whom the private tombs belonged; see Nicolai, p. H. Presumably, the Ferretti family was able to acquire the marble bust and to substitute the stone copy as a condition for their approval of this undertaking. See Nicolai, no. 37, and Martin (1994) for the two inscriptions set up at this time.

[11] For a full account of the bibliography on Sanmicheli in respect to the Ferretti monument, see Nino Carboneri's annotated bibliography in *Sanmicheli* (1960), pp. 255–6. The most recent book on the architect—Puppi (1971) and its 2nd edn. (1986)—does not mention the Ferretti monument. Howard Burns, in a talk given at the Annual Meeting of the College Art Association in Feb. 1987, attributed the tomb to Palladio.

[12] See Ch. 4, above.

[13] The necrology is found in ASV, Provveditori e Sopravveditori alla Sanità, b. 797, unpaginated: 'Laus Deo, di 2 ap'l. M. Zuan batti fereto d. avvocato da Innota amalà adì 23 marzo, et p[er] ava[n]ti era amalà—s. moritio.' S. Maurizio is very near S. Stefano. There is a corte Ferreta near S. Fantino, which is also in the neighbourhood. Tassini (1887), p. 239, suggests that some 18th-cent. Ferrettis who lived in this courtyard were descended from Giovanni Battista Ferretti. Perhaps Ferretti resided in this same place.

7. ORSATO GIUSTINIANI (Pl. 87)

Marble

Height (with base): 72 cm.; breadth: 62 cm.

Signed (on rim of left arm): ALEXANDER.VICTOR.F.

Bust and socle are in one piece

Museo Civico, Padua

Provenance: Giusti Collection, Padua, until given to the Museo Civico in the 1930s[1]

This bust was disovered by Vittorio Zippel in 1923 in the palace of Count Vettor Giusti in Padua.[2] According to the Count, the bust had always

been in his family, coming down to him from the Venetian Counts Giustinian of which the Giusti are a Paduan branch. Giusti found nothing in his family archives concerning the bust.

Proceeding on the assumption that the person portrayed should be a member of the Giustiniani family, Zippel identified the bust as Orsato Giustiniani (1538–1603) on the basis of a print of a medal of an 'Orsatus Giustinianus' reproduced in Litta. According to Litta, the medal was in the collection of the Museo della Biblioteca di S. Marco; Zippel reports that he searched for the medal but could not find it.[3]

While, as Leithe-Jasper has remarked, the resemblance between the bust and medal is 'not entirely compelling', Vittoria did indeed execute a bust of Giustiniani.[4] The proof can be found in the *Rime di Celio Magno et Orsatto Giustiniani*, published in Venice in 1600. This collection contains a poem addressed to Giustiniani by Valerio Marcellino in which the latter speaks of the bust by Vittoria of Giustiniani:

> Quando del tuo valor l'alto concetto
> Al gran Vittoria pose in man lo stile,
> Scolpì non pur il volto tuo gentile,
> Ma la divina mente, e l'intelletto.[5]

Since contemporary evidence of a bust of Giustiniani by Vittoria exists, and since the bust in Padua seems always to have been in the Giustiniani family, it seems that Zippel was indeed correct and that the bust portrays the poet Orsato Giustiniani.

The reference in Marcellino's poem supplies a *terminus ante quem* of 1600; hence, the bust was made in the sitter's lifetime. Furthermore, since the bust and socle are in one piece, the image was most likely meant as a private image to be kept in the home where, in fact, it remained until given to the Museo Civico in Padua.[6] On stylistic grounds, the bust can be assigned to the late 1570s, inasmuch as its affinities are to other busts from that time such as those of Rangone and Ottaviano Grimani.[7]

Litta supplies a full biography of the poet.[8] Born on 27 September 1538, the son of Michele and of Elena di Gasparo Mazza, Giustiniani was a member

of the Quarantia Civil, the Magistrato alle acque and the Dieci Savi. He also was the *provveditore* of Salò and Orzinovi. In 1585, his translation of *Oedipus Tyrannus* was performed for the opening of the Teatro Olimpico in Vicenza. In 1600, he published a book of poems with Celio Magno. Like Girolamo Molin (see cat. no. 40), he was a member of the circle of Domenico Venier. Married in 1559, he died in 1603.

[1] Moschetti (1938), i, p. 284, writes that although the museum owns the bust, it had not yet entered the collection.

[2] Zippel (1926), pp. 73–4.

[3] Ibid., p. 74; Litta (1819–1902), vi: the medal (no. 10) is reproduced on an unnumbered plate following plate X.

[4] Leithe-Jasper in *Genius* (1983), p. 390.

[5] Magno and Giustiniani (1600), p. 96. Taddeo (1974), p. 213, notes this poem but not its significance for securing the identity of the bust.

[6] On this issue, see cat. no. 4.

[7] Leithe-Jasper in *Genius* (1983), p. 390, observes that the style of dress and the graphic formation of the folds of the cloak would be in keeping with a date of 1575–80.

[8] Litta (1819–1902), vi, plate X.

8. GIROLAMO GRIMANI (Pls. 75–7)

Marble
Dimensions unknown: over life-size
Signed (on rim of right shoulder reading from bottom up):
　　F. ALEXANDER. VICTOR
Bust and socle are separate
S. Giuseppe di Castello, Venice, left wall of the apse

Vittoria was paid by Marino Grimani for this bust of his father on 6 August 1573, as evidenced by the entry in the artist's own handwriting in a book of receipts that belonged to Grimani and is now in the Archivio di Stato in Venice. The entry reads:

　　　　　　　　　+adì. 6. Agosto 1573
R[ice]vi io Alessandro Vitoria dal Clar[issi]mo S[ign]or Marin Grimani Ducati sesanta p[er] resto e saldo dil ritrato di marmo dil Clar[issi]mo S[ignor] suo Padre val Duc[ati] no. 60.[1]

Thus the bust dates from 1573 and is posthumous, Girolamo Grimani having died in 1570.[2]

Although the bust dates from the early 1570s, it is not mentioned by Sansovino in 1581 but first appears in the guide literature with Stringa in 1603.[3] This is because the bust was not set in place in its monument in S. Giuseppe until the 1580s.

The payments for the decoration of the high altar chapel in S. Giuseppe survive in another book of receipts that belonged to Marino Grimani.[4] They demonstrate that the monument is not by Vittoria. The two caryatids that flank the monument were commissioned on 1 May 1582 from Francesco Casela, and they were delivered to the church on 15 October 1582.[5] They are copies of the caryatids on the monument to Giulio Contarini in S. Maria del Giglio.[6] On 28 July 1583, 'zuane de spagno' was paid for carving the 738 letters of the inscription 'nelli epitafii meso a S. Isepo del cl[arissi]mo mio padre'.[7] On 2 November 1583, the epitaph was gilded. On 4 November 1583, 'm[esser]o zuane tagia p[ie]ra' was paid 310 ducats 'p[er] il deposito a S. Iosef'. In March 1585, Zuane Tagliapietra was still receiving payments for having made the vase at the top of the monument and for other accoutrements.[8] The bust seemingly was not set in place until 1589.[9]

Thus, the patron of the high altar chapel was, as Stringa correctly states, Marino Grimani, not his father Girolamo.[10] Furthermore, the funerary monument of Girolamo Grimani is a copy, by another hand, of an earlier monument by Vittoria, not the model on which later monuments by Vittoria are based.[11]

A methodological lesson to be learned from this is that the death date of a sitter has no necessary relation to dating his bust or tomb. In the literature, the bust and monument of Girolamo Grimani have always been dated to *c.*1570 because Grimani died in that year. Yet the documentation proves that the bust dates from three years after Grimani's death, and that his monument was not finished until thirteen years after he died. A tomb can be made years before the sitter died, as is the case with Benedetto Manzini, Marc'Antonio Grimani, and Giulio Contarini, or directly after his death, as is the case with Paolo Costabile, or many years after the sitter expired. Moreover, as this tomb demonstrates, the wealth of the individual family does not

determine the speed with which the tomb is set up: the Grimani were one of the richest families, if not the richest, in Venice, yet Marino did not erect his father's tomb until thirteen years after he died. The da Lezze tomb in the Gesuiti is another example of a monument set up years after the people buried in it died.[12]

Girolamo Grimani (1497–1570) was a distinguished senator and was sent to Rome as an ambassador four times. Pope Pius IV knighted him. On 15 April 1560 he was elected a Procurator *de Citra*.[13] In 1559 he was Gerolamo Priuli's most serious rival for the dogeship; he was notorious for his avarice and, during the ducal conclave, boys yelled outside the palazzo Ducale: 'Se voi fate Doge il Grimani, noi lo daremo a mangiar cani.'[14]

[1] ASV, Archivio Grimani-Barbarigo, b. 29. The smallish book of receipts bears on the cover 'MDLXX. RECEVERI' and the number '14'. The entries in the book run from 10 Mar. 1570 to 19 Sept. 1575.

[2] Another bust for which there is a receipt is that of Paolo Costabile (see cat. no. 2). Costabile died in Venice on 17 Sept. 1582 and Vittoria received the balance for his fee on 25 May 1583. Thus an 8-month period is involved between commissioning and completion. Since Vittoria was paid for the Grimani bust in Aug. 1573, the bust was probably commissioned in late 1572 or early 1573.

[3] Sansovino (1604), p. 128*b*. Stringa writes that the high altar chapel has been 'ultimamente in bellissimo disegno fabricato da Marino Grimani Doge, che al presente vive . . . nel mezo della quale [i.e. the high altar chapel] su'l suolo vi è la sepoltura di esso Doge, ove giaciono, & riposano al presente le ossa di Girolamo Grimani suo padre, Procuratore, Cavalliere, e Senator gravissimo, in memoria di cui il detto Doge fece porre la sua statua ad alto nel muro . . .'.

[4] ASV, Archivio Grimani-Barbarigo, b. 33, fos. 281r–281v, and 309v–311r.

[5] Ibid., fo. 281v: '15 dito [October] p[er] contadì a S[ignor] franc[esc]o casela scultor a bo[n] conto L. 124.' The contract had been made on 1 Mar. of the same year (fo. 281v): 'p[rimo] mazo p[er] Marcado fato co[n] m[esser] franc[esc]o casela scultor p[er] far due figure p[er] il deposito del S[ignor] Cl[arissi]mo mio padre a s[an] Iosef di pietra viva a d[ucati] 28 l'una et le pietre condute a casa sua et deve finirle p[er] tuto l'uno luio pros[s]imo.'

[6] See cat. no. 1.

[7] ASV, Archivio Grimani-Barbarigo, b. 33, fo. 281r: 'di 2 luio p[er] contadì a S[ignor] zuane da spagna p[er] scriver letere 738 nelli epitafii meso a S[an] Isepo del cl[arissi]mo mio padre, L. 42.'

[8] Ibid., fo. 281r.

[9] For a detailed account of the Grimani chapel in S. Giuseppe, see Martin (1991*b*); cf. Hochman (1992), pp. 46–9.

[10] Sansovino (1664), p. 73, for instance, cites Girolamo as the patron of the chapel.

[11] See Sponza (1984), pp. 23–4, for earlier bibliography that dates the monument to 1570; he correctly states that the Grimani monument post-dates that of Giulio Contarini. For the latter, see cat. no. 1.

[12] See cat. no. 15.

[13] Cicogna (1824–53), iv, p. 148, provides a biography of Grimani.

[14] See Da Mosto (1939), p. 268. See also Grendler (1979), pp. 308–9.

9. GIROLAMO GRIMANI (Pl. 78)

Terracotta, gilded

Height (with base): 74 cm.; breadth: 64 cm.; baseline: 34.5 cm.; base: 10 cm.

Signed (on rim of right arm, reading from top to bottom): <ALEXANDER < V < F

Bust and socle are in one piece

Pinacoteca Manfrediana, Seminario Patriarcale, Venice

Provenance: originally in the palazzo Grimani at S. Luca; collection of David Weber; given to the Seminary by Weber by 1827

Condition: excellent; the bust still has its original gilding

Until the twentieth century, this bust was held to be a portrait of Jacopo Sansovino. Its earliest mention comes in Moschini's edition of Temanza in 1827 where, in a note, the author states that the bust came from the palazzo Grimani and was given to the Patriarchal Seminary by David Weber.[1] As a portrait of Sansovino, it was placed in the Seminary above the urn containing Sansovino's remains in the Oratoria della SS Trinità.[2] Lorenzetti was apparently the first to recognize that the bust in fact represents Girolamo Grimani.[3]

Vittoria's connections with the Grimani family go back to at least the early 1560s. The palazzo Grimani at S. Luca was commissioned by Girolamo Grimani from Michele Sanmicheli in 1556; after Sanmicheli's death in 1559, the palace was continued by Giangiacomo dei Grigi.[4] On 3 December 1563, Vittoria recorded in his notebooks that he was paid by Giangiacomo for the Victories 'ala porta dil S[ign]or Hieronimo Clar[issimo] Grimani sopra chanal [sic] grando [sic]'.[5] These reliefs are still in place.

Since the marble bust of Grimani, now over his tomb in S. Giuseppe di Castello, is documented to

August 1573, the question is whether the terracotta was made as a model for the marble or was an independent commission.[6]

Considering the radical changes made between the terracotta and marble, it seems more likely that the terracotta was made independently.[7] In terms of the silhouette of the bust, the terracotta corresponds most closely to the marble of Niccolo Massa, probably from around 1569.[8] It seems likely that the terracotta of Grimani preceded his death in 1570 and was not made in marble because it was intended as a private portrait for the house, which role it apparently fulfilled until passing into the collection of David Weber in the early nineteenth century.[9]

For a biography of Grimani, see cat. no. 8.

[1] Temanza (1827), p. 52, n. 58: '10, 11: busti di Iacopo Sansovino e di Tiziano Vecellio [this is probably the terracotta of Marino Grimani now in the Cà d'Oro, see cat. no. 12], i quali furono nel palazzo Grimani a san Luca: il primo, con il nome dell'autore, e ora nell'Oratorio del Seminario patriarcale, per dono del sig. David Weber, l'altro nell'Accademia delle bell'Arti.' On Weber, see the entry in Zorzi (1988), pp. 162–3.

[2] Moschini (1842), p. 55.

[3] Lorenzetti (1927), p. 10. When S. Geminiano was torn down in 1807, Sansovino's remains were first transferred to S. Maurizio and then to the Seminary in 1820. In 1929, the 400th anniversary of his appointment as Protomagister of the Procurators of St Mark, his ashes were interred in S. Marco where they still remain.

[4] See Gallo (1960), pp. 120–1.

[5] Predelli (1908), p. 130.

[6] For the marble bust of Grimani see cat. no. 8.

[7] See the discussion in Ch. 7, above.

[8] See cat. no. 18.

[9] A terracotta bust by Vittoria of Girolamo's son Marino (see cat. no. 12) was in the 'camera grande verso Rialto' in the Grimani palace at S. Luca; it would seem very likely that this bust was in that room as well; see Hochman (1992), p. 50, n. 18.

10. MARC'ANTONIO GRIMANI
(Pls. 54–5)

Marble
Height (with base): 85 cm.; (without base): 70 cm.; breadth (at tips of arms): 70 cm.
Signed (on rim of right arm): ALESSĀDRO VITORIA F
Bust and socle are separate
Inscribed (on socle): MARC.ANT.GRIM.D.M.PROCU-
RATOR BENEMERITUS
Grimani Chapel, S. Sebastiano, Venice

The Grimani chapel in S. Sebastiano contains three sculptures by Vittoria: the statues of Sts Mark and Anthony Abbot to either side of the altar, and the monument to the patron, Marc'Antonio Grimani. The latter is located on the left wall of the chapel and consists of a bust, the pedestal to the bust, and the plaque underneath containing the epitaph. Much information as to the decoration of the chapel can be found in Grimani's will and two codicils.[1] When the will was written, on 21 September 1558, none of the sculpture had been made. The bust is not mentioned although the epitaph is ordered to be made and Grimani states that he has 'ultimamente' had two niches fashioned inside the chapel, which he orders to be occupied by statues of his patrons, Sts Mark and Anthony Abbot.[2]

Both the bust and the statues are mentioned in the first codicil which was written in sections over a period of five years: from 10 October 1559 to 7 March 1564. The chapel is not referred to in the section from 1559. In the part of the codicil written at an undeterminable time in 1561, Grimani specifies that the monks of S. Sebastiano are to care for the chapel:

. . . lassi ut supra tuti siano et stiano in mano delli sop[ra]ditti fratti over convento continuamente ben governati et custoditi p[er] il sop[ra]dito efeto cercha la cons[er]vation de la antedita capella la qual volgio sia in sua protecion et governo et manenimento con tute suc et mie figure in dita poste con tuti li soi belli et rari adornamenti stando et restando quella a laude del s[ignor] Idio prima et a memoria mia in eternum . . .[3]

The phrase 'tute sue et mie figure' refers to the bust and to the statues of the saints.[4] Therefore, all three pieces of sculpture in the chapel can be dated to 1559–61, at least five years before Grimani died.

In another passage from the first codicil, in a section that dates from 8 March 1562, Grimani explicitly mentions the bust and also refers to Vittoria:

Item volgio et expresamente ordeno che se tolgii subito la morte mia la Copia del mio retrato marmoreo

qual ho meso nela mia capella de s[an] sebastian et sia de beletiss[im]o marmaro et posto ogni diligente cura in farlo sculpir da valenti come de M[esser]o alexandro . . .[5]

Stylistically, the bust of Grimani is closest to that of Benedetto Manzini, which was finished by 1561.[6] These two portraits must be more or less contemporaneous.

Marc'Antonio Grimani was elected a Procurator in 1565, at least two or three years after the bust was made and in place. Thus, the inscription on the socle which calls Grimani a 'Procurator Benemeritus' must have been added after the bust was already set up. As this indicates, socle inscriptions are not reliable evidence for the dating of a bust.

Marc'Antonio Grimani was the son of Francesco, the son of Piero; his mother was a daughter of Andrea Diedo. Born in 1484, he married Beatrice Tron in 1510. In 1538 he served as a *Savio di Terraferma* and was *Podestà* of Padua in 1552–3. He was balloted for Doge in 1553. Elected a Procurator *de Ultra* on 1 February 1565, replacing Andrea Cappello, he died on 25 February 1566.[7] There was a portrait of Grimani by Paolo Veronese in the Sala del Maggior Consiglio, but it perished in the fire of 1577.[8] Vittoria also executed a bust of Marc'Antonio's son, Ottaviano.[9]

[1] ASV, Notarili e Testamenti, Cesare Zilliol, b. 1262, fasc. 1, fos. 18ʳ–61ʳ (an autograph copy is contained in ASV, C. Zilliol, b. 1260, no. 759). The will and two codicils are long and complicated documents. They have been discussed only by Cicogna (1824–53), iv, pp. 156–8, who notes the will from 21 Sept. 1558, and codicils of 24 Mar. 1564 and of 2 Feb. 1565 (*m.v.*), and states that from them one can see that 'quest'anno pure [1564] ha eseguito il ritratto in marmo' of Grimani. He dated all the statues to 1564, presumably because they are all mentioned in the first codicil from 1564. Later scholarship has, with one exception, followed Cicogna's dating: Giovanelli (1858), p. 32; Serra (1923), pp. 48–9; Cessi (1961*b*), p. 29; Pope-Hennessy (1964), ii, p. 529. Leithe-Jasper (1963), p. 123, gives a dating of 1558–64. Cicogna, however, misdated the first codicil, thus invalidating his conclusions. The first codicil was in fact written over a period of five years and only given to the notary on 24 Mar. 1564. The whole testament can be plotted as follows:

Will: fos. 18ʳ–40ᵛ: 21 Sept. 1558
First Codicil: fos. 40ᵛ–42ʳ: 10 Oct. 1559
 fos. 42ʳ–42ᵛ: 3 Feb. 1560 (1559 *m.v.*)
 fos. 42ᵛ–45ʳ: some time in 1561
 fos. 45ʳ–53ʳ: 8 Mar. 1562
 fo. 53ʳ: 7 Mar. 1564
Second Codicil: fos. 53ᵛ–61ʳ: 2 Feb. 1566 (1565 *m.v.*)

The only part of the first codicil actually written in 1564 is the very last paragraph which, as can be seen from the autograph copy in b. 1260, was tacked on at the very end: the ink is of a lighter colour and the writing is much smaller than in the rest of the document because of the lack of space at the bottom of the page. The only part of the codicil whose dating is imprecise is fos. 42ᵛ–45ʳ; see n. 3. Richardson (1980), p. 179, refers to a will by M. A. Grimani from 1555; no such document exists. Because of this, he misdates the *terminus ante quem* for Schiavone's frescoes in the Grimani chapel, placing them between 1548 and 1553.

[2] ASV, C. Zilliol, b. 1262, fasc. 1, fo. 20ʳ: 'Item ordeno et volgio che dentro la ditta mia Capella sopra una bela et conveniente piera marmorea biancha il mio ephitafio sia fatto con poche parolle et sucintamente narando del tuto la verità Adornando quello onestamente segondo il bisogno et p[er] che ho fatto fare ultimamente dentro dita mia Capella dui nighi belli et ornatti dove volgio vi vadi dentro due belli et conveniente figure la prima sia de s[ant]o Marco alla banda destra e l'altra de s[ant]o Antt[oni]o ala banda sinistra . . .' Since both the *targa* containing the epitaph of Grimani and the bust are by Vittoria and since Grimani does not mention the bust when he orders the epitaph to be made, its commission could not yet have been given.

[3] ASV, C. Zilliol, b. 1262, fasc. 1, fo. 44ʳ. The dating of this passage can be determined as follows. On fo. 45ʳ, Grimani writes, 'Item con el nome de dio benedetto millecinquecentosesantadoi adi 8 de mese di marzo azonzo a questo mio codicillo'. On fo. 42ᵛ he writes, 'Atrovandomi fino l'ano passato 1560'. Since the passage of fo. 44ʳ comes after the reference to 1561 and before the reference to 1562, it must be from 1561.

[4] In the passage from fo. 20ʳ quoted in n. 2, Grimani refers to the statues of Sts Mark and Anthony as 'figure'; on fo. 50ʳ, he calls the bust 'mio retrato'; on fo. 57ʳ, he notes how much money he has spent to adorn the chapel 'com si belle et preciose piere et figure de beletiss[im]o marmoro'; on fo. 59ʳ he refers to 'le figure di S[an] Marco et s[ant]o Antt[oni]o insieme con la mia Statua posta nel muro'; on fo. 59ᵛ, Grimani twice differentiates between the statues and the bust as 'figure' and 'statua', but also at one point writes 'ditte mie figure massime la mia statua'. Thus, a constant terminology is not employed; sometimes the bust is included under the rubric 'figura' and sometimes it is specified as 'statua'. The passage from fo. 57ᵛ, because it is in the second codicil, must include the bust within the term 'figure'. Since, in the passage from fo. 20ʳ, Grimani differentiates between the 'figure' as 'sue' and 'mie', he must be referring to the bust as well as to the statues.

[5] ASV, C. Zilliol, b. 1262, fo. 50ʳ. Grimani's wish was apparently not carried out; I know of no copy of his bust.

[6] See cat. no. 16.

[7] For all of the above information, see Cicogna (1824–53), iv, pp. 157–8, where a simple biography of Grimani is given. The inscription on Grimani's monument states that he died on 25 Feb. 1565, but this date is in *more veneto* as attested by his necrology. All necrologies are in *more veneto* and Grimani's reads: '25 Feb. 1565: Il cl[arissi]mo M[esser] Marc ant[oni]o Grimani Procurator, am[malat]o da vechiezza, S. Boldo' (ASV, Provveditori e Sopravveditori alla Sanità, b. 801, unpaginated).

[8] See Cicogna (1824–53), iv, p. 158.

[9] See cat. no. 13.

11. MARINO GRIMANI (Pl. 111)

Marble

Height: (with base): 89 cm.; (without base) 77.5 cm.; breadth: 55 cm.; baseline: 45 cm.

Signed (on rim of left arm reading from bottom up): ALEXANDER . VICTORIA . F

Bust and socle are in one piece

Museum of the palazzo Venezia, Rome

Provenance: palazzo Grimani at S. Luca, Venice; Collection Count Gregory Stroganoff, Rome, second half of the nineteenth century; given by Stroganoff to the Italian state in 1924, from which time it has been in the palazzo Venezia[1]

This bust was first published in 1911 by Pollak and Muñoz where, in comparing the marble to the 'terre cuite du Musée du Palais Ducal de Venise', the sitter is identified as Marino Grimani.[2] As with its terracotta version, the marble is always dated to 1588–95 in the belief that Grimani is depicted in the robes of a Procurator. His garb alone, however, gives no basis for such a dating: people of various ranks wore such brocaded robes and Grimani's apparel here does not necessarily place the execution of the bust to his tenure as a Procurator.[3] In this case, however, the traditional dating turns out to be none the less correct, for Vittoria was paid a first instalment of 30 ducats for this bust on 11 December 1592, and a balance of 40 ducats on 28 April 1593 by Marino Grimani.[4]

While the face of the marble is very finely carved and worked, closely based on the terracotta and resembling, in its technique, the face of Orsato Giustiniani, the torso is schematically rendered and significantly tighter than that of the terracotta—indeed, it is 10 cm. smaller in breadth. The resulting visual effect is that the marble carries a much diminished feeling of scale as compared to the terracotta. I would suggest that while the head of the statue is autograph, the torso was left to the studio to carry out, thus explaining its weak rendering and lack of presence.

The phenomenon of a strong, forceful terracotta and a weaker, more mechanical marble is also to be seen in the busts of Francesco Duodo.[5] Because the marble *Marino Grimani* is in one piece, like that of Francesco Duodo, which is known to have been originally commissioned as a private image, it may be assumed that the marble of Grimani was also commissioned as such.[6]

Marino Grimani, the eighty-ninth Doge of Venice, was the son of Girolamo and Donata Pisani. Born on 1 July 1532, he held many offices in the Venetian government, such as *podestà* of Brescia and of Padua, as well as ambassador to Popes Sixtus V, Gregory XIV, and Clement VIII. Elected a Procurator *de Ultra* in 1588, he rose to the dogeship on 26 April 1595. He died on 25 December 1605.[7]

[1] On the provenance of this bust and its bibliography, see Santangelo (1954), p. 18. In Pollak and Muñoz (1911), i, p. vii, it is stated that Stroganoff assembled his collection between 1865 and 1910.

[2] Pollak and Muñoz (1911), ii, p. 127; vol. ii is by Muñoz. By this time, then, the terracotta had been rescued from anonymity and identified as Grimani. Santangelo (1954), p. 18, erroneously gives the location of the terracotta as the Correr Museum; it has been in the Cà d'Oro since 1926; see cat. no. 12.

[3] See the examples for this in cat. no. 12 on the terracotta version of the Marino Grimani.

[4] See Hochman (1992), p. 44.

[5] See cat. nos. 4 and 5.

[6] Ibid.

[7] For a brief biography of Grimani and bibliography on him, see Da Mosto (1939), pp. 311–16.

12. MARINO GRIMANI (Pl. 110)

Terracotta, gilded

Height (with socle): 84 cm.; (without socle) 74 cm.; breadth: 64.5 cm.; baseline: 45 cm.

Signed (on rim of right arm): A> V> F>

Bust and socle are in one piece

Galleria Giorgio Franchetti alla Cà d'Oro, Venice

Provenance: palazzo Grimani at S. Luca; collection of David Weber in the early nineteenth century; sold by Weber to the Accademia delle Belle Arti in 1820; transferred to the Museo Archeologico between 1862 and 1872; transferred to the Cà d'Oro in 1926[1]

The provenance of this bust is very confused and the clearest way of approaching the problem is to work backwards. The bust is now in the Cà d'Oro where it has been since the museum opened in January 1927. Moschetti lists it in his 1929 catalogue as Marino Grimani, terracotta, height

84 cm., and signed on the back with the initials A.V. F.; he also, fortunately, states that it came from the Museo Archeologico.[2] In 1923, Serra lists a bust of Marino Grimani in the Museo Archeologico, in terracotta and signed A.V. F.[3] Planiscig in 1921 also mentions a terracotta bust of Marino Grimani signed A.V. F. and in the Museo Archeologico.[4] In the entry for the marble bust of Grimani in Rome, the authors of the catalogue of the Stroganoff collection mention a terracotta version in the Ducal Palace in Venice; this is apparently the first time the terracotta was identified as Marino Grimani.[5]

Prior to this time, the identity of the sitter was unknown. Venturi, in 1896, describes this bust only as a signed terracotta of a Venetian patrician.[6] The earliest notice of the bust as being in the archaeological museum comes in Valentinelli's catalogue from 1872 where it is described as 'il busto in terra cotta dorata, di grandezza ordinaria, d'un patrizio veneziano, modellato da Alessandro Vittoria, che v'oppose il proprio nome'.[7] In this book, the author lists three busts by Vittoria, two in marble and one in terracotta; the marbles are the *Benedetto Manzini* and the *Giovanni Donà* (at this time, the *Girolamo Contarini* was still in the Accademia).[8] Because Valentinelli describes the bust as gilded terracotta and only one terracotta by Vittoria is ever listed as being in the archaeological museum, and because Planiscig, Serra, and Moschetti all state that the *Grimani* came from the museum, the reference by Valentinelli must indicate the *Grimani*.

Where was the bust before then? I think that this portrait must be identical with a terracotta, often called 'Titian', mentioned in catalogues of the Accademia and other sources preceding 1872. The earliest mention of this 'Titian' appears in Moschini's edition of Temanza in 1827. In a lengthy footnote giving additional busts by Vittoria not recorded by Temanza, Moschini describes numbers 10 and 11 as 'busti di Jacopo Sansovino e di Tiziano Vecellio, i quali furono nel palazzo Grimani a san Luca: il primo, con il nome dell'autore, è ora nell'Oratorio del Seminario patriarchale, per dono del sig. David Weber, l'altro nell'Accademia delle bell'Arti.'[9]

The bust of 'Sansovino' is the gilded terracotta of Girolamo Grimani (father of Marino) still in the Seminary.[10] It and the 'Titian' in the Accademia are both said to be from the palazzo Grimani. Giovanelli (writing in the 1830s but not published until 1858) also mentions these busts. He invents a story of Vittoria fashioning busts of Titian and Sansovino 'in plastica' and then revealing them as a surprise at a party for the two artists. He also states that the bust of Sansovino is signed while that of Titian is not, that the Sansovino is in the Seminary and the Titian in the Accademia, and that the 'morbida e piumosa' beard of the Titian surpasses that of the Sansovino.[11] Luigi Zandomeneghi, in 1830, mentions a 'busto di Tiziano' by Vittoria.[12] Francesco Zanotto, in his 1856 guide to Venice, mentions a 'ritratto di un vecchio' in the Accademia whose authorship is given as 'd'ignoto'; Zanotto adds, however, that it was a gift of David Weber, the same man who gave the 'Sansovino' to the Seminary.[13] The 1862 catalogue of the Accademia also lists a 'ritratto di un vecchio', calls it a gift of David Weber, and gives its height as 77 cm.[14] This object is not mentioned in any later catalogues of the Accademia.

To sum up: Moschini writes that there is a bust of Titian by Vittoria in the Accademia and that it, like the terracotta of 'Sansovino' (Girolamo Grimani) came from the Grimani palace, and that the 'Sansovino' was given to the Seminary by David Weber. Giovanelli states that there are busts by Vittoria of Sansovino in the Seminary and of Titian in the Accademia, that the latter is unsigned, and that both are terracotta. Zanotto in 1856 and the Accademia catalogue in 1862 both state that there is a bust of an old man, not in marble, in the Accademia, donated by David Weber. Hence, both the busts of 'Sansovino' and of 'Titian' are said to be from the Grimani palace and both are, at one time or the other, connected with Weber. That the 'Sansovino' in the Seminary turns out to be Girolamo Grimani, the patron of the Grimani palace, adds veracity to Moschini's report that it, like the 'Titian', came from the palace. If the 'Titian' were the same object as the Marino Grimani, that would mean that it too

came from the family palace; why should not these portraits of father and son have come from the same place? Furthermore, if the 'Titian' and the bust of Marino Grimani were the same object, this would explain why it disappears from the Accademia after 1862 and shows up in the archaeological museum in 1872.[15] Another factor that connects the busts of Girolamo and Marino Grimani to each other is their gilding. Marino does bear a generalized resemblance to Titian and, as Giovanelli states, the beard of Marino is more 'morbida e piumosa' than that of his father.

Finally, David Weber did indeed sell a terracotta bust by Vittoria to the Accademia. On 2 February 1820, Weber sold to the Accademia a double portrait by Tullio Lombardo, two marble busts by Bernini, and a 'Busto di creta cotta, originale di Alessandro Vittoria, rappresentante forse un Senatore'.[16] While problems remain—such as why Giovanelli says the 'Titian' is unsigned, and why the authorship of the bust goes unnoted by Zanotto or by the 1862 catalogue of the museum—the *Marino Grimani* is the only terracotta by Vittoria that can be linked up with the bust sold by Weber in 1820 to the Accademia, and it makes sense that it should have come from the Grimani palace.[17]

The traditional dating of this bust to Grimani's tenure as a Procurator from 1588 to 1595, on the grounds that Grimani is shown here attired in the robes of a Procurator, cannot be upheld.[18] Many different ranks of people wore these brocaded robes. Pietro Zen, for instance, is depicted in exactly the same kind of robes in his terracotta bust, but Zen never achieved procuratorial rank.[19] The distinguishing mark of a Procurator is the brocaded stole, such as those worn by Domenico Duodo and Vincenzo Morosini in their busts.

Michel Hochman has recently clarified the date of this bust and of the marble based on it, showing that they do indeed date from Grimani's term as Procurator. On 11 December 1592, Grimani made a first payment to Vittoria of 30 ducats for a marble portrait. On both 6 March and 29 March 1593 he records paying 26 lire for the gilding of his bust 'de terra' by Vittoria. On 28 April 1593 he paid Vittoria a balance of 40 ducats for both the terracotta and the marble busts.[20] The terracotta, hence, must have been finished by early March 1593 and the marble by the next month. Hochman also found a payment recording that the terracotta was placed in the 'camera granda verso Rialto' in the palace at S. Luca, thus documenting that this bust, like the 'Titian' first mentioned by Moschini in 1827, did indeed come from the Grimani palace.[21]

For a biography of Grimani, see cat. no. 11.

[1] See text of catalogue entry.

[2] Moschetti (1929), pp. 120–2.

[3] Serra (1923), p. 82 and also his list of works on p. 93.

[4] Planiscig (1921), p. 518.

[5] Pollak and Muñoz (1911), ii, p. 127.

[6] Venturi (1896), p. 57: '[besides the marble busts of Benedetto Manzini and Girolamo Contarini, the museum has another bust by Vittoria] in terracotta, di patrizio veneziano, col nome dello scultore (A.V.F.).'

[7] Valentinelli (1872), p. 44, no. 76. The author adds that the Accademia made a gesso of the bust in 1850.

[8] See cat. nos. 16, 3, and 31.

[9] Temanza (1827), p. 53, n. 58.

[10] See cat. no. 9.

[11] Giovanelli (1858), pp. 29–30.

[12] Zandomeneghi (1830), p. 6.

[13] Zanotto (1856), p. 524, no. 93. Although the medium of this bust is not specifically given, it precedes a list of the marble busts in the Accademia; hence, this bust was not of marble and could have been terracotta. On p. 525, no. 5, in the list of marbles, Zanotto mentions the bust by Vittoria of Girolamo Contarini from S. Sepolcro; see cat. no. 31.

[14] *Accademia* (1862), p. 28.

[15] The Accademia was reorganized between 1885 and 1887, at which time most of its sculpture collection was sent to the Archaeological Museum (which at that time was in the Ducal Palace). Most of these sculptures were sent to the Cà d'Oro when it opened in the 1920s; see Moschini-Marconi (1962), p. xxiv. I assume that the removal of the *Marino Grimani* was an early instance of what later became a policy of making the Accademia solely a painting gallery and transferring its sculpture elsewhere.

[16] The receipt of this transaction still survives in the archives of the Accademia delle Belle Arti in Venice, no. 108. I was guided to look for it by references in the literature on the double portrait by Tullio (the *Bacchus and Ariadne* now in the Cà d'Oro) stating that it was part of a sale that included a bust by Vittoria. The two busts by Bernini are those of Cardinals Agostino and Pietro Valier, now in the Seminario Patriarchale; see Wittkower (1981), pp. 194–5, no. 25. I am deeply indebted to the former Director of the Accademia, Dr Nedo Fiorentin, who searched the archives for me and found the receipt of this sale. The Tullio sold for 440 lire, the Vittoria for 330 lire, and the two Berninis for 220 lire. Weber was an Austrian and a friend of both Cicogna and Moschini. He also owned the terracotta busts of Girolamo Grimani and Apollonio Massa now in the Patriarchal Seminary; see cat. nos. 9 and 17 and the entry on Weber in Zorzi (1988), pp. 162–3.

[17] A bronze bust, now in the Frick Collection, New York, and given to Cattaneo, has a cartellino on its base inscribed 'Titi[a]no Vecelli'. When this bust was in the collection of Louis Stern in Paris, it was occasionally thought to be the lost bust of Titian from the pal. Grimani, but it has been rightly discounted as such ever since Planiscig; see Planiscig (1921), p. 460, and Pope-Hennessy (1970b), p. 172.

[18] See, for instance, Planiscig (1921), p. 518; Serra (1923), p. 82; Moschetti (1929), pp. 120–2; Santangelo (1954), p. 18 (re the marble bust); Cessi (1962), p. 17.

[19] See cat. no. 23.

[20] Hochman (1992), p. 50, n. 18, prints all the archival passages; the source cited by him is ASV, Archivio Grimani-Barbarigo, b. 30, Notatorio 1589–1604.

[21] Ibid.

13. OTTAVIANO GRIMANI (Pls. 82–3)

Marble
Height (with socle): 80.5 cm.; breadth: 69.2 cm.
Signed (on rim of left arm): ALEXANDER.VICTOR.F.
Inscribed (on socle): OCTAVI GRIM. D.M. PROCURA-
TOR
Staatliche Museen zu Berlin, Preussischer Kulturbesitz,
Skulpturensammlung
Provenance: in Venice, perhaps in the Grimani palace at SS
Ubaldo e Agata until 1840; bought in 1841 by the Berlin
museum[1]

Cicogna first notes this bust: 'In questo mese di Ottobre 1840 ho veduto presso un Rigattiere in Calle de' Fabri un assai bel busto in marmo di questo [Ottaviano] Grimani scolpito dal Vittoria . . . Non dubito che questo busto spettasse alla famiglia Grimani de' SS. Ubaldo e Agata.'[2] The very next year it was bought by the Berlin museum.

Both Serra and Planiscig date the bust to 1571–6, the years in which Grimani was a Procurator, on the grounds that he is in his official dress.[3] But he is not dressed as a Procurator; he wears exactly the same clothes as does Orsato Giustiniani (Pl. 87), and the latter never held procuratorial office. Cessi, on stylistic grounds, dates the bust to the 1580s.[4]

The bust bears closest comparison to the Rangone and Giustiniani portraits, both of which are from the 1570s.[5]

Next to nothing is known about Ottaviano Grimani. Born in 1516, he was the son of Marc'

Antonio Grimani, also a Procurator of St Mark's, who also had his bust made by Vittoria.[6] Ottaviano was elected a Procurator *de Citra* on 17 January 1571. Dying in 1576, he lies buried in the Grimani chapel in S. Sebastiano with his father. In his will, Marc'Antonio specified that the only other person who could be buried in the chapel was Ottaviano.[7] Perhaps the bust was meant as a pendant to the father's but never put in place.[8] Because the socle and bust are separate, the portrait probably was meant to be a public image.[9]

[1] See Schottmüller (1913), p. 169, no. 399.
[2] Cicogna (1824–53), iv, p. 751.
[3] Serra (1923), pp. 62–3; Planiscig (1921), p. 481.
[4] Cessi (1962), p. 13.
[5] See cat. nos. 20 and 7.
[6] See cat. no. 10; Cicogna (1824–53), iv, p. 158, provides a sketch of Ottaviano's life.
[7] ASV, Notarili e Testamenti, C. Zilliol, b. 1262, fasc. 1, fo. 19ʳ.
[8] The busts do face in opposite directions, and thus could work as pendants on opposite walls of the chapel.
[9] See cat. no. 4 for a discussion of this issue.

14. GIOVANNI BATTISTA GUALDO (Pls. 84–5)

Terracotta, gilded
Dimensions unknown; over life-size
Signed (on rim of right arm, reading from bottom up):
ALEXANDRO VICTOR . . .
Bust and socle are in one piece
Inscribed (on socle): JOAN. BAP. | GUALDUS
Cathedral, Vicenza, left transept over door leading to sacristy

The Gualdo monument in the cathedral of Vicenza has received almost no attention in the literature on Vittoria, even though both of the busts on the monument are signed with his name and even though the monument itself is very much in his style. Its first association with Vittoria comes in 1956, when Arslan assigned it (rightly) to the artist.[1] Leithe-Jasper, in 1963, gave the design of the monument to Vittoria.[2] I am aware of no further examination of this tomb complex until now.[3]

The monument itself (Pl. 84) is an impressive ensemble that can be divided into three levels.

The bottom level, which extends to the height of the lintel of the door to the sacristy, contains two sarcophagi, that of Girolamo on the left, and that of Giovanni Battista, Girolamo's nephew, on the right. These sarcophagi rest on supports that in turn rest on relatively high bases. The middle, 'attic', level runs between the lintel of the sacristy door up to the beginning of the segmented pediment above the door. Busts of the deceased rest in the attic level on ledges directly on an axis above their respective sarcophagi. Above, and almost as large as the preceding two storeys, rises the third level. Directly above the segmented pediment appear two putti holding the Gualdo coat of arms. Above them looms a triangular pediment formed by volutes on the sides joined by a level top. At the pinnacle stands Charity, while at her left and right recline, respectively, Faith and Hope. The whole complex is formed of stucco, and obviously derives from Vittoria's work at the Libreria and the Ducal Palace. Its more immediate companions are the work in stucco done by Vittoria and his shop in S. Giuliano and in S. Giovanni in Bragora.[4]

The inscription over the sacristy portal states that the monument was raised by Giovanni Battista Gualdo in 1574.[5] Dian states that Giambattista Gualdo had made a request as early as 1560 to erect a monument.[6] Perhaps the request was approved then but, going by the inscription, the complex was not finished until 1574, eight years after Girolamo Gualdo had died in 1566.

I agree with Arslan, who attributed the bust of the patron, Giovanni Battista Gualdo, to the master himself and rightly noted the 'inferior quality' of the bust of Girolamo, which is patently from a weaker hand (cat. no. 38, Pl. 86). Indeed, the bust of Giovanni Battista, full of bite and individuality, takes its place as a fully mature statement by the artist. Since its baseline runs straight across its entire length, jutting out from both sides above the socle, it cannot date from earlier than the mid-1570s. It finds very close companions in the *Ottaviano Grimani* in Berlin (cat. no. 13) and the *Orsato Giustiniani* in Padua (cat. no. 7).

Just because the inscription states that the monument was raised in 1574 does not necessarily mean that every element of it was in place then. While it was hardly necessary for Vittoria to make this bust in Vicenza, he did journey to that city in September 1576, staying there perhaps until April 1577, and it is certainly possible that the bust was made at this time.[7] Unless more documentation turns up, however, I do not think that a more precise dating than *c.*1575–85 can be given to this portrait, which seems very close stylistically to the terracotta in Paris (Pl. 114) and to that of an unknown woman in Vienna (Pl. 92).[8]

Giovanni Battista Gualdo, a member of one of the most prominent families of Vicenza, was born in 1551 and died in 1588.[9] As stated on his sepulchral inscription, he was a canon of the cathedral.[10] Although the inscription at the top of the monument specifically states that Giovanni Battista was the patron of the monument, it seems very likely that Vittoria was acquainted with Giambattista's uncle, Girolamo Gualdo, one of the most important collectors of ancient art in the Veneto in the sixteenth century. See the discussion of this matter in cat. no. 38 on the bust of Girolamo Gualdo.

[1] Arslan (1956), p. 33, no. 156, attributes the monument to 'Alessandro Vittoria (?)'.

[2] Leithe-Jasper (1963), p. 169, suggests that Vittoria made drawings for the monument that then were carried out by local Vicentine artists.

[3] I understand that Don Mario Saccardo, of the cathedral in Vicenza, is preparing a detailed study of the Gualdo monument.

[4] See Cessi (1961a), pp. 63–4, for the stuccoes in S. Giuliano over the altar of the Blessed Sacrament.

[5] DEO OPT MAX | HVISQV SACRARII ORNAMETO | IOANNES BAPTISTA GUALDUS | CANONICUS VIC P | ANNO SALUTIS | MDLXXIIII ('to the greatest, best God, Giovanni Battista Gualdo, canon and vicar, set up [this monument] as an ornament of this sacristy in the year of our salvation 1574').

[6] G. Dian, *Serie dei Canonici della Cattedrale* as reported in Forlati (1956), p. 151, n. 227.

[7] See the discussion of this issue in cat. no. 36 on the bust of 'Girolamo Forni'. Some Vicentine friends hired a barge to transport Vittoria and his family to Vicenza in Sept. 1576; the artist was back in Venice by at least 27 Apr. 1577.

[8] See, respectively, cat. nos. 28 and 27.

[9] See Dian (as in n. 6) as reported in Forlati (1956), p. 152, n. 238.

10 IOANNES BAPTISTA | GVALDUS HUIUS | ECCLESIAE CANONICUS | VIVENS | H. M. S. P. C. ('Giovanni Battista Gualdo, Canon of this church, while living, took care to raise this monument to his family').

15. PRIAMO DA LEZZE (Pls. 63–4)

Marble
Dimensions unknown; over life-size
Unsigned[1]
Bust and socle are separate
Inscribed (on socle): PRIAMUS. LEGGIUS. | D. MR.
 PROCURAT
S. Maria Assunta, Venice, set in the central section of the da
 Lezze family monument on the inside façade

The bust of Priamo da Lezze rests atop the central sarcophagus of the da Lezze family monument, which occupies the inside façade of S. Maria Assunta. This church was originally S. Maria dei Crociferi, but after the order of the Crociferi was suppressed in 1656, the building was passed on to the Society of Jesus.[2] From 1714 to 1729, the church underwent an extensive restoration and reconstruction by Domenico Rossi.[3] To the left of the bust of Priamo is that of his son, Giovanni (Zuanne), and to Priamo's right is the bust of Zuanne's son, Andrea.[4] All three men were Procurators of St Mark's.

This portrait is one of the eight mentioned by Vasari in the 1568 edition of the *Lives*: 'Ha [Vittoria] parimente ritratto . . . messer Priamo da Lagie . . .'[5] Thus, the bust must predate 1568, and most likely predates 1566, the year of Vasari's last visit to Venice. Vasari gives no location for the bust, which is understandable since it was not placed on the da Lezze monument until at least the late 1570s.[6] In 1581, Francesco Sansovino records that the monument is in place on the inside façade of the Crociferi.[7] He gives no attributions, as does neither Stringa nor Martinioni.[8]

Vasari's lack of a location and Sansovino's lack of an attribution have confused later scholarship and the bust has only generally been accepted as being by Vittoria in the twentieth century.[9] Yet there is no reason to doubt that Vasari's 'Priamo da Lagie' is identical with this bust. In the first place, Vasari's 'Lagie' is well within the rather wide parameters of sixteenth-century orthography. The latinized form of the name, for instance, appears with two 'gs' on the socle inscription, 'Leggius', but with only one 'g' on the sepulchral inscription, 'Legio'. Sansovino gives the name as 'Legge'. It should also be remembered that Vasari gives Ferretti's name as 'Feredo'.[10]

More importantly, the bust is completely in Vittoria's style in terms of the rendering of the physiognomy, pose, and spirit. In terms of the termination of the torso and the shape of the silhouette, the bust of da Lezze is closest to the bust of Manzini which dates from *c*.1560–1, and definitely precedes the innovations worked out in the bust of Niccolo Massa from *c*.1569.[11] Thus, on stylistic grounds, a dating to the first half of the 1560s makes the most sense for the portrait of da Lezze, a dating that accords with its mention by Vasari. Consequently, this bust postdates those of Giovanni Battista Ferretti, Marc'Antonio Grimani, and Benedetto Manzini, with all of which it shares so many traits that the attribution of the design of the bust to Sansovino and only the execution of it to Vittoria is unfeasible.[12]

In dating from the first half of the 1560s, this bust, like the marble bust of Girolamo Grimani, is posthumous, Priamo having died in 1557.[13] As again in the case of the marble bust of Grimani in S. Giuseppe di Castello, that of da Lezze significantly predates the monument (Pl. 64) in which it is set, since the da Lezze monument was constructed from around 1576 to about 1580. The basis for this dating is supplied by the will of Zuanne da Lezze, written on 26 July 1576 in which he states:

. . . lasso alli mei comissarii habbino cura di sepelire il corpo mio nello emolumento alli Croschieri con quello modo, che a loro parerà; et non essendo finito p[er] sorte esso emolumento debbano con ogni diligentia farlo finire secondo lo forma, patto, e condicion ch[e] è dechiarito nello scritto fatto con maestro X[hristo]phoro de zorzi posto ne lo mio catastico a k[ar]te 290.[14]

Therefore, while a contract and a design for the monument were fixed by 1576, and work had perhaps begun, the tomb was not finished by then. Since Sansovino says in 1581 that the sarcophagi of Priamo and Zuanne are in place, the whole work must have been erected between c.1576 and c.1580.

The monument has had a somewhat confused history of attributions, but is now generally accepted as by, or at least designed by, Jacopo Sansovino.[15] Yet the date of the monument, begun five or six years after the latter's death, and the gaps in Francesco Sansovino's description of it, raise doubts as to whether the tomb is actually by Jacopo Sansovino.[16]

In this connection, it is interesting to note the comment about the tomb given by Molmenti and Fulin, who characterize it as a 'coretto lavoro nello stile del classicismo nella sua parte inferiore, laddove nella superiore lo sprezzamento del frontespizio accusa la decadenza'.[17] While Sansovino does not employ broken pediments as part of his architectural vocabulary, Vittoria uses them constantly: on the second storey of S. Giuliano, on the altar of the Merciai in S. Giuliano, on the altar of the Luganegheri in S. Salvator, on the façade of the palazzo Balbi, and on the façade of the Ateneo Veneto. In addition, the tight, compressed niches of the da Lezze monument are also similar to those on the Ateneo Veneto.[18] Furthermore, there is no tomb by Sansovino that contains the feature of sarcophagi mounted by portrait busts. The first appearance of this motif in Venice is the Ferretti tomb in S. Stefano where the bust is by Vittoria.[19] On the whole, an attribution of the da Lezze monument to Vittoria, rather than to Sansovino, seems more justified.[20]

Priamo da Lezze was born in 1469. In 1506 he was the *podestà* and Captain of Belluno; in 1520, *podestà* and Captain of Treviso; and in 1530 the Captain of Padua. In 1554 he was balloted for Doge and on 6 April 1556 he was elected a Procurator *de Citra* of S. Marco. He died on 7 or 8 September 1557.[21]

[1] The only other unsigned marble bust by Vittoria, besides that of Giovanni Battista Ferretti (cat. no. 6), is the *Giulio Contarini* in S. Maria del Giglio, but it is flanked by two caryatids, each of which is prominently signed; see cat. no. 1.

[2] See Lorenzetti (1963), p. 396.

[3] Ibid., p. 397.

[4] The bust of Zuanne is fully signed by Giulio del Moro; see Comastri (1988), p. 93. The bust of Andrea da Lezze is a very weak and mediocre work in a Vittoriesque style.

[5] Vasari (1878–85), vii, p. 520; see n. 9 for a full quotation of this pasage.

[6] See below.

[7] Sansovino (1581), p. 61v: 'Dentro dalla porta maggiore, è collocato in bel sepolchro Priamo da Legge Procurator di San Marco, col figliuolo parimente Procuratore.' It should be noted that Sansovino here makes no mention of his father in connection with the da Lezze monument. He also makes no mention of any busts, saying merely that the tomb is on the inside façade and that Priamo and Zuanne da Lezze are buried there.

[8] Sansovino (1604), p. 148a: 'La porta maggiore di dentro è tutta ornata all'intorno & per tutta la facciata di dentro di tre bellissimi & richissimi deposti, congiunti in uno. In quel di mezzo è la memoria di Priamo da Legge, che fu Procurator di San Marco col suo sepolcro in aria & sua statua . . .' Since Sansovino mentions only 2 tombs while Stringa mentions 3, this presumably means that the sarcophagus of Andrea was set in place between 1581 and 1604. Sansovino (1664), p. 170: 'Il Sepulcro di Priamo da Legge, accenato sopra dal Sansovino, è grande, e Maestoso, che occupa tutta la facciata di dentro della Porta Maggiore, costrutto di bellissimi Marmi, e compartito, con mirabil ordine di Architettura, in tre spatii, in quello di mezzo sta l'Urna in aria con il ritratto in marmo del predetto Priamo . . .'

[9] Temanza (1778), p. 496, paraphrasing Vasari almost word for word, gives the name 'Andrea da Lezze'. Vasari's passage runs: 'Ha parimente ritratto messer Andrea Loredan, messer Priamo da Lagie, e dua fratelli da Ca' Pellegrini, oratori, cioè, messer Vincenzio e messer Giovan Battista.' Temanza, after listing the busts by Vittoria to be found 'nelle Chiese, ed altri luoghi pubblici', states: 'Fece pure li busti al naturale di M. Andrea Loredano, di M. Andrea da Lezze, e di Vicenzo, e fratelli Pellegrini oratori chiarissimi.' Since Temanza did not list the bust under those found in churches, it seems unlikely that he believed a bust on the da Lezze tomb to be by Vittoria. He seems just to have repeated the 'M. Andrea' from Andrea Loredano over into da Lezze's name. The bust was apparently unknown to Moschini since he mentions neither it nor the da Lezze monument in Moschini (1815) or in Temanza (1827). Giovanelli (1858), p. 39, repeats Temanza's 'Andrea da Lezze', gives no location and, adducing no grounds, assigns it to 1567–8. Neither Serra (1923) nor Planiscig (1921) mentions a bust of da Lezze. Lorenzetti (1927), pp. 79–80, gives both the da Lezze monument and the bust of Priamo (who he incorrectly states died in 1567) to Jacopo Sansovino. Venturi (1937), pp. 145–6, correctly notes that Priamo died in 1557, gives the bust to Vittoria, and identifies it as 'forse il ritratto di Priamo da Lagie ricordato dal Vasari'. Cessi (1961b), p. 36, gives the bust to Vittoria and dates it c.1569. Mariacher (1962), basing himself on Lorenzetti, suggests an attribution to Sansovino and a dating of 1567. Pope-Hennessy (1964), ii, p. 529, gives the bust to Vittoria, but Middeldorf (1976), p. 77, does not. Hubala (1974), p. 277, suggests Sansovino. Lewis (1983), p. 351, n. 73, dates the da Lezze bust'c.1558' and says that 'although it was very probably carved by

the young Alessandro Vittoria [who was 33 in 1558!]', the invention is by Sansovino.

[10] See cat. no. 6.

[11] See cat. nos. 16 and 18.

[12] This is Lewis's position, see n. 9.

[13] For the Grimani bust, see cat. no. 8.

[14] ASV, Notarili e Testamenti, G. Secco, b. 1194, fo. 85ᵛ.

[15] As can be seen from nn. 8 and 9, no attribution is given by Sansovino, Stringa, or Martinioni. The first time an attribution is given is by Zanotto (1856), p. 311, who assigns it to Longhena on false grounds which have found no support in the later literature. Molmenti and Fulin (1881), pp. 249–50, mention, without identifying it, a print of the tomb from the 18th cent. that bears the inscription 'invenzione di Jacopo Sansovino'. While they do not explicitly endorse this attribution, they suggest, on the basis of the motif of the broken pediment in the second storey, that the monument underwent significant alterations in the 17th cent. Lorenzetti (1927), pp. 79–80, gave the first reasoned attribution of the monument to Sansovino, basing himself on stylistic similarities between the monument and the ground floor of the Scuola della Misericordia, as well as on the close personal ties between Zuanne da Lezze and Sansovino. He also identified the print that attributes the monument to Sansovino as being from the late 17th cent. and by Francesco Lucini and A. Forri. Douglas Lewis has discussed the da Lezze tomb on more than one occasion. In his dissertation (1979a), p. 333, n. 34, he claims that Lorenzetti was unable to decide whether the tomb was by Sansovino or Longhena. But this is not true, since Lorenzetti never mentions Longhena in connection with the tomb. Lewis then goes on to say that the monument's 'full description by F. Sansovino in 1581, 17 years before Longhena was born, means that the attribution to him [Longhena] can only have been an unconsidered suggestion [on the part of Lorenzetti]'. Since all that Sansovino states is that Priamo and Zuanne da Lezze are buried on the inside façade of S. Maria dei Crociferi (see full quote in n. 7), one can hardly designate the passage as a 'full description'. In Lewis (1979b), his review of Howard (1975), p. 39, he faults Howard for not including the da Lezze tomb in her book, and bases his assigning of the monument to Sansovino primarily on the 'special relationship' between Zuanne da Lezze and Sansovino (a point already made by Lorenzetti), and dates the monument 'from the late period of c. 1558 ff'. Lewis apparently bases this date on Priamo da Lezze's death date of 1557. But since Zuanne da Lezze's will demonstrates that the tomb was not yet finished by 1576, 19 years after Priamo's death and 6 years after the death of Jacopo Sansovino, Lewis's dating is invalid. Furthermore, the monument to Girolamo Grimani in S. Giuseppe, erected in 1582–4, more than 10 years after Grimani's death in 1570, provides additional evidence that it is mistaken to assume that tombs are invariably erected immediately after a death; for the Grimani monument, see cat. no. 8.

[16] See the quotations and comments in nn. 8 and 9.

[17] Molmenti and Fulin (1881), pp. 249–50.

[18] Bruce Boucher pointed this out to me.

[19] See cat. no. 6.

[20] Bruce Boucher and I have been discussing the da Lezze monument for many years now. In my dissertation, I gave the above quotation from Zuanne de Lezze's will and attributed the tomb to Vittoria (pp. 183–5), as I did also in Martin (1993a), p. 369. Boucher (1991), i, p. 244, also rejects the tomb as being by Sansovino. See now Dario (1994), pp. 62–9.

[21] For the above information, see G.-A. Cappellari Vivaro, *Il Campidoglio Veneto* (Bibl. Marciana, MS It. cl. VII, 8305), ii, fos. 207ʳ–209ʳ.

16. BENEDETTO MANZINI (Pls. 58–9)

Marble

Height (including the socle): 72 cm.; breadth (at shoulders): 54 cm.

Signed (on rim of right arm): ALESSANDRO VITORIA F[1]

Bust and socle are separate

Galleria Giorgio Franchetti alla Cà d'Oro, Venice

Provenance: S. Geminiano until 1807; on deposit at the Headquarters of the Knights of Malta until 1834–5; Museo Archeologico until 1927; since 1927 in the Cà d'Oro[2]

The circumstances of the commissioning of this bust are not known. Its earliest mention comes in Francesco Sansovino's *Delle cose notabili che sono in Venetia, Libri due* (introduction dated 17 September 1561). On p. 22*b* of this dialogue between a 'Venetiano' and a 'Forestiero', the two men discuss the church of S. Geminiano, which prompts the Venetian to praise the church's priest, Benedetto Manzini, for his many good qualities. He adds that the state paid for a magnificent organ in the church and then notes: 'Vedrete poi nella medesima chiesa un ritratto nella facciata entrando a man destra, di detto piovano di marmo, così espressivo della sua somiglianza, che Alessandro Vittoria, che n'è stato lo scultore, confessa tal hora di non haver a far mai meglio.' Thus, the bust was already in place by September 1561.[3]

Stylistically, the bust of Manzini is closest to that of Marc'Antonio Grimani, which dates from between 1559 and 1561.[4] In no other portraits by Vittoria are the almost violent movement and *contrapposto* of the *Grimani* and *Manzini* busts present. In addition, they are the only busts signed in Italian, not Latin. A dating of 1560–1 seems likely for the *Manzini*. Inasmuch as the bust of Manzini is not mentioned—although Manzini himself is—in the 1560 edition of Sansovino's *Dialogo di tutte le*

cose notabili che sono in Venetia, this may provide support for a dating to 1561.[5] The anecdote reported by Sansovino in 1561—that Vittoria thought the bust of Manzini to be the best thing he had ever done—would imply that the work had been recently finished. A dating to 1561 means that the bust was executed and in place nine years before Manzini died.

Vasari mentions the bust in 1568: 'et in San Geminiano il piovano di detta chiesa'.[6] Sansovino provides a good description of the sculpture's original location in the church. After stating that the bust of Matteo Eletti, a former priest of S. Geminiano, is placed between the two columns on the wall to the left of the high altar, Sansovino adds that there is 'un'altra [testa] pur di marmo di Benedetto Manzini fatta da Alessandro Vittoria, e posta anco fra due altre colonne dalla destra [of the high altar]'.[7] It has been claimed that 'Manzini's gaze is fixed on the altar so that he participated, as it were, in the Eucharist'.[8] But if Sansovino's location of the bust is correlated with the ground-plan of S. Geminiano (Pl. 61), it becomes clear that Manzini's torso originally faced the congregation as he leaned to his right and gazed at the bust of his predecessor, Matteo Eletti.[9] In fact, seven busts by Vittoria or his shop remain *in situ* in various churches; only one of them looks directly at the high altar and could qualify as an example of the 'ewige Anbetung'.[10]

A sepulchral inscription for Manzini was set up in S. Geminiano in 1552, eighteen years before his death.[11] Since the location of the inscription was never specified, it is impossible to know whether the bust was placed in conjunction with it, although this seems likely.

Benedetto Manzini was born in 1500 and died on 1 December 1570.[12] He was a canon of St Mark's and from 1545 was elected *piovano* of S. Geminiano.[13] He was also the rector (*Rettore*) of the parish of S. Paolo in Maser from 1554 to 1564; he seemingly was the first rector nominated by the Barbaro family, for whom Vittoria worked during the late 1550s.[14] In 1557, at the instigation of Manzini, the remodelling and completion of S. Geminiano was begun by Jacopo Sansovino.[15] During Manzini's last illness, he was attended by Apollonio Massa, of whom a terracotta bust by Vittoria survives.[16]

This sculpture was not the only portrait of Manzini in S. Geminiano. The figure of S. Severo in the canvasses by Veronese that functioned as the cover for the organ in S. Geminiano also portrays Manzini; Pignatti dates these pictures to around 1560 (Pl. 62).[17] On 29 October 1558, Manzini offered to spend 200 ducats on the building of a new organ, which eventually cost 600 ducats.[18]

[1] These letters were once blacked in; traces of black paint remain.

[2] S. Geminiano was torn down in 1807; see Cicogna (1824–53), iv, p. 6. Cicogna, ibid., p. 692, states that the Headquarters of the Knights of Malta was used as a depository and that the *Manzini* was there until it was moved to the Biblioteca Marciana in 1834. Valentinelli (1872), p. 17, states that this bust entered the museum in 1835. The Cà d'Oro opened on 18 Jan. 1927.

[3] This source has had a much-confused identity in the secondary literature. Cicogna (1824–53), vi, p. 814, gives the quotation reproduced in this entry and identifies it only as from a 'codicetto' in dialogue form from the late 16th cent. Moschetti (1929), p. 98, identifies the source as Anselmo Guisconi, *Cose notabili* (Venice, 1561), p. 22, but this is incorrect. Anselmo Guisconi (a pseudonym used by Francesco Sansovino) published in 1556 a book entitled *Tutte le cose notabili che sono in Venezia, dialogo 1556*; neither on p. 22 nor anywhere else is Manzini or his bust noted. Moschini (1934), p. 132, n. 23, states correctly that Sansovino mentions the Manzini bust in 1561 but cites no source. Venturi (1937), p. 148, cites the correct year, 1561, and the correct author, Sansovino, but cites the title of Guisconi's book as the source. Among later scholars, only Pope-Hennessy (1964), ii, p. 529, has heeded Moschini and Venturi and dated the Manzini bust to 'before 1561'. Giovanelli (1858), p. 32, dates the bust to 1564; Serra (1923), p. 51, to 1567; Cessi (1961b), p. 30, dates it to pre-1566 on the assumption that Vasari saw it on his trip to Venice during that year; Leithe-Jasper, in *Genius* (1983), p. 388, dates the bust to pre-1568 on the basis of its mention in the 2nd edn. of the *Lives*.

[4] See cat. no. 10.

[5] Sansovino (1560), p. 43.

[6] Vasari (1878–85), vii, p. 519.

[7] Sansovino (1561), p. 43a.

[8] Leithe-Jasper, in *Genius* (1983), p. 388.

[9] For information on Matteo Eletti and his bust—to which the *Manzini* was most likely meant as a pendant—see Schulz (1984), pp. 257 and 264. Schulz shows that this bust is by Bartolomeo di Francesco Bergamasco, not Cristoforo dal Legname as Sansovino states, and that it was in place in S. Geminiano before 17 June 1525.

[10] These busts are: *Giulio Contarini* in S. Maria del Giglio; *Marc'Antonio Grimani* in S. Sebastiano; *Alvise Tiepolo* in S. Antonin; *Vincenzo Morosini* in S. Giorgio Maggiore; *Alessandro Vittoria* in S.

Zaccaria; *Tommaso Contarini* in the Madonna dell'Orto; and *Jacopo Soranzo* in S. Maria degli Angeli in Murano. Only the last looks at the high altar. Girolamo Grimani in S. Giuseppe di Castello gazes at his portrait in the high altarpiece, but the bust was placed in its present position more than ten years after it was made and Vittoria seemingly had nothing to do with its present location; see cat. no. 8. The same circumstances apply to the bust of Priamo da Lezze in the Gesuiti; see cat. no. 15. For the concept of the 'ewige Anbetung', see Bruhns (1940), *passim*.

11 Cicogna (1824–53), iv, p. 108: BENEDICTUS MANZINUS | IN D. MARCI AEDE CANON. | IN H. ANTISTES H.S. DE | FUNCTOR. DIVER- SOR. V.P. | UBI DIEM PERMANSURAE | QUIET. EXPECTANS SUCC. S. | IN FRATER. HOSPIT. GRA | TIS INVITAT MDLII ('Benedetto Manzini, a Canon of S. Marco, and the pastor of this church, while living, set up this tomb, a guest-chamber of the dead; awaiting the day of abiding death, he freely invites his successors to the hospitality of the brotherhood. 1552').

12 Ibid., p. 108. Cicogna publishes Manzini's necrology.

13 Ibid., p. 108.

14 Ibid. For Vittoria and the Barbaro, see Ch. 4, above. For Manzini and Maser, see Bassi (1968), pp. 46 and 134.

15 For Manzini and S. Geminiano, see Howard (1975), pp. 81–2. On p. 82, Howard states that the busts of Eletti, Manzini, and Tommaso Rangone (also by Vittoria) were placed in the church 'in recognition of their efforts [to build the church]', implying that all three busts were put in the church at the same time, but this is not the case. For the bust of Rangone, see cat. no. 20. Sansovino, Rangone, and Vittoria were all also involved at just about the same time with the rebuilding of S. Giuliano.

16 Cicogna (1824–53), iv, p. 108. See also cat. no. 17 for the bust of Massa.

17 Pignatti (1976), i, p. 124, no. 120 with bibliography. On the Venetian practice of pairing S. Geminiano with S. Severo, see Tramontin (1965), pp. 147–8 and 153. Vittoria and Veronese were both at work in S. Geminiano not long after they had both worked at S. Sebastiano. To the best of my knowledge, that Manzini is por- trayed in the painting as S. Severo has never previously been noticed.

18 Gallo (1957), p. 97, n. 82, cites a document from 29 Oct. 1558 in which Manzini offers the 200 ducats for the organ (in an earlier article, Gallo (1939), p. 145, the date of the document is given as 9 Oct.). Gallo also, p. 97, quotes from Manzini's will that he paid for the 'novo l'organo doppio cum li suoi ornamenti'. In his 1939 article, p. 145, Gallo cites a 17th-cent. document that also says that Manzini paid for the organ and that the instrument cost 600 ducats. But Sansovino, in 1561 (see n. 3 and text), writes that the state paid for the organ. Perhaps Manzini paid 200 ducats and the state paid the remaining 400.

17. APOLLONIO MASSA (Pl. 109)

Terracotta; the bust has never been gilded[1]
Height: 77 cm.; breadth: 63 cm.; socle: 10 cm.; baseline: 45 cm.
Unsigned
Bust and socle are in one piece
Pinacoteca Manfrediana, Seminario Patriarcale, Venice
Provenance: Church of the Convertite della Giudecca until

1817; collection of David Weber until 1822; from 1822 at the Seminary

Cicogna gives the earliest notice of this bust and its first attribution to Vittoria, stating that it was in the Church of the Convertite until 1817, where he himself saw it, placed above an epitaph which he records as APOLLONIUS MASSA MED- ICUS ET PROCURATOR MONASTERII. MDLXXXVII.[2] Cicogna continues: 'Cosicché abbiamo l'epoca dell'opera del Vittoria che è senza nome dello scultore.'[3] He further adds that the bust was donated to the Seminary in 1822.

Gianantonio Moschini provides the information that David Weber gave the bust to the Seminary. He also states that the nuns of the Convertite erected the monument—which was not Massa's tomb; he was buried in S. Domenico di Castello as was his uncle, Niccolo—in thanks to him for all the services he rendered to them as their doctor, and notes that a marble bust of Apollonio is in the Ateneo Veneto.[4]

Both Planiscig and Serra agree with Cicogna that the date of the epitaph, 1587, provides a dating for the bust.[5] But Lorenzetti, Vittorio Moschini, and Cessi all assign it to before 1572 on the grounds that it is the model for the marble bust of Apollonio, in the Ateneo Veneto since 1810, gener- ally attributed to Vittoria, and dated to 1572.[6] There are no grounds for this latter view, inasmuch as the marble of Apollonio is not by Vittoria.[7]

Although the terracotta is unsigned and appar- ently was not once mentioned throughout the seventeenth or eighteenth centuries, there seems no reason to doubt that it is by Vittoria and that the date of the inscription that was originally over it reflects the date of its execution.[8] The nuns of the Convertite were supposedly the patrons: why would they erect in 1587 an inscription to Massa and place on it a bust that predated 1572? Where would this bust have come from? From Massa? Had it already been in the convent? Unlike a bust on a tomb, which could pre- or postdate by many years the death of the sitter, there is no reason to doubt that an honorary monument set up to a person

during his lifetime should not date from the year inscribed on that monument.

Furthermore, the bust fits into the late 1580s on stylistic grounds. The squarish shape of the torso is, for instance, quite close to that of the marble bust of Francesco Duodo which I date for independent stylistic reasons to the second half of the 1580s.[9] Furthermore it is only in the 1580s that, with the busts of Doge da Ponte and of Antonio Zorzi, terracotta busts begin to be displayed as public images.[10]

Apollonio was the son of Antonio, who was the brother of Niccolo Massa (cat. no. 18); Cicogna supplies a brief biography.[11] Apollonio studied at his uncle's expense in Italy and at Leipzig, to which city he departed from Venice on 5 October 1538. He received his doctorate there, returning to Venice in 1542; that same year, he entered the Collegio Fisico. He married in 1551 and lived in the parish of S. Provolo. In 1575, he was one of the doctors and surgeons assigned by the *Magistrato alla Sanità* to fight against the plague. He died on 22 June 1590; his necrology reports his age as 75, thus giving a birth date for him of 1514 or 1515.[12]

[1] Information provided by Monsignor Antonio Niero.
[2] Cicogna (1824–53), iv, p. 691, no. 1.
[3] Ibid.
[4] Moschini (1842), p. 142.
[5] Serra (1923), p. 79; he erroneously states that the bust remained in the Convertite until 1882; Planiscig (1921), p. 511.
[6] Moschini (1940), p. 15; Lorenzetti (1963), p. 510; Cessi (1961b), p. 39. See cat. no. 74 for the marble bust of Apollonio.
[7] Ibid.
[8] The bust is noted neither by Stringa nor Martinioni, nor have I found any other notice prior to Cicogna's. Moschini does not mention it in his 1827 edition of Temanza; apparently he knew of its existence only after Weber gave it to the Seminary.
[9] See cat. no. 4.
[10] See cat. nos. 19 and 49.
[11] For the information below, see Cicogna (1824–53), ii, p. 429.
[12] The necrology is ASV, Provveditori e Sopravveditori alla Sanità, b. 822, c.48 v: 'adi 22 Zugno 1590: l'ecelente m[esser] Apolonio masa de ani 75 da febre già uno mese. s[an] provolo.'

18. NICCOLO MASSA (Pl. 79)

Marble
Dimensions unknown; over life-size
Signed (on rim of right shoulder:) ALEXANDER. V. F.

Bust and socle are in one piece
Ateneo Veneto, Venice
Provenance: the cloister of S. Domenico di Castello until 1807; in deposit until 1810; from 1810, in the Ateneo Veneto[1]

The bust of Niccolo Massa was originally on Massa's tomb in the main cloister of S. Domenico di Castello, as reported by Francesco Sansovino in 1581:

Et nel suo Chiostro principale giace in bellissimo sepolcro di marmo in aria, compartito in due parti, Nicolò Massa Filosofo & Medico illustre di tempi nostri, il quale ha scritto diverse opere, che vanno per le mani de gli huomini dotti, & fu riputato & stimato molto dalla nobilitate Venitiana, eretto da Maria Grifalconi sua figliuola al suo nome, col ritratto di marmo scolpito da Alessandro Vittoria . . .[2]

There it remained until the Napoleonic suppression of S. Domenico in 1807.

The inscription on the tomb, today preserved in the courtyard of the Seminario Patriarchale, reads: NICOLAI | MASSAE | MAGNI | PHIL. AC | MEDICI | OSSA. | MARIA. F[ilia] P[osuit] | M.D. LXIX ('Maria [his] daughter placed [here] the bones of Nicolo Massa, the great philosopher and physician. 1569').

Just because the tomb was set up in 1569 does not mean the bust was commissioned then. In his will of 28 July 1569, Massa writes:

Inanzi ordeno che la mia sepultura sia fata nel monasterio de San Domenego da Castello segondo l'ordine descrito in uno mio testamento fato peravanti de man proprio, intendendossi levate quelle parolle de pompa e vanità.[3]

Cicogna records that Massa made an earlier will in September 1566; this is probably the will made 'peravanti' referred to by Massa in 1569.[4] I have not been able to find this will from 1566. But since in that will he ordered how he wanted his tomb to be, perhaps he also made arrangements at that time about his bust. A safe dating for the portrait would be 1566–9.

Both Cicogna and J. R. Lind provide full biographies of Niccolo Massa.[5] Born in Venice on 14

March 1489, he studied navigation before turning to the arts and sciences. In 1515, he received his doctorate in surgery from the Collegio Fisico in Venice, where he also took his *laurea* in medicine in 1521. He was especially renowned as an expert on syphilis and has been called the last great pre-Vasalian Italian anatomist. He died on 27 August 1569.[6]

Vittoria and Massa seem to have known each other. There is one entry in Vittoria's account book where he records having bought some flour from Massa:

Adi 20 Setembrio 1568. Ricordo io Alessandro Vitoria chome questo dì s[e]sto contai al gastaldo del S[ign]or Nicolo Massa scudi disnove per resto e saldo di dieci stara di farina, presente il servitor dil S[ign]or Nicolo, dal fronte roto . . . Scudi, no. 19-.[7]

One of the witnesses to Massa's will from 1569 was Giovanbattista Peranda, of whom Vittoria made a bust in 1586.[8] The artist also fashioned a terracotta bust of Niccolo's nephew, Apollonio Massa, now in the Seminario Patriarchale.[9]

[1] S. Domenico di Castello was suppressed and destroyed in 1807. In 1806, the Scuola di S. Fantin was also suppressed, and in 1808 this building was taken over by the Società Veneta di Medicina. In 1810, the society was given permission by the Demanio to collect the tombs of physicians from suppressed churches. This is how the bust of Massa (and of Rangone, cat. no. 20, and of Apollonio Massa, cat. no. 74) came to this building which, in 1811, became the seat of the Ateneo Veneto; see Pavanello (1914), p. 66.

[2] Sansovino (1581), p. 5*b*.

[3] ASV, Notarili e Testamenti, Marcantonio Cavanis, b. 196, no. 870.

[4] Cicogna (1824–53), ii, p. 428.

[5] See Cicogna (1824–53), i, pp. 113–14, and ii, p. 428; and also Lind (1975), pp. 167–73.

[6] Tassini (1887), p. 298, publishes Massa's necrology.

[7] Predelli (1908), p. 134.

[8] For the *Peranda*, see cat. no. 43.

[9] For the terracotta bust of Apollonio, see cat. no. 17. The marble bust of Apollonio Massa, enshrined with Niccolo's in the Ateneo Veneto, is not by Vittoria; see cat. no. 74.

19. NICCOLO DA PONTE (Pl. 90)

Terracotta
Height (with socle): 100 cm.; breadth: 78 cm.
Signed (on rim of right arm): A.V.F.

Bust and socle are in one piece
Pinacoteca Manfrediana, Seminario Patriarcale, Venice
Provenance: on da Ponte's tomb in S. Maria della Carità until 1807; from 1807 in the Seminario Patriarchale[1]

In 1582, Doge Niccolo da Ponte entrusted the commission for his tomb in S. Maria della Carità to Marc'Antonio Barbaro.[2] Vincenzo Scamozzi was the architect of the monument, Girolamo Campagna executed the figural sculpture, and Vittoria made the bust.[3] The tomb is described as finished by 15 April 1584, and thus the bust was presumably modelled between 1582 and 1584.[4] In his will of 6 June 1585, da Ponte states that the bust is in place.[5] An eighteenth-century print by Dionisio Valesi depicts the tomb before its destruction in 1807.[6]

The monument is the first ducal tomb to feature a portrait bust; previously, full-length figures were the norm.[7] It is remarkable that the Doge should have himself represented in the lowly medium of terracotta.[8] One of only two autograph terracottas by Vittoria for a tomb, it is by far his largest portrait, his only half-length, and his only bust of a Doge in ducal regalia.[9]

The immense, spreading volume of da Ponte's robes corresponds with similar characteristics found on other busts from the 1580s such as the Costabile and Zen busts (see cat. nos. 2 and 23).

Niccolo da Ponte, the eighty-seventh Doge of Venice, was born on 15 January 1491.[10] A distinguished diplomat, he served as *Rettore* at Corfu, *Luogotenente* of Udine, and *Podestà* of Padua, as well as the Venetian ambassador to the Council of Trent, Emperor Charles V, and Francis II. Knighted by Pope Paul III, he was elected a Procurator *de Ultra* on 30 July 1570. Elected Doge on 11 March 1578, he died on 30 July 1585.

[1] S. Maria della Carità was suppressed in 1807 and turned into the Accademia delle Belle Arti; see Zorzi (1972), i, pp. 102–6. For the dismantlement and dispersion of the tomb, see Selvatico (1847), p. 349. For the inscription from the tomb, see Moschini (1842), p. 74.

[2] Sansovino (1604), p. 427*b*: 'Venuto fermo pensiero l'anno 1582 al Doge Ponte . . . di voler fare il suo Deposito nella Chiesa della Carità . . . diede carico di terminare essa opera a

Marc'Antonio Barbaro Cavaliere . . . il sudetto Scamozzi Architetto . . . hebbe il carico, et ordino l'opera . . . il ritratto di detto Prencipe, [è] fatto da Alessandro Vittoria, Scultore celebre . . .'

[3] See n. 2 for Scamozzi and Vittoria; for Campagna, see Sansovino (1604), p. 186a.

[4] Scamozzi (1619). The introduction to this book is by Lodovico Roncone and is dated 15 Apr. 1584. On the third page of the introduction, Roncone mentions the tomb of da Ponte among the examples of Vincenzo Scamozzi's architecture, hence, the tomb must have been finished by that date.

[5] ASV, Notarili e Testamenti, C. Zilliol, b. 1260, no. 780: 'Il no[stro] corpo vogliamo che sia posto nella n[ostr]a Arca, et Monumento, ch'abbiamo fatto fare alla Carità, et la n[ostr]a figura è stata posta sopra esso, fatta di Mano di Aless[andr]o Vittoria.'

[6] The print is in the Gherro collection in the Museo Civico Correr, Venice, 4, nos. 487 and 489.

[7] A good survey of the situation is found in Da Mosto (1939). See also Ch. 7, above.

[8] See the discussion of the terracottas in Ch. 7, above.

[9] Although Vittoria did make busts of Marino Grimani and Sebastiano Venier, who subsequently became Doges, they are portrayed as Venetian patricians; see cat. nos. 11, 12, and 22. The other sepulchral terracotta bust that is autograph is the *Giovanni Battista Gualdo*; see cat. no. 14.

[10] A full biography and bibliography for da Ponte are found in Brown (1974). See also now Gullino (1986), pp. 723–8.

20. TOMMASO RANGONE (Pl. 80)

Bronze
Height: 81 cm.
Unsigned
Bust and socle are in one piece
Ateneo Veneto, Venice
Provenance: S. Geminiano until 1807; on deposit at the Demanio until 1810; from 1810 in the Ateneo Veneto[1]

The first mention of this bust comes in Rangone's will from August 1577 in which he speaks of his 'D. atque giminiani sub porticu aere meo honestiori, meis cum insignibus inscriptionibus, cupreaque imagine, pulcherimoque (my beautiful and faithful bronze portrait which, with my notable inscriptions, is above the door at S. Geminiano)'.[2] Sansovino, in 1581, notes the bust in S. Geminiano: 'Et su la porta per fianco verso S. Moisé, la testa di bronzo di Tomaso da Ravenna, Procurator della Chiesa.'[3] He gives no attribution, as does neither Stringa nor Martinioni and, remarkably, the first attribution to Vittoria came only in 1881 in the guidebook by Molmenti and Fulin.[4]

Cicogna published a record from the archives of S. Geminiano testifying that, on 15 September 1571, Rangone was granted permission to construct a *sottoportico* near the sacristy and to place his bust there along with an inscription.[5] Later scholarship has taken the 1571 date as that of the execution of the bust.[6]

But such a dating is too early. While Rangone's will from 1577 gives the *terminus ante quem*, the concession granted to Rangone in 1571 does not necessarily provide the date of the bust, although it does probably give the date of its commissioning.

Stylistically, the busts of Giulio Contarini, Girolamo Grimani, and Rangone form a coherent, related group in terms of pose, attitude, richness of modelling, and chiaroscuro effects. The bust of Grimani was paid for in 1573, the *Contarini* is mentioned in 1576, and the *Rangone* in 1577.[7]

Among these busts, the most significant difference is in the shape of the silhouette. Whereas in the *Contarini* the shape of the torso and silhouette are squarish and the movement of the left shoulder, while noticeable, is not strong, in the *Grimani* the movement of the left shoulder and its projection beyond the edge of the socle are quite pronounced. Since this effect is further increased in the *Rangone*, as is the way the baseline juts straight out from the socle, the chronological sequence would seem to be: *Contarini*, c.1571, *Grimani*, 1573, and *Rangone*, c.1575. These same effects of increasing the breadth of the torso and extending the baseline straight out from the socle are then carried still further in the busts of Ottaviano Grimani and Orsato Giustiniani from the second half of the 1570s.[8] The *Rangone* is Vittoria's only bronze bust.

Weddigen gives a full account of Rangone's life and activities as a scholar and patron.[9] Born in 1493 in Ravenna as Tommaso Giannoti, he studied in Ferrara, Padua, and Bologna. In the 1520s, he was in the service of the condottiere Guido Rangone, from whom he took his name. From 1534, he practised medicine in Venice. The author of treatises on syphilis as well as the plague, he also worked as an astrologer. An expert on hygiene, he advised the

Provveditori alla sanità and lectured on anatomy. In 1551, he founded a house in Padua where thirty-two students from Venice and Ravenna could prepare for the university.

In 1562 he became the guardian of the Scuola Grande di S. Marco and in the following year was knighted by Doge Girolamo Priuli. While guardian of the Scuola—whose robes he wears in the bust—Vittoria became a member. Both at this time and when he was again guardian in 1568, Rangone commissioned paintings from Tintoretto for the Scuola.

He was a Procurator of S. Geminiano, S. Giuliano (which was restored at his expense by Sansovino and Vittoria), S. Giovanni in Bragora (Vittoria's parish), S. Sepolcro, and SS Giovanni and Paolo. In 1572, the Emperor Maximilian II created him a palatine count. Rangone died on 10 September 1577.

For Vittoria's participation in the bronze statue of Rangone over the portal of S. Giuliano, see Chapter 4, above. The artist also made a statue of Rangone as St Thomas, now in the Seminario Patriarchale, that originally stood over the portal of the convent of S. Sepolcro.[10] Rangone witnessed Vittoria's will of 24 October 1566, in which the artist willed to Rangone, 'per molte cortesie haute da sua magnificentia', the statue of St Thomas mentioned above.[11]

[1] S. Geminiano was torn down in 1807; see Zorzi (1972), ii, p. 334. See cat. no. 18 for why busts of physicians were gathered at the Scuola di S. Fantin, now the Ateneo Veneto.

[2] ASV, Notarili e Testamenti, B. Fiume, b. 421, no. 1172, fo. 2 v. According to the heading on the will, it was written on 10 Aug. 1577.

[3] Sansovino (1581), p. 43*a*.

[4] Molmenti and Fulin (1881), p. 158.

[5] Cicogna (1824–53), vi, p. 821. See also Jacopo Morelli, *Alcune memorie spettanti alla chiesa ora demolita di S. Geminiano in Venezia* (Bibl. Civ. Correr, Cod. Cicogna 980), p. 33, n. 14.

[6] Serra (1923), p. 61, Planiscig (1921), p. 483, and Pope-Hennessy (1970*a*), p. 416, all date the bust to 1571. Venturi (1937), p. 156, gives a very garbled account, stating that the bust was taken from S. Geminiano and put in the Ateneo Veneto in 1571. Cessi (1961*b*), p. 38, places it in the early 1570s. Leithe-Jasper, in *Genius* (1983), p. 389, writes that it was presumably made shortly after the concession of 1571.

[7] For the busts of Contarini and Grimani, see cat. nos. 1 and 8.

[8] For the busts of Giustiniani and Ottaviano Grimani, see cat. nos. 7 and 13.

[9] Weddigen (1974), pp. 7–76.

[10] See ibid., pp. 68–9.

[11] Gerola (1924–5), pp. 342–5.

21. TOMMASO RANGONE (Pl. 81)

Terracotta
Height: 81 cm.; socle: 10 cm.; breadth: 68 cm.
Unsigned
Museo Civico Correr, Venice
Provenance: passed with Rangone's library to the Capuchin monks at the Redentore after Rangone's death; in the collection of the Marciana by 1842; from there to the Museo Correr between 1859 and 1899[1]

The first mention of this bust appears in Cicogna: 'Busto al naturale, rappresentante un Veneto Magistrato. È in terra cotta. Ha di dietro le solite sigle A.V.F., sta nel Museo Marciano; e dicesi nel catalogo: "proveniente dalla Chiesa de' Cappuccini di Venezia".'[2] Although the present bust is unsigned, this notice must refer to the *Rangone* because it is the only bust by Vittoria with a provenance from the Redentore, the church of the Capuchins in Venice.[3] Rangone's library passed to the Redentore, where it remained until the nineteenth century, when it was broken up, with many volumes then passing to the Marciana.[4] Weddigen assumes that the terracotta passed to the Redentore along with the books, and Cicogna's later location of the terracotta as the 'Museo Marciano' confirms this assumption. Lazari does not mention the terracotta in his catalogue of the Museo Correr from 1859, hence the bust must still have been in the Marciana at that time.[5] It must have entered the Museo Correr prior to 1899, however, because it is mentioned in the list of works in the museum compiled in that year.[6] This latter work is apparently the first time the bust was correctly identified.

All scholars except Serra have taken the terracotta as the model for the bronze and all, without

exception, date the bronze to *c.*1571 because that is when Rangone received permission to erect a bust of himself in S. Geminiano.[7] On stylistic grounds, however, the bronze makes sense as coming after the marble bust of Girolamo Grimani, finished in 1573; I date the bronze to *c.*1575.[8] Serra, because he feels that Rangone looks older in the terracotta than in the bronze, thinks that the terracotta must be 'some time after' the bronze.[9]

In comparing the bronze with the terracotta, one sees that the faces and attitudes are identical; the only significant difference comes in how the torso is terminated. While the baseline of the bronze is straight directly above the socle, and then curves up gradually on the left side to the termination of the arm and moves up in steps to the termination of the arm on the right side, the baseline of the terracotta runs straight across its whole length; more accurately, it runs along a slightly downward curve from left to right, and moves directly out into space from each side of the socle. Furthermore, the forward movement of Rangone's right shoulder and the backward motion of his left shoulder are more pronounced in the bronze than in the terracotta. The central fold of his robe also differs from bronze to terracotta: in the bronze, it moves down along the central axis from his beard to the centre of his chest and then curves to the left; in the terracotta, it runs along a straight diagonal from slightly to the right of the central axis at the top, ending slightly to the left of the central axis above the socle.

Why are there these differences and what do they mean? One technical or physical feature of the terracotta that has never been noted is that the head is attached to the torso, a feature not found in any other autograph terracotta by Vittoria. A very noticeable join runs all around the collar; the join is cracked directly behind the beard, where there is some solder-like material.

I would suggest that this feature indicates that while the head of the terracotta was used as a model for the head of the bronze, the torso was added later, and this explains why its shape differs from the torso of the bronze. In the bronze, Vittoria is still experimenting with a combination of straight and rounded terminations. Completely straight terminations begin only with pieces such as the *Ottaviano Grimani* from the latter half of the 1570s.[10] Hence, I would suggest that while the head of the terracotta served as the model for the bronze, the torso comes from somewhat later, perhaps *c.*1576–7.

It is also not impossible that the torso of the *Rangone* served in the workshop as the model torso for the busts from the 1580s that show a baseline extending straight out from the socle, such as in the busts of Vincenzo Morosini and Antonio Zorzi.[11] This would also help to explain why the head here is attached to, rather than integral with, the torso, and why the torso is unsigned.

See cat. no. 20 for a biography of Rangone.

[1] See below.
[2] Cicogna (1824–53), v, pp. 666–7, no. 4 (vol. v was published in 1842); I have been unable to find anything corresponding to the 'catalogo' mentioned by Cicogna; despite Cicogna's assertion, the bust is not signed.
[3] See Lorenzetti (1949). The *Rangone* is entered on p. 64, no. 106, and its provenance given as 'Dono dei Frati Cappuccini del Redentore. Cl. XXVII, no. 110.'
[4] Weddigen (1974), p. 68.
[5] Lazari (1859). The only terracotta by Vittoria cited by Lazari is that of Francesco Duodo, which Lazari thought represented Sebastiano Venier (see cat. no. 5).
[6] *Correr* (1899), p. 52, n. 114: 'Vittoria, Alessandro—n. 1525 m. 1608—Tommaso Rangone detto il Filologo Ravennate—d. Frati Cappucini del Redentore.'
[7] See cat. no. 20.
[8] Ibid. See also the discussion in Ch. 6, above.
[9] Serra (1923), pp. 61–2 and 88.
[10] See cat. no. 13 for the bust of Ottaviano Grimani.
[11] See cat. nos. 42 and 49. In Ch. 7, above, I suggest that the *Pietro Zen* provided the model torso. It is of course possible that the torso now attached to the terracotta head of Rangone was originally made in the mid-1580s in connection with the *Zen*.

22. SEBASTIANO VENIER (Pl. 89)

Marble
Dimensions unknown; over life-size
Signed (on rim of left arm): [ALEXANDER ?] < VICTORIA

Bust and socle are in one piece (?)
Palazzo Ducale, Venice

The first notice of this bust appears in Vittoria's will from 1608:

Lasso il retratto [sic] del Ser[enissi]mo Principe Sebastian Veniero di marmo in habito di generale a questa Ser[enissi]ma Signoria acciò sia reposto nelle salle dell'Ecc[elentissi]mo Conseglio [sic] di Dieci come cosa rara per felicissima memoria della vittoria.[1]

The 'most happy victory' referred to is the battle of Lepanto where, in October 1571, the Venetian navy, under the command of Venier, together with Spanish forces, defeated the Turkish navy. Vittoria's bequest to the government was accepted and the bust has been in the Ducal Palace since 1609.[2]

No documentary evidence exists as to when the bust was made, only that it was in the artist's possession when he died and that, judging from Vittoria's words in his will, it was made to commemorate in some way the sitter's victory at Lepanto. Stylistically, the bust makes sense as dating from the late 1570s on account of its affinities with the busts of Orsato Giustiniani and Ottaviano Grimani, both from the late 1570s (Pls. 87 and 82).[3] The bust is integral with its socle, implying that it was meant as a private image. I can offer no plausible reason as to why it was in Vittoria's studio at the end of his life.

Martinioni makes no reference to this bust. Its earliest mention seems to be in Moschini-Temanza, where Moschini states that Vittoria left it to the Republic in his will and describes it as 'ora nel Tribunale dell'Apello'.[4] Giovanelli claims that Vittoria made this bust 'per proprio conto' in July 1596 and kept it in his possession because of the esteem in which the artist held Venier.[5] He further states that the bust was originally in the room of the Council of Ten, where it remained until the fall of the Republic. Serra agrees with Giovanelli's dating but says that, contrary to Vittoria's wishes, the bust was erected in 1608 above the door of another room.[6] Planiscig also places the bust in the 1590s.[7] Venturi, as usual, offers no dating, but places it

among busts from the 1580s.[8] Cessi correctly places the bust in the late 1570s, c.1577–8.[9] The bust is now above the door to the stairs leading to the Sale d'Armi and was originally set up, as the inscription shows, in 1609, not 1608.[10] Whether this is its original location is doubtful; while Giovanelli is not a reliable source, Moschini is, and the latter's notation that the bust is 'now' in the Tribunale dell'Apello implies that it was originally elsewhere.[11]

Born c.1496, Venier was elected Doge on 11 June 1577 and died on 3 March 1578. Buried in S. Maria degli Angeli on Murano, no monument was erected to him until 1907, when his remains were transferred to SS Giovanni e Paolo.[12]

[1] Predelli (1908), pp. 224–5.
[2] The inscription on the moulding of the wall below the bust reads: SEBASTIANO VENERIO PRINCIPI INVICTIS NAVALI VICTORIA AD ECHINADAS CLARISS. | LEONARDUS MOCENICUS HUIUS ARMAMEN. PRAEFECT. P. C. | ANNO CD. DC.VIIII, thus informing us that the memorial was set up in 1609.
[3] See cat. nos. 7 and 13.
[4] Temanza (1827), p. 52, n. 58, no. 5.
[5] Giovanelli (1858), pp. 92–3.
[6] Serra (1923), p. 83.
[7] Planiscig (1921), p. 518.
[8] Venturi (1937), pp. 170–1.
[9] Cessi (1962), pp. 7–8.
[10] This is noted correctly by Lorenzetti (1963), p. 266.
[11] I do not know to what current room the Tribunale dell'Apello refers.
[12] Da Mosto (1960), pp. 287–91, and Lorenzetti (1963), p. 348.

23. PIETRO ZEN (Pl. 108)

Terracotta
Height (with socle): 74 cm.; breadth: 62 cm.
Signed (on rim of left arm): ALEX. VICTOR. F
Inscribed (on socle): PETRUS ZE; (on rim of right arm): A.AE.LXV.
Bust and socle are in one piece
Pinacoteca Manfrediana, Seminario Patriarchale, Venice
Provenance: in the palazzo Zen near the Frari until the 1830s; from then in the Seminario Patriarcale[1]

The first mention of this bust occurs in Cicogna in 1830: 'No. 2. Busto in terracotta rappresentante il patrizio PIETRO ZEN, sta in casa Zeno a 'Frari, e

sperasi che per dono del nobil possessore abbia a passare a decorar le pareti del nostro Seminario. Ha il nome dello scultore.'[2] The bust had been given to the Seminary by 1838, since Cicogna notes it as there in that year.[3] In his guide to the Seminary, Moschini writes that the portrait was donated by 'dama Chiara Zen, contessa Carlotti'.[4]

There are two schools of thought as to the date of this bust: those who believe that the A.AE.LXV ('ad aetatem 65') refers to Vittoria and those who believe that it refers to Zen.[5] The latter is preferable, and this would date the bust to 1583–5, close to the *Costabile* and *da Ponte* busts. In its masterful command of terracotta and in the sense of scale communicated by the expanding edges of the robe, the *Zen* seems very similar to the *da Ponte* while the introspective, sorrowful mood of Zen's face reminds one of the equally inner mood of the *Costabile*.

Furthermore, the torso of this bust served as the model torso for busts from Vittoria's workshop starting with that of Vincenzo Morosini.[6] Because the *Morosini* dates from 1587–8, the *Zen* must thus precede it.

Pietro Zen was the son of the Procurator Girolamo. His most notable accomplishment, which Sansovino mentions, was that in 1553 he revived the ceremonies held in S. Marco in memory of his famous forebear, Cardinal Zen. At that time, Pietro was the head of the Forty.[7] In 1585, he was one of the electors of Doge Cicogna. Born in 1520, he died in 1591. Although often described as a Procurator, Zen never achieved that rank.[8] His brother, Simon, was a noted collector of antiquities.[9]

[1] See below.
[2] Cicogna (1824–53), iii, p. 513.
[3] Cicogna (1824–53), iv, p. 691.
[4] Moschini (1842), p. 142.
[5] Moschini, ibid., p. 142, Serra (1923), p. 78, and Planiscig (1921), p. 511, all think the age written on the bust refers to Zen; Cessi (1962), p. 19, believes that it refers to Vittoria, thus dating the bust to 1590.
[6] See cat. no. 42.
[7] Sansovino (1581), p. 201a. Sansovino also provides the information as to what office Zen held at that time and who his father was.

[8] See, for instance, Cessi (1962), p. 19. In the Seminary, the bust is labelled 'Procuratore Zen'.
[9] See Zorzi (1988), p. 71.

24. YOUNG MAN ('ZORZI')
(Pls. 112–13)

Terracotta
Height (with base): 90.2 cm.; breadth: 61.6 cm.
Signed (on rim of right arm): A.V.F.
Bust and socle are in one piece
National Gallery of Art (Kress Collection), Washington, DC
Provenance: palazzo Carregiani (formerly Zorzi), Venice; Oesterreichisches Museum für Kunst und Industrie, Vienna, in 1865; transferred to the Kunsthistorisches Museum in 1940; acquired by Kress in 1954[1]

The first mention of this bust came in 1858 in Gar's publication of Giovanelli's manuscript about Vittoria. At the back of the book, Gar printed 'Notizie' about the artist communicated to him by Emanuele Cicogna and Vincenzo Lazari which contains the passage:

Nell'anno scorso 1854 ho veduti tre busti in terra cotta nel cortile della casa Carragiani, al Ponte dei Greci, sul rivo di San Lorenzo. Due sono di donna, uno di uomo.[2] Uno dei due ha le parole ALEX·VICTORIA·F· nel solito lembo di dietro. Quello dell'uomo ha le speciali sigle A.V.F. pure di dietro. Quel palazzo, che è Carragiani oggidì, era al tempo del Vittoria della famiglia Zorzi o Giorgi; ed è quindi presumibile che quei tre busti rappresentino personaggi di casa Zorzi. E tanto più il crederei, che il Vittoria stesso si sa avere lavorato di stucchi in quel palazzo.[3]

Because of the original location of this, and the other two, terracottas, the sitters have traditionally been considered members of the Zorzi family.

Of great sensitivity and freshness, this portrait of a young man—unique in Vittoria's œuvre in being the only bust of someone not of mature or advanced years—is difficult to place chronologically. It corresponds most closely, in terms of the deep modelling of the drapery and the irregular termination, with the portrait of an unknown man

in armour in the Victoria and Albert Museum, London (cat. no. 26), similarly undated. Planiscig included all three busts from the palazzo Carregiani in his discussion of Vittoria's latest busts from the 1590s, but this is surely too late—the colour and vividness of the present bust have nothing to do with the dull, lacklustre portraits of the 1590s.[4] Serra placed it in the early 1560s, which is too early—Vittoria was still using a rounded termination at that time.[5] I agree with Cessi, who dates it to the 1570s, near the two versions of Tommaso Rangone.[6] The richness of modelling in the 'Zorzi' and the magisterially sensitive rendering of the face indeed resemble the Rangone and other busts from the later 1570s, such as the Orsato Giustiniani (cat. no. 7), Ottaviano Grimani (cat. no. 13), and Sebastiano Venier (cat. no. 22). With the exception of the bust of Doge da Ponte, this is Vittoria's largest terracotta.

[1] Full details concerning the provenance can be found in Middeldorf (1976), pp. 76–7. See now also Sculpture (1994), p. 234. The inventory number is 1961.9.106.

[2] The busts of the two women are cat. nos. 27 and 81.

[3] Giovanelli (1858), p. 119 (this communication was written by Cicogna).

[4] Planiscig (1921), p. 521.

[5] Serra (1923), p. 48.

[6] Cessi (1962), p. 38.

25. PORTRAIT OF A MAN (Pls. 94–5)

Terracotta
Height: 83.8 cm.
Signed (on rim of right arm): ALEXANDER VICTOR F
Bust and socle are in one piece
Victoria and Albert Museum, London
Provenance: palazzo Manfrin, Venice; F. Cavendish-Bentinck Coll., acquired prior to 1870; since 1871 in the Victoria and Albert Museum[1]

This portrait of an unknown man is very close, in overall stylistic features, especially in terms of the silhouette, the modelling of the drapery, and the termination of the baseline, to the marble of Ottaviano Grimani in Berlin (cat. no. 13, Pl. 82).

Compositionally, it is almost the reverse of the Grimani, except that this sitter's head bends slightly foward as it turns. On account of its close resemblance to the Grimani, this terracotta can be safely assigned to the second half of the 1570s.

The bust is discussed only by Pope-Hennessy and Cessi. The former does not suggest any dating, while the latter puts the bust in the late 1580s, after that of Vincenzo Morosini (cat. no. 42).[2] But this is too late, as evidenced by the dry, schematic quality of the Morosini (Pl. 103) itself. When acquired by the Victoria and Albert Museum, the cartouche on the socle carried a painted inscription reading: PAOLO VERONESE. The features of the sitter do not correspond to those of Veronese and the inscription was removed when the bust was cleaned.[3]

I fully agree with Pope-Hennessy that this bust and cat. no. 26 are the only autograph terracottas by Vittoria out of the six left to the Victoria and Albert by Cavendish-Bentinck.[4] These two possess a dynamic quality and brio of execution totally missing in the other four busts which are all static, matte, and bland. Nevertheless, I should like to point out that Pope-Hennessy compares the two autograph terracottas with busts that are not by Vittoria himself: the bust of 'Pietro Zen', in Berlin, is from the workshop (see cat. no. 48), and the bust of 'Francesco Duodo' in the Musée Jacquemart-André is a copy of the portrait of Paresano Paresani on his tomb in S. Fantin by Giulio del Moro (see cat. no. 73).

[1] Full information as to the provenance of this bust can be found in Pope-Hennessy (1964), ii, p. 531. This piece is described on p. 532, no. 571, inventory number A.11–1948.

[2] Ibid., pp. 533–4; Cessi (1962), pp. 15–16.

[3] Pope-Hennessy (1964), ii, p. 532, no. 571.

[4] Ibid., pp. 533–4.

26. MAN IN ARMOUR (Pls. 96–7)

Terracotta
Height: 82.6 cm.
Signed (on rim of right arm): A. V. F.

Bust and socle are in one piece
Victoria and Albert Museum, London
Provenance: see cat. no. 25

This terracotta seems closely related to cat. nos. 24 ('*Zorzi*'), 25, and to the bust of Apollonio Massa (cat. no. 17). All four were most likely executed between 1575 and 1585; a more precise dating cannot be supplied in the current state of knowledge. Cessi places this bust, like cat. no. 25, at the end of the 1580s, around the time of the *Vincenzo Morosini* (cat. no. 42).[1]

[1] Cessi (1962), pp. 15–16. For further information about this piece, see Pope-Hennessy (1964), ii, p. 531, no. 569. The inventory number is A.9-1948.

In terms of overall feeling and facture, I find this piece similar to the terracotta of Girolamo Grimani (Pl. 78, cat. no. 9). The relatively narrow torsos are similar in scale, as is the way the baseline runs flush with the upper edge of the socle. Because the terracotta of Grimani must precede his marble bust, which dates from 1573, I date the terracotta to *c.*1570, after the *Niccolo Massa* (see cat. nos. 8, 9, and 18). I would tentatively assign the *Portrait of a Woman* to the same period, the early 1570s.

[1] For the provenance of this bust, see Middeldorf (1976), pp. 76–7; its inventory no. is 9905.
[2] Planiscig (1921), p. 521.
[3] Cessi (1961*b*), p. 34.

27. PORTRAIT OF A WOMAN
(Pls. 92–3)

Terracotta
Height: 83 cm.
Unsigned
Bust and socle are in one piece
Kunsthistorisches Museum, Vienna
Provenance: palazzo Carregiani (formerly Zorzi), Venice; acquired by the Oesterreichisches Museum für Kunst und Industrie, Vienna, in 1865; transferred to the Kunsthistorisches Museum in 1940[1]

This is Vittoria's sole bust, in any medium, of a woman. Like its partner from the Carregiani palace—the young '*Zorzi*' in Washington (cat. no. 24)—it is difficult to date. Planiscig placed it in the 1590s.[2] Neither Serra nor Venturi treats this piece. Cessi dates it to the late 1550s and finds it similar to the bronze statue of Tommaso Rangone over the portal of S. Giuliano.[3] This is manifestly too early—the present piece has a straight baseline, which Vittoria did not adopt until *c.*1570. During the 1550s and 1560s, he was still employing a rounded, semi-circular baseline, as in the busts of Ferretti (cat. no. 6), Marc'Antonio Grimani (cat. no. 10), Priamo da Lezze (cat. no. 15), and Benedetto Manzini (cat. no. 16).

28. PORTRAIT OF AN UNKNOWN
MAN (Pls. 114–15)

Terracotta
Height: 86 cm.
Unsigned
Bust and socle are in one piece
Musée du Louvre, Paris
Provenance: unknown before being given to the Louvre in 1921 by G. Brauer[1]

This bust, which has never before been illustrated, has been published only once, in Paul Vitry's supplement to the sculpture catalogue of the Louvre.[2] This is a shame, since it is of high quality and undoubtedly autograph. Going by style, the bust could date from anywhere between *c.*1575 and 1590 or so. It cannot date from before *c.*1575 since the baseline runs straight across the entire bottom of the bust, thus showing the solution for terminations that Vittoria adopted from about this time until the end of his career. It strikes me as quite similar to the bust of Giovanni Battista Gualdo (cat. no. 14).

[1] Vitry (1933), p. 85, gives the provenance as 'Caple. Don G. Brauer'. Godefroy Brauer (1857–1923) was a Hungarian-born antiques dealer in Paris who made many donations to the Louvre. Although the piece was given to the museum in 1921, it did not

physically enter the collection until 1936, after the death of Brauer's wife. Other sculptures given by Brauer include two bronze low reliefs attributed to Riccio and a terracotta high relief

attributed to Jacopo della Quercia; see *Donateurs* (1989), p. 157.

[2] Vitry (1933), p. 85. The inventory number for the bust is 1885.

WORKS ATTRIBUTED TO VITTORIA'S STUDIO

29. VINCENZO ALESSANDRI (Pl. 155)

Marble
Dimensions unknown (life-size?)
Unsigned
Inscribed (on socle): VINC s | ALEXANDRIUS | A SECR. s SER. ae | REIP ae V ae
Whereabouts unknown

The first mention of this bust comes from Cicogna; he gives a short description, transcribes the inscription on the socle, and states that he saw it in the possession of the sculptor, Angelo Zordan (or Giordani). Although Cicogna specifies that the piece is unsigned, he says that 'gl'intelligenti' attribute it to Vittoria.[1] The only other mention of this bust is by Serra, who also ascribes it to Vittoria, dates it to *c.*1580, and states it was in a sale in New York in 1919; he illustrates it on pl. XVII.[2]

Judging from the illustration in Serra, the bust cannot be given autograph status; its execution is far too dry and weak. The modelling lies all on the surface of the face with little indication of the underlying bone and muscle structure, so surely handled in the autograph busts. The treatment of the hair, rendered mechanically as separate tufts and seeming more like a wig than actual hair, is quite close to the hair and beard on the bust of Alvise Tiepolo, which I assign to the workshop.[3] This feature, plus the tight silhouette of the torso (which in turn lacks corporeality), bespeaks a workshop origin for the present bust as well, with a dating from the 1580s or 1590s.

Vincenzo Alessandri was the secretary of the Venetian Senate during the latter part of the sixteenth century. He is known of from 1566 to 1595. In 1570, he was sent to Persia on an unsuccessful mission to persuade King Tamas to make war on the Turkish sultan.[4]

[1] Cicogna (1824–53), vi, p. 943, no. 2: 'Busto al naturale di marmo di carrara, vestito alla romana con bottone alla spalla destra, barba prolissa, cappelli piuttosto ricci e lunghi, avente sulla faccia due porri l'uno sopra il ciglio destra, e l'altro sopra il sinistro.'

[2] Serra (1923), p. 55; he does not say what sale it was in.

[3] See cat. no. 45.

[4] See Berengo (1960), p. 174.

30. LORENZO CAPPELLO (Pl. 107)

Marble
Height (with socle): 90 cm.; breadth: 70 cm.
Signed (on rim of right shoulder): ALEXANDER < VICTORIA < F
Bust and socle are separate
Inscribed (on socle): LAURENTIUS CAPELLO SEN: | PETRIS SEN. FILIUS | AETA. LVI
Museo del Castello Buon Consiglio, Trent
Provenance: palazzo Cappello, Venice; acquired by Gianantonio Moschini in 1830; given by Moschini to the city of Trent in 1830[1]
Condition: generally good; a large, repaired crack on the bottom right side of the torso runs from the central fold to his right arm

Cicogna mentions this bust, noting that Moschini bought it in 1830 from the 'casa Cappello a santa Maria Formosa' and then gave it to the city of Trent.[2] He also gives a reference to this event in the newspaper, *Messagiere Tirolese*. In that journal, on 17 December 1830, a small article was published concerning the donation from Canon Moschini, who presented the bust in honour of the artist's native city, along with an encomium by Luigi Zandomeneghi to the portrait.[3] Moschini must have discovered the bust between 1827 and 1830, inasmuch as he does not mention it in his edition of Temanza in 1827. Giovanelli notes the bust, dates it to 1599, calls it 'egregiamente scolpito', and quotes Zandomeneghi's praise of it.[4] Serra refers the reader to Giovanelli's dating of the bust.[5]

Planiscig lists this piece as being among Vittoria's last works.[6] Cessi correctly states that no documentary grounds exist for assigning the work to 1599, but he agrees that it must be one of Vittoria's last works.[7]

Although the socle of this bust corresponds to no other work by the artist, and would seem to date from the seventeenth century, as Moschini reports that the bust comes from the Cappello family palace, there seems no reason to doubt the identity of the sitter as set forth on the socle. There was a Lorenzo Cappello, son of Piero, who was born in 1543 and died in 1612.[8] It is stated on the socle that his age is 56, thus giving 1599 or 1600 as the year the bust was executed.[9]

This date seems quite right on stylistic grounds, since the large dimensions of the bust correspond to other late busts such as those of Antonio Montecatino and Jacopo Soranzo, both also from the late 1590s.[10] The pedestrian modelling and carving of the portrait, however, lead me to assign it to the workshop. Unlike the busts of Doge da Ponte, Ottaviano Grimani, or Orsato Giustiniani, where the relatively large dimensions are supported by a vivid presence and powerful feeling of scale, here the portrait seems overblown and grandiose. The somewhat schematic rendering of the flesh reminds me of the technique employed in the face of the 'Procurator' in the Metropolitan Museum and I am tempted to assign both busts to the same hand.[11] The torso of the *Cappello* is a slight variant of the standard torso that was also employed in the busts of Domenico Duodo, Vincenzo Morosini, Alvise Tiepolo, and Antonio Zorzi.[12]

Very little seems to be known about Lorenzo Cappello. Cappellari states that this Lorenzo, son of Pietro, commanded a galley at his own expense in the war with Cyprus in 1571, and that in 1580 he was a *provveditore sopra li conti*.[13]

[1] See below.
[2] Cicogna (1824–53), iii, p. 513, no. 3.
[3] Zandomeneghi (1830), pp. 5–6; the dispatch from Trent is dated 6 Dec.
[4] Giovanelli (1858), pp. 94–6.
[5] Serra (1923), p. 84.
[6] Planiscig (1921), p. 519.

[7] Cessi (1962), p. 21.
[8] See Marco Barbaro, *Genealogie Venete* (Mus. Civ. Correr, Cod. Cicogna, 2498–2504), ii, albero L Capello.
[9] I assume that Moschini tracked down Lorenzo in the source books and came up with the date of 1599 by doing some simple arithmetic. He probably told the appropriate people in Trent the identity and birth date of the sitter, allowing them to assign 1599 to the bust.
[10] See cat. nos. 41 and 44.
[11] See cat. no. 50.
[12] See cat. nos. 35, 42, 45, and 49.
[13] See G. A. Cappellari Vivaro, *Il Campidoglio Veneto* (Bibl. Marciana, MS It. cl. VII, 8305), i, fo. 229 r.

31. GIROLAMO CONTARINI (Pl. 126)

Pietra viva?
Dimensions unknown; life-size
Unsigned
Socle is missing[1]
Palazzo Ducale, Venice
Provenance: on Contarini's tomb in S. Sepolcro until 1807; Accademia delle Belle Arti until *c*.1888; Museo del Palazzo Ducale since *c*.1888[2]

In his will written in 1576, the year before his death, Girolamo Contarini left instructions concerning his tomb:

Voglio che il mio corpo sia sepulto nella mia archa nella gesia del Sto. sepulcro in questa Città, onde sono li altri mei, et dove prego M[adonn]a Marina mia car[issi]ma consorte, a venir anco essa quando piacerà a sua divina Magiesta dopo longi anni. Nella qual gesia voglio che sia posto il mio deposito di piera viva et imagine scolpita, per mezzo al altar grande il qual hora si atrova appresso li R[everend]e mie sorelle in ditto monasterio.[3]

This passage documents that the Contarini had their family tomb, the *archa*, in S. Sepolcro, that Contarini wanted his tomb made from *pietra viva*, and that a sculptured portrait ('imagine scolpita') of himself was to be placed on it. The 'R[everend]e mie sorelle' are Contarini's sisters, Eletta, Arcangela, and Felice, who all were nuns at the convent of S. Sepolcro.[4]

Contarini's intentions were carried out and Stringa first notes the presence of the tomb in the church. After giving a long description of the monument to the Holy Sepulchre that occupied the centre of the church, Stringa adds:

Dietro a questo [the Santo Sepulcro] vi è l'altare ove odono messa le Monache, e dirimpetto a quello vi si vede una statua di pietra viva, sotto la quale si legge quest'Epigrafo: HIERONYMO CONTARENO DIVI MARCI PROCURATORI, MARITIMA DISCIPLINA FORTITUDINE ANIMI ET BELLICUS ARTIBUS PRAESTANTISSIMO, TRIREMIBUS SEMEL, ET ITERUM PRAEFESTO, CYPRI A PIRATIBUS DEFENSORI, AMICO VERO, ET FIDELI ALOYSIUS FOSCARIUS P.C. VIXIT ANNOS LVI. OBIIT M.D.LXXVII.[5]

Stringa makes no attribution. From then on, the tomb is regularly mentioned in the guide literature, but always without attribution.[6]

Pietro Edwards was apparently the first to assign the bust to Vittoria when, in 1807, he claimed it for the Regno Italico as part of the Napoleonic suppression of the monasteries.[7] From this time on, the bust has been regularly ascribed to Vittoria.[8]

Because Contarini died in 1577 but his tomb is not mentioned by Francesco Sansovino in 1581, the monument and bust most likely date from the early 1580s.[9] As stated in the inscription, the monument was commissioned and set up by Alvise Foscari, Contarini's business partner and executor of his will. Hence, the monument precedes by only a few years another tomb in S. Sepolcro designed by Vittoria, that of Giovanni Battista Peranda.[10] The bust is of high quality but should not be attributed to Vittoria; it is instead, perhaps, an early work by Giulio del Moro.[11]

Girolamo Contarini was born on 28 March 1521, the son of Marcantonio di Andrea and Lucrezia di Pietro Contarini.[12] He was granted early entrance to the Maggior Consiglio in 1541 at the age of 20.[13] In 1542, he received his first public commission as a *sopracomito di galera*. From then on, his naval career advanced rapidly. In 1546, he was elected as one of the governors of the Collegio della milizia da mar; in 1552, he became one of the twenty governors of the triremes of the Republic, and in 1553 he was made *Capitano delle fuste* (the small galleys). As such, he was charged to step up the campaign against the Uskok pirates; it is this mission that is referred to on his sepulchral inscription.

After serving as *provveditore* at Marano from 1556 to 1557, he returned to sea in 1558 as one of the *governatori di galera*. In 1569, he once more served as a governor of the Collegio della milizia da mar, and was one of the assistants in 1571 to Vincenzo Morosini who had been placed in charge of the defence of the Lido against the Turks (Morosini's monument in S. Giorgio Maggiore was designed by Vittoria[14]). On 20 April 1572, Contarini was elected a Procurator *de Ultra* for the price of 16,000 ducats. He conducted trade together with his partner, Alvise Foscari. He died on 10 April 1577, perhaps of the plague.

The close resemblance of this bust to the man portrayed in two portraits by Veronese, one in Philadelphia (Pl. 127) and the other in Dresden, allows the sitter of these pictures to be identified as Girolamo Contarini.[15]

[1] The bust is presently supported by a socle and pedestal of later date. Presumably, it did once have its own original socle. Nevertheless, the bust of Giovanni Battista Peranda, which also came from S. Sepolcro, similarly now lacks a socle; see cat. no. 43.

[2] For a detailed *apparatus criticus* on the Contarini bust, see Martin (1988) and (1993a). On 29 May 1807, the bust was removed from S. Sepolcro by Pietro Edwards, who had been commissioned to lay hold of art works of special importance from suppressed churches and monasteries by the Napoleonic administration. As such, the bust passed into the collection of the newly founded Accademia delle Belle Arti; see Zorzi (1972), ii, p. 384. Moschini (1815), ii, p. 528, first lists the bust as being in the Accademia. The last time the bust appears in a catalogue of the Accademia is in Nicoletti (1887), p. 190. Between 1885 and 1887, the Accademia was reorganized by Giulio Cantalamessa, and most of the sculpture was sent to the Museo del Palazzo Ducale (at this time, the Museo Archeologico was also in the Ducal Palace). Most of these sculptures were later sent to the Cà d'Oro; see Moschini-Marconi (1962), p. xxiv. Venturi (1896) mentions the bust as being in the Ducal Palace. For many years, the bust was displayed in the Armory of the Ducal Palace. I wish to thank Dr Michela Knezevich for allowing me to view the bust and for all her other help and assistance.

[3] ASV, Notarili e Testamenti, C. Zilliol, b. 1264, fasc. 8, fo. 82 r. Contarini composed the will on 7 June 1576, Zilliol made the official copy on 9 Mar. 1577. Contarini left 400 ducats to be spent on his tomb, a goodly sum.

[4] See Derosas (1983a), p. 217.

[5] Sansovino (1604), p. 132a. The inscription translates as : 'To Giralomo Contarini, Procurator of St Mark, most excellent in maritime knowledge, in courage of soul, and in the arts of war; once the director of the triremes and also the defender of Cyprus from pirates; to a true and faithful friend, Alvise Foscari took care to place [this monument]. He lived 56 years, he died in 1577.'

[6] See, for instance, Sansovino (1664), p. 78, and Martinelli (1705), p. 126.

[7] Zorzi (1972), ii, p. 384, quotes from ASV, Demanio 1806–1813, b. Edwards, concerning the statue: 'mezzo busto, rappresentante un General Patrizio Veneto' to which Zorzi adds 'da lui attribuito al Vittoria: è il busto del Contarini'. Zorzi does not note the subsequent history of the bust.

[8] See n. 2.

[9] Giovanelli (1858), p. 82, says the bust was made in 1579; Serra (1923), p. 73, must be talking about this bust when he speaks of the portrait of 'Alessandro Contarini' in the Museo Archeologico; he places it close to the bust of Tommaso Contarini in the Madonna dell'Orto, which he dates to c.1578. Planiscig (1921), p. 500, includes this bust among those he dates from the end of the 1570s; he also misidentifies it as Alessandro Contarini, and locates it in the Archaeological Museum in the Ducal Palace. Neither Venturi nor Cessi mentions the bust.

[10] See cat. no. 43.

[11] See Martin (1993a).

[12] For a full account of Contarini's life, see Derosas (1983a).

[13] Ibid., p. 217, states that on 4 Dec. 1539, Contarini was granted early entrance to the Maggior Consiglio, but this is not quite correct. On 4 Dec., St Barbara's Day, a lottery was held, called the Balla d'Oro, whose winners won the right to enter the Great Council at age 20 instead of 25. Contarini must have been one of the winners in 1539, but he had to wait until 1541, when he reached age 20, to take his seat in the council; this is why his first commission came only in 1542.

[14] See cat. no. 42.

[15] See Martin (1993a).

32. TOMMASO CONTARINI (Pl. 98)

Marble
Dimensions unknown; life-size
Signed (on rim of right arm): ALEXANDER. VICTORIA. F.
Bust and socle are in one piece
Contarini Chapel, Madonna dell'Orto, Venice

In the centre of the Contarini chapel in the Madonna dell'Orto, the fourth on the left, lies the cover for the family *arca*, just below the steps of the altar that features an altarpiece by Tintoretto, *St Agnes reviving the son of Licinus*. On each of the side walls of the chapel are three memorials to members of the family:

Altar

1. Alvise (†1579, Procurator, nephew of nos. 2 and 5)
2. Gasparo (†1542, cardinal)
3. Carlo (†1688, ambassador)
4. Tommaso (†1614, ambassador)
5. Tommaso (†1578, Procurator)
6. Alvise (†1651, son of no. 4)

The ensemble is architecturally uniform: each bust, backed by a slab of black marble, rests atop a console to which the epitaph is affixed. The console in turn rests on a base. The whole is enclosed by an aedicule composed of two Corinthian columns with impost blocks on top and bases beneath; the columns support pediments. The two central monuments have triangular pediments while the others have broken pediments. These two central memorials (nos. 2 and 5) are to Cardinal Gasparo, the famous reformist, and his brother Tommaso, a distinguished Procurator. Each of them died childless but the family line was continued by their brother Vincenzo whose son Alvise (no. 1), also a Procurator, is commemorated to the left of his uncle Gasparo. To the right of Procurator Tommaso is the memorial to his grand-nephew, Tommaso the younger (no. 4); tomb no. 6 is to Alvise, Tommaso the younger's son, and no. 3 honours Carlo, a grand-nephew of Alvise the younger.

Only the memorials to Cardinal Gasparo and his brother, the Procurator Tommaso, date from the sixteenth century. The epitaph on Carlo's tomb (no. 3), which features a Berninesque bust of the deceased, states that his wife, Piuchebella Grimani, set it up.[1] It therefore must post-date Carlo's death in 1688. The epitaphs to Alvise the younger (no. 6) and to his father, Tommaso the younger (no. 4), state that Vincenzo Contarini, Alvise's younger brother, set them up in 1653.[2] The epitaph to Procurator Alvise (no. 1) adduces no date of erection or patron.[3] But because it is surmounted by a bust executed by the same extremely mediocre seventeenth-century hand that carved the busts of Tommaso the younger and Alvise the younger, this monument was also probably constructed in 1653. Further support that only two tombs existed in the Contarini chapel prior to 1653 is supplied by Cardinal Giovanni Dolfin who specified in his will of 1612 that his tomb in S. Michele in Isola be 'nell'istessa forma, che sono li doi depositi delli sig[no]ri Contarini nella Chiesa della Madonna dell'horto in Venetia';[4] by Stringa and Martinioni who both mention only the tombs of Cardinal

Gasparo and Procurator Tommaso;[5] and by the way the edge of the monument to Alvise the younger cuts into the corner pilaster of the chapel (Pl. 99), suggesting that it had to be wedged into the existing space at a later date.

When the two original tombs were placed in the chapel is not known. The remains of Cardinal Gasparo were transferred on 17 December 1563 to the Madonna dell'Orto from Bologna, where he had died on 24 August 1542 and had been buried in S. Procolo.[6] According to the epitaph, the cardinal's tomb was set up by his nephews Alvise (tomb no. 1) and Gasparo ([†]1571); this would imply that his tomb was in place before the death of Gasparo in 1571.[7] The epitaph for Procurator Tommaso, who died in 1578, names the patrons as Tommaso the younger (tomb no. 4) 'and others'.[8]

But no mention of the Contarini chapel—either of the tombs or the altarpiece by Tintoretto—is made by Sansovino in 1581, who does, however, note the *Adoration of the Golden Calf* and the *Last Judgement* by Tintoretto in the choir of the church.[9] Such a *lapsus* makes it very difficult to posit that the bust of Cardinal Contarini was in the chapel during most of the 1570s. The earliest notice of the altarpiece in the chapel comes in Borghini's *Il Riposo*.[10] Borghini gathered the Venetian material for his book during a visit he made in the summer of 1582, so the altarpiece must have been in place at that time. Recent scholarship dates the *St Agnes* to *c.*1577–8. Apparently the decoration of the chapel began in the late 1570s, before the death of Procurator Alvise, and perhaps before that of his uncle, the Procurator Tommaso.

This does not mean, however, that the busts were made or set in place at this time: the bust of Procurator Alvise, set up after 1653 to a man who died in 1579, gives ample proof that an image of the deceased is not automatically made immediately after his death. I would suggest that the monuments to Cardinal Gasparo and to Procurator Tommaso the elder (nos. 2 and 5) were in place by *c.*1585, that tombs nos. 1, 4, and 6 were set up in 1653, and that tomb no. 3 was erected some time after 1688.

The Contarini chapel is unique in Venice; I know of no other chapel given over to six family tombs comprising a unified ensemble. One does find such phenomena, however, in the seventeenth century in Rome, such as the Frangipane chapel in S. Marcello; there, as in the Contarini chapel, one sees six monuments to members of the same family, with three set up on each side wall. Grisebach noted the similarities between the two chapels, remarking that the very 'Roman' character of the wall tombs of the Frangipane has a Venetian counterpart in the Contarini chapel.[11] Indeed, having opposing sets of commemorative busts on the side walls of a chapel is very much a Roman, not a Venetian, practice. As stated above, the memorials of Tommaso Junior and his son Alvise were set up in 1653 by Vincenzo, Tommaso Junior's younger son. It is worth noting that Tommaso Junior was the Venetian ambassador to Rome from 1611 to 1614. Furthermore, Alvise (tomb no. 6) raised an epitaph to his father in Rome.[12] Hence, Tommaso Junior and his family were familiar with Rome and this could explain why the Contarini chapel has such a Roman cast to it. The Duodo family monument raised *c.*1658 at the family palace in Monselice also resembles the Contarini chapel: it shows three niches, each containing busts set above epitaphs, hence it takes the form of one wall of the Contarini chapel (Pl. 125). The Duodo monument further demonstrates that such commemorative arrangements were a seventeenth-century taste.

The bust of Cardinal Gasparo is not by Vittoria or by his shop.[13] That of the Procurator Tommaso is from the workshop. Considering its similarities to the busts of Giovanni Battista Peranda and Vincenzo Morosini, it most likely dates from the second half of the 1580s. The *Tommaso Contarini* shares with the *Peranda* and the *Morosini* a hardness and dryness in the carving and a flatness in the drapery patterns; as in the *Morosini*, extensive use has been made of the drill to render the beard. A likely candidate for its authorship would therefore be Vigilio Rubini.[14]

One anomaly of the bust is its tiny socle which has no counterpart in any other busts by Vittoria or

his circle. Doubtless, it was made so small to match the equally small socle on the bust of Cardinal Gasparo, to which it presumably was ordered as a pendant; this special circumstance presumably also explains why socle and bust are in one piece. Cessi has suggested that the architecture of the tombs (of Tommaso and Gasparo) was designed by Vittoria.[15] This seems quite likely: the vocabulary of the forms in the aedicules is almost exactly the same as that around the Zane altar by Vittoria in the Frari.

Tommaso Contarini was born in 1488. He was *Podestà* of Verona in 1540–1. Elected a Procurator *de Citra* on 16 March 1557 (and therefore a patron of the Montefeltro altar by Vittoria in S. Francesco della Vigna), he became Captain-General in the following year. He was balloted for Doge in 1556 and 1559, but lost both times. Sansovino records that he had a very beautiful garden in his palace near the Madonna dell'Orto.[16] He died aged 90 in 1578.[17]

[1] See Cicogna (1824–53), iii, p. 250, inscr. 10.
[2] The inscription for Alvise reads: VINCENT[U]S CONT[ARENU]S PATRUO. SUO. H[OC] M[ONUMENTUM] P[OSUIT] A[NN]O M.DC.LIII; that for Tommaso Junior reads: VINCENTIUS CONTARENUS IUSTA FECIT. ANNO COMINI M.DC. LIII. For the inscriptions, see Cicogna (1824–53), iii, p. 246, inscr. 8, and p. 248, inscr. 9.
[3] See Cicogna (1824–53), iii, p. 244, inscr. 7.
[4] Lavin (1968), pp. 238–9, n. 106, published the archival reference: Archivio dello Stato di Roma, 30, Not. Cap. Uff. 10, Not. Francesco Micenus, fo. 281.
[5] Sansovino (1604), pp. 146a–146b; Sansovino (1664), p. 165.
[6] Cicogna (1824–53), iii, p. 232 and n. 2.
[7] See Cicogna (1824–53), iii, p. 226.
[8] See ibid., p. 241.
[9] Sansovino (1581), p. 59b.
[10] Borghini (1584), p. 553.
[11] Grisebach (1936), p. 68.
[12] See Benzoni (1983), pp. 82–91.
[13] See cat. no. 69.
[14] For the busts of Morosini and Peranda, see cat. nos. 42 and 43.
[15] See Cessi (1961a), p. 52.
[16] Sansovino (1581), p. 137.
[17] See the entry on Tommaso in Derosas (1983b), pp. 300–5.

33. VENETIAN NOBLEMAN ('TOM-MASO CONTARINI') (Pl. 128)

Terracotta
Height: 72.5 cm.
Signed (on rim of right arm): A.V. F.

Bust and socle are in one piece
Metropolitan Museum of Art, New York
Provenance: Vivian Collection; purchased in 1911 by the Metropolitan from Duveen[1]

This bust was first published by the Metropolitan Museum in 1911 and was also included in the catalogue of sculpture put out by the museum in 1913.[2] Originally called, for unknown reasons, a portrait of Simone Contarini, a Venetian diplomat and poet who lived from 1563 to 1633, the bust was later identified as a depiction of Tommaso Contarini, the same man buried in the Madonna dell'Orto.[3] Serra mentions this piece, calls it Simone Contarini, and dates it to the 'estrema attività' of Vittoria.[4]

The resemblance to Tommaso Contarini (see cat. no. 32), however, is generic, as are the typology and facture of this piece. The type is thoroughly Vittoriesque: the baseline derives from the busts of Sebastiano Venier (cat. no. 22) and Domenico Duodo (cat. no. 35); the folds of the drapery follow the usual rule of counterbalancing the turn of the head to the right; 'Contarini's' left shoulder extends further out to the right as in the busts of Tommaso Rangone (see cat. nos. 20 and 21); the vertical striations on the back of the bust are rendered as they are in all of Vittoria's terracotta portraits; the shape of the socle is canonic (although the addition of the impost block beneath it is not).

But the bust lacks life and, while it seems to be a genuine sixteenth-century object, cannot be considered autograph. The scale is small, lacking the over-life-size vitality of the autograph portraits. The head appears to be attached, unlike almost all the autograph pieces.[5] The flat and schematic rendering of the beard—a completely decorative arrangement of drill holes—speaks particularly against autograph status for the piece.[6]

[1] This information concerning the provenance comes from the catalogue cards in the Department of European Sculpture and Decorative Arts in the Metropolitan Museum of Art. I am grateful to the curator of sculpture, Dr James David Draper, for allowing me to consult the cards. I do not know who 'Colonel' Vivian was. The inventory number is 11.184.
[2] *Bulletin of the Metropolitan Museum*, 6 (Dec. 1911), pp. 232–3; this bust called 'Simone Contarini' and attributed to Vittoria. Breck (1913), no. 87, called it 'Simone Contarini' and attributed it to Vittoria.

³ This identification was advanced by the curator of sculpture, John Phillips, in the 1930s.

⁴ Serra (1923), pp. 72–3. Serra finds this bust very similar to that of Tommaso Contarini; I suspect that this is why the Metropolitan later changed the identification of the sitter to Tommaso Contarini.

⁵ The one exception to this rule is the terracotta of Tommaso Rangone; see cat. no. 21.

⁶ Cessi (1963), p. 32, considers this piece a copy of a lost original by Vittoria.

34. VENETIAN GENTLEMAN ('TOMMASO CONTARINI') (Pl. 129)

Terracotta
Height: 71 cm.
Unsigned
Royal Ontario Museum, Toronto
Provenance: unknown prior to acquisition by Toronto in 1957

This bust first entered the literature with Cessi, who attributed it to the master and associated it with the bust of Giovanni Battista Peranda (cat. no. 43) dating from 1586.[1] Cessi suggested identifying the sitter as 'forse' Tommaso Contarini. In 1980, the bust was officially published, when it was described as a 'Bust of a Venetian Nobleman, workshop of Alessandro Vittoria, c. 1580–90'.[2] The author rightly notes that 'although the bust conforms with what may be described as a Vittoria type, there is no conclusive proof to establish it as an autograph work . . .' and compares the modelling of the head and the 'soft' treatment of the beard with the bust in Berlin called 'Pietro Zen' (cat. no. 48). The author also finds the treatment of the drapery on the bust in Toronto comparable with that of two of the terracotta busts in London, those of the *Self-Portrait* and the *Unknown Man Wearing the Order of St Michael* (cat. nos. 47 and 54) and states that thermoluminescence tests conducted on the bust in Toronto place it c. 1509–1629, just as tests on the busts in London placed them in the sixteenth century.[3]

I agree with assigning this bust to the workshop. Not only are the draperies of the bust in Toronto quite similar to those of the terracottas in London, they all share an even more important feature, the generalized, schematic, and uninflected rendering of the head and face. As such, even though all of them seem to be genuine late sixteenth-century or early seventeenth-century objects, their author can probably be termed someone not directly associated with the master, but familiar with his idiom. The feature of the two swags of drapery at either end of the baseline, for instance, derives from the bust of Sebastiano Venier (cat. no. 22).

¹ Cessi (1962), p. 12.
² Keeble (1980), p. 430, fig. 7. The inventory no. is 957.202.
³ See cat. no. 51, text and n. 2.

35. DOMENICO DUODO (Pl. 106)

Marble
Height (with socle): 80 cm.; breadth: 64 cm.; socle: 12 cm.; baseline: 48 cm.
Signed (on rim of right arm reading from bottom up): ALEXANDER. VICTORIA. F.[1]
Bust and socle are separate
Galleria Giorgio Franchetti alla Cà d'Oro, Venice
Provenance: palazzo Duodo at Monselice until 1899; Accademia delle Belle Arti, Venice, until 1926; since then in the Cà d'Oro[2]

This bust is recorded in Vittoria's account book:

Adì 10 Marzo 1596
Contai a m[esser]o Piero furlan squadratore per aver lavorato giorni dua sul ritratto dil Procurator Duodo S[igno]r Domenico val. L. 6[3]

Thus the bust had been ordered and was being worked on—and was probably finished—before Domenico Duodo died in December 1596. Since the bust is in two pieces, it most likely was meant as a public image, and perhaps, like the bust of Duodo's brother Francesco, was planned to be placed in the chapel of St Francis of Paola in S. Maria del Giglio. It was, however, never placed there.[4]

The torso—another version of the model torso previously employed on the busts of Vincenzo Morosini, Antonio Zorzi, and Alvise Tiepolo—can

be securely assigned to Vittoria's workshop; perhaps it is the work of the 'Piero furlan' cited in the above payment.[5] The head seems autograph.

Domenico Duodo was born on 19 October 1513.[6] In 1561 he was a member of the Collegio de XX Savi selected from the Senate.[7] In 1579 he was a *Consigliero*.[8] He succeeded his brother Francesco as a Procurator *de Ultra* on 17 November 1592, the day after Francesco died. Sansovino mentions that the two brothers owned a beautiful collection of antiquities.[9] Domenico died on 2 December 1596.[10]

 [1] The rim, or back edge, of the torso is polished and smoothed down only in the area of the signature; the remainder of the rim was left unfinished. I know of no other bust where this is the case.
 [2] See cat. no. 4 for the provenances of the Duodo busts.
 [3] Predelli (1908), p. 199.
 [4] See cat. no. 4 for Francesco Duodo wanting his marble bust to be placed in S. Maria del Giglio, and for the issue of busts whose torsos are separate from their bases. Like his brother, Domenico Duodo asked in his will to be buried in S. Angelo but was instead buried in S. Maria del Giglio; see Domenico's will, ASV, Notarili e Testamenti, G. Secco, b. 1190, no. 172, summarized by Puppi and Olivato (1974), p. 70, n. 36.
 [5] This is Piero's only appearance in the account books.
 [6] This is Domenico's birth date according to the *Genealogia di famiglie patrizie* (Bibl. del Mus. Civ. Correr, MSS P.D. c.2803), p. 196; his necrology, however, calls him 86 at his death in 1596, see n. 10.
 [7] See G. A. Cappellari Vivaro, *Il Campidoglio Veneto* (Bibl. Marciana, MS It. cl. VII, 8305), fo. 48 r.
 [8] Ibid., fo. 48 r.
 [9] Sansovino (1581), p. 138 v.
 [10] Domenico's necrology—ASV, Provveditori e Sopravveditori alla Sanità, b. 826, unpaginated—reads: 'adi 2 [decem]brio 1596 . . . s[ign]or domenego duodo procurator di anni 86 da vegeza [vechiezza]—s. m[a]ria zobenigo.' Puppi and Olivato (1974), p. 70, n. 36, supply an incorrect death date of 1598. See also Grendler (1979), p. 322, for a list of the offices held by Duodo. Like his brother Francesco, Domenico Duodo was among the 'primi' of the Venetian patriciate.

36. 'GIROLAMO FORNI' (Pl. 157)

Stucco
Dimensions unknown
Unsigned
Private collection, Vicenza
Provenance: unknown

That Vittoria and Girolamo Forni knew each other is well attested on documentary grounds. The con-tract for hiring the barge that transported the artist and his family from Venice to Vicenza on 27 September 1576 survives in Vittoria's *Memorie*, where it states that the arrangements for this were made in Vicenza by Girolamo Forni, Vincenzo Scamozzi, and Ottaviano Ridolfi.[1] Further-ermore, Forni mentions 'la mia testa e ritratto di stucco . . . fattura del già Alessandro Vittoria, mio cordialissimo amico', in his will of 1610.[2] No such bust was known until Zorzi published the present bust, and the relevant portions of the will, in 1966.[3] The portrait is inscribed on the socle HIERON-IMUS A FURNIS Q. HIERONIMI; Zorzi dated it to the time of the artist's stay in Vicenza from September 1576 to December 1577.[4] But is this bust in Vicenza the object mentioned in Forni's will?

Zorzi uncritically accepts the bust and places it within the traditional dating of Vittoria's second stay in Vicenza because of the link between the artist and Forni at this time, attested by the docu-ment for the barge. But there are problems with this, foremost among them the error of the accepted dating of the artist's stay in Vicenza in the 1570s. Giovanelli made the first reference to the contract in the *Memorie* concerning the barge that took Vittoria and his family to Vicenza in Septem-ber 1576.[5] He then hypothesizes, on no factual basis, that Vittoria stayed in Vicenza until the autumn of 1577, then made a trip to Trent, from where, after the fire in the palazzo Ducale of 20 December 1577, he was called back to Venice.[6] Predelli, Serra, Planiscig, Venturi, Cessi, and Zorzi, basing themselves in varying degrees on Giovanelli, all place Vittoria outside Venice from September 1576 to December 1577 (or later).[7]

But two different documentary sources prove that this cannot be the case. In one of the booklets in the *Memorie* there is a notice dealing with repairs to Vittoria's house paid for on '10 Aprile 1577, in Venetia'.[8] How could Vittoria make a payment in Venice in April 1577 if he was in Vicenza then? The other notice of Vittoria's presence in Venice before his supposed 'return' there in December 1577 concerns an attack made on the artist. In 1909,

Molmenti published a report made to the Council of Forty dated 27 April 1577 'di metter per venir in cognitione de quelli scelerati incogniti che hanno assaltato Alessandro Vittoria scultor, che andava a casa sua, et con una arma nuda uno di loro l'ha sequitato finir nel suo horto per amazarlo'.[9] Molmenti states that the attack must have occurred prior to September 1576 because from then until December 1577, according to Predelli and Giovanelli, Vittoria was in Vicenza. But why make a report about an assault seven or eight months after it occurred? Since both the memo in the *Memorie* and the notice concerning the attack place Vittoria in Venice in April 1577, the artist must have returned to the city from Vicenza by that month. For whatever reason, Vittoria and his family went to Vicenza in September 1576, but he was certainly back in Venice by at least April 1577, if not earlier.

Hence, Vittoria's 'soggiorno nel vicentino' during the 1570s was not as extensive as has traditionally been thought.[10] Even so, the bust of Forni need not have been made then anyway: the artist was already acquainted with Ottaviano Ridolfi during his earlier stay in Vicenza in 1551–3, and he could easily have come to know Forni at that time as well.[11] That Vittoria made a trip to Vicenza in 1576 is no basis, in and of itself, for dating the bust of Forni to that time.

There are, however, strong reasons for considering this bust a pseudo-antique object. As Irene Favaretto observed, the bust of 'Forni' resembles the stucco bust of Antoninus Pius by Vittoria in the palazzo Thiene, for which a gesso model survives in the Museo del Liviano in Padua.[12] While this is true, the 'Forni' bears an even closer resemblance to a gesso head in the Museo del Liviano in Padua called only 'an Oriental' (Pl. 156).[13] Erkinger Schwarzenberg says that this head was cast from a head in Vienna that came from the Obizzi del Cataio collection, and that the same person is depicted in a head in the British Museum datable to c.170 BC.[14] The same person is also depicted in a bust in a private German collection.[15] The similarity of the bust of 'Forni' to the head in Padua prob-

ably explains why its head is attached to the torso, not integral with it.[16]

Because of the similarity of the 'Forni' to the head in Padua, which once belonged to Marco Mantova Benavides, it is not impossible that the bust has some connection with Vittoria.[17] Because, however, the piece derives from antique sculpture, it cannot represent Girolamo Forni, and the bust of him mentioned in his will is yet to be found. I know of no reference to this piece since Zorzi's article of 1966. I hope that the ownership of the bust will eventually come to light and that the object will be exhibited and studied to the extent it deserves.

Girolamo Forni was a painter specializing in portraits who died on 26 January 1610.[18] Like so many of Vittoria's patrons, he was a collector of ancient art.[19]

[1] Predelli (1908), pp. 57–8.

[2] Zorzi (1966), p. 167, see n. 3.

[3] Ibid., pp. 166–8.

[4] Ibid.

[5] Giovanelli (1858), p. 79.

[6] Ibid., pp. 79–80.

[7] Predelli (1908), pp. 17–18; Serra (1923), pp. 70–2; Planiscig (1921), pp. 498–9, records Vittoria's 'flight' from Venice in 1576, and seems to say that he did not return to Venice until 1578. Venturi (1937), on p. 69 of his chronology, states that Vittoria fled Venice because of the plague in 1576 and returned in Dec. of 1577; he cites Predelli as his source. Cessi (1960a), p. 18, dates Vittoria's second stay in Vicenza from Sept. 1576 to Dec. 1577, citing Giovanelli; in the 'Chronologia' in the back of each of his booklets on the artist, Cessi gives the same information, but cites Predelli (1908), pp. 17–18. Zorzi (1966), pp. 166–8, dates the artist's stay in Vicenza from Sept. 1576 to 'late' 1577.

[8] Predelli (1908), p. 155.

[9] Molmenti (1909), pp. 4–5.

[10] This of course brings into question many of the attributions made by Zorzi (1966).

[11] For Ridolfi at the pal. Thiene with Vittoria in the 1550s, see Palladio (1570), ii, p. 12.

[12] Favaretto (1976–7), p. 406, n. 21.

[13] Candida (1967) discusses this head on pp. 65–7, no. 12; she concludes that it is based on an antique original of the 2nd cent. BC that is lost or presently unknown. She considers it a head 'di grande forza'.

[14] See Schwarzenberg (1970), p. 612.

[15] Further information on this bust is published in Weski and Frosien-Leinz (1987), i, p. 108, ills. 79–80, and in Frosien-Leinz (1990), p. 213, ills. 9a, 9b.

[16] See Zorzi (1966), p. 168.

[17] On these heads, see Ch. 2, above.

[18] See Zorzi (1962c), ii, pp. 72–9, and Zorzi (1966), pp. 166–8, for biographical information on Forni.

[19] See Favaretto (1990), p. 117, with bibliographic references.

37. PALMA GIOVANE (Pls. 130–1)

Terracotta
Height: 78 cm.
Unsigned
Bust and socle are in one piece
Kunsthistorisches Museum, Vienna
Provenance: Collection Willy von Dirksen, Berlin; Lepkes
Auctionshaus, Berlin, 1931; in Kunsthistorisches Museum
by c.1940[1]

This bust entered the literature in 1921 when Planiscig published it, accepting it as by the master and dating it to the later 1580s.[2] Serra includes the bust in his list of works by Vittoria but does not discuss it in his text.[3] Venturi accepts the piece, as does Cessi who dates it to the early 1570s.[4] Palma and Vittoria were closely associated—Palma was in many ways a protegé of Vittoria—hence it would not be surprising for the older artist to make a portrait of the younger artist.[5]

The authenticity of the bust would seem to be confirmed by drawings of it from the Tiepolo workshop. K. T. Parker first noticed this in relation to a drawing sold at Christie's in 1934 (now in the Ashmolean), and realized the identity of the face when he saw this bust illustrated in Planiscig.[6] He cited the bust as the prototype for all the uses of the head by the Tiepolo workshop, concluding that the present bust 'must either have belonged to the Tiepolo or otherwise have been constantly accessible to them' and says that he knows of no similar case in the œuvre, though one may yet be recognized.[7]

The various drawings made by the Tiepolo workshop would indeed seem to have been made after the present bust. Yet, I find it difficult to accept the present bust as autograph. Like the terracotta in Toronto (cat. no. 34) and the four workshop terracottas in London (cat. nos. 47, 51, 52, and 54), the facture is very smooth and uninflected, lacking the bite of individuality and particularity so viscerally present in the autograph terracottas. The skin is very smooth, even the wrinkles on the forehead seeming more like incised lines on the surface of the clay rather than like puckers or creases of skin. The hair on the head as well as Palma's beard and moustache are relatively unarticulated—they seem flat, despite the projection of the upper lip. The eyes and eye sockets are similarly unarticulated. A constant element in Vittoria's portraiture—and one that no doubt the artist imposed to a greater or lesser degree on each of his sitters—are deep sockets that make the eyes penetrating and prominent. The eye sockets in the present bust are, instead, rather shallow and lack the subtle detailing and modelling found on the eyes of the autograph portraits. Although the shoulders are displaced—Palma's right shoulder and arm come forward of his left—the bust remains static and stolid. Palma's left arm is lost underneath his cloak. The thick sash around his waist finds no counterpart in any other bust, nor does the exposed, cut-off right arm; except for portraits of men in armour, Vittoria never shows an exposed arm cut off below the shoulder, but always masks the truncation at the shoulder by means of the drapery. Perhaps most importantly, the scale seems small, lacking the larger-than-life-size presence of the autograph busts. While the Tiepolo workshop may well have had this bust in its studio, I do not think that it is by Vittoria, and it may well be an independent creation by another artist, such as Jacopo Albarelli.

[1] Planiscig (1921), p. 509, gives the location of the bust as the 'Dirkens' collection; Rudolph Lepke's Auctions-Haus, 28 and 29 Apr. 1931, no. 86, tafel 13: 'Terrakottabüste des Malers Jacopo Palma, H. 74 cm.'; Venturi (1937), p. 167, Pl. 130, calls the piece 'ex-Lepke', implying that it had not yet entered the Kunsthistorisches Museum. The inventory no. is 9965.

[2] Planiscig (1921), p. 509.

[3] Serra (1923), p. 94, seemingly knew of the bust only from Planiscig; he repeats the error of placing it in the 'Dirkens' collection.

[4] Venturi (1937), p. 166, n. 1; Cessi (1961b), pp. 42–3.

[5] For the most recent account of relations beween the two artists, see Rinaldi (1984), i, p. 15 and passim.

[6] Parker (1935), pp. 61–3, pl. 64, and also Parker (1956), p. 544, no. 1101. These drawings, and the present bust, have also been discussed by Schwarz (1965), pp. 161–4, and by the same author (1971), pp. 210–15. Schwarz accepts the bust as by Vittoria and dates it to the late 1580s or early 1590s.

[7] A similar case has now been found: see Knox and Martin (1987), pp. 159–63.

38. GIROLAMO GUALDO
(Pls. 84 and 86)

Terracotta, gilded
Dimensions unknown; life-size
Signed (on rim of left arm reading from top down):
 ALEXANDRO VICTOR[IA]
Bust and socle seem to be in one piece
Inscribed (on socle): HIERONI | GUALDUS
Cathedral, Vicenza, left transept over door leading to sacristy

This bust sits above the left-hand tomb of the magnificent Gualdo monument in the cathedral of Vicenza. The inscription below Gualdo's sarcophagus reads: HIERONYMO GUALDO HUIUS | ECCLESIAE CANONICO ET P AP. | MORIB. ET. DOCTRINA PRAESTATISS. | PATRUO DE SE OPT. M. IO. BAP. CAN. | P. C.[1] This terracotta has never been discussed in any of the literature about Vittoria, despite the fact that it is signed and has on occasion been attributed to the artist. For a discussion of the monument and its commissioning, see cat. no. 14 on the bust of Giovanni Battista Gualdo (who was the patron).

I agree with those, such as Arslan, who see this bust as a product of the workshop, as its marked inferiority to the bust of Giovanni Battista amply demonstrates.[2] It presumably dates to the same time as the latter bust, namely, the 1570s or 1580s.

Girolamo Gualdo, like Andrea Loredan (see cat. no. 55), was a collector of ancient art. Indeed, he owned what was by far the most famous art collection in Vicenza in the sixteenth century, a collection that was significantly expanded in the seventeenth century, and then dispersed in the early eighteenth century. Born in 1492, Girolamo pursued a career in the Church. After several years passed in Rome, he returned to his home town in 1532 in the capacity of Protonotary Apostolic (as noted in his sepulchral inscription). His primary occupation, however, seems to have been his art collection. Composed of statues, inscriptions, and architectural fragments, the collection seems to have been arranged according to a design inspired or even based on that of Marco Mantova Benavides in Padua. The collection was not limited to ancient

art, however, but also included modern artists. Gualdo owned a series of family portraits, and some pieces by Antonio Lombardo, Donatello, and Riccio were perhaps assembled by him. Girolamo died in 1566 and named as his heir Giuseppe Brogliani, his sister's son, who adopted the name Gualdo to carry on the family (his only other nephew, Giovanni Battista, who is buried with him, had taken holy orders).[3]

So although Giovanni Battista, as stated by the inscription at the top of the monument, was responsible for its commission, his uncle's interests in ancient art and connections with Benavides raise the possibility that Vittoria had been known to the family for a long time. Indeed, it would seem out of the question that the young artist would not have come in contact with Girolamo Gualdo while at work in Vicenza on the palazzo Thiene from 1551 to 1553. In the seventeenth century the Gualdo collection possessed at least three items by Vittoria (all lost): a *St Sebastian*, a *Virgin and Child with St John*, and a *Head of Hercules*. Girolamo Gualdo the younger, great-nephew of the Girolamo portrayed here, states that he bought the *Head of Hercules*. Could the other two items have belonged to Girolamo the elder or to Giovanni Battista?[4]

[1] 'To Girolamo Gualdo, his wonderful uncle, canon of this church and protonotary apostolic, most excellent in doctrine and in morals, Giovanni Battista, canon, took care to set up this monument.'
[2] Arslan (1956), p. 33, no. 156.
[3] See Favaretto (1990), pp. 118–21.
[4] See Gualdo (1972), p. 65, and Ch. 3, above.

39. GUGLIELMO HELMAN (Pls. 158–9)

Marble?
Dimensions unknown; over life-size
Signed (on rim of right arm): A. V. F.
S. Maria Formosa, over door in right transept

Struck by the Vittoriesque features of the Helman monument in S. Maria Formosa, I noticed in 1991 that the bust on the left, that of Guglielmo, bears Vittoria's initials. The Helman monument has

never been discussed in relation to Vittoria; indeed, information about it is almost non-existent from any aspect. None the less, the design of the monument as a whole derives from the da Lezze monument in S. M. Assunta, attributed here to Vittoria (see cat. no. 15, Pl. 64). It also seems related in format to the memorial to three members of the Cappello family on the lateral façade of S. Maria Formosa, as well as to the monument raised in SS Giovanni e Paolo by Palma Giovane to himself, Palma Vecchio, and Titian.[1]

The only monograph on the church remains that of Pavanello from 1921. He writes only: 'Non indegno di essere riguardato è il monumento, che circonda la porta laterale, eretto alla memoria della famiglia fiamminga Hellemans, ricchi negozianti della seconda metà del secolo XVI. Peccato che la zona pittorica sia quasi del tutto scomparsa.'[2] Lorenzetti gives a laconic: 'Sulla par[ete] di fondo: Monum. funebre, ricco di marmi e scult. della famiglia Hellemans; sec. XVII.'[3] The guidebook of the Touring Club Italiano does not note the tomb at all, nor does Hubala in his guide to Venice in the *Reclams Kunstführer* series.

Some information can be derived from the three inscriptions on the monument. The central inscription, in the middle of the attic, directly below the sarcophagus, reads: 'Guglielmo and Antonio, with their brothers, Arnoldo, Pietro, Francesco, Giovanni Battista, and Carlo, born of Peter Helman of Antwerp, renowned observers of the Catholic faith, even more famous for their wealth, piety, charity, and generosity, a great part of their wealth having been spent on the poor, had among them such great harmony of spirit, that it was allowed that they do business in all the realms of the world, and, at the same time, that they have a home everywhere to all kings and princes; enrolled by decree among the citizens of the most gracious and serene Venetian Republic, hindered by untimely death, they are held in this tomb, and the other [brothers] in other [tombs] elsewhere.'[4]

The inscription on the right, beneath the bust of Antonio, reads: 'I, Antonio, have come to recognize that hopes are deceptive, having been made poor in my short time of life. Having arisen among fellow citizens in Belgium, dying in this city Venice, I am covered by this tomb. Died 17 February 1582.'[5]

The inscription on the left side of the monument, beneath the bust of Guglielmo—the one that bears Vittoria's initials—reads: 'I lived for others while I had life; after death, however, I did not perish, but in cold marble I live . . . I was Guglielmo Helman. Flanders grieves for me, the Adriatic sighs for me, and poverty summons me. Died 16 September 1593.'[6]

The Helman family was one of several Flemish merchant families who transferred to Venice as a result of the Sack of Antwerp in 1576 and the blockade of the Scheldt river in 1585. Tucci states that Guglielmo Helman and his brother Carlo headed one of Venice's most active firms, and that Guglielmo obtained Venetian citizenship in 1579, followed by Carlo in 1596.[7] (Antonio was also a citizen, as stated in the inscription.) As stated in the inscription, there were seven sons of Pietro (Peter) Helman (there were also five daughters): Guglielmo ([†]1593), Antonio ([†]1582), Carlo ([†]1605), Arnoldo, Giovanni Battista, Francesco, and Pietro. Antonio made his will on 19 April 1581. He lists himself as resident in the parish of S. Giovanni Crisostomo, makes no mention of a tomb, and names his brothers Guglielmo, Arnoldo, and Pietro as his executors.[8] Guglielmo made his will on 16 December 1583, calling himself a resident of the parish of S. Maria Formosa and naming his brothers Arnoldo and Pietro as his executors, and, like his brother, makes no mention of a tomb. He died on 16 September 1593.[9]

Considering the higher quality of Guglielmo's bust, and the specific reference to it in his inscription, it would seem possible that Guglielmo was the patron of the monument. Although his will makes no mention of a tomb, the will predates his death by ten years, and arrangements for a tomb could have been made in the meantime. Until I can conduct archival research on this monument, I can offer no more than a dating to the 1590s and an attribution of the tomb and the busts to the

workshop of Vittoria, perhaps after a design by the master. For a terracotta that seems related to this bust, see cat. no. 54, below.

[1] See Rinaldi (1984), i, p. 124, no. 401, for this monument set up by Palma Giovane.

[2] Pavanello (1921), p. 6.

[3] Lorenzetti (1963), p. 381.

[4] I thank Kenneth S. Rothwell, Jr., for his extensive help in translating all three inscriptions. 'Guilelmus et Antonius cum Arnoldo Pet. Franc. Io. Bapt. | et Carolo fratrib. ex Petro Helle-mans Antwerpiae | progeniti catholicae relig. cultores clari divitiis | pietate charitate et liberalitate clariores in pauperes | magna divitiar parte erogata tanta inter se fuere | animor concordia ut licet in omnibus mundi regnis | negociarentur una tamen sibi domus ubiq. esset unde | regibus et principibus cunctis gratiss. et ser. Venet. reip. | decreto inter cives adscripti immatura morte | praeventi hoc tumulo et caeteri alibi clauduntur.'

[5] 'Spes ego fallaces cognovi | Antonius esse | Exiguo vitae tempore | factus inops | Inter concives Belgeas exores | in urbe | Hac Veneta moriens | contegor hoc tumulo. | Obiit XV. Kalen-das martii | M D LXXXII.'

[6] 'Vixi aliis dum vita fuit | post funera tandem | Non perii at gelido | in marmore vivo vi . . . | Helmanus Gulielmus eram | me Flandria luget | Adria suspirat | pauperiesque vocat | Obiit XVI Kal. octob: | M D XCIII.' In Cicogna's unpublished tran-scriptions of inscriptions in S. Maria Formosa (included in Bibl. Civ. Correr, Cod. Cicogna 2012, p. 2), he gives a reading for line 4 of 'in marmore vivo mihi' but I am unable to see 'mihi' in the now somewhat effaced inscription.

[7] Tucci (1973), pp. 357 and 363.

[8] The will, ASV, Notarili e Testamenti, F. Mondo, b. 681, no. 206, is summarized in Brulez (1965), p. 14, no. 30.

[9] Guglielmo's will is in ASV, Notarili e Testamenti, F. Mondo, b. 685, no. 1478 (a copy is in b. 687). The will is summarized by Brulez (1965), pp. 27–8, no. 75, and printed in full on pp. 584–6. Brulez also summarizes and prints the will of Carlo Helman, of 6 June 1605. Carlo interestingly leaves a legacy to Giovanni Gabrieli, the composer and organist of S. Marco, but yet again makes no reference to a family tomb in S. Maria Formosa (or anywhere else).

40. GIROLAMO MOLIN (Pl. 74)

Stone (*pietra viva*?), originally gilded

Dimensions unknown; life-size

Unsigned

Bust and socle are in one piece

S. Maria del Giglio, Venice, over a door after the first chapel on the right

In 1581, Sansovino noted this bust as being in S. Maria del Giglio, but gave no attribution.[1] Never-theless, a full account of the commissioning of the bust is given by Giovanni Maria Verdizotti in his *Vita del clarissimo M. Girolamo Molin*. After stating that Giulio Contarini was Molin's oldest and closest friend, Verdizotti goes on to say:

Onde finalmente questo Cla[rissimo] Senatore [Con-tarini] essendo rimesso all'arbitrio di lui [Molin] per l'istesso testamento di far sepellir il suo corpo, dove gli piacesse, ricordevole della passata amicitia del suo caro compagno, fratello in beninvolenza reciproca, l'ha fatto sepellire nella chiesa di Santa Maria Giubenico in Venetia, la quale chiesa è nella parochia nella quale esso [Contarini] habita. Et oltra l'haverlo fatto porre in un sepolcro a questo effetto ordinato, vicino al suo & della sua familia, & collocar la sua immagine da M. Alessandro Vittoria, ottimo maestro de quell'arte scolpita, l'ha honorato d'un epitafio composto da lui medesimo, in un marmo per eterna memoria intagliato del tenor che segue: HIERONIMO MOLINO VERO MUSARUM ALUMNO QUI HUMO CINERES IMAGINEM NOBIS COELO ANIMAM DICAVIT VII. KAL. IAN. MD.LXIX. IULIUS CONTARENUS DIVI MARCI PROCURATOR INSIGNI AMORE AC PIETATE HAEC FIERI CURAVIT.[2]

The inscription still survives today above Molin's bust placed above the entrance to the so-called Molin chapel in S. Maria del Giglio.

Giulio Contarini, therefore, was the patron of this bust, and it must have been ordered after Molin's death on Christmas Day 1569.[3] Although Verdizotti's *Vita* of Molin was published in 1573, the introduction to the book, written by Celio Magno and dedicated to Giulio Contarini, is dated from Zara on 20 October 1572; Magno also men-tions the bust and says that it is in place.[4] Thus, the portrait must date from between 1570 and 1572. Sansovino notes that the bust was gilded, traces of which can still be observed on its torso.[5]

Despite Verdizotti's specific statement that the bust is by 'M. Alessandro Vittoria, ottimo maestro di quell'arte scolpita', the mediocre, not to say bland, quality of the work itself denies it autograph status and instead marks it as the earliest bust assign-able to Vittoria's workshop. This may explain the inexpensive material employed—*pietra viva* instead of marble—and why the bust is unsigned. A com-parison of this bust with that of its patron, Giulio

Contarini (Pl. 70), also in S. Maria del Giglio, is the clearest proof that while the bust of Contarini is by Vittoria, that of Molin is by another, far weaker artist.[6]

None the less, the bust is not without interest as a product of the workshop. It reveals, for instance, how a Vittoriesque 'formula' for a portrait bust had already come into existence and could be drawn upon at will. There really is nothing to go on as regards an attribution within Vittoria's workshop; probably a number of members of the *bottega* would have been capable of the bust of Molin.

The first time that the bust was attributed to Vittoria was in Moschini's edition of Temanza's *Vita* of Vittoria; it was Moschini who found the reference to Vittoria in Verdizotti.[7] Giovanelli assigns the bust to 1570.[8] Serra mentions this bust but does not discuss it.[9] Neither Planiscig, Venturi, nor Cessi mentions this portrait.

The bust and inscription occupy a most inconspicuous location in S. Maria del Giglio, and whether they are in fact in their original position is unclear.[10]

A complete and well-documented biography of Girolamo Molin was written by Elisa Greggio.[11] Born in 1500, Girolamo was the son of Pietro, son of Giacomo; his mother was Chiara Cappello, a sister of Vicenzo Cappello, the famous naval commander whose funerary monument stands on the façade of S. Maria Formosa.[12] Although he held a number of minor public offices, Molin principally pursued literary activities and was as well an amateur painter.[13] As a poet, Molin was a *bembista*, and associated with men such as Bembo, Aretino, Daniele Barbaro, Bernardo Tasso, and Sperone Speroni.[14] Domenico Venier and Giulio Contarini were his special friends.[15] He was probably a member of the Accademia della Fama, as was Camillo Trevisan, and was a frequent visitor to Trevisan's palace on Murano which contained stuccoes by Vittoria.[16] Molin is one of the participants in the discussions held in *Il Diamerone* by Valerio Marcellino and in *I Diporti* by Girolamo Parabosco.[17] He never published any poetry during

his lifetime, nor did he ever marry. He named as his heir Marc'Antonio Molin, whom he had raised as a son and who was the son-in-law of Giulio Contarini.[18] Molin died on Christmas Day 1569.[19]

[1] Sansovino (1581), p. 44*b*: 'Illustrano questo Sacrario due chiarissimi personaggi, e famosi, e per eccelente dottrina. L'uno è Sebastiano Foscarini . . . L'altro è Hieronimo Molino cultissimo Poeta nella lingua Toscana, del quale vanno per le mani de gli huomini dotti un Volume di Rime molto leggiadre e al quale Giulio Contarini, come ottimo amico, pose la statua aurea con questa inscritione.' For the inscription, see n. 2.

[2] Verdizotti (1573), p. 11; this work is appended to the *Rime di M. Girolamo Molin*. The *Rime* of Molin were, as Verdizotti states, put together after Molin's death by himself, Giulio Contarini, and Domenico Venier. As can be seen from the quotation in n. 1, Sansovino likewise names Giulio Contarini as the patron. The inscription translates as: 'To Girolamo Molin, true student of the Muses, who gave his mortal remains to the earth, his image to us, but his soul to heaven, on 25 December 1569. Giulio Contarini, Procurator of St Mark's, took care to set up these things as a sign of love and piety.'

[3] Molin's will is ASV, Notarili e Testamenti, C. Zilliol, b. 1262, fasc. 2, fos. 87r–89r. It was written on 20 May 1567. On fo. 87v, Molin writes: 'Com[m]issario di q[ue]sto mio Testamento voglio che sia il Cl[arissi]mo m[esser] Giulio Contarini procuratore di s[an] Marco, il quale amo, et nel quale molto confido . . . Et voglio . . . che il corpo mio sia posto dove parerà al ditto mio com[m]issario . . . L'animo mio è de trovarmi un loco dove io habbia ad esser sepolto . . . ma non havendo fin hora trovato questo loco rimetto questo carico in tutto come piacerà al dito mio com[m]issario, eccettuando il loco di santo Job.' Since Molin left Contarini in charge of his burial, all the arrangements for Molin's monument must be posthumous.

[4] Celio Magno, 'Al Clarissimo M. Giulio Contarini Il Procuratore' (this is the Introductory Letter to the *Vita* of Molin, see n. 2), p. 4v. For information and bibliography on Magno, see *Dizionario Enciclopedia* (1967), iii, p. 456.

[5] See n. 1.

[6] For the bust of Giulio Contarini, see cat. no. 1.

[7] Temanza (1827), p. 50, n. 52.

[8] Giovanelli (1858), p. 66.

[9] Serra (1923), p. 75.

[10] See the extensive discussion of this issue in Martin (1988), pp. 259–62.

[11] Greggio (1894), pp. 188–202 and 255–323.

[12] Verdizotti (1573), p. 3.

[13] Greggio (1894), *passim*, gives the various offices Molin held. Molin's work as a painter is evidenced by a letter to him from Aretino in which Aretino speaks of Molin copying a *Christ* by Titian; see Greggio (1894), p. 273.

[14] Verdizotti (1573), p. 6.

[15] Ibid., pp. 7 and 11.

[16] Greggio (1894), p. 269. For Molin and Trevisan, see Urbani de Gheltof (1890), p. 23.

[17] Marcellino (1563); Parabosco (1558).

[18] Verdizotti (1573), p. 11.

[19] Greggio (1894), p. 275, publishes Molin's necrology.

41. ANTONIO MONTECATINO
(Pl. 132)

Marble
Dimensions unknown; over life-size
Signed (on rim of left arm reading from bottom up):
ALEXANDER. VICTORIA
Bust and socle appear to be in one piece
S. Paolo, Ferrara; the monument is attached to the first column on the right side of the nave before the crossing

This bust is mentioned in Vittoria's account book:

Adì 23 Ottobrio 1599. Contai a m[esser]o Batista bressan squadrator per aver laborato giorni tre sul ritrato dil Ill[ust]re Monte Catino ferarese . . . L 71/2[1]

This is the last time a payment for a bust is recorded in the account book. According to the inscription on the monument to Montecatino, he died on 28 March 1599, hence the bust was being worked on seven months after the sitter's death. Again according to the inscription, the monument was raised by Montecatino's sister Helen and his nephew (her son?) Alberto. They thus are presumably the patrons.

The bust entered the literature with Moschini's edition of Temanza in 1827; Moschini knew of it because of the reference in the account book.[2] Giovanelli repeats Moschini almost word for word, adding that the bust is 'bello e vivace quanto dire si possa'.[3] Serra notes the payment and includes the bust among other 'opere scialbe'.[4] Planiscig cites the present bust as among Vittoria's last portraits and judges it of higher quality than the busts of Alvise Tiepolo and Jacopo Soranzo.[5] Cessi, while finding the bust 'immobile' accepts it as by the master.[6]

This portrait comes entirely from the workshop, as attested by its bland, dry, schematic, textureless rendering. Its large size and the quadratic shape of the torso connect it to other workshop busts from the 1590s, such as the 'Pietro Zen' (Pl. 137) in Berlin and the Jacopo Soranzo (Pl. 133) in S. Maria degli Angeli.[7] If these last two busts are by Andrea dell'Aquila, this bust is most likely by him as well.

Antonio Montecatino lived from 1533 to 1599. The only information I have on him comes from his sepulchral inscription,[8] which states that he was a lawyer, a councillor to Duke Alfonso II, and led delegations to the Pope and to the King of France.

[1] Predelli (1908), p. 199.
[2] Temanza (1827), p. 53, n. 58: '12. busto dell'illustre Montecatino ferrarese, pel quale die soldi a M. Battista Bressan, che ci aveva lavorato, il dì 23 di ottobre del 1599, busto che fu posto nella chiesa di s. Paolo a Ferrara, i cui scrittori, errando, lo dicono opera di Alessandro Vicentino.' I do not know who the 'scrittori' are to whom Moschini refers.
[3] Giovanelli (1858), p. 94.
[4] Serra (1923), p. 84.
[5] Planiscig (1921), p. 519; for the busts of Soranzo and Tiepolo, see cat. nos. 44 and 45.
[6] Cessi (1962), p. 22.
[7] See cat. no. 44 for the bust of Soranzo, cat. no. 48 for the 'Pietro Zen'.
[8] 'D.O.M. | MALVIT DIGNITATES MERERI QUAM CONSEQUI QUAS | RECEPIT. COHONESTAVIT. ALFONSO II DUCI SERAVES, CONSILIA | OPEPAM, FIDELITER PRAESTITIT. LEGATIONES PRO ILLO | AD REGEM FALL. AD SUMMOS PONT. PERFECIT. URBEM REGII | REXIT. NON SEMEL UNIVERSAM DITIONEM CONSILIARIUS, PRODUX. ADMINISTRAVIT. FERRARIAE TRIBUNATUM | GESSIT. GYMNASIUM DOCTRINA DECORAVIT, REGIMINE | AMPLIFICAVIT, NULLAM GRAVIS, ET INCULPATI, VIRI PRAESTANTIAM NON PRAESETULIT NOMINE, SCRIPTUS, RE, PHILOSOPHUS. | ANTONIUS MONTECATINUS | OBIIT ANNO MDICIX AETATIS LXII. V. KAL. APRILIS. | HELENA MONTECATINA SOROR AC | ALBERTUS MONTECATINUS NEPOS HAERES P.'

42. VINCENZO MOROSINI (Pls. 3, 103)

Marble
Dimensions unknown; over life-size
Signed (on rim of right shoulder): A. V. F.
Bust and socle are separate
S. Giorgio Maggiore, Venice, left transept, over the door leading to the campanile

A payment for work on this bust is recorded in Vittoria's account book:

adì 26 febraro 1587
Contai a Vigilio ducati vintido e mezo in più volte a rason de mezo ducato al giorno per aver lavorato sule figure di palazo, et sul ritrato dil S. Vicenzo Morosini procurator val . . . Duc. 22 1/2.[1]

Vigilio is Vittoria's nephew, Vigilio Rubini; the 'figure di palazo' are the statues of Justice and

Venice on the Ducal Palace.[2] The date, 26 February 1587, should be in *more veneto*, and thus actually 26 February 1588.

Because Morosini died on 1 March 1588, it is known that the bust was commissioned and being worked on, if not finished, before the patron's death.[3] Stringa first mentions the monument and gives it no attribution.[4] Martinioni specifically mentions the bust but again leaves it unattributed.[5] Moschini first credited the bust to Vittoria on the basis of the above entry from the account book.[6]

The bust bears surprising resemblances to that of Girolamo Molin in S. Maria del Giglio (see cat. no. 40). Like the *Molin*, the *Morosini* is flat and lifeless. The eyes are vacant and unseeing, the features rendered without great individuality, and the forked ends of the beard are attached to the chest of the torso. Here, furthermore, the drill is conspicuously used, especially on the brocade of Morosini's stole; such a heavy use of the drill finds no corresponding examples in Vittoria's autograph work. On the basis of the entry in the account book, it seems safe to attribute this bust to Vigilio Rubini. The torso is a variant of that on the bust of Pietro Zen.[7]

Vincenzo Morosini was the son of Barbone, son of Giustiniano, Morosini. Born on 9 April 1511, he married in 1536 and in 1542. After serving as Prefect of Bergamo in 1555, he became a *Savio di Terraferma* in 1565. With Niccolo da Ponte, he went as an ambassador to Pope Gregory XIII in 1572. Elected a Procurator *de Citra* in 1578, he was Pasquale Cicogna's strongest rival for the Dogeship in 1585. He was one of the most prominent patricians of his time: Grendler tellingly observes that Morosini enjoyed thirty-two successful elections to the 'great offices' of the Venetian government.[8] Morosini died on 1 March 1588.[9]

[1] Predelli (1908), p. 197.
[2] On Rubini, see Zorzi (1962*b*), pp. 112–14.
[3] Morosini received permission to be buried in his chapel on 7 Nov. 1585; see Cicogna (1824–53), iv, p. 350.
[4] Sansovino (1604), pp. 176*a*–*b*.
[5] Sansovino (1664), p. 222.
[6] Temanza (1827), p. 58, n. 54.

[7] Cessi (1962), p. 15, implies that the piece is an autograph work; Serra (1923), p. 80, reports that 'non si ha notizia' of the bust of Morosini; Planiscig (1921) does not mention it.
[8] See Grendler (1979), p. 319, n. 53.
[9] Cicogna (1824–53), iv, p. 350, gives a biography of Morosini.

43. GIOVANNI BATTISTA PERANDA (Pl. 100)

Marble
Dimensions unknown; over life-size
Signed (on rim of left shoulder reading from bottom up): ALEXAN. VICT.
There is no socle[1]
S. Maria degli Angeli, Murano, above entrance
Provenance: in S. Sepolcro until 1807; in the Seminario Patriarchale until some time before 1940, when it was moved to S. Maria degli Angeli on Murano[2]

More than a page of Vittoria's account book is devoted to payments to various assistants for work on the Peranda monument.[3] They run through a four-month period from 15 September 1586 to 10 January 1587. Hence, work apparently began seven months after Peranda died in February 1586.

The bust, framed by a scallop shell, rests above an inscribed *targa* decorated with putti. Although all of the payments in the account book refer specifically to work performed 'sul ornamento' of the memorial and not to the bust, the latter can also be safely assigned to the workshop. Its dull, stolid character, cramped outline and scale, and especially the hardness of its carving and modelling demonstrate that it cannot be from the master's hand. The dryness of the execution has much in common with the bust of Vincenzo Morosini in S. Giorgio Maggiore, and Venturi may well be right to suggest Vigilio Rubini as the author.[4]

According to the inscription, Laura Foscarini, Peranda's wife, was the patron.[5] Presumably, the monument was set up early in 1587, after the last payment for it is mentioned in the account book under 10 January 1586 (m.v.). The monument is first mentioned by Stringa, who attributes the bust to Vittoria.[6] Since Planiscig, the portrait has been regularly assigned to the workshop.[7] In its original

location, the memorial faced the monument to Girolamo Contarini.[8]

Giovanni Battista Peranda died on 16 February 1586 at the age of 54 and thus was most likely born in 1531.[9] He is listed in the 1587 edition of *Tutte le cose notabili di Venezia*, along with Apollonio Massa, as one of the four most eminent physicians of Venice.[10] Stringa describes him as a 'Filosopho e Medico celebre, oltre a diverse prose, & versi latini, & volgari, scrisse diverse Trattati nel la medicina'.[11] In 1563, Peranda was the Prior of the College of Medicine in Venice; thus, he had already achieved prominence in his profession by his early thirties.[12] In 1569, he was one of the witnesses to Niccolo Massa's will.[13] His distinguished clientele included Marino Grimani.

He also was Vittoria's doctor. In a document that probably dates from 1582 addressed to the tax commissioners of Venice, Vittoria states that he suffers from 'dua infermittà inchurabille', and that one of these infirmities 'mi condusse quindici giorni fa vicinissimo alla morte, chome farà fede lo Eccel[entissi]mo S[igno]r Zua[n]battista Peranda e tutta la mia contrada'.[14]

Peranda's life came to a violent end. He died as a result of the seven wounds he received on the night of 22 January 1586 when, returning home from visiting a patient, he was attacked by Alvise Foscarini, the nephew of his wife Laura, 'per passati rancori'.[15]

[1] The absence of a socle is strange; perhaps it was lost during one of the times the monument was moved. See cat. no. 31 for the bust of Girolamo Contarini, which also was originally in S. Sepolcro and which also lacks its original socle.

[2] S. Sepolcro was suppressed and destroyed in 1807; see Zorzi (1972), ii, p. 384. Because the bust came to the Seminary, Gianantonio Moschini probably salvaged it; see the introduction and p. 63 to Moschini (1842). Moschini (1940), p. 8, states that the Peranda monument was already in Murano and, p. 4, that the collection at the seminary was reorganized in 1937. The monument was probably moved that year.

[3] Predelli (1908), pp. 195–7.

[4] Venturi (1937), p. 138. For the bust of Morosini, see cat. no. 42.

[5] The inscription reads: JO. BAPTISTAE PERANDAE PHILOSOPHO, AC MEDICO NOBILISSIMO, QUI PRAECLARISSIMARUM ARTIUM PRAESIDIO MUNITUS, VEL FLORENTIS INGENII ACUMINE VEL DIUTURNO MEDICINAE USU, DESPERATOS QUOQUE DUM SANARI POSSE OSTENDIS-

SET, IMMITI FATO CIVITATI EREPTUS EST, LAURA FUSCARENA UXOR MOESTISS. VIRO DE SE BENEM. F. DECESSIT XIV. KALEND. MARTII MDLXXXVI ANNO AETATIS LIIII ('To Giovanni Battista Peranda, most noble philosopher and physician, who, protected by the aid of the most excellent arts, whether by the acuteness of his flourishing genius or the use of everduring physic, and who was wont to heal even those despaired of, was carried off by cruel destiny, Laura Foscarini, his most sorrowful wife, made [this tomb] as a memorial to him; he died the 16th of February 1586 at age 54').

[6] Sansovino (1604), p. 132a.

[7] Planiscig (1921), p. 512; Serra (1923), p. 62, calls it mediocre; Venturi (1937), p. 138; Cessi (1961a), pp. 57–8; Zorzi (1972), ii, p. 384, gives no attribution.

[8] See cat. no. 31.

[9] Tassini (1887), pp. 600–1, prints Peranda's necrology, which gives his age as 52. Nevertheless, the epitaph gives his age as 54 and is a more reliable source; see n. 5.

[10] Sansovino (1587b), p. 200.

[11] Sansovino (1604), p. 419a.

[12] Agostini (1754), ii, p. 587.

[13] Massa's will is published in Lind (1975), pp. 167–73.

[14] See Gerola (1924–5), p. 353.

[15] See Tassini (1879), p. 283, no. 17.

44. JACOPO SORANZO (Pl. 133)

Marble
Dimensions unknown; over life-size
Signed (on rim of right arm): ALEXANDER.VICTORIA.F
Bust and socle are separate
S. Maria degli Angeli, Murano, left wall of apse

This bust entered the literature when Giovanelli's book was published by Gar in 1858. At the end of the book, Gar printed 'Notizie relative ad Alessandro Vittoria comunicate a Tommaso Gar dai chiarissimi signori Emanuele Cicogna e Vincenzo Lazari' in which the bust is cited.[1] Since then it has been regularly mentioned as being by Vittoria, with a dating from the 1590s.[2]

The bust certainly dates from either the late 1590s or early 1600s and is definitely a product of the workshop. The very large dimensions, the quadratic shape of the torso, the schematic rendering of the features, the disposition of the draperies, and the proportions of the bust to the socle, are so close to that of the '*Pietro Zen*' in Berlin (cat. no. 48, Pl. 137), that I suspect that the same hand carved both pieces. Cessi has suggested that the bust of 'Zen' is by Andrea dell'Aquila; if this be correct, then the bust of Soranzo is by him as well.[3]

Jacopo Soranzo, son of Francesco, was born in 1536. He was distinguished as an ambassador, serving as Venetian envoy to England in 1552 (directly after Daniele Barbaro's ambassadorship), to the Emperor Ferdinand in 1554, to Pope Pius IV in 1562, and, after having served in the Turkish war of 1571–3, to Pope Gregory XIII in 1576. In 1576 he was elected a Procurator. In 1584, however, he was stripped of his procuratorship and banished from Venice for having revealed state secrets to foreign powers. In 1586 he was allowed to return to Venice, where he died in 1599.[4] Like several other patrons of Vittoria, he was well known for his pro-papal sympathies.[5]

[1] Giovanelli (1858), pp. 119–20: 'Nello stesso anno 1854, col-l'amico Dottore Vincenzo Lazari, ho scoperto un busto bellissimo in marmo, di Jacopo Soranzo, collocato in una nicchia alla parete sinistra della cappella maggiore della chiesa, oggidì chiusa, di Santa Maria degli Angeli in Murano. Questo busto ha nel solito sito le parole ALEXANDER. VICTORIA. F. Tale busto non fu ricordato nemmeno nella *Guida di Murano* dell'Ab. Moschini. Il Soranzo moriva nel 1599.'

[2] Serra (1923), p. 84, calls it a weak work and dates it 'probably' to 1599; Planiscig (1921), p. 519, calls it one of the last busts and finds it of lower quality than that of Montecatino; Cessi (1962), pp. 21–2, also groups it among the 'last works' with the Monte-catino and Cappello busts.

[3] Cessi (1963), pp. 28–37.

[4] See Marco Barbaro, *Genealogie Venete* (Bibl. Civ. Correr, Cod. Cicogna, 2498–2504), vi, p. 529.

[5] See Grendler (1979), p. 323, n. 58, and Lowry (1971), p. 294.

45. ALVISE TIEPOLO (Pl. 105)

Marble
Dimensions unknown; over life-size
Signed (on rim of right arm): ALEX. VICTORIA. F
Bust and socle are separate
Chapel of S. Sabba, S. Antonin, Venice

The date of this bust can be accurately determined from the research of Stefania Mason Rinaldi who found in the Venetian archives the account book of the Tiepolo family.[1] The account book shows that Vittoria received a (first?) payment of 20 ducats on 14 June 1594 and the balance of 50 ducats for the portrait on 16 December 1594.[2] There is also an entry in Vittoria's own account book pertaining to

this bust: 'Adì 27 Zugno 1594. Contai a M[esser]o Andrea squadratore per aver lavorato sul ritrat[t]o dil Clar[issi]mo Tiepolo . . . L[ire] 6.'[3]

Three payments were made by the Tiepolo on 14 June 1594: the 20 ducats to Vittoria, plus 93 lire for having the altar consecrated and 13 lire for setting the bust in place.[4] Hence, the bust must have been finished by June 1594. This makes the bust posthumous, Alvise Tiepolo having died on 22 January 1591, demonstrating again the lapse of time that can occur between the death of a person and the execution of his sepulchral image.[5]

The mediocre quality of the *Tiepolo*, with its schematic modelling of the facial features, hair, and beard, clearly reveals its workshop status in common with other busts from the 1590s. The torso employed is the model torso also seen in the busts of Vincenzo Morosini, Antonio Zorzi, Domenico Duodo, and Lorenzo Capello.[6]

The records from the Tiepolo account book comprise the most complete account of payments to Vittoria for a portrait bust. In 1557, the artist received 35 scudi from Daniele Barbaro as the balance for the bust of Giovanni Battista Ferretti; no earlier payments are recorded.[7] In August 1573, Vittoria was paid 60 ducats by Marino Grimani as the balance for the portrait of his father, Girolamo Grimani.[8] In May 1583, Vittoria received 56 gold scudi from the monks of S. Domenico di Castello for the bust of Paolo Costabile.[9] And between December 1592 and April 1593, Marino Grimani paid Vittoria a total of 70 ducats for his marble portrait.[10]

Serra rightly assigns this bust to the workshop; Planiscig notes only that the *Tiepolo* (and *Soranzo*) is of lower quality than the busts of Lorenzo Cappello and Antonio Montecatino; Venturi calls this bust 'tutto vigore e saldezza', while Cessi, though noting that the piece appears conventional, also praises it.[11]

Alvise (or Luigi) Tiepolo, son of Lorenzo, was born in 1528. Elected a Procurator *de Citra* on 28 January 1571, he died in January 1591. As stated in his epitaph, he was instrumental in erecting the

chapel in S. Antonin, where he lies buried, to S. Sabba.[12]

¹ Rinaldi (1976–7), pp. 193–212. The archival designation is ASV, Archivio Tiepolo, Consegna 2, busta 108.

² Ibid., p. 208: 'Adi 14 zugno [15]94 contadì al [V]it[t]oria p[er] il ritratto d[ucat]i 20', and p. 210: '1594, 16 [Decem]bre Pagam[en]to ad Alessandro Vittoria Scultor d[ucat]i 50 a conto del Ritratto di Marmo e di Terra dell'Ill[ustrissi]mo Alv[is]e Proc[urato]r Tiepolo.' According to this notice, there was also a terracotta of Tiepolo; I have found no further mention of this object.

³ Predelli (1908), p. 199.

⁴ Rinaldi (1976–7), p. 208.

⁵ Tiepolo's necrology can be found in ASV, Provveditori e Sopravveditori alla Sanità, b. 822, c.184ʳ: 'adi 22 Zener 1590: Il Cl[arissi]mo Sig[no]r Al[vis]e Tiepolo procurator de an[n]i 60 de febre già giorni 8—S. Zeminia.' All necrologies are given in *more veneto*, hence, Tiepolo died on 22 Jan. 1591. The date on Tiepolo's epitaph is also given in *more veneto*, thus Tiepolo is usually erroneously said to have died in 1590 (see n. 12 for the epitaph). Other examples in Vittoria's *œuvre* of long lapses between the death of a sitter and execution of his portrait are Priamo da Lezze (cat. no. 15) and Girolamo Grimani (cat. no. 8). As stated in the epitaph (see n. 12), the monument was set up by Alvise's son, Francesco Tiepolo, who was the patron.

⁶ See, respectively, cat. nos. 42, 49, 35, and 30.

⁷ See cat. no. 6.

⁸ See cat. no. 8.

⁹ See cat. no. 2.

¹⁰ See cat. no. 11.

¹¹ Serra (1923), p. 82; Planiscig (1921), p. 519; Venturi (1937), p. 174, n. 1; Cessi (1962), pp. 19–20.

¹² The epitaph reads: ALOYSIO THEUPOLO D[IVI] MARCI PROC[URATORI] LAURENTII F[ILIO] SENAT[O] AMPLISS[IMO] & INTEGERRIMO, CUM MAIOREUM SUORUM, QUI D[IVI] SABAE CORPORE HANC ECCLESIAM DONARUNT RELGIONIS VISTIGIA IMITATURUS PRAEVENTUS ESSET; UT SINGULARIS EIUS PIETATIS, VOLUNTATISQ[UE] TESTIMONIUM APPARERET. FRANCES[CUS] F[ILIUS] OB MEAM IN PATREM OBSERVAN[S] F[ECIT] C[URAVIT]. VIX[IT] AN[NOS] LXII. MEN[SIS] V. DI[ES] I. OBIIT ANNO M. D. X. C. DIE. XX IAN[URARIS] ('To Alvise Tiepolo, son of Lorenzo, Procurator of St Mark, a great and irreproachable senator, who, with his family, . . . so that it appear as a testimony of his singular piety and good will. Francesco, his son, observing my [respect] to my father, set up [this monument]. He lived sixty-two years, five months, one day. He died on the twentieth day of January 1590 [*m.v.*]').

46. ALESSANDRO VITTORIA (Pl. 134)

Marble
Dimensions unknown; over life-size
Signed (on rim of left arm reading from bottom up): ALEXANDER VICTORIA F
Bust and socle are separate
S. Zaccaria, Venice, left aisle

Despite Cessi's assertion that this bust must post-date 1595 because it is not mentioned in Vittoria's will of 25 February 1595, the bust is indeed referred to there:

Desidero esser sepelito in qualche chiesa di monache, dove parerà ad es[s]i me' commisiarii, facendo mettere in opera et finire quella sepoltura, nella quale doveranno esser collocate quelle due figure de marmo che se attrovano al presente nell'intrare della mia porta maista, una per banda, et il mio retratto de marmo, conforme al desegno che io lascio nel mio scrittore.[1]

The 'due figure di marmo' at the entrance to Vittoria's house are the two caryatids on the artist's monument. They are first cited in Vittoria's will of 29 July 1576, in which he instructs that they are to be placed on his tomb.[2] They are cited again in the will of 6 May 1584, but no portrait is mentioned then.[3]

Hence, the bust probably dates from between 1584 and 1595. Stylistically, its stolid quality fits in quite well with a date from the first half of the 1590s in accordance with examples such as the *Alvise Tiepolo* (cat. no. 45). Venturi pronounced the bust 'esguito secondo le regole di un manierismo asciutto e forbito, consono ai modi di Vigilio Rubini'.[4] Rubini is indeed a likely candidate as the author of this bust.

¹ Cessi (1962), p. 25; the passage from the will is taken from Gerola (1924–5), p. 354.

² Ibid., p. 350.

³ Ibid., p. 353.

⁴ Venturi (1937), p. 145.

47. ALESSANDRO VITTORIA (Pl. 135)

Terracotta
Height: 80 cm.
Unsigned
Socle and base are in one piece
Victoria and Albert Museum, London
Provenance: palazzo Manfrin, Venice; acquired prior to 1870 for the F. Cavendish-Bentinck Collection; in the Victoria and Albert since 1871[1]

John Pope-Hennessy rightly denied this bust autograph status, calling it 'a free version of the self-

portrait of Vittoria in San Zaccaria (1602–5), from which it differs in the handling of the hair, the position of the buttons at the throat and certain details of the drapery'. He suggests that it, and three other terracottas in the museum with the same provenance, were made in the nineteenth century.[2] Thermoluminescence tests conducted on this object in 1975, however, placed it between 1550 and 1710.[3] Boucher observed that this bust (and the other three terracottas doubted by Pope-Hennessy) looks like a cast after an original model, for it lacks 'the crisper treatment of features, hair and drapery found in hand modelled clay'. He further states that, like most casts, this one has been covered with a mixture of water and clay to give it 'a more polished surface'. Boucher supports the 'traditional' attribution of this piece to Vittoria, but says it 'must have been cast after a portrait of Vittoria, presumably the model used by the artist' for the bust on his tomb.[4]

I agree that this bust is a cast, and see no reason to attribute it to the master. This piece is of higher quality than the other three dubious terracottas in the Victoria and Albert, but that can be explained by its being based on an original by the master whereas the others (except for cat. no. 54) appear to be *centos* or free inventions. On the basis of the thermoluminescence tests, this object could have been made well into the seventeenth century, and perhaps was.

There is no basis for designating this piece as the model for the marble self-portrait on the sculptor's sepulchral monument in S. Zaccaria. Another such object has appeared in the literature. Serra states that a copy of the bust on Vittoria's tomb was in the Capel Cure sale at Christie's in London on 4–6 May 1905.[5] In a report on this sale in *L'Arte*, an anonymous reviewer noted that although the catalogue called this object the model for the bust on the artist's tomb, he thought it was a copy of that bust.[6] Since the terracotta in the Victoria and Albert Museum has been there since 1871, the bust in the Capel Cure sale cannot have been the same object. Hence, like the busts of Palma Giovane and Apollonio Massa, various ver-

sions of the self-portrait have been in circulation for some time.[7]

The object in the Capel Cure sale was more likely to have been the original model of the marble in S. Zaccaria. The entry in the sale catalogue reads: '#90. A Bust of Alessandro Vittoria, modelled for his own tomb in the San Zaccharia [*sic*], Venice, by himself—prepared in 1595. The bust has a modern body.'[8] That a modern torso was added to the head implies that the head was valuable and worth saving—hence, perhaps autograph.

[1] For the provenance, see Pope-Hennessy (1964), ii, p. 531, no. 568. The inventory number is A. 12–1948.
[2] Ibid., pp. 533–4. For the other 3 terracottas, see cat. nos. 51, 52, and 54.
[3] See Boucher in *Palladio* (1975), p. 99, no. 182.
[4] Ibid. Cessi (1963), pp. 31–2, hypothesizes that this piece is a copy of the marble of Vittoria set on his tomb in S. Zaccaria.
[5] Serra (1923), p. 87.
[6] *L'Arte* (1905), p. 286.
[7] For the versions of the busts of Palma and of Apollonio Massa, see cat. nos. 62, 63, 66, and 67.
[8] *Capel-Cure* (1905), p. 16.

48. 'PIETRO ZEN' (Pl. 137)

Marble
Height: 91.5 cm.
Signed (on rim of left shoulder): ALEXANDER. VICTORIA. F
Relation of socle to bust not known
Staatliche Museen zu Berlin, Preussischer Kulturbesitz, Skulpturensammlung
Provenance: acquired by the Kaiser Friedrich Museum in Venice in 1841 from the dealer Paiaro[1]

Ever since this bust was acquired by Berlin in 1841, it has been catalogued as being by Vittoria and identified as Pietro Zen, the same man depicted in the terracotta in the Seminario Patriarchale. But in the 1933 edition of the Berlin catalogues, Schottmüller changed the designation of the bust to 'Workshop of Alessandro Vittoria' because its quality—'despite the signature'—is so low.[2] I agree with this assessment. The boring, flat, completely quadratic handling of the drapery of the cloak, the

schematic rendering of the beard, the vapid expression of the face, as well as the overall very heavy, bulky feeling of the work as a whole cannot be considered autograph, although they have much in common with the bust of Jacopo Soranzo, which would seem to be by the same hand as the present bust. The bust of Soranzo was probably made in the 1590s, around the time of the sitter's death (see cat. no. 44); the 'Pietro Zen' must also date from this decade or perhaps the very early 1600s and it is certainly by a prominent member of Vittoria's workshop.

The features of the sitter do not correspond to those on the terracotta portrait of Pietro Zen (Pl. 108) except in a most general way; furthermore, Pietro Zen was never a military man, and thus there is no reason why he should be depicted in armour. The identity of the sitter is unknown.[3]

Schottmüller provides a full bibliography up to 1933.[4] This is perhaps a bust mentioned by Cicogna.[5] Planiscig accepts the bust and dates it to around 1570.[6] Venturi correctly notes that this bust does not portray Pietro Zen and writes that, compared with the bust of Sebastiano Venier, it lacks life on account of its cold academicism.[7] Cessi attributes this bust, with a question mark, to Andrea dell'Aquila and this, in my opinion, is reasonable, and perhaps correct.[8]

[1] See Schottmüller (1913), p. 169, no. 400.

[2] Schottmüller (1933), p. 188, no. 304.

[3] In this context, it should be remembered that the terracotta of Giralomo Grimani was, for over 100 years, unquestioningly accepted as representing Jacopo Sansovino (see cat. no. 9), that the copy in the Musée Jacquemart-André of the bust of Paresano Paresani by Giulio del Moro in S. Fantin is still today called Francesco Duodo (see cat. no. 73), and that the terracotta of Francesco Duodo in the Correr Museum was, for at least 60 years, called Sebastiano Venier (see cat. no. 5). The last example is the most egregious misidentification: Francesco Duodo was quite bald; Venier, of whom many portraits in different media survive, possessed a full head of hair.

[4] Schottmüller (1933), p. 188.

[5] Cicogna (1824–53), iv, p. 692, no. 3 (Cicogna states, however, that this sitter is dressed in a 'sottana con buttoni' and the present sitter wears armour underneath his cloak). A marble bust noted by Cicogna (1824–53), v, p. 666, no. 1, corresponds very closely to the present bust, but Cicogna says he saw it in Venice in 1843, two years after the 'Pietro Zen' was bought by Berlin.

[6] Planiscig (1921), p. 480.

[7] Venturi (1937), p. 172.

[8] Cessi (1963), pp. 28–37. Pl. 137 illustrated here shows the bust before it was damaged in 1945.

49. ANTONIO ZORZI (Pl. 104)

Terracotta, gilded
Dimensions unknown; life-size
Unsigned
Bust and socle are in one piece
S. Stefano, Venice, on the wall to the right of the main entrance

This bust goes unmentioned in the literature, except for modern guidebooks, in which it is regularly assigned to Vittoria's workshop.[1] While this designation is certainly correct, the quality of this piece is no lower than others from the *bottega*, such as those of Giovanni Battista Peranda (cat. no. 43), Tommaso Contarini (cat. no. 32), or Alvise Tiepolo (cat. no. 45). Furthermore, this bust is important as the only sepulchral—therefore public—terracotta bust in Venice, besides that of Doge da Ponte (cat. no. 19).[2]

The date of the bust can be easily deduced. Senator Antonio Zorzi's tomb was set up in 1588.[3] The torso of this bust, as well as the pose of the head, is an exact replica of the torso on the bust of Vincenzo Morosini in S. Giorgio Maggiore (cat. no. 42). The latter was being worked on in February 1588, hence the bust of Zorzi must have been made later on in that same year. The dry execution of the Morosini is also echoed in the bust of Zorzi, making it most likely that Vigilio Rubini authored the *Zorzi* as well as the *Morosini*.[4] That both of these busts from 1588 are by assistants and employ a standard torso demonstrates vividly how Vittoria's autograph production had fallen off sharply by the second half of the 1580s.[5]

Although the terracotta of Doge da Ponte provides a magnificent precedent for the use of this lowly material in a sepulchral image, the bust of Zorzi inspired no further examples of terracotta tomb busts. The design of the tomb, with the bust set above a small sarcophagus set in turn above a console bearing the sepulchral inscription, finds

parallels in the tombs of the Contarini in the Madonna dell'Orto (see cat. no. 32) and in that of the da Lezze family in S. Maria Assunta (see cat. no. 15). I think that these parallels provide further support for attributing the designs of these tombs to Vittoria. The contrast between Zorzi's tomb and the corresponding monument to the left of the portal in S. Stefano—the recumbent marble effigy of Jacopo Suriano—illustrates perfectly the transformation of Venetian tomb design during the sixteenth century.

Antonio Zorzi, son of Francesco, was born in 1504, married Angela Loredan in 1516, and died on 9 October 1565.[6] His son Francesco died in 1540, and his daughter Christina married Alvise Zorzi, son of Benetto, in 1542.[7] The altar in S. Stefano to the titular saint was originally to the right of the entrance. Nicolai states that the Zorzi family had the rights to this altar, and that Antonio had the altar rebuilt.[8] His sepulchral monument was raised next to this altar (which was moved in the eighteenth century) by, as recorded in the inscription, his daughter and son-in-law. The latter, Alvise Zorzi, was elected a Procurator *de Ultra* on 5 February 1591; he died in June 1594. So, once again, this commission came from someone in the highest rung of the Venetian hierarchy.

[1] Lorenzetti (1963), p. 502; *Venezia e dintorni* (1969), p. 280; Niero (1978), p. 54.

[2] See, however, the Gualdo monument in Vicenza, cat. nos. 14 and 38. The terracotta bust of Apollonio Massa, cat. no. 17, was a public bust but not a sepulchral image.

[3] The inscription reads: 'ANTONIO GEORGIO FRANC. F. SENATORI AMPLISS | ET OMNIBUS EXEMPLIS IN REP. SPECTATISS | QUI AB HEREDE IUSSIT HANC ARAM D. STEPHANO | PROTOMART ERIGI ANNUO REDITU LEGATO | UT DIVINAE MAIEST COELESTIS HOSTIA | QUOTIDIE IMMOLETUR CHORUSQ. PUERORUM HUIC | AUGUSTINIAE SODALITATI INAUGURATUS PRO | SALUTE ANIMAE ILLIUS DEUM PURE DEPRECETUR | CHRISTINA F. UNICA ET ALOYSIUS GEORGIUS | BENED.F.GENER PATRI ET SOCERO BENEMERENTI | UNANIMI CONCORDIA P.P. | AN. M.D.L.X.X.X.VIII' ('To Antonio Zorzi, son of Francesco, most honourable Senator and highly esteemed in all matters of government, who ordered this altar to St Stephen, the first martyr, to be erected by means of a yearly bequest from his family so that a daily sacrifice be made to the heavenly host, having founded a boys' choir in this Augustinian sodality, so that it please God for the repose of his soul, Cristina, his only daughter, and his son-in-law Alvise Zorzi, son of Benetto, with one accord, as patrons

placed [this memorial] to their father and father-in-law in the year 1588').

[4] See cat. no. 42.

[5] See discussion in Ch. 7, above.

[6] The guide literature, see no. 1, universally gives Zorzi's death date as 1588, which is actually the date of the monument.

[7] See Marco Barbaro, *Genealogie Venete* (Bibl. Civ. Correr, Cod. Cicogna 2499), iii, p. 235.

[8] Agostino Nicolai, *Memoria manoscritta sopra la chiesa e monastero di Santo Stefano in Venezia* (Bibl. Civ. Correr, Cod. Cicogna 1877), unpaginated, no. 37 under 'Lapidi Sepolchrali', no. 4.

50. VENETIAN GENTLEMAN ('PROCURATOR') (Pl. 138)

Marble
Height: 75 cm.; breadth: 41 cm.
Signed (on rim of right arm): ALEXANDER. VICTORIA. F.
Bust and socle are in one piece
Metropolitan Museum of Art, New York
Provenance: Bardini Collection (Florence); von Guilleaume Collection (Cologne); purchased by the Metropolitan Museum in 1956 from the art market[1]

Planiscig first published this bust. He attributed it to Vittoria, called it the bust of a Procurator, and placed it in the 1580s, after the bust of Doge da Ponte.[2] Information about the bust was also published after its acquisition by the Metropolitan, when it was again called an unidentified Procurator and given to the master.[3] Cessi mentions this bust, calls it a 'Venetian Procurator', assigns it to the master, and dates it to the 1590s. Cessi rightly notes, however, that it lacks the vitality found in the master's best portraits.[4]

There are no grounds for calling this bust a portrait of a Procurator: the attire of the sitter is that of any Venetian gentleman. Nor do I accept it as autograph. The small feeling of scale in the bust bespeaks its origin in the workshop, as does the busy treatment of the drapery. While the overhanging drapery swags at either end of the baseline appear in many busts, the fussiness of the undercloak is quite foreign to Vittoria's practice of articulating the drapery in simple, clear lines; the band of cloth running across the man's chest from lower left to upper right finds no correspondence

in the rest of the master's *œuvre*. The incised nature of the wrinkles on the sitter's face, as well as the mechanical quality of the curls of his hair, and the flat, attached nature of the beard—extensively worked with the drill—likewise stamp this work as coming from the workshop.

The small scale of the torso, plus the treatment of the skin, hair, and beard bear so many similarities to the bust of '*Pellegrini*' in Vicenza, that I would suggest that the same hand carved them both.[5] The bust probably comes from the 1590s or early 1600s.

[1] When Planiscig published the bust, he knew of it only from the catalogue of the sale of the Bardini Collection; it was no. 371 in that sale, held at Christie's, London, 5 June 1899. The rest of the information concerning the provenance comes from the catalogue cards in the Department of European Sculpture and Decorative Arts in the Metropolitan Museum. I thank Dr James David Draper, the curator of sculpture, for allowing me to consult them. The inventory number is 56.26.

[2] Planiscig (1921), p. 511, Pl. 553.

[3] Phillips (1957), p. 150.

[4] Cessi (1962), p. 21. Cessi wrongly states that Serra refers to this bust, confusing a reference Serra makes to the terracotta of 'Tommaso [Simone] Contarini' in the Metropolitan with this piece, which entered the museum 30 years after Serra wrote his book. See cat. no. 33 for the bust mentioned by Serra.

[5] See cat. no. 53.

and another (cat. no. 52) derive from the busts of Pietro Zen and Domenico Duodo (cat. nos. 23 and 35), the heads have the character of free inventions.[3]

The torso of the present bust is almost exactly the same as that of the bust of Lorenzo Cappello in Trent (cat. no. 30), itself a close version of the standard torso used in Vittoria's workshop from the 1580s on. The overall stolidity of the piece and the treatment of the beard find parallels in the busts of Alvise Tiepolo (cat. no. 45) and the unknown man ('*Procurator*') in the Metropolitan Museum of Art (cat. no. 50). The present piece is most likely a late product of the workshop.

[1] Pope-Hennessy (1964), ii, p. 531 and pp. 533–4. The inventory number of this piece is A.8-1948. Pope-Hennessy notes that the present bust bears no resemblance to Marc'Antonio Grimani (see cat. no. 10). The other terracottas in this group, all of which have the same provenance, are cat. nos. 47, 52, and 54.

[2] Boucher in *Palladio* (1975), nos. 182 (here, cat. no. 47) and 237 (here, cat. no. 52), reports that tests were conducted on these two objects; the implication is that all four terracottas were tested. Cessi (1963), p. 32, suggests that this bust derives from a lost original by Vittoria.

[3] Pope-Hennessy (1964), ii, pp. 533–4.

51. PORTRAIT OF AN UNKNOWN MAN ('MARC'ANTONIO GRIMANI') (Pl. 139)

Terracotta
Height: 83.8 cm.
Unsigned
Bust and socle are in one piece
Inscribed (in paint on socle): Marco Antonio Grimani | 1565
Victoria and Albert Museum, London
Provenance: see cat. no. 47

This is one of the four terracottas in the Victoria and Albert Museum that Pope-Hennessy suspected of being products of the nineteenth century.[1] Although thermoluminescence tests place all of these objects in the sixteenth or seventeenth century, none of them can be considered autograph.[2] Pope-Hennessy notes that while this bust

52. MEMBER OF THE NAVAGERO FAMILY (?) (Pl. 140)

Terracotta
Height: 78.7 cm.
Signed (on rim of left shoulder): A.V.F.
Inscribed (on socle): NAVAGIER
Bust and socle are in one piece
Victoria and Albert Museum, London
Provenance: see cat. no. 47

This bust shares with cat. nos. 47, 51, and 54 the same stolid, static pose, smooth facture, and generalized features that give all of them a workshop status. Thermoluminescence tests have placed the present work between 1525 and 1680.[1] The torso here is yet another close variant on the standardized torso, employed in Vittoria's workshop during the 1580s and 1590s and seen as well on the busts of Pietro Zen, Lorenzo Cappello, Vincenzo

Morosini, Alvise Tiepolo, and Antonio Zorzi.[2] The torso is particularly close to that of the *Domenico Duodo* (cat. no. 35), with the difference that here the edges bow out and down. Boucher states that the man seems to wear the robes and stole of a Procurator, but the sitter may well not have held this rank—both Pietro Zen and Giovanni Donà wear similar robes and stoles, and they never achieved procuratorial status.

[1] Boucher in *Palladio* (1975), pp. 132–3, no. 237. The inventory number of this piece is A.10–1948. Cessi (1963), p. 32, speculates that this piece is a copy of a very late work by Vittoria.
[2] See cat. nos. 23, 30, 42, 45, and 49.

53. MEMBER OF THE PELLEGRINI FAMILY (?) (Pl. 136)

Marble
Height: 62 cm.; breadth: 56 cm.
Signed (on rim of right arm): AL. VICT. TRID. F.
Bust and socle are separate (present socle is modern)
Museo Civico, Vicenza
Provenance: palazzo Zaguri, Venice; entered Tornieri Collection, Vicenza, in 1811; in public collections of the city of Vicenza from 1829[1]

The first mention of this bust in the literature seems to come in Moschini's list of busts not mentioned by Temanza, in which appears '13. Nella casa Tornieri in Vicenza vi ha bel busto con il nome del nostro Vittoria, scritto così: *Vict. Trid*'.[2] Other than mentions in the local literature, this bust is never again noted, until recently, in studies of Vittoria.

Its omission is quite proper since the bust cannot claim autograph status due to its poor quality. The mechanical treatment of the hair and beard, plus the small scale of the whole make it very close to the '*Procurator*' in the Metropolitan Museum. I am tempted to see the same hand at work in both pieces.[3]

Mancini has ascertained that the Zaguri family, from whose palazzo this bust comes, were the heirs of the family of Vincenzo Pellegrini, Vittoria's lawyer, of whom the artist made a bust prior to 1566 (see cat. nos. 56 and 57). On the basis of his

discovery, Mancini identifies this bust as the lost bust of Pellegrini.[4] While it is extremely interesting that this bust probably belonged to the Pellegrini, and it may possibly even portray Pellegrini (or his brother), the bust is certainly not autograph as its style manifestly proclaims. The signature is furthermore unusual in format—no other bust is signed with this inscription—and the fairly straight baseline used here cannot predate 1575. It is not impossible that this object could be a copy of Vittoria's bust of Pellegrini.

[1] A full account of the provenance of this bust is given in Zorzi (1962c), i, p. 263. Arnaldo Tornieri purchased the bust from the Zaguri palace in Venice in 1811; at his death in 1829, the bust passed to the commune of Vicenza. The inventory number is E II-320.
[2] Temanza (1827), p. 53, n. 58.
[3] For the bust in the Metropolitan Museum, see cat. no. 50.
[4] See Mancini (1995), pp. 144–7. Mancini claims that the bust comes from the very house where Vincenzo Pellegrini lived, but it is unclear to me that Pellegrini lived in the pal. Zaguri; see cat. nos. 56 and 57, below.

54. MAN WEARING THE ORDER OF ST MICHAEL (GUGLIELMO HELMAN?) (Pl. 141)

Terracotta
Height: 87 cm.
Signed (on rim of back left side): A.V.F.
Bust and socle are in one piece
Victoria and Albert Museum, London
Provenance: see cat. no. 47

This bust falls under the same category of workshop production as cat. nos. 47, 51, and 52, with which it shares its matte, uninflected surface and facture. Pope-Hennessy reasonably suggests that this object might represent King Henry III of France.[1] The swags of the drapery derive from the bust of Sebastiano Venier in the Ducal Palace (see cat. no. 22). Even the distinctly seventeenth-century style of the beard would appear to argue against autograph status for the piece.

None the less, as once suggested by Cessi, this bust does seem to relate to Vittoria.[2] I find the head

of this piece strikingly similar to that of Guglielmo Helman (see cat. no. 39, and Pl. 159) in S. Maria Formosa. Although the goatee on the Helman bust is noticeably longer than the beard here, and the turn of the head is reversed, the shape of the head and cast of the face, plus the hair style, all seem to me very close in both of them. The torsos are entirely different.

What the relationship between the two is I cannot yet state with confidence, beyond assigning both to the very late workshop of Vittoria.

[1] Pope-Hennessy (1964), ii, p. 534. The inventory number of this bust is A.13–1948.
[2] Cessi (1963), p. 32, states that this piece seems to derive from a very late work by Vittoria, from around the time of the *Montecatino*, the *Tommaso Contarini*, and the *Self-Portrait* in S. Zaccaria.

LOST WORKS

55. ANDREA LOREDAN

Lost, probably marble

This is one of the eight busts mentioned by Vasari in the 1568 edition of the *Lives*. The list is carefully arranged in two parts: the first four are public busts with their locations in churches clearly stated, while the last four, for which no locations are given, must have been private objects. Since Loredan's bust appears in the latter group, it must have been a private image.[1]

Vittoria and Loredan knew each other from at least 1552, and Loredan's status as a collector of antiquities makes him a most likely candidate for commissioning a classicizing bust of himself.[2]

Andrea Loredan, son of Bernardin, was born *c.*1490 and died in 1569.[3] See Chapter 5, above, for an account of Loredan's life.

[1] See discussion in text above, Ch. 5 (in relation to da Lezze bust). The passage from Vasari appears at the beginning of Ch. 5.
[2] See Ch. 5 for the documentary evidence concerning the acquaintance of the two men, for Loredan's importance as a collector, and for a biography of Loredan.
[3] See *Genealogia di famiglie patrizie* (Bibl. Civ. Correr, MSS P.D. c.2803), p. 267. It has proved impossible to locate Loredan's will in the Venetian archives. Although the index for wills lists a reference for Andrea's son, Bernardino, that document (which might mention a bust of his father) was not in the *busta* indicated.

56 and 57. VINCENZO AND GIOVANNI BATTISTA PELLEGRINI

Lost.

In Vasari's list of Vittoria's portraiture, after stating that the artist has depicted Andrea Lordean and Priamo da Lezze, the biographer concludes with the names of 'dua fratelli da Cà Pellegrini oratori, cioè Messer Vincenzio and Messer Giovanbattista'.[1] This is the only mention of these busts, except for that by Giovanelli, who repeats the names and writes that both brothers died in the same year, either 1567 or 1568.[2]

But this cannot be correct, as demonstrated by a mention of Vincenzo Pellegrini in Vittoria's *Memorie*. On 30 March 1569, the artist records paying 'Vincenzo Pelegrini' 35 lire for defending him 'al Coleio [collegio]' in the property case brought against him by the Memmo family.[3] Thus Vincenzo Pellegrini was the artist's lawyer, and hence a likely candidate for a portrait bust.[4] Both Vincenzo Pellegrini and Vittoria also belonged to the Scuola Grande di S. Marco.[5] Since Vittoria knew Vincenzo, he must have known Giovanni Battista Pellegrini (b. 1525) as well. Perhaps these busts were made during the mid-1560s, in the gap between the busts of da Lezze and Niccolo Massa.

Vincenzo Pellegrini, born in Padua in 1518, was a

prominent lawyer; see Chapter 5, above, for his activities as an art patron.[6] Garzoni lists the 'dottissimo Pellegrino' among the leading advocates of his day and, more importantly, Valerio Marcellino cites Pellegrini as a member of the circle of Camillo Trevisan.[7] Vittoria also made a bust of Trevisan, as well as executing stuccoes in his palace on Murano. The garden of that palace served as a kind of salon for leading humanists, including Girolamo Molin, of whom the artist also made a portrait bust.[8] Vincenzo Pellegrini made his will on 15 September 1575.[9] He lived on the upper floor of Niccolo da Ponte's palace near S. Maurizio, for which he paid a yearly rent of 120 ducats.[10] Vincenzo's son Pietro owned a collection of antiquities; perhaps this interest, shared by so many of Vittoria's patrons, was held by Vincenzo as well.[11] Cat. no. 53 has recently been identified as the lost bust of Vincenzo Pellegrini, an attribution with which I do not agree; see cat. no. 53.

[1] Vasari (1878–85), vii, pp. 519–20.
[2] Giovanelli (1858), p. 39.
[3] Predelli (1908), p. 142: '30. Dito [Marzo] per contadì a M. Vincenzo Pelegrini che parlò in Coleio quando el presentò la suplica scudi cinque val . . . L.35 s.——'. This comes from c.62 in the *Memorie*, in a section under the heading '+ Al nome de Dio, adì, 28, febraro, 1568 [*m.v.*], in Venetia'. For the lawsuit with the Memmo, see Predelli (1908), pp. 24–5. Pellegrini did not die until after 15 Sept. 1575.
[4] Of the 8 portraits cited by Vasari, 3 depicted lawyers: Ferretti (cat. no. 6), Camillo Trevisan (cat. no. 58), and Pellegrini.
[5] For Pellegrini as a member of the Scuola, see Mancini (1991), p. 174. Vittoria entered the Scuola 24 Jan. 1562 (*m.v.*); see Predelli (1908), p. 131.
[6] For biographical information on Pellegrini, see Mancini (1991) and Mancini (1995).
[7] See Garzoni (1586), p. 134; other eminent lawyers cited by Garzoni are Camillo Trevisan and Giovanni Battista Ferretti. The 'valorisissimo M. Vicenzo Pellegrini' is mentioned among the salon of the pal. Trevisan in the unpaginated introduction to Marcellino (1563).
[8] For this circle of humanists, see cat. no. 58 on Camillo Trevisan.
[9] ASV, Notarili e Testamenti, Girolamo Longin, b. 1200, no. 57. He apparently died shortly after making his will. The will makes no reference to a bust.
[10] See Brown (1974), p. 43. Mancini (1991), p. 178, and (1995), p. 146, assumes that Vincenzo lived in the pal. Zaguri (Campo S. Maurizio, 2667), but offers no direct documentary support. Brown cites archival evidence that Pellegrini paid rent to Niccolo da Ponte. Da Ponte built his palace in 1564; located at 2746 calle del Dose, it is quite close to the pal. Zaguri—both are in the neighbourhood of S. Maurizio.

[11] For Pietro Pellegrini's collection, see Zorzi (1988), pp. 76–7; see also Mancini (1991), p. 188, and Mancini (1995), pp. 139–47. Mancini (1995), p. 145, dates the Pellegrini busts to c.1562–6; in Martin (1988), pp. 306–7, I dated them to the mid-1560s.

58. CAMILLO TREVISAN

Lost

The evidence concerning this lost bust is confusing and unclear. Vasari mentions it along with three other busts by Vittoria set in churches. He first cites the bust of Ferretti in S. Stefano, then that of 'Camillo Trevisano, oratore, posta nella chiesa di San Giovanni e Polo', then the bust of Marc'Antonio Grimani in S. Sebastiano, concluding with that of Benedetto Manzini in S. Geminiano.[1] The bust of Grimani is still *in situ*, the copy of the *Ferretti* is above his tomb in S. Stefano, and numerous references attest to the existence of the *Manzini* in S. Geminiano before the church's destruction in 1807.[2] Temanza, writing prior to the Napoleonic rape of Venice, likewise clearly includes the bust of Trevisan as a public portrait by Vittoria, mentioning it after citing the busts of Giulio Contarini in S. Maria del Giglio and of Mocenigo in S. Lucia, and follows the reference to a bust of Trevisan in SS Giovanni e Paolo by listing the busts of da Ponte in S. Maria della Carità, of Tommaso and Gasparo Contarini in the Madonna dell'Orto, of Ferretti in S. Stefano, and of Manzini in S. Geminiano. Again, all these busts are or were where Temanza places them.[3]

Yet there exists not one reference to a bust of Camillo Trevisan in SS Giovanni e Paolo in the guide literature. As instructed in his will, Trevisan was buried in the Dominican basilica, where the family had their vault.[4] None the less, I have found no mention in any sixteenth-, seventeenth-, or eighteenth-century source for the bust as being in that church, and cannot explain this contradiction in the literature.[5]

It is quite believable that Vittoria made a bust of Trevisan, since he was a patron of the artist,

commissioning from Vittoria the stucco decoration of his palace on Murano; the work is recorded in the artist's account book.[6] Perhaps in the 1560s it was planned to place the bust on Trevisan's tomb, but this was never in fact carried out, as was the case with the marble portrait of Francesco Duodo.[7]

[1] Vasari (1878–85), vii, pp. 519–20.
[2] See, respectively, cat. nos. 10, 6, and 16.
[3] Temanza (1778), pp. 495–6.

[4] Trevisan's will is in ASV, Notarili e Testamenti, M. A. Cavanis, b. 197, 2nd fasc., fos. 49ʳ–51ʳ, dated 22 Oct. 1564. On fo. 49ʳ, Trevisan stated 'Voglio che'l mio corpo sia sepulto nella nostra archa a S. Zuanne Polo da poi, che non ho fatto altro deposito, come havevo in animo, senza Pompe de Baldachini, e cose simile, ma positivamente'. The passage implies that he had intended to construct a tomb, which could explain why he had a bust made.
[5] Moschini, in Temanza (1827), p. 51, n. 54, writes that 'Indarno si ricerca a' ss. Giovanni e Paolo questo busto, il quale non si sa che mai vi sia stato'.
[6] Predelli (1908), pp. 184–5; the payments are all from 1557. See the discussion of Trevisan and his palace in Ch. 5, above.
[7] For the *Duodo*, see cat. no. 4.

COPIES AND REPLICAS

59 and 60. AFTER *GIULIO CONTARINI*

Terracotta
Formerly Heim Gallery, London
Private collection, England

Cat. no. 59 was published in the exhibition catalogue, *Sculptures of the 15th and 16th Centuries*', of the Heim Gallery, London, no. 31, in 1972 as the terracotta model for the marble portrait of Contarini in S. Maria del Giglio. Although I have not seen the piece, it bears all the marks of a copy, not a model: all has been smoothed back and toned down in comparison with the marble; the figure appears static rather than in movement, and the appearance of the whole gives the impression of something not being worked out, but transcribed from.[1] The socle, furthermore, is separate from the base—something that occurs in no autograph terracotta—and the striations on the back of the piece are, like cat. no. 62, rough and coarse, unlike the carefully fine striations on the autograph busts.[2]

Another version of the *Contarini*, cat. no. 60, also in terracotta, was in a British private collection in the late 1980s.[3]

[1] See also Knox and Martin (1987), pp. 159–63; figures 2 and 3 in this article should have read 'After Alessando Vittoria'.
[2] If one compares the rough striations here on the back of the bust with the smooth, regular striations on the back of cat. no. 24

(Pl. 113), the '*Zorzi*', the difference in both technique and hands is clear.
[3] I thank Elizabeth Martin of Sotheby's for sending me a photograph of this bust, which was with Wertheim in Berlin in the 1920s, and has been shattered and repaired.

61. AFTER *FRANCESCO DUODO*

Photo no. 100875, filed under 'Vittoria' in the Fototeca of the Kunsthistorisches Institut in Florence, illustrates a truncated version of the bust of Francesco Duodo in the Cà d'Oro (cat. no. 4). The object is listed as being in a private collection in Berlin.

62. AFTER *PALMA GIOVANE*
(Pls. 160–1)

Terracotta
Philadelphia Museum of Art

This object, as demonstrated by the precise mouldings and cavities on the interior of the head and torso, was cast from some other object. It is almost identical with the bust of Palma in Vienna (cat. no. 37) but, because the numbers of buttons on the tunic and other details differ from the Vienna bust, could not have been cast from that piece. The scale

is well under life-size; this object is probably nineteenth century.[1]

[1] I wish to express my great thanks to Dr Carl Brandon Strehlke, who invited me to the Philadelphia Museum to examine this sculpture. Its accession number is 1986-83-1.

63. 'PALMA GIOVANE'

Photo no. 128356, filed under 'Vittoria' in the Fototeca of the Kunsthistorisches Institut in Florence, illustrates a bust, at Lepke's auction house in Berlin in 1929, called 'Palma Giovane'. The bust bears no resemblance to Palma or to the style of Vittoria.

64. AFTER *MARINO GRIMANI*

Photo no. 160460, filed under 'Vittoria' in the Fototeca of the Kunsthistorisches Institut in Florence, illustrates a head after the marble bust of Marino Grimani (cat. no. 11). Its location is listed as the Museum für Kunst und Gewerbe, Hamburg, inventory no. 1965, 44. No medium or dimensions are given.

65. AFTER *MARINO GRIMANI*
(Pl. 162)

Terracotta
Height: 70.1 cm.
Walters Art Gallery, Baltimore
Condition: good; bears traces of polychromy

Cessi published this bust, the head of which derives from the marble *Marino Grimani* (cat. no. 11), ascribing it to the circle of Alessandro Vittoria.[1] I can suggest no closer attribution.

[1] Cessi (1962), p. 18. The inventory no. is 27.225. I thank Mr David Pearce of the Walters Art Gallery for his help in obtaining information for me concerning this object.

66. AFTER *APOLLONIO MASSA*
(Pl. 163)

Terracotta
Height: 80.6 cm.; breadth: 49.5 cm.
Unsigned
Metropolitan Museum of Art, New York
Provenance: Stanley Mortimer Collection; given to the Metropolitan in 1961[1]

This is a truncated replica (missing the full expanse of the arms) of the bust of Massa in the Seminario Patriarchale in Venice (cat. no. 17). The modelling and execution are much drier and tighter than in the bust in Venice, and the angle of the head to the shoulders differs. It is perhaps the same bust as cat. no. 67. The socle was left in an unfinished state.

[1] My information concerning this bust comes from the catalogue cards in the Department of European Sculpture and Decorative Arts in the Metropolitan Museum. I thank the curator of sculpture, Dr James David Draper, for allowing me to consult the cards. The inventory number is 61.239.

67. AFTER *APOLLONIO MASSA*

Photo no. 101515, filed under 'Vittoria' in the Fototeca of the Kunsthistorisches Institut in Florence, illustrates another truncated version of the *Apollonio Massa*. Its location is given as Julius Böhler, Munich, no date.

68. AFTER *PIETRO ZEN*

Photo no. 60122, filed under 'Vittoria' in the Fototeca of the Kunsthistorisches Institut in Florence, illustrates a replica of the terracotta bust of Pietro Zen in the Seminario Patriarchale in Venice (cat. no. 23). Its location is given as Julius Böhler, Munich, 1929.

WORKS NOT BY VITTORIA

69. GASPARO CONTARINI (Pl. 142)

Marble
Dimensions unknown; life-size
Unsigned
Bust and socle are in one piece
Contarini Chapel, Madonna dell'Orto, Venice

Cardinal Gasparo Contarini died in Bologna in 1543; his remains were transferred to the Madonna dell'Orto on 17 December 1563. The bust was first mentioned by Stringa in 1604, who states that the Contarini Chapel contains the tombs of Cardinal Gasparo and his brother Tommaso, and notes that each has a bust on it; he makes no attributions.[1] Martinioni, in 1664, makes the first attribution to Vittoria.[2] After Martinioni, the bust is regularly assigned to Vittoria.[3] Planiscig calls it the earliest surviving portrait by Vittoria, and says it must date from around 1563 when the Cardinal's remains came to Venice.[4] Serra adopts the same reasoning.[5] In 1958, Fiocco attributed the bust, on stylistic grounds, to Danese Cattaneo; this attribution is, on the whole, now accepted.[6]

I find Fiocco's attribution very attractive; the bust, in any case, is certainly not by Vittoria. I cannot, however, agree with the commonly accepted belief that the bust was set up in 1563—when the remains of the Cardinal came to Venice—because I find it impossible to believe that a bust of Gasparo Contarini, in the Madonna dell'Orto from 1563, would have gone unmentioned by Francesco Sansovino in his guidebook of 1581. The bust probably does date from the early 1560s, but it could not have been in the church until c.1580.[7]

Some important information discovered by Gigliola Fragnito about this bust has yet to enter the art historical literature. On 4 January 1561, two years before the transfer of the Cardinal's remains, Ludovico Beccadelli wrote to Alvise Contarini (the Cardinal's nephew and, according to the epigraph, one of the people who sponsored the monument;

his monument is to the left of the Cardinal's) in Rome that he had succeeded ('miracolasamente') in finding, in Bologna in the preceding September, the death-mask made of Contarini eighteen years before. He adds that before he left Bologna he had a cast made of the mask, but with its eyes open, which has 'succeeded well'. He asks Alvise Contarini for instructions as to what to do with these objects, adding that in any case it will be necessary to make another cast, either in clay or wax, and to take away 'quello aspetto di morto, il che saprà ogni maestro che non sia goffo', which can then serve as the model for the sculptor that Contarini has chosen to make a marble version.[8] Fragnito advances the hypothesis that the bust was commissioned from Vittoria towards the end of 1560 and was probably finished before the Cardinal's remains were brought to Venice in 1563. Beccadelli's letter proves that the bust was commissioned after January 1561.

[1] Sansovino (1604), pp. 146a–b.
[2] Sansovino (1664), p. 165.
[3] See, for instance, Temanza (1778), p. 496, and Cicogna (1824–53), ii, p. 227.
[4] Planiscig (1921), p. 460.
[5] Serra (1923), pp. 47–8.
[6] Fiocco (1958), pp. 35–7. Others who support the attribution to Cattaneo are Macchioni (1979), p. 451, and Boucher in *Genius* (1983), p. 351. See now, however, Rossi (1995), pp. 163–4, n. 112d, who rejects an attribution to Cattaneo but offers no alternative suggestion. Cessi (1962), pp. 22–4, rejects Fiocco's attribution of the bust of Gasparo to Cattaneo, accepts the bust as by Vittoria, finds it similar in style to the bust of Tommaso Contarini, calls them 'opere di gusto nuovo, fin qui inconsueto al Vittoria', and dates them both to c.1600. The bust of Gasparo indeed differs from the rest of Vittoria's work because it is not by him.
[7] See cat. no. 32 for my reading of the chronology of the Contarini Chapel.
[8] This passage is printed in Fragnito (1978), pp. 19–20, n. 18.

70. 'ADMIRAL CONTARINI' (Pl. 143)

Terracotta
Height (with socle): 89.5 cm.

Unsigned
Formerly Kaiser Friedrich Museum, Berlin
Provenance: acquired by Berlin in 1841 from the dealer
 Paiaro; in Kaiser Friedrich Museum until destroyed in
 1945[1]

This bust has been universally accepted as being by
Vittoria, although there is no reason to consider it
as such.[2] While, judging from photographs, the
quality of the bust seems fairly high, the termina-
tion of the torso and shape of the socle are totally
uncharacteristic of Vittoria. The traditional identi-
fication of the sitter as an Admiral Contarini,
perhaps a Giovanni Contarini, has no factual basis.
I am tempted to assign this bust to the same hand
that made the terracotta of 'Carlo Zen' (cat.no.78)
in the Seminario Patriarchale, where the shape of
the socle and the termination of the torso are very
similar.[3]

 [1] For the provenance, see Schottmüller (1933), p. 187. Dr
Ursula Schlegel kindly provided me with the information that this
work was one of the sculptures lost at the end of the Second World
War from the Berlin Museum.
 [2] For bibliography prior to 1933, see Schottmüller (1913),
p. 187. Venturi (1937), p. 166, accepts the bust and praises it
highly; he implies a dating in the 1570s. Cessi (1961b), p. 42,
dates the bust to after 1571 (since it is supposed to represent a
victor of the battle of Lepanto) and, unaware that it was destroyed
in 1945, calls it 'oggi conservato allo Staatliche Museum di
Berlin'.
 [3] See cat. no. 78.

71. KNIGHT OF SANTIAGO ('JACOPO CONTARINI') (Pl. 144)

Terracotta
Height: 72 cm.; breadth: 53.2 cm.
Unsigned
Bust and socle are in one piece
National Gallery of Art, Washington, DC
Provenance: Clarence Mackay Collection; acquired by the
 Kress Collection in 1941[1]

In 1976, Ulrich Middeldorf removed this piece
from Vittoria's œuvre, assigning it to 'the Venetian
School, third quarter of the sixteenth century'.[2]
The bust indeed has no connection with either

Vittoria or his workshop. The National Gallery
now attributes the piece to Jacopo Albarelli (Ve-
netian, active 1594–1638), dates it to c.1600–25,
and entitles it 'A Knight of Santiago'.[3]

 [1] For details of the provenance and bibliography, see Middel-
dorf (1976), p. 77. The accession number is 1943.4.85.
 [2] Ibid., p. 76.
 [3] See Sculpture (1994), p. 20.

72. ANDREA DOLFIN (Pl. 118)

Marble
Height: 73 cm.
Unsigned
Bust and socle are in one piece (?)
Dolfin Monument, S. Salvatore, Venice

Both Planiscig and Serra attribute this bust to
Vittoria; it is, however, by Girolamo Campagna.[1]
Timofiewitsch gives the fullest justification for
Campagna's authorship of the work, citing
Stringa's description of the tomb from 1603: that
the monument 's'è per fare . . . & si sono quasi del
tutto fornite dal petto in su le statue al naturale delli
predetti Procuratore, & Procuratessa di mano del
soprascritto Campagna . . .'.[2] The hard unexpres-
siveness of the bust corresponds to Campagna's
portrait style, as can be seen by comparing this
work with Campagna's signed bust of Lorenzo
Bragadin, now in the Seminario Patriarchale.[3]
Timofiewitsch dates the bust to 1603–4.[4]

 [1] Planiscig (1921), p. 534; Serra (1923), p. 85.
 [2] Timofiewitsch (1972), pp. 273–6; see Sansovino (1604), p.
94ᵛ.
 [3] Timofiewitsch (1972), p. 297.
 [4] Ibid., p. 273.

73. PARESANO PARESANI ('FRANCESCO DUODO') (Pl. 145)

Marble
Height (with socle): 86 cm. (without socle) 73 cm.
Unsigned
Bust and socle are in one piece
Musée Jacquemart-André, Paris

Provenance: acquired by the Jacquemart-André from Guggenheim in Venice in 1889[1]

Although this bust has been regularly accepted as a portrait of Francesco Duodo by Vittoria ever since it was acquired by the Musée Jacquemart-André, it is in fact an exact copy of the bust of Paresano Paresani signed by Giulio del Moro, and placed over Paresani's monument in S. Fantin (Pl. 146)[2]

[1] See Moureyre-Gavoty (1975), p. 178, Inv. 661.
[2] See Martin (1993a), pp. 367–71.

74. APOLLONIO MASSA (Pl. 147)

Marble
Dimensions unknown; life-size
Unsigned
Bust and socle are in one piece
Ateneo Veneto, Venice
Provenance: originally over Massa's tomb in the cloister of S. Domenico di Castello until 1807; on deposit until 1810; from then, in the Ateneo Veneto[1]

This bust is mentioned by Francesco Sansovino in 1581. After describing the tomb of Niccolo Massa, Apollonio's uncle, in the cloister of S. Domenico di Castello, Sansovino continues: 'Et dall'altra parte della porta del Capitolo de' frati (luogo parimente della predetta famiglia [Massa]), è posta la memoria del modo medesimo di Apollonio Massa filosopho, & Medico, suo [Niccolo's] nipote, con queste parole: MONUMENTUM APOLLONIO MASSAE, PHILOSOPHO AC MEDICO ANTONII FILIO POSITUM, UT ESSET EIUS INDICIUM VIRTUTIS, AD FAMILIAE NOMINISQUE MEMORIAM SEMPITER-NAM, M.D.LXXII. KAL. AUG.'[2] No attribution is given. Just because Sansovino does not assign the bust to Vittoria, however, is not sufficient grounds for denying his authorship. In Sansovino's descrip-tion of S. Geminiano, for instance, he ascribes the bust of Manzini to Vittoria, but not that of Tommaso Rangone. Likewise, in the pages on S.

Maria del Giglio, Sansovino assigns the bust of Giulio Contarini to Vittoria but not that of Girolamo Molin. Yet, the bust of Rangone is by Vittoria and the Molin was designed by him.[3]

In this case, the weakness of execution and char-acterization exclude this bust from the canon of Vittoria's works. The bland, generalized depiction of Massa's physiognomy, his unfocused stare, and, above all, the flat, two-dimensional rendering of his beard betray this portrait as the work of another hand. A comparison with the terracotta of Massa by Vittoria confirms these observations. While in the terracotta (Pl. 109; cat. no. 17) the texture of flesh, cloth, and hair are clearly differentiated, tex-tures in the marble are barely indicated. While the silhouette of the terracotta is lively and irregular, that of the marble is smooth and abstract. This is distinctly visible in the treatment of the heads. In the terracotta, the expanding, sculptural volume of the beard moves with the turn of Massa's head, and contrasts with the deep cavities of his eyes and the tight skin of his straight, high, jutting brow; in the marble the brow has been rounded off, and the whole area from the top of the skull to the end of the beard is one flat, smooth, motionless, oblong plane. One can feel in the terracotta where the join of the head and neck must be, although they hidden by the beard. In the marble, although simi-larly hidden by the beard, the neck approaches that of a giraffe. I find great similarities between this bust and that of Marc'Antonio Ruzzini, signed by Domenico da Salò, in the Statens Museum for Kunst in Copenhagen (Pl. 148), and would suggest that they are by the same hand.[4]

For a biography of Massa, see cat. no. 17.

[1] See cat. no. 18, n. 1.
[2] Sansovino (1581), p. 6a; the inscription translates: 'the memo-rial set up to Apollonio Massa, son of Antonio, a physician and philosopher, so that it be a sign of his virtue and an eternal memo-rial of his family name, 1 August 1572'; hence, Massa's tomb inscription was set up 18 years before he died.
[3] See cat. nos. 20 (Rangone), 1 (Giulio Contarini), and 40 (Molin).
[4] For the bust by Salò, see Olsen (1980), p. 111; Olsen suggests a date of the 1560s for the Ruzzini. Although Pavanello (1914), p. 67, n. 1, and Zampetti (1973), p. 40, both state that Zanotto (1856)

was the first to accept this bust as being by Vittoria, the first attribution is actually in Temanza (1827), p. 52, n. 58, no. 3. Cicogna (1824–53), i, p. 115, mentions the bust but does not ascribe it to Vittoria. Giovanelli (1858), p. 26, assigns it to the artist. Planiscig (1921), p. 480, attributes the bust to Vittoria and, on the basis of the inscription, dates it to 1572, as does Serra (1923), p. 62, who adds that 'è invero strano che non sia stato subito riconosciuto per opera sua [Vittoria]'. Cessi (1961b), p. 39, accepts the bust. Zorzi (1972), ii, p. 331, rightly states that the bust is not by Vittoria.

75. BERNARDO MOCENIGO

Marble
Dimensions unknown
Unsigned
Seminario Patriarchale, Venice
Provenance: in the Mocenigo chapel in S. Lucia; after the suppression and destruction of S. Lucia in 1861, removed to the Seminario Patriarchale[1]

In Martinioni's edition of Sansovino from 1664, this bust is mentioned as being in the Mocenigo family chapel in S. Lucia and is attributed to Vittoria.[2] Nevertheless, the work is clearly from the seventeenth century and has nothing in common with Vittoria, being instead a pale reflection of Bernini's style.[3] The piece has been persuasively attributed to Giusto le Court.[4]

[1] See Zorzi (1972), ii, pp. 345–6, for the history of S. Lucia.
[2] Sansovino (1664), p. 141. After 1664, the bust is regularly cited in the guide literature: Temanza (1778), p. 495, calls the sitter 'Lazzaro Mocenigo'; Moschini, in Temanza (1827), p. 51, corrects this to Bernardo; Moschini (1815), ii, p. 80, also notes the bust (which he calls 'lavorato con merito'); Giovanelli (1858), p. 91, dates the bust to 1591; Serra (1923), Planiscig (1921), and Venturi (1937) do not mention the bust; Cessi (1962), p. 19, cites the reference in Giovanelli and calls the bust lost.
[3] Moschini (1940), p. 8, was the first to note that this bust is in fact a 'goffa opera della metà del secolo XVII'. Zorzi (1972), ii, p. 346, also discredits an attribution of this bust to Vittoria.
[4] See Niero (1988), pp. 137–40 and illustration 2.

76. LEONARDO RINALDI (Pl. 149)

Marble
Height: 24 cm.; breadth: 23 cm.
Signed (at the base of the spine): LEONARDUS | RINALDIUS | A. VICTORIA F. | MDXXXXVI
National Gallery, London

Provenance: William Gibson Collection, London; given to the National Gallery in 1964[1]

Cessi published this bust in 1967, claiming it to be a portrait Vittoria supposedly executed in Vicenza in 1546 or 1547; this claim cannot be substantiated.[2] The National Gallery rightly does not accept this work as being by Vittoria.[3] The scale is too small, the rendering of the features too smooth, bland, and dry, the treatment of the hair too fussy and repetitive to be from Vittoria's hand. The blank eyes find no correspondence in Vittoria's œuvre, nor does the extensive use of the drill in the beard and hair. The emotional coldness of the work likewise speaks against Vittoria, as does the hardness of the facture and modelling.

The signature and inscription cannot be authentic. Although Temanza mentions a bust in the Arnaldi palace in Vicenza dated either 1546 or 1547, it was supposedly inscribed with the name 'Leonardus Bissarius'.[4] It should be noted that in the earliest surviving busts from Vittoria's hand, those of Marc'Antonio Grimani (cat. no. 10) and Benedetto Manzini (cat. no. 16), the signature is in Italian, 'Vittoria', not Latin, 'Victoria', as in the present bust.

While the inscription is surely spurious, I do not think the bust is a fake. Stylistic correspondences exist between it and a bust that Leithe-Jasper has attributed to Agostino Zoppo (Pl. 150); the present bust may also be by him.[5] The National Gallery has recently suggested that the bust may be of Roman seventeenth-century origin.[6]

[1] See National Gallery (1973), p. 791, no. 6357.
[2] See Cessi (1967), pp. 14–21; see discussion in Martin (1988), pp. 30–2. Why Cessi says that a bust inscribed 'Leonardo Rinaldi' represents someone named Leonardo Arnaldi is one of the many mysteries left unexplained in his article.
[3] In National Gallery (1973), the bust is called 'ascribed to Alessandro Vittoria'.
[4] This bust, mentioned by Temanza (1778), p. 478, has had a complicated history. Although the secondary literature has always taken it that Temanza attributed the bust to Vittoria, this is not the case; see Martin (1988), pp. 30–2.
[5] Leithe-Jasper (1975), pp. 133–6, Pl. 64.
[6] See Baker and Henry (1995), p. 737.

77. ALESSANDRO VITTORIA (Pl. 151)

Marble
Height: 63 cm.
Unsigned
Formerly Kaiser Friedrich Museum, Berlin
Provenance: in a niche in the garden of Vittoria's house in the Calle della Pietà until 1832; acquired by Berlin from the dealer Paiaro in 1841; destroyed in 1945[1]

Until 1933 this bust was accepted as a self-portrait by the master. But in the new edition of the Berlin catalogue published in that year, Schottmüller called the bust, following a suggestion by Gramberg, the work of Jacopo Albarelli.[2] Albarelli was a sculptor and painter, a student of Palma Giovane, active in Venice, who lived from approximately 1550 to 1630.[3] Schottmüller rightly notes that, even taking into consideration the extensive weathering of the bust from its having been outdoors for two centuries, the schematic quality of the work hardly corresponds to Vittoria's autograph style. Gramberg's suggestion of Albarelli is based on a comparison of this bust with that of Palma Giovane on Palma's memorial in SS. Giovanni e Paolo which, on the authority of Ridolfi, is by Albarelli.[4] These two busts do indeed seem related and could be by the same hand. Furthermore, considering Albarelli's close relationship to Palma, and Palma's close relationship to Vittoria, Albarelli would be a likely candidate for having made a memorial bust to Vittoria.[5]

[1] This bust is first mentioned in Temanza (1827), p. 17, and then in Cicogna (1824–53), iv, p. 692, no. 6. See Schottmüller (1933), p. 188, for bibliography prior to 1933. Dr Michael Knuth kindly informed me that this piece was lost during the Second World War.
[2] Ibid., p. 188.
[3] See Ferro (1907), p. 179.
[4] Ridolfi (1914–24), i, p. 204.
[5] The most recent discussion about Palma and Vittoria is Rinaldi (1984), *passim*.

78. 'CARLO ZEN' (Pl. 164)

Terracotta
Dimensions unknown
Unsigned
Socle and bust are in one piece

Pinacoteca Manfrediana, Seminario Patriarcale, Venice
Provenance: given by Contessa Chiara Zen to the Seminario Patriarchale c.1838; since then in the Seminary[1]

This terracotta is universally accepted as being by Vittoria although it is clearly not from his hand.[2] It is in fact a *cento*, employing the head of Sebastiano Venier, taken from the bust by Vittoria in the Ducal Palace (cat. no. 22), combined with a torso similar to that on the bust of Venier by Aspetti in the Ducal Palace. In terms of facture and the rendering of the torso and socle, it resembles the terracotta formerly in Berlin of a man usually called 'Admiral Contarini' (cat. no. 70).

[1] Moschini (1842), p. 142.
[2] Serra (1923), p. 79, places the bust as being before 1585; Planiscig (1921), p. 511, terms the bust 'usually known as Carlo Zen' and dates it to the 1580s; Venturi (1937), p. 166, calls the bust (understandably) 'Sebastiano Venier', accepts it as by Vittoria, and implies a dating of around 1580; Moschini (1940), p. 15, calls the bust a 'Condottiero' perhaps of the Zen family, and notes that it is unsigned; Cessi (1961b), p. 35, dates it to around 1570.

79. PORTRAIT OF A DOGE (FRANCESCO CONTARINI?) (Pl. 154)

Marble
Height: 76.2 cm.
Unsigned
Metropolitan Museum of Art, New York
Provenance: Lieben Collection, Vienna; Michael Friedsam Collection, New York; given to the Metropolitan Museum in 1931[1]

This bust, described by Planiscig as a portrait of Sebastiano Venier by Vittoria, has been recognized since 1940 as a seventeenth-century work, probably portraying Francesco Contarini, who was Doge of Venice from 1623 to 1624.[2]

[1] My information concerning the provenance of this piece comes from the catalogue cards of the Department of European Sculpture and Decorative Arts in the Metropolitan Museum. I thank the curator of sculpture, Dr James David Draper, for allowing me to consult the cards. The inventory number for the bust is 32.100.156.
[2] Planiscig (1921), p. 461. J. G. Phillips established the attribution of the bust to a 17th-cent. hand and established the identity

of the sitter by comparing it to the bust of Contarini on his tomb, plus the existence of the words 'Francesco Contarini' on the back of the bust in painted letters. This object is also mentioned by Breck (1932), p. 58.

80. TWO BUSTS OF UNKNOWN MEN (Pl. 150)

Bronze
Kunsthistorisches Museum, Vienna

In a footnote, Serra calls these two busts (nos. 7572 and 7573) 'opere imitate dal Vittoria', even though one of them, he claims, is signed, giving a reference to Planiscig.[1] In his catalogue of the Estensische Collection, Planiscig does indeed mention these pieces, but makes neither an attribution to Vittoria nor any note of a signature, calling them simply 'Venezianisch, 16. Jahrhundert, Ende'.[2]

Leithe-Jasper has attributed these busts to Agostino Zoppo.[3] It is on the basis of his attribution of no. 7572 that I also attribute the marble bust of 'Leonardo Rinaldi' in the National Gallery, London, to Zoppo (see cat. no. 76). If these attributions be correct, then they are the only identifiable examples of portrait busts by Zoppo, who was making classicizing busts at the same time as Cattaneo's and Vittoria's earliest essays in the genre.[4]

[1] Serra (1923), p. 68, n. 2. Pl. 151 illustrates no. 7572.
[2] Planiscig (1919), unpaginated, nos. 211–12.
[3] Leithe-Jasper (1975), pp. 133–5.
[4] See ibid. and Ch. 2, above.

81. 'A LADY OF THE ZORZI FAMILY' (Pls. 152 and 153)

Terracotta
Height: 81 cm.; breadth: 59 cm.
Signed (on rim of right shoulder): ALEXAN. VICTORIA. F.
Bust and socle are in one piece
National Gallery of Art, Washington, DC
Provenance: see cat. no. 24

Because this portrait comes from the palazzo Zorzi in Venice, like the autograph cat. nos. 24 and 27, it is universally attributed to Vittoria. I none the less find it, despite the signature, impossible to accept, nor do I consider it a product of the workshop.[1] The matte, smooth, uninflected facture, the silhouette of the torso, the pneumatic quality of the face, the pop eyes with their blank eyeballs, even the arrangement of the drapery simply have nothing to do with Vittoria and do not correspond with any of his autograph pieces. Nor does the facture of the back of the bust correspond to autograph pieces: compare Pl. 153 with Pl. 113 (the back of cat. no. 24) or with Pl. 115 (the back of cat. no. 28). Presumably this bust, at some undetermined date, was given the signature it now sports, either out of ignorance or mendaciousness, to make it correspond to the real Vittoria busts in the palazzo. To my eye the bust bears more similarities to pieces by Aspetti, such as the three bronze busts in the palazzo Ducale (Pls. 119–21) and to works such as that of an unknown man in the Musée Jacquemart-André, which latter piece I would attribute to the circle of Aspetti.[2]

[1] For a complete bibliography for this piece, see Middeldorf (1976), pp. 76–7; Middeldorf accepts the piece as being by Vittoria. See now also *Sculpture* (1994), p. 234. The inventory no. is 1961.9.107.
[2] For the bust in Paris, see Moureyre-Gavoty (1975), no. 195.

BIBLIOGRAPHY

UNPUBLISHED MATERIAL

MODENA, ARCHIVIO DI STATO

Archivio Segreto Estense; Archivio per Materie; Belle Arti, Scultori, b. 17: letters from Alessandro Vittoria to Duke Ercole II.

Cancelleria Ducale; Estero; Ambasciatori, Agenti e Corrispondenti Estensi, b. 38: letter from Girolamo Feruffini to Duke Ercole II.

PADUA, BIBLIOTECA DEL SEMINARIO

MS DCXIX, 6: 'Lettere di diverse scritte al celebre Prof. e di Padova Marco Mantova e copiate circa l'anno 1748 dell'Abbate Giuseppe Dr Gennari da un codice Ms. siccom'egli offerisce alla pag. 52.'

VENICE, ARCHIVIO DELL'ACCADEMIA

No. 108: receipt to David Weber for sale of sculptures to the Accademia.

VENICE, ARCHIVIO DI STATO. NOTARILI E TESTAMENTI

M. A. Cavanis, b. 194, no. 542: will of Giovanni Donà.
Ibid., b. 196, no. 870: will of Niccolo Massa.
Ibid., b. 197: will of Camillo Trevisan.
Vincenzo Conti, b. 240, no. 155: will of Francesco Duodo.
B. Fiume, b. 421, no. 1172: will of Tommaso Rangone.
Paolo Leoncino, b. 605, no. 24: will of Alessandro Vittoria, 1584.
Girolamo Longin, b. 1200, no. 57: will of Vincenzo Pellegrini.
Vittore Maffei, b. 657, no. 13: will of Alessandro Vittoria, 1576.
G. Secco, b. 1190, no. 172: will of Domenico Duodo.
Ibid., b. 1194: will of Giovanni da Lezze.
Cesare Zilliol, b. 1260, no. 780: will of Niccolo da Ponte.
Ibid., b. 1262, fasc. 1: will of Marc'Antonio Grimani.
Ibid., b. 1262, fasc. 2: will of Girolamo Molin.
Ibid., b. 1263: will of Girolamo Zane.
Ibid., b. 1264, fasc. 8: will of Girolamo Contarini.
Ibid., b. 1264, fasc. 11: wills of Giulio Contarini.

VENICE, ARCHIVIO DI STATO. ARCHIVIO GRIMANI-BARBARIGO

b. 29: book of receipts by Marino Grimani.
b. 33: book of receipts by Marino Grimani.

VENICE, ARCHIVIO DI STATO. PROVVEDITORI E SOPRAVVEDITORI ALLA SANITÀ: NECROLOGIES

b. 797; b. 801; b. 822; b. 826; b. 838.

VENICE, ARCHIVIO DI STATO. ARCHIVIO DI S. ZACCARIA
b. 18 and b. 19: *Commissaria Vittoria*.

VENICE, ARCHIVIO DI STATO. DEMANIO 1806–1813
b. Edwards.

VENICE, ARCHIVIO DI STATO. ARCHIVIO PROCURATIA DE SUPRA
b. 68.

VENICE, ARCHIVIO DI STATO. ARCHIVIO DEI PROCURATORI DI S. MARCO MISTI
b. 12, fasc. 1.
b. 12A, fasc. 1.

VENICE, BIBLIOTECA CIVICO CORRER
Cod. Cicogna 980: Jacopo Morelli, *Alcune memorie spettanti alla chiesa ora demolita di S. Geminiano in Venezia*.
Cod. Cicogna 1877: Agostino Nicolai, *Memoria manoscritta sopra la chiesa e monastero di Santo Stefano in Venezia*.
Cod. Cicogna 2012: E. A. Cicogna, *Iscrizioni veneziane inedite*.
Cod. Cicogna 2012, no. 7: E. A. Cicogna, *Inscrizioni nella chiesa di S. Maria del Giglio d.a. Zobenigo*.
Cod. Cicogna 2498–2504: Marco Barbaro, *Genealogie Venete*.
Cod. Cicogna 3430: *Famiglie Venete e Forestiere*.
MSS Gradenigo 228: Jan Grevembroch, *Monumenta veneta ex antiquis rederibus Templorum, aliarumq. Aedium Vetustate collapsarum. Collecta, Studio, et Cura Petri Gradonici*.
MS P.D. 207b: *Raccolta di lettere inedite di vari letterati italiani*.
MSS P.D.c. 2803: *Genealogia di famiglie patrizie*.

VENICE, BIBLIOTECA MARCIANA
MS It. cl. VII, 8304–8307: Girolamo Alessandro Cappellari Vivaro, *Il Campidoglio Veneto*.

PUBLISHED MATERIAL

Accademia (1862): *Catalogo degli oggetti d'arte esposti al pubblico nella I. R. Accademia di Belle Arti in Venezia* (Venice, 1862).
Agostini (1754): Agostini, G. degli, *Istoria degli scritori viniziani* (2 vols.; Venice, 1754).
Allison (1976): Allison, A[nn]. H[ersey]., 'Four New Busts by Antico', *Mitteilungen des Kunsthistorischen Institutes in Florenz*, 20 (1976), pp. 213–24.
Allison (1993/4): Allison, Ann Hersey, 'The Bronzes of Pier Jacopo Alari-Bonacolsi', *Jahrbuch der Kunsthistorischen Sammlungen in Wien*, 89/90 (53/54) (1993–4), pp. 35–310.
Ambrosi (1894): Ambrosi, Francesco, *Scrittori ed artisti trentini* (Trent, 1894).
Anderson (1979): Anderson, Jaynie, 'A Further Inventory of Gabriele Vendramin's Collection', *Burlington Magazine*, 121 (1979), pp. 639–48.
Anti (1942): Anti, Carlo, *Il mito della tomba di Livio* (Padua, 1942).

Apollonio (1911): Apollonio, Ferdinando, *La chiesa e il convento di S. Stefano in Venezia, Memoria* (Venice, 1911).

Aretino (1957–9): Aretino, Pietro, *Lettere sull'arte di Pietro Aretino*, ed. F. Pertile and E. Camesasca (3 vols.; Milan, 1957–9).

Arslan (1956): Arslan, Edoardo, *Vicenza: le chiese* (Rome, 1956).

L'Arte (1905): *L'Arte*, 8 (1905), p. 286.

Avesani (1969): Avesani, R., 'Lazzaro Bonamico', in *Dizionario biografico degli italiani*, 11 (Rome, 1969), pp. 533–40.

Azzi Visentini (1984): Azzi Visentini, Margherita, *L'Orto botanico di Padova e il giardino del Rinascimento* (Milan, 1984).

Baiocchi (1983): Baiocchi, A., 'Alessandro Contarini', in *Dizionario biografico degli italiani*, 28 (Rome, 1983), pp. 72–4.

Baker (1995): Baker, Malcolm, 'The Making of Portrait Busts in the mid-18th Century: Roubiliac, Scheemakers, and Trinity College, Dublin', *Burlington Magazine*, 137 (1995), pp. 821–31.

Baker and Henry (1995): Baker, Christopher, and Henry, Tom, *The National Gallery Complete Illustrated Catalogue* (New Haven and London, 1995).

Ballarin (1968): Ballarin, Alessandro, 'La decorazione ad affresco della villa veneta nel quinto decennio del cinquecento: la villa di Livigliano', *Bollettino del Centro Internazionale di Studi di Architettura*, 10 (1968), pp. 115–26.

Ballarin (1993): Ballarin, Alessandro, 'Une nouvelle perspective sur Giorgione: les portraits des années 1500–1503', in *Le siècle de Titien: L'âge d'or de la peinture à Venise*, exh. cat. (Paris, 1993), pp. 281–95.

Barbaro (1556): Barbaro, Daniele, *I dieci libri dell'architettura di M. Vitruvio* (Venice, 1556).

Barbieri (1987): Barbieri, Franco, *Vicenza, città di palazzi* (Milan, 1987).

Bassi (1987): Bassi, Elena, *Palazzi di Venezia* (3rd edn.; Venice, 1987).

Bassi (1968): Bassi, Umberto, *Cronaca di Maser: delle sue chiese e della villa Palladiana dei Barbaro (1152–1955)* (Montebelluna, 1968).

Battilotti (1980): Battilotti, Donata, *Vicenza al tempo di Andrea Palladio attraverso i libri dell'estimo del 1563–64* (Vicenza, 1980).

Battilotti (1985): Battilotti, Donata, 'Villa Barbaro a Maser: un difficile cantiere', *Storia dell'arte*, 53 (1985), pp. 33–48.

Beltrami (1955): Beltrami, D., *Saggio di storia dell'agricoltura nella Repubblica di Venezia durante l'età moderna* (Venice and Rome, 1955).

Bembo (1808–10): Bembo, Pietro, *Opere* (6 vols.; Milan, 1808–10).

Benavides (1566): Benavides, Marco Mantova, *Illustrium Iureconsultorum Imagines* (Rome, 1566).

Benzoni (1983): Benzoni, G., 'Alvise Contarini', in *Dizionario biografico degli italiani*, 28 (Rome, 1983), pp. 82–91.

Berengo (1960): Berengo, M., 'Vincenzo degli Alessandri', in *Dizionario biografico degli italiani*, 2 (Rome, 1960), p. 174.

Bertolotti (1890): Bertolotti, Antonio, *Figuli, fonditori e scultori in relazione con la corte di Mantova nei secoli XV, XVI, XVII: notizie e documenti raccolti negli archivi mantovani* (Milan, 1890).

Beyer (1987): Beyer, Andreas, *Andrea Palladio: Teatro Olimpico. Triumpharchitektur für eine humanistische Gesellschaft* (Frankfurt-on-Main, 1987).

Bistort (1912): Bistort, G., *Il magistrato alle pompe nella republica di Venezia: studio storico* (Venice, 1912).

Bode (1980): Bode, Wilhelm, *The Italian Bronze Statuettes of the Renaissance*, rev. and ed. J. D. Draper (New York, 1980).

Bodon (1988): Bodon, G., 'Nuovi elementi per lo studio del busto di Tito Livio al Palazzo della Ragione a Padova', *Bollettino del Museo Civico di Padova*, 77 (1988), pp. 81–96.

Bodon (1991): Bodon, G., 'Studi antiquari fra XV e XVII secolo. La famiglia Maggi da Bassano e la sua collezione di antichità', *Bollettino del Museo Civico di Padova*, 80 (1991), pp. 23–172.

Boerio (1856): Boerio, Giuseppe, *Dizionario del dialetto veneziano* (Venice, 1856).

Bolzoni (1981): Bolzoni, Lina, 'L'Accademia Veneziana: splendore e decadenza di una utopia enciclopedica', in *Università, Accademie e Società scientifiche in Italia e in Germania dal Cinquecento al Settecento*, ed. L. Boehm and E. Raimondi (Bologna, 1981), pp. 117–67.

Borghini (1584): Borghini, Rafaello, *Il riposo* (Florence, 1584).

Boselli (1978): Boselli, Orfeo, *Osservazioni della scoltura antica*, ed. P. Dent Weil (Florence, 1978).

Bottari and Ticozzi (1822–5): Bottari, Giovanni, and Ticozzi, Stefano, *Raccolta di lettere sulla pittura, scultura ed architettura* (8 vols.; Milan, 1822–5).

Boucher (1979): Boucher, Bruce, 'The Last Will of Daniele Barbaro', *Journal of the Warburg and Courtauld Institutes*, 42 (1979), pp. 277–82.

Boucher (1980): Boucher, Bruce, 'A Statuette by Girolamo Campagna and a Portrait by Leandro Bassano', *Arte Veneta*, 34 (1980), pp. 159–64.

Boucher (1991): Boucher, Bruce, *The Sculpture of Jacopo Sansovino* (2 vols.; London and New Haven, 1991).

Braudel (1958): Braudel, Fernand, 'La vita economica di Venezia nel secolo XVI', in *Civiltà veneziana del rinascimento* (Florence, 1958), pp. 81–102.

Braudel (1973): Braudel, Fernand, *The Mediterranean and the Mediterranean World in the Age of Philip II* (2 vols.; New York, 1973; trans. of French edn., Paris, 1949).

Breck (1913): Breck, Joseph, *The Metropolitan Museum of Art: Catalogue of Romanesque, Gothic, and Renaissance Sculpture* (New York, 1913).

Breck (1932): Breck, Joseph, 'The Michael Friedsam Collection: European Decorative Arts', *Metropolitan Museum Bulletin*, 27 (1932), pp. 53–70.

Bresciani Alvarez (1980): Bresciani Alvarez, Giulio, 'Il monumento a Tito Livio', in *Alvise Cornaro e il suo tempo*, exh. cat. (Padua, 1980), pp. 282–3.

Brinckmann (1925): Brinckmann, A. E., *Barockskulptur* (Berlin, 1925).

Brown (1969): Brown, Clifford, '"Una testa de Platone Antica con la Punta dil Naso di Cera": Unpublished Negotiations between Isabella d'Este and Niccolo and Giovanni Bellini', *Art Bulletin*, 51 (1969), pp. 372–7.

Brown (1977): Brown, Clifford M., 'The Grotta of Isabella d'Este', *Gazette des Beaux-Arts*, 6/89 (1977), pp. 155–71.

Brown (1974): Brown, William A., 'Niccolo da Ponte: The Political Career of a Sixteenth-Century Patrician', Ph.D. thesis (New York University, 1974).

Bruhns (1940): Bruhns, Leo, 'Das Motiv der ewigen Anbetung in der römische Grabplastik des 16. 17. und 18. Jahrhunderts', *Römisches Jahrbuch für Kunstgeschichte*, 4 (1940), pp. 253–432.

Brulez (1965): Brulez, Wilfrid, *Marchands Flamands à Venise, I (1568–1605)* (Brussels and Rome, 1965).

Brunetti (1953): Brunetti, Mario, *S. Maria del Giglio, nell'arte e nella storia* (Venice, 1953).

Burns (1979): Burns, Howard, 'Le opere minori del Palladio', *Bollettino del Centro Internazionale di Studi di Architettura Andrea Palladio*, 21 (1979), pp. 9–34.

Bush (1976): Bush, Virginia, *Colossal Sculpture of the Cinquecento* (New York, 1976).

Caiani (1968): Caiani, Anna, 'Un palazzo veronese a Murano: note e aggiunte', *Arte veneta*, 22 (1968), pp. 47–59.

Calore (1988): Calore, Andrea, 'Note sul monumento ad Alessandro Contarini nella basilica del Santo', *Il Santo*, 28/2 (1988), pp. 71–9.

Campori (1873): Campori, Giuseppe, *Memorie biografiche degli scultori, architetti, pittori della provincia di Carrara* (Modena, 1873).

Campori (1874): Campori, Giuseppe, 'Une statue de Jacopo Sansovino', *Gazette des Beaux-Arts*, 10/35 (1874), pp. 321–34.

Candida (1967): Candida, Bianca, *I calchi rinascimentali della collezione Mantova Benavides nel museo del Liviano a Padova* (Padua, 1967).

Cantalamessa (1902): Cantalamessa, Giulio, 'Le R. Gallerie di Venezia', *Gallerie nazionali italiane*, 5 (1902), pp. 22–60.

Capel-Cure (1905): *Catalogue of the Collection of Italian Bronzes, Faience, objects of Art and Furniture of the 15th, 16th, 17th, and 18th Centuries . . . the Property of Francis Capel-Cure, Esq.*, Christie's, London (Thursday, 4 May 1905).

Carpeggiani (1977): Carpeggiani, Paolo, 'G. M. Falconetto: temi ed eventi di una architettura civile', in *Padova: case e palazzi*, ed. L. Puppi and F. Zuliani (Padua, 1977), pp. 71–99.

Cecchetti (1874): Cecchetti, Bartolommeo, *La Repubblica di Venezia e la corte di Roma nei Rapporti della Religione* (2 vols.; Venice, 1874).

Cessi (1960a): Cessi, Francesco, *Alessandro Vittoria, bronzista* (Trent, 1960).

Cessi (1960b): Cessi, Francesco, *Alessandro Vittoria, medaglista* (Trent, 1960).

Cessi (1961a): Cessi, Francesco, *Alessandro Vittoria, architetto e stuccatore* (Trent, 1961).

Cessi (1961b): Cessi, Francesco, *Alessandro Vittoria, scultore*, i (Trent, 1961).

Cessi (1962): Cessi, Francesco, *Alessandro Vittoria, scultore*, ii (Trent, 1962).

Cessi (1963): Cessi, Francesco, 'Problemi attributivi attorno al nome di Alessandro Vittoria', *Studi trentini di scienze storiche*, 42 (1963), pp. 28–37.

Cessi (1965): Cessi, Francesco, *Giovanni Da Cavino medaglista padovano del cinquecento* (Padua, 1965).

Cessi (1967): Cessi, Francesco, 'Una primizia di Alessandro Vittoria ritrattistica: il busto in marmo di Leonardo Arnaldi', *Studi trentini di scienze storiche*, 46 (1967), pp. 14–21.

Cevese (1966): Cevese, Roberto, *I palazzi Thiene* (Vicenza, 1966).

Chambers (1970): Chambers, D. S., *The Imperial Age of Venice* (London, 1970).

Chavasse (1988): Chavasse, Ruth, 'Humanism Commemorated: The Venetian Memorials to Benedetto Brugnolo and Marcantonio Sabellico', in *Florence and Italy: Renaissance Studies in Honour of Nicolai Rubinstein*, ed. P. Denley and C. Elam (London, 1988), pp. 455–61.

Chojnacki (1985): Chojnacki, Stanley, 'Kinship Ties and Young Patricians in Fifteenth-Century Venice', *Renaissance Quarterly*, 37 (Summer 1985), pp. 240–70.

Cicero (1926): Cicero, M. T., *Philippics*, trans. W. C. A. Ker (London and New York, Loeb Classical Library, 1926).

Cicogna (1824–53): Cicogna, Emmanuele Antonio, *Delle iscrizioni veneziane* (6 vols.; Venice, 1824–53).

Cicognara (1858): Cicognara, Leopoldo, Diedo, Antonio, and Selva, Giovanni, *Le fabbriche cospicui di Venezia, edizione con copiose note ed aggiunte di Francesco Zanotto* (2 vols.; Venice, 1858).

Coletti (1941): Coletti, Luigi, 'La crisi manieristica nella pittura veneziana', *Convivium*, 13 (1941) pp. 109–26.

Comastri (1988): Comastri, Enrico, 'Profilo di Giulio del Moro', *Arte veneta*, 42 (1988), pp. 87–97.

Conforti Calcagni (1980): Conforti Calcagni, Annamaria, 'Bartolomeo Ridolfi', in Marini (1980), pp. 172–85.

Connell (1988): Connell, Susan, *The Employment of Sculptors and Stone-Masons in Venice in the Fifteenth Century*, Ph.D. thesis (London, 1976; publ. New York and London, 1988).

Contarini (1544): Contarini, Gasparo, *La Republica e i Magistrati di Vinegia* (Venice, 1544).

Cooper (1990): Cooper, Tracy E., 'La facciata commemorativa di S. Giorgio Maggiore', in *Andrea Palladio: nuovi contributi* (Milan, 1990), pp. 136–45.

Correr (1899): *Museo civico e raccolta Correr, Venezia: elenco degli oggetti esposti* (Venice, 1899).

'Costabili' (1984): 'Costabili, Paolo', in *Dizionario biografico degli italiani*, 30 (Rome, 1984), pp. 261–2; unsigned entry.

Courajod (1884): Courajod, L., 'Simone Bianco, sculpteur du XVIe siècle', *Chronique des Arts* (1884), p. 221.

Cozzi (1973): Cozzi, Gaetano, 'Authority and the Law in Renaissance Venice', in *Renaissance Venice*, ed. J. Hale (London, 1973), pp. 293–345.

Cozzi (1979): Cozzi, Gaetano, *Paolo Sarpi tra Venezia e l'Europa* (Turin, 1979).

Cozzi (1980): Cozzi, Gaetano, 'La politica del diritto nella Repubblica di Venezia', in *Stato, società e giustizia nella Repubblica Veneta (secoli XV–XVIII)* (Rome, 1980), pp. 122–52.

Cozzi (1982): Cozzi, Gaetano, *Repubblica di Venezia e stati italiani. Politica e giustizia dal secolo XVI al secolo XVII* (Turin, 1982).

Cozzi (1984): Cozzi, Gaetano, 'Politica, cultura e religione', in *Cultura e società nel rinascimento tra riforme e manierismi*, ed. V. Branca and C. Ossola (Florence, 1984), pp. 21–42.

Cozzi (1986): Cozzi, Gaetano, 'Venezia, una repubblica di principi?', *Studi veneziani*, 11 (1986), pp. 139–57.

Cropper (1985): Cropper, Elizabeth, 'Prolegomena to a New Interpretation of Bronzino's Florentine Portraits', in *Renaissance Studies in Honor of Craig Hugh Smyth*, ed. C. Elam (Florence, 1985), ii, pp. 149–60.

Dacos and Furlan (1987): Dacos, Nicole, and Furlan, Caterina, *Giovanni da Udine, 1487–1561* (Udine, 1987).

Da Mosto (1937–40): Da Mosto, Andrea, *L'Archivio di stato di Venezia: indice generale storico, descrittivo ed analitico* (2 vols.; Rome, 1937–40).

Da Mosto (1939): Da Mosto, Andrea, *I Dogi di Venezia con particolare riguardo alle loro tombe* (Venice, 1939).

Da Mosto (1960): Da Mosto, Andrea, *I Dogi di Venezia nella vita pubblica e privata* (Milan, 1960).

Dario (1994): Dario, Marisa, 'Il monumento funebre ai procuratori Priamo, Giovanni e Andrea da Lezze, nella chiesa dei Gesuiti a Venezia. Nuove considerazioni per un'attribuzione a Jacopo Sansovino', *Arte veneta*, 46 (1994), pp. 62–9.

Da Tiziano a El Greco (1981): *Da Tiziano a El Greco: per la storia del manierismo a Venezia, 1540–1590*, exh. cat. (Milan, 1981).

Davis (1976a): Davis, Charles, ' "Colossum Facere Ausus Est": L'Apoteosi d'Ercole e il colosso padovano dell'Ammannati', *Psicon*, 6–7 (1976), pp. 37–41.

Davis (1976b): Davis, Charles, 'Ammannati, Michelangelo and the tomb of Francesco del Nero', *Burlington Magazine*, 118 (1976), pp. 472–84.

Del Piero (1902): Del Piero, Antonio, 'Della vita e degli studi di Giov. Battista Ramusio', *Nuovo archivio veneto*, NS 4/2 (1902), pp. 5–112.

Derosas (1983a): Derosas, Renzo, 'Girolamo Contarini', in *Dizionario biografico degli italiani*, 28 (Rome, 1983), pp. 217–18.

Derosas (1983b): Derosas, Renzo, 'Tommaso Contarini', in *Dizionario biografico degli italiani*, 28 (Rome, 1983), pp. 300–5.

De Vecchi (1977): De Vecchi, Pier Luigi, 'Il museo gioviano e le "verae imagines" degli uomini illustri', in *Omaggio a Tiziano: la cultura artistica milanese nell'età di Carlo V*, exh. cat. (Milan, 1977), pp. 87–93.

Dizionario Enciclopedia (1967): *Dizionario Enciclopedia della letteratura italiana*, 3 (Rome, 1967).

Dolce (1559): Dolce, Lodovico (ed.), *Lettere di diversi eccellentissimi huomini* (Venice, 1559).

Dolce (1968): Dolce, Lodovico, *Dolce's 'Aretino' and Venetian Art Theory of the Cinquecento*, ed. M. Roskill (New York, 1968).

Donateurs (1989): *Les donateurs du Louvre*, exh. cat. (Paris, 1989).

Donati (1987): Donati, Claudio, *L'idea di nobiltà in Italia, secoli XIV–XVII* (Rome and Bari, 1987).

Donato (1985): Donato, Maria Monica, 'Gli eroi romani tra storia ed *exemplum*. I primi cicli umanistici di Uomini Famosi', in *Memoria dell antico nell'arte italiana*, ed. S. Settis, ii (Turin, 1985), pp. 97–152.

Draper (1985): Draper, James David, in *Liechtenstein: The Princely Collections*, exh. cat. (New York, 1985), pp. 209–12.

Draper (1987): Draper, James David, in *Die Bronzen der Fürstlichen Sammlung Liechtenstein*, exh. cat. (Frankfurt-on-Main, 1987), pp. 257–61.

Dwyer (1990): Dwyer, Eugene, 'Marco Mantova Benavides e i ritratti di giureconsulti illustri', *Bollettino d'arte*, 64 (1990), pp. 59–70.

Eisler (1989): Eisler, Colin, *The Genius of Jacopo Bellini* (New York, 1989).

Facciolati (1757): Facciolati, Jacopo, *Fasti Gymnasii Patavini*, 3 parts in 1 (Padua, 1757).

Favaretto (1972): Favaretto, Irene, 'Andrea Mantova Benavides: inventorio delle antichità di casa Mantova Benavides—1695', *Bollettino del Museo Civico di Padova*, 61 (1972), pp. 35–164.

Favaretto (1976–7): Favaretto, Irene, 'Alessandro Vittoria e la collezione di Marco Mantova Benavides', *Atti dell'Istituto Veneto di Scienze, Lettere ed Arti*, 135 (1976–7), pp. 401–11.

Favaretto (1980): Favaretto, Irene, 'Il museo di Marco Mantova Benavides', in Marini (1980), pp. 134–8.

Favaretto (1985): Favaretto, Irene, 'Simone Bianco: uno scultore del XVI secolo di fronte all'antico', *Quaderni ticinesi di Numismatica e Antichità classiche*, 14 (1985), pp. 405–21.

Favaretto (1990): Favaretto, Irene, *Arte antica e cultura antiquaria nelle collezioni venete al tempo della Serenissima* (Rome, 1990).

Ferretti (1572): Ferretti, Giovanni Battista, *Conciliorum sive Responsorum* (Venice, 1572).

Ferretti (1981): Ferretti, Massimo, 'Falsi e tradizione artistica', *Storia dell'arte italiana*, 10/3 (Turin, 1981), pp. 118–95.

Ferro (1907): Ferro, L., 'Giacomo Albarelli', in *Allgemeines Lexikon der bildenden Künstler*, ed. U. Thieme and F. Becker, i (Leipzig, 1907), p. 179.

Finlay (1978): Finlay, Robert, 'The Venetian Republic as a Gerontocracy: Age and Politics in the Renaissance', *Journal of Medieval and Renaissance Studies*, 8 (1978), pp. 157–78.

Finlay (1980): Finlay, Robert, *Politics in Renaissance Venice* (New Brunswick, NJ, 1980).

Fiocco (1958): Fiocco, Giuseppe, 'Segnalazioni venete nel Museo di Kieff: due busti di Danese Cattaneo', *Arte veneta*, 12 (1958), pp. 35–7.

Fittschen (1985): Fittschen, Klaus, 'Sul ruolo del ritratto antico nell'arte italiana', in *Memoria dell'antico nell'arte italiana*, ed. S. Settis, ii (Turin, 1985), pp. 383–412.

Fittschen (1990): Fittschen, Klaus, 'The Bronze Bust of the "Young Marcus Aurelius" by Antico and its Antique Model', *The J. Paul Getty Museum Journal*, 18 (1990), pp. 113–26.

Fletcher (1981): Fletcher, J. M., 'Isabella d'Este, Patron and Collector', in *Splendours of the Gonzaga*, exh. cat. (London, 1981), pp. 51–63.

Fontana (1980): Fontana, Vincenzo, 'Costruire a Venezia nel cinquecento: progetto, materiali, cantiere e teoria in palazzo Grimani a S. Luca', in *Congresso nazionale di storia dell'arte. I* (Rome, 1980), pp. 41–53.

Forlati (1956): Forlati, Tamaro, Forlati, Ferdinando, and Barbieri, Franco, *Il Duomo di Vicenza* (Vicenza, 1956).

Forsmann (1973): Forsmann, Erik, *The Palazzo da Porto Festa* (University Park, Pa., and London, 1973).

Foscari (1984): Foscari, Antonio, 'Festoni e putti nella decorazione della Libreria di San Marco', *Arte Veneta*, 38 (1984), pp. 23–30.

Foscari and Tafuri (1982): Foscari, Antonio, and Tafuri, M., 'Sebastiano da Lugano, i Grimani e Jacopo Sansovino: artisti e committenti nella chiesa di Sant'Antonio di Castello', *Arte Veneta*, 36 (1982), pp. 100–23.

Foscari and Tafuri (1983): Foscari, Antonio, and Tafuri, M., *L'Armonia e i conflitti: la chiesa di S. Francesco della Vigna nella Venezia del '500* (Turin, 1983).

Fragnito (1978): Fragnito, Gigiola, *Memoria individuale e costruzione biografica: Beccadelli, Della Casa, Vettori alle origini di un mito* (Urbino, 1978).

Frank (1985–6): Frank, Martina, 'Spazio pubblico. Prospetti di chiese a glorificazione gentilizia nella Venezia del Seicento: riflessioni su una tipologia', *Atti dell'Istituto Veneto di Scienze, Lettere ed Arti*, 144 (1985–6), pp. 109–26.

Franzoi (1990): Franzoi, U., Pignatti, T., and Wolters, W., *Il palazzo ducale di Venezia* (Treviso, 1990).

Franzoni (1981): Franzoni, Lanfranco, 'Antiquari e collezionisti nel cinquecento', in *Storia della cultura veneta*, 3/3 (Vicenza, 1981), pp. 207–66.

Frey (1955): Frey, Dagobert, 'Apokryphe Liviusbildnisse der Renaissance', *Wallraf-Richartz-Jahrbuch*, 17 (1955), pp. 132–5.

Frey and Frey (1923–40): Frey, K., and Frey, H.W., *Der litterarische Nachlass Giorgio Vasaris* (2 vols.; Munich, 1923–40).

Frosien-Leinz (1990): Frosien-Leinz, Heike, 'Venezianische Antikennachahmungen im Antiquarium der Münchner Residenz aus der Sammlung Albrechts V', in *Venezia e l'archeologia: un importante capitolo nella storia del gusto dell'antico nella cultura artistica veneziana* (Rome, 1990), pp. 209–15.

Gaeta (1958): Gaeta, Franco (ed.), *Nunziature di Venezia* (2 vols.; Rome, 1958).

Gallo (1935): Gallo, Rodolfo, 'Per il "San Lorenzo Martire" di Tiziano', *Rivista di Venezia*, 14 (Apr., 1935), pp. 155–74.

Gallo (1939): Gallo, Rodolfo, 'Per la datazione delle opere del Veronese', *Emporium*, 89 (1939), pp. 145–52.

Gallo (1957): Gallo, Rodolfo, 'Contributi su Jacopo Sansovino', *Saggi e memorie di storia dell'arte*, 1 (1957), pp. 85–105.

Gallo (1960): Gallo, Rodolfo, 'Michele Sanmicheli a Venezia', in *Michele Sanmicheli 1484–1559: studi raccolti dall'Academia di Agricoltura, Scienze, e Lettere* (Verona, 1960), pp. 97–160.

Galvin and Lindley (1988): Galvin, C., and Lindley, P., 'Pietro Torrigiano's Portrait Bust of King Henry VII', *Burlington Magazine*, 130 (1988), pp. 892–902.

Garzoni (1586): Garzoni, T., *Piazza universale* (Venice, 1586).

Genius (1983): *The Genius of Venice*, ed. J. Martineau and C. Hope, exh. cat. (London, 1983).

Gerola (1924–5): Gerola, Giuseppe, 'Nuovi documenti veneziani su Alessandro Vittoria', *Atti del Reale Istituto di Scienze, Lettere, ed Arti*, 84 (1924–5), pp. 339–59.

Gilbert (1973): Gilbert, Felix, 'Venice in the Crisis of the League of Cambrai', in *Renaissance Venice*, ed. J. Hale (London, 1973), pp. 274–92.

Giovanelli (1858): Giovanelli, Benedetto, *Vita di Alessandro Vittoria, scultore trentino*, ed. T. Gar (Trent, 1858).

Goffen (1986): Goffen, Rona, *Piety and Patronage in Renaissance Venice: Bellini, Titian, and the Franciscans* (New Haven and London, 1986).

Gombrich (1966): Gombrich, E. H., 'The Style all'antica: Imitation and Assimilation', in *Norm and Form* (London, 1966), pp. 122–8.

Gonzaga (1981): *Splendours of the Gonzaga*, exh. cat. (Milan, 1981).

Gonzati (1852–4): Gonzati, Benedetto, *La basilica di S. Antonio di Padova* (2 vols.; Padua, 1852–4).

Gorini (1973): Gorini, Giovanni, 'Appunti su Giovanni da Cavino', in *La medaglia d'arte* (Udine, 1973), pp. 110–20.

Gorini (1987): Gorini, Giovanni, 'New Studies on Giovanni da Cavino', *Studies in the History of Art* (National Gallery of Art, Washington, DC), 21 (1987), pp. 45–54.

Greggio (1894): Greggio, Elisa, 'Girolamo Molin', *Ateneo veneto*, 18/2 (1894), pp. 188–202 and 255–323.

Grendler (1977): Grendler, Paul, *The Roman Inquisition and the Venetian Press, 1540–1605* (Princeton, 1977).

Grendler (1979): Grendler, Paul, 'The 3 Savi sopra eresia 1547–1605: A Prosopographical Study', *Studi veneziani*, NS 3 (1979), pp. 283–340.

Grisebach (1936): Grisebach, August, *Römische Porträtbüsten der Gegenreformation* (Leipzig, 1936).

Gronau (1919–32): Gronau, Georg, 'Die Statue des Federigo di Montefeltro im herzöglichen Palast von Urbino', *Mitteilungen des Kunsthistorischen Institutes in Florenz*, 3 (1919–32), pp. 254–67.

Grossato (1966): Grossato, Lucio, *Affreschi del Cinquecento in Padova* (Padua, 1966).

Gualdo (1972): Gualdo, Girolamo, *1650. Il giardino di Chà Gualdo*, ed. L. Puppi (Florence, 1972).

Guazzo (1546): Guazzo, Marco, *Historia di tutti i fatti di memoria nel mondo* (Venice, 1546).

Guisconi (1556): Guisconi, Anselmo, *Tutte le cose notabili che sono in Venezia, dialogo 1556* (Venice, 1556).

Gullino (1985): Gullino, G., 'Giovanni da Lezze', in *Dizionario biografico degli italiani*, 31 (Rome, 1985), pp. 752–5.

Gullino (1986): Gullino, G., 'Niccolo da Ponte', in *Dizionario biografico degli italiani*, 32 (Rome, 1986), pp. 723–8.

Gullino (1991): Gullino, G., 'Giovanni Donà', in *Dizionario biografico degli italiani*, 40 (Rome, 1991), pp. 732–3.

Gullino (1993): Gullino, G., 'Francesco Duodo', in *Dizionario biografico degli italiani*, 42 (Rome, 1993), pp. 30–3.

Haskell and Penny (1981): Haskell, Francis, and Penny, Nicholas, *Taste and the Antique* (New Haven and London, 1981).

Held (1963): Held, Julius, 'The Early Appreciation of Drawings', in *Studies in Western Art* (Acts of the 20th International Congress of the History of Art) 3 (Princeton, 1963), pp. 72–95.

Hiesinger (1976): Hiesinger, Kathryn, 'The Fregoso Monument: A Study in Sixteenth-Century Tomb Monuments and Catholic Reform', *Burlington Magazine*, 118 (1976), pp. 283–93.

Hill (1967): Hill, G. F., *Renaissance Medals from the Samuel H. Kress Collection at the National Gallery of Art*, rev. and enlarged G. Pollard (London, 1967).

Hirthe (1986): Hirthe, Thomas, 'Die Libreria des Jacopo Sansovino: Studien zu Architektur und Ausstattung eines öffentlichen Gebäudes in Venedig', *Münchner Jahrbuch der bildenden Kunst*, 37 (1986), pp. 131–76.

Hochman (1992): Hochman, Michel, 'Le mécenat de Marino Grimani', *Revue de l'Art*, 95 (1992), pp. 41–51.

Howard (1975): Howard, Deborah, *Jacopo Sansovino: Architecture and Patronage in Renaissance Venice* (New Haven and London, 1975).

Hubala (1974): Hubala, Erich, 'Venedig. Brenta-Villen, Chioggia, Murano, Torcello', in *Reclams Kunstführer Italien II, i. Venedig*, ed. M. Wundram (Stuttgart, 1974).

Humfrey (1993): Humfrey, Peter, *The Altarpiece in Renaissance Venice* (New Haven and London, 1993).

Ivanoff (1961a): Ivanoff, Nicola, 'Ignote primizie veneziane di Alessandro Vittoria', *Emporium*, 134 (1961), pp. 242–50.

Ivanoff (1961b): Ivanoff, Nicola, 'La scala d'oro del Palazzo Ducale di Venezia', *La critica d'arte*, 8 (1961), pp. 27–41.

Ivanoff (1968): Ivanoff, Nicola, 'La Libreria Marciana: arte e iconologia', *Saggi e memorie di storia dell'arte*, 6 (1968), pp. 33–78.

Jones (1926): Jones, H. Stuart, *The Sculpture of the Palazzo dei Conservatori* (Oxford, 1926).

Joost-Gaugier (1983): Joost-Gaugier, C. L., 'The Casa degli Specchi at Padua, its Architect Annibale da Bassano, Tito Livio and a Peculiar Historical Connection', *Bollettino del Museo Civico di Padova*, 72 (1983), pp. 113–24.

Keeble (1980): Keeble, K. Corey, 'Italian Renaissance Stucco and Terracotta Sculpture in the Royal Ontario Museum, Toronto', *Apollo*, 111 (June 1980), pp. 424–31.

Keller (1971): Keller, Fritz-Eugen, 'Alvise Cornaro zitiert die Villa des Marcus Terentius Varro in Cassino', *L'Arte*, NS 4 (1971), pp. 29–53.

Keutner (1969): Keutner, Herbert, *Sculpture: Renaissance to Rococo* (London, 1969).

Kinney (1976): Kinney, Peter, *The Early Sculpture of Bartolomeo Ammannati* (New York, 1976).

Kleinschmidt (1977): Kleinschmidt, Irene, 'Gruppenvotivbilder venezianischer Beamter (1550–1630) im Palazzo der Camerlenghi und im Dogenpalast', *Arte veneta*, 31 (1977), pp. 104–18.

Klinger (1985): Klinger, Linda, 'Portrait Collections and Portrait Books in the Sixteenth Century: The Case of Paolo Giovio and Marco Mantova Benavides', in *Paolo Giovio: il rinascimento e la memoria. Atti del convegno giugno, 1983* (Como, 1985), p. 181.

Knox and Martin (1987): Knox, George, and Martin, Thomas, 'Giambattista Tiepolo: A Series of Chalk Drawings after Alessandro Vittoria's Bust of Giulio Contarini', *Master Drawings*, 25/2 (1987), pp. 159–63.

Krahn (1988): Krahn, Volker, *Bartolomeo Bellano: Studien zur Paduaner Plastik der Quattrocento* (Augsburg, 1988).

Kurz (1982): Kurz, Otto, 'Early Art Forgeries', in *Selected Studies*, 2 (London, 1982), pp. 179–94.

Ladendorf (1958): Ladendorf, Heinz, *Antikenstudien und Antikencopien* (2nd edn.; Berlin, 1958).

Lane (1973): Lane, Frederic C., *Venice, A Maritime Republic* (Baltimore, 1973).

Langenskiold (1938): Langenskiold, Eric, *Michele Sanmicheli, the Architect of Verona: His Life and Works* (Uppsala, 1938).

Laven (1957): Laven, P. J., 'Daniele Barbaro, Patriarch Elect of Aquileia with special reference to his Circle of Scholars and to his Literary Achievement', Ph.D. thesis (University of London, 1957).

Laven (1967): Laven, P. J., 'The Causa Grimani and its Political Overtones', *Journal of Religious History*, 4 (1967), pp. 182–205.

Lavin (1968): Lavin, Irving, 'Five New Youthful Sculptures by Gianlorenzo Bernini and a Revised Chronology of His Early Works', *Art Bulletin*, 50 (1968), pp. 223–48.

Lavin (1970): Lavin, Irving, 'On the Sources and Meaning of the Renaissance Portrait Bust', *Art Quarterly*, 33 (1970), pp. 207–26.

Lavin (1975): Lavin, Irving, 'On Illusion and Allusion in Italian Sixteenth Century Portrait Busts', *Proceedings of the American Philosophical Society*, 119 (1975), pp. 353–62.

Lazari (1859): Lazari, Vincenzo, *Notizie delle opere d'arte e d'antichità della raccolta Correr di Venezia* (Venice, 1859).

Legner (1967): Legner, A., 'Anticos Apoll vom Belvedere', *Städel-Jahrbuch*, 1 (1967), pp. 102–18.

Leithe-Jasper (1963): Leithe-Jasper, Manfred, 'Alessandro Vittoria: Beiträge zu einer Analyse des Stils seiner figurlichen Plastiken unter Berücksichtigung der Beziehungen zur Gleichzeitige Malerei in Venedig', Ph.D. thesis (University of Vienna, 1963).

Leithe-Jasper (1975): Leithe-Jasper, Manfred, 'Beiträge zum Werke des Agostino Zoppos', *Jahrbuch des Stiftes Klosterneuberg*, 9 (1975), pp. 109–38.

Leithe-Jasper (1986): Leithe-Jasper, Manfred, *Renaissance Master Bronzes*, exh. cat. (London, 1986).

Leoni (1994): *Los Leoni (1509–1608): Escultores del Renacimiento italiano al servicio de la corte de España*, exh. cat. (Madrid, 1994).

Levi (1932): Levi, Alda, 'Ritratti romani lavorati nel rinascimento', *Historia: studi storici per l'antichità classica*, 6 (1932), pp. 276–91.

Lewis (1984): Lewis, Carolyn Kolb, 'New Evidence for Villa Pisani at Montagnana', in *Interpretazioni veneziane: studi di storia dell'arte in onore di Michelangelo Muraro*, ed. D. Rosand (Venice, 1984), pp. 227–39.

Lewis (1979a): Lewis, Douglas, *The Late Baroque Churches of Venice* (New York, 1979).

Lewis (1979b): Lewis, Douglas, 'Sansovino and Venetian Architecture', *Burlington Magazine*, 121 (1979), pp. 38–41.

Lewis (1983): Lewis, Douglas, 'The Sculptures in the Chapel of the Villa Giustinian at Roncade and their Relation to those in the Giustinian Chapel at San Francesco della Vigna', *Mitteilungen des Kunsthistorischen Institutes in Florenz*, 27 (1983), pp. 307–52.

Lightbown (1986): Lightbown, Ronald, *Mantegna: With a Complete Catalogue of the Paintings, Drawings and Prints* (Berkeley, 1986).

Lind (1975): Lind, J. R., *Studies in Pre-Vasalian Anatomy: Biography, Translations, Documents* (Philadelphia, 1975).

Litta (1819–1902): Litta, Pompeo, *Famiglie celebri italiane* (11 vols.; Milan, 1819–1902).

Logan (1984): Logan, Oliver, 'La committenza artistica pubblica e privata', in *Cultura e società nel rinascimento tra riforme e manierismi*, ed. V. Branca and C. Ossola (Florence, 1984), pp. 271–88.

Lorenzetti (1909): Lorenzetti, Giulio, 'Note su Alessandro Vittoria', *L'Arte*, 12 (1909), pp. 65–8.

Lorenzetti (1927): Lorenzetti, Giulio, *Itinerario Sansovino a Venezia* (Venice, 1927).

Lorenzetti (1938): Lorenzetti, Giulio, 'Una nuova data sicura nella cronologia Tintorettiana', *Ateneo Veneto*, 123/3–4 (1938), pp. 129–39.

Lorenzetti (1963): Lorenzetti, Giulio, *Venezia e il suo estuario* (3d edn.; Trieste, 1963).

Lorenzetti (1949): Lorenzetti, Giulio, Mariacher, Giovanni, and Pignatti, Terisio, *Civico Museo Correr: Catalogo della Quadreria* (Venice, 1949).

Lorenzi (1868): Lorenzi, G. B., *Documenti per servire alla storia del Palazzo Ducale di Venezia* (Venice, 1868).

Lorenzoni (1977): Lorenzoni, Giovanni, 'L'intervento dei Carraresi, la Reggia e il Castello', in *Padova: case e palazzi* (Padua, 1977), pp. 29–49.

Lotz (1966): Lotz, Wolfgang, 'La transformazione Sansoviniana di Piazza S. Marco e l'urbanistica del Cinquecento', *Bollettino del Centro Internazionale di Studi di Architettura Andrea Palladio*, 8/2 (1966), pp. 114–22.

Lowry (1971): Lowry, Martin J. C., 'The Reform of the Council of Ten, 1582–3: An Unsettled Problem?', *Studi veneziani*, 13 (1971), pp. 275–310.

Luchs (1989): Luchs, Alison, 'Tullio Lombardo's Cà d'Oro Relief: A Self-Portrait with the Artist's Wife?', *Art Bulletin*, 71 (1989), pp. 230–6.

Ludwig (1902): Ludwig, Gustav, 'Bonifazio de' Pitati di Verona: Eine archivalische Untersuchung', *Jahrbuch der Königlich Preussischen Kunstsammlungen*, 23 (1902), pp. 36–66.

Ludwig (1911): Ludwig, Gustav, *Archivalische Beiträge zur Geschichte der Venezianische Malerei* (Berlin, 1911).

Macchioni (1979): Macchioni, S., 'Danese Cattaneo', in *Dizionario biografico degli italiani*, 22 (Rome, 1979), pp. 449–56.

Machiavelli (1950): Machiavelli, Niccolo, *The Prince and The Discourses* (Modern Library edn.; New York, 1950).

Magagnato (1966): Magagnato, Licisco, *Il Palazzo Thiene* (Vicenza, 1966).

Magagnato (1968): Magagnato, Licisco, 'I collaboratori veronesi di Andrea Palladio', *Bollettino del Centro Internazionale di Studi di Architettura*, 10 (1968), pp. 170–87.

Magno (1573): Magno, Celio, 'Al Clarissimo M. Giulio Contarini Il Procurator', in Giovanni Maria Verdizotti, *Rime di M. Girolamo Molin* (Venice, 1573).

Magno and Giustiniani (1600): Magno, Celio, and Giustiniani, Orsato, *Rime di Celio Magno et Orsatto Giustiniani* (Venice, 1600).

Mancini (1991): Mancini, Vincenzo, 'I Pellegrini e la loro villa a San Siro', *Bollettino del Museo Civico di Padova*, 80 (1991), pp. 173–96.

Mancini (1995): Mancini, Vincenzo, *Antiquari, 'Vertuosi' e Artisti: Saggi sul collezionismo tra Padova e Venezia alla metà del cinquecento* (Padua, 1995).

Mantegna (1992): *Andrea Mantegna*, exh. cat. (Milan, 1992).

Mantese (1969–70): Mantese, G., *La famiglia Thiene e la riforma protestante a Vicenza nella seconda metà del secolo XVI* (Vicenza, 1969–70).

Marcellino (1563): Marcellino, Valerio, *Il Diamerone, Ove con vive ragioni si mostra, La Morte non esser quel male, che'l senso si persuade* (Venice, 1563).

Mariacher (1962): Mariacher, Giovanni, *Il Sansovino* (Venice, 1962).

Marinelli (1980): Marinelli, Sergio, 'Figure e sfondi: aspetti della pittura veronese alla metà del cinquecento', in Marini (1980), pp. 187–202.

Marini (1980): Marini, Paola (ed.), *Palladio e Verona*, exh. cat. (Verona, 1980).

Martin (1988): Martin, Thomas, 'The Portrait Busts of Alessandro Vittoria', Ph.D. thesis (Columbia University, 1988).

Martin (1991a): Martin, Thomas, 'Due artisti del tardo rinascimento: Veronese e Vittoria', in *Crisi e rinnovamenti nell'autunno del rinascimento a Venezia*, ed. V. Branca and C. Ossola (Florence, 1991), pp. 311–26.

Martin (1991b): Martin, Thomas, 'Grimani Patronage in S. Giuseppe di Castello: Veronese, Vittoria and Smeraldi', *Burlington Magazine*, 133 (Dec. 1991), pp. 825–33.

Martin (1993a): Martin, Thomas, 'Giulio del Moro and Alessandro Vittoria: New Attributions and Suggestions', *Apollo*, 137/376 (June 1993), pp. 367–71.

Martin (1993b): Martin, Thomas, 'Michelangelo's *Brutus* and the Classicizing Portrait Bust in Sixteenth-Century Italy', *Artibus et Historiae*, 27 (1993), pp. 67–83.

Martin (1994): Martin, Thomas, 'Le Premier Buste attesté, sculpté par Alessandro Vittoria (1525–1608), identifié au Louvre', *Revue du Louvre*, 5/6 (1994), pp. 48–54.

Martinelli (1705): Martinelli, Domenico, *Il ritratto overo le cose più notabili di Venezia. Diviso in due parti . . . Ampliato con la relazione delle fabriche pubbliche, e private, & altre cose più notabili successe dall'anno 1682. sino al presente 1704* (Venice, 1705).

Martinelli (1956): Martinelli, Valentino, 'Novità berniniane. Un busto ritrovato: la madre di Urbano VIII. Un crocefisso ritrovato?', *Commentari*, 7 (1956), pp. 21–40.

Marx (1980): Marx, Barbara, 'Venezia—Altera Roma? Ipotesi sull'umanesimo veneziano', *Quellen und Forschungen aus italienischen Archiven und Bibliotheken*, 60 (1980), pp. 325–73.

Matteacci (1613): Matteacci, Giuseppe, *Ragionamenti politici da suo filiolo Pietro raccolti* (Venice, 1613).

Mazzacurati (1980): Mazzacurati, Giancarlo, 'Pietro Bembo', in *Storia della cultura veneta*, 3/2 (Vicenza, 1980), pp. 1–59.

McAndrew (1983): McAndrew, John, *L'Architettura veneziana del primo rinascimento* (2nd edn.; Venice, 1983).

Meller (1963): Meller, Peter, 'Physiognomical Theory in Renaissance Heroic Portraits', in *Studies in Western Art* (Acts of the 20th Congress of the History of Art) 2 (Princeton, 1963), pp. 53–69.

Meller (1977): Meller, Peter, 'Marmi e bronzi di Simone Bianco', *Mitteilungen des Kunsthistorischen Institutes in Florenz*, 21 (1977), pp. 199–209.

Messia (1565): Messia, Pietro, *Della selva di varia lettione di Pietro Messia, parti cinque . . . ampliate et di nuovo riveduta per Francesco Sansovino* (Venice, 1565).

Michiel (1884): Michiel, Marcantonio, *Notizia d'opere di disegno*, ed. G. Frizzoni (Bologna, 1884).

Middeldorf (1976): Middeldorf, Ulrich, *Sculptures from the Samuel H. Kress Collection: European Schools, XIV–XIX Century* (London and New York, 1976).

Middeldorf (1979): Middeldorf, Ulrich, 'Die Zwölf Caesaren von Desiderio da Settignano', *Mitteilungen des Kunsthistorischen Institutes in Florenz*, 23 (1979), pp. 297–312.

Molin (1573): Molin, Girolamo, *Rime di M. Girolamo Molin*, ed. G. M. Verdizotti (Venice, 1573).

Molmenti (1909): Molmenti, Pompeo, 'Un documento inedito su Alessandro Vittoria', *Il Marzocco*, 12 (Nov. 1909), pp. 4–5.

Molmenti and Fulin (1881): Molmenti, Pompeo, and Fulin, Rinaldo, *Guida artistica e storica di Venezia e delle isole circonvicine* (Venice, 1881).

Mommsen (1952): Mommsen, T. E., 'Petrarch and the Decoration of the Sala Virorum Illustrium in Padua', *Art Bulletin*, 34 (1952), pp. 95–116.

Montagu (1985): Montagu, Jennifer, *Alessandro Algardi* (2 vols.; New Haven and London, 1985).

Montagu (1989): Montagu, Jennifer, *Roman Baroque Sculpture: The Industry of Art* (New Haven and London, 1989).

Morosini (1718): Morosini, Andrea, *Historiarum Venetorum* (Venice, 1718).

Morozzo della Rocca and Tiepolo (1958) Morozzo della Rocca, R., and Tiepolo, M. F., 'Cronologia veneziana del '500', in *La civiltà veneziana del rinascimento* (Florence, 1958), pp. 199–249.

Moschetti (1929): Moschetti, Andrea, *La reale galleria Giorgio Franchetti alla Cà d'Oro* (Venice, 1929).

Moschetti (1938): Moschetti, Andrea, *Il museo civico di Padova* (2 vols.; Padua, 1938).

Moschini (1815): Moschini, Gianantonio, *Guida per la città di Venezia all'amico delle belle arti* (2 vols.; Venice, 1815).

Moschini (1842): Moschini, Gianantonio, *La chiesa e il seminario di S. M. della Salute in Venezia* (Venice, 1842).

Moschini (1934): Moschini, Vittorio, 'Aspetti del gusto artistico del Vittoria', *Rivista di Venezia*, 13 (1934), pp. 125–40.

Moschini (1940): Moschini, Vittorio, *Le raccolte del Seminario di Venezia* (Rome, 1940).

Moschini-Marconi (1962): Moschini-Marconi, Sandra, *Gallerie dell'Accademia di Venezia: opere d'arte del secolo XVI* (Rome, 1962).

Moureyre-Gavoty (1975): Moureyre-Gavoty, Françoise de la, *Institut de France, Paris—Musée Jacquemart-André: sculpture italienne* (Inventaire des collections publiques françaises, 19) (Paris, 1975).

Muir (1981): Muir, Edward, *Civic Ritual in Renaissance Venice* (Princeton, 1981).

Munman (1971): Munman, Robert, 'The Monument to Vittor Cappello of Antonio Rizzo', *Burlington Magazine*, 113 (1971), pp. 138–43.

Muraro (1968): Muraro, Michelangelo, 'Donatello e Squarcione', in *Donatello e il suo tempo: atti dell'VIII Convegno Internazionale di studi sul rinascimento* (Florence, 1968), pp. 387–97.

Nardi (1963): Nardi, Bruno, 'La scuola di Rialto e l'umanesimo veneziano', in *Umanesimo europeo e l'umanesimo veneziano* (Venice, 1963), pp. 93–139.

National Gallery (1973): *The National Gallery: Illustrated General Catalogue* (London, 1973).

Natur und Antike (1985): *Natur und Antike in der Renaissance*, exh. cat. (Frankfurt-on-Main, 1985).

Nicoletti (1887): Nicoletti, A. G., *Catalogo delle RR. Gallerie di Venezia* (Venice, 1887).

Niero (1978): Niero, Antonio, *Chiesa di Santo Stefano in Venezia* (Padua, 1978).

Niero (1988): Niero, Antonio, 'Precisazione e attribuzione per Giusto le Court', *Arte veneta*, 42 (1988), pp. 137–40.

Norris (1979): Norris, A. S., 'Giovanni da Cavino', in *Dizionario biografico degli italiani*, 23 (Rome, 1979), pp. 109–12.

Norwich (1982): Norwich, John Julius, *A History of Venice* (New York, 1982).

Oberziner (1911): Oberziner, Ludovico, 'Intorno a una sorella di Alessandro Vittoria', *Archivio trentino*, 26 (1911), pp. 65–71.

Olivato (1980): Olivato, Loredana, 'Il mito di Roma come rivendicazione di un primato. La patavinitas di Alvise Cornaro collezionista e promotore delle arti figurative', in *Alvise Cornaro e il suo tempo*, exh. cat. (Padua, 1980), pp. 106–14.

Olsen (1980): Olsen, Harald, *Aeldre udenlandsk skulptur*, i. *Tekst* (Copenhagen, 1980).

Ongania (1881–93): Ongania, Ferdinando, *La basilica di S. Marco a Venezia* (16 vols.; Venice, 1881–93).

Ongaro (1981): Ongaro, Giuseppe, 'La medicina nello studio di Padova e nel Veneto', in *Storia della cultura veneta*, 3/3 (Vicenza, 1981), pp. 75–134.

Pagan (1973–4): Pagan, Pietro, 'Sulla Accademia "Venetiana" o della "Fama"', *Atti dell'Istituto Veneto di Scienze, Lettere ed Arti*, 132 (1973–4), pp. 359–92.

Palladio (1570): Palladio, Andrea, *I quattro libri dell'architettura* (Venice, 1570).

Palladio (1975): *Andrea Palladio, 1508–1580: The Portico and the Farmyard*, exh. cat. (London, 1975).

Palladio e Verona see Marini (1980).

Palluchini and Rossi (1982): Palluchini, Rodolfo, and Rossi, Paola, *Tintoretto* (2 vols.; Venice, 1982).

Panofsky (1964): Panofsky, Erwin, *Tomb Sculpture* (New York, 1964).

Parabosco (1558): Parabosco, Girolamo, *I Diporti* (Venice, 1558).

Paravia (1833): Paravia, Pier Alessandro, *Della cappella Grimani in S. Francesco della Vigna e della nuova tavola di altare che vi fu collocata* (Venice, 1833).

Parker (1935): Parker, K. T., '? Lorenzo Tiepolo', *Old Master Drawings*, 9 (Mar. 1935), pp. 61–3.

Parker (1956): Parker, K. T., *Catalogue of the Collection of Drawings in the Ashmolean Museum*, ii. *Italian Schools* (Oxford, 1956).

Pavanello (1914): Pavanello, Giuseppe, *La scuola di S. Fantin ora Ateneo Veneto* (Venice, 1914).

Pavanello (1921): Pavanello, Giuseppe, *La chiesa di S. Maria Formosa nella VI sua ricostruzione (659–1921)* (Venice, 1921).

Pellegrini (1952): Pellegrini, Francesco (ed.), *Vita di Gerolamo Fracastoro con la versione di alcuni suoi canti* (Verona, 1952).

Perry (1972): Perry, Marilyn, 'The Statuario Pubblico of the Venetian Republic', *Saggi e memorie di storia dell'arte*, 8 (1972), pp. 75–150.

Perry (1975): Perry, Marilyn, 'A Greek Bronze in Renaissance Venice', *Burlington Magazine*, 117 (1975), pp. 204–11.

Perry (1978): Perry, Marilyn, 'Cardinal Domenico Grimani's Legacy of Ancient Art to Venice', *Journal of the Warburg and Courtauld Institutes*, 41 (1978), pp. 215–44.

Perry (1981): Perry, Marilyn, 'A Renaissance Showplace of Art: The Palazzo Grimani at S. Maria Formosa', *Apollo*, 113 (1981), pp. 215–21.

Phillips (1957): Phillips, J. G., 'Recent Acquisitions of European Sculpture', *Metropolitan Museum of Art Bulletin*, 15 (Feb. 1957), pp. 150–4.

Phillips (1965): Phillips, J. G., 'Western European Arts', *Metropolitan Museum of Art Bulletin*, (Oct. 1965), pp. 76–9.

Pignatti (1966): Pignatti, Terisio, *Le pitture di Paolo Veronese nella chiesa di San Sebastiano in Venezia* (Milan, 1966).

Pignatti (1976): Pignatti, Terisio, *Veronese: l'opera completa* (2 vols.; Venice, 1976).

Piovan (1988): Piovan, F., *Per la biografia di Lazzaro Bonamico: Ricerche sul periodo dell'insegnamento padovano (1530–1552)* (Padua, 1988).

Pittoni (1909): Pittoni, Laura, *Jacopo Sansovino, scultore* (Venice, 1909).

Pizzo (1989): Pizzo, Marco, 'Alessandro Vittoria e la collezione Grimani', *Bollettino del Museo Civico di Padova*, 78 (1989), pp. 103–16.

Planiscig (1919): Planiscig, Leo, *Die Estensische Kunstsammlung* (Vienna, 1919).

Planiscig (1921): Planiscig, Leo, *Der Venezianische Bildhauer der Renaissance* (Vienna, 1921).

Planiscig (1924): Planiscig, Leo, 'Simon Bianco', *Belvedere*, 5 (1924), pp. 157–63.

Planiscig (1935a): Planiscig, Leo, 'Domenico da Salò', in *Allgemeines Lexikon der Bildenden Künstler*, ed. U. Thieme and F. Becker, xxix (Leipzig, 1935), p. 353.

Planiscig (1935b): Planiscig, Leo, 'Pietro da Salò', in *Allgemeines Lexikon der Bildenden Künstler*, ed. U. Thieme and F. Becker, xxix (Leipzig, 1935), pp. 353–4.

Pollak and Muñoz (1911): Pollak, Ludwig, and Muñoz, Antonio, *La collection Stroganoff* (2 vols., Rome, 1911).

Pope-Hennessy (1964): Pope-Hennessy, John, *Catalogue of Italian Sculpture in the Victoria and Albert Museum* (2 vols.; London, 1964).

Pope-Hennessy (1966): Pope-Hennessy, John, *The Portrait in the Renaissance* (Princeton, 1966).

Pope-Hennessy (1970a): Pope-Hennessy, John, *Italian High Renaissance and Baroque Sculpture* (2nd edn.; London and New York, 1970).

Pope-Hennessy (1970b): Pope-Hennessy, John, *Sculpture in the Frick Collection: Italian* (New York, 1970).

Pope-Hennessy (1971): Pope-Hennessy, John, *Italian Renaissance Sculpture* (2nd edn.; London and New York, 1971).

Pope-Hennessy (1980): Pope-Hennessy, John, 'The Relations between Florentine and Venetian Sculpture in the Sixteenth Century', in *Florence and Venice: Comparisons and Relations*, ii (Florence, 1980), pp. 323–35.

Pope-Hennessy (1985): Pope-Hennessy, John, *Cellini* (New York, 1985).

Portenari (1623): Portenari, A., *Della Felicità di Padova* (Padua, 1623).

Predelli (1908): Predelli, Riccardo, 'Le memorie e le carte di Alessandro Vittoria', *Archivio trentino*, 23 (1908), pp. 1–265.

Prodi (1973): Prodi, Paolo, 'The Structure of the Church in Renaissance Venice: Suggestions for Research', in *Renaissance Venice*, ed. J. R. Hale (London, 1973), pp. 409–30.

Pullan (1973): Pullan, Brian, 'The Occupations and Investments of the Venetian Nobility in the Middle and Late Sixteenth Century', in *Renaissance Venice*, ed. J. R. Hale (London, 1973), pp. 379–408.

Puppi (1971): Puppi, Lionello, *Michele Sanmicheli, architetto di Verona* (Padua, 1971).

Puppi (1973): Puppi, Lionello, *Andrea Palladio* (2 vols.; Milan, 1973).

Puppi (1974): Puppi, Lionello, 'Domenico Campagnola', in *Dizionario biografico degli italiani*, 17 (Rome, 1974), pp. 312–17.

Puppi (1976): Puppi, Lionello, 'Committenza e ideologia urbana nella pittura padovana del '500: l'anno quaranta e l'ipotesi di un "scuola"', in *Dopo Mantegna: Arte a Padova e nel territorio nei secoli XV e XVI*, exh. cat. (Milan, 1976), pp. 69–72.

Puppi (1977): Puppi, Lionello, 'Il rinnovamento tipologica del cinquecento', in *Padova: case e palazzi*, ed. L. Puppi and F. Zuliani (Padua, 1977), pp. 101–40.

Puppi (1978): Puppi, Lionello, 'Il "Colosso" del Mantova', in *Essays Presented to Myron P. Gilmore*, ed. S. Bertelli and G. Ramakus, ii (Florence, 1978), pp. 311–29.

Puppi (1980): Puppi, Lionello, 'Per Paolo Veronese architetto: un documento inedito, una firma e uno strano silenzio di Palladio', *Palladio*, 3 (1980), pp. 53–76.

Puppi (1982): Puppi, Lionello, 'Il tempio e gli eroi', in *La grande vetrata di SS Giovanni e Paolo* (Venice, 1982), pp. 21–35.

Puppi (1986): Puppi, Lionello, *Michele Sanmicheli architetto: opera completa* (Rome, 1986; 2nd edn. of Puppi (1971)).

Puppi (1987): Puppi, Lionello, 'I costumi per la recita inaugurale del Teatro Olimpico a Vicenza', *Storia dell'arte*, 61 (1987), pp. 189–200.

Puppi (1988): Puppi, Lionello, 'Paolo Veronese e l'architettura', in *Paolo Veronese: disegni e dipinti*, exh. cat. (Vicenza, 1988), pp. 31–6.

Puppi and Puppi Olivato (1974): Puppi, Lionello, and Puppi Olivato, Loredana, 'Scamozziana: progetti per la "via romana" di Monselice e alcune altre novità grafiche con qualche quesito', *Antichità viva*, 13/4 (July–Aug. 1974), pp. 54–80.

Queller (1986): Queller, Donald E., *The Venetian Patriciate: Reality versus Myth* (Urbana, Ill., and Chicago, 1986).

Radcliffe (1992): Radcliffe, Anthony, Baker, M., and Maek-Gerard, M., *The Thyssen-Bornemisza Collection: Renaissance and Later Sculpture with Works of Art in Bronze* (London, 1992).

Raggio (1988): Raggio, Olga, in *The Metropolitan Museum of Art: Recent Acquisitions: A Selection 1987–1988* (New York, 1988).

Ravà (1920): Ravà, Aldo, 'Il "Camerino delle antigaglie" di Gabriele Vendramin', *Nuovo archivio veneto*, 39 (1920), pp. 155–81.

Rave (1959): Rave, P. O., 'Paolo Giovio und die Bildnisvitenbücher des Humanismus', *Jahrbuch der Berliner Museen*, NS 1 (1959), pp. 119–54.

Rearick (1958–9): Rearick, W. R., 'Battista Franco and the Grimani Chapel', *Saggi e memorie di storia dell'arte*, 2 (1958–9), pp. 105–38.

Rearick (1988): Rearick, W. R., *The Art of Paolo Veronese, 1528–1588*, exh. cat. (New York, 1988).

Richardson (1980): Richardson, Francis, *Andrea Schiavone* (Oxford, 1980).

Ridolfi (1914–24): Ridolfi, Carlo, *Le maraviglie dell'arte* (1648), ed. D. von Hadeln (2 vols.; Berlin, 1914–24).

Rigoni (1970): Rigoni, Erice, *L'Arte rinascimentale in Padova: studi e documenti* (Padua, 1970).

Rinaldi (1976–7): Rinaldi, Stefania Mason, 'Il libro dei conti della famiglia Tiepolo per la cappella di S. Sabba in S. Antonin', *Atti dell'Istituto Veneto di Scienze, Lettere, ed Arti*, 135 (1976–7), pp. 193–212.

Rinaldi (1984): Rinaldi, Stefania Mason, *Palma il giovane: l'opera completa* (2 vols.; Milan, 1984).

Rinehart (1967): Rinehart, Sheila, 'A Bernini Bust at Castle Howard', *Burlington Magazine*, 109 (1967), pp. 437–43.

Roeck (1992): Roeck, Bernd, 'Zu Kunstaufträgen des Dogen Agostino Barbarigo in Venedig und die "Pala Barbarigo" Giovanni Bellinis', *Zeitschrift für Kunstgeschichte*, 1 (1992), pp. 1–34.

Romano (1986): Romano, Serena, 'La facciata di Palazzo Trevisan a Murano', in *Urbs Picta: la città affrescata nel veneto* (Treviso, 1986), pp. 95–101.

Rosand (1982): Rosand, David, *Painting in Cinquecento Venice: Titian, Veronese, Tintoretto* (New Haven and London, 1982).

Rose (1969): Rose, Paul L., 'The Accademia Venetiana: Science and Culture in Renaissance Venice', *Studi veneziani*, 11 (1969), pp. 191–242.

Rossetti (1765): Rossetti, Giovambattista, *Descrizione delle pitture, sculture, ed architettura di Padova* (Padua, 1765).

Rossi (1995): Rossi, Massimiliano, *La poesia scolpita: Danese Cataneo nella Venezia del cinquecento* (Lucca, 1995).

Saccomani (1985): Saccomani, Elisabetta, 'Note sulla pittura padovana intorno al 1540', in *Marco Mantova Benavides: il suo museo e la cultura padovana del cinquecento*, ed. I. Favaretto (Padua, 1985), pp. 241–52.

Salomonio (1701): Salomonio, Jacopus, *Urbis Patavini Inscriptiones sacrae, et prophanae* (Padua, 1701).

Sanmicheli (1960): Michele Sanmicheli, 1484–1559: studi raccolti dall' Accademia di Agricoltura, Scienze e Lettere (Verona, 1960).

Sansovino (1560): Sansovino, Francesco, *Dialogo di tutte le cose notabili che sono in Venetia* (Venice, 1560).

Sansovino (1561): Sansovino, Francesco, *Delle cose notabili che sono in Venetia* (Venice, 1561).

Sansovino (1562): Sansovino, Francesco, *Cose notabili di Venezia* (Venice, 1562).

Sansovino (1565): Sansovino, Francesco, *Della selva di varia lettione di Pietro Messia, parti cinque . . . ampliate et di nuovo riveduta per Francesco Sansovino* (Venice, 1565).

Sansovino (1581): Sansovino, Francesco, *Venetia, città nobilissima et singolare* (Venice, 1581).

Sansovino (1583): Sansovino, Francesco, *Delle cose notabili che sono in Venetia* (Venice, 1583).

Sansovino (1587a): Sansovino, Francesco, *Delle cose notabili della Città di Venetia Libri II* (Venice, 1587).

Sansovino (1587b): Sansovino, Francesco, *Tutte le cose notabili di Venezia* (Venice, 1587).

Sansovino (1604): Sansovino, Francesco, *Venetia, città nobilissima et singolare*, ed. G. Stringa (Venice, 1604).

Sansovino (1664): Sansovino, Francesco, *Venetia, città nobilissima et singolare*, ed. G. Martinioni (Venice, 1664).

Santa Maria (1778): Santa Maria, Angiolgabriello di, *Biblioteca e Storia di quegli scrittori così della città come del territorio di Vicenza* (4 vols.; Vicenza, 1778).

Santangelo (1954): Santangelo, Antonio, *Museo di Palazzo Venezia: catalogo delle sculture* (Rome, 1954).

Sanudo (1879–1903): Sanudo, Marin, *I diarii*, ed. R. Fulin (58 vols.; Venice, 1879–1903).

Sartori (1976): Sartori, Antonio, *Documenti per la storia dell'arte a Padova* (Vicenza, 1976).

Sartori (1983): Sartori, Antonio, *Archivio Sartori, documenti di storia e arte francescana*, ed. G. Luisetto, i. *Basilica e convento del Santo* (Padua, 1983).

Scamozzi (1619): Scamozzi, Giovanni Domenico, *Tutte l'opere d'architettura et prospettive di Sebastiano Serlio* (Venice, 1619).

Scardeone (1560): Scardeone, Bernardino, *De Antiquitate Urbis Patavii et Claris Patavinis* (Basle, 1560).

Schlegel (1979): Schlegel, Ursula, 'Simone Bianco und die venezianische Malerei', *Mitteilungen des Kunsthistorischen Institutes in Florenz*, 23 (1979), pp. 187–96.

Schlegel (1990): Schlegel, Ursula, 'Eine unbekannte Büste von Simone Bianco', *Antologia di belle arti*, NS 35–8 (1990), pp. 148–52.

Schottmüller (1913): Schottmüller, Frida, Königliche Museen zu Berlin, *Beschreibung der Bildwerke der Christlichen Epochen*, Zweite Auflage, Fünfter Band: *Die italienischen und spanischen Bildwerke der Renaissance und des Barocks in Marmor, Ton, Holz und Stucke* (Berlin, 1913).

Schottmüller (1933): 2nd edition of above.

Schrade (1960): Schrade, Leo, *La Représentation d'Edipo Tiranno au Teatro Olimpico* (Paris, 1960).

Schulz (1981): Schulz, Anne Markham, 'Pietro Lombardo's Barbarigo Tomb in the Venetian Church of S. Maria della Carità', in *Art the Ape of Nature: Studies in Honor of H. W. Janson* (New York, 1981), pp. 171–92.

Schulz (1983): Schulz, Anne Markham, *Antonio Rizzo: Sculptor and Architect* (Princeton, 1983).

Schulz (1984): Schulz, Anne Markham, 'Bartolomeo di Francesco Bergamasco', in *Interpretazioni veneziane: studi di storia dell'arte in onore di Michelangelo Muraro* , ed. D. Rosand (Venice, 1984), pp. 257–74.

Schulz (1985): Schulz, Anne Markham, 'Paolo Stella Milanese', *Mitteilungen des Kunsthistorischen Institutes in Florenz*, 29 (1985), pp. 75–110.

Schütz-Rautenberg (1978): Schütz-Rautenberg, Gesa, *Künstlergrabmäler des 15. und 16. Jahrhunderts in Italien* (Cologne and Vienna, 1978).

Schwarz (1965): Schwarz, Heinrich, 'Palma Giovane and his Family: Observations on some Portrait Drawings', *Master Drawings*, 3 (1965), pp. 161–4.

Schwarz (1971): Schwarz, Heinrich, 'Portrait Drawings of Palma Giovane and his Family: A Postscript', in *Studi di storia dell'arte in onore di Antonio Morassi* (Venice, 1971), pp. 210–15.

Schwarzenberg (1970): Schwarzenberg, Erkinger, Review of Bianca Candida, *I calchi rinascimentali della collezione Mantova Benavides nel museo del Liviano a Padova*, *Gnomon*, 42 (1970), pp. 610–13.

Schweikhart (1968): Schweikhart, Gunther, 'Studien zum Werk des Giovanni Maria Falconetto', *Bollettino del Museo Civico di Padova*, 57 (1968), pp. 17–67.

Schweikhart (1980): Schweikhart, Gunther, 'La cultura archeologica di Alvise Cornaro', in *Alvise Cornaro e il suo tempo*, exh. cat. (Padua, 1980), pp. 64–71.

Schweikhart (1991): Schweikhart, Gunther, 'Ein unbekannter Entwurf für das Grabmal des Alessandro Contarini in S. Antonio in Padua', *Wallraf-Richartz-Jahrbuch*, 52 (1991), pp. 317–19.

Sculpture (1994): *Sculpture: An Illustrated Catalogue. National Gallery of Art* (Washington, DC, 1994).

Selvatico (1847): Selvatico, Pietro, *Sulla architettura e scultura in Venezia dal medio evo ai nostri giorni* (Venice, 1847).

Semenzato (1962): Semenzato, Camillo, 'Il gusto di Alessandro Vittoria', *Critica d'arte*, 50 (1962), pp. 28–35.

Semenzato (1967): Semenzato, Camillo, 'Il Vittoria', *Rinascimento europeo e rinascimento veneziano* (Venice, 1967), pp. 275–80.

Serlio (1537): Serlio, Sebastiano, *Regole generali di architettura sopra le cinque maniere de gli edifici* (Venice, 1537).

Serra (1923): Serra, Luigi, *Alessandro Vittoria* (Rome, 1923).

Simane (1993): Simane, Jan, *Grabmonumente der Dogen: Venezianische Sepulkralkunst im Cinquecento* (Centro tedesco di Studi veneziani), 11 (Sigmaringen, 1993).

Sinding-Larsen (1962): Sinding-Larsen, Staale, 'Titian's Madonna di Cà Pesaro and its Historical Significance', *Acta ad archaeologiam et artium historiam pertinentia* (Institutum Romanum Norvegiae), 1 (1962), pp. 139–69.

Sinding-Larsen (1974): Sinding-Larsen, Staale, *Christ in the Council Hall: Studies in the Religious Iconography of the Venetian Republic* (Institutum Romanum Norvegiae), 5 (Rome, 1974).

Soravia (1822): Soravia, Giambattista, *Le chiese di Venezia descritte ed illustrate* (Venice, 1822).

Sponza (1982): Sponza, Sandro, 'Appunti su Alessandro Vittoria', *Studi trentini*, 61 (1982), pp. 185–202.

Sponza (1984): Sponza, Sandro, 'Per la chiesa di S. Giuseppe di Castello: scoperte, conferme, puntualizzazioni', *Provincia di Venezia*, 3 (1984), pp. 22–31.

Stella (1967): Stella, A., *Dall'anabattismo al socianesimo nel cinquecento veneto* (Padua, 1967).

Taddeo (1974): Taddeo, Eduardo, *Il manierismo letterario e i lirici veneziani del tardo cinquecento* (Rome, 1974).

Tafuri (1969): Tafuri, Manfredo, *Jacopo Sansovino e l'architettura del '500 a Venezia* (Padua, 1969).

Tafuri (1984): Tafuri, Manfredo, 'Renovatio urbis Venetiarum: il problema storiografico', in *Renovatio Urbis: Venezia nell'età di Andrea Gritti (1523–1538)*, ed. M. Tafuri (Rome, 1984), pp. 9–55.

Tafuri (1989): Tafuri, Manfredo, *Venice and the Renaissance* (Cambridge and London, 1989; trans. of Italian edn., Turin, 1985).

Tassini (1879):Tassini, Giuseppe,'Iscrizioni dell'ex chiesa e monastero del S. Sepolcro in Venezia', *Archivio veneto*, 17 (1879), p. 283.

Tassini (1887):Tassini, Giuseppe, *Curiosità veneziane ovvero origini delle denominazioni stradali di Venezia*, ed. L. Moretti (Venice, 1887; repr. Venice, 1970).

Temanza (1778):Temanza,Tommaso, *Vite dei più celebri architetti e scultori veneziani* (Venice, 1778).

Temanza (1827):Temanza,Tommaso, *Vita di Alessandro Vittoria*, ed. G. Moschini (Venice, 1827).

Thomson (1993):Thomson, David, *Renaissance Architecture: Critics, Patrons, Luxury* (Manchester and New York, 1993).

Timofiewitsch (1968):Timofiewitsch,Wladimir, *Die Sakrale Architektur Palladios* (Munich, 1968).

Timofiewitsch (1972):Timofiewitsch,Wladimir, *Girolamo Campagna: Studien zur Venezianischen Plastik um das Jahr 1600* (Munich, 1972).

Tiziano (1990): *Tiziano*, exh. cat. (Venice, 1990).

Tramontin (1965):Tramontin, Silvio, *Il culto dei santi a Venezia* (Venice, 1965).

Traversari (1968):Traversari, Gustavo, *Museo Archeologico di Venezia: i ritratti* (Rome, 1968).

Tucci (1973):Tucci, Ugo,'The Psychology of the Venetian Merchant in the Sixteenth Century', in *Renaissance Venice*, ed. J. Hale (London, 1973), pp. 346–78.

Ullman (1955): Ullman, B. L., *Studies in the Italian Renaissance* (Rome, 1955).

Urbani de Gheltof (1877): Urbani de Gheltof, G. M.,'Del busto di un sommo guerriero eseguito in plastica da Alessandro Vittoria', *Bullettino di arti, industrie e curiosità veneziane*, 1 (1877), pp. 5–7.

Urbani de Gheltof (1890): Urbani de Gheltof, G. M., *Il Palazzo di Camillo Trevisan a Murano* (Venice, 1890).

Valentinelli (1872): Valentinelli, Giuseppe, *Museo archeologico della Reale Biblioteca Marciana di Venezia* (Venice, 1872).

Varro (1934): Varro, M. T., *On Agriculture*, trans. W. D. Hooper (Cambridge, Mass., and New York, Loeb Classical Library, 1934).

Vasari (1878–85): Vasari, Giorgio, *Le vite de' più eccellenti pittori, scultori ed architetti*, ed. G. Milanesi (9 vols.; Milan, 1878–85).

Vasari (1981): *Giorgio Vasari: principi, letterati e artisti nelle carte di Giorgio Vasari*, exh. cat. (Florence, 1981).

Vasoli (1981): Vasoli, Cesare,'Le accademie fra cinquecento e seicento e il loro ruolo nella storia della tradizione enciclopedica', in *Università, accademie e società scientifiche in Italia e in Germania dal cinquecento al settecento*, ed. L. Boehm and E. Raimondi (Bologna, 1981), pp. 81–106.

Venezia e dintorni (1969): *Venezia e dintorni: guida d'Italia del Touring Club Italiano* (2nd edn.; Milan, 1969).

Ventura (1964): Ventura, Angelo, *Nobiltà e popolo nella società veneta del '400 e '500* (Bari, 1964).

Ventura (1968): Ventura, Angelo,'Considerazioni sull'agricoltura veneta, sulla accumulazione originaria del capitale nei secoli XVI e XVII', *Studi storici*, 9 (1968), pp. 674–722.

Venturi (1896): Venturi, Adolfo,'Museo del Palazzo Ducale in Venezia', *Le gallerie nazionali italiane*, 2 (1896), pp. 47–74.

Venturi (1937): Venturi, Adolfo,'Alessandro Vittoria', in *Storia dell'arte italiana*, 10/3 (Milan, 1937), pp. 65–179.

Verdizotti (1573):Verdizotti,Giovanni Maria,'Vita del clarissimo M. Girolamo Molin', in *Rime di Girolamo Molin* (Venice, 1573).

Vico (1558):Vico, Enea, *Discorsi di M. Enea Vico Parmigiano sopra le medaglie de gli antichi divisi in due libri* (Venice, 1558).

Vitry (1933):Vitry, Paul, *Catalogue des sculptures du moyen age, de la renaissance, et des temps modernes* (Paris, 1933).

Weddigen (1974): Weddigen, Erasmus, 'Thomas Philologus Ravennas: Gelehrter, Wohltäter und Mäzen', *Saggi e memorie di storia dell'arte*, 9 (1974), pp. 7–76.

Weiss (1969): Weiss, Roberto, *The Renaissance Discovery of Classical Antiquity* (Oxford, 1969).

Weski and Frosien-Leinz (1987): Weski, E., and Frosien-Leinz, H., *Das Antiquarium der Münchner Residenz: Katalog der Skulpturen* (2 vols.; Munich, 1987).

Wethey (1971): Wethey, W. E., *The Paintings of Titian*, ii. *The Portraits* (London, 1971).

Wittkower (1951): Wittkower, Rudolf, *Bernini's Bust of Louis XIV* (London and New York, 1951).

Wittkower (1959): Wittkower, Rudolf, 'Melchiorre Caffà's Bust of Alexander VII', *Metropolitan Museum of Art Bulletin*, 17 (1959), pp. 197–204.

Wittkower (1977): Wittkower, Rudolf, *Sculpture: Processes and Principles* (New York, 1977).

Wittkower (1981): Wittkower, Rudolf, *Gian Lorenzo Bernini, Sculptor of the Roman Baroque* (3d edn.; London, 1981).

Wolters (1968a): Wolters, Wolfgang, *Plastische Deckendekorationen des Cinquecento in Venedig und im Veneto* (Berlin, 1968).

Wolters (1968b): Wolters, Wolfgang, 'La decorazione plastica delle volte e dei soffiti a Venezia e nel Veneto nel secolo XVI', *Bollettino del Centro Internazionale degli Studi dell'Architettura Andrea Palladio*, 10 (1968), pp. 268–78.

Wolters (1980): Wolters, Wolfgang, 'La decorazione interna della Loggia e dell'Odeo Cornaro', in *Alvise Cornaro e il suo tempo*, exh. cat. (Padua, 1980), pp. 72–9.

Wolters (1987): Wolters, Wolfgang, *Storia e politica nei dipinti di Palazzo Ducale: aspetti dell'autocelebrazione della Repubblica di Venezia nel cinquecento* (Venice, 1987; trans. of German edn., 1983).

Wolters and Huse (1990): Wolters, Wolfgang, and Huse, Norbert, *The Art of Renaissance Venice* (Chicago and London, 1990; trans. of German edn., 1986).

Woolf (1968): Woolf, S. J., 'Venice and the Terraferma: Problems of the Change from Commercial to Landed Activities', in *Crisis and Change in the Venetian Economy of the 16th and 17th Centuries*, ed. B. Pullan (London, 1968), pp. 172–203.

Zampetti (1973): Zampetti, Pietro, *Guida alle opere d'arte della scuola di S. Fantin* (Venice, 1973).

Zandomeneghi (1830): Zandomeneghi, Luigi, *Messagiero Tirolese con privilegio* (17 Dec. 1830) pp. 5–6.

Zanotto (1856): Zanotto, Francesco, *Nuovissima guida di Venezia e delle isole* (Venice, 1856).

Zava Bocazzi (1965): Zava Bocazzi, Franca, *La basilica dei SS Giovanni e Paolo in Venezia* (Venice, 1965).

Zimmerman (1976): Zimmerman, T. C. Price, 'Paolo Giovio and the Evolution of Renaissance Art Criticism', in *Cultural Aspects of the Italian Renaissance: Essays in Honour of Paul Oskar Kristeller*, ed. C. Clough (New York, 1976), pp. 406–24.

Zippel (1926): Zippel, Vittorio, 'Un busto ignoto del Vittoria', *L'Arte*, 29 (1926), pp. 73–4.

Zorzi (1972): Zorzi, Alvise, *Venezia scomparsa* (2 vols.; Milan, 1972).

Zorzi (1962a): Zorzi, Elda, 'Un antiquario padovano del secolo XVI: Alessandro Maggi da Bassano', *Bollettino dei musei civici di Padova*, 51 (1962), pp. 41–98.

Zorzi (1951): Zorzi, Giangiorgio, 'Alessandro Vittoria a Vicenza e lo scultore Lorenzo Rubini', *Arte veneta*, 5 (1951), pp. 141–57.

Zorzi (1962b): Zorzi, Giangiorgio, 'Le statue di Agostino Rubini nel teatro Olimpico di Vicenza', *Arte veneta*, 16 (1962), pp. 111–20.

Zorzi (1965a): Zorzi, Giangiorgio, *Le opere pubbliche e i palazzi privati di Andrea Palladio* (Venice, 1965).

Zorzi (1965b): Zorzi, Giangiorgio, 'Un nuovo soggiorno di Alessandro Vittoria nel Vicentino', *Arte veneta*, 19 (1965), pp. 83–94.

Zorzi (1966): Zorzi, Giangiorgio, 'Un nuovo soggiorno di Alessandro Vittoria nel Vicentino', *Arte veneta*, 20 (1966), pp. 157–76.

Zorzi (1969): Zorzi, Giangiorgio, *Le ville e i teatri di Andrea Palladio* (Vicenza, 1969).

Zorzi (1962c): Zorzi, Giangiorgio, Marzari, V., and Barbieri, Franco, *Il museo civico di Vicenza: dipinti e sculture dal XVI al XVIII secolo* (2 vols.; Venice, 1962).

Zorzi (1987): Zorzi, Marino, *La Libreria di San Marco* (Milan, 1987).

Zorzi (1988): Zorzi, Marino (ed.), *Collezioni di antichità a Venezia nei secoli della repubblica* (Rome, 1988).

Zuraw (1993): Zuraw, Shelley, 'The Medici Portraits of Mino da Fiesole', in *Piero de' Medici 'il Gottoso' (1416–1469) Kunst im Dienste der Mediceer*, ed. A. Beyer and B. Boucher (Berlin, 1993), pp. 317–39.

INDEX

PLATES

PLATES

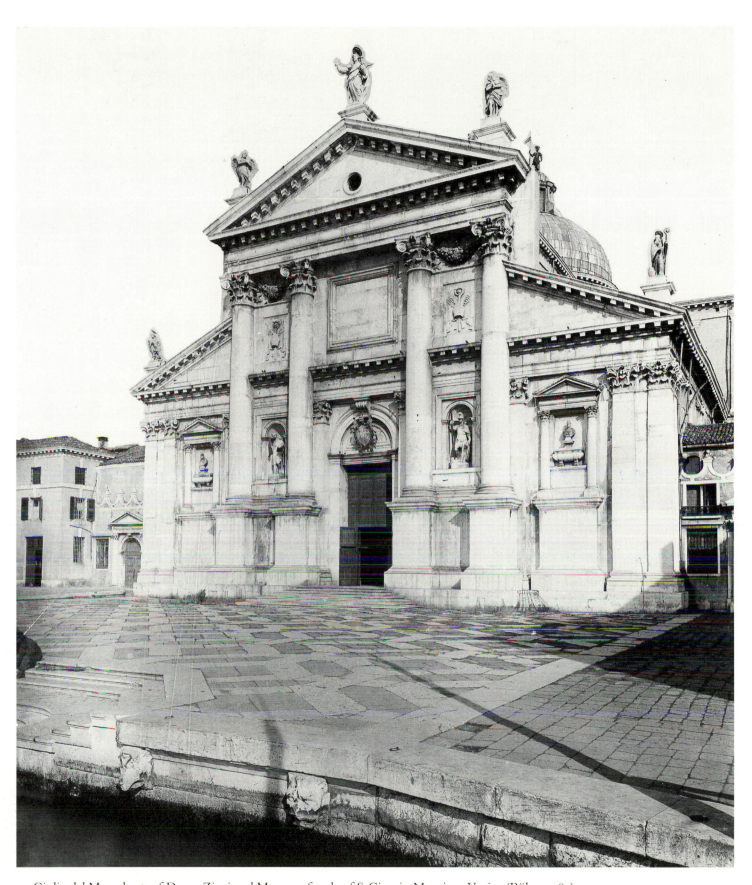

1. Giulio del Moro, busts of Doges Ziani and Memmo, façade of S. Giorgio Maggiore, Venice (Böhm 3580)

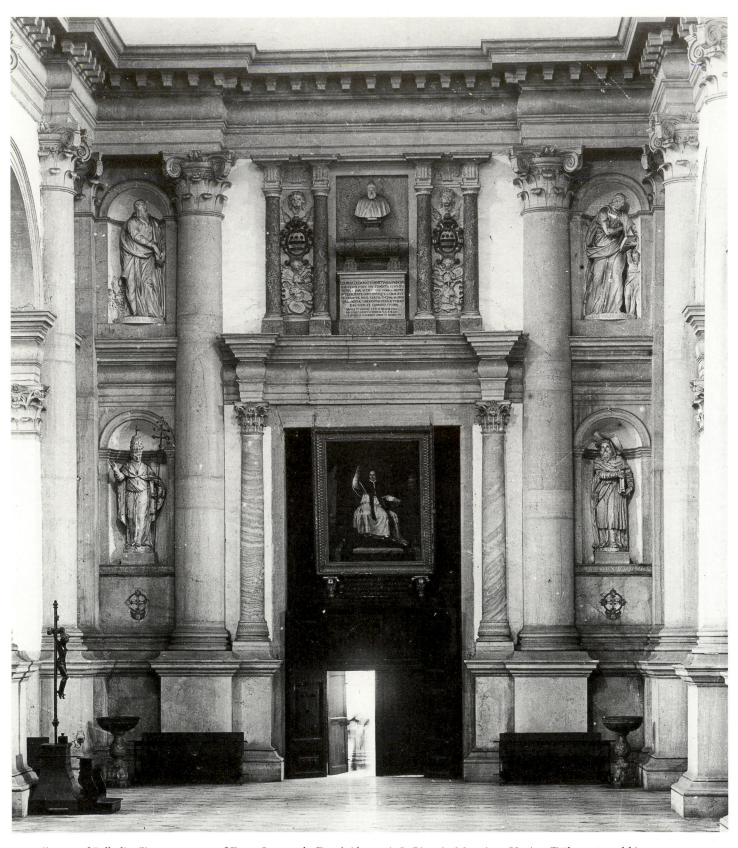

2. Follower of Palladio (?), monument of Doge Leonardo Donà (d. 1612), S. Giorgio Maggiore, Venice (Böhm 3671, dtl.)

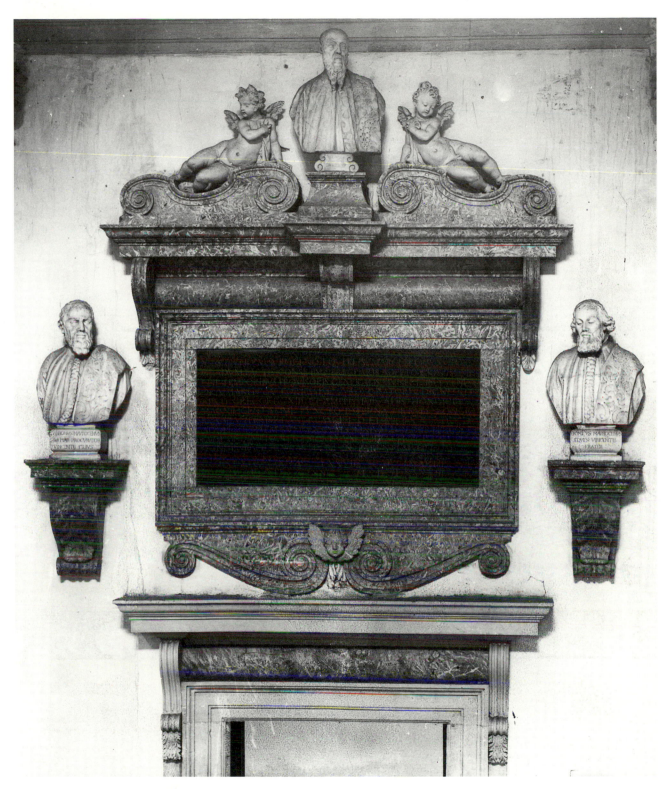

3. Alessandro Vittoria, monument of Vincenzo Morosini (busts of sons are later additions), S. Giorgio Maggiore, Venice (Fondazione Giorgio Cini, Istituto di storia dell'arte, 24598)

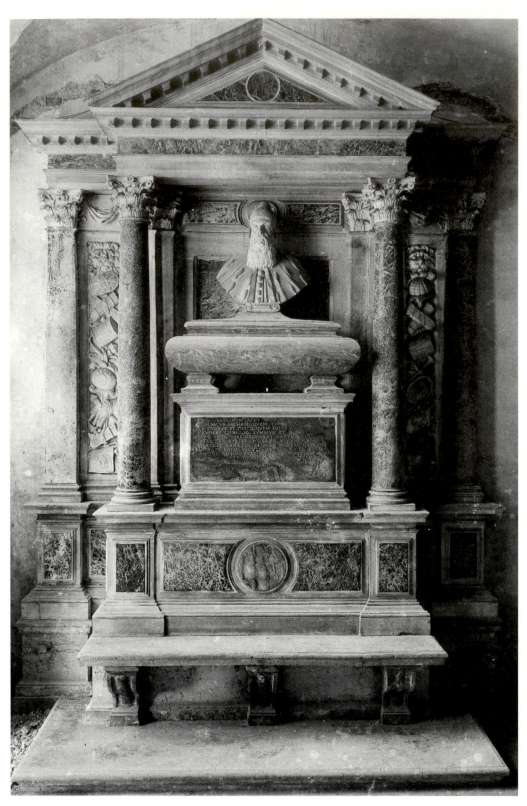

4. Monument of Doge Domenico Michiel, tomb by B. Longhena (*c.* 1640), bust by G. B. Paliari, in passageway to right of tribune, S. Giorgio Maggiore, Venice (Böhm 4606)

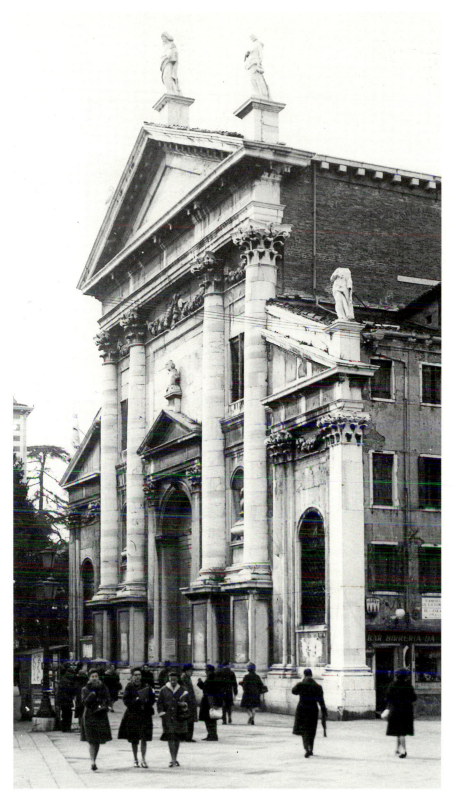

6. Tomb of Benedetto Brugnolo (d. 1505), S. Maria Gloriosa dei Frari, Venice (The Conway Library, Courtauld Institute of Art, B72/1930)

5. G. Gnoccola, bust of Doge Carlo Contarini (d. 1656), over portal of S. Vidal, Venice (Böhm 4918)

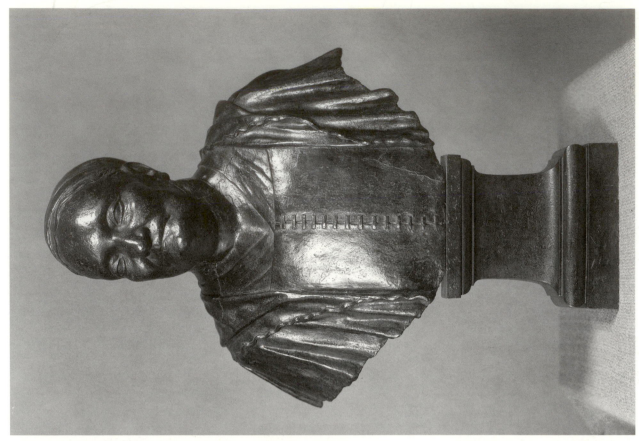

8. Bust of Agnesina Badoer Giustinian, Widener Collection, © Board of Trustees, National Gallery of Art, Washington, DC (Museum photo)

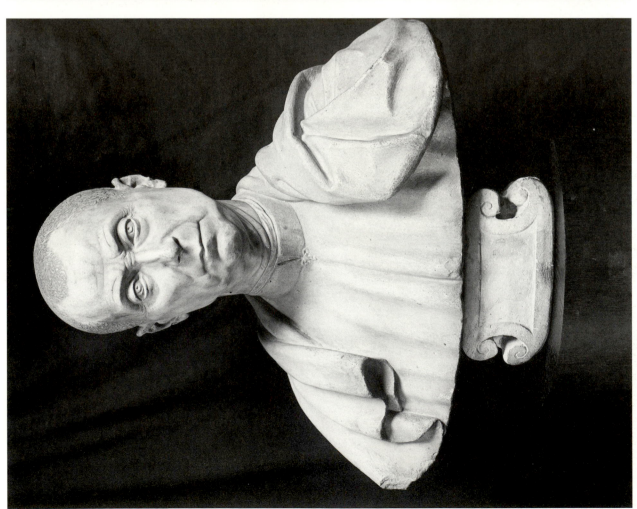

7. Bartolomeo Bergamasco, bust of Matteo de' Eletti, Cà d'Oro, Venice (orig. S. Geminiano, Venice) (Alinari/Art Resource)

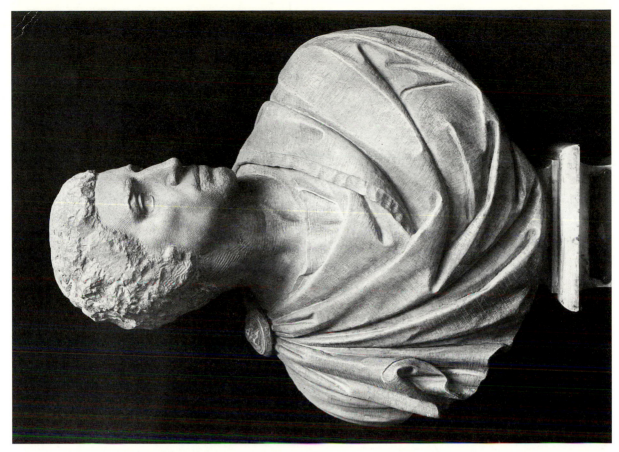

10. Michelangelo, bust of Brutus, Museo Nazionale del Bargello, Florence (Alinari 2718)

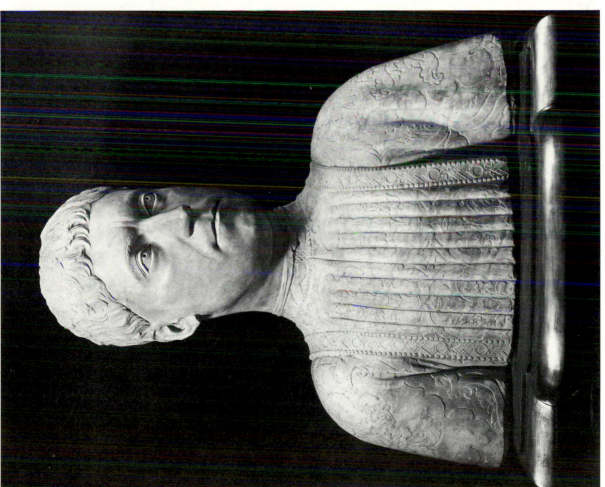

9. Mino da Fiesole, bust of Piero de' Medici, Museo Nazionale del Bargello, Florence (Alinari/Art Resource 2738)

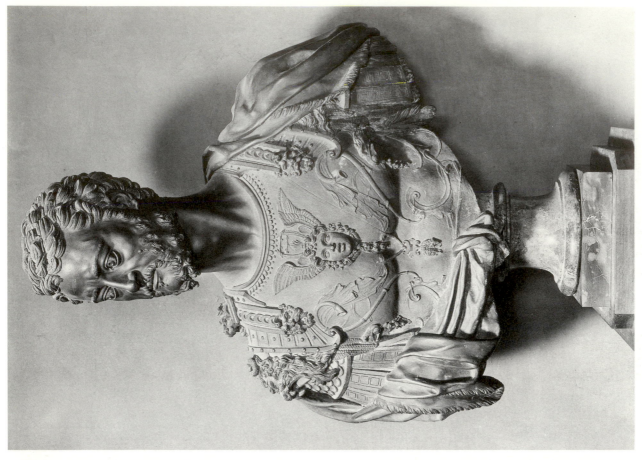

12. Benvenuto Cellini, bust of Duke Cosimo I, Museo Nazionale del Bargello, Florence (Alinari 2662)

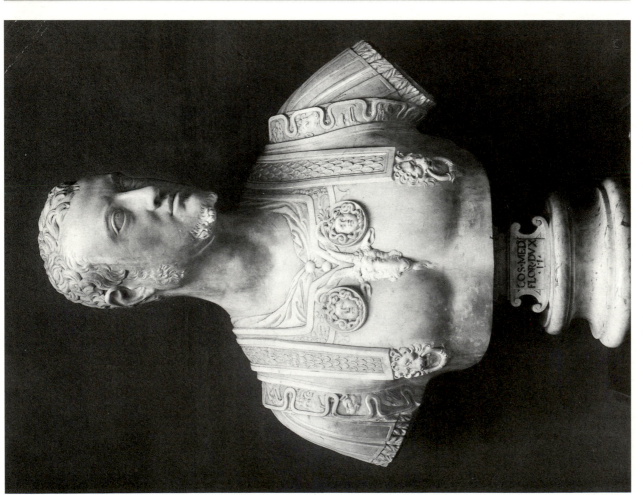

11. Baccio Bandinelli, bust of Duke Cosimo I, Museo Nazionale del Bargello, Florence (Alinari 4770)

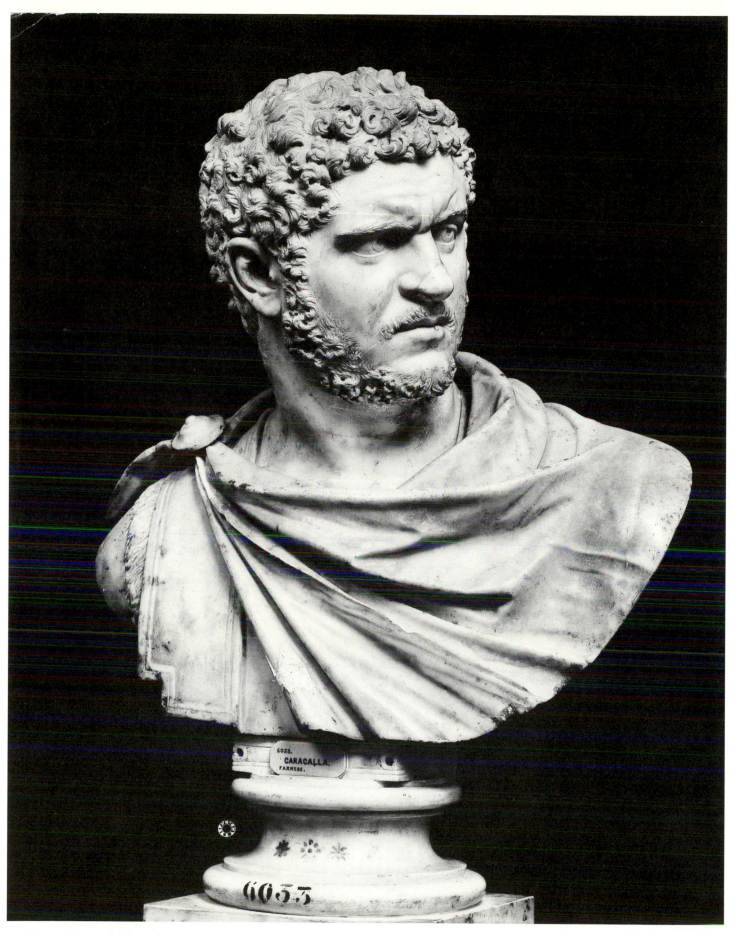

13. Bust of Emperor Caracalla, Museo Archeologico Nazionale, Naples (Alinari/Art Resource, AN 23058)

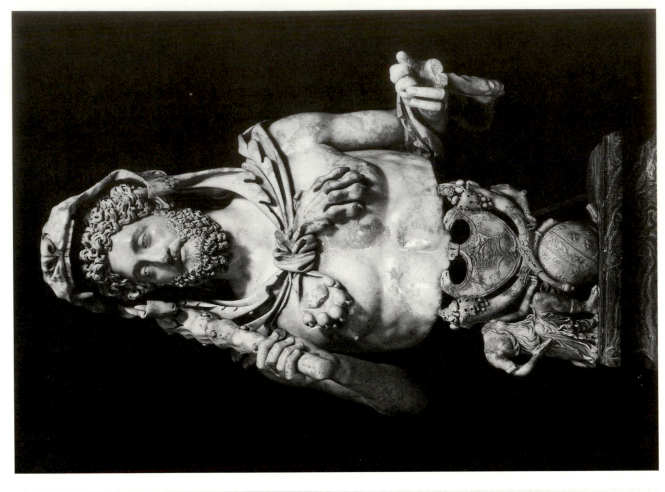

15. Bust of Hercules, Emperor Commodus as model, Musei Capitolini, Rome (Alinari/Art Resource AL1549)

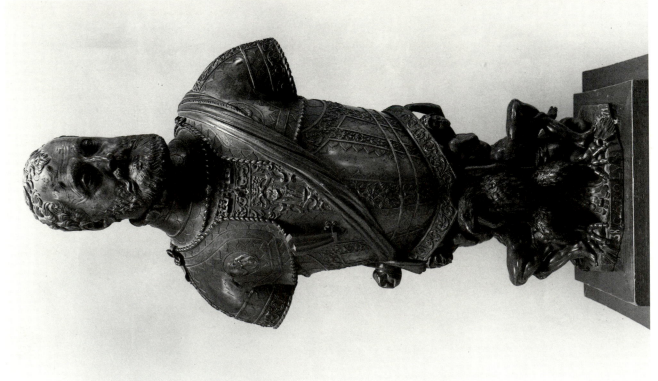

14. Leone and Pompeo Leoni, bust of Emperor Charles V, Museo del Prado, Madrid (Museum photo)

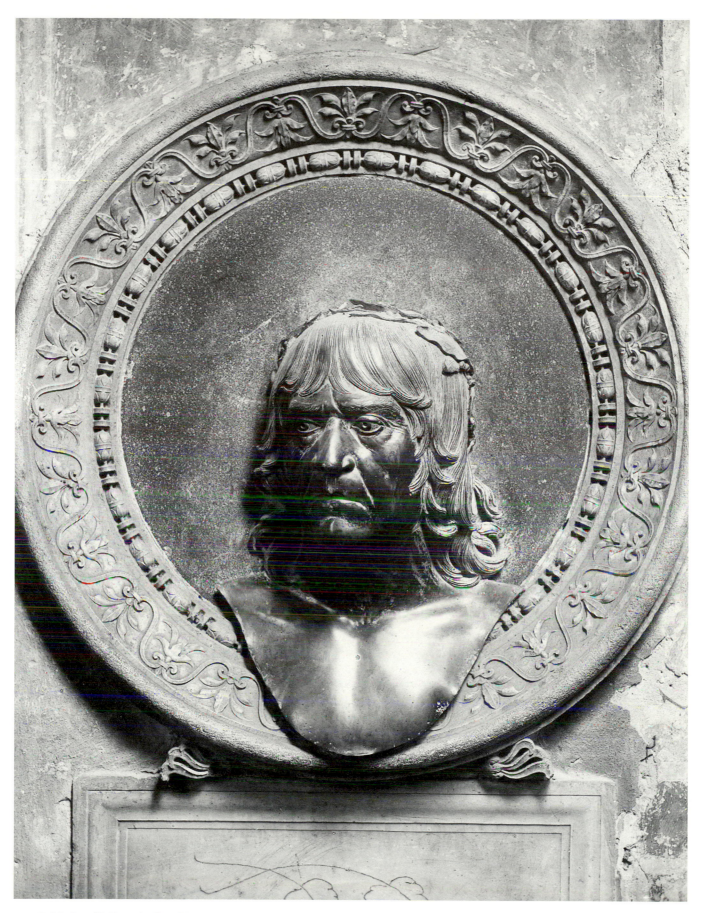

16. G. M. Cavalli (?) or Andrea Mantegna (?), portrait of Andrea Mantegna, S. Andrea, Mantua (Alinari/Art Resource AL18657)

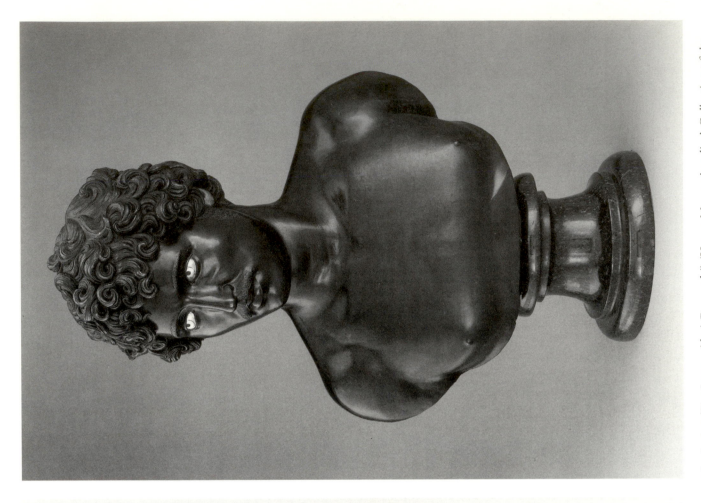

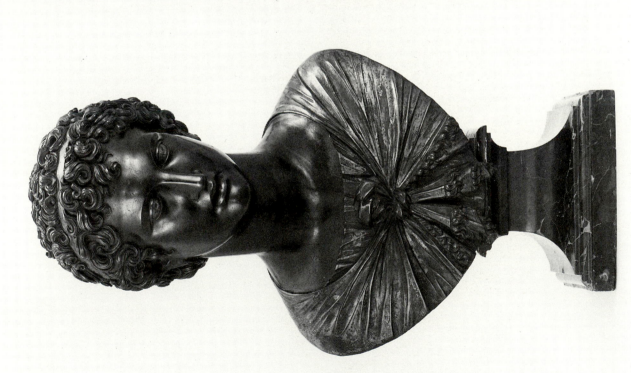

18. Antico (Pier Jacopo Alari-Bonacolsi). 'Young Marcus Marcus Aurelius'. Collection of the J. Paul Getty Museum, Los Angeles, California (Museum photo)

17. Antico (Pier Jacopo Alari-Bonacolsi). 'Youth'. Liechtenstein Collection, Vaduz (by gracious permission of His Serene Highness, the Prince of Liechtenstein)

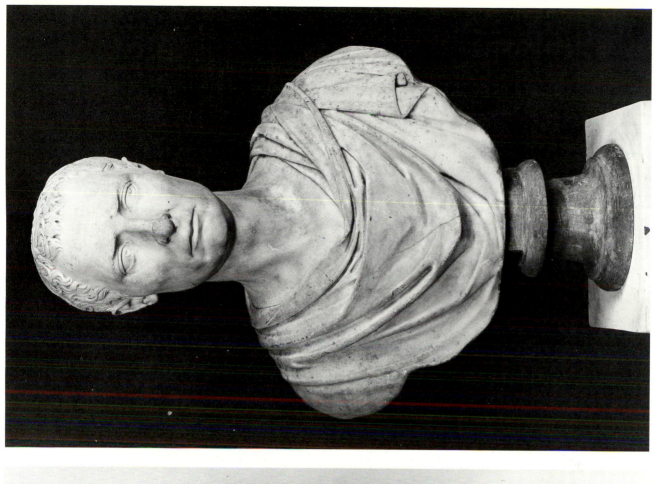

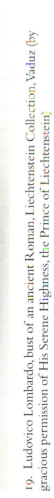

20. Simone Bianco, bust of an ancient Roman, Musée du Louvre, Paris (© Réunion des musées nationaux)

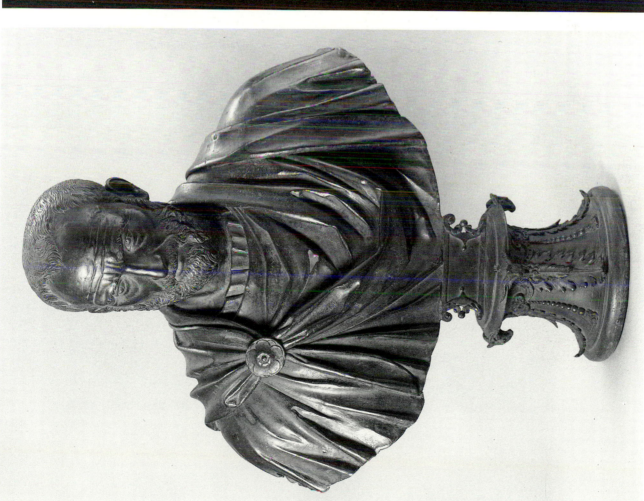

19. Ludovico Lombardo, bust of an ancient Roman, Liechtenstein Collection, Vaduz (by gracious permission of His Serene Highness, the Prince of Liechtenstein)

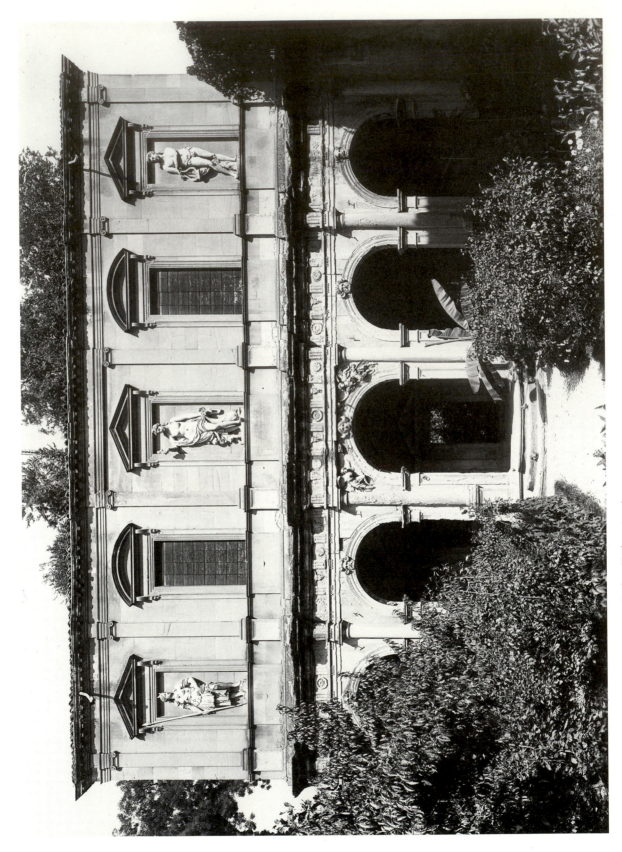

21. Gianmaria Falconetto, Loggia Cornaro, Padua (Böhm 6331)

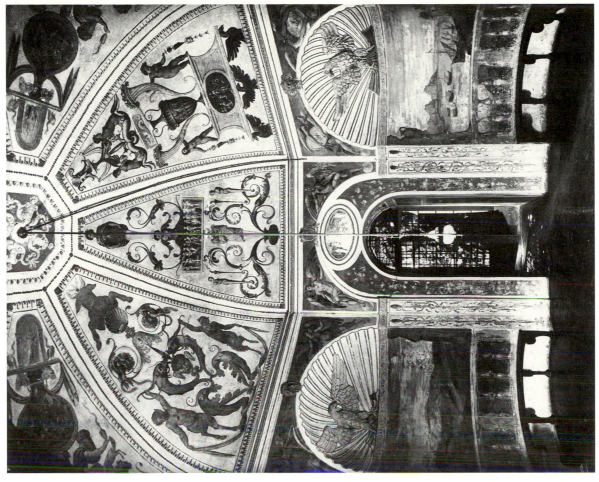

23. Interior of Odeon Cornaro (Böhm 6329)

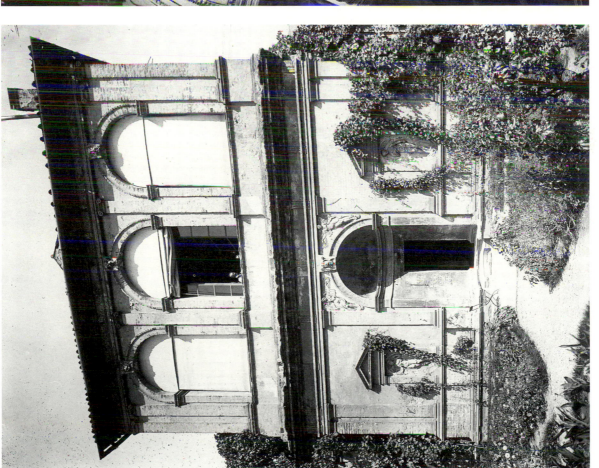

22. Gianmaria Falconetto and Alvise Cornaro, Odeon Cornaro, Padua (Böhm 6328)

24. Domenico Campagnola(?), figure of Brutus (on far left), Sala dei Giganti, University of Padua, Padua

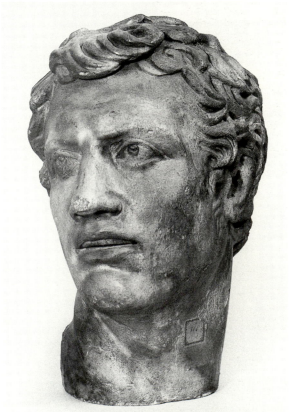

25. Head of 'Milicho', Museo di Scienze Archeologie e d'Arte, Padua (by kind permission of the Museum of Archaeology and Art, University of Padua)

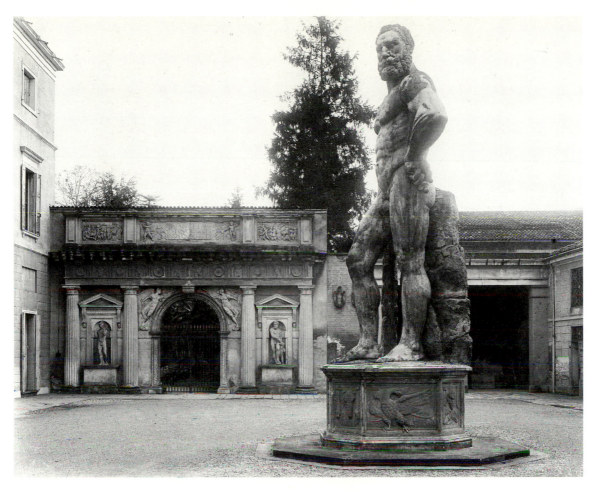

26. Bartolommeo Ammannati,
Hercules and triumphal arch in
courtyard of palazzo Benavides,
Padua (Böhm 6082)

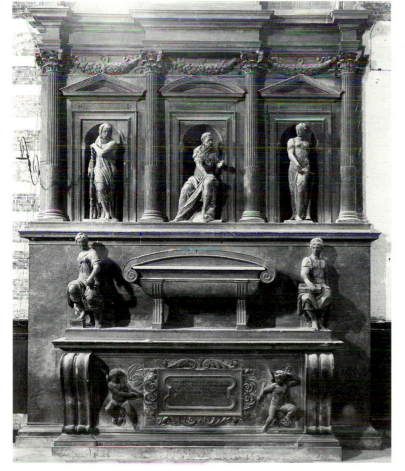

27. Bartolommeo Ammannati,
tomb of Marco Mantova
Benavides, church of the
Eremitani, Padua (Böhm 6087)

29. Danese Cattaneo, monument to Pietro Bembo, Basilica del Santo, Padua (Alinari 12241)

28. Agostino Zoppo, monument to Livy, Palazzo della Ragione, Padua (Böhm 6398)

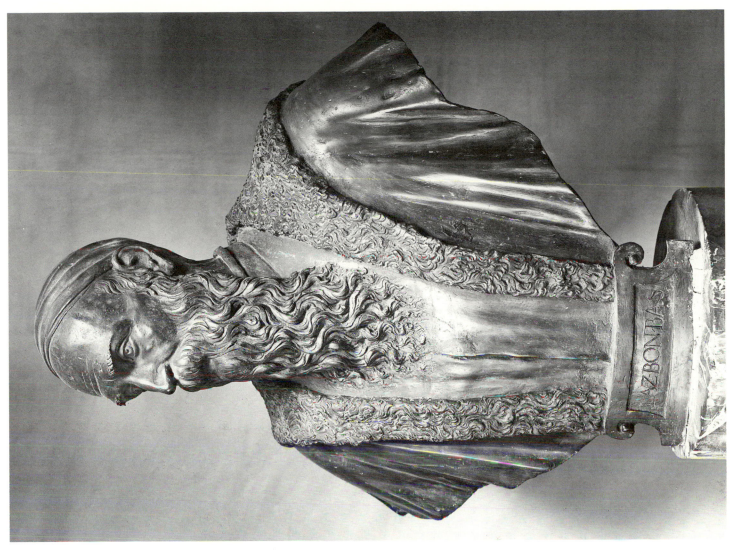

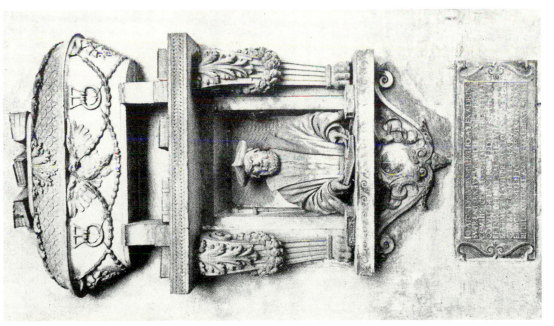

30. Vincenzo and Giovanni Girolamo Grandi, tomb of Giovanni Antonio de' Rossi, Basilica del Santo, Padua

31. Danese Cattaneo, bust of Lazzaro Bonamico, Museo Civico, Bassano del Grappa (Alinari 20502)

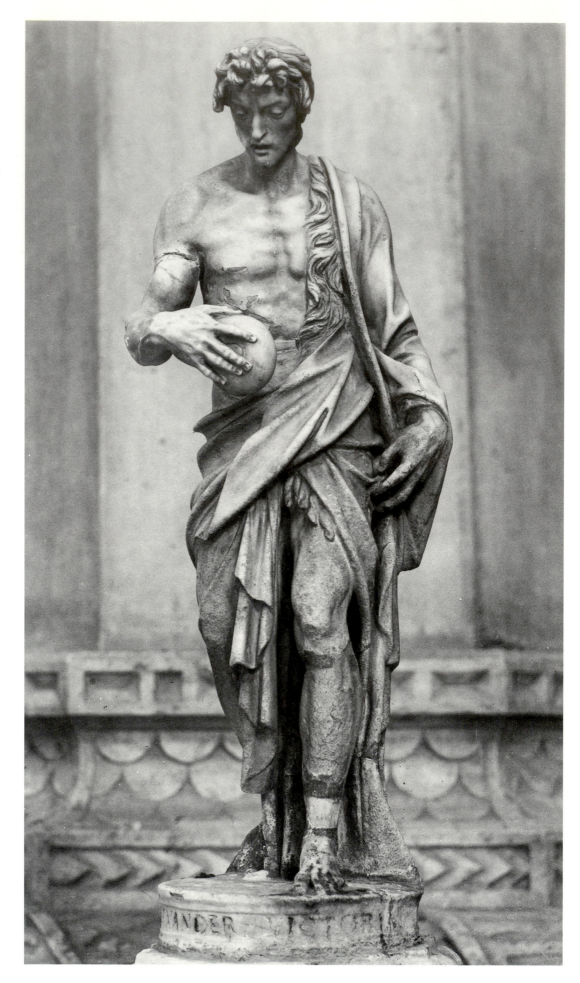

32. Alessandro
Vittoria, St John the
Baptist, S. Zaccaria,
Venice (Böhm 13140)

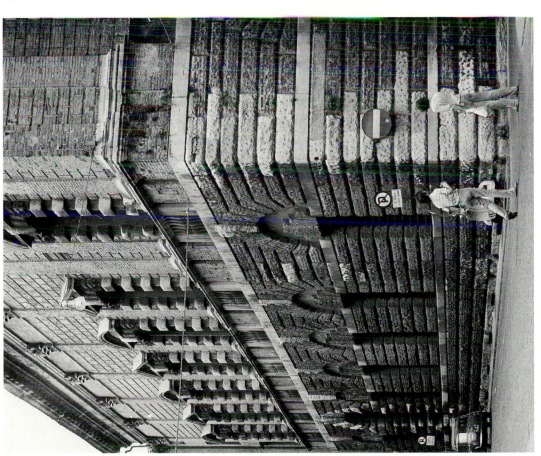

33. Andrea Palladio, palazzo Thiene, Vicenza (The Conway Library, Courtauld Institute of Art A78/3173)

34. Alessandro Vittoria, stuccoes in the Sala dei Principi in the palazzo Thiene (Centro Internazionale di Studi di Architettura 'Andrea Palladio', Vicenza)

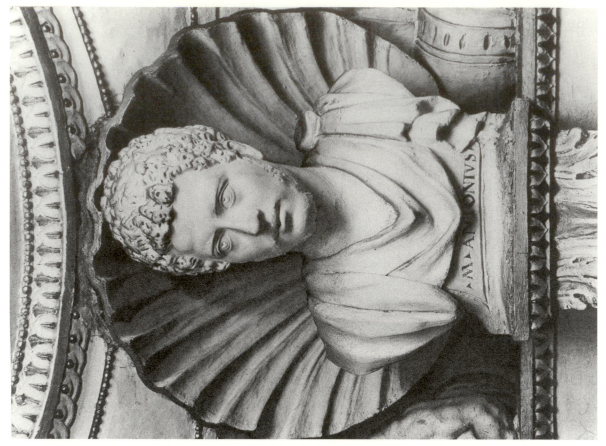

36. Alessandro Vittoria, bust of Mark Anthony, palazzo Thiene, Vicenza (Vajenti)

35. Gianmaria Falconetto, design for a tomb, Musée du Louvre, Paris (© Réunion des musées nationaux)

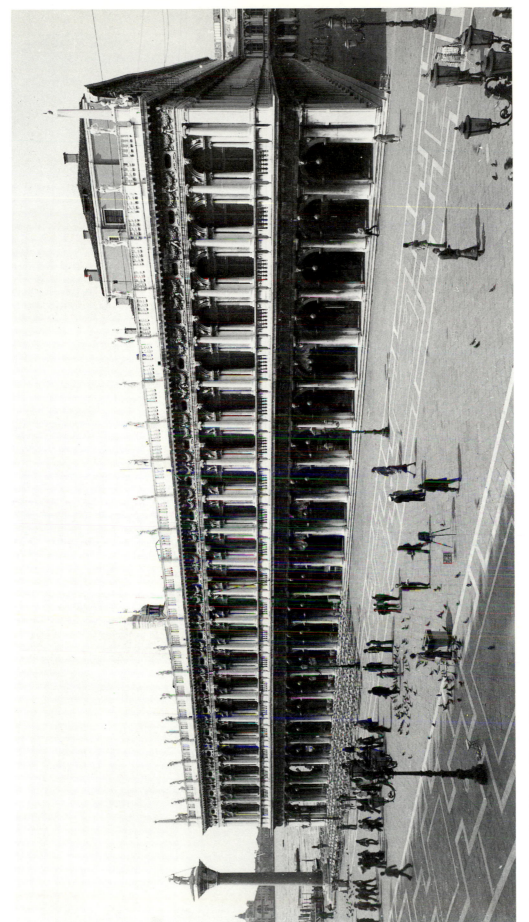

37. Jacopo Sansovino, Libreria, Venice (Böhm 1993)

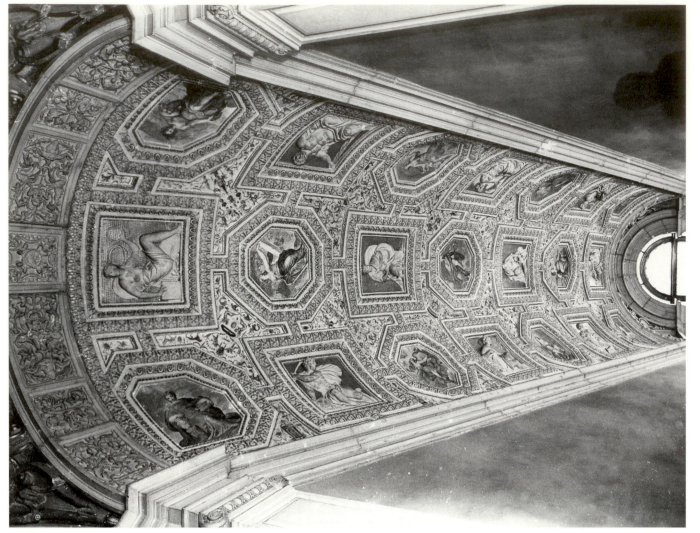

39. Jacopo Sansovino and Alessandro Vittoria, staircase of Libreria, Venice (Böhm 1747)

38. Alessandro Vittoria, Feminone, Libreria, Venice (Böhm 1203)

41. Alessandro Vittoria, dome on first landing of Libreria staircase, Venice (Martin)

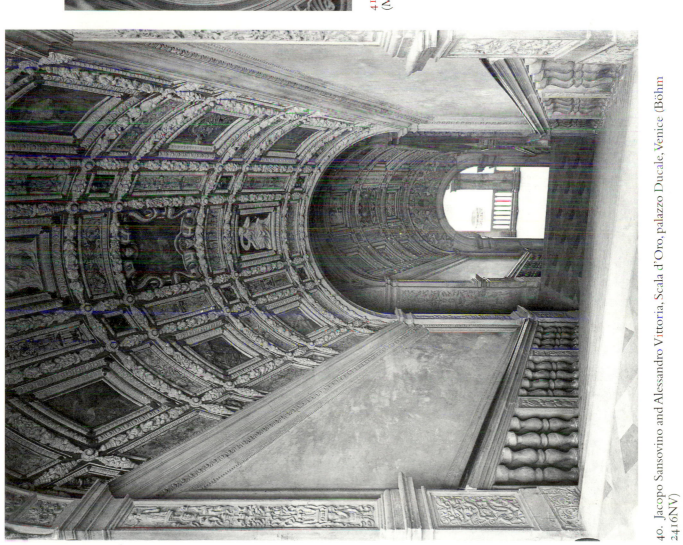

40. Jacopo Sansovino and Alessandro Vittoria, Scala d'Oro, palazzo Ducale, Venice (Böhm 2416NV)

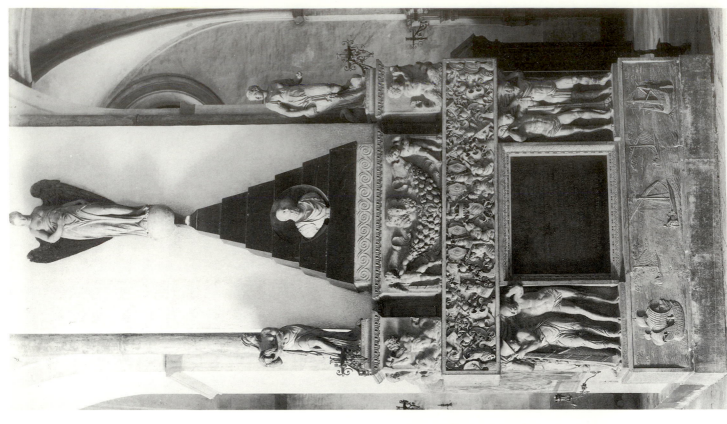

42. Alessandro Vittoria, dome on second landing of Libreria staircase, Venice (Böhm 7767)

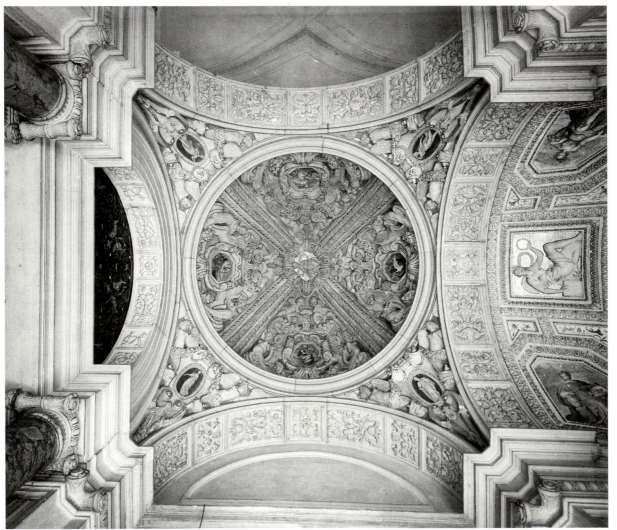

43. Michele Sanmicheli *et al.*, tomb of Alessandro Contarini, Basilica del Santo, Padua (Alinari/Art Resource AL 12242)

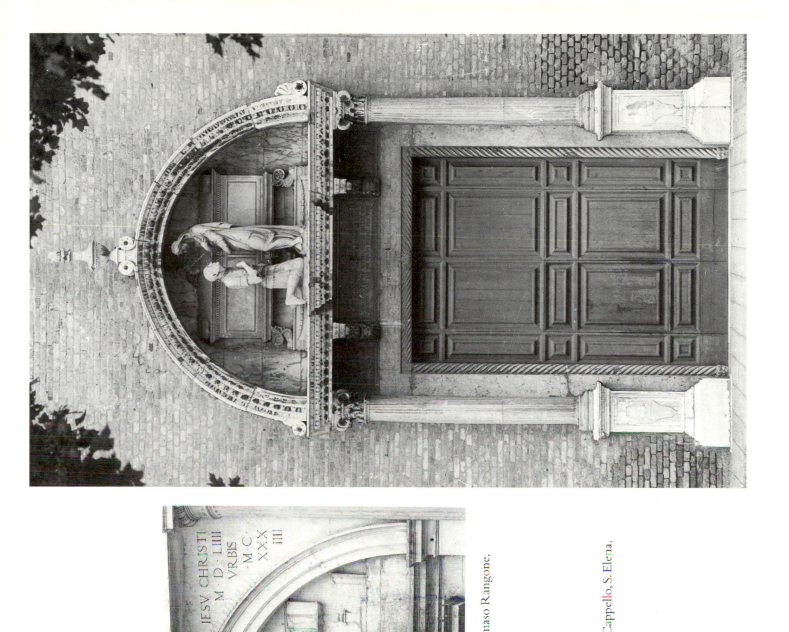

44. Jacopo Sansovino and Alessandro Vittoria, monument to Tommaso Rangone,
S. Giuliano, Venice (Böhm 22295)

45. Monument to Vettor Cappello, S. Elena,
Venice (Böhm 9312)

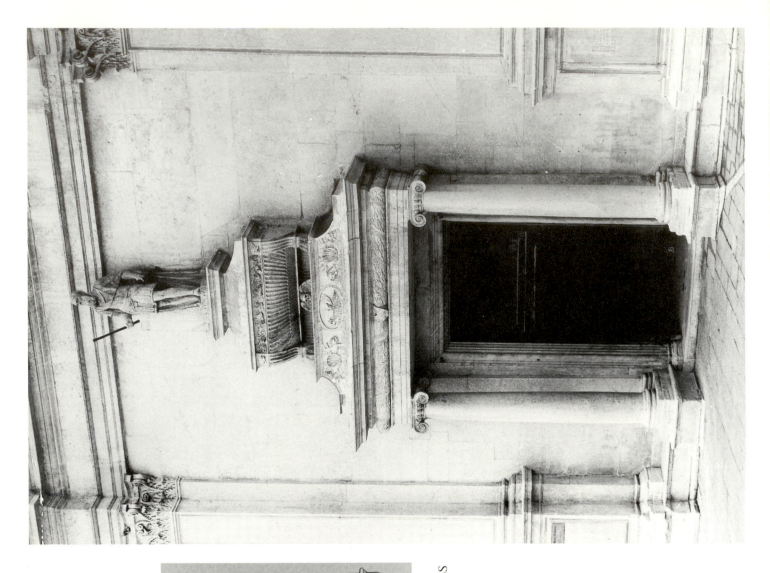

46. Monument to Pietro Grimani, formerly S. Antonio di Castello, Venice (from Jan Grevembroch, *Monumenta Veneta* . . ., Biblioteca Civico Correr, MSS Gradenigo 228, III, 49) (Museum photo)

47. Domenico da Salò, monument to Vincenzo Cappello, S. Maria Formosa, Venice (Böhm 22637)

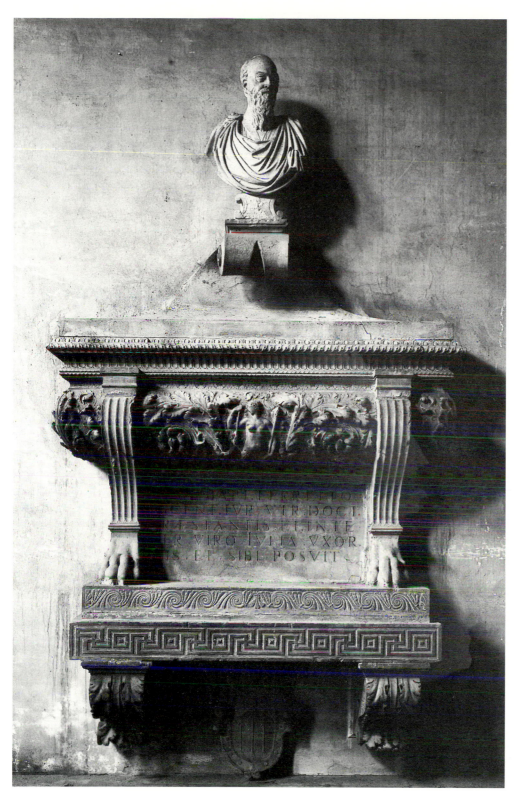

1. Original location of Ferretti tomb.

2. Location of Ferretti tomb from 1704 to 1742.

3. Location of Ferretti tomb from 1742 on.

49. Ground-plan of S. Stefano
(rendering by James Paonessa)

48. Monument of Giovanni Battista
Ferretti, bust after Alessandro Vittoria,
S. Stefano, Venice (Böhm 4160)

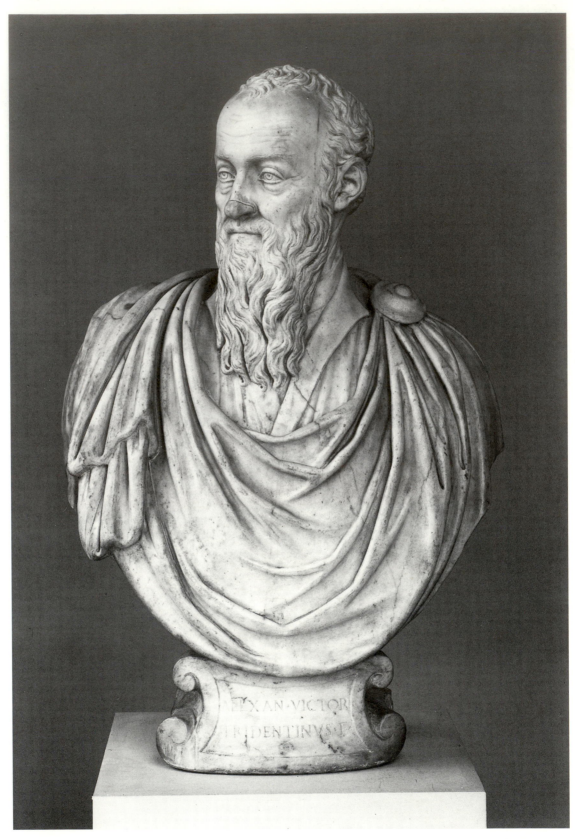

50. Alessandro Vittoria, bust of Giovanni Battista Ferretti, Musée du Louvre, Paris (© Réunion des musées nationaux)

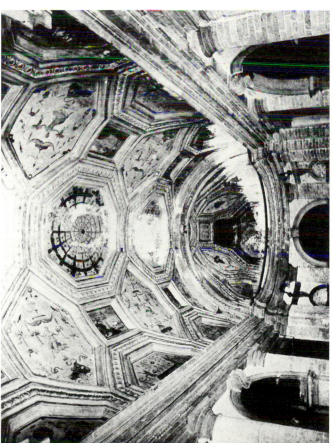

51. Andrea Palladio and Daniele Barbaro (?), centralized room of palazzo Trevisan on Murano, Venice

52. Pellegrini chapel, S. Sebastiano, Venice (Böhm 12826)

53. Andrea Schiavone, frescoes, and Alessandro Vittoria, stuccoes, Grimani chapel, S. Sebastiano, Venice (Böhm 13263)

54. Alessandro Vittoria, Grimani chapel, S. Sebastiano, Venice (The Conway Library, Courtauld Institute of Art, A78/4909)

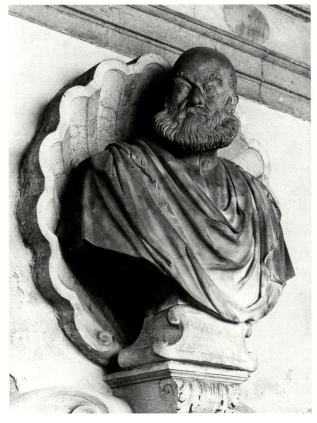

55. Alessandro Vittoria, bust of Marc'Antonio Grimani, S. Sebastiano, Venice (Böhm 13124)

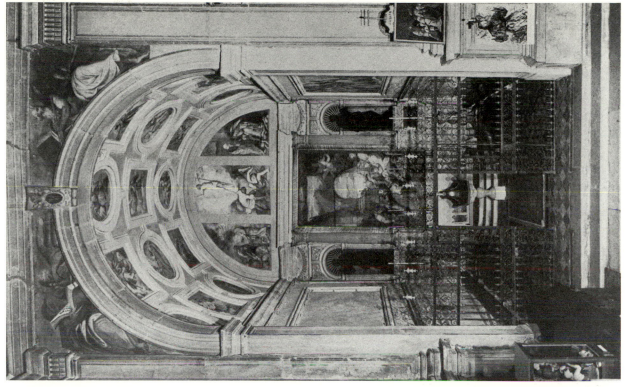

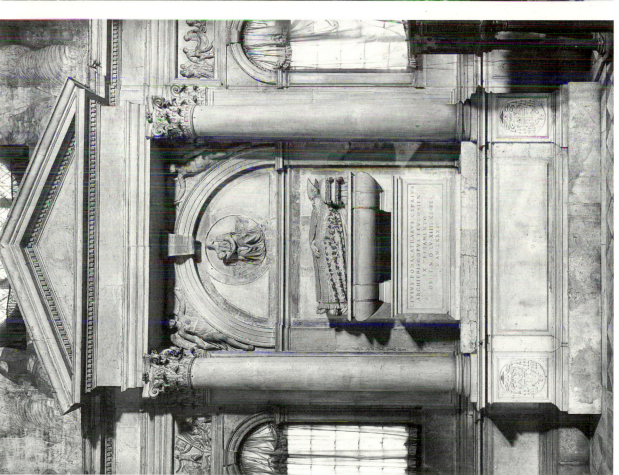

56. Jacopo Sansovino, tomb of Bishop Livio Podecataro, S. Sebastiano, Venice (Art Resource/Alinari AL38826)

57. Grimani chapel, S. Francesco della Vigna, Venice

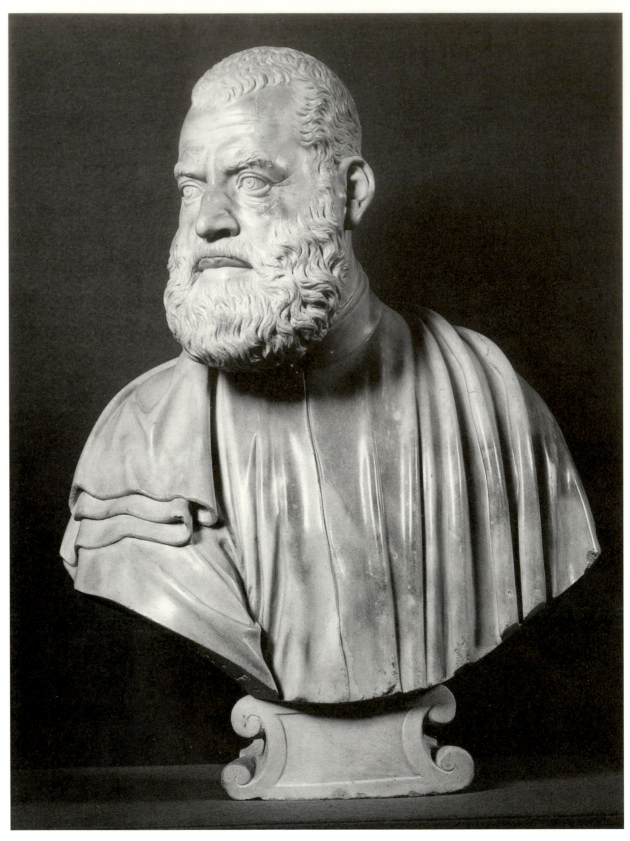

58. Alessandro Vittoria, bust of Benedetto Manzini (front), Cà d'Oro, Venice (orig. S. Geminiano) (The Conway Library, Courtauld Institute of Art, B84/241)

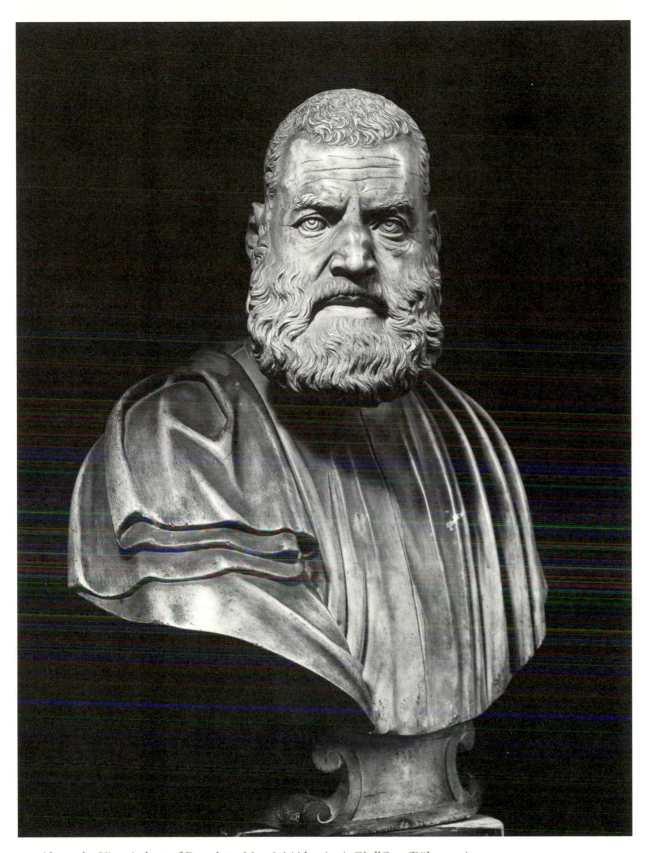

59. Alessandro Vittoria, bust of Benedetto Manzini (side-view), Cà d'Oro, (Böhm 725)

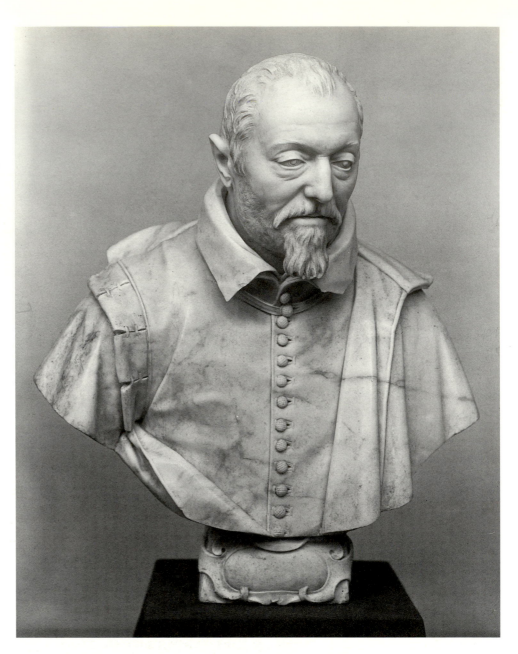

60. Gianlorenzo
Bernini, bust of
Antonio Cepparelli,
S. Giovanni dei
Fiorentini, Rome
(Gabinetto Fotografico
Nazionale, E60239)

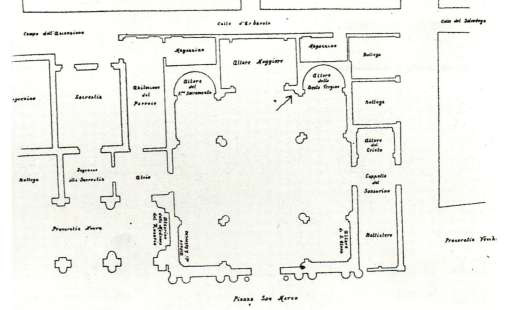

61. Ground-plan of
S. Geminiano, Venice
(after Gallo, 1957)

62. Paolo Veronese, SS Geminiano and Severo, Galleria Estense, Modena (orig. S. Geminiano, Venice) (Museum photo)

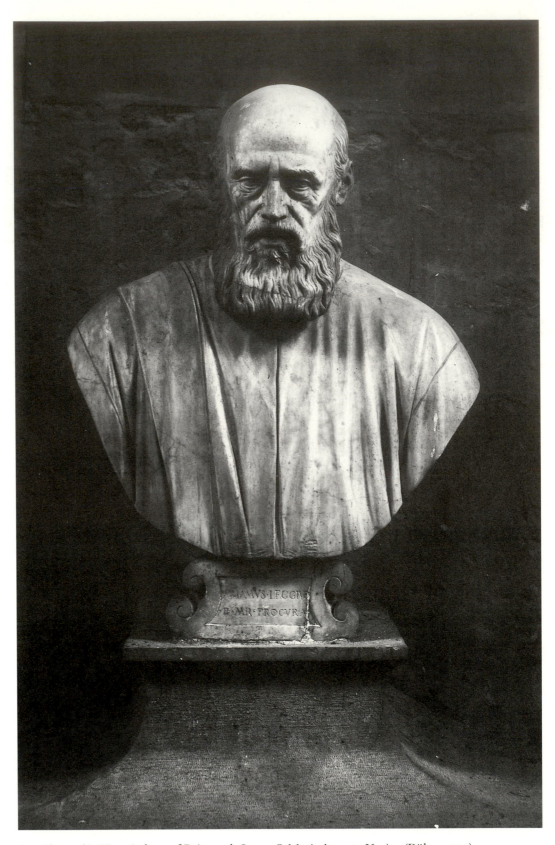

63. Alessandro Vittoria, bust of Priamo da Lezze, S. Maria Assunta, Venice (Böhm 4070)

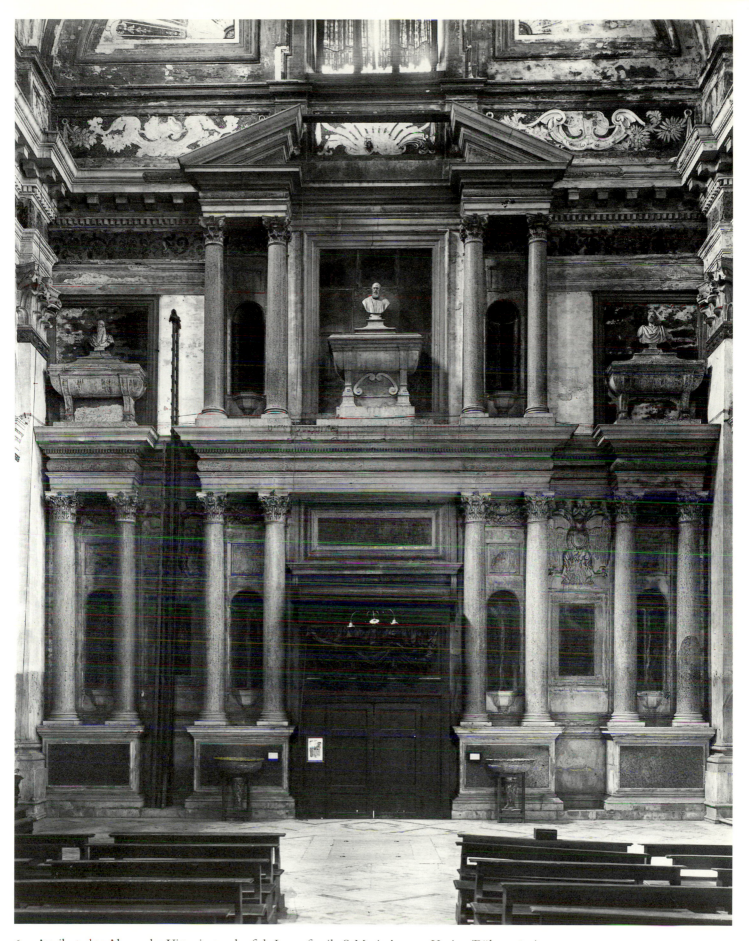

64. Attributed to Alessandro Vittoria, tomb of da Lezze family, S. Maria Assunta, Venice (Böhm 3690)

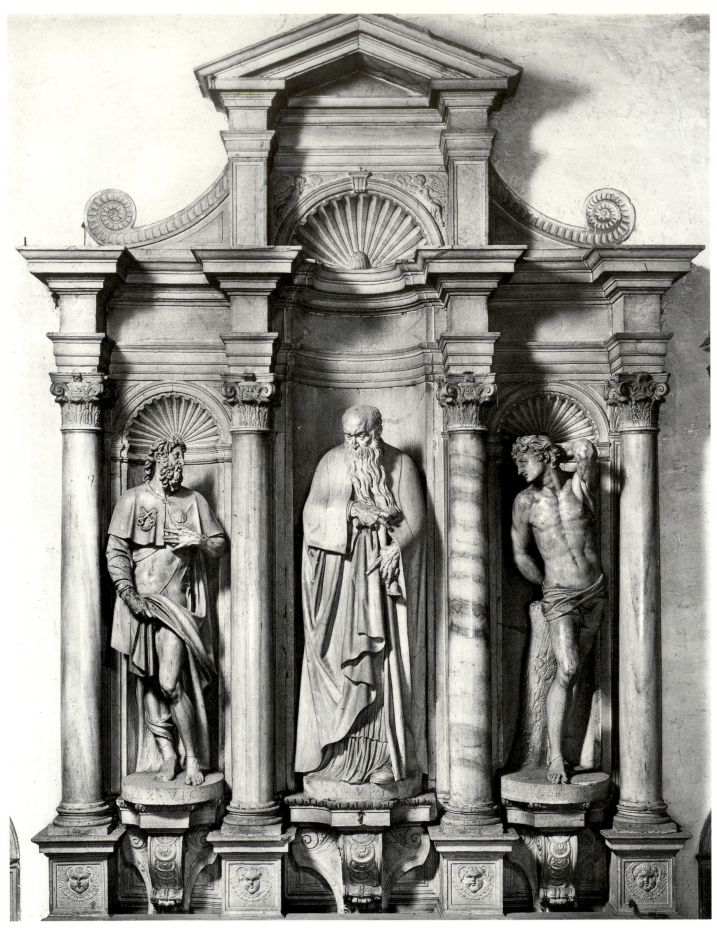

65. Alessandro Vittoria, Montefeltro altarpiece, S. Francesco della Vigna, Venice (Alinari/Art Resource AL12969)

66. Titian, *Madonna of the Pesaro Family*, S. Maria Gloriosa dei Frari, Venice (Böhm 9050)

67. Alessandro Vittoria, Zane altar,
S. Maria Gloriosa dei Frari, Venice
(The Conway Library, Courtauld
Institute of Art B72/1978)

68. Titian, *Assunta* (seen through
choir), S. Maria Gloriosa dei Frari,
Venice (Böhm 3536)

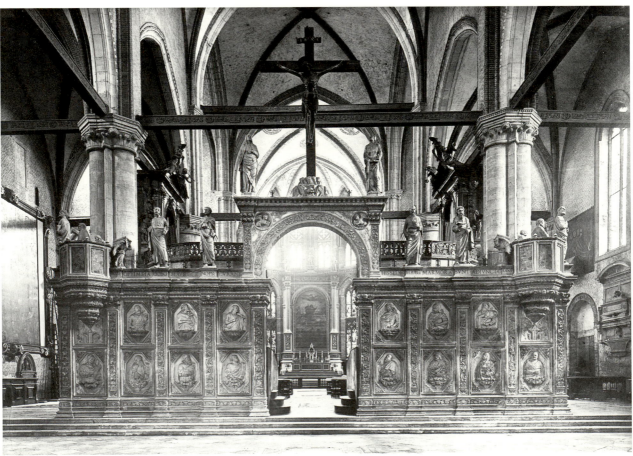

69. Girolamo Campagna, *God the Father and the Four Evangelists*, high altar, S. Giorgio Maggiore, Venice (Fondazione Giorgio Cini, Istituto di storia dell'arte 2346)

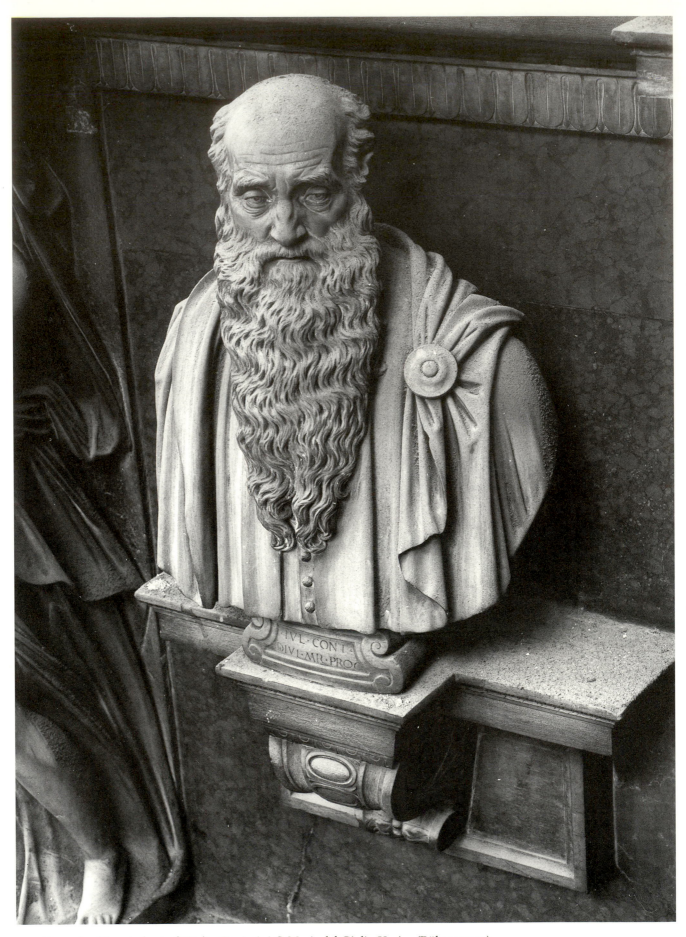

70. Alessandro Vittoria, bust of Giulio Contarini, S. Maria del Giglio, Venice (Böhm 13151)

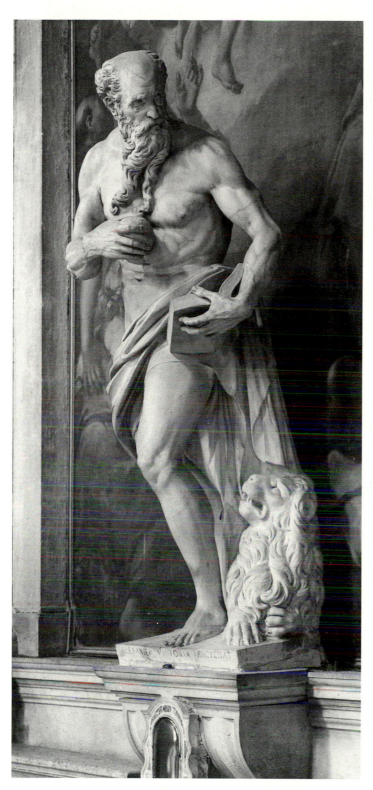

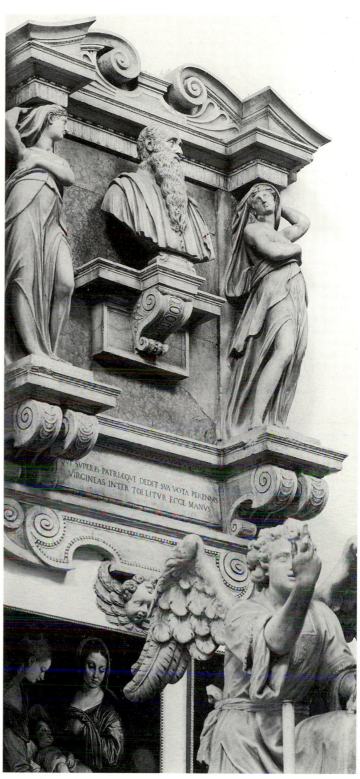

71. Alessandro Vittoria, *St Jerome* from Zane altar, S. Maria Gloriosa dei Frari, Venice (The Conway Library, Courtauld Institute of Art B72/2078)

72. Alessandro Vittoria, monument of Giulio Contarini, S. Maria del Gigio, Venice (The Conway Library, Courtauld Institute of Art, A78/3404)

74. Workshop of Vittoria, bust of Girolamo Molin, S. Maria del Giglio, Venice (Böhm 13152)

73. Alessandro Vittoria, *targa* to Henry III, palazzo Ducale, Venice (Böhm 15047)

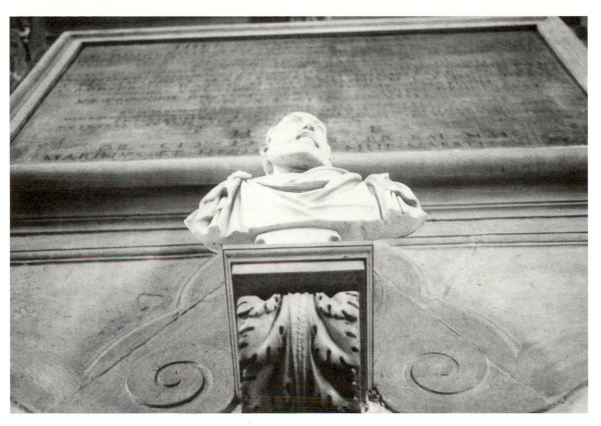

75. Bust of Girolamo Grimani viewed from below (Martin)

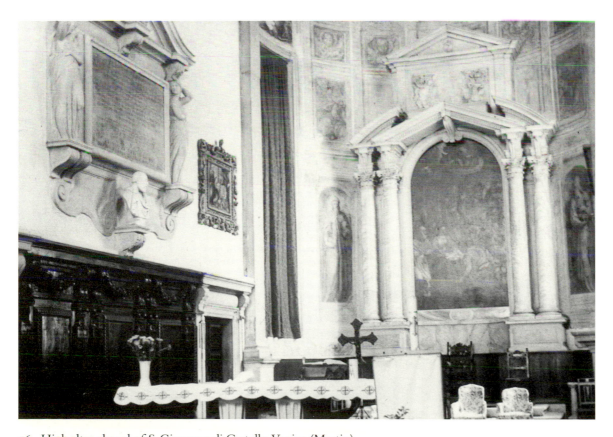

76. High altar chapel of S. Giuseppe di Castello, Venice (Martin)

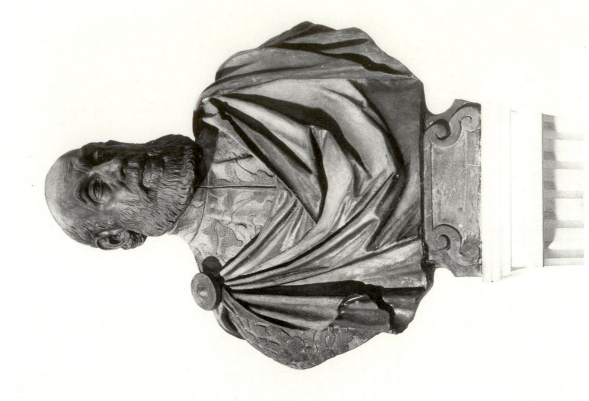

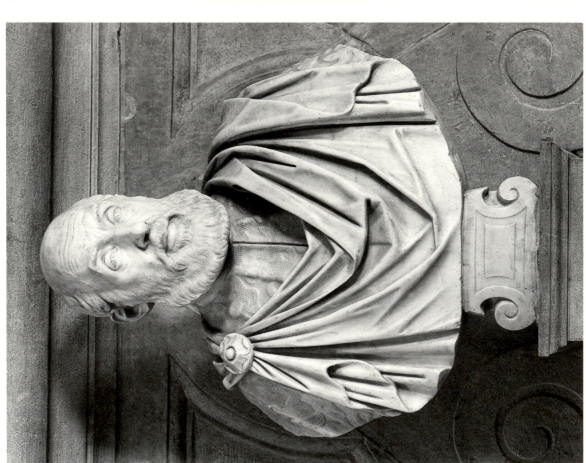

77. Alessandro Vittoria, bust of Girolamo Grimani, S. Giuseppe di Castello, Venice (Böhm 14800A)

78. Alessandro Vittoria, bust of Girolamo Grimani, Seminario Partriarcale, Venice (Alinari/Art Resource AL 12656)

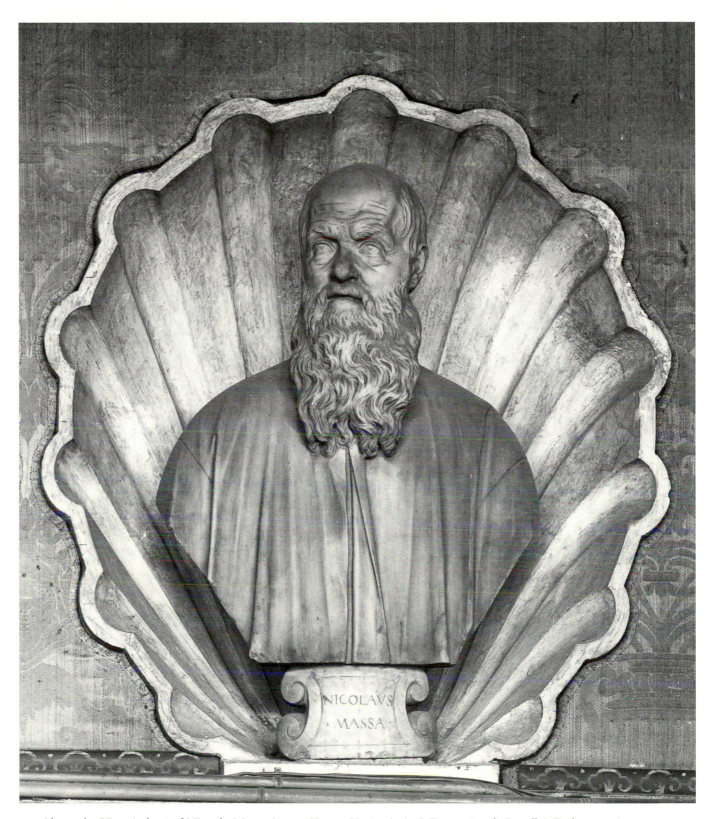

NICOLAVS
MASSA

79. Alessandro Vittoria, bust of Niccolo Massa, Ateneo Veneto, Venice (orig. S. Domenico di Castello) (Böhm 1915)

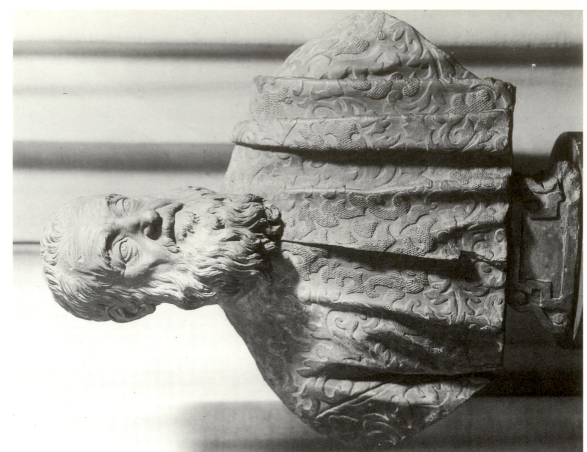

81. Alessandro Vittoria, bust of Tommaso Rangone, Museo Civico Correr, Venice (Museum photo)

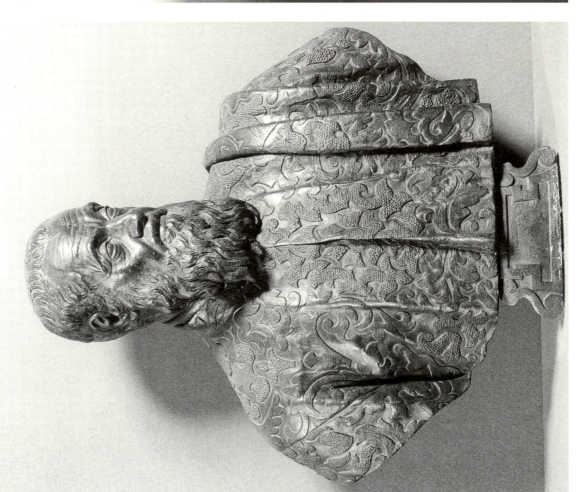

80. Alessandro Vittoria, bust of Tommaso Rangone, bronze, Ateneo Veneto, Venice (orig. S. Geminiano) (The Conway Library, Courtauld Institute of Art B84/246)

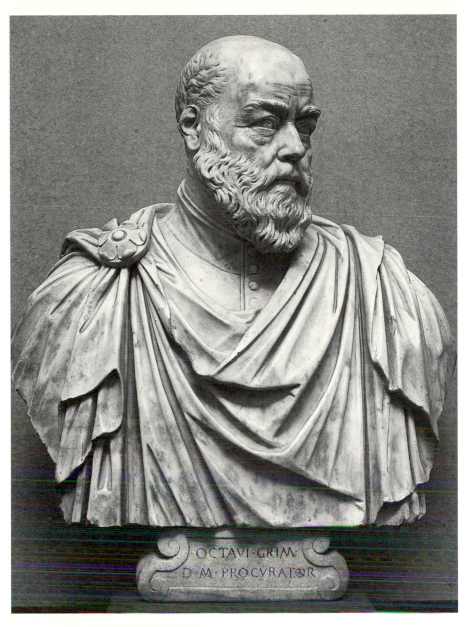

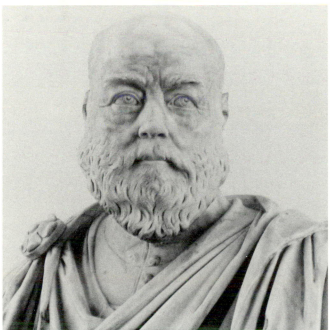

82. Alessandro Vittoria, bust of Ottaviano Grimani, Staatliche Museen zu Berlin, Preussischer Kulturbesitz, Berlin (Museum photo)

83. Detail of bust of Ottaviano Grimani (Martin)

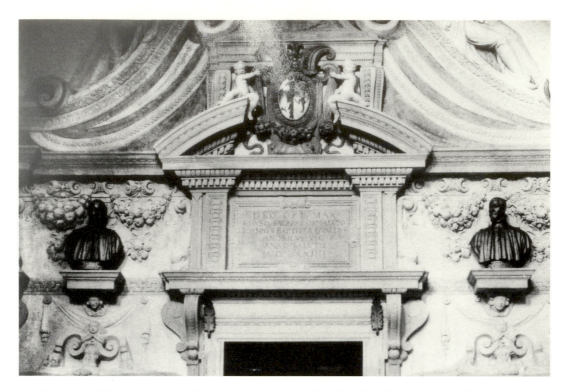

84. Alessandro Vittoria, tomb of Girolamo and Giovanni Battista Gualdo, Cathedral, Vicenza (Martin)

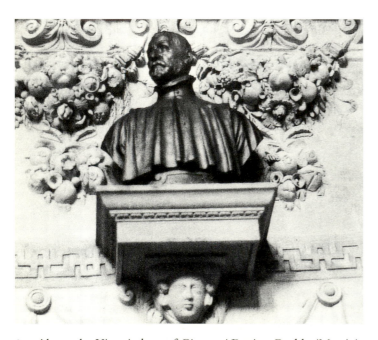

85. Alessandro Vittoria, bust of Giovanni Battista Gualdo (Martin)

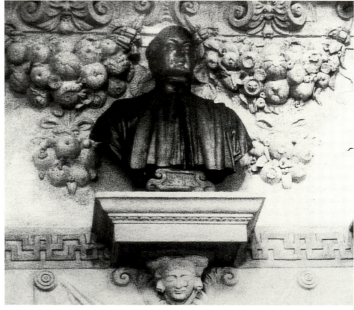

86. Workshop of Vittoria, bust of Girolamo Gualdo (Martin)

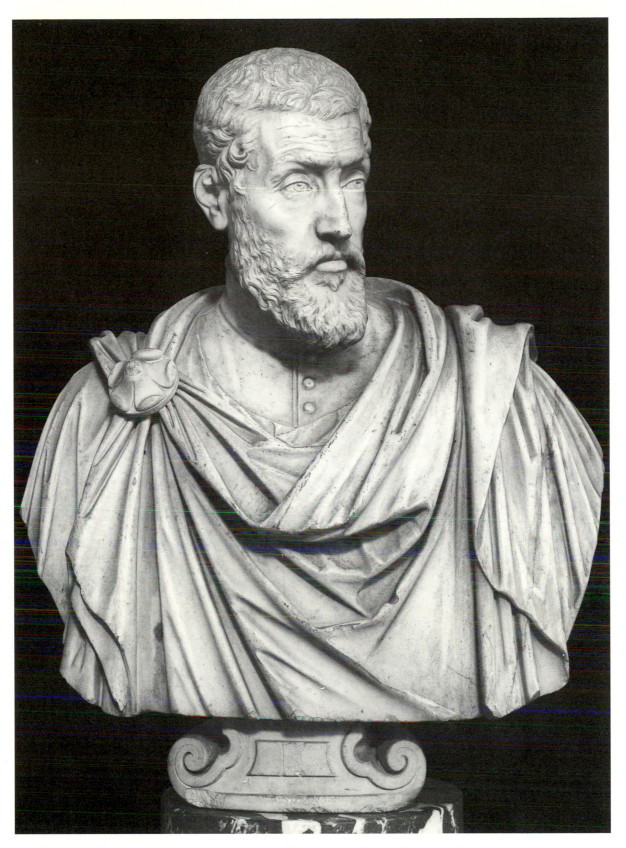

87. Alessandro Vittoria, bust of Orsato Giustiniani, Museo Civico, Padua (Museum photo)

88. Alessandro Vittoria,
bust of Paolo Costabile,
Museo Nazionale del
Bargello, Florence (orig.
S. Domenico di Castello,
Venice) (Soprintendenza
dei beni artistici e storici di
Firenze 13539)

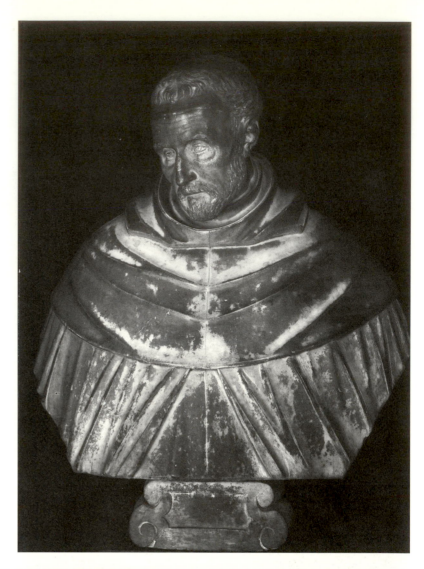

89. Alessandro Vittoria,
bust of Sebastiano Venier,
palazzo Ducale, Venice
(Böhm 2757)

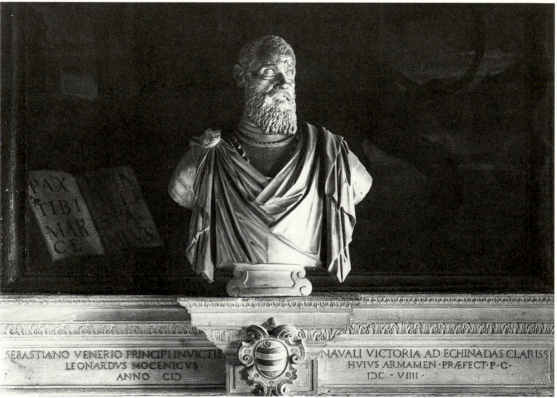

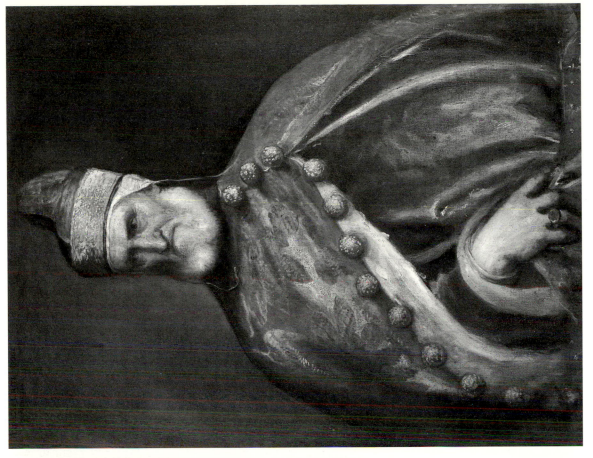

91. Titian, *Doge Andrea Gritti*, Samuel H. Kress Collection, © Board of Trustees, National Gallery of Art, Washington, DC (Museum photo)

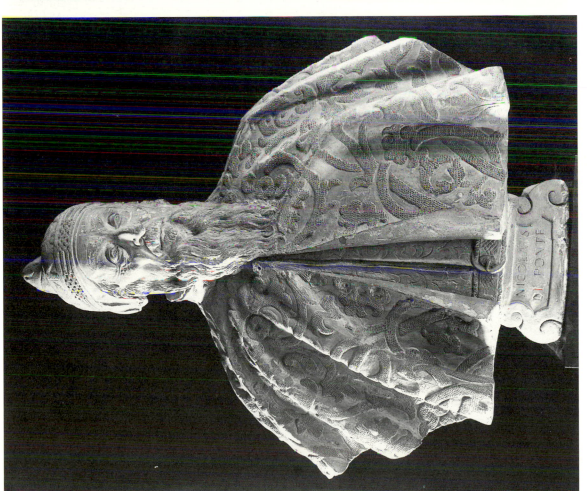

90. Alessandro Vittoria, bust of Niccolo da Ponte, Seminario Patriarcale, Venice (orig. S. Maria della Carità) (Böhm 2545N)

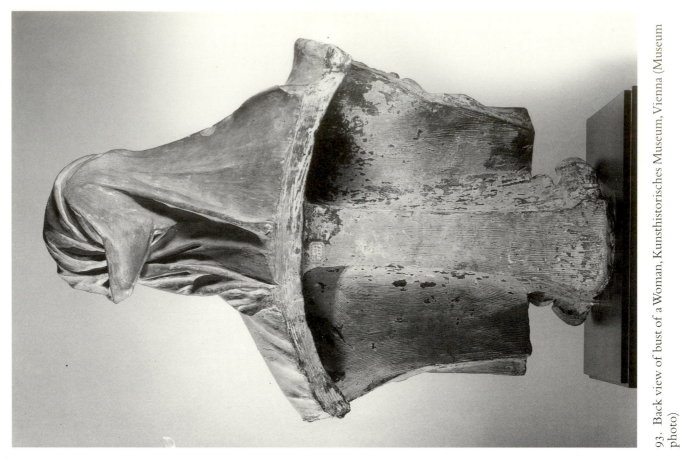

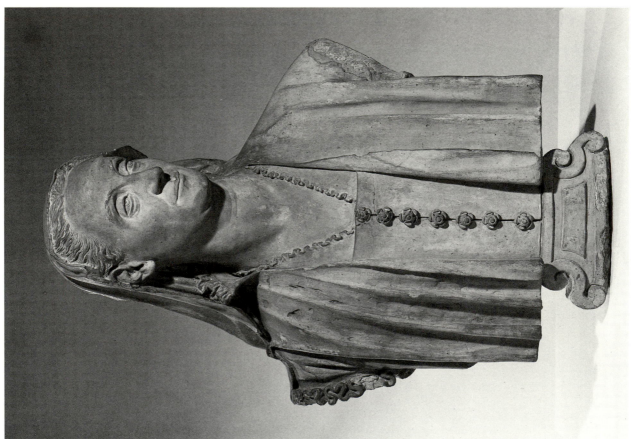

92. Alessandro Vittoria, bust of a Woman, Kunsthistorisches Museum, Vienna (Museum photo)

93. Back view of bust of a Woman, Kunsthistorisches Museum, Vienna (Museum photo)

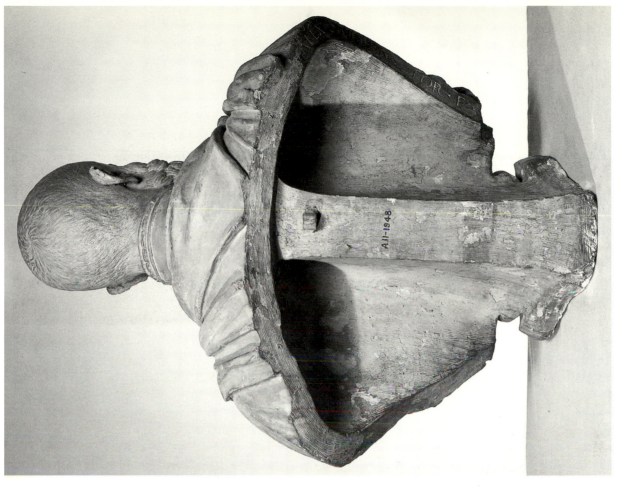

95. Back view of bust of a Man, Courtesy of the Board of Trustees of the Victoria & Albert Museum, London (Museum photo)

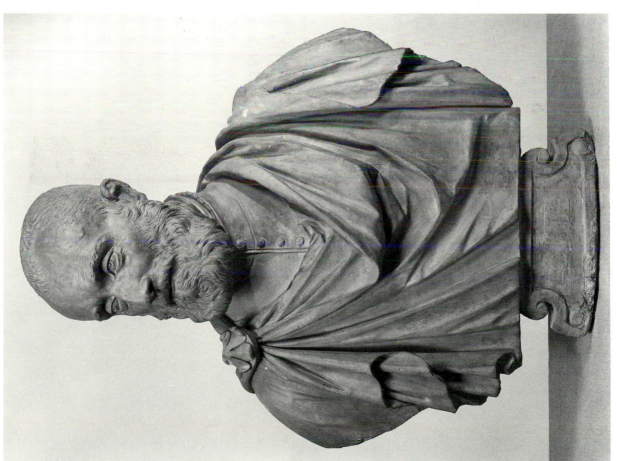

94. Alessandro Vittoria, bust of a Man ('Paolo Veronese'), Courtesy of the Board of Trustees of the Victoria & Albert Museum, London (Museum photo)

97. Back view of bust of a Man in Armour, Courtesy of the Board of Trustees of the Victoria & Albert Museum, London (Museum photo)

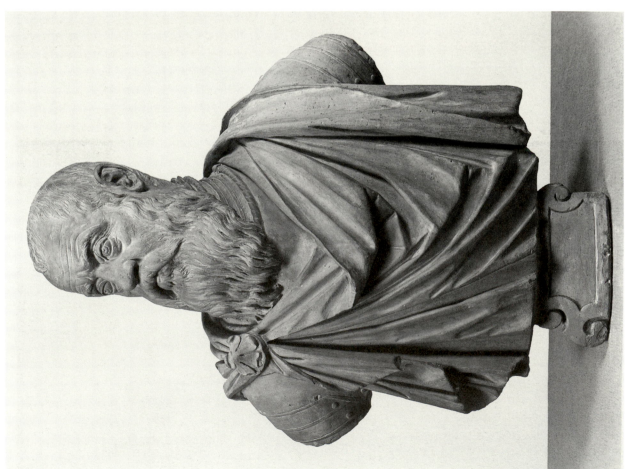

96. Alessandro Vittoria, bust of a Man in Armour, Courtesy of the Board of Trustees of the Victoria & Albert Museum, London (Museum photo)

99. Right-hand wall of Contarini chapel, Madonna dell'Orto, Venice (Böhm 4193)

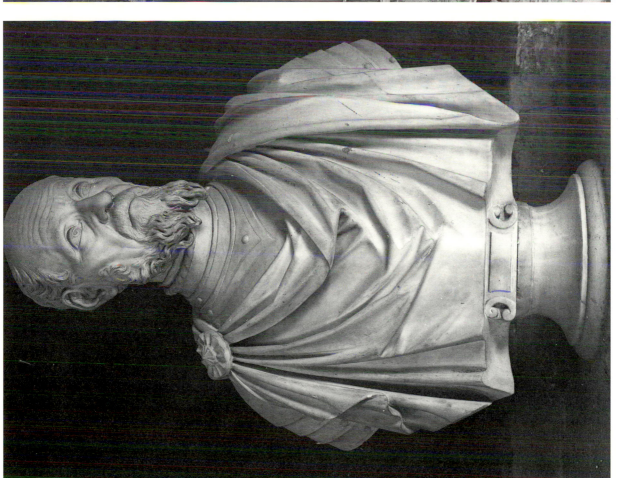

98. Workshop of Vittoria, bust of Tommaso Contarini, Contarini Chapel, Madonna dell'Orto, Venice (Böhm 14282)

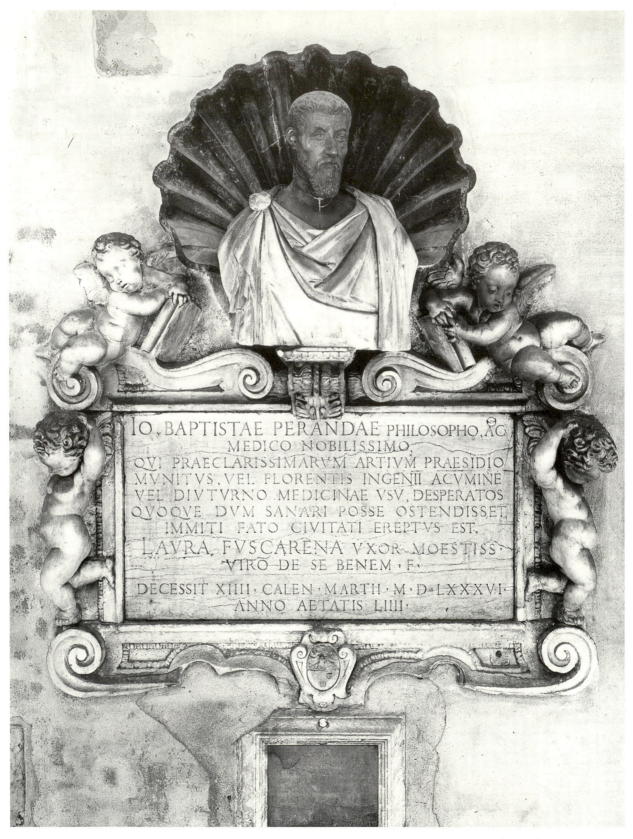

IO. BAPTISTAE PERANDAE PHILOSOPHO, AC
MEDICO NOBILISSIMO,
QVI PRAECLARISSIMARVM ARTIVM PRAESIDIO
MVNITVS, VEL FLORENTIS INGENII ACVMINE
VEL DIVTVRNO MEDICINAE VSV, DESPERATOS
QVOQVE DVM SANARI POSSE OSTENDISSET,
IMMITI FATO CIVITATI EREPTVS EST,
LAVRA FVSCARENA VXOR MOESTISS
VIRO DE SE BENEM. F.

DECESSIT XIIII CALEN MARTII M D LXXXVI
ANNO AETATIS LIIII

100. Workshop of Vittoria, monument of Giovanni Battista Peranda, S. Maria degli Angeli, Murano (orig. S. Sepolcro, Venice) (Böhm 2538N)

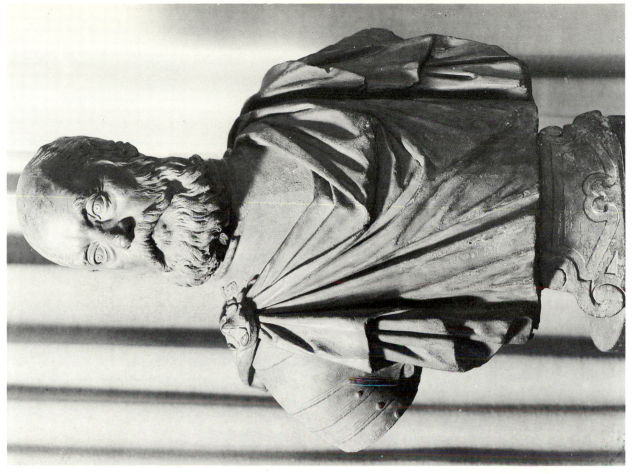

102. Alessandro Vittoria, bust of Francesco Duodo, Museo Civico Correr, Venice (Museum photo)

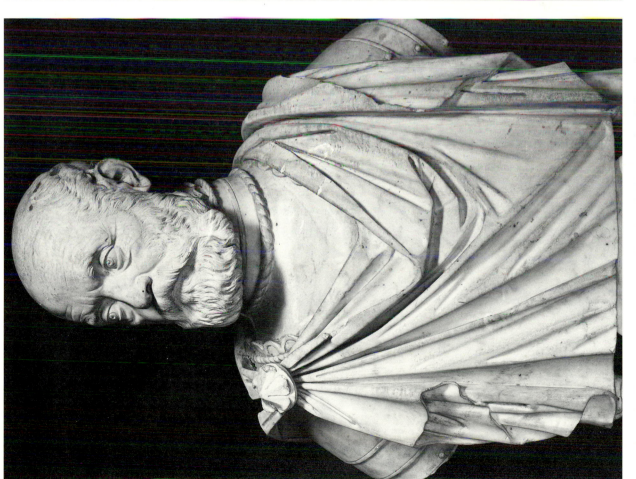

101. Alessandro Vittoria, bust of Francesco Duodo, Cà d'Oro, Venice (Böhm 723)

104. Workshop of Vittoria, bust of Antonio Zorzi, S. Stefano, Venice (Böhm 13148)

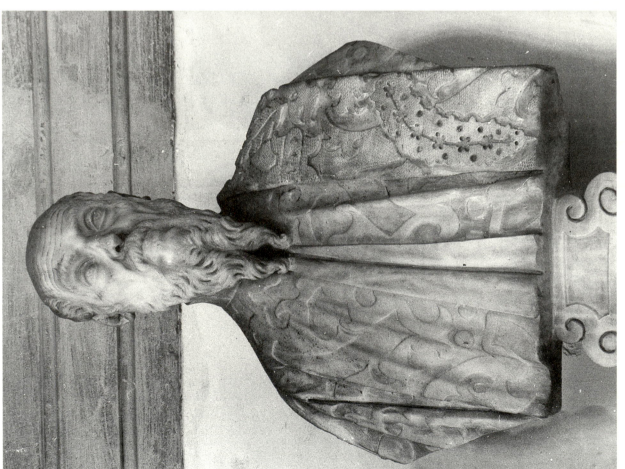

103. Workshop of Vittoria, bust of Vincenzo Morosini, S. Giorgio Maggiore, Venice (Böhm 13195)

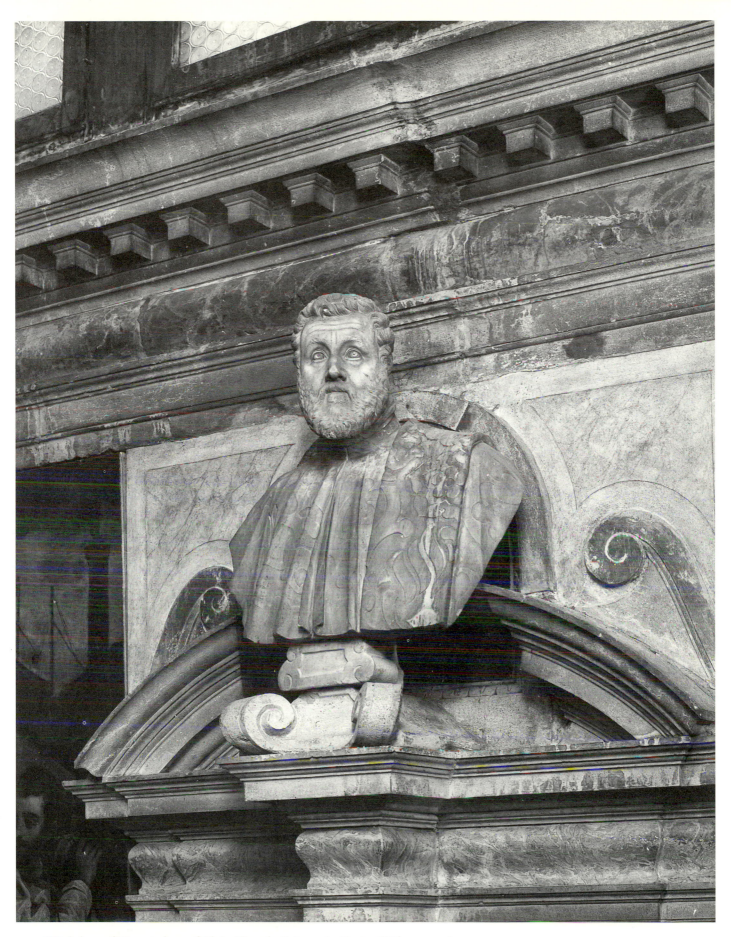

105. Workshop of Vittoria, bust of Alvise Tiepolo, S. Antonin, Venice (Böhm 13129)

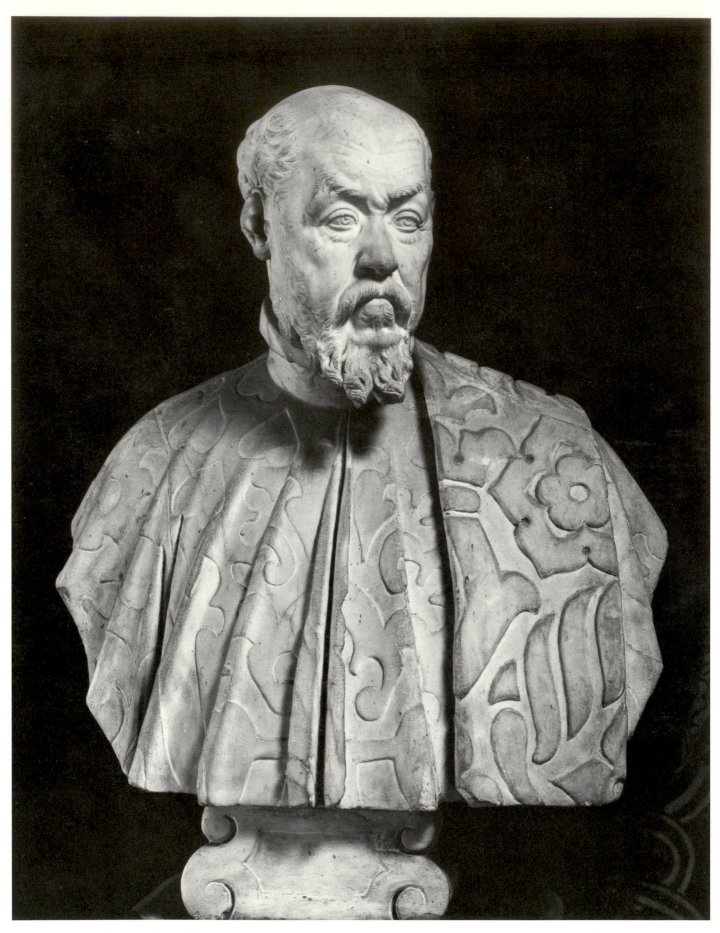

106. Workshop of Vittoria, bust of Domenico Duodo, Cà d'Oro, Venice (Böhm 726)

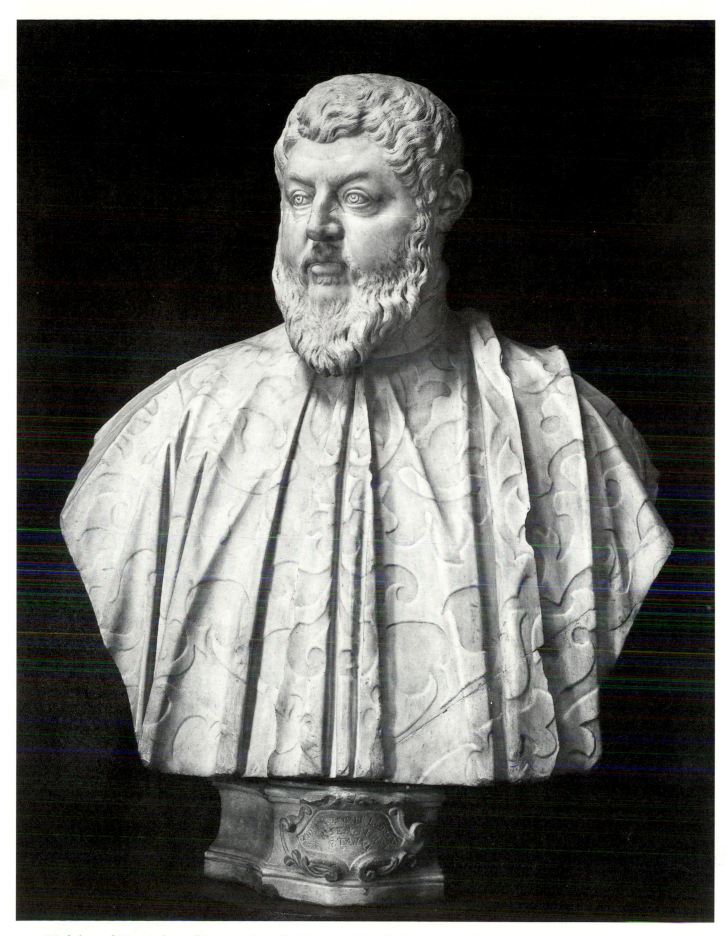

107. Workshop of Vittoria, bust of Lorenzo Cappello, Museo del Castello Buon Consiglio, Trent (Alinari/Art Resource AL21120)

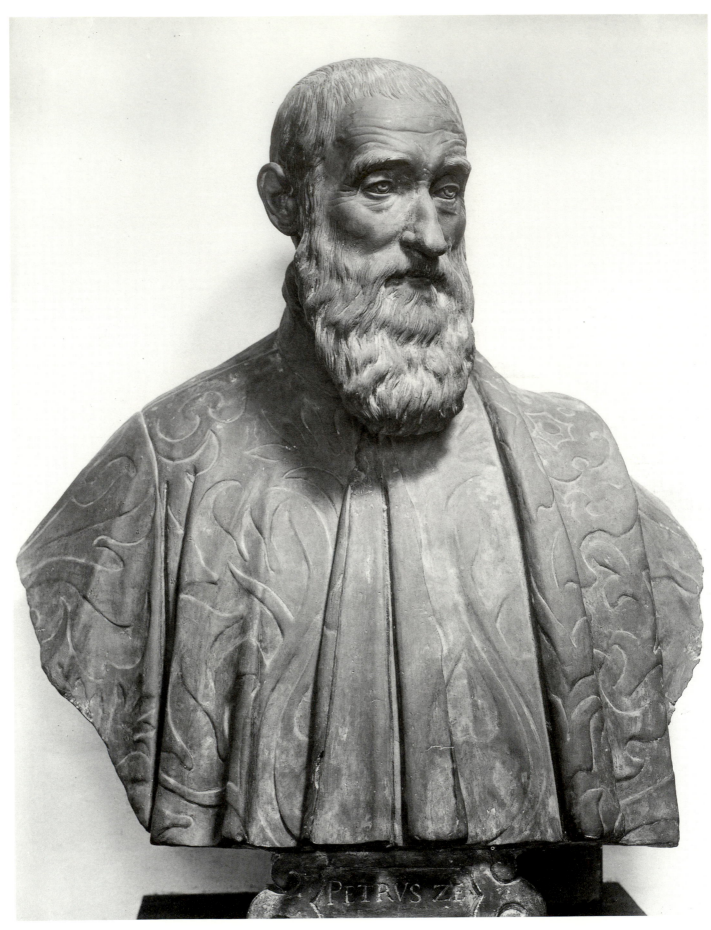

108. Alessandro Vittoria, bust of Pietro Zen, Seminario Patriarcale, Venice (Alinari/Art Resource AL13025)

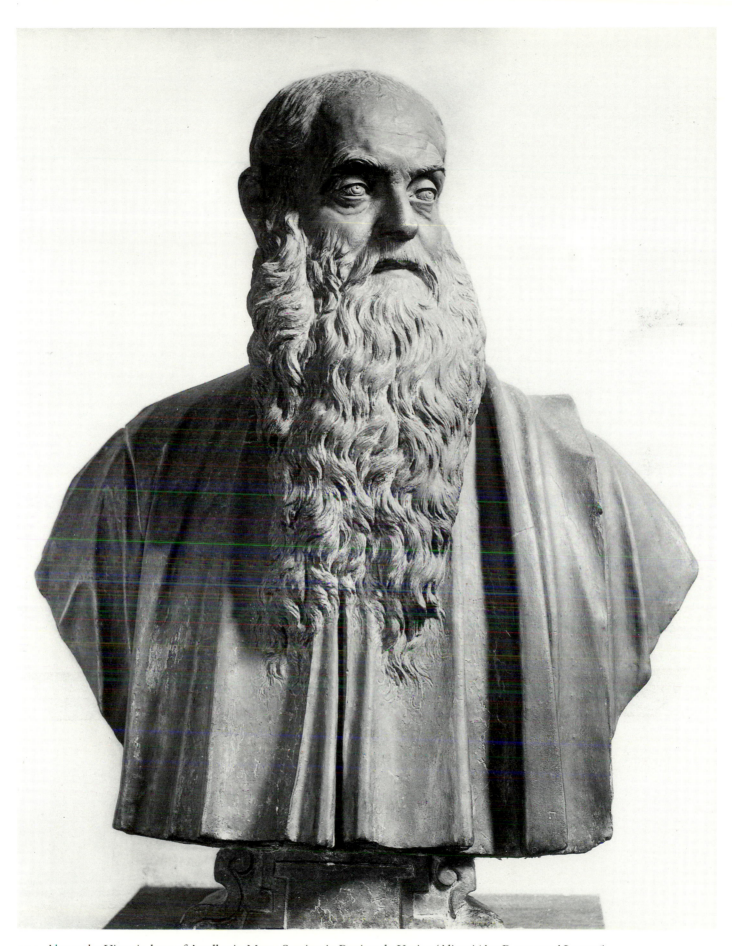

109. Alessandro Vittoria, bust of Apollonio Massa, Seminario Patriarcale, Venice (Alinari/Art Resource AL 13026)

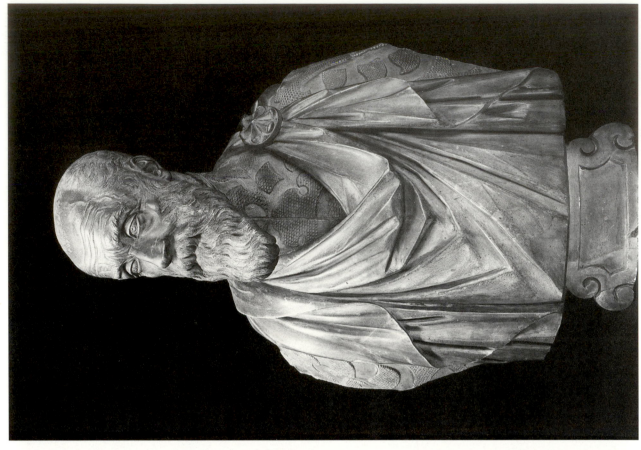

111. Vittoria and workshop, bust of Marino Grimani, Museo del Palazzo Venezia, Rome (Alinari/Art Resource AL40773)

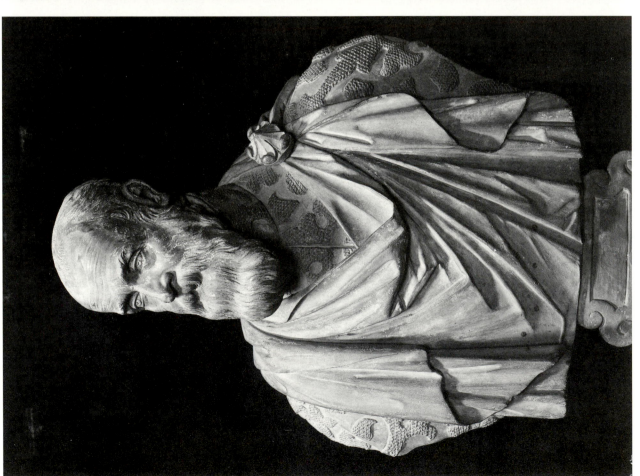

110. Alessandro Vittoria, bust of Marino Grimani, Cà d'Oro, Venice (Böhm 727)

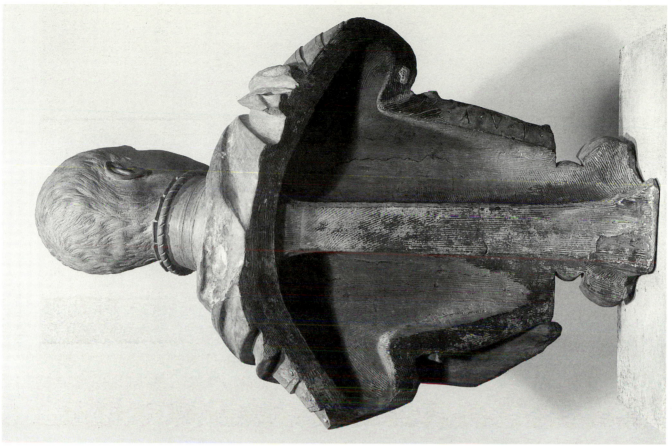

113. Back view of bust of 'Young Zorzi', Samuel H. Kress Collection, © Board of Trustees, National Gallery of Art, Washington, DC (Museum photo)

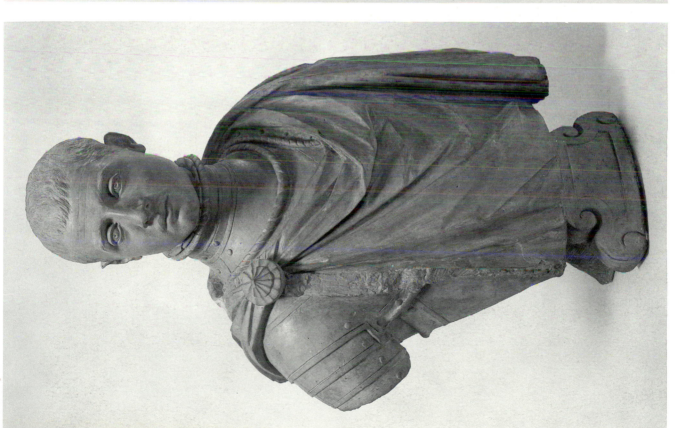

112. Alessandro Vittoria, bust of 'Young Zorzi', Samuel H. Kress Collection, © Board of Trustees, National Gallery of Art, Washington, DC (Museum photo)

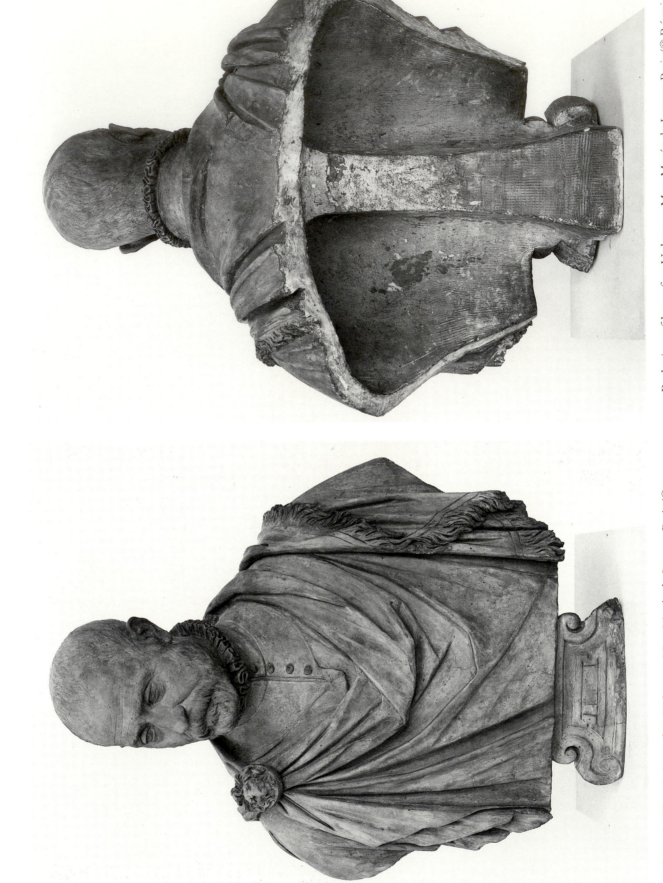

114. Alessandro Vittoria, bust of an Unknown Man, Musée du Louvre, Paris (© Réunion des musées nationaux)

115. Back view of bust of an Unknown Man, Musée du Louvre, Paris (© Réunion des musées nationaux)

116. Alessandro Vittoria, model of 'Architecture', Museo di Scienze
Archeologiche e d'Arte, Padua (by kind permission of the Museum of
Science and Archaeology, University of Padua)

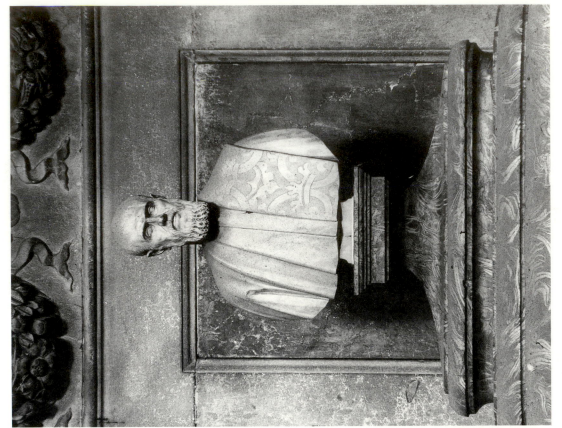

118. Girolamo Campagna, bust of Andrea Dolfin, S. Salvatore, Venice (Böhm 12253)

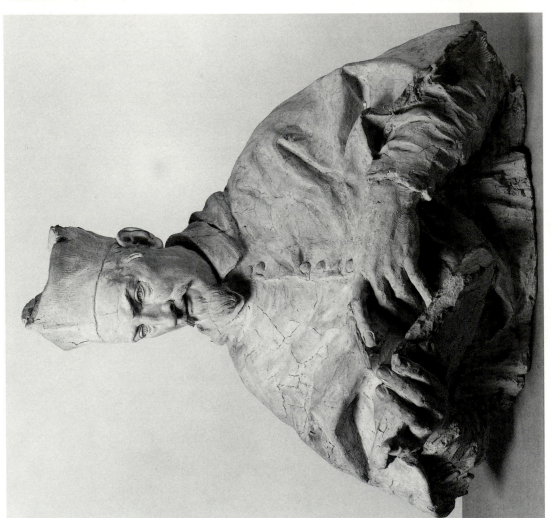

117. Alessandro Algardi, bust of Cardinal Paolo Emilio Zacchia, Courtesy of the Board of Trustees of the Victoria & Albert Museum, London (Museum photo)

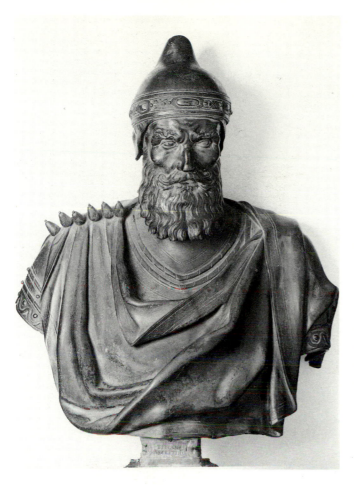

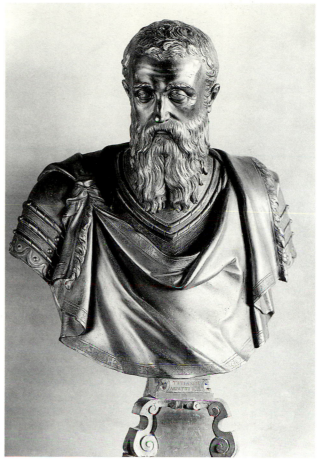

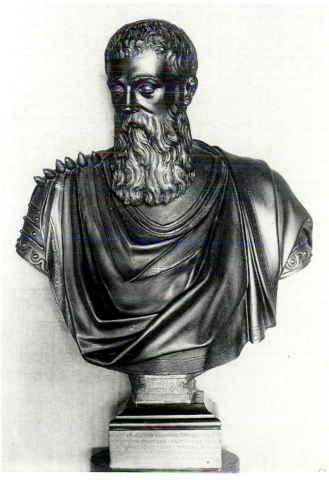

119 (above, left). Tiziano Aspetti, bust of Sebastiano Venier, palazzo Ducale, Venice (Böhm 20119)

120 (above, right). Tiziano Aspetti, bust of Antonio Barbarigo, palazzo Ducale, Venice (Böhm 2689)

121 (left). Tiziano Aspetti, bust of Marc'Antonio Bragadin, palazzo Ducale, Venice (Böhm 2688)

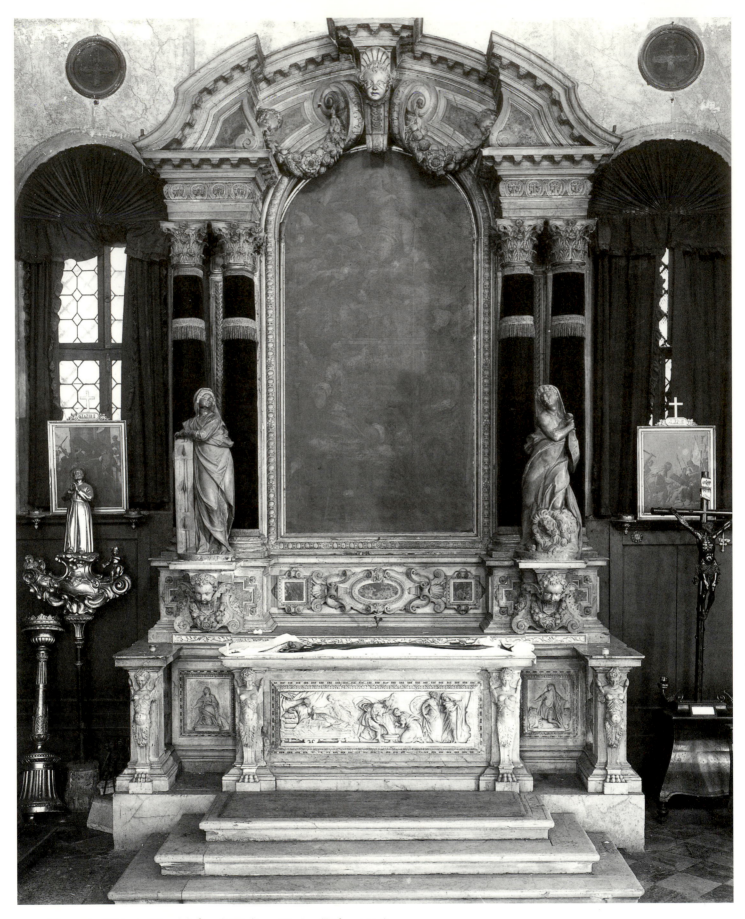

122. Alessandro Vittoria, Merciai altar, S. Giuliano, Venice (Böhm 3634)

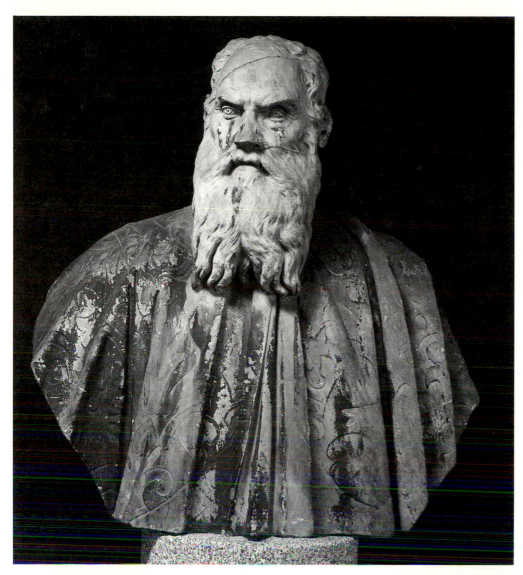

123. Alessandro Vittoria, bust of Giovanni Donà, Cà d'Oro, Venice (orig. SS Giovanni e Paolo) (Böhm 724)

124 (below, left). Alessandro Vittoria, bust of Giovanni Donà *in situ* (from Jan Grevembroch, *Monumenta Veneta . . .*, Biblioteca Civico Correr, Mss. Gradenigo 228, III, 89) (Museum photo)

125 (below, right). Duodo Monument, Monselice

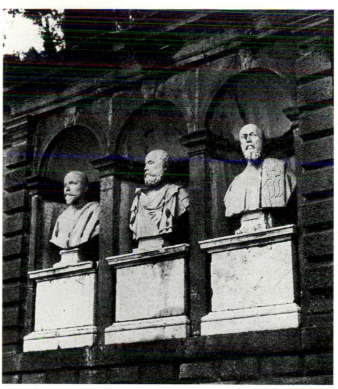

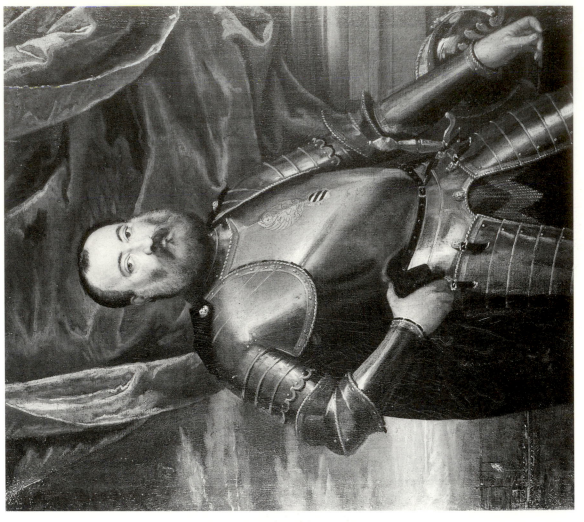

127. Paolo Veronese, portrait of Girolamo Contarini, John G. Johnson Collection, Philadelphia Museum of Art (Museum photo)

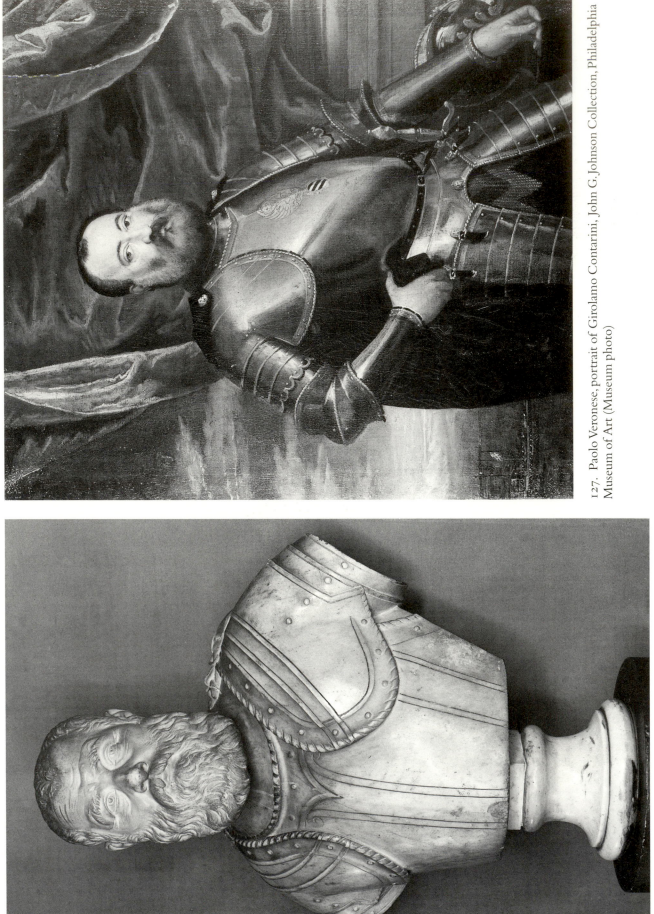

126. Workshop of Vittoria (Giulio del Moro?), bust of Girolamo Contarini, palazzo Ducale, Venice (orig. S. Sepolcro) (Böhm 15049)

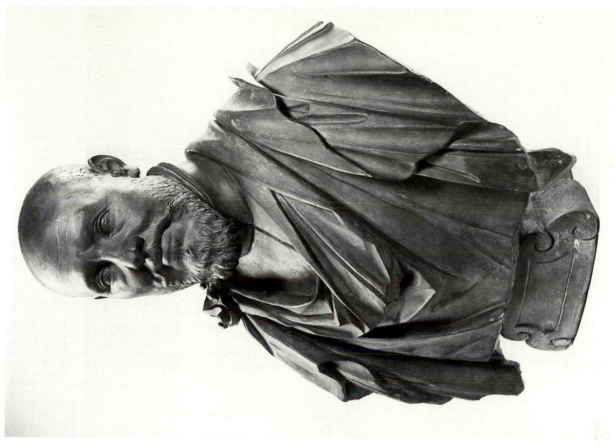

129. Workshop of Vittoria, bust of 'Tommaso Contarini', Royal Ontario Museum, Toronto (Museum photo)

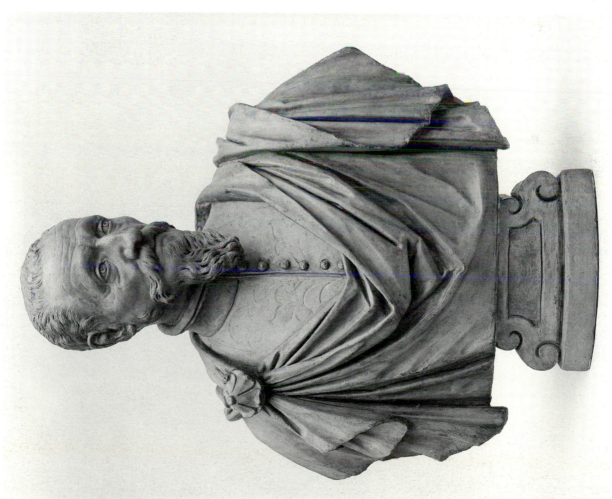

128. Workshop of Vittoria, bust of a Venetian nobleman ('Tommaso Contarini'), Metropolitan Museum of Art, New York, Hewitt Fund (Museum photo)

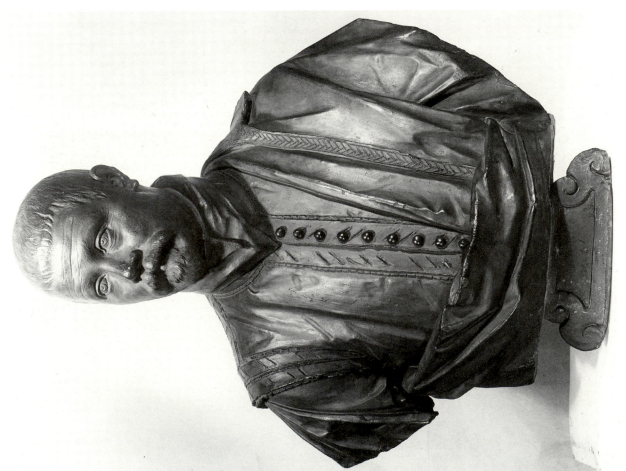

131. Back view of bust of Palma Giovane, Kunsthistorisches Museum, Vienna (Museum photo)

130. Workshop of Vittoria, bust of Palma Giovane, Kunsthistorisches Museum, Vienna (Museum photo)

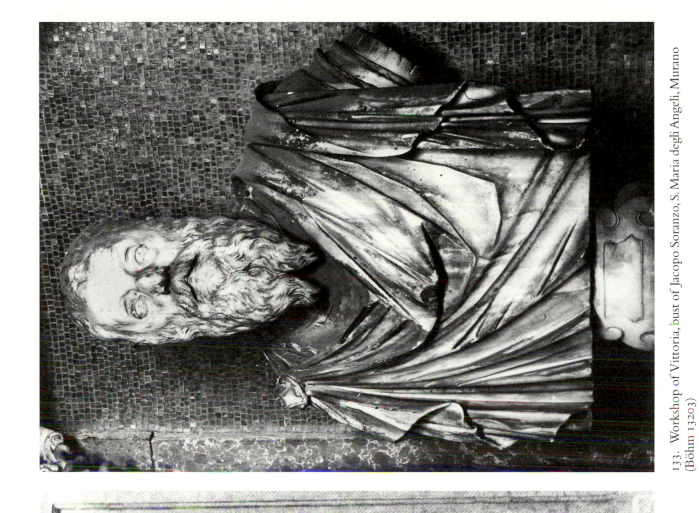

133. Workshop of Vittoria, bust of Jacopo Soranzo, S. Maria degli Angeli, Murano (Böhm 13203)

132. Workshop of Vittoria, bust of Antonio Montecatino, S. Paolo, Ferrara

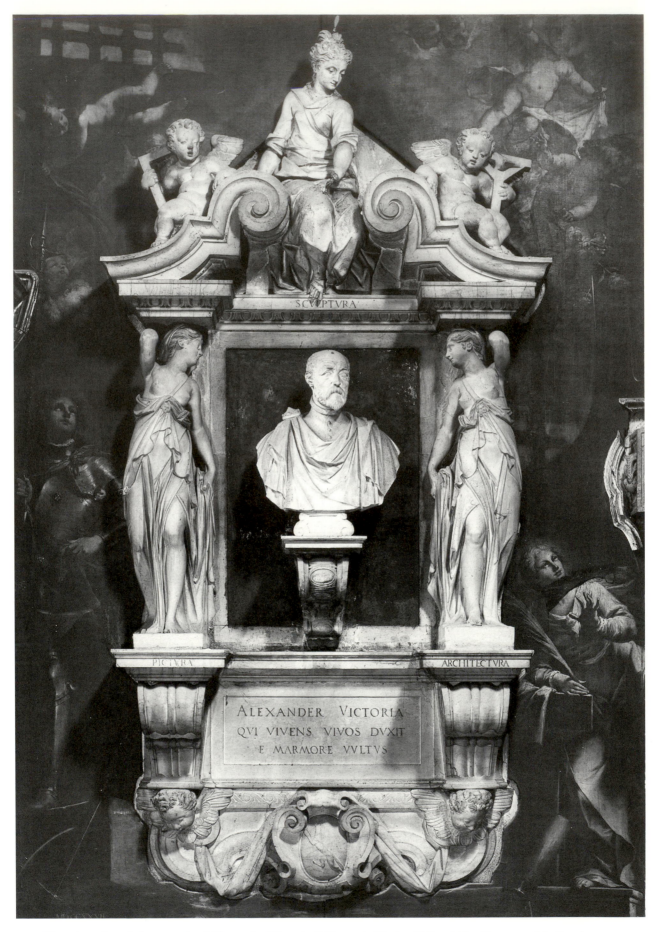

134. Vittoria and workshop, tomb of Alessandro Vittoria, S. Zaccaria, Venice (Alinari/Art Resource AL38730)

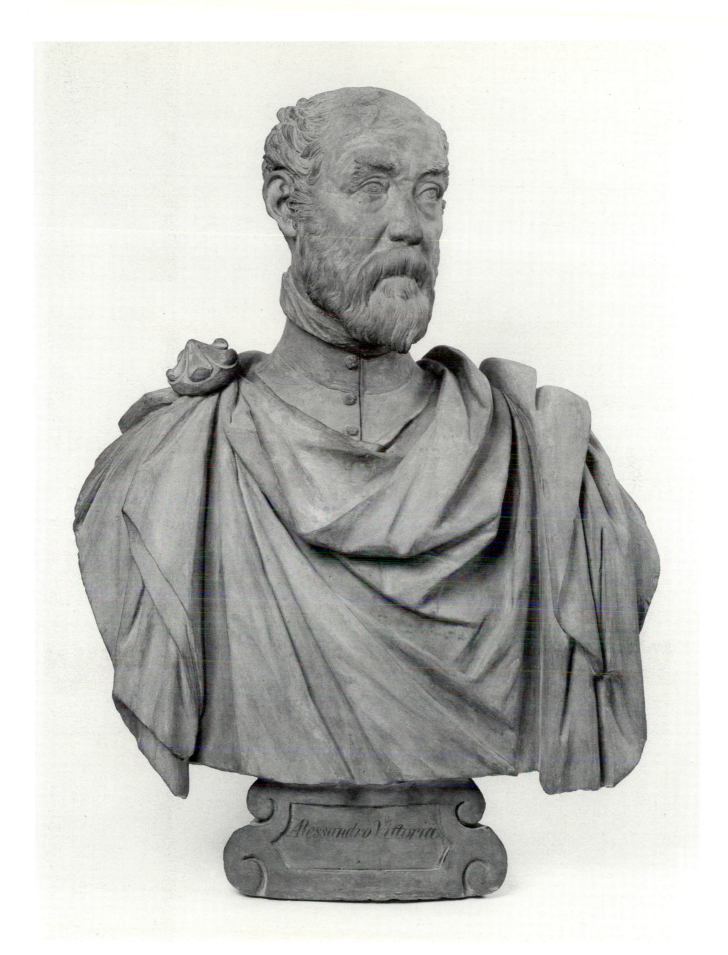

135. Workshop of Vittoria, bust of Alessandro Vittoria, Courtesy of the Board of Trustees of the Victoria & Albert Museum, London (Museum photo)

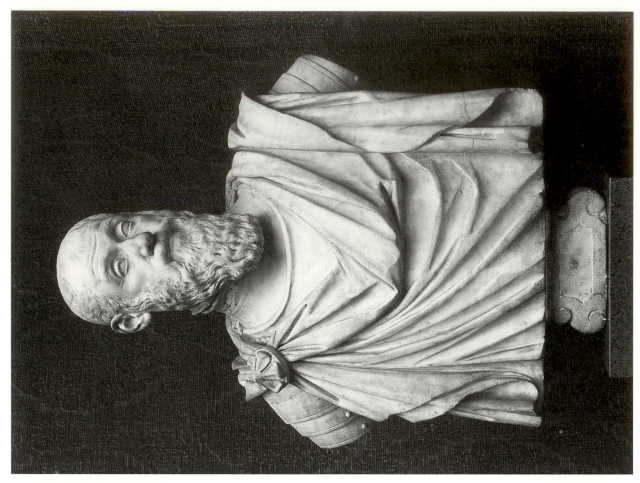

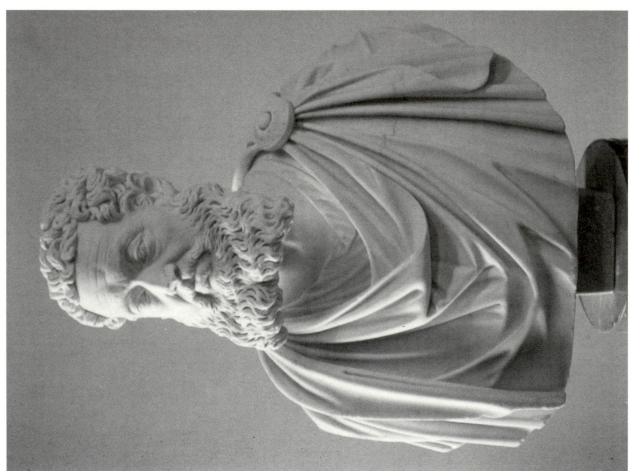

136. Workshop of Vittoria, bust of a member of the Pellegrini family?, Museo Civico,
Vicenza (Museum photo)

137. Workshop of Vittoria, bust of 'Pietro Zen', Staatliche Museen zu Berlin,
Preussischer Kulturbesitz, Berlin (Museum photo)

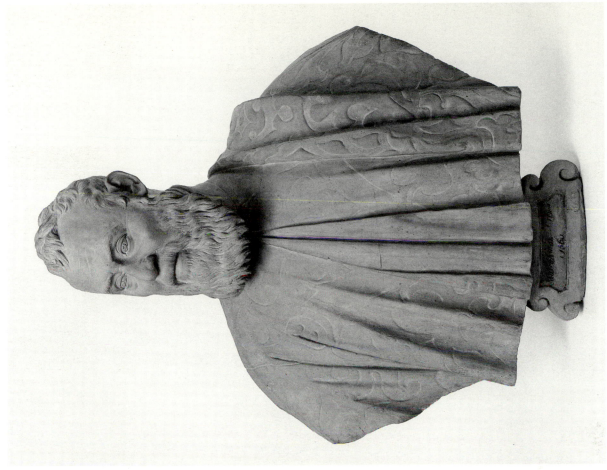

139. Workshop of Vittoria, bust of a Man ('Marc'Antonio Grimani'), Courtesy of the Board of Trustees of the Victoria & Albert Museum, London (Museum photo)

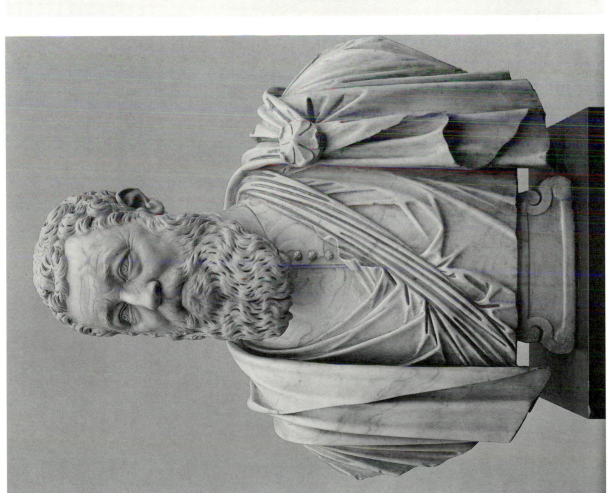

138. Workshop of Vittoria, bust of a Venetian gentleman ('Procurator'), Metropolitan Museum of Art, New York, Harris Brisbane Dick Fund (Museum photo)

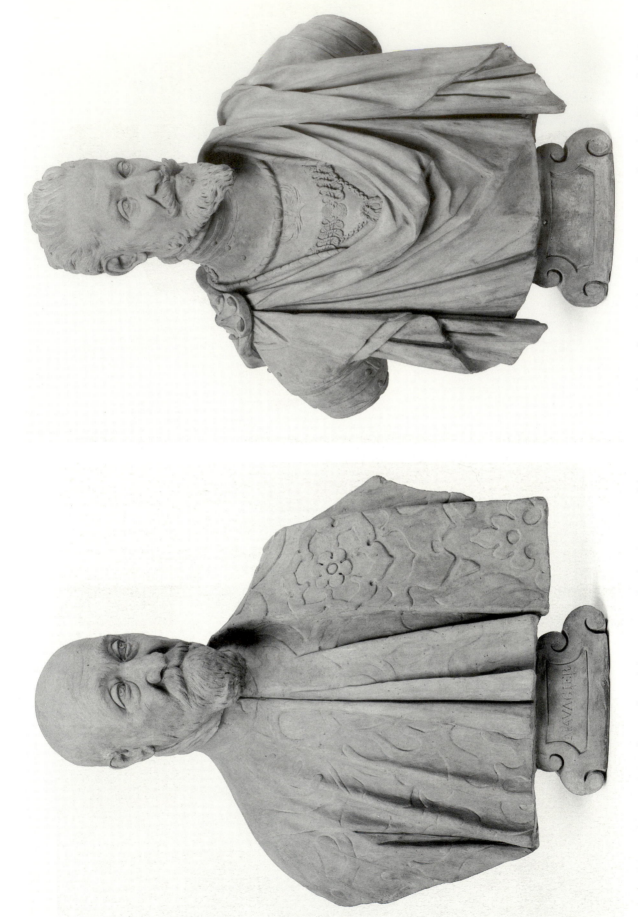

140. Workshop of Vittoria, bust of a member of the Navagero family?, Courtesy of the Board of Trustees of the Victoria & Albert Museum, London (Museum photo)

141. Workshop of Vittoria, bust of a man wearing the order of St Michael, Courtesy of the Board of Trustees of the Victoria & Albert Museum, London (Museum photo)

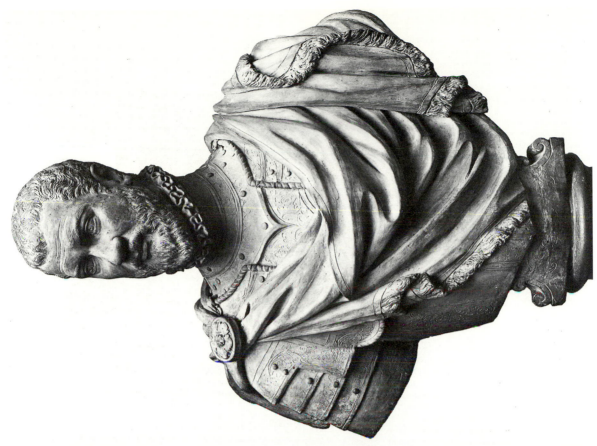

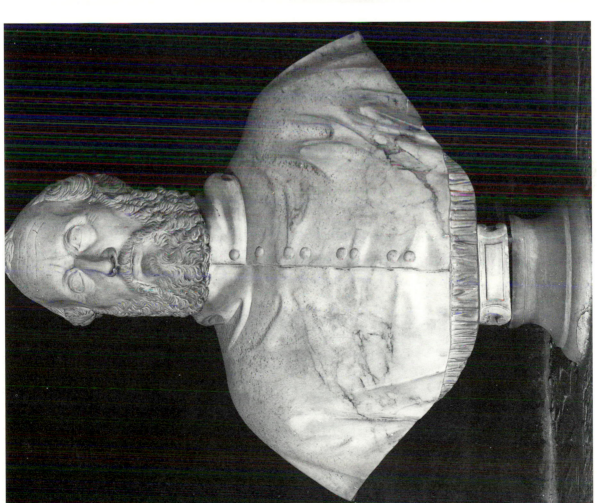

143. 'Admiral Contarini', formerly Kaiser Friedrich Museum, Berlin (photo courtesy of the Staatliche Museen, Berlin, Preussischer Kulturbesitz)

142. Bust of Cardinal Gasparo Contarini, Contarini Chapel, Madonna dell'Orto, Venice (Alinari 14281)

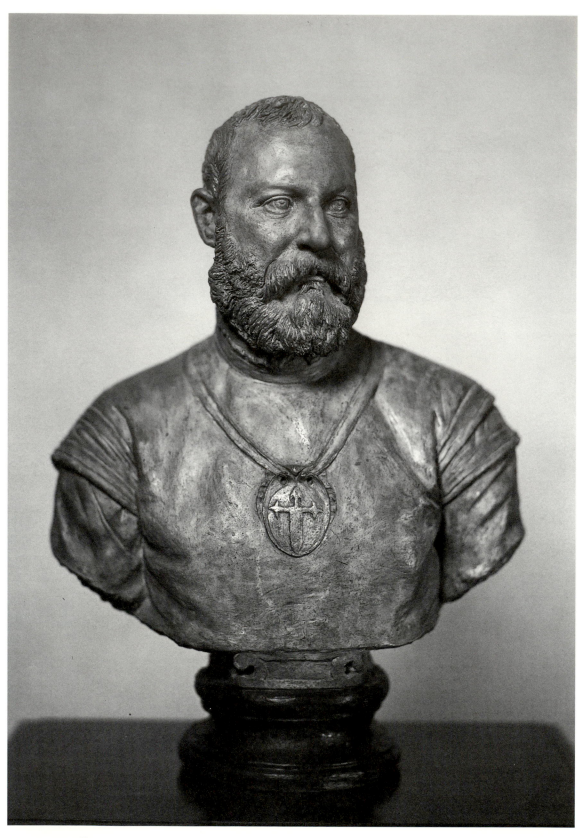

144. Jacopo Albarelli (?), bust of a Knight of Santiago, Samuel H. Kress Collection, © Board of Trustees, National Gallery of Art, Washington, DC (Museum photo)

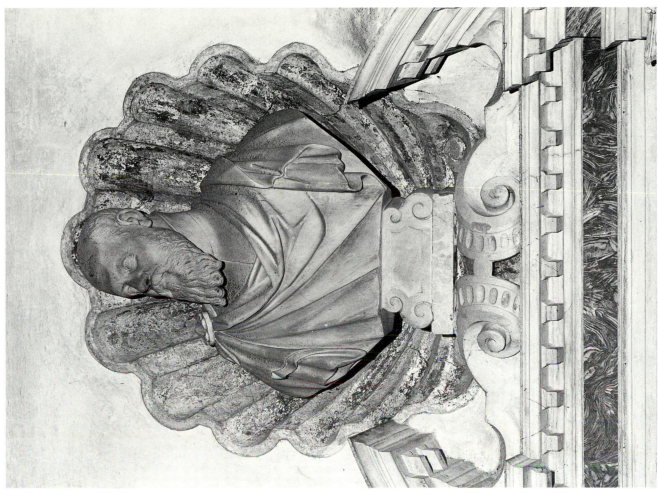

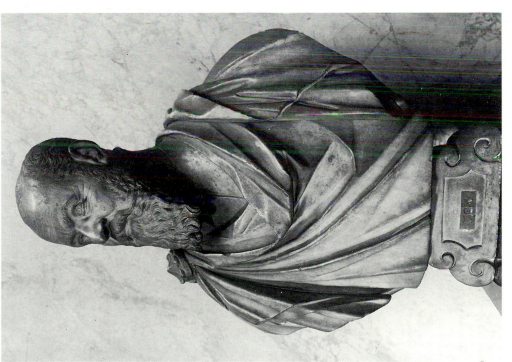

145. Giulio del Moro, bust of Paresano Paresani ('Francesco Duodo'), Musée Jacquemart-André, Paris (Bulloz)

146. Giulio del Moro, bust of Paresano Paresani, S. Fantin, Venice (Böhm 18646)

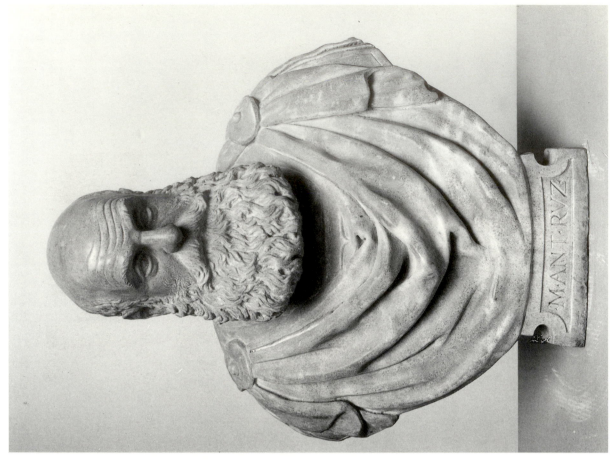

148. Domenico da Salò, bust of Marc'Antonio Ruzzini, Statens Museum for Kunst, Copenhagen (photo courtesy of the Statens Museum for Kunst, Copenhagen)

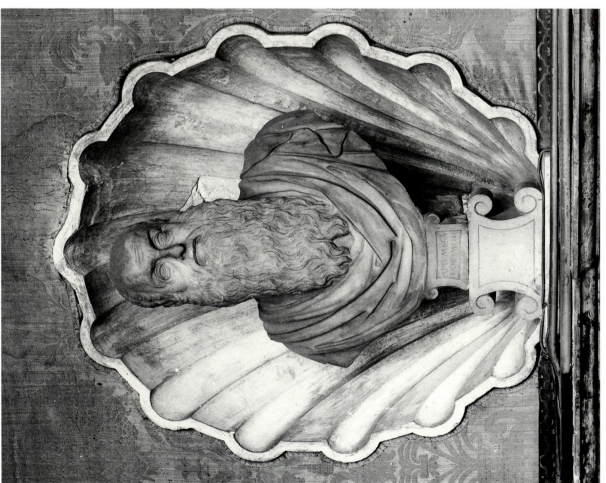

147. Domenico da Salò (?), bust of Apollonio Massa, Ateneo Veneto, Venice (orig. S. Domenico di Castello) (Böhm 1914)

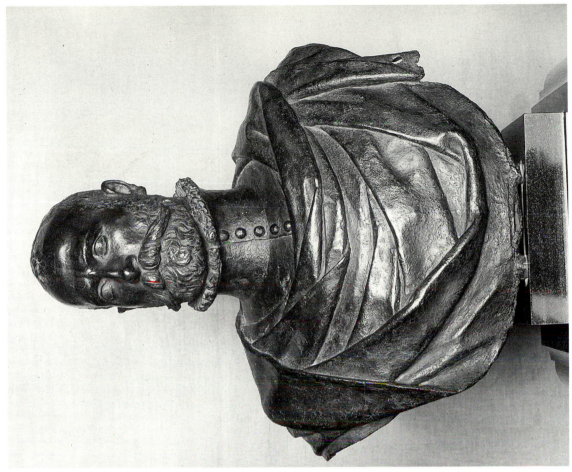

150. Agostino Zoppo, bust of an Unknown Man, Kunsthistorisches Museum, Vienna (Museum photo)

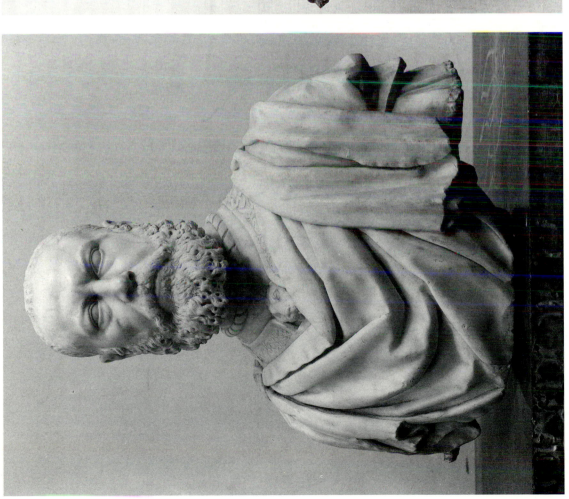

149. 'Leonardo Rinaldi', National Gallery, London (reproduced by courtesy of the Trustees, The National Gallery, London)

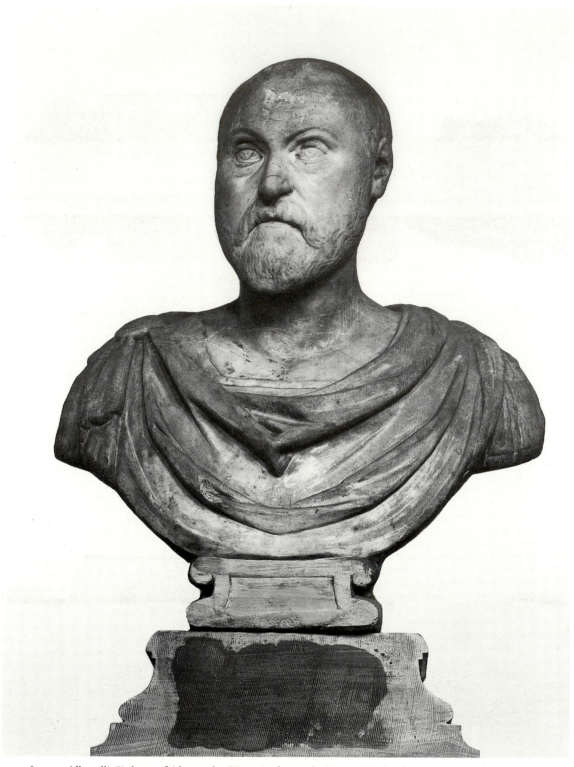

151. Jacopo Albarelli (?), bust of Alessandro Vittoria, formerly Kaiser Friedrich Museum, Berlin (photo courtesy of the Staatliche Museen, Berlin, Preussischer Kulturbesitz)

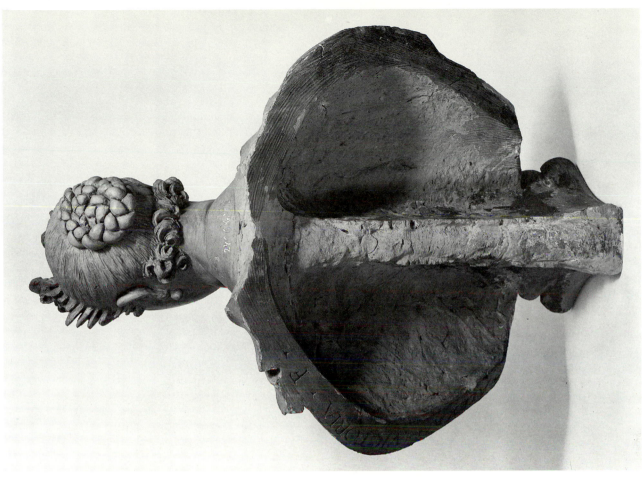

153. Back view of bust of an Unknown Woman, Samuel H. Kress Collection, © Board of Trustees, National Gallery of Art, Washington, DC (Museum photo)

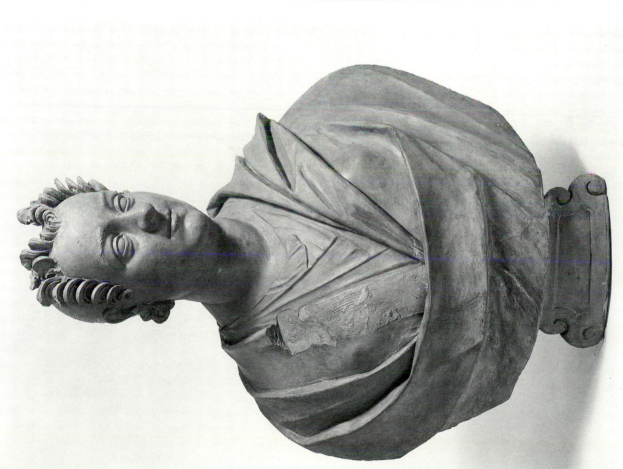

152. Bust of an Unknown Woman, Samuel H. Kress Collection, © Board of Trustees, National Gallery of Art, Washington, DC (Museum photo)

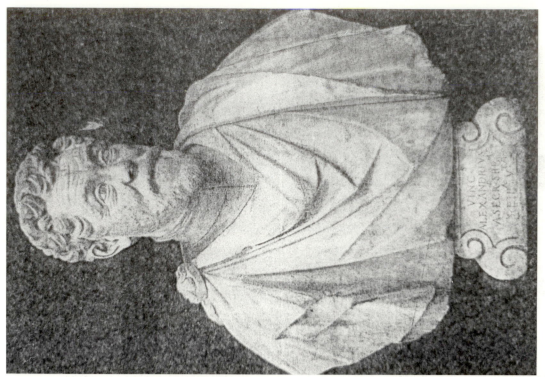

155. Workshop of Vittoria, bust of Vincenzo Alessandri, whereabouts unknown

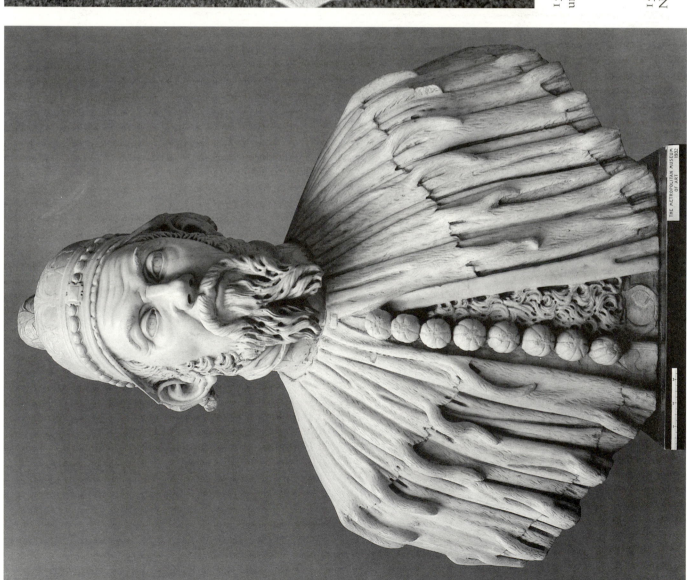

154. Doge Francesco Contarini (?), Metropolitan Museum of Art, New York, Michael Friedsam Collection (Museum photo)

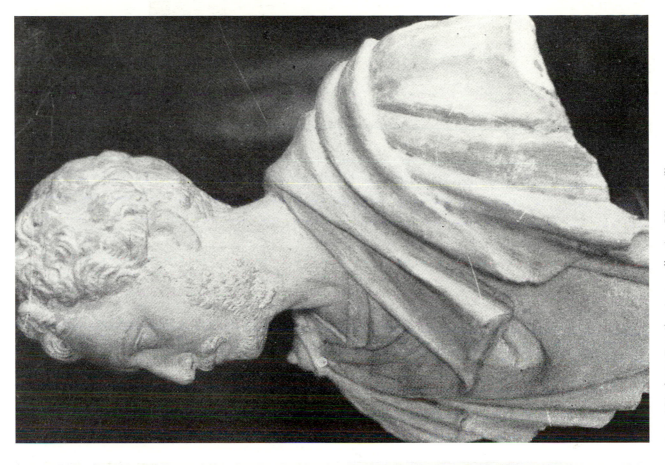

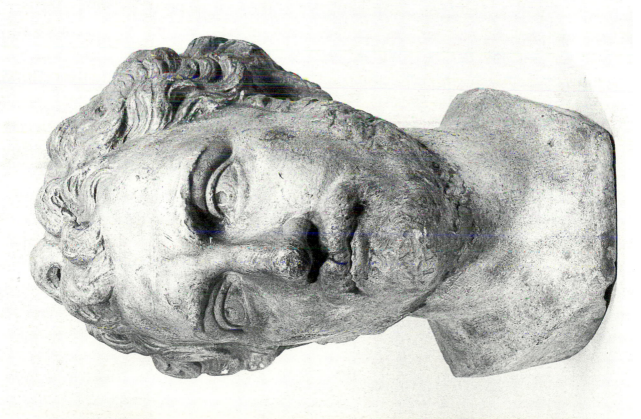

157. 'Girolamo Forni', private collection, Vicenza (?)

156. Head of an 'Oriental', Museo di Scienze Archeologie e d'Arte, Padua (by kind permission of the Museum of Archaeology and Art, University of Padua)

159. Workshop of Vittoria, bust of Guglielmo Helman from Helman monument (Böhm 21634)

158. Workshop of Vittoria, monument of Guglielmo and Antonio Helman, S. Maria Formosa, Venice (Böhm 22630)

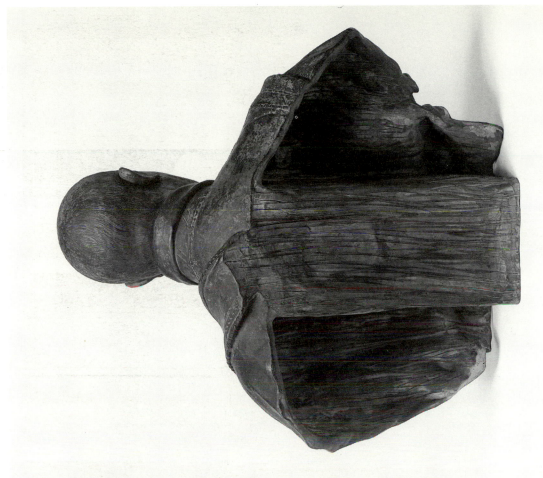

161. Back view of bust after bust of Palma Giovane, Philadelphia Museum of Art, Philadelphia (Museum photo)

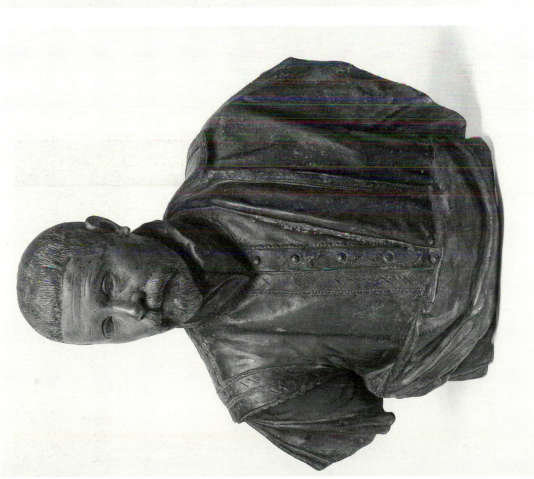

160. After bust of Palma Giovane, Philadelphia Museum of Art, Philadelphia (Museum photo)

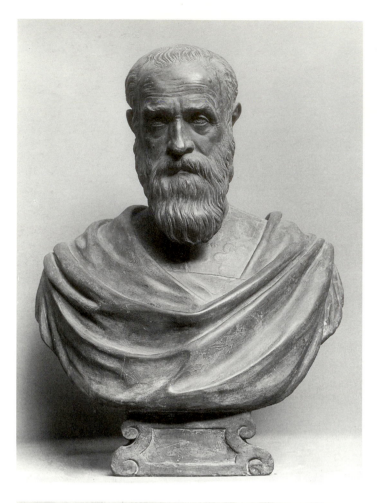

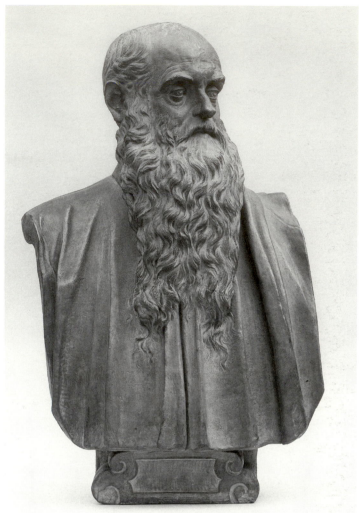

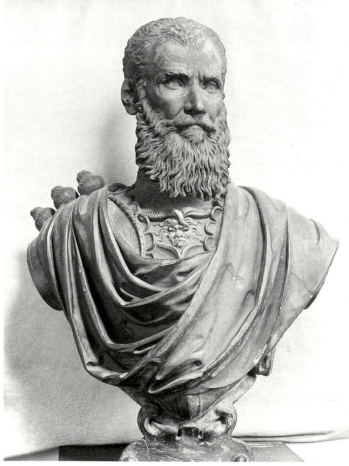

162 (above, left). After bust of Marino Grimani, The Walters Art Gallery, Baltimore (Museum photo)

163 (above, right). After bust of Apollonio Massa, Metropolitan Museum of Art, New York, Gift of Stanley Mortimer (Museum photo)

164 (left). 'Carlo Zen', Seminario Patriarcale, Venice (Alinari/Art Resource AL 13024)